The Philosophy of Art

READINGS ANCIENT AND MODERN

The Philosophy of Art

READINGS ANCIENT AND MODERN

Alex Neill
Trinity University

Aaron Ridley
University of Southampton

Boston, Massachusetts Burr Ridge, Illinois Dubuque, Iowa
Madison, Wisconsin New York, New York San Francisco, California
St. Louis, Missouri

McGraw-Hill

A Division of The McGraw-Hill Companies

This book was set in Palatino by ComCom, Inc.
The editors were Cynthia Ward, Judith R. Cornwell, and David Dunham;
the production supervisor was Kathryn Porzio.
The cover was designed by Jo Jones.
R. R. Donnelley & Sons Company was printer and binder.

Cover: Tiepolo: "The Triumph of Virtue and Nobility over Ignorance."

THE PHILOSOPHY OF ART
Readings Ancient and Modern

Acknowledgments appear on pages xv–xviii, and on this page by reference.

This book is printed on acid-free paper.

90 DOC DOC 019876543

ISBN 0-07-046192-9

Library of Congress Cataloging-in-Publication Data

Neill, Alex.
 The philosophy of art: readings ancient and modern / Alex Neill,
Aaron Ridley.
 p. cm.
 Includes bibliographical references.
 ISBN 0-07-046192-9
 1. Art—Philosophy. 2. Aesthetics. I. Ridley, Aaron.
II. Title.
BH39.N43 1995
111'.85—dc20 94-37453

http://www.mhhe.com

ABOUT THE EDITORS

ALEX NEILL is an assistant professor of philosophy at Trinity University, San Antonio, Texas. He has also taught at Cambridge University, Southampton University, and Anglia Polytechnic University in the United Kingdom, and at Penn State Harrisburg in the United States. He is associate editor of the journal *Philosophy and Literature* and has published a number of articles on topics in aesthetics. With Aaron Ridley, he is editor of *Arguing about Art: Contemporary Philosophical Debates* (McGraw-Hill, 1994).

AARON RIDLEY is a lecturer in philosophy at the University of Southampton, England. He has also taught at Cambridge University, the University College of North Wales, Bangor, Anglia Polytechnic University in the United Kingdom, and at Ithaca College in the United States. He is the author of *Music, Value and the Passions* (Cornell University Press, 1995) and a number of articles on topics in aesthetics. With Alex Neill, he is editor of *Arguing about Art: Contemporary Philosophical Debates* (McGraw-Hill, 1994).

CONTENTS

PREFACE

This anthology is intended to provide teachers of courses in aesthetics and the philosophy of art with a wide range of readings from both the history of the philosophy of art and contemporary work in the field. It is intended to make such courses more convenient and rewarding to teach. It is also intended to provide students of every degree of sophistication with readings from which they can benefit. Some will find in this collection an introduction to the philosophy of art. Others will find food to deepen their thoughts.

Our first priority has been to include complete pieces wherever possible, and really substantial excerpts where we have had to excerpt. There are no mere snippets here. Inevitably, this means that we have had to omit much that we would have liked to include. We have decided to concentrate on theoretical works, rather than on works which address topics in what is sometimes described as "applied aesthetics." (Our book *Arguing about Art: Contemporary Philosophical Debates* [McGraw-Hill, 1995] is a collection of essays on topics of the latter kind.)

We have kept editorial comment to a minimum, believing that as much space as possible in a book of this sort should be devoted to the primary texts, rather than to commentary upon them. However, we have included brief introductory paragraphs to each of the selected readings. These are intended to provide the student with some background to the claims which the author makes, and an indication of what sort of claims those are as well as to suggest some of the connections between different readings. These features, we hope, should enhance the versatility and usefulness of the collection.

Inevitably, the organization of the material in this collection is somewhat arbitrary. Many of the pieces could, without strain, have been assigned to other sections. Our thematic ordering merely represents one possible principle about which a course on the philosophy of art might be constructed. We begin with the artist, and a variety of reflections on the creative process. We then turn to what the artist produces—artworks. There are a number of writings here which attempt to explore the essential nature of artworks, and some which reject the project embodied in any such attempt. Audiences, the recipients of artworks, come next. We have selected a broad range of pieces which focus on the logic of taste, and on interpretation and authorial intention. And we turn

finally to a set of wider questions concerning the power of art to allay or to realize various human fears and aspirations.

Again, however, this is not the only way in which to organize the material that we have collected in this book. In "Notes on Course Organization," following this preface, we have included some suggestions for alternative orderings of the text, based around the themes of "Art and Emotion," "Art and Knowledge," and "Art and Society," which might be adopted by instructors using the book as the main text in an undergraduate course in the philosophy of art.

Not all of the pieces collected here are equally accessible to an undergraduate readership—although none should be impenetrable. Adorno's piece, for instance, is not tremendously easy to understand; nor is Kant's. But the fact of the matter is platitudinous enough. If one wants the best that has been said and thought about the philosophy of art, then one must expect it to be of varying degrees of complexity, and to be expressed with varying degrees of clarity. We have tried, however, to exclude things which flirt too much with the incomprehensible. We have sought a balance between the philosophically interesting and the readable; and happily, we believe that balance can be struck without undue cost to what is philosophically interesting.

If anyone thinks that we have got the balance wrong, then we should be very grateful to hear from them. In the meantime, however, we hope that this collection will prove as useful to the instructor and as stimulating to the student as we have tried to make it. We have not been alone in our efforts to make this a useful and stimulating collection. Many people have helped us, and their help has come in a wide variety of forms. So for a kaleidoscopic range of assistance, we would like to thank Allan Carlson, Ann Clarke, Sylvia Crisantes, Flo Leibowitz, Jerrold Levinson, Doug McKenty, Marianne Neill, Jim Rather, Chuck Salman, Ann Spencer, Michael Tanner, Kendall Walton and, at McGraw-Hill, David Dunham, Patty Rodney, and our editors Judy Cornwell and Cynthia Ward. We should also like to thank the reviewers who commented on the manuscript at various stages: Jay E. Bachrach, Central Washington University; James D. Carney, Arizona State University; Earle J. Coleman, Virginia Commonwealth University; Susan Feagin, University of Missouri, Kansas City; Garry Hagberg, Bard College; Hilde Hein, Holy Cross College; James Manns, University of Kentucky; James Treanor, Southwest Texas State; Robert Vance, The University of North Carolina at Chapel Hill; Sue Weinberg, Hunter College, CUNY; and Mary Wiseman, Brooklyn College, CUNY.

<div align="right">

Alex Neill
Aaron Ridley

</div>

NOTES ON COURSE ORGANIZATION

Here we suggest some alternative ways in which the contents of this book might be organized. For example, they might be organized so as to offer an historical survey. Such a course might begin with Plato and Aristotle, and the quarrel between philosophy and poetry; move on to Hume and Kant on the paradox of taste; take in the various facets of Romanticism, from Wordsworth to Nietzsche; and conclude in the present century, with its urge to define and its obsession with the problems of interpretation. Interesting courses could also be constructed by combining Sections 1 and 4, or 1 and 3, or 2 and 3, and so on.

Alternatively, the material in this book might be used to construct courses based around the themes of "Art and Emotion," "Art and Knowledge," and "Art and Society." We list some possible orderings of the material for each of these themes below. We imagine that these might be used as modules in a broader course on the philosophy of art: They might be combined with each other, or with some of the sections of the book as they appear in the table of contents. Alternatively, each of them might be used as the basis for a complete course, in which case they could helpfully be supplemented with readings (indicated at the end of each module) from our companion collection *Arguing about Art*.

Art and Emotion

1. Plato: the *Ion;* Wordsworth: from the Preface to *Lyrical Ballads.*
2. Dewey: "Having an Experience"; Collingwood: from *The Principles of Art;* Bell: "The Aesthetic Hypothesis."
3. Elliott: "Aesthetic Theory and the Experience of Art"; Sircello: "Expressive Properties of Art"; Robinson: "Style and Personality in the Literary Work."
4. Plato: from the *Republic;* Aristotle: from the *Poetics;* Tolstoy: from *What Is Art?*

Unit 1 contains readings which conceive of art as essentially an overflow of passion not wholly subject to the artist's control. This raises two questions: First, is it plausible to think of art as essentially emotional? Second, if we do think in this way about art, what are the implications for the *value* of art? The readings in Unit 2 offer approaches to the first question; each presents a way

of understanding the emotional character of art. In Unit 3 the readings expand on and analyze aspects of the theories presented in the previous unit. In Unit 4 the readings return to the second of the questions raised by the readings in Unit 1: What consequences does thinking of art as essentially emotional have for our conception of the value of art?

For a complete course focusing on art and emotion, these readings might usefully be supplemented by the chapters "Appreciation, Understanding, and Nature," "Feelings and Fictions," "The Pleasures of Tragedy," and "Sentimentality" in our collection *Arguing about Art.*

Art and Knowledge

1. Plato: the *Ion;* Eliot: "Tradition and the Individual Talent"; Nochlin: "Why Have There Been No Great Women Artists?"
2. Plato: from the *Republic;* Aristotle: from the *Poetics;* Robinson: "Style and Personality in the Literary Work."
3. Hume: "Of the Standard of Taste"; Kant: "Analytic of the Beautiful"; Sibley: "Aesthetic Concepts"; Walton: "Categories of Art"; Cavell: "Aesthetic Judgment and a Philosophical Claim"; Isenberg: "Critical Communication."
4. Weitz: "The Role of Theory in Aesthetics"; Mandelbaum: "Family Resemblances and Generalization Concerning the Arts"; Danto: "The Artworld"; Dickie: "The New Institutional Theory of Art"; Levinson: "Defining Art Historically"; Eldridge: "Form and Content: An Aesthetic Theory of Art."

Unit 1 raises questions about what an artist needs to know in order to create works of art. The readings in Unit 2 are concerned with what we can learn from art. (In a complete course on art and knowledge, all the material in the second part of Section 3, Intention and Interpretation, could also be included here.) Unit 3 focuses on what we can know about art: Can our judgments about art amount to knowledge claims? And in Unit 4, the readings address the project of defining art: How do we know what counts as art?

In a complete course emphasizing the theme of art and knowledge, these readings might be supplemented with the chapters "Fakes and Forgeries," "Appreciation, Understanding, and Nature," and "Musical Profundity" from *Arguing about Art.*

Art and Society

1. Danto: "The Artworld"; Dickie: "The New Institutional Theory of Art"; Levinson: "Defining Art Historically."
2. Nietzsche: *The Birth of Tragedy;* Battersby: From *Gender and Genius;* Fish: "Is There a Text in This Class?"; Adorno: "On the Fetish Character in Music and the Regression of Listening;" Nochlin: "Why Have There Been No Great Women Artists?"
3. Plato: from the *Republic;* Aristotle: from the *Poetics;* Tolstoy: from *What Is Art?;* Dewey: "Art and Civilization"; Beardsley: "The Arts in the Life of Man."

The readings in Unit 1 explore the issue whether art has an essentially social nature. The role of society in the production and the reception of art is addressed by the readings in Unit 2. And in Unit 3 the effects of art on culture and civilization are explored.

For a complete course focusing on art and society, these readings might usefully be supplemented by the chapters "Colorizing Movies," "Feminism and Aesthetics," "The Idea of the Museum," and "Sentimentality" in *Arguing about Art.*

ACKNOWLEDGMENTS

1. The *Ion* by Plato, translated by Paul Woodruff. (Footnotes omitted.) In *Two Comic Dialogues,* published by Hackett Publishing Company. Reprinted by permission of Hackett Publishing Company. All rights reserved.

2. Excerpts from the Preface to the second edition of *Lyrical Ballads* (1802) by William Wordsworth.

3. Excerpts from sections 1, 7, 8, 9, 10, 11, 12, 13, 14 of *The Birth Of Tragedy* by Friedrich Nietzsche, translated by Walter Kaufmann. (Footnotes omitted.) Copyright © 1967 by Random House, Inc. Reprinted by permission of Random House, Inc.

4. "Creative Writers and Day-Dreaming" by Sigmund Freud, translated by I. F. Grant Duff. (Some footnotes omitted.) In Volume IX of *The Standard Edition of the Complete Psychological Works of Sigmund Freud,* edited by James Strachey, published by The Institute of Psycho-Analysis and The Hogarth Press. Also titled "The Relation of the Poet to Day-Dreaming," in *The Collected Papers, Volume 4,* by Sigmund Freud, authorized translation under the supervision of Joan Riviere, published by Basic Books, Inc. Reprinted by permission of Basic Books, a division of HarperCollins Publishers, Inc., and Random House UK Ltd.

5. "Tradition and the Individual Talent" by T. S. Eliot. In *The Sacred Wood: Essays on Poetry and Criticism,* by T. S. Eliot, published by Methuen & Co. Reprinted by permission.

6. "Having an Experience" by John Dewey. Reprinted by permission of The Putnam Publishing Group from *Art as Experience* by John Dewey. Copyright © 1934 by John Dewey. Copyright © 1962 by Roberta L. Dewey. Copyright © 1974 by The John Dewey Foundation.

7. "The Play of Art" by Hans-Georg Gadamer, translated by Nicholas Walker. From *The Relevance of the Beautiful,* by Hans-Georg Gadamer, edited by Robert Bernasconi, published by Cambridge University Press. English translation © Cambridge University Press 1986. Reprinted with the permission of Cambridge University Press.

8. Chapters 4 and 5 of *Gender and Genius* by Christine Battersby. First published by The Women's Press Ltd, 1989, 34 Great Sutton Street, London EC1V 0DX. Reprinted by permission of The Women's Press Ltd. Excerpts form *The Journals of Anaïs Nin*, edited by Gunther Stuhlmann, published 1966–77 by Peter Owen Publishers Ltd., reprinted by permission of Peter Owen Publishers Ltd., London.

9. "The Aesthetic Hypothesis" by Clive Bell. From *Art* by Clive Bell, published by G. P. Putnam's Sons.

10. "Modernist Painting" by Clement Greenberg. From *Art and Literature* (Spring 1961). Used by permission of Mrs. Janice Greenberg.

11. Excerpts from *The Principles of Art* by R. G. Collingwood. Published by Oxford University Press.

12. "Aesthetic Theory and the Experience of Art" by R. K. Elliott. From *The Proceedings of the Aristotelian Society*, Volume LXII (1966–67). Reprinted by courtesy of the editor of the Aristotelian Society: © 1967.

13. "Expressive Properties of Art" by Guy Sircello. From Guy Sircello, *Mind and Art: An Essay on the Varieties of Expression.* © 1972 by Princeton University Press. Reprinted by permission of Princeton University Press.

14. "The Role of Theory in Aesthetics" by Morris Weitz. From the *Journal of Aesthetics and Art Criticism,* Volume 15 (1956). Reprinted by permission of the American Society for Aesthetics.

15. "Family Resemblances and Generalizations Concerning the Arts" by Maurice Mandelbaum. From the *American Philosophical Quarterly*, Volume 2 (1965). Reprinted by permission of the *American Philosophical Quarterly.*

16. "The Artworld" by Arthur Danto. From the *Journal of Philosophy*, Volume 61 (1964). Reprinted by permission.

17. "The New Institutional Theory of Art" by George Dickie. From *Aesthetics, Proceedings of the Eighth International Wittgenstein Symposium, Part I*, edited by Rudolph Haller, published by Holder-Pichler-Tempsky. Reprinted by permission.

18. "Defining Art Historically" by Jerrold Levinson. From the *British Journal of Aesthetics*, Volume 19 (1979). Reprinted by permission of Oxford University Press.

19. "Form and Content: An Aesthetic Theory of Art" by Richard Eldridge. From the *British Journal of Aesthetics*, Volume 25 (1985). Reprinted by permission of Oxford University Press.

20. "Of the Standard of Taste" by David Hume, with editorial notes by Eugene F. Miller. In *Essays Moral, Political and Literary,* by David Hume, edited by Eugene F. Miller. Revised edition published by Liberty Fund, Inc., 8335 Allison Pointe Trail, #300, Indianapolis, IN 46250, 1987.

21. "Analytic of the Beautiful" by Immanuel Kant, translated by James Creed Meredith. From *The Critique of Judgment,* by Immanuel Kant, translated with analytical indexes by James Creed Meredith. Published by Oxford University Press.

22. Excerpts from "Psychical Distance" by Edward Bullough. From the *British Journal of Psychology,* Volume 5, 1912. Published by permission of the British Psychological Society.

23. "Aesthetic Concepts" by Frank Sibley. From the *Philosophical Review,* Volume 68 (1959).

24. "Categories of Art" by Kendall Walton. From the *Philosophical Review,* Volume 79 (1970).

25. "Aesthetic Judgment and a Philosophical Claim" by Stanley Cavell. Excerpted from "Aesthetic Problems of Modern Philosophy," in *Must We Mean What We Say,* by Stanley Cavell, second edition published by Cambridge University Press. © Stanley Cavell 1969. © Cambridge University Press 1976. Reprinted with the permission of Cambridge University Press.

26. "Critical Communication" by Arnold Isenberg. From the *Philosophical Review,* Volume 58 (1949).

27. "The Intentional Fallacy" by W. K. Wimsatt and Monroe C. Beardsley. Reprinted from *The Verbal Icon* by W. K. Wimsatt. Copyright © 1954 by the University Press of Kentucky, renewed 1982 by Margaret H. Wimsatt. Reprinted with the permission of the University Press of Kentucky.

28. "The Death of the Author" by Roland Barthes. From *Image-Music-Text* by Roland Barthes, translated by Stephen Heath. English translation copyright © 1977 by Stephen Heath. Reprinted by permission of Hill and Wang, a division of Farrar, Straus & Giroux, Inc., and HarperCollins Publishers Limited.

29. "In Defense of the Author" by E. D. Hirsch, Jr. From *Validity in Interpretation* by E. D. Hirsch, Jr., published by Yale University Press. Copyright © 1967 by Yale University Press. Reprinted with the permission of Yale University Press.

30. "Criticism as Retrieval" by Richard Wollheim. From *Art and Its Objects* by Richard Wollheim, second edition published by Cambridge University Press. © Cambridge University Press 1980. Reprinted with the permission of Cambridge University Press.

31. "Intentional Visual Interest: Picasso's *Portrait of Kahnweiler*" by Michael Baxandall. From *Patterns of Intention* by Michael Baxandall, published by Yale University Press. Copyright © 1985 by Yale University. Reprinted with the permission of Yale University Press.

32. "Style and Personality in the Literary Work" by Jenefer Robinson. From the *Philosophical Review,* Volume 94 (1985). Copyright 1985 by Cornell

University. Reprinted by permission of the *Philosophical Review* and the author.

33. "Is There a Text in This Class?" by Stanley Fish. Reprinted by permission of the publishers from *Is There A Text In This Class?* by Stanley Fish, Cambridge, Mass.: Harvard University Press. Copyright © 1980 by the President and Fellows of Harvard College.

34. "Against Interpretation" by Susan Sontag. From *Against Interpretation and Other Essays* by Susan Sontag. Copyright © 1964, 1966 by Susan Sontag. Reprinted by permission of Farrar, Straus & Giroux, Inc.

35. Excerpts from *The Republic of Plato,* translated by F. M. Cornford. (Some footnotes omitted.) Published by Oxford University Press.

36. Excerpts from the *Poetics* by Aristotle, translated by Stephen Halliwell. (Some footnotes omitted.) From *The Poetics of Aristotle,* translation and commentary by Stephen Halliwell, published by Gerald Duckworth & Co. Ltd. Reprinted by permission of Gerald Duckworth & Co. Ltd.

37. Excerpts from *What Is Art?* by Leo Tolstoy, translated by Aylmer Maude. Published by Oxford University Press.

38. "Art and Civilization" by John Dewey. Reprinted by permission of The Putnam Publishing Group from *Art as Experience* by John Dewey. Copyright © 1934 by John Dewey. Copyright © 1962 by Roberta L. Dewey. Copyright © 1974 by The John Dewey Foundation.

39. Excerpts from "On the Fetish Character in Music and the Regression of Listening" by Theodor Adorno. In *The Essential Frankfurt School Reader,* edited by Andrew Arato and Eike Gebhardt. Reprinted by permission of The Continuum Publishing Company.

40. "The Arts in the Life of Man" by Monroe C. Beardsley. Excerpted from *Aesthetics: Problems in the Philosophy of Criticism* by Monroe C. Beardsley, second edition published by the Hackett Publishing Company. Reprinted by permission of Hackett Publishing Company. All rights reserved.

41. Excerpts from "Why Have There Been No Great Women Artists?" by Linda Nochlin. From *ARTnews,* Volume 69, Number 9 (January 1971). © 1971, 1973 Art News Associates.

The Philosophy of Art

READINGS ANCIENT AND MODERN

INTRODUCTION

The philosophy of art has a history as long as the history of philosophy itself. Twenty-five centuries ago, Pythagoras was speculating on the mathematical relations between music and the cosmos, and Xenophanes was complaining that the poets told lies about the gods. By the time Greek philosophy reached its zenith in the fourth century B.C., the philosophy of art already had a history; and the issues that Plato and Aristotle discussed had already been settled, unsettled, resettled, raised again, and generally disputed over. And this fact is hardly surprising. For art is one of the things that sets human beings apart from other animals. The making and the enjoyment of art are distinctively human activities; and like all distinctively human activities they arouse deep human curiosity. So far as we know, only people have made representations of the lives that they lead. Only human beings have made songs, poems, stories, and dramas out of their experiences or have sought to capture the look of things in paint and stone. This urge, this human urge to represent the world is so striking and so mysterious that the development of a tradition of reflecting philosophically upon art was surely inevitable. Even if we had no evidence for the fact, we could be certain that there were philosophers of art long before the earliest texts in the philosophy of art which we know about were written.

The Greeks were fascinated by questions concerning the nature and the purpose, and indeed the *truthfulness,* of artistic representations. But they were also intrigued by the relation of art to the emotions; by the educational value and the social dangers of art; by the fact that even tragedies seemed to be enjoyable; by the nature of the creative process; and by any number of other issues that the existence and experience of art suggest. Almost all of the questions that captured the Greeks' attention are still being discussed today, two and a half thousand years later. But over that time, other questions have been added. The period between classical antiquity and the Renaissance was a rich

1

one for the development of art. (Indeed, the modern conception of art had its genesis in the Renaissance; the Greeks did not distinguish what in modern times would be called "art" from what would now be called "craft.") But it was not a particularly rich time for the philosophy of art. Although a number of important philosophers of late antiquity and the medieval period—including Plotinus, Augustine, and Aquinas—did write on topics in aesthetics, it was not until the eighteenth century that the philosophy of art really came into its own. And in the eighteenth century it was questions about the relationship between artworks and audience that primarily interested philosophers. The most widely discussed questions concerned the "faculty of taste" and the perception of beauty. (It was at this time, and to cover these issues, that the term "aesthetics" was introduced as a technical term—although it has since become more or less synonymous with the term "philosophy of art.") By the nineteenth century, however, the emphasis had shifted from the relationship between audience and artwork to the relationship between artist and artwork. Questions concerning creativity, originality, and expression were hotly debated until, inevitably, the romantic fascination with genius went out of vogue. In our own century, the emphasis has shifted again, to an analytic obsession with artworks. Questions concerning the definition of art and the meaning of artworks have predominated (although an interest in the artwork-audience relationship is reflected in the contemporary concern with interpretation). So the scene shifts, and priorities change. But through all these fluctuations in emphasis, certain questions have retained their power to provoke, even as further compelling questions have been raised. The history of the philosophy of art, then, is not only an impressively long one but also a singularly rich one.

It would have been possible to organize this collection on strictly historical principles. But because the philosophy of art has not always followed the scheme just elaborated with perfect fidelity (there's always somebody born in the wrong century), a chronological approach would have resulted in an organization that was nearly, but not quite, thematic. And we felt that this nearly thematic quality would be irritating. So we opted instead for a fully and properly thematic approach, with a section on artists, a section on artworks, a section on audiences, and a final section on the relation between art and various moral concerns.

Section 1 is devoted to issues surrounding creativity. How does an artist create a work of art? What is involved in the creative process? What impulses lie behind the creative process? What makes an artist an artist? The classic answer is given by Plato in the *Ion*. According to him, artistic creativity is a matter of divine inspiration. The artist functions as a sort of public-address system for the gods. The artist is therefore quite ignorant of the principles of his or her craft, and is an artist only because divinely chosen. Not everyone has agreed with Plato about this: Wordsworth, for instance, attributed the creation of art to "the spontaneous overflow of powerful feelings." Nietzsche prefigures Freud by tracing creativity to a "Dionysian" impulse—an impulse to

ecstatic intoxication. Gadamer compares creativity to play, while Freud likens creativity to daydreaming. And are artists really as little responsible for what they create as Plato suggests? Not according to T. S. Eliot. Eliot reflects in detail upon the complex interactions between "Tradition and the Individual Talent" that underlie the creation of works of art; for him, an artist's awareness of the art of the past is a vital ingredient in the creative process. These are just some of the views expressed in this section. But with intoxicated impulses, divine interventions, dreams, and spontaneously overflowing emotions about the place, it certainly gets us off to a heady start.

Section 2 is about artworks; and it is divided into two parts. The first part, called "Form and Content," is concerned with the subject matter of art and with what art can mean. There are clearly many approaches that one might take to such issues, and we have chosen our readings to reflect that range. For example, we have Collingwood's proposal that the true subject matter of art is emotion and that its meanings are the emotions it expresses. And we have Bell's idea that paintings mean nothing beyond themselves and consist only of "significant form."

The readings just mentioned might as easily have appeared in the second part of this section, called "The Project of Definition," for both Collingwood and Bell, in addressing the problem of the content of art, claim also to have defined the concept of art. Collingwood defines art as the expression of emotion; Bell defines it as "significant form." And the concept of art has received a bewildering variety of definitions apart from these. It is this bewilderment and the genuine difficulty that it reflects which accounts for the rather cautious tone of the readings in this second part of the section. Indeed, the caution amounts at times—as it does in Morris Weitz's essay—to a rejection of the very possibility of defining art. The readings here represent various attempts to define art—in terms of its institutions, its history, and its peculiarly aesthetic qualities—in response to Weitz's challenge. As they show, the project of definition is a difficult one. These readings underline some of the obstacles that must be overcome before a convincing definition of art can be given—*if*, that is, one can be given at all.

Section 3 is about audiences and, again, is divided into two parts. The first is called "The Logic of Taste." Here we encounter the classic writings of Hume and Kant as they give their very different solutions to a famous paradox. Value judgments about art appear to be made on the basis of subjective feelings, and yet they also appear to be capable of being correct or incorrect. Some people simply seem to have *better* taste than others, which it would seem that they couldn't have if matters of taste were merely matters of feeling. So what is it to have taste? Hume and Kant offer their answers in this section. And so does Sibley: He uses the label "taste" to describe the capacity to apply certain concepts—"aesthetic concepts"—to the properties of artworks. People with good taste are better at applying these concepts than are other people. But there are some thorny questions here. If you're not particularly good at applying such concepts, is there any point in anyone telling

you that such concepts apply to a particular work of art? Or, more generally, is there any point in arguing about matters of criticism? Several of the readings are expressly concerned with the nature of criticism and with the role of that peculiar member of the audience—the critic. Indeed, Hume derives his solution to the paradox of taste from considerations about the qualities that the perfect critic, in his opinion, would have. So this part of the section has many facets.

The second part of the section, called "Intention and Interpretation," addresses some of the issues that arise from an audience's attempts to *understand* works of art. One issue concerns the relevance that knowledge of the artist's intentions has for any such attempt. Wimsatt and Beardsley argue in a famous paper that knowledge of an artist's intentions—as gleaned from biographies, letters, public statements, and so forth—is irrelevant to the understanding of any work of art. This is a view which is echoed, from another tradition, by Barthes, and which both Wollheim and Hirsch take issue with. Another significant issue raised here concerns the possibility of giving a determinate, or objective, interpretation of any work of art at all, by whatever means. Skepticism about the possibility of stable interpretation underlies much recent critical theory; and the outright rejection of that possibility is responsible for some of the worst critical excesses—often in the form of an "anything-goes" style of criticism. Do works of art have stable and determinate meanings? What might be thought to fix or determine the meaning of a work of art? The readings in this section address these and related questions.

Section 4, called "Art: Purposes and Perils," is devoted to questions about the consequences, both moral and political, that art, and the experience of art, might have. The first readings are taken from two of the most venerable classics of all—Plato's *Republic* and Aristotle's *Poetics*—and one of the issues they discuss is among those mentioned at the beginning of this introduction: the question whether artistic representations tell us the *truth* about the world. Plato and Aristotle agreed that the pursuit of truth was a morally valuable activity. Therefore they both saw this question as a moral one. If artistic representations are prone to mislead people about the truth of things, as Plato held, then art is morally corrupting and should be closely controlled. But if art *does*, or can, tell us the truth, as Aristotle believed, then art is morally wholesome and should be encouraged. This debate about the moral, and ultimately the political, desirability of art has continued to fascinate artists and philosophers over the centuries. And the other readings chosen in this section—whether they celebrate art as a force for the good (e.g., Dewey) or question its social and ideological effects (e.g., Adorno)—represent some of the more recent answers to one of the oldest questions in the philosophy of art.

That completes this brief survey of the varied contents of the present collection. Our survey is intended to give a general indication of the kinds of issues raised and to give a hint as to how they have been organized. It is not

intended to be comprehensive. Many of the writers whose works appear in this collection have not been mentioned at all. This reflects only a limitation of space, not a judgment of value. There are more detailed introductions to each of the readings as they appear in the main body of the book itself. It remains only to hope that the reader benefits from and enjoys whichever selections he or she chooses to read.

1

ARTISTS: CONCEPTS OF CREATIVITY

INTRODUCTION

How does an artist create a work of art? What is involved in the creative process? What impulses lie behind the creative process? What makes an artist an artist? A classic answer is given by Plato in the *Ion*. Plato, who lived (roughly) from 427 to 347 B.C., is the earliest of the great philosophers to have left us extensive writings on the philosophy of art. His attitude toward art was always complex and ambivalent. On the one hand, he was himself a considerable artist, as his philosophical dialogues show, and he was much impressed by the spell that art can cast over an audience. At the same time his own first commitment was to the pursuit of truth; and from this perspective he found what he took to be the irrational or unphilosophical aspects of art disturbing. Indeed, in the *Republic* (*see* Section 4), he seems to declare that art was so injurious to the pursuit of truth that it should be banned from the ideal state. The *Ion* is an earlier work than the *Republic*, but here too we find Plato worried about the irrationality of art and about the relation of art to knowledge. His subject in the *Ion* is creativity. The artist (or the "rhapsode"—a creative reciter of verses) is, according to Plato, creative because he or she is inspired. To "inspire" means literally to "breathe into"; and it is in this sense that Plato uses the term. Artists are inspired because they are "breathed into" by the gods. The gods speak through them; artists are merely divine mouthpieces. There is nothing rational about what artists do when they create works of art. Nor is there any particular knowledge which an artist needs or employs. An artist, according to Plato, is quite passive during the act of creation. Indeed the artist is quite literally in the *grip* of the creative process. Such an account of creativity does not seem to flatter the artist. Not only is the artist's "activity" essentially passive, in Plato's view, and of doubtful rationality, but the responsibility for what is created is transferred elsewhere; and whatever truth there may be in a work of art (and there may be none, for the gods can be mischievous!), certainly doesn't derive from any knowledge that the artist possesses. But Plato's account does accord well with the beliefs of some artists. Shelley, for instance, felt that the *Ion* explained his own sense that he was merely a "vehicle" for his art, and that he was possessed by some higher power whenever he sat down to write poetry.

And the theory of divine inspiration can also be read as a foreshadowing of certain more recent theories, which locate the sources of creativity in the unconscious. So, for all its apparently fantastical quality, Plato's conception of creativity is a rich one.

The *Ion*

Plato

SOCRATES: Ion! Hello. Where have you come from to visit us this time? From your home in Ephesus?

ION: No, no, Socrates. From Epidaurus, from the festival of Asklepius.

S: Don't tell me the Epidaurians hold a contest for *rhapsodes* in honor of the god?

I: They certainly do! They do it for every sort of poetry and music.

S: Really? Did you enter the contest? And how did it go for you?

I: First prize, Socrates! We carried it off.

S: That's good to hear. Well, let's see that we win the games at Athens, next.

I: We'll do it, Socrates, god willing.

S: You know, Ion, many times I've envied you rhapsodes your profession. Physically, it is always fitting for you in your profession to be dressed up to look as beautiful as you can; and at the same time it is necessary for you to be at work with poets—many fine ones, and with Homer above all, who's the best poet and the most divine—and you have to learn his thought, not just his verses! Now that is something to envy! I mean, no one would ever get to be a good rhapsode if he didn't understand what is meant by the poet. A rhapsode must come to present the poet's thought to his audience; and he can't do that beautifully unless he knows what the poet means. So this all deserves to be envied.

I: That's true, Socrates. And that's the part of my profession that took the most work. I think I speak more beautifully than anyone else about Homer; neither Metrodorus of Lampsacus nor Stesimbrotus of Thasos nor Glaucon nor anyone else past or present could offer as many beautiful thoughts about Homer as I can.

S: That's good to hear, Ion. Surely you won't begrudge me a demonstration?

I: Really, Socrates, it's worth hearing how well I've got Homer dressed up. I think I'm worthy to be crowned by the Sons of Homer with a golden crown.

S: Really, I shall make time to hear that later. Now I'd just like an answer to this: Are you so wonderfully clever about Homer alone—or also about Hesiod and Archilochus?

I: No, no. Only about Homer. That's adequate, I think.

S: Is there any subject on which Homer and Hesiod both say the same things?

I: Yes, I think so. A good many.

S: Then, on those subjects, would you explain Homer's verse more beautifully than Hesiod's?

I: Just the same Socrates, on those subjects, anyway, where they say the same things.

S: And how about the subjects on which they do not say the same things? Divination, for example. Homer says something about it and so does Hesiod.

I: Certainly.

S: Well. Take all the places where those two poets speak of divination, both where they agree and where they don't: who would explain those more beautifully, you, or one of the diviners if he's good?

I: One of the diviners.

S: Suppose *you* were a diviner: if you were really able to explain the places where the two poets agree, wouldn't you also know how to explain the places where they disagree?

I: That's clear.

S: Then what in the world is it that you're clever about in Homer but not in Hesiod and the other poets? Does Homer speak of any subjects that differ from those of *all* the other poets? Doesn't he mainly go through tales of war, and of how people deal with each other in society—good people and bad, ordinary folks and craftsmen? And of the gods, how *they* deal with each other and with men? And doesn't he recount what happens in heaven and in hell, and tell of the births of gods and heroes? Those are the subjects of Homer's poetry-making, aren't they?

I: That's true, Socrates.

S: And how about the other poets? Didn't they write on the same subjects?

I: Yes, but Socrates, they didn't do it the way Homer did.

S: How, then? Worse?

I: Much worse.

S: And Homer does it better?

I: *Really* better.

S: Well now, Ion, dear heart, when a number of people are discussing arithmetic, and one of them speaks best, I suppose *someone* will know how to pick out the good speaker.

I: Yes.

S: Will it be the same person who can pick out the bad speakers, or someone else?

I: The same, of course.

S: And that will be someone who has mastered arithmetic, right?

I: Yes.

S: Well. Suppose a number of people are discussing healthy nutrition, and one of them speaks best. Will one person know that the best speaker speaks best, and another that an inferior speaker speaks worse? Or will the same man know both?

I: Obviously, the same man.

S: Who is he? What do we call him?

I: A doctor.

S: So, to sum it up, this is what we're saying: when a number of people speak on the same subject, it's always the same person who will know how to pick out good speakers and bad speakers. If he doesn't know how to pick out a bad speaker, he certainly won't know a good speaker—on the same subject, anyway.

I: That's so.

S: Then it turns out that the same person is "wonderfully clever" about both speakers.

I: Yes.

S: Now *you* claim that Homer and the other poets (including Hesiod and Archilochus) speak on the same subjects, but not equally well. *He's* good, and they're inferior.

I: Yes, and it's true.

S: Now if you really do know who's speaking well, you'll know that the inferior speakers are speaking worse.

I: Apparently so.

S: You're superb! So if we say that Ion is equally clever about Homer and the other poets, we'll make no mistake. Because you agree yourself that the same person will be an adequate judge of all who speak on the same subjects, and that almost all the poets *do* treat the same subjects.

I: Then how in the world do you explain what *I* do, Socrates? When someone discusses another poet I pay no attention, and I have no power to contribute anything worthwhile: I simply doze off. But let someone mention Homer and right away I'm wide awake and I'm paying attention and I have plenty to say.

S: *That's* not hard to figure out, my friend. Anyone can tell that you are powerless to speak about Homer on the basis of knowledge or mastery. Because if your ability came by mastery, you would be able to speak about all the other poets as well. Look, there is an art of poetry as a whole, isn't there?

I: Yes.

S: And now take the whole of *any* other subject: won't it have the same discipline throughout? And this goes for every subject that can be mastered. Do you need me to tell you what I mean by this, Ion?

I: Lord, yes, I do, Socrates. I love to hear you wise men talk.

S: I wish that were true, Ion. But wise? Surely you are the wise men, you rhapsodes and actors, you and the poets whose work you sing. As for me, I say nothing but the truth, as you'd expect from an ordinary man. I mean, even this question I asked you—look how commonplace and ordinary a matter it is. Anybody could understand what I meant: don't you use the same discipline throughout whenever you master the whole of a subject? Take this for discussion—painting is a subject to be mastered as a whole, isn't it?

I: Yes.

S: And there are many painters, good and bad, and there have been many in the past.

I: Certainly.

S: Have you ever known anyone who is clever at showing what's well painted and what's not in the work of Polygnotus, but who's powerless to do that for other painters? Someone who dozes off when the work of other painters is displayed, and is lost, and has nothing to contribute—but when he has to give judgment on Polygnotus or any other painter (so long as it's just *one*), he's wide awake and he's paying attention and he has plenty to say—have you ever known anyone like that?

I: Good lord no, of course not!

S: Well. Take sculpture. Have you ever known anyone who is clever at explaining which statues are well made in the case of Daedalus, son of Metion, or Epeius, son of Panopeus, or Theodorus of Samos, or any other *single* sculptor, but who's lost when he's among the products of other sculptors, and he dozes off and has nothing to say?

I: Good lord no. I haven't.

S: And further, it is my opinion, you've never known anyone ever—not in flute-playing, not in cithara-playing, not in singing to the cithara, and not in rhapsodizing—you've never known a man who is clever at explaining Olympus or Thamyrus or Orpheus or Phemius, the rhapsode from Ithaca, but who has nothing to contribute about Ion, the rhapsode from Ephesus, and cannot tell when he does his work well and when he doesn't—you've never known a man like that.

I: I have nothing to say against you on that point, Socrates. But *this* I know about myself: I speak about Homer more beautifully than anybody else and I have lots to say; and everybody says I do it well. But about the other poets I do not. Now see what that means.

S: I do see, Ion, and I'm going to announce to you what I think that is. As I said earlier, that's not a subject you've mastered—speaking well about Homer; it's a divine power that moves you, as a "Magnetic" stone moves iron rings. (That's what Euripides called it; most people call it "Heracleian.") This stone not only pulls those rings, if they're iron, it also puts power *in* the rings, so that they in turn can do just what the stone does—pull other rings—so that there's sometimes a very long chain of iron pieces and rings hanging from one another. And the power in all of them depends on this stone. In the same way, the Muse makes some people inspired herself, and then through those who are inspired a chain of other enthusiasts is suspended. You know, none of the epic poets, if they're good, are masters of their subject; they are inspired, possessed, and that is how they utter all those beautiful poems. The same goes for lyric poets if they're good: just as the Corybantes are not in their right minds when they dance, lyric poets, too, are not in their right minds when they make those beautiful lyrics, but as soon as they sail into harmony and rhythm they are possessed by Bacchic frenzy. Just as Bacchus worshippers when they are possessed draw honey and milk from rivers, but not when they are in their right minds—the soul of a lyric poet does this too, as they say themselves. For of course poets tell us that they gather songs at honey-flowing springs, from glades and gardens of the Muses, and that they bear songs to us as bees carry honey, flying like bees. And what they say is true. For a poet is an airy thing, winged and holy, and he is not able to make poetry until he becomes inspired and goes out of his mind and his intellect is no longer in him. As long as a human being has his intellect in his possession he will always lack the power to make poetry or sing prophecy. Therefore because it's not by mastery that they make poems or say many lovely things about their subjects (as you do about Homer)—but because it's by a divine gift— each poet is able to compose beautifully only that for which the Muse has aroused him: one can do dithyrambs, another encomia, one can do dance songs, another, epics, and yet another, iambics; and each of them is worth-

less for the other types of poetry. You see, it's not mastery that enables them to speak those verses, but a divine power, since if they knew how to speak beautifully on one type of poetry by mastering the subject, they could do so for all the others also. That's why the god takes their intellect away from them when he uses them as his servants, as he does prophets and godly diviners, so that we who hear should know that *they* are not the ones who speak those verses that are of such high value, for their intellect is not in them: the god himself is the one who speaks, and he gives voice through them to us. The best evidence for this account is Tynnichus from Chalcis, who never made a poem anyone would think worth mentioning, *except* for the praise-song everyone sings, almost the most beautiful lyric-poem there is, and simply, as he says himself, "an invention of the Muses." In this more than anything, then, I think, the god is showing us, so that we should be in no doubt about it, that these beautiful poems are not human, not even *from* human beings, but are divine and from gods; that poets are nothing but representatives of the gods, possessed by whoever possesses them. To show *that*, the god deliberately sang the most beautiful lyric poem through the most worthless poet. Don't you think I'm right, Ion?

I: Lord yes, *I* certainly do. Somehow you touch my soul with your words, Socrates, and I do think it's by a divine gift that good poets are able to present these poems to us from the gods.

S: And you rhapsodes in turn present what the poets say.

I: That's true too.

S: So you turn out to be representatives of representatives.

I: Quite right.

S: Hold on, Ion; tell me this. Don't keep any secrets from *me*. When you recite epic poetry well and you have the most stunning effect on your spectators, either when you sing of Odysseus—how he leapt into the doorway, his identity now obvious to the suitors, and he poured out arrows at his feet—or when you sing of Achilles charging at Hector, or when you sing a pitiful episode about Andromache or Hecuba or Priam, are you at that time in your right mind, or do you get beside yourself? And doesn't your soul, in its enthusiasm, believe that it is present at the actions you describe, whether they're in Ithaca or in Troy or wherever the epic actually takes place?

I: What a vivid example you've given me, Socrates! I won't keep secrets from *you*. Listen, when *I* tell a sad story, my eyes are full of tears; and when I tell a story that's frightening or awful, my hair stands on end with fear and my heart jumps.

S: Well, Ion, should we say this man is in his right mind at times like these: when he's at festivals or celebrations, all dressed up in fancy clothes, with golden crowns, and he weeps, though he's lost none of his finery—or when he's standing among millions of friendly people and he's frightened, though no one is undressing him or doing him any harm? Is he in his right mind then?

I: Lord no, Socrates. Not at all, to tell the truth.

S: And you know that you have the same effects on most of your spectators too, don't you?

I: I know very well that we do. I look down at them every time from up on the rostrum, and they're crying and looking terrified, and as the stories are told they are filled with amazement. You see I must keep my wits and pay close attention to them: if I start them crying, *I* will laugh as I take their money, but if *they* laugh, I shall cry at having lost money.

S: And you know that this spectator is the last of the rings, don't you—the ones that I said take their power from each other by virtue of the Heracleian stone [the magnet]? The middle ring is you, the rhapsode or actor, and the first one is the poet himself. The god pulls people's souls through all these wherever he wants, looping the power down from one to another. And just as if it hung from that stone, there's an enormous chain of choral dancers and dance teachers and assistant teachers hanging off to the sides of the rings that are suspended from the Muse. One poet is attached to one Muse, another to another (we say he is "possessed," and that's near enough, for he is *held*). From these first rings, from the poets, *they* are attached in their turn and inspired, some from one poet, some from another: some from Orpheus, some from Musaeus, and many are possessed and held from Homer. You are one of *them*, Ion, and you are possessed from Homer. And when anyone sings the work of another poet, you're asleep and you're lost about what to say; but when any song of that poet is sounded, you are immediately awake, your soul is dancing, and you have plenty to say. You see it's not because you're a master of knowledge about Homer that you can say what you say, but because of a divine gift, because you are possessed. That's how it is with the Corybantes, who have sharp ears only for the specific song that belongs to whatever god possesses them; they have plenty of words and movements to go with *that* song; but they are quite lost if the music is different. That's how it is with you, Ion: when anyone mentions Homer, you have plenty to say, but if he mentions the others you are lost; and the explanation of this, for which you ask me—why it is that you have plenty to say about Homer but not about the others—is that it's not mastering the subject, but a divine gift, that makes you a wonderful singer of Homer's praises.

I: You're a good speaker, Socrates. Still, I would be amazed if you could speak well enough to convince me that I am possessed or crazed when I praise Homer. I don't believe you'd think so if you heard me speaking on Homer.

S: And I really do want to hear you, but not before you answer me this: on which of Homer's subjects do you speak well? I don't suppose you speak well on *all* of them.

I: I do, Socrates, believe me, on every single one!

S: Surely not on those subjects you happen to know nothing about, even if Homer does speak of them.

I: And these subjects Homer speaks of, but I don't know about—what are they?

S: But doesn't Homer speak about professional subjects in many places, and say a great deal? Chariot driving, for example. I'll show you, if I can remember the lines.

I: No, I'll recite them. I *do* remember.

S: Then tell me what Nestor says to his son Antilochus, when he advises him to take care at the turning post in the horse race they held for Patroclus's funeral.

I: "Lean," he says,

> Lean yourself over on the smooth-planed chariot
> Just to the left of the pair. Then the horse on the right—
> Goad him, shout him on, easing the reins with your hands.
> At the post let your horse on the left stick tight to the turn
> So you seem to come right to the edge, with the hub
> Of your welded wheel. But escape cropping the stone . . .

5

S: That's enough. Who would know better, Ion, whether Homer speaks correctly or not in these particular verses—a doctor or a charioteer?

I: A charioteer, of course.

S: Is that because he is a master of that profession, or for some other reason?

I: No. It's because he's a master of it.

S: Then to each profession a god has granted the ability to know a certain function. I mean, the things navigation teaches us—we won't learn them from medicine as well, will we?

I: Of course not.

S: And the things medicine teaches us we won't learn from architecture.

I: Of course not.

S: And so it is for every other profession: what we learn by mastering one profession we won't learn by mastering another, right? But first, answer me this. Do you agree that there are different professions—that one is different from another?

I: Yes.

S: And is this how you determine which ones are different? When *I* find that the knowledge [involved in one case] deals with different subjects from the knowledge [in another case], then I claim that one is a different profession from the other. Is that what you do?

I: Yes.

S: I mean if there is some knowledge of the same subjects, then why should we say there are two different professions?—Especially when each of them would allow us to know the same subjects! Take these fingers: I know there are five of them, and you know the same thing about them that I do. Now suppose I asked you whether it's the same profession—arithmetic—that teaches you and me the same things, or whether it's two different ones. Of course you'd say it's the same one.

I: Yes.

S: Then tell me now what I was going to ask you earlier. Do you think it's the same way for every profession—the same profession must teach the same subjects, and a different profession, if it *is* different, must teach not the same subjects, but different ones?

I: That's how I think it is, Socrates.

S: Then a person who has not mastered a given profession will not be able to be a good judge of the things which belong to that profession, whether they are things said or things done.

I: That's true.

S: Then who will know better whether Homer speaks beautifully or not in the lines you quoted? You, or a charioteer?

I: A charioteer.

S: That's because you're a rhapsode, of course, and not a charioteer.

I: Yes.

S: And the rhapsode's profession is different from the charioteer's.

I: Yes.

S: If it's different, then its knowledge is of different subjects also.

I: Yes.

S: Then what about the time Homer tells how Hekamede, Nestor's woman, gave barley-medicine to Machaon to drink? He says something like this—

> Over wine of Pramnos, she grated goat's milk cheese
> With a brazen grater. . . . And onion relish for the drink . . .

Is Homer right or not: would a fine diagnosis here come from a doctor's profession or a rhapsode's?

I: A doctor's.

S: And what about the time Homer says:

> Leaden she plunged to the floor of the sea like a weight
> That is fixed to a field cow's horn. Given to the hunt
> It goes among ravenous fish, carrying death.

Should we say it's for a fisherman's profession or a rhapsode's to tell whether or not he describes this beautifully?

I: That's obvious, Socrates. It's for a fisherman's.

S: All right, look. Suppose you were the one asking questions, and you asked me, "Socrates, since you're finding out which passages belong to each of the professions Homer treats—which are the passages that each profession should judge—come tell me this: which are the passages that belong to a diviner and to divination, passages he should be able to judge as to whether they're well or badly composed?" Look how easily I can give you a true answer. Often, in the *Odyssey*, he says things like what Theoklymenus says—the prophet of the sons of Melampus:

> Are you mad? What evil is this that's upon you? Night
> Has enshrouded your hands, your faces, and down to your knees.
> Wailing spreads like fire, tears wash your cheeks.
> Ghosts fill the dooryard, ghosts fill the hall, they rush
> 5 To the black gate of hell, they drop below darkness. Sunlight
> Has died from a sky run over with evil mist.

And often in the *Iliad*, as in the battle at the wall. There he says:

> There came to them a bird as they hungered to cross over.
> An eagle, a high-flier, circled the army's left
> With a blood-red serpent carried in its talons, a monster,
> Alive, still breathing, it had not yet forgotten its warlust,
> 5 For it struck its captor on the breast, by the neck;

It was writhing back, but the eagle shot it groundwards
In agony of pain, and dropped it in the midst of the throng,
Then itself, with a scream, soared on a breath of the wind.

I shall say that these passages and those like them belong to a diviner.
They are for him to examine and judge.

I: That's a true answer, Socrates.

S: Well, *your* answers are true, too, Ion. Now *you* tell me—just as I picked out
for you, from the *Odyssey* and the *Iliad,* passages that belong to a diviner
and ones that belong to a doctor and ones that belong to a fisherman—in
the same way, Ion, since you have more experience with Homer's work
than I do, you pick out for me the passages that belong to the rhapsode
and to his profession, the passages a rhapsode should be able to examine
and to judge better than anyone else.

I: My answer, Socrates, is "all of them."

S: That's not *your* answer, Ion. Not "all of them." Or are you really so forget-
ful? But no, it would not befit a *rhapsode* to be forgetful.

I: What do you think I'm forgetting?

S: Don't you remember you said that a rhapsode's profession is different from
a charioteer's?

I: I remember.

S: And didn't you agree that because they are different they will know dif-
ferent subjects?

I: Yes.

S: So a rhapsode's profession, on *your* view, will not know everything, and
neither will a rhapsode.

I: But things like that are exceptions, Socrates.

S: By "things like that" you mean that almost all the subjects of the other pro-
fessions are exceptions, don't you? But then what sort of thing *will* a rhap-
sode know, if not everything?

I: My opinion, anyhow, is that he'll know what it's fitting for a man or a
woman to say—or for a slave or a freeman, or for a follower or a leader.

S: So—what should a leader say when he's at sea and his ship is hit by a
storm—do you mean a rhapsode will know better than a navigator?

I: No, no. A navigator will know *that.*

S: And when he's in charge of a sick man, what should a leader say—will a
rhapsode know better than a doctor?

I: Not that, either.

S: But he *will* know what a slave should say. Is that what you mean?

I: Yes.

S: For example, what should a slave who's a cowherd say to calm down his
cattle when they're going wild—will a rhapsode know what a cowherd
does not?

I: Certainly not.

S: And what a woman who spins yarn should say about working with wool?

I: No.

S: And what a man should say, if he's a general, to encourage his troops?

I: Yes! That's the sort of thing a rhapsode will know.

S: What? Is a rhapsode's profession the same as a general's?

I: Well, *I* certainly would know what a general should say.

S: Perhaps that's because you're also a general by profession, Ion. I mean, if you were somehow both a horseman and a cithara-player at the same time, you would know good riders from bad. But suppose I asked you: "Which profession teaches you good horsemanship—the one that makes you a horseman, or the one that makes you a cithara-player?"

I: The horseman, I'd say.

S: Then if you also knew good cithara-players from bad, the profession that taught you *that* would be the one which made you a cithara-player, not the one that made you a horseman. Wouldn't you agree?

I: Yes.

S: Now, since you know the business of a general, do you know this by being a general or by being a good rhapsode?

I: I don't think there's any difference.

S: What? Are you saying there's no difference? On your view is there one profession for rhapsodes and generals, or two?

I: One, I think.

S: So anyone who is a good rhapsode turns out to be a good general too.

I: Certainly, Socrates.

S: It also follows that anyone who turns out to be a good general is a good rhapsode too.

I: No. This time I don't agree.

S: But you do agree to this: anyone who is a good rhapsode is a good general too.

I: I quite agree.

S: And aren't you the best rhapsode in Greece?

I: By far, Socrates.

S: Are you also a general, Ion? Are you the best in Greece?

I: Certainly, Socrates. That, too, I learned from Homer's poetry.

S: Then why in heaven's name, Ion, when you're both the best general *and* the best rhapsode in Greece, do you go around the country giving rhapsodies but not commanding troops? Do you think Greece really needs a rhapsode who is crowned with a golden crown? And does not need a general?

I: Socrates, *my* city is governed and commanded by you [by Athens]; we don't need a general. Besides, neither your city nor Sparta would choose me for a general. You think you're adequate for that yourselves.

S: Ion, you're superb. Don't you know Apollodorus of Cyzike?

I: What does *he* do?

S: He's a foreigner who has often been chosen by Athens to be their general. And Phanosthenes of Andros and Herakleides of Clazomenae—they're also foreigners; they've demonstrated that they are worth noticing, and Athens appoints them to be generals or other sorts of officials. And do you think that *this* city, that makes such appointments, would not select Ion of Ephesus and honor him, if they thought he was worth noticing? Why? Aren't you people from Ephesus Athenians of long standing? And isn't Ephesus a city that is second to none?

But *you,* Ion, you're doing me wrong, if what you say is true that what enables you to praise Homer is knowledge or mastery of a profession. You

assured me that you knew many lovely things about Homer, you promised to give a demonstration; but you're cheating me, you're a long way from giving a demonstration. You aren't even willing to tell me what it is that you're so wonderfully clever *about,* though I've been begging you for ages. Really, you're just like Proteus, you twist up and down and take many different shapes, till finally you've escaped me altogether by turning yourself into a general, so as to avoid proving how wonderfully wise you are about Homer.

If you're really a master of your subject, and if, as I said earlier, you're cheating me of the demonstration you promised about Homer, then you're doing me wrong. But if you're not a master of your subject, if you're possessed by a divine gift from Homer, so that you make many lovely speeches about the poet without knowing anything—as *I* said about you— then you're not doing me wrong. So choose, how do you want us to think of you—as a *man* who does wrong, or as someone *divine?*

I: There's a great difference, Socrates. It's much lovelier to be thought divine.

S: Then *that* is how we think of you, Ion, the lovelier way: it's as someone divine, and not as master of a profession, that you are a singer of Homer's praises.

READING 2

INTRODUCTION

William Wordsworth (1770–1850) is best known as one of the great English poets of the Romantic tradition. The reading that follows is taken from his preface to the 1802 edition of *Lyrical Ballads,* the collection of his and his friend Samuel Taylor Coleridge's poems. Although the author of the preface is undoubtedly Wordsworth, many of the ideas that it presents are Coleridge's. (Indeed, at least part of the preface is based on notes that Coleridge wrote.) The preface begins with an account of what the poems in *Lyrical Ballads* are about, and this leads into a defense of a particular theory of poetic language. In Wordsworth's view, the language appropriate to poetry is essentially the language of everyday life: language "arising out of repeated experience and regular feelings." But this raises the question, What distinguishes a poet from any other language user? Or as Wordsworth asks, "What is a Poet?" The answer that he gives to this question is far from simple; indeed, it has been regarded by many as simply confused. However, it is an answer which reflects a commonly held intuition about the nature of artistic creation, and one that has been enormously influential. For Wordsworth, the distinguishing feature of the poet, and the source of poetic creativity, lies in the ability to feel and to give expression to feelings. "Poetry," he says, "is the spontaneous overflow of powerful feelings: it takes its origin from emotion recollected in tranquillity." However, Wordsworth claims, this does not mean that poetry is fated to be no more than the record of a particular poet's emotional experiences. For poetry, he insists, is the source of a special variety of truth: truth "not individual and local, but gen-

eral and operative." In the latter claim, he echoes the conception of dramatic truth that Aristotle presents in the *Poetics* (*see* Section 4). But perhaps more significantly, Wordsworth, one of the great poets of the English language, lends his authority to a philosophical theory of art that was later advanced by Tolstoy (*see* Section 4), an artist of a very different kind and of very different sensibilities. This is the "expression theory" of art, which finds its most subtle and influential philosophical statement in R. G. Collingwood's *The Principles of Art* (*see* Section 2). Wordsworth's preface illustrates vividly the implications of expression theory for our understanding of artistic creativity; and illustrates too how certain considerations about the creative process might add plausibility to the expression theory of art.

From the Preface to *Lyrical Ballads*

William Wordsworth

The principal object, then, proposed in these Poems was to choose incidents and situations from common life, and to relate or describe them, throughout, as far as was possible in a selection of language really used by men, and, at the same time, to throw over them a certain colouring of imagination, whereby ordinary things should be presented to the mind in an unusual aspect; and, further, and above all, to make these incidents and situations interesting by tracing in them, truly though not ostentatiously, the primary laws of our nature: chiefly, as far as regards the manner in which we associate ideas in a state of excitement. Humble and rustic life was generally chosen, because, in that condition, the essential passions of the heart find a better soil in which they can attain their maturity, are less under restraint, and speak a plainer and more emphatic language; because in that condition of life our elementary feelings co-exist in a state of greater simplicity, and, consequently, may be more accurately contemplated, and more forcibly communicated; because the manners of rural life germinate from those elementary feelings, and, from the necessary character of rural occupations, are more easily comprehended, and are more durable; and, lastly, because in that condition the passions of men are incorporated with the beautiful and permanent forms of nature. The language, too, of these men has been adopted (purified indeed from what appear to be its real defects, from all lasting and rational causes of dislike or disgust) because such men hourly communicate with the best objects from which the best part of language is originally derived; and because, from their rank in society and the sameness and narrow circle of their intercourse, being less under the influence of social vanity, they convey their feelings and notions in simple and unelaborated expressions. Accordingly, such a language, arising out of repeated experience and regular feelings, is a more permanent, and a far more philosophical language, than that which is frequently substituted for it by Poets, who think that they are conferring honour upon themselves and their art, in proportion as they separate themselves from the sympathies of men, and indulge in arbitrary and capricious habits of expression, in order to furnish food for fickle tastes, and fickle appetites, of their own creation.*

*It is worth while here to observe, that the affecting parts of Chaucer are almost always expressed in language pure and universally intelligible even to this day.

I cannot, however, be insensible to the present outcry against the triviality and meanness, both of thought and language, which some of my contemporaries have occasionally introduced into their metrical compositions; and I acknowledge that this defect, where it exists, is more dishonourable to the Writer's own character than false refinement or arbitrary innovation, though I should contend at the same time, that it is far less pernicious in the sum of its consequences. From such verses the Poems in these volumes will be found distinguished at least by one mark of difference, that each of them has a worthy *purpose*. Not that I always began to write with a distinct purpose formally conceived; but habits of meditation have, I trust, so prompted and regulated my feelings, that my descriptions of such objects as strongly excite those feelings, will be found to carry along with them a *purpose*. If this opinion be erroneous, I can have little right to the name of a Poet. For all good poetry is the spontaneous overflow of powerful feelings: and though this be true, Poems to which any value can be attached were never produced on any variety of subjects but by a man who, being possessed of more than usual organic sensibility, had also thought long and deeply. For our continued influxes of feeling are modified and directed by our thoughts, which are indeed the representatives of all our past feelings; and, as by contemplating the relation of these general representatives to each other, we discover what is really important to men, so, by the repetition and continuance of this act, our feelings will be connected with important subjects, till at length, if we be originally possessed of much sensibility, such habits of mind will be produced, that, by obeying blindly and mechanically the impulses of those habits, we shall describe objects, and utter sentiments, of such a nature, and in such connection with each other, that the understanding of the Reader must necessarily be in some degree enlightened, and his affections strengthened and purified. . . .

Taking up the subject, then, upon general grounds, let me ask, what is meant by the word Poet? What is a Poet? To whom does he address himself? And what language is to be expected from him?—He is a man speaking to men: a man, it is true, endowed with more lively sensibility, more enthusiasm and tenderness, who has a greater knowledge of human nature, and a more comprehensive soul, than are supposed to be common among mankind; a man pleased with his own passions and volitions, and who rejoices more than other men in the spirit of life that is in him; delighting to contemplate similar volitions and passions as manifested in the goings-on of the Universe, and habitually impelled to create them where he does not find them. To these qualities he has added a disposition to be affected more than other men by absent things as if they were present; an ability of conjuring up in himself passions, which are indeed far from being the same as those produced by real events, yet (especially in those parts of the general sympathy which are pleasing and delightful) do more nearly resemble the passions produced by real events, than anything which, from the motions of their own minds merely, other men are accustomed to feel in themselves:—whence, and from practice, he has acquired a greater readiness and power in expressing what he thinks and feels, and especially those thoughts and feelings which, by his own choice, or from the structure of his own mind, arise in him without immediate external excitement.

But whatever portion of this faculty we may suppose even the greatest

Poet to possess, there cannot be a doubt that the language which it will suggest to him, must often, in liveliness and truth, fall short of that which is uttered by men in real life, under the actual pressure of those passions, certain shadows of which the Poet thus produces, or feels to be produced, in himself.

However exalted a notion we would wish to cherish of the character of a Poet, it is obvious, that while he describes and imitates passions, his employment is in some degree mechanical, compared with the freedom and power of real and substantial action and suffering. So that it will be the wish of the Poet to bring his feelings near to those of the persons whose feelings he describes, nay, for short spaces of time, perhaps, to let himself slip into an entire delusion, and even confound and identify his own feelings with theirs; modifying only the language which is thus suggested to him by a consideration that he describes for a particular purpose, that of giving pleasure. Here, then, he will apply the principle of selection which has been already insisted upon. He will depend upon this for removing what would otherwise be painful or disgusting in the passion; he will feel that there is no necessity to trick out or to elevate nature: and, the more industriously he applies this principle, the deeper will be his faith that no words, which *his* fancy or imagination can suggest, will be to be compared with those which are the emanations of reality and truth.

But it may be said by those who do not object to the general spirit of these remarks, that, as it is impossible for the Poet to produce upon all occasions language as exquisitely fitted for the passion as that which the real passion itself suggests, it is proper that he should consider himself as in the situation of a translator, who does not scruple to substitute excellencies of another kind for those which are unattainable by him; and endeavours occasionally to surpass his original, in order to make some amends for the general inferiority to which he feels that he must submit. But this would be to encourage idleness and unmanly despair. Further, it is the language of men who speak of what they do not understand; who talk of Poetry as of a matter of amusement and idle pleasure; who will converse with us as gravely about a *taste* for Poetry, as they express it, as if it were a thing as indifferent as a taste for rope-dancing, or Frontiniac or Sherry. Aristotle, I have been told, has said, that Poetry is the most philosophic of all writing: it is so: its object is truth, not individual and local, but general, and operative; not standing upon external testimony, but carried alive into the heart by passion; truth which is its own testimony, which gives competence and confidence to the tribunal to which it appeals, and receives them from the same tribunal. Poetry is the image of man and nature. The obstacles which stand in the way of the fidelity of the Biographer and Historian, and of their consequent utility, are incalculably greater than those which are to be encountered by the Poet who comprehends the dignity of his art. The Poet writes under one restriction only, namely, the necessity of giving immediate pleasure to a human Being possessed of that information which may be expected from him, not as a lawyer, a physician, a mariner, an astronomer, or a natural philosopher, but as a Man. Except this one restriction, there is no object standing between the Poet and the image of things; between this, and the Biographer and Historian, there are a thousand.

Nor let this necessity of producing immediate pleasure be considered as a degradation of the Poet's art. It is far otherwise. It is an acknowledgment of the beauty of the universe, an acknowledgment the more sincere, because not formal, but indirect; it is a task light and easy to him who looks at the world in the spirit of love: further, it is a homage paid to the native and naked dignity of man, to the grand elementary principle of pleasure, by which he knows, and feels, and lives, and moves. We have no sympathy but what is propagated by pleasure: I would not be misunderstood; but wherever we sympathise with pain, it will be found that the sympathy is produced and carried on by subtle combinations with pleasure. We have no knowledge, that is, no general principles drawn from the contemplation of particular facts, but what has been built up by pleasure, and exists in us by pleasure alone. The Man of science, the Chemist and Mathematician, whatever difficulties and disgusts they may have had to struggle with, know and feel this. However painful may be the objects with which the Anatomist's knowledge is connected, he feels that his knowledge is pleasure; and where he has no pleasure he has no knowledge. What then does the Poet? He considers man and the objects that surround him as acting and re-acting upon each other, so as to produce an infinite complexity of pain and pleasure; he considers man in his own nature and in his ordinary life as contemplating this with a certain quantity of immediate knowledge, with certain convictions, intuitions, and deductions, which from habit acquire the quality of intuitions; he considers him as looking upon this complex scene of ideas and sensations, and finding every where objects that immediately excite in him sympathies which, from the necessities of his nature, are accompanied by an overbalance of enjoyment.

To this knowledge which all men carry about with them, and to these sympathies in which, without any other discipline than that of our daily life, we are fitted to take delight, the Poet principally directs his attention. He considers man and nature as essentially adapted to each other, and the mind of man as naturally the mirror of the fairest and most interesting properties of nature. And thus the Poet, prompted by this feeling of pleasure, which accompanies him through the whole course of his studies, converses with general nature, with affections akin to those, which, through labour and length of time, the Man of science has raised up in himself, by conversing with those particular parts of nature which are the objects of his studies. The knowledge both of the Poet and the Man of science is pleasure; but the knowledge of the one cleaves to us as a necessary part of our existence, our natural and unalienable inheritance; the other is a personal and individual acquisition, slow to come to us, and by no habitual and direct sympathy connecting us with our fellow-beings. The Man of science seeks truth as a remote and unknown benefactor; he cherishes and loves it in his solitude: the Poet, singing a song in which all human beings join with him, rejoices in the presence of truth as our visible friend and hourly companion. Poetry is the breath and finer spirit of all knowledge; it is the impassioned expression which is in the countenance of all Science. Emphatically may it be said of the Poet, as Shakespeare hath said of man, 'that he looks before and after.' He is the rock of defence for human nature; an upholder and preserver, carrying everywhere with him relationship and love. In spite of difference of soil and climate, of language and manners, of laws and customs: in

spite of things silently gone out of mind, and things violently destroyed; the Poet binds together by passion and knowledge the vast empire of human society, as it is spread over the whole earth, and over all time. The objects of the Poet's thoughts are every where; though the eyes and senses of man are, it is true, his favourite guides, yet he will follow wheresoever he can find an atmosphere of sensation in which to move his wings. Poetry is the first and last of all knowledge—it is as immortal as the heart of man. If the labours of Men of science should ever create any material revolution, direct or indirect, in our condition, and in the impressions which we habitually receive, the Poet will sleep then no more than at present; he will be ready to follow the steps of the Man of science, not only in those general indirect effects, but he will be at his side, carrying sensation into the midst of the objects of the science itself. The remotest discoveries of the Chemist, the Botanist, or Mineralogist, will be as proper objects of the Poet's art as any upon which it can be employed, if the time should ever come when these things shall be familiar to us, and the relations under which they are contemplated by the followers of these respective sciences shall be manifestly and palpably material to us as enjoying and suffering beings. If the time should ever come when what is now called science, thus familiarised to men, shall be ready to put on, as it were, a form of flesh and blood, the Poet will lend his divine spirit to aid the transfiguration, and will welcome the Being thus produced, as a dear and genuine inmate of the household of man.—It is not, then, to be supposed that any one, who holds that sublime notion of Poetry which I have attempted to convey, will break in upon the sanctity and truth of his pictures by transitory and accidental ornaments, and endeavour to excite admiration of himself by arts, the necessity of which must manifestly depend upon the assumed meanness of his subject.

What has been thus far said applies to Poetry in general; but especially to those parts of composition where the Poet speaks through the mouths of his characters; and upon this point it appears to authorise the conclusion that there are few persons of good sense, who would not allow that the dramatic parts of composition are defective, in proportion as they deviate from the real language of nature, and are coloured by a diction of the Poet's own, either peculiar to him as an individual Poet or belonging simply to Poets in general; to a body of men who, from the circumstance of their compositions being in metre, it is expected will employ a particular language.

It is not, then, in the dramatic parts of composition that we look for this distinction of language; but still it may be proper and necessary where the Poet speaks to us in his own person and character. To this I answer by referring the Reader to the description before given of a Poet. Among the qualities there enumerated as principally conducing to form a Poet, is implied nothing differing in kind from other men, but only in degree. The sum of what was said is, that the Poet is chiefly distinguished from other men by a greater promptness to think and feel without immediate external excitement, and a greater power in expressing such thoughts and feelings as are produced in him in that manner. But these passions and thoughts and feelings are the general passions and thoughts and feelings of men. And with what are they connected? Undoubtedly with our moral sentiments and animal sensations, and with the causes which excite these; with the operations of the elements, and the appear-

ances of the visible universe; with storm and sunshine, with the revolutions of the seasons, with cold and heat, with loss of friends and kindred, with injuries and resentments, gratitude and hope, with fear and sorrow. These, and the like, are the sensations and objects which the Poet describes, as they are the sensations of other men, and the objects which interest them. The Poet thinks and feels in the spirit of human passions. How, then, can his language differ in any material degree from that of all other men who feel vividly and see clearly? It might be *proved* that it is impossible. But supposing that this were not the case, the Poet might then be allowed to use a peculiar language when expressing his feelings for his own gratification, or that of men like himself. But Poets do not write for Poets alone, but for men. Unless therefore we are advocates for that admiration which subsists upon ignorance, and that pleasure which arises from hearing what we do not understand, the Poet must descend from this supposed height; and, in order to excite rational sympathy, he must express himself as other men express themselves. To this it may be added, that while he is only selecting from the real language of men, or, which amounts to the same thing, composing accurately in the spirit of such selection, he is treading upon safe ground, and we know what we are to expect from him. Our feelings are the same with respect to metre; for, as it may be proper to remind the Reader, the distinction of metre is regular and uniform, and not, like that which is produced by what is usually called POETIC DICTION, arbitrary, and subject to infinite caprices upon which no calculation whatever can be made. In the one case, the Reader is utterly at the mercy of the Poet, respecting what imagery or diction he may choose to connect with the passion; whereas, in the other, the metre obeys certain laws, to which the Poet and Reader both willingly submit because they are certain, and because no interference is made by them with the passion, but such as the concurring testimony of ages has shown to heighten and improve the pleasure which coexists with it. . . .

I have said that poetry is the spontaneous overflow of powerful feelings: it takes its origin from emotion recollected in tranquillity: the emotion is contemplated till, by a species of re-action, the tranquillity gradually disappears, and an emotion, kindred to that which was before the subject of contemplation, is gradually produced, and does itself actually exist in the mind. In this mood successful composition generally begins, and in a mood similar to this it is carried on; but the emotion, of whatever kind, and in whatever degree, from various causes, is qualified by various pleasures, so that in describing any passions whatsoever, which are voluntarily described, the mind will, upon the whole, be in a state of enjoyment. If Nature be thus cautious to preserve in a state of enjoyment a being so employed, the Poet ought to profit by the lesson held forth to him, and ought especially to take care, that, whatever passions he communicates to his Reader, those passions, if his Reader's mind be sound and vigorous, should always be accompanied with an overbalance of pleasure. Now the music of harmonious metrical language, the sense of difficulty overcome, and the blind association of pleasure which has been previously received from works of rhyme or metre of the same or similar construction, an indistinct perception perpetually renewed of language closely resembling that of real life, and yet, in the circumstance of metre, differing

from it so widely—all these imperceptibly make up a complex feeling of delight, which is of the most important use in tempering the painful feeling always found intermingled with powerful descriptions of the deeper passions. This effect is always produced in pathetic and impassioned poetry; while, in lighter compositions, the ease and gracefulness with which the Poet manages his numbers are themselves confessedly a principal source of the gratification of the Reader. All that it is *necessary* to say, however, upon this subject, may be effected by affirming, what few persons will deny, that, of two descriptions, either of passions, manners, or characters, each of them equally well executed, the one in prose and the other in verse, the verse will be read a hundred times where the prose is read once.

READING 3

INTRODUCTION

Friedrich Nietzsche was born in 1844 and died, insane, in 1900. His startlingly original writings—which blend irony with polemic, and offer deep critiques of culture in strange exclamatory epigrams—have left an indelible mark on twentieth-century thought, both within and beyond the traditional boundaries of philosophy. Indeed, Nietzsche's announcement of the "Death of God" in *The Gay Science* (1882) can be seen as a key moment in the inauguration of the modern era: Old certainties are ushered out, and a new search for meaning, for value, begins. *The Birth of Tragedy*, however, was published a decade before the Death of God. It was Nietzsche's first book and was written at a time when he had not yet achieved the compression and lucidity that typify his mature style. He was also still very much in thrall to the metaphysics of Schopenhauer, which he was later to discard. But *The Birth of Tragedy* is characteristic of its author even so. For example, the opposition—fundamental to *The Birth of Tragedy*—between the "Apollinian" spirit of order and restraint and the "Dionysian" spirit of ecstatic intoxication was to preoccupy him throughout his life. He also embarks here on his famous love-hate relationship with the spirit of Socrates. And certain features of his method are also typical. Nietzsche began his career as a philologist, and it was perhaps this that prompted him to look so often to the history of a thing when he wished to discover its meaning. In *On the Genealogy of Morals* (1887), for instance, he produced a critique of traditional morality from a reconstructed history of Christian psychology. And in *The Birth of Tragedy* he traces the origins of that synthesis of the Apollinian and the Dionysian which he discovered in Greek drama through another of his ingeniously reconstructed histories. There is no shortage, either, in this work, of those brilliantly perceptive remarks about psychology and culture for which his later writings are celebrated. But Nietzsche's distinctive achievement in *The Birth of Tragedy* is to have diagnosed the passion and the pessimism that lie at the heart of the creative process, and to have revealed a darker side to the enlightenment of ancient Greece. There can be no doubt that *The Birth of Tragedy*, for all

its occasional obscurities, is one of the most significant statements about tragedy, and one of the most thought-provoking reflections upon creativity, ever written.

When *The Birth of Tragedy* went into a new edition in 1886, Nietzsche appended to it an "Attempt at a Self-Criticism," in which he diagnosed the faults of his earlier work, and underlined how far he had moved on in the meantime. Terse, lucid, and perversely cheerful, the "Attempt" is a fine example of Nietzsche's mature style.

From *The Birth of Tragedy*

Friedrich Nietzsche

We shall have gained much for the science of aesthetics, once we perceive not merely by logical inference, but with the immediate certainty of vision, that the continuous development of art is bound up with the *Apollinian* and *Dionysian* duality—just as procreation depends on the duality of the sexes, involving perpetual strife with only periodically intervening reconciliations. The terms Dionysian and Apollinian we borrow from the Greeks, who disclose to the discerning mind the profound mysteries of their view of art, not, to be sure, in concepts, but in the intensely clear figures of their gods. Through Apollo and Dionysus, the two art deities of the Greeks, we come to recognize that in the Greek world there existed a tremendous opposition, in origin and aims, between the Apollinian art of sculpture, and the nonimagistic, Dionysian art of music. These two different tendencies run parallel to each other, for the most part openly at variance; and they continually incite each other to new and more powerful births, which perpetuate an antagonism, only superficially reconciled by the common term "art"; till eventually, by a metaphysical miracle of the Hellenic "will," they appear coupled with each other, and through this coupling ultimately generate an equally Dionysian and Apollinian form of art—Attic tragedy.

In order to grasp these two tendencies, let us first conceive of them as the separate art worlds of *dreams* and *intoxication*. These physiological phenomena present a contrast analogous to that existing between the Apollinian and the Dionysian.

[The] joyous necessity of the dream experience has been embodied by the Greeks in their Apollo: Apollo, the god of all plastic energies, is at the same time the soothsaying god. He, who (as the etymology of the name indicates) is the "shining one," the deity of light, is also ruler over the beautiful illusion of the inner world of fantasy. The higher truth, the perfection of these states in contrast to the incompletely intelligible everyday world, this deep consciousness of nature, healing and helping in sleep and dreams, is at the same time the symbolical analogue of the soothsaying faculty and of the arts generally, which make life possible and worth living. But we must also include in our image of Apollo that delicate boundary which the dream image must not overstep lest it have a pathological effect (in which case mere appearance would deceive us as if it were crude reality). We must keep in mind that measured restraint, that freedom from the wilder emotions, that calm of the sculptor god. His eye must be "sunlike," as befits his origin; even when it is angry

and distempered it is still hallowed by beautiful illusion. And so, in one sense, we might apply to Apollo the words of Schopenhauer when he speaks of the man wrapped in the veil of *māyā* (*Welt als Wille und Vorstellung,* I, p. 416): "Just as in a stormy sea that, unbounded in all directions, raises and drops mountainous waves, howling, a sailor sits in a boat and trusts in his frail bark: so in the midst of a world of torments the individual human being sits quietly, supported by and trusting in the *principium individuationis.*" In fact, we might say of Apollo that in him the unshaken faith in this *principium* and the calm repose of the man wrapped up in it receive their most sublime expression; and we might call Apollo himself the glorious divine image of the *principium individuationis,* through whose gestures and eyes all the joy and wisdom of "illusion," together with its beauty, speak to us.

In the same work Schopenhauer has depicted for us the tremendous *terror* which seizes man when he is suddenly dumfounded by the cognitive form of phenomena because the principle of sufficient reason, in some one of its manifestations, seems to suffer an exception. If we add to this terror the blissful ecstasy that wells from the innermost depths of man, indeed of nature, at this collapse of the *principium individuationis,* we steal a glimpse into the nature of the *Dionysian,* which is brought home to us most intimately by the analogy of intoxication.

Either under the influence of the narcotic draught, of which the songs of all primitive men and peoples speak, or with the potent coming of spring that penetrates all nature with joy, these Dionysian emotions awake, and as they grow in intensity everything subjective vanishes into complete self-forgetfulness. In the German Middle Ages, too, singing and dancing crowds, ever increasing in number, whirled themselves from place to place under this same Dionysian impulse. In these dancers of St. John and St. Vitus, we rediscover the Bacchic choruses of the Greeks, with their prehistory in Asia Minor, as far back as Babylon and the orgiastic Sacaea. There are some who, from obtuseness or lack of experience, turn away from such phenomena as from "folk-diseases," with contempt or pity born of the consciousness of their own "healthy-mindedness." But of course such poor wretches have no idea how corpselike and ghostly their so-called "healthy-mindedness" looks when the glowing life of the Dionysian revelers roars past them.

Under the charm of the Dionysian not only is the union between man and man reaffirmed, but nature which has become alienated, hostile, or subjugated, celebrates once more her reconciliation with her lost son, man. Freely, earth proffers her gifts, and peacefully the beasts of prey of the rocks and desert approach. The chariot of Dionysus is covered with flowers and garlands; panthers and tigers walk under its yoke. Transform Beethoven's "Hymn to Joy" into a painting; let your imagination conceive the multitudes bowing to the dust, awestruck—then you will approach the Dionysian. Now the slave is a free man; now all the rigid, hostile barriers that necessity, caprice, or "impudent convention" have fixed between man and man are broken. Now, with the gospel of universal harmony, each one feels himself not only united, reconciled, and fused with his neighbor, but as one with him, as if the veil of *māyā* had been torn aside and were now merely fluttering in tatters before the mysterious primordial unity. . . .

[We must now try] to find our way through the labyrinth, as we must call it, of *the origin of Greek tragedy.* I do not think I am unreasonable in saying that the problem of this origin has as yet not even been seriously posed, to say nothing of solved, however often the ragged tatters of ancient tradition have been sewn together in various combinations and torn apart again. This tradition tells us quite unequivocally *that tragedy arose from the tragic chorus,* and was originally only chorus and nothing but chorus. Hence we consider it our duty to look into the heart of this tragic chorus as the real proto-drama, without resting satisfied with such arty clichés as that the chorus is the "ideal spectator" or that it represents the people in contrast to the aristocratic region of the scene. . . .

An infinitely more valuable insight into the significance of the chorus was displayed by Schiller in the celebrated Preface to his *Bride of Messina,* where he regards the chorus as a living wall that tragedy constructs around itself in order to close itself off from the world of reality and to preserve its ideal domain and its poetical freedom.

With this, his chief weapon, Schiller combats the ordinary conception of the natural, the illusion usually demanded in dramatic poetry. Although the stage day is merely artificial, the architecture only symbolical, and the metrical language ideal in character, nevertheless an erroneous view still prevails in the main, as he points out: it is not sufficient that one merely tolerates as poetic license what is actually the essence of all poetry. The introduction of the chorus, says Schiller, is the decisive step by which war is declared openly and honorably against all naturalism in art. . . .

It is indeed an "ideal" domain, as Schiller correctly perceived, in which the Greek satyr chorus, the chorus of primitive tragedy, was wont to dwell. It is a domain raised high above the actual paths of mortals. For this chorus the Greek built up the scaffolding of a fictitious *natural state* and on it placed fictitious *natural beings.* On this foundation tragedy developed and so, of course, it could dispense from the beginning with a painstaking portrayal of reality. Yet it is no arbitrary world placed by whim between heaven and earth; rather it is a world with the same reality and credibility that Olympus with its inhabitants possessed for the believing Hellene. The satyr, as the Dionysian chorist, lives in a religiously acknowledged reality under the sanction of myth and cult. That tragedy should begin with him, that he should be the voice of the Dionysian wisdom of tragedy, is just as strange a phenomenon for us as the general derivation of tragedy from the chorus.

Perhaps we shall have a point of departure for our inquiry if I put forward the proposition that the satyr, the fictitious natural being, bears the same relation to the man of culture that Dionysian music bears to civilization. Concerning the latter, Richard Wagner says that it is nullified by music just as lamplight is nullified by the light of day. Similarly, I believe, the Greek man of culture felt himself nullified in the presence of the satyric chorus; and this is the most immediate effect of the Dionysian tragedy, that the state and society and, quite generally, the gulfs between man and man give way to an overwhelming feeling of unity leading back to the very heart of nature. The metaphysical comfort—with which, I am suggesting even now, every true tragedy leaves us—that life is at the bottom of things, despite all the changes of appear-

ances, indestructibly powerful and pleasurable—this comfort appears in incarnate clarity in the chorus of satyrs, a chorus of natural beings who live ineradicably, as it were, behind all civilization and remain eternally the same, despite the changes of generations and of the history of nations.

With this chorus the profound Hellene, uniquely susceptible to the tenderest and deepest suffering, comforts himself, having looked boldly right into the terrible destructiveness of so-called world history as well as the cruelty of nature, and being in danger of longing for a Buddhistic negation of the will. Art saves him, and through art—life.

For the rapture of the Dionysian state with its annihilation of the ordinary bounds and limits of existence contains, while it lasts, a *lethargic* element in which all personal experiences of the past become immersed. This chasm of oblivion separates the worlds of everyday reality and of Dionysian reality. But as soon as this everyday reality re-enters consciousness, it is experienced as such, with nausea: an ascetic, will-negating mood is the fruit of these states.

In this sense the Dionysian man resembles Hamlet: both have once looked truly into the essence of things, they have *gained knowledge,* and nausea inhibits action; for their action could not change anything in the eternal nature of things; they feel it to be ridiculous or humiliating that they should be asked to set right a world that is out of joint. Knowledge kills action; action requires the veils of illusion: that is the doctrine of Hamlet, not that cheap wisdom of Jack the Dreamer who reflects too much and, as it were, from an excess of possibilities does not get around to action. Not reflection, no—true knowledge, an insight into the horrible truth, outweighs any motive for action, both in Hamlet and in the Dionysian man.

Now no comfort avails any more; longing transcends a world after death, even the gods; existence is negated along with its glittering reflection in the gods or in an immortal beyond. Conscious of the truth he has once seen, man now sees everywhere only the horror or absurdity of existence; now he understands what is symbolic in Ophelia's fate; now he understands the wisdom of the sylvan god, Silenus: he is nauseated.

Here, when the danger to his will is greatest, *art* approaches as a saving sorceress, expert at healing. She alone knows how to turn these nauseous thoughts about the horror or absurdity of existence into notions with which one can live: these are the *sublime* as the artistic taming of the horrible, and the *comic* as the artistic discharge of the nausea of absurdity. The satyr chorus of the dithyramb is the saving deed of Greek art; faced with the intermediary world of these Dionysian companions, the feelings described here exhausted themselves. . . .

The satyr, like the idyllic shepherd of more recent times, is the offspring of a longing for the primitive and the natural; but how firmly and fearlessly the Greek embraced the man of the woods, and how timorously and mawkishly modern man dallied with the flattering image of a sentimental, flute-playing, tender shepherd! Nature, as yet unchanged by knowledge, with the bolts of culture still unbroken—that is what the Greek saw in his satyr who nevertheless was not a mere ape. On the contrary, the satyr was the archetype of man, the embodiment of his highest and most intense emotions, the ecstatic reveler enraptured by the proximity of his god, the sympathetic companion in

whom the suffering of the god is repeated, one who proclaims wisdom from the very heart of nature, a symbol of the sexual omnipotence of nature which the Greeks used to contemplate with reverent wonder.

The satyr was something sublime and divine: thus he had to appear to the painfully broken vision of Dionysian man. The contrived shepherd in his dress-ups would have offended him: on the unconcealed and vigorously magnificent characters of nature, his eye rested with sublime satisfaction; here the true human being was disclosed, the bearded satyr jubilating to his god. Confronted with him, the man of culture shriveled into a mendacious caricature.

Schiller is right about these origins of tragic art, too: the chorus is a living wall against the assaults of reality because it—the satyr chorus—represents existence more truthfully, really, and completely than the man of culture does who ordinarily considers himself as the only reality. The sphere of poetry does not lie outside the world as a fantastic impossibility spawned by a poet's brain: it desires to be just the opposite, the unvarnished expression of the truth, and must precisely for that reason discard the mendacious finery of that alleged reality of the man of culture.

The contrast between this real truth of nature and the lie of culture that poses as if it were the only reality is similar to that between the eternal core of things, the thing-in-itself, and the whole world of appearances: just as tragedy, with its metaphysical comfort, points to the eternal life of this core of existence which abides through the perpetual destruction of appearances, the symbolism of the satyr chorus proclaims this primordial relationship between the thing-in-itself and appearance. The idyllic shepherd of modern man is merely a counterfeit of the sum of cultural illusions that are allegedly nature; the Dionysian Greek wants truth and nature in their most forceful form—and sees himself changed, as by magic, into a satyr.

The reveling throng, the votaries of Dionysus jubilate under the spell of such moods and insights whose power transforms them before their own eyes till they imagine that they are beholding themselves as restored geniuses of nature, as satyrs. The later constitution of the chorus in tragedy is the artistic imitation of this natural phenomenon, though, to be sure, at this point the separation of Dionysian spectators and magically enchanted Dionysians became necessary. Only we must always keep in mind that the public at an Attic tragedy found itself in the chorus of the *orchestra,* and there was at bottom no opposition between public and chorus: everything is merely a great sublime chorus of dancing and singing satyrs or of those who permit themselves to be represented by such satyrs. . . .

The chorus is the "ideal spectator" insofar as it is the only beholder, the beholder of the visionary world of the scene. A public of spectators as we know it was unknown to the Greeks: in their theaters the terraced structure of concentric arcs made it possible for everybody to actually *overlook* the whole world of culture around him and to imagine, in absorbed contemplation, that he himself was a chorist.

In the light of this insight we may call the chorus in its primitive form, in proto-tragedy, the mirror image in which the Dionysian man contemplates himself. This phenomenon is best made clear by imagining an actor who, being truly talented, sees the role he is supposed to play quite palpably before his

eyes. The satyr chorus is, first of all, a vision of the Dionysian mass of specta-
tors, just as the world of the stage, in turn, is a vision of this satyr chorus: the
force of this vision is strong enough to make the eye insensitive and blind to
the impression of "reality," to the men of culture who occupy the rows of seats
all around. . . .

In the face of our learned views about elementary artistic processes, this
artistic proto-phenomenon which we bring up here to help explain the tragic
chorus is almost offensive, although nothing could be more certain than the
fact that a poet is a poet only insofar as he sees himself surrounded by figures
who live and act before him and into whose inmost nature he can see. Owing
to a peculiar modern weakness, we are inclined to imagine the aesthetic
protophenomenon in a manner much too complicated and abstract. . . . At bot-
tom, the aesthetic phenomenon is simple: let anyone have the ability to behold
continually a vivid play and to live constantly surrounded by hosts of spirits,
and he will be a poet; let anyone feel the urge to transform himself and to
speak out of other bodies and souls, and he will be a dramatist.

The Dionysian excitement is capable of communicating this artistic gift to
a multitude, so they can see themselves surrounded by such a host of spirits
while knowing themselves to be essentially one with them. This process of the
tragic chorus is the *dramatic* proto-phenomenon: to see oneself transformed
before one's own eyes and to begin to act as if one had actually entered into
another body, another character. This process stands at the beginning of the
origin of drama. Here we have something different from the rhapsodist who
does not become fused with his images but, like a painter, sees them outside
himself as objects of contemplation. Here we have a surrender of individual-
ity and a way of entering into another character. And this phenomenon is
encountered epidemically: a whole throng experiences the magic of this trans-
formation. . . .

Such magic transformation is the presupposition of all dramatic art. In this
magic transformation the Dionysian reveler sees himself as a satyr, *and as a
satyr, in turn, he sees the god,* which means that in his metamorphosis he beholds
another vision outside himself, as the Apollinian complement of his own state.
With this new vision the drama is complete.

In the light of this insight we must understand Greek tragedy as the
Dionysian chorus which ever anew discharges itself in an Apollinian world of
images. Thus the choral parts with which tragedy is interlaced are, as it were,
the womb that gave birth to the whole of the so-called dialogue, that is, the
entire world of the stage, the real drama. In several successive discharges this
primal ground of tragedy radiates this vision of the drama which is by all
means a dream apparition and to that extent epic in nature; but on the other
hand, being the objectification of a Dionysian state, it represents not Apollin-
ian redemption through mere appearance but, on the contrary, the shattering
of the individual and his fusion with primal being. Thus the drama is the
Dionysian embodiment of Dionysian insights and effects and thereby sepa-
rated, as by a tremendous chasm, from the epic.

The *chorus* of the Greek tragedy, the symbol of the whole excited Dionysian
throng, is thus fully explained by our conception. Accustomed as we are to the
function of our modern stage chorus, especially in operas, we could not com-

prehend why the tragic chorus of the Greeks should be older, more original and important than the "action" proper, as the voice of tradition claimed unmistakably. And with this traditional primacy and originality we could not reconcile the fact that the chorus consisted only of humble beings who served—indeed, initially only of goatlike satyrs. Finally, there remained the riddle of the orchestra in front of the scene. But now we realize that the scene, complete with the action, was basically and originally thought of merely as a *vision;* the chorus is the only "reality" and generates the vision, speaking of it with the entire symbolism of dance, tone, and words. In its vision this chorus beholds its lord and master Dionysus and is therefore eternally the *serving* chorus: it sees how the god suffers and glorifies himself and therefore does not itself *act.* But while its attitude toward the god is wholly one of service, it is nevertheless the highest, namely the Dionysian, expression of *nature* and therefore pronounces in its rapture, as nature does, oracles and wise sayings: *sharing his suffering* it also shares something of his *wisdom* and proclaims the truth from the heart of the world. That is the origin of the fantastic and seemingly so offensive figure of the wise and rapturous satyr who is at the same time "the simple man" as opposed to the god—the image of nature and its strongest urges, even their symbol, and at the same time the proclaimer of her wisdom and art—musician, poet, dancer, and seer of spirits in one person.

Dionysus, the real stage hero and center of the vision, was, according both to this insight and to the tradition, not actually present at first, in the very oldest period of tragedy; he was merely imagined as present, which means that originally tragedy was only "chorus" and not yet "drama." Later the attempt was made to show the god as real and to represent the visionary figure together with its transfiguring frame as something visible for every eye—and thus "drama" in the narrower sense began. Now the dithyrambic chorus was assigned the task of exciting the mood of the listeners to such a Dionysian degree that, when the tragic hero appeared on the stage, they did not see the awkwardly masked human being but rather a visionary figure, born as it were from their own rapture. . . .

This is the Apollinian state of dreams in which the world of the day becomes veiled, and a new world, clearer, more understandable, more moving than the everyday world and yet more shadowy, presents itself to our eyes in continual rebirths. Accordingly, we recognize in tragedy a sweeping opposition of styles: the language, color, mobility, and dynamics of speech fall apart into the Dionysian lyrics of the chorus and, on the other hand, the Apollinian dream world, and become two utterly different spheres of expression. The Apollinian appearances in which Dionysus objectifies himself are no longer "an eternal sea, changeful strife, a glowing life," like the music of the chorus, no longer those forces, merely felt and not condensed into images, in which the enraptured servant of Dionysus senses the nearness of the god: now the clarity and firmness of epic form addresses him from the scene; now Dionysus no longer speaks through forces but as an epic hero, almost in the language of Homer. . . .

When after a forceful attempt to gaze on the sun we turn away blinded, we see dark-colored spots before our eyes, as a cure, as it were. Conversely, the bright image projections of the Sophoclean hero—in short, the Apollinian

aspect of the mask—are necessary effects of a glance into the inside and terrors of nature; as it were, luminous spots to cure eyes damaged by gruesome night. Only in this sense may we believe that we properly comprehend the serious and important concept of "Greek cheerfulness." The misunderstanding of this concept as cheerfulness in a state of unendangered comfort is, of course, encountered everywhere today.

Sophocles understood the most sorrowful figure of the Greek stage, the unfortunate Oedipus, as the noble human being who, in spite of his wisdom, is destined to error and misery but who eventually, through his tremendous suffering, spreads a magical power of blessing that remains effective even beyond his decease. The noble human being does not sin, the profound poet wants to tell us: though every law, every natural order, even the moral world may perish through his actions, his actions also produce a higher magical circle of effects which found a new world on the ruins of the old one that has been overthrown. That is what the poet wants to say to us insofar as he is at the same time a religious thinker. As a poet he first shows us a marvelously tied knot of a trial, slowly unraveled by the judge, bit by bit, for his own undoing. The genuinely Hellenic delight at this dialectical solution is so great that it introduces a trait of superior cheerfulness into the whole work, everywhere softening the sharp points of the gruesome presuppositions of this process. . . .

If this explanation does justice to the poet one may yet ask whether it exhausts the contents of the myth—and then it becomes evident that the poet's whole conception is nothing but precisely that bright image which healing nature projects before us after a glance into the abyss. Oedipus, the murderer of his father, the husband of his mother, the solver of the riddle of the Sphinx! What does the mysterious triad of these fateful deeds tell us?

There is a tremendously old popular belief, especially in Persia, that a wise magus can be born only from incest. With the riddle-solving and mother-marrying Oedipus in mind, we must immediately interpret this to mean that where prophetic and magical powers have broken the spell of present and future, the rigid law of individuation, and the real magic of nature, some enormously unnatural event—such as incest—must have occurred earlier, as a cause. How else could one compel nature to surrender her secrets if not by triumphantly resisting her, that is, by means of something unnatural? It is this insight that I find expressed in that horrible triad of Oedipus' destinies: the same man who solves the riddle of nature—that Sphinx of two species—also must break the most sacred natural orders by murdering his father and marrying his mother. Indeed, the myth seems to wish to whisper to us that wisdom, and particularly Dionysian wisdom, is an unnatural abomination; that he who by means of his knowledge plunges nature into the abyss of destruction must also suffer the dissolution of nature in his own person. "The edge of wisdom turns against the wise: wisdom is a crime against nature": such horrible sentences are proclaimed to us by the myth; but the Hellenic poet touches the sublime and terrible Memnon's Column of myth like a sunbeam, so that it suddenly begins to sound—in Sophoclean melodies.

Let me now contrast the glory of activity, which illuminates Aeschylus' *Prometheus,* with the glory of passivity. What the thinker Aeschylus had to say

to us here, but what as a poet he only allows us to sense in his symbolic image, the youthful Goethe was able to reveal to us in the audacious words of his Prometheus:

> Here I sit, forming men
> in my own image,
> a race to be like me,
> to suffer, to weep,
> to delight and to rejoice,
> and to defy you,
> as I do.

5

Man, rising to Titanic stature, gains culture by his own efforts and forces the gods to enter into an alliance with him because in his very own wisdom he holds their existence and their limitations in his hands. But what is most wonderful in this Prometheus poem, which in its basic idea is the veritable hymn of impiety, is the profoundly Aeschylean demand for *justice.* The immeasurable suffering of the bold "individual" on the one hand and the divine predicament and intimation of a twilight of the gods on the other, the way the power of these two worlds of suffering compels a reconciliation, a metaphysical union—all this recalls in the strongest possible manner the center and main axiom of the Aeschylean view of the world which envisages Moira enthroned above gods and men as eternal justice. . . .

But Aeschylus' interpretation of the myth does not exhaust the astounding depth of its terror. Rather the artist's delight in what becomes, the cheerfulness of artistic creation that defies all misfortune, is merely a bright image of clouds and sky mirrored in a black lake of sadness. The Prometheus story is an original possession of the entire Aryan community of peoples and evidences their gift for the profoundly tragic. Indeed, it does not seem improbable that this myth has the same characteristic significance for the Aryan character which the myth of the fall has for the Semitic character, and that these two myths are related to each other like brother and sister. The presupposition of the Prometheus myth is to be found in the extravagant value which a naïve humanity attached to *fire* as the true palladium of every ascending culture. But that man should freely dispose of fire without receiving it as a present from heaven, either as a lightning bolt or as the warming rays of the sun, struck these reflective primitive men as sacrilege, as a robbery of divine nature. Thus the very first philosophical problem immediately produces a painful and irresolvable contradiction between man and god and moves it before the gate of every culture, like a huge boulder. The best and highest possession mankind can acquire is obtained by sacrilege and must be paid for with consequences that involve the whole flood of sufferings and sorrows with which the offended divinities have to afflict the nobly aspiring race of men. This is a harsh idea which, by the *dignity* it confers on sacrilege, contrasts strangely with the Semitic myth of the fall in which curiosity, mendacious deception, susceptibility to seduction, lust—in short, a series of pre-eminently feminine affects was considered the origin of evil. What distinguishes the Aryan notion is the sublime view of *active sin* as the characteristically Promethean virtue.

With that, the ethical basis for pessimistic tragedy has been found: the justification of human evil, meaning both human guilt and the human suffering it entails.

The misfortune in the nature of things, which the contemplative Aryan is not inclined to interpret away—the contradiction at the heart of the world reveals itself to him as a clash of different worlds, e.g., of a divine and human one, in which each, taken as an individual, has right on its side, but nevertheless has to suffer for its individuation, being merely a single one beside another. In the heroic effort of the individual to attain universality, in the attempt to transcend the curse of individuation and to become the *one* world-being, he suffers in his own person the primordial contradiction that is concealed in things, which means that he commits sacrilege and suffers. . . .

Whoever understands this innermost kernel of the Prometheus story— namely, the necessity of sacrilege imposed upon the titanically striving individual—must also immediately feel how un-Apollinian this pessimistic notion is. For Apollo wants to grant repose to individual beings precisely by drawing boundaries between them and by again and again calling these to mind as the most sacred laws of the world, with his demands for self-knowledge and measure.

Lest this Apollinian tendency congeal the form to Egyptian rigidity and coldness, lest the effort to prescribe to the individual wave its path and realm might annul the motion of the whole lake, the high tide of the Dionysian destroyed from time to time all those little circles in which the one-sidedly Apollinian "will" had sought to confine the Hellenic spirit. The suddenly swelling Dionysian tide then takes the separate little wave-mountains of individuals on its back, even as Prometheus' brother, the Titan Atlas, does with the earth. This Titanic impulse to become, as it were, the Atlas for all individuals, carrying them on a broad back, higher and higher, farther and farther, is what the Promethean and the Dionysian have in common.

In this respect, the Prometheus of Aeschylus is a Dionysian mask, while in the aforementioned profound demand for justice Aeschylus reveals to the thoughtful his paternal descent from Apollo, the god of individuation and of just boundaries. So the dual nature of Aeschylus' Prometheus, his nature which is at the same time Dionysian and Apollinian, might be expressed thus in a conceptual formula: "All that exists is just and unjust and equally justified in both."

That is your world! A world indeed! . . .

The tradition is undisputed that Greek tragedy in its earliest form had for its sole theme the sufferings of Dionysus and that for a long time the only stage hero was Dionysus himself. But it may be claimed with equal confidence that until Euripides, Dionysus never ceased to be the tragic hero; that all the celebrated figures of the Greek stage—Prometheus, Oedipus, etc.—are mere masks of this original hero, Dionysus. That behind all these masks there is a deity, that is one essential reason for the typical "ideality" of these famous figures which has caused so much astonishment. Somebody, I do not know who, has claimed that all individuals, taken as individuals, are comic and hence untragic—from which it would follow that the Greeks simply *could* not suffer individuals on the tragic stage. In fact, this is what they seem to have felt; and

the Platonic distinction and evaluation of the "idea" and the "idol," the mere image, is very deeply rooted in the Hellenic character.

Using Plato's terms we should have to speak of the tragic figures of the Hellenic stage somewhat as follows: the one truly real Dionysus appears in a variety of forms, in the mask of a fighting hero, and entangled, as it were, in the net of the individual will. The god who appears talks and acts so as to resemble an erring, striving, suffering individual. That he *appears* at all with such epic precision and clarity is the work of the dream-interpreter, Apollo, who through this symbolic appearance interprets to the chorus its Dionysian state. In truth, however, the hero is the suffering Dionysus of the Mysteries, the god experiencing in himself the agonies of individuation, of whom wonderful myths tell that as a boy he was torn to pieces by the Titans and now is worshiped in this state as Zagreus. Thus it is intimated that this dismemberment, the properly Dionysian *suffering,* is like a transformation into air, water, earth, and fire, that we are therefore to regard the state of individuation as the origin and primal cause of all suffering, as something objectionable in itself. From the smile of this Dionysus sprang the Olympian gods, from his tears sprang man. In this existence as a dismembered god, Dionysus possesses the dual nature of a cruel, barbarized demon and a mild, gentle ruler. But the hope of the epopts* looked toward a rebirth of Dionysus, which we must now dimly conceive as the end of individuation. It was for this coming third Dionysus that the epopts' roaring hymns of joy resounded. And it is this hope alone that casts a gleam of joy upon the features of a world torn asunder and shattered into individuals; this is symbolized in the myth of Demeter, sunk in eternal sorrow, who *rejoices* again for the first time when told that she may *once more* give birth to Dionysus. This view of things already provides us with all the elements of a profound and pessimistic view of the world, together with the *mystery doctrine of tragedy:* the fundamental knowledge of the oneness of everything existent, the conception of individuation as the primal cause of evil, and of art as the joyous hope that the spell of individuation may be broken in augury of a restored oneness. . . .

Greek tragedy met an end different from that of her older sister-arts: she died by suicide, in consequence of an irreconcilable conflict; she died tragically, while all the others passed away calmly and beautifully at a ripe old age. If it be consonant with a happy natural state to take leave of life easily, leaving behind a fair posterity, the closing period of these older arts exhibits such a happy natural state: slowly they sink from sight, and before their dying eyes stand their fairer progeny, who lift up their heads impatiently, with a bold gesture. But when Greek tragedy died, there rose everywhere the deep sense of an immense void. Just as Greek sailors in the time of Tiberius once heard on a lonesome island the soul-shaking cry, "Great Pan is dead," so the Hellenic world was now pierced by the grievous lament: "Tragedy is dead! Poetry itself has perished with her! Away with you, pale, meager epigones! Away to Hades, that you may for once eat your fill of the crumbs of our former masters!"

When a new artistic genre blossomed forth after all, and revered tragedy

*Those initiated into the mysteries.

as its predecessor and mistress, it was noted with horror that she did indeed bear the features of her mother—but those she had exhibited in her long death-struggle. It was *Euripides* who fought this death struggle of tragedy; the later artistic genre is known as *New Attic Comedy*. In it the degenerate form of tragedy lived on as a monument of its exceedingly painful and violent death.

This connection helps to explain the passionate attachment that the poets of the New Comedy felt for Euripides; so that we are no longer surprised at the wish of Philemon, who would have let himself be hanged at once, merely that he might visit Euripides in the lower world—if only he could be certain that the deceased still had possession of his reason. But if we desire, as briefly as possible, and without claiming to say anything exhaustive, to characterize what Euripides has in common with Menander and Philemon, and what appealed to them so strongly as worthy of imitation, it is sufficient to say that Euripides brought the *spectator* onto the stage. He who has perceived the material out of which the Promethean tragic writers prior to Euripides formed their heroes, and how remote from their purpose it was to bring the faithful mask of reality onto the stage, will also be aware of the utterly opposite tendency of Euripides. Through him the everyday man forced his way from the spectators' seats onto the stage; the mirror in which formerly only grand and bold traits were represented now showed the painful fidelity that conscientiously reproduces even the botched outlines of nature.

Odysseus, the typical Hellene of the older art, now sank, in the hands of the new poets, to the figure of the Graeculus, who, as the good-naturedly cunning house-slave, henceforth occupies the center of dramatic interest. What Euripides claims credit for in Aristophanes' *Frogs*, namely, that his nostrums have liberated tragic art from its pompous corpulency, is apparent above all in his tragic heroes. The spectator now actually saw and heard his double on the Euripidean stage, and rejoiced that he could talk so well. But this joy was not all: one could even learn from Euripides how to speak oneself. He prides himself upon this in his contest with Aeschylus: from him the people have learned how to observe, debate, and draw conclusions according to the rules of art and with the cleverest sophistries. Through this revolution in ordinary language, he made the New Comedy possible. For henceforth it was no longer a secret how—and with what maxims—everyday life could be represented on the stage. Civic mediocrity, on which Euripides built all his political hopes, was now given a voice, while heretofore the demigod in tragedy and the drunken satyr, or demiman, in comedy, had determined the character of the language. And so the Aristophanean Euripides prides himself on having portrayed the common, familiar, everyday life and activities of the people, about which all are qualified to pass judgment. If the entire populace now philosophized, managed land and goods, and conducted lawsuits with unheard-of circumspection, he deserved the credit, for this was the result of the wisdom he had inculcated in the people.

It was to a populace thus prepared and enlightened that the New Comedy could address itself: it was Euripides who had taught, as it were, the chorus; only now the chorus of spectators had to be trained. As soon as this chorus was trained to sing in the Euripidean key, there arose that drama which resembles a game of chess—the New Comedy, with its perpetual triumphs of cunning and craftiness. But Euripides—the chorus master—was praised con-

tinually: indeed, people would have killed themselves in order to learn still more from him, if they had not known that the tragic poets were quite as dead as tragedy. But with that, the Hellene had given up his belief in immortality; not only his belief in an ideal past, but also his belief in an ideal future. The words of the well-known epitaph, "frivolous and eccentric when an old man," also suit aging Hellenism. The passing moment, wit, levity, and caprice are its highest deities; the fifth estate, that of the slaves, now comes to power, at least in sentiment; and if we may still speak at all of "Greek cheerfulness," it is the cheerfulness of the slave who has nothing of consequence to be responsible for, nothing great to strive for, and who does not value anything in the past or future higher than the present.

It was this semblance of "Greek cheerfulness" which so aroused the profound and formidable natures of the first four centuries of Christianity: this womanish flight from seriousness and terror, this craven satisfaction with easy enjoyment, seemed to them not only contemptible, but a specifically anti-Christian sentiment. And it is due to their influence that the conception of Greek antiquity which endured through the centuries clung with almost unconquerable persistency to that pink hue of cheerfulness—as if there had never been a sixth century with its birth of tragedy, its mysteries, its Pythagoras and Heraclitus, as if the works of art of the great period simply did not exist, though these phenomena can hardly be explained as having originated in any such senile and slavish pleasure in existence and cheerfulness, and point to a wholly different conception of the world as the ground of their existence. . . .

These considerations make it clear that our formula—that Euripides brought the spectator onto the stage in order to make him truly competent to pass judgment—was merely provisional; we must penetrate more deeply to understand his tendency. Conversely, it is well known that Aeschylus and Sophocles during the whole of their lives, and indeed long after, were in complete possession of the people's favor, so there can be no question of a false relation between art and the public in the case of these predecessors of Euripides. What was it then that forcibly drove this artist, so richly endowed, so constantly impelled to production, from the path warmed by the sun of the greatest names in poetry and covered by the cloudless heaven of popular favor? What strange consideration for the spectator led him to oppose the spectator? How could he, out of too great a respect for his public—despise his public?

Euripides—and this is the solution of the riddle just propounded—undoubtedly felt himself, as a poet, superior to the masses in general; but to two of his spectators he did not feel superior. He brought the masses onto the stage; but these two spectators he revered as the only competent judges and masters of his art. Complying with their directions and admonitions, he transferred the entire world of sentiments, passions, and experiences, hitherto present at every festival performance as the invisible chorus on the spectators' benches, into the souls of his stage-heroes. He yielded to their demands, too, when for these new characters he sought out a new language and a new tone. Only in their voices could he hear any conclusive verdict on his work, and also the encouragement that promised eventual success when, as usual, he found himself condemned by the public judgment.

Of these two spectators, one is—Euripides himself, Euripides *as thinker,*

not as poet. It might be said of him, as of Lessing, that his extraordinary fund of *critical* talent, if it did not create, at least constantly stimulated his productive *artistic* impulse. With this gift, with all the brightness and dexterity of his critical thinking, Euripides had sat in the theater and striven to recognize in the masterpieces of his great predecessors, as in paintings that have become dark, feature after feature, line after line. And here he had experienced something which should not surprise anyone initiated into the deeper secrets of Aeschylean tragedy. He observed something incommensurable in every feature and in every line, a certain deceptive distinctness and at the same time an enigmatic depth, indeed an infinitude, in the background. Even the clearest figure always had a comet's tail attached to it which seemed to suggest the uncertain, that which could never be illuminated. A similar twilight shrouded the structure of the drama, especially the significance of the chorus. And how dubious the solution of the ethical problems remained to him! How questionable the treatment of the myths! How unequal the distribution of good and bad fortune! Even in the language of the Old Tragedy there was much he found offensive, or at least enigmatic; especially he found too much pomp for simple affairs, too many tropes and monstrous expressions to suit the plainness of the characters. So he sat in the theater, pondering uneasily, and as a spectator he confessed to himself that he did not understand his great predecessors. But if the understanding was for him the real root of all enjoyment and creation, he had to inquire and look around to see whether no one else had the same opinion and also felt this incommensurability. But most people, and among them the finest individuals, had only a suspicious smile for him, and none could explain to him why the great masters were still in the right despite his scruples and objections. And in this state of torment, he found *that other spectator* who did not comprehend tragedy and therefore did not esteem it. Allied with him, he could now venture from his solitude to begin the tremendous struggle against the art of Aeschylus and Sophocles—not with polemical essays, but as a dramatic poet who opposed *his* conception of tragedy to the traditional one. . . .

Before we name this other spectator, let us pause here a moment to recall to our minds our previously described impression of the discordant and incommensurable elements in the nature of Aeschylean tragedy. Let us recall our surprise at the *chorus* and the *tragic hero* of that tragedy, neither of which we could reconcile with our own customs any more than with tradition—till we rediscovered this duality itself as the origin and essence of Greek tragedy, as the expression of two interwoven artistic impulses, *the Apollinian and the Dionysian*.

To separate this original and all-powerful Dionysian element from tragedy, and to reconstruct tragedy purely on the basis of an un-Dionysian art, morality, and world view—this is the tendency of Euripides as it now reveals itself to us in clear illumination.

In the evening of his life, Euripides himself propounded to his contemporaries the question of the value and significance of this tendency, using a myth. Is the Dionysian entitled to exist at all? Should it not be forcibly uprooted from Hellenic soil? Certainly, the poet tells us, if it were only possible: but the good Dionysus is too powerful; his most intelligent adversary—like Pentheus in the

Bacchae—is unwittingly enchanted by him, and in this enchantment runs to meet his fate. The judgment of the two old men, Cadmus and Tiresias, seems also to be the judgment of the old poet: the reflection of the wisest individuals does not overthrow these old popular traditions, nor the perpetually self-propagating worship of Dionysus; rather it is proper to display a diplomatically cautious interest in the presence of such marvelous forces—although the possibility remains that the god may take offense at such lukewarm participation, and eventually transform the diplomat—like Cadmus—into a dragon. This is what we are told by a poet who opposed Dionysus with heroic valor throughout a long life—and who finally ended his career with a glorification of his adversary and with suicide, like a giddy man who, to escape the horrible vertigo he can no longer endure, casts himself from a tower.

This tragedy was a protest against the practicability of his own tendency; but alas, it had already been put into practice! The marvel had happened: when the poet recanted, his tendency had already triumphed. Dionysus had already been scared from the tragic stage, by a demonic power speaking through Euripides. Even Euripides was, in a sense, only a mask: the deity that spoke through him was neither Dionysus nor Apollo, but an altogether newborn demon, called *Socrates*.

This is the new opposition: the Dionysian and the Socratic—and the art of Greek tragedy was wrecked on this. Though Euripides may seek to comfort us by his recantation, he does not succeed: the most magnificent temple lies in ruins. What does the lamentation of the destroyer profit us, or his confession that it was the most beautiful of all temples? And even if Euripides has been punished by being changed into a dragon by the art critics of all ages—who could be content with so miserable a compensation?

Let us now approach this *Socratic* tendency with which Euripides combated and vanquished Aeschylean tragedy.

We must now ask ourselves, what could be the aim of the Euripidean design, which, in its most ideal form, would wish to base drama exclusively on the un-Dionysian? What form of drama still remained, if it was not to be born of the womb of music, in the mysterious twilight of the Dionysian? Only *the dramatized epos*—but in this Apollinian domain of art the *tragic* effect is certainly unattainable. The subject matter of the events represented is not decisive; indeed, I suggest that it would have been impossible for Goethe in his projected *Nausikaa* to have rendered tragically effective the suicide of this idyllic being, which was to have completed the fifth act. So extraordinary is the power of the epic-Apollinian that before our eyes it transforms the most terrible things by the joy in mere appearance and in redemption through mere appearance. The poet of the dramatized epos cannot blend completely with his images any more than the epic rhapsodist can. He is still that calm, unmoved contemplation which sees the images *before* its wide-open eyes. The actor in this dramatized epos still remains fundamentally a rhapsodist: the consecration of the inner dream lies on all his actions, so that he is never wholly an actor.

How, then, is the Euripidean play related to this ideal of the Apollinian drama? Just as the younger rhapsodist is related to the solemn rhapsodist of old times. In the Platonic *Ion*, the younger rhapsodist describes his own nature

as follows: "When I am saying anything sad, my eyes fill with tears; and when I am saying something awful and terrible, then my hair stands on end with fright and my heart beats quickly." Here we no longer remark anything of the epic absorption in mere appearance, or of the dispassionate coolness of the true actor, who precisely in his highest activity is wholly mere appearance and joy in mere appearance. Euripides is the actor whose heart beats, whose hair stands on end; as Socratic thinker he designs the plan, as passionate actor he executes it. Neither in the designing nor in the execution is he a pure artist. Thus the Euripidean drama is a thing both cool and fiery, equally capable of freezing and burning. It is impossible for it to attain the Apollinian effect of the epos, while, on the other hand, it has alienated itself as much as possible from Dionysian elements. Now, in order to be effective at all, it requires new stimulants, which can no longer lie within the sphere of the only two art-impulses, the Apollinian and the Dionysian. These stimulants are cool, para-doxical thoughts, replacing Apollinian contemplation—and fiery *affects*, replacing Dionysian ecstasies; and, it may be added, thoughts and affects copied very realistically and in no sense dipped into the ether of art.

So we see that Euripides did not succeed in basing the drama exclusively on the Apollinian, and his un-Dionysian tendency actually went astray and became naturalistic and inartistic. Now we should be able to come closer to the character of *aesthetic Socratism,* whose supreme law reads roughly as fol-lows, "To be beautiful everything must be intelligible," as the counterpart to the Socratic dictum, "Knowledge is virtue." With this canon in his hands, Euripides measured all the separate elements of the drama—language, char-acters, dramaturgic structure, and choric music—and corrected them accord-ing to this principle.

The poetic deficiency and degeneration, which are so often imputed to Euripides in comparison with Sophocles, are for the most part products of this penetrating critical process, this audacious reasonableness. . . .

Sophocles said of Aeschylus that he did what was right, though he did it unconsciously. This was surely not how Euripides saw it. He might have said that Aeschylus, *because* he created unconsciously, did what was *wrong.* The divine Plato, too, almost always speaks only ironically of the creative faculty of the poet, insofar as it is not conscious insight, and places it on a par with the gift of the soothsayer and dream-interpreter: the poet is incapable of com-posing until he has become unconscious and bereft of understanding. Like Plato, Euripides undertook to show to the world the reverse of the "unintelli-gent" poet; his aesthetic principle that "to be beautiful everything must be con-scious" is, as I have said, the parallel to the Socratic, "to be good everything must be conscious." So we may consider Euripides as the poet of aesthetic Socratism.

Socrates, however, was that *second spectator* who did not comprehend and therefore did not esteem the Old Tragedy; in alliance with him Euripides dared to be the herald of a new art. If it was this of which the older tragedy perished, then aesthetic Socratism was the murderous principle; but insofar as the strug-gle was directed against the Dionysian element in the older tragedy, we may recognize in Socrates the opponent of Dionysus. . . .

That Socrates was closely related to the tendency of Euripides did not

escape the notice of contemporaneous antiquity. The most eloquent expression of this felicitous insight was the story current in Athens that Socrates used to help Euripides write his plays. Whenever an occasion arose to enumerate the demagogues of the day, the adherents of the "good old times" would mention both names in the same breath. To the influence of Socrates and Euripides they attributed the fact that the old Marathonian stalwart fitness of body and soul was being sacrificed more and more to a dubious enlightenment that involved the progressive degeneration of the powers of body and soul. It is in this tone, half indignant, half contemptuous, that Aristophanic comedy used to speak of both of them—to the consternation of modern men, who are quite willing to give up Euripides, but who cannot give sufficient expression to their astonishment that in Aristophanes Socrates should appear as the first and supreme *Sophist,* as the mirror and epitome of all sophistical tendencies. Their only consolation is to pillory Aristophanes himself as a dissolute, mendacious Alcibiades of poetry. Without here defending the profound instinct of Aristophanes against such attacks, I shall continue to show, by means of the sentiments of the time, the close connection between Socrates and Euripides. With this in view, we must remember particularly how Socrates, as an opponent of tragic art, refrained from attending tragedies and appeared among the spectators only when a new play of Euripides was to be performed. Most famous of all, however, is the juxtaposition of the two names by the Delphic oracle, which designated Socrates as the wisest of men and at the same time decided that the second prize in the contest of wisdom belonged to Euripides.

Sophocles was named third in order of rank—he who could boast that, as compared with Aeschylus, he did what was right because he *knew* what was right. Evidently it is precisely the degree of the brightness of this *knowledge* which distinguishes these three men in common as the three "knowing ones" of their time.

The most acute word, however, about this new and unprecedented value set on knowledge and insight was spoken by Socrates when he found that he was the only one who acknowledged to himself that he knew *nothing,* whereas in his critical peregrinations through Athens he had called on the greatest statesmen, orators, poets, and artists, and had everywhere discovered the conceit of knowledge. To his astonishment he perceived that all these celebrities were without a proper and sure insight, even with regard to their own professions, and that they practiced them only by instinct. "Only by instinct": with this phrase we touch upon the heart and core of the Socratic tendency. With it Socratism condemns existing art as well as existing ethics. Wherever Socratism turns its searching eyes it sees lack of insight and the power of illusion; and from this lack it infers the essential perversity and reprehensibility of what exists. Basing himself on this point, Socrates conceives it to be his duty to correct existence: all alone, with an expression of irreverence and superiority, as the precursor of an altogether different culture, art, and morality, he enters a world, to touch whose very hem would give us the greatest happiness. . . .

We are offered a key to the character of Socrates by the wonderful phenomenon known as "the *daimonion* of Socrates." In exceptional circumstances, when his tremendous intellect wavered, he found secure support in the utter-

ances of a divine voice that spoke up at such moments. This voice, whenever it comes, always *dissuades*. In this utterly abnormal nature, instinctive wisdom appears only in order to *hinder* conscious knowledge occasionally. While in all productive men it is instinct that is the creative-affirmative force, and consciousness acts critically and dissuasively, in Socrates it is instinct that becomes the critic, and consciousness that becomes the creator—truly a monstrosity *per defectum!* Specifically, we observe here a monstrous *defectus* of any mystical disposition, so Socrates might be called the typical *non-mystic*, in whom, through a hypertrophy, the logical nature is developed as excessively as instinctive wisdom is in the mystic. But the logical urge that became manifest in Socrates was absolutely prevented from turning against itself; in its unbridled flood it displays a natural power such as we encounter to our awed amazement only in the very greatest instinctive forces. Anyone who, through the Platonic writings, has experienced even a breath of the divine naïveté and sureness of the Socratic way of life, will also feel how the enormous driving-wheel of logical Socratism is in motion, as it were, *behind* Socrates, and that it must be viewed through Socrates as through a shadow.

His own sense of this relationship found expression in the dignified seriousness with which he everywhere, even before his judges, insisted on his divine calling. At bottom, it was as impossible to refute him here as to approve of his instinct-disintegrating influence. In view of this indissoluble conflict, when he had at last been brought before the forum of the Greek state, only one kind of punishment was indicated: exile. Being thoroughly enigmatical, unclassifiable, and inexplicable, he might have been asked to leave the city, and posterity would never have been justified in charging the Athenians with an ignominious deed. But that he was sentenced to death, not exile, Socrates himself seems to have brought about with perfect awareness and without any natural awe of death. He went to his death with the calm with which, according to Plato's description, he leaves the Symposium at dawn, the last of the revelers, to begin a new day, while on the benches and on the earth his drowsy table companions remain behind to dream of Socrates, the true eroticist. *The dying Socrates* became the new ideal, never seen before, of noble Greek youths: above all, the typical Hellenic youth, Plato, prostrated himself before this image with all the ardent devotion of his enthusiastic soul. . . .

Let us now imagine the one great Cyclops eye of Socrates fixed on tragedy, an eye in which the fair frenzy of artistic enthusiasm had never glowed. To this eye was denied the pleasure of gazing into the Dionysian abysses. What, then, did it have to see in the "sublime and greatly lauded" tragic art, as Plato called it? Something rather unreasonable, full of causes apparently without effects, and effects apparently without causes; the whole, moreover, so motley and manifold that it could not but be repugnant to a sober mind, and a dangerous tinder for sensitive and susceptible souls. We know the only kind of poetry he comprehended: the *Aesopian fable*; and this he favored no doubt with the smiling accommodation with which the good honest Gellert sings the praise of poetry in the fable of the bee and the hen:

> Poems are useful: they can tell
> The truth by means of parable
> To those who are not very bright.

But to Socrates it seemed that tragic art did not even "tell the truth"; moreover, it addressed itself to "those who are not very bright," not to the philosopher: a twofold reason for shunning it. Like Plato, he reckoned it among the flattering arts which portray only the agreeable, not the useful; and therefore he required of his disciples abstinence and strict separation from such unphilosophical attractions—with such success that the youthful tragic poet Plato first burned his poems that he might become a student of Socrates. But where unconquerable propensities struggled against the Socratic maxims, their power, together with the impact of his tremendous character, was still great enough to force poetry itself into new and hitherto unknown channels.

An instance of this is Plato, who in condemning tragedy and art in general certainly did not lag behind the naïve cynicism of his master; he was nevertheless constrained by sheer artistic necessity to create an art form that was related to those forms of art which he repudiated. Plato's main objection to the older art—that it is the imitation of a phantom and hence belongs to a sphere even lower than the empirical world—could certainly not be directed against the new art; and so we find Plato endeavoring to transcend reality and to represent the idea which underlies this pseudo-reality. Thus Plato, the thinker, arrived by a detour where he had always been at home as a poet—at the point from which Sophocles and the older art protested solemnly against that objection. If tragedy had absorbed into itself all the earlier types of art, the same might also be said in an eccentric sense of the Platonic dialogue which, a mixture of all extant styles and forms, hovers midway between narrative, lyric, and drama, between prose and poetry, and so has also broken the strict old law of the unity of linguistic form. This tendency was carried still further by the *Cynic* writers, who in the greatest stylistic medley, oscillating between prose and metrical forms, realized also the literary image of the "raving Socrates" whom they represented in real life.

The Platonic dialogue was, as it were, the barge on which the shipwrecked ancient poetry saved herself with all her children: crowded into a narrow space and timidly submitting to the single pilot, Socrates, they now sailed into a new world, which never tired of looking at the fantastic spectacle of this procession. Indeed, Plato has given to all posterity the model of a new art form, the model of the *novel*—which may be described as an infinitely enhanced Aesopian fable, in which poetry holds the same rank in relation to dialectical philosophy as this same philosophy held for many centuries in relation to theology: namely, the rank of *ancilla*. This was the new position into which Plato, under the pressure of the demonic Socrates, forced poetry.

Here *philosophic thought* overgrows art and compels it to cling close to the trunk of dialectic. The *Apollinian* tendency has withdrawn into the cocoon of logical schematism; just as in the case of Euripides we noticed something analogous, as well as a transformation of the *Dionysian* into naturalistic affects. Socrates, the dialectical hero of the Platonic drama, reminds us of the kindred nature of the Euripidean hero who must defend his actions with arguments and counterarguments and in the process often risks the loss of our tragic pity; for who could mistake the *optimistic* element in the nature of dialectic, which celebrates a triumph with every conclusion and can breathe only in cool clarity and consciousness—the optimistic element which, having once penetrated tragedy must gradually overgrow its Dionysian regions and impel it neces-

sarily to self-destruction—to the death-leap into the bourgeois drama. Consider the consequences of the Socratic maxims: "Virtue is knowledge; man sins only from ignorance; he who is virtuous is happy." In these three basic forms of optimism lies the death of tragedy. For now the virtuous hero must be a dialectician; now there must be a necessary, visible connection between virtue and knowledge, faith and morality; now the transcendental justice of Aeschylus is degraded to the superficial and insolent principle of "poetic justice" with its customary *deus ex machina*.

As it confronts this new Socratic-optimistic stage world, how does the *chorus* appear now, and indeed the whole musical-Dionysian substratum of tragedy? As something accidental, a dispensable vestige of the origin of tragedy; while we have seen that the chorus can be understood only as the *cause* of tragedy, and of the tragic in general. This perplexity in regard to the chorus already manifests itself in Sophocles—an important indication that even with him the Dionysian basis of tragedy is beginning to break down. He no longer dares to entrust to the chorus the main share of the effect, but limits its sphere to such an extent that it now appears almost co-ordinate with the actors, just as if it were elevated from the orchestra into the scene; and thus its character is, of course, completely destroyed, even if Aristotle favors precisely this theory of the chorus. This alteration in the position of the chorus, which Sophocles at any rate recommended by his practice and, according to tradition, even by a treatise, is the first step toward the *destruction* of the chorus, whose phases follow one another with alarming rapidity in Euripides, Agathon, and the New Comedy. Optimistic dialectic drives *music* out of tragedy with the scourge of its syllogisms; that is, it destroys the essence of tragedy, which can be interpreted only as a manifestation and projection into images of Dionysian states, as the visible symbolizing of music, as the dream-world of a Dionysian intoxication.

If we must thus assume an anti-Dionysian tendency operating even prior to Socrates, which merely received in him an unprecedentedly magnificent expression, we must not draw back before the question of what such a phenomenon as that of Socrates indicates; for in view of the Platonic dialogues we are certainly not entitled to regard it as a merely disintegrating, negative force. And though there can be no doubt that the most immediate effect of the Socratic impulse tended to the dissolution of Dionysian tragedy, yet a profound experience in Socrates' own life impels us to ask whether there is *necessarily* only an antipodal relation between Socratism and art, and whether the birth of an "artistic Socrates" is altogether a contradiction in terms.

For with respect to art that despotic logician occasionally had the feeling of a gap, a void, half a reproach, a possibly neglected duty. As he tells his friends in prison, there often came to him one and the same dream apparition, which always said the same thing to him: "Socrates, practice music." Up to his very last days he comforts himself with the view that his philosophizing is the highest of the muses, and he finds it hard to believe that a deity should remind him of the "common, popular music." Finally, in prison, in order that he may thoroughly unburden his conscience, he does consent to practice this music for which he has but little respect. And in this mood he writes a prelude to Apollo and turns a few Aesopian fables into verse. It was something akin to the

demonic warning voice that urged him to these practices; it was his Apollinian insight that, like a barbaric king, he did not understand the noble image of a god and was in danger of sinning against a deity—through his lack of understanding. The voice of the Socratic dream vision is the only sign of any misgivings about the limits of logic: Perhaps—thus he must have asked himself—what is not intelligible to me is not necessarily unintelligent? Perhaps there is a realm of wisdom from which the logician is exiled? Perhaps art is even a necessary correlative of, and supplement for science? . . .

Attempt at a Self-Criticism

Whatever may be at the bottom of this questionable book, it must have been an exceptionally significant and fascinating question, and deeply personal at that: the time in which it was written, in *spite* of which it was written, bears witness to that—the exciting time of the Franco-Prussian War of 1870/71. As the thunder of the battle of Wörth was rolling over Europe, the muser and riddle-friend who was to be the father of this book sat somewhere in an Alpine nook, very bemused and beriddled, hence very concerned and yet unconcerned, and wrote down his thoughts about the *Greeks*—the core of the strange and almost inaccessible book to which this belated preface (or postscript) shall now be added. A few weeks later—and he himself was to be found under the walls of Metz, still wedded to the question marks that he had placed after the alleged "cheerfulness" of the Greeks and of Greek art. Eventually, in that month of profoundest suspense when the peace treaty was being debated at Versailles, he, too, attained peace with himself and, slowly convalescing from an illness contracted at the front, completed the final draft of *The birth of Tragedy out of the Spirit of Music.*—Out of music? Music and tragedy? Greeks and the music of tragedy? Greeks and the art form of pessimism? The best turned out, most beautiful, most envied type of humanity to date, those most apt to seduce us to life, the Greeks—how now? They of all people should have *needed* tragedy? Even more—art? For what—Greek art?

You will guess where the big question mark concerning the value of existence had thus been raised. Is pessimism *necessarily* a sign of decline, decay, degeneration, weary and weak instincts—as it once was in India and now is, to all appearances, among us, "modern" men and Europeans? Is there a pessimism of *strength*? An intellectual predilection for the hard, gruesome, evil, problematic aspect of existence, prompted by well-being, by overflowing health, by the *fullness* of existence? . . .

Still, I do not want to suppress entirely how disagreeable it now seems to me, how strange it appears now, after sixteen years—before a much older, a hundred times more demanding, but by no means colder eye which has not become a stranger to the task which this audacious book dared to tackle for the first time: *to look at science in the perspective of the artist, but at art in that of life.*

To say it once more: today I find it an impossible book: I consider it badly written, ponderous, embarrassing, image-mad and image-confused, sentimental, in places saccharine to the point of effeminacy, uneven in tempo, without

the will to logical cleanliness, very convinced and therefore disdainful of proof, mistrustful even of the *propriety* of proof, a book for initiates, "music" for those dedicated to music, those who are closely related to begin with on the basis of common and rare aesthetic experiences, "music" meant as a sign of recognition for close relatives *in artibus*—an arrogant and rhapsodic book that sought to exclude right from the beginning the *profanum vulgus* of "the educated" even more than "the mass" or "folk." Still, the effect of the book proved and proves that it had a knack for seeking out fellow-rhapsodizers and for luring them on to new secret paths and dancing places. What found expression here was anyway—this was admitted with as much curiosity as antipathy—a *strange* voice, the disciple of a still "unknown God," one who concealed himself for the time being under the scholar's hood, under the gravity and dialectical ill humor of the German, even under the bad manners of the Wagnerian. Here was a spirit with strange, still nameless needs, a memory bursting with questions, experiences, concealed things after which the name of Dionysus was added as one more question mark. What spoke here—as was admitted, not without suspicion—was something like a mystical, almost maenadic soul that stammered with difficulty, a feat of the will, as in a strange tongue, almost undecided whether it should communicate or conceal itself. It should have *sung*, this "new soul"—and not spoken! What I had to say then—too bad that I did not dare say it as a poet: perhaps I had the ability. Or at least as a philologist: after all, even today practically everything in this field remains to be discovered and dug up by philologists! Above all, the problem that there *is* a problem here— and that the Greeks, as long as we lack an answer to the question "what is Dionysian?" remain as totally uncomprehended and unimaginable as ever.

READING 4

INTRODUCTION

Sigmund Freud (1856–1939) was the founder of psychoanalysis; and it is difficult to overestimate the influence and effect that his work has had on modern thought. It has been particularly influential in the development of critical thinking about art: Psychoanalytic theory (though not all of it Freudian) has played an enormous role, for example, in recent film theory and literary criticism. In "Creative Writers and Day-Dreaming" (1908), Freud suggests that in order to understand artistic creativity, we should look to children at play. When children play, says Freud, they create imaginative worlds of their own, worlds in which they may become completely absorbed. As they grow older, children stop playing, but they continue to create absorbing imaginative worlds in their fantasies and daydreams. Daydreaming is familiar to all of us. But, as Freud shows, this activity—like childrens' play itself—is highly complicated. He suggests that an understanding of the complex character of daydreams and daydreamers may illuminate the nature of artistic creations and their creators. Indeed, he holds, some creations—such as myths—

may be fully understandable only in terms of the "wishful phantasies of whole nations, the *secular dreams* of youthful humanity." Freud does not develop these ideas at very great length here, but what he does say is provocative and challenging. And the influence of Freud's ideas has been so great as to be detectable in almost all subsequent thinking about artistic creativity.

"Creative Writers and Day-Dreaming"

Sigmund Freud

We laymen have always been intensely curious to know—like the Cardinal who put a similar question to Ariosto*—from what sources that strange being, the creative writer, draws his material, and how he manages to make such an impression on us with it and to arouse in us emotions of which, perhaps, we had not even thought ourselves capable. Our interest is only heightened the more by the fact that, if we ask him, the writer himself gives us no explanation, or none that is satisfactory; and it is not at all weakened by our knowledge that not even the clearest insight into the determinants of his choice of material and into the nature of the art of creating imaginative form will ever help to make creative writers of *us*.

If we could at least discover in ourselves or in people like ourselves an activity which was in some way akin to creative writing! An examination of it would then give us a hope of obtaining the beginnings of an explanation of the creative work of writers. And, indeed, there is some prospect of this being possible. After all, creative writers themselves like to lessen the distance between their kind and the common run of humanity; they so often assure us that every man is a poet at heart and that the last poet will not perish till the last man does.

Should we not look for the first traces of imaginative activity as early as in childhood? The child's best-loved and most intense occupation is with his play or games. Might we not say that every child at play behaves like a creative writer, in that he creates a world of his own, or, rather, re-arranges the things of his world in a new way which pleases him? It would be wrong to think he does not take that world seriously; on the contrary, he takes his play very seriously and he expends large amounts of emotion on it. The opposite of play is not what is serious but what is real. In spite of all the emotion with which he cathects his world of play, the child distinguishes it quite well from reality; and he likes to link his imagined objects and situations to the tangible and visible things of the real world. This linking is all that differentiates the child's 'play' from 'phantasying'.

The creative writer does the same as the child at play. He creates a world of phantasy which he takes very seriously—that is, which he invests with large amounts of emotion—while separating it sharply from reality. Language has preserved this relationship between children's play and poetic creation. It gives [in German] the name of *'Spiel'* ['play'] to those forms of imaginative

*Cardinal Ippolito d'Este was Ariosto's first patron, to whom he dedicated the *Orlando Furioso*. The poet's only reward was the question: 'Where did you find so many stories, Lodovico?'

writing which require to be linked to tangible objects and which are capable of representation. It speaks of a *'Lustspiel'* or *'Trauerspiel'* ['comedy' or 'tragedy': literally, 'pleasure play' or 'mourning play'] and describes those who carry out the representation as *'Schauspieler'* ['players': literally 'show-players']. The unreality of the writer's imaginative world, however, has very important consequences for the technique of his art; for many things which, if they were real, could give no enjoyment, can do so in the play of phantasy, and many excitements which, in themselves, are actually distressing, can become a source of pleasure for the hearers and spectators at the performance of a writer's work.

There is another consideration for the sake of which we will dwell a moment longer on this contrast between reality and play. When the child has grown up and has ceased to play, and after he has been labouring for decades to envisage the realities of life with proper seriousness, he may one day find himself in a mental situation which once more undoes the contrast between play and reality. As an adult he can look back on the intense seriousness with which he once carried on his games in childhood; and, by equating his ostensibly serious occupations of to-day with his childhood games, he can throw off the too heavy burden imposed on him by life and win the high yield of pleasure afforded by *humour*.

As people grow up, then, they cease to play, and they seem to give up the yield of pleasure which they gained from playing. But whoever understands the human mind knows that hardly anything is harder for a man than to give up a pleasure which he has once experienced. Actually, we can never give anything up; we only exchange one thing for another. What appears to be a renunciation is really the formation of a substitute or surrogate. In the same way, the growing child, when he stops playing, gives up nothing but the link with real objects; instead of *playing,* he now *phantasies.* He builds castles in the air and creates what are called *day-dreams.* I believe that most people construct phantasies at times in their lives. This is a fact which has long been overlooked and whose importance has therefore not been sufficiently appreciated.

People's phantasies are less easy to observe than the play of children. The child, it is true, plays by himself or forms a closed psychical system with other children for the purposes of a game; but even though he may not play his game in front of the grown-ups, he does not, on the other hand, conceal it from them. The adult, on the contrary, is ashamed of his phantasies and hides them from other people. He cherishes his phantasies as his most intimate possessions, and as a rule he would rather confess his misdeeds than tell anyone his phantasies. It may come about that for that reason he believes he is the only person who invents such phantasies and has no idea that creations of this kind are widespread among other people. This difference in the behaviour of a person who plays and a person who phantasies is accounted for by the motives of these two activities, which are nevertheless adjuncts to each other.

A child's play is determined by wishes: in point of fact by a single wish—one that helps in his upbringing—the wish to be big and grown up. He is always playing at being 'grown up', and in his games he imitates what he knows about the lives of his elders. He has no reason to conceal this wish. With the adult, the case is different. On the one hand, he knows that he is

expected not to go on playing or phantasying any longer, but to act in the real world; on the other hand, some of the wishes which give rise to his phantasies are of a kind which it is essential to conceal. Thus he is ashamed of his phantasies as being childish and as being unpermissible.

But, you will ask, if people make such a mystery of their phantasying, how is it that we know such a lot about it? Well, there is a class of human beings upon whom, not a god, indeed, but a stern goddess—Necessity—has allotted the task of telling what they suffer and what things give them happiness.* These are the victims of nervous illness, who are obliged to tell their phantasies, among other things, to the doctor by whom they expect to be cured by mental treatment. This is our best source of knowledge, and we have since found good reason to suppose that our patients tell us nothing that we might not also hear from healthy people.

Let us now make ourselves acquainted with a few of the characteristics of phantasying. We may lay it down that a happy person never phantasies, only an unsatisfied one. The motive forces of phantasies are unsatisfied wishes, and every single phantasy is the fulfilment of a wish, a correction of unsatisfying reality. These motivating wishes vary according to the sex, character and circumstances of the person who is having the phantasy; but they fall naturally into two main groups. They are either ambitious wishes, which serve to elevate the subject's personality; or they are erotic ones. In young women the erotic wishes predominate almost exclusively, for their ambition is as a rule absorbed by erotic trends. In young men egoistic and ambitious wishes come to the fore clearly enough alongside of erotic ones. But we will not lay stress on the opposition between the two trends; we would rather emphasize the fact that they are often united. Just as, in many altar-pieces, the portrait of the donor is to be seen in a corner of the picture, so, in the majority of ambitious phantasies, we can discover in some corner or other the lady for whom the creator of the phantasy performs all his heroic deeds and at whose feet all his triumphs are laid. Here, as you see, there are strong enough motives for concealment; the well-brought-up young woman is only allowed a minimum of erotic desire, and the young man has to learn to suppress the excess of self-regard which he brings with him from the spoilt days of his childhood, so that he may find his place in a society which is full of other individuals making equally strong demands.

We must not suppose that the products of this imaginative activity—the various phantasies, castles in the air and day-dreams—are stereotyped or unalterable. On the contrary, they fit themselves in to the subject's shifting impressions of life, change with every change in his situation, and receive from every fresh active impression what might be called a 'date-mark'. The relation of a phantasy to time is in general very important. We may say that it hovers, as it were, between three times—the three moments of time which our ideation

*This is an allusion to some well-known lines spoken by the poet-hero in the final scene of Goethe's *Torquato Tasso:*

'Und wenn der Mensch in seiner Qual verstummt,
Gab mir ein Gott, zu sagen, wie ich leide.'

('And when mankind is dumb in its torment, a god granted me to tell how I suffer.')

involves. Mental work is linked to some current impression, some provoking occasion in the present which has been able to arouse one of the subject's major wishes. From there it harks back to a memory of an earlier experience (usually an infantile one) in which this wish was fulfilled; and it now creates a situation relating to the future which represents a fulfilment of the wish. What it thus creates is a day-dream or phantasy, which carries about it traces of its origin from the occasion which provoked it and from the memory. Thus past, present and future are strung together, as it were, on the thread of the wish that runs through them.

A very ordinary example may serve to make what I have said clear. Let us take the case of a poor orphan boy to whom you have given the address of some employer where he may perhaps find a job. On his way there he may indulge in a day-dream appropriate to the situation from which it arises. The content of his phantasy will perhaps be something like this. He is given a job, finds favour with his new employer, makes himself indispensable in the business, is taken into his employer's family, marries the charming young daughter of the house, and then himself becomes a director of the business, first as his employer's partner and then as his successor. In this phantasy, the dreamer has regained what he possessed in his happy childhood—the protecting house, the loving parents and the first objects of his affectionate feelings. You will see from this example the way in which the wish makes use of an occasion in the present to construct, on the pattern of the past, a picture of the future.

There is a great deal more that could be said about phantasies; but I will only allude as briefly as possible to certain points. If phantasies become over-luxuriant and over-powerful, the conditions are laid for an onset of neurosis or psychosis. Phantasies, moreover, are the immediate mental precursors of the distressing symptoms complained of by our patients. Here a broad by-path branches off into pathology.

I cannot pass over the relation of phantasies to dreams. Our dreams at night are nothing else than phantasies like these, as we can demonstrate from the interpretation of dreams. Language, in its unrivalled wisdom, long ago decided the question of the essential nature of dreams by giving the name of 'day-dreams' to the airy creations of phantasy. If the meaning of our dreams usually remains obscure to us in spite of this pointer, it is because of the circumstance that at night there also arise in us wishes of which we are ashamed; these we must conceal from ourselves, and they have consequently been repressed, pushed into the unconscious. Repressed wishes of this sort and their derivatives are only allowed to come to expression in a very distorted form. When scientific work had succeeded in elucidating this factor of *dream-distortion*, it was no longer difficult to recognize that night-dreams are wish-fulfilments in just the same way as day-dreams—the phantasies which we all know so well.

So much for phantasies. And now for the creative writer. May we really attempt to compare the imaginative writer with the 'dreamer in broad daylight', and his creations with day-dreams? Here we must begin by making an initial distinction. We must separate writers who, like the ancient authors of

epics and tragedies, take over their material ready-made, from writers who seem to originate their own material. We will keep to the latter kind, and, for the purposes of our comparison, we will choose not the writers most highly esteemed by the critics, but the less pretentious authors of novels, romances and short stories, who nevertheless have the widest and most eager circle of readers of both sexes. One feature above all cannot fail to strike us about the creations of these story-writers; each of them has a hero who is the centre of interest, for whom the writer tries to win our sympathy by every possible means and whom he seems to place under the protection of a special Providence. If, at the end of one chapter of my story, I leave the hero unconscious and bleeding from severe wounds, I am sure to find him at the beginning of the next being carefully nursed and on the way to recovery; and if the first volume closes with the ship he is in going down in a storm at sea, I am certain, at the opening of the second volume, to read of his miraculous rescue— a rescue without which the story could not proceed. The feeling of security with which I follow the hero through his perilous adventures is the same as the feeling with which a hero in real life throws himself into the water to save a drowning man or exposes himself to the enemy's fire in order to storm a battery. It is the true heroic feeling, which one of our best writers has expressed in an inimitable phrase: 'Nothing can happen to *me!*' It seems to me, however, that through this revealing characteristic of invulnerability we can immediately recognize His Majesty the Ego, the hero alike of every day-dream and of every story.

Other typical features of these egocentric stories point to the same kinship. The fact that all the women in the novel invariably fall in love with the hero can hardly be looked on as a portrayal of reality, but it is easily understood as a necessary constituent of a day-dream. The same is true of the fact that the other characters in the story are sharply divided into good and bad, in defiance of the variety of human characters that are to be observed in real life. The 'good' ones are the helpers, while the 'bad' ones are the enemies and rivals, of the ego which has become the hero of the story.

We are perfectly aware that very many imaginative writings are far removed from the model of the naïve day-dream; and yet I cannot suppress the suspicion that even the most extreme deviations from that model could be linked with it through an uninterrupted series of transitional cases. It has struck me that in many of what are known as 'psychological' novels only one person—once again the hero—is described from within. The author sits inside his mind, as it were, and looks at the other characters from outside. The psychological novel in general no doubt owes it special nature to the inclination of the modern writer to split up his ego, by self-observation, into many part-egos, and, in consequence, to personify the conflicting currents of his own mental life in several heroes. Certain novels, which might be described as 'eccentric', seem to stand in quite special contrast to the type of the day-dream. In these, the person who is introduced as the hero plays only a very small active part; he sees the actions and sufferings of other people pass before him like a spectator. Many of Zola's later works belong to this category. But I must point out that the psychological analysis of individuals who are not creative writers, and who diverge in some respects from the so-called norm, has shown

us analogous variations of the day-dream, in which the ego contents itself with the role of spectator.

If our comparison of the imaginative writer with the day-dreamer, and of poetical creation with the day-dream, is to be of any value, it must, above all, show itself in some way or other fruitful. Let us, for instance, try to apply to these authors' works the thesis we laid down earlier concerning the relation between phantasy and the three periods of time and the wish which runs through them; and, with its help, let us try to study the connections that exist between the life of the writer and his works. No one has known, as a rule, what expectations to frame in approaching this problem; and often the connection has been thought of in much too simple terms. In the light of the insight we have gained from phantasies, we ought to expect the following state of affairs. A strong experience in the present awakens in the creative writer a memory of an earlier experience (usually belonging to his childhood) from which there now proceeds a wish which finds its fulfilment in the creative work. The work itself exhibits elements of the recent provoking occasion as well as of the old memory.

Do not be alarmed at the complexity of this formula. I suspect that in fact it will prove to be too exiguous a pattern. Nevertheless, it may contain a first approach to the true state of affairs; and, from some experiments I have made, I am inclined to think that this way of looking at creative writings may turn out not unfruitful. You will not forget that the stress it lays on childhood memories in the writer's life—a stress which may perhaps seem puzzling—is ultimately derived from the assumption that a piece of creative writing, like a day-dream, is a continuation of, and a substitute for, what was once the play of childhood.

We must not neglect, however, to go back to the kind of imaginative works which we have to recognize, not as original creations, but as the re-fashioning of ready-made and familiar material. Even here, the writer keeps a certain amount of independence, which can express itself in the choice of material and in changes in it which are often quite extensive. In so far as the material is already at hand, however, it is derived from the popular treasure-house of myths, legends and fairy tales. The study of constructions of folk-psychology such as these is far from being complete, but it is extremely probable that myths, for instance, are distorted vestiges of the wishful phantasies of whole nations, the *secular dreams* of youthful humanity.

You will say that, although I have put the creative writer first in the title of my paper, I have told you far less about him than about phantasies. I am aware of that, and I must try to excuse it by pointing to the present state of our knowledge. All I have been able to do is to throw out some encouragements and suggestions which, starting from the study of phantasies, lead on to the problem of the writer's choice of his literary material. As for the other problem—by what means the creative writer achieves the emotional effects in us that are aroused by his creations—we have as yet not touched on it at all. But I should like at least to point out to you the path that leads from our discussion of phantasies to the problems of poetical effects.

You will remember how I have said that the day-dreamer carefully con-

ceals his phantasies from other people because he feels he has reasons for being ashamed of them. I should now add that even if he were to communicate them to us he could give us no pleasure by his disclosures. Such phantasies, when we learn them, repel us or at least leave us cold. But when a creative writer presents his plays to us or tells us what we are inclined to take to be his personal day-dreams, we experience a great pleasure, and one which probably arises from the confluence of many sources. How the writer accomplishes this is his innermost secret; the essential *ars poetica* lies in the technique of overcoming the feeling of repulsion in us which is undoubtedly connected with the barriers that rise between each single ego and the others. We can guess two of the methods used by this technique. The writer softens the character of his egoistic day-dreams by altering and disguising it, and he bribes us by the purely formal—that is, aesthetic—yield of pleasure which he offers us in the presentation of his phantasies. We give the name of an *incentive bonus*, or a *fore-pleasure*, to a yield of pleasure such as this, which is offered to us so as to make possible the release of still greater pleasure arising from deeper psychical sources. In my opinion, all the aesthetic pleasure which a creative writer affords us has the character of a fore-pleasure of this kind, and our actual enjoyment of an imaginative work proceeds from a liberation of tensions in our minds. It may even be that not a little of this effect is due to the writer's enabling us thenceforward to enjoy our own day-dreams without self-reproach or shame. This brings us to the threshold of new, interesting and complicated enquiries; but also, at least for the moment, to the end of our discussion.

R E A D I N G 5

INTRODUCTION

T. S. Eliot (1888–1965) is the author of poetry, including *The Waste Land*, that is among the central work of modernism. But he was also a philosopher, an editor, and a literary critic of great acuity. Perhaps his most important contribution to the theory of art is his essay "Tradition and the Individual Talent" (1919)—itself an important document of modernism. Unlike the writers who have preceded him in this section, Eliot has little to say about the distinctive psychology or individuality of artists. Indeed, he says that the process of artistic creation involves "a continual *extinction* of personality." His emphasis is not so much on the artist as creative *individual*, as on the complex interactions between the artist and the broad historical and cultural context of which he or she is a part. According to Eliot, an artist's awareness and understanding of the tradition within which he or she is working is a vital element in the creative process. What sort of art an artist creates depends partly on the ways in which the artist engages with his or her tradition, and partly on the character of that tradition itself. Eliot's point is not simply that an artist is shaped and constrained by the tradition in which he or she works, so that creativity is neither perfectly free nor essentially personal. He is also concerned

with the impact which an artist may have on his or her tradition—on the ways in which an artist can shape, as well as be shaped by, a tradition. Eliot thinks that what happens in the creation of a genuinely significant work of art "is something that happens simultaneously to all the works of art which preceded it. . . . the *whole* existing order must be, if ever so slightly, altered." Eliot's essay represents an important contribution to the discussion of creativity—a contribution which, with its emphasis on the contextual and the impersonal, stands in stark contrast to positions such as those we have considered thus far.

"Tradition and the Individual Talent"

T. S. Eliot

I

In English writing we seldom speak of tradition, though we occasionally apply its name in deploring its absence. We cannot refer to "the tradition" or to "a tradition"; at most, we employ the adjective in saying that the poetry of So-and-so is "traditional" or even "too traditional." Seldom, perhaps, does the word appear except in a phrase of censure. If otherwise, it is vaguely approbative, with the implication, as to the work approved, of some pleasing archæological reconstruction. You can hardly make the word agreeable to English ears without this comfortable reference to the reassuring science of archæology.

Certainly the word is not likely to appear in our appreciations of living or dead writers. Every nation, every race, has not only its own creative, but its own critical turn of mind; and is even more oblivious of the shortcomings and limitations of its critical habits than of those of its creative genius. We know, or think we know, from the enormous mass of critical writing that has appeared in the French language the critical method or habit of the French; we only conclude (we are such unconscious people) that the French are "more critical" than we, and sometimes even plume ourselves a little with the fact, as if the French were the less spontaneous. Perhaps they are; but we might remind ourselves that criticism is as inevitable as breathing, and that we should be none the worse for articulating what passes in our minds when we read a book and feel an emotion about it, for criticizing our own minds in their work of criticism. One of the facts that might come to light in this process is our tendency to insist, when we praise a poet, upon those aspects of his work in which he least resembles anyone else. In these aspects or parts of his work we pretend to find what is individual, what is the peculiar essence of the man. We dwell with satisfaction upon the poet's difference from his predecessors, especially his immediate predecessors; we endeavour to find something that can be isolated in order to be enjoyed. Whereas if we approach a poet without this prejudice we shall often find that not only the best, but the most individual parts of his work may be those in which the dead poets, his ancestors, assert their immortality most vigorously. And I do not mean the impressionable period of adolescence, but the period of full maturity.

Yet if the only form of tradition, of handing down, consisted in following the ways of the immediate generation before us in a blind or timid adherence

to its successes, "tradition" should positively be discouraged. We have seen many such simple currents soon lost in the sand; and novelty is better than repetition. Tradition is a matter of much wider significance. It cannot be inherited, and if you want it you must obtain it by great labour. It involves, in the first place, the historical sense, which we may call nearly indispensable to anyone who would continue to be a poet beyond his twenty-fifth year; and the historical sense involves a perception, not only of the pastness of the past, but of its presence; the historical sense compels a man to write not merely with his own generation in his bones, but with a feeling that the whole of the literature of Europe from Homer and within it the whole of the literature of his own country has a simultaneous existence and composes a simultaneous order. This historical sense, which is a sense of the timeless as well as of the temporal and of the timeless and of the temporal together, is what makes a writer traditional. And it is at the same time what makes a writer most acutely conscious of his place in time, of his contemporaneity.

No poet, no artist of any art, has his complete meaning alone. His significance, his appreciation is the appreciation of his relation to the dead poets and artists. You cannot value him alone; you must set him, for contrast and comparison, among the dead. I mean this as a principle of æsthetic, not merely historical, criticism. The necessity that he shall conform, that he shall cohere, is not one-sided; what happens when a new work of art is created is something that happens simultaneously to all the works of art which preceded it. The existing monuments form an ideal order among themselves, which is modified by the introduction of the new (the really new) work of art among them. The existing order is complete before the new work arrives; for order to persist after the supervention of novelty, the *whole* existing order must be, if ever so slightly, altered; and so the relations, proportions, values of each work of art toward the whole are readjusted; and this is conformity between the old and the new. Whoever has approved this idea of order, of the form of European, of English literature, will not find it preposterous that the past should be altered by the present as much as the present is directed by the past. And the poet who is aware of this will be aware of great difficulties and responsibilities.

In a peculiar sense he will be aware also that he must inevitably be judged by the standards of the past. I say judged, not amputated, by them; not judged to be as good as, or worse or better than, the dead; and certainly not judged by the canons of dead critics. It is a judgment, a comparison, in which two things are measured by each other. To conform merely would be for the new work not really to conform at all; it would not be new, and would therefore not be a work of art. And we do not quite say that the new is more valuable because it fits in; but its fitting in is a test of its value—a test, it is true, which can only be slowly and cautiously applied, for we are none of us infallible judges of conformity. We say: it appears to conform, and is perhaps individual, or it appears individual, and may conform; but we are hardly likely to find that it is one and not the other.

To proceed to a more intelligible exposition of the relation of the poet to the past: he can neither take the past as a lump, an indiscriminate bolus, nor can he form himself wholly on one or two private admirations, nor can he form himself wholly upon one preferred period. The first course is inadmissible, the

second is an important experience of youth, and the third is a pleasant and highly desirable supplement. The poet must be very conscious of the main current, which does not at all flow invariably through the most distinguished reputations. He must be quite aware of the obvious fact that art never improves, but that the material of art is never quite the same. He must be aware that the mind of Europe—the mind of his own country—a mind which he learns in time to be much more important than his own private mind—is a mind which changes, and that this change is a development which abandons nothing *en route,* which does not superannuate either Shakespeare, or Homer, or the rock drawing of the Magdalenian draughtsmen. That this development, refinement perhaps, complication certainly, is not, from the point of view of the artist, any improvement. Perhaps not even an improvement from the point of view of the psychologist or not to the extent which we imagine; perhaps only in the end based upon a complication in economics and machinery. But the difference between the present and the past is that the conscious present is an awareness of the past in a way and to an extent which the past's awareness of itself cannot show.

Some one said: "The dead writers are remote from us because we *know* so much more than they did." Precisely, and they are that which we know.

I am alive to a usual objection to what is clearly part of my programme for the *métier* of poetry. The objection is that the doctrine requires a ridiculous amount of erudition (pedantry), a claim which can be rejected by appeal to the lives of poets in any pantheon. It will even be affirmed that much learning deadens or perverts poetic sensibility. While, however, we persist in believing that a poet ought to know as much as will not encroach upon his necessary receptivity and necessary laziness, it is not desirable to confine knowledge to whatever can be put into a useful shape for examinations, drawing-rooms, or the still more pretentious modes of publicity. Some can absorb knowledge, the more tardy must sweat for it. Shakespeare acquired more essential history from Plutarch than most men could from the whole British Museum. What is to be insisted upon is that the poet must develop or procure the consciousness of the past and that he should continue to develop this consciousness throughout his career.

What happens is a continual surrender of himself as he is at the moment to something which is more valuable. The progress of an artist is a continual self-sacrifice, a continual extinction of personality.

There remains to define this process of depersonalization and its relation to the sense of tradition. It is in this depersonalization that art may be said to approach the condition of science. I shall, therefore, invite you to consider, as a suggestive analogy, the action which takes place when a bit of finely filiated platinum is introduced into a chamber containing oxygen and sulphur dioxide.

II

Honest criticism and sensitive appreciation is directed not upon the poet but upon the poetry. If we attend to the confused cries of the newspaper critics and the susurrus of popular repetition that follows, we shall hear the names

of poets in great numbers; if we seek not Blue-book knowledge but the enjoyment of poetry, and ask for a poem, we shall seldom find it. In the last article I tried to point out the importance of the relation of the poem to other poems by other authors, and suggested the conception of poetry as a living whole of all the poetry that has ever been written. The other aspect of this Impersonal theory of poetry is the relation of the poem to its author. And I hinted, by an analogy, that the mind of the mature poet differs from that of the immature one not precisely in any valuation of "personality," not being necessarily more interesting, or having "more to say," but rather by being a more finely perfected medium in which special, or very varied, feelings are at liberty to enter into new combinations.

The analogy was that of the catalyst. When the two gases previously mentioned are mixed in the presence of a filament of platinum, they form sulphurous acid. This combination takes place only if the platinum is present; nevertheless the newly formed acid contains no trace of platinum, and the platinum itself is apparently unaffected; has remained inert, neutral, and unchanged. The mind of the poet is the shred of platinum. It may partly or exclusively operate upon the experience of the man himself; but, the more perfect the artist, the more completely separate in him will be the man who suffers and the mind which creates; the more perfectly will the mind digest and transmute the passions which are its material.

The experience, you will notice, the elements which enter the presence of the transforming catalyst, are of two kinds: emotions and feelings. The effect of a work of art upon the person who enjoys it is an experience different in kind from any experience not of art. It may be formed out of one emotion, or may be a combination of several; and various feelings, inhering for the writer in particular words or phrases or images, may be added to compose the final result. Or great poetry may be made without the direct use of any emotion whatever: composed out of feelings solely. Canto XV of the *Inferno* (Brunetto Latini) is a working up of the emotion evident in the situation; but the effect, though single as that of any work of art, is obtained by considerable complexity of detail. The last quatrain gives an image, a feeling attaching to an image, which "came," which did not develop simply out of what precedes, but which was probably in suspension in the poet's mind until the proper combination arrived for it to add itself to. The poet's mind is in fact a receptacle for seizing and storing up numberless feelings, phrases, images, which remain there until all the particles which can unite to form a new compound are present together.

If you compare several representative passages of the greatest poetry you see how great is the variety of types of combination, and also how completely any semi-ethical criterion of "sublimity" misses the mark. For it is not the "greatness," the intensity, of the emotions, the components, but the intensity of the artistic process, the pressure, so to speak, under which the fusion takes place, that counts. The episode of Paolo and Francesca employs a definite emotion, but the intensity of the poetry is something quite different from whatever intensity in the supposed experience it may give the impression of. It is no more intense, furthermore, than Canto XXVI, the voyage of Ulysses, which has not the direct dependence upon an emotion. Great variety is possible in the

process of transmutation of emotion: the murder of Agamemnon, or the agony of Othello, gives an artistic effect apparently closer to a possible original than the scenes from Dante. In the *Agamemnon,* the artistic emotion approximates to the emotion of an actual spectator; in *Othello* to the emotion of the protagonist himself. But the difference between art and the event is always absolute; the combination which is the murder of Agamemnon is probably as complex as that which is the voyage of Ulysses. In either case there has been a fusion of elements. The ode of Keats contains a number of feelings which have nothing particular to do with the nightingale, but which the nightingale, partly, perhaps, because of its attractive name, and partly because of its reputation, served to bring together.

The point of view which I am struggling to attack is perhaps related to the metaphysical theory of the substantial unity of the soul: for my meaning is, that the poet has, not a "personality" to express, but a particular medium, which is only a medium and not a personality, in which impressions and experiences combine in peculiar and unexpected ways. Impressions and experiences which are important for the man may take no place in the poetry, and those which become important in the poetry may play quite a negligible part in the man, the personality.

I will quote a passage which is unfamiliar enough to be regarded with fresh attention in the light—or darkness—of these observations:

> And now methinks I could e'en chide myself
> For doating on her beauty, though her death
> Shall be revenged after no common action.
> Does the silkworm expend her yellow labours
> 5 For thee? For thee does she undo herself?
> Are lordships sold to maintain ladyships
> For the poor benefit of a bewildering minute?
> Why does yon fellow falsify highways,
> And put his life between the judge's lips,
> 10 To refine such a thing—keeps horse and men
> To beat their valours for her? . . .

In this passage (as is evident if it is taken in its context) there is a combination of positive and negative emotions: an intensely strong attraction toward beauty and an equally intense fascination by the ugliness which is contrasted with it and which destroys it. This balance of contrasted emotion is in the dramatic situation to which the speech is pertinent, but that situation alone is inadequate to it. This is, so to speak, the structural emotion, provided by the drama. But the whole effect, the dominant tone, is due to the fact that a number of floating feelings, having an affinity to this emotion by no means superficially evident, have combined with it to give us a new art emotion.

It is not in his personal emotions, the emotions provoked by particular events in his life, that the poet is in any way remarkable or interesting. His particular emotions may be simple, or crude, or flat. The emotion in his poetry will be a very complex thing, but not with the complexity of the emotions of people who have very complex or unusual emotions in life. One error, in fact, of eccentricity in poetry is to seek for new human emotions to express; and in this search for novelty in the wrong place it discovers the perverse. The busi-

ness of the poet is not to find new emotions, but to use the ordinary ones and, in working them up into poetry, to express feelings which are not in actual emotions at all. And emotions which he has never experienced will serve his turn as well as those familiar to him. Consequently, we must believe that "emotion recollected in tranquillity" is an inexact formula. For it is neither emotion, nor recollection, nor, without distortion of meaning, tranquillity. It is a concentration, and a new thing resulting from the concentration, of a very great number of experiences which to the practical and active person would not seem to be experiences at all; it is a concentration which does not happen consciously or of deliberation. These experiences are not "recollected," and they finally unite in an atmosphere which is "tranquil" only in that it is a passive attending upon the event. Of course this is not quite the whole story. There is a great deal, in the writing of poetry, which must be conscious and deliberate. In fact, the bad poet is usually unconscious where he ought to be conscious, and conscious where he ought to be unconscious. Both errors tend to make him "personal." Poetry is not a turning loose of emotion, but an escape from emotion; it is not the expression of personality, but an escape from personality. But, of course, only those who have personality and emotions know what it means to want to escape from these things.

III

<center>ὁ δὲ νοῦς ἴσως θειότεόν τι χαὶ ἀπαθές ἐστιν</center>

This essay proposes to halt at the frontier of metaphysics or mysticism, and confine itself to such practical conclusions as can be applied by the responsible person interested in poetry. To divert interest from the poet to the poetry is a laudable aim: for it would conduce to a juster estimation of actual poetry, good and bad. There are many people who appreciate the expression of sincere emotion in verse, and there is a smaller number of people who can appreciate technical excellence. But very few know when there is expression of *significant* emotion, emotion which has its life in the poem and not in the history of the poet. The emotion of art is impersonal. And the poet cannot reach this impersonality without surrendering himself wholly to the work to be done. And he is not likely to know what is to be done unless he lives in what is not merely the present, but the present moment of the past, unless he is conscious, not of what is dead, but of what is already living.

READING 6

INTRODUCTION

John Dewey (1859–1952) is widely regarded as one of the most important figures in American philosophy. In "Having an Experience," a chapter from his book *Art as Experience* (1934), Dewey gives an account of artistic creativity that derives from his reflections on the varieties of experience that everyday life affords us. Dewey

suggests that there is an important difference between merely experiencing and "having *an* experience." *An* experience "is a whole and carries with it its own individualizing quality and self-sufficiency." Dewey regards experiences of this sort as particularly significant: They have a formal quality, involving "internal integration and fulfillment reached through ordered and organized movement." That is, he suggests, such experiences have an aesthetic quality. (In this respect, Dewey's account has affinities with formalist theories, such as that of Clive Bell. *See* Section 2.) In Dewey's view, the artist is one who makes experience of this sort available to others through his or her artworks; the creative process, then, involves being open to experience, recognizing its aesthetic character, and displaying and communicating that character in works of art. (Here Dewey gestures toward expression theories, like those of Wordsworth, Collingwood, and Tolstoy. *See* Sections 2 and 4.) As he says, "An object is peculiarly and dominantly esthetic, yielding the enjoyment characteristic of esthetic perception, when the factors that determine anything which can be called *an* experience are lifted high above the threshold of perception and are made manifest for their own sake."

"Having an Experience"

John Dewey

Experience occurs continuously, because the interaction of live creature and environing conditions is involved in the very process of living. Under conditions of resistance and conflict, aspects and elements of the self and the world that are implicated in this interaction qualify experience with emotions and ideas so that conscious intent emerges. Oftentimes, however, the experience had is inchoate. Things are experienced but not in such a way that they are composed into *an* experience. There is distraction and dispersion; what we observe and what we think, what we desire and what we get, are at odds with each other. We put our hands to the plow and turn back; we start and then we stop, not because the experience has reached the end for the sake of which it was initiated but because of extraneous interruptions or of inner lethargy.

In contrast with such experience, we have *an* experience when the material experienced runs its course to fulfillment. Then and then only is it integrated within and demarcated in the general stream of experience from other experiences. A piece of work is finished in a way that is satisfactory; a problem receives its solution; a game is played through; a situation, whether that of eating a meal, playing a game of chess, carrying on a conversation, writing a book, or taking part in a political campaign, is so rounded out that its close is a consummation and not a cessation. Such an experience is a whole and carries with it its own individualizing quality and self-sufficiency. It is *an* experience.

Philosophers, even empirical philosophers, have spoken for the most part of experience at large. Idiomatic speech, however, refers to experiences each of which is singular, having its own beginning and end. For life is no uniform uninterrupted march or flow. It is a thing of histories, each with its own plot, its own inception and movement toward its close, each having its own partic-

ular rhythmic movement; each with its own unrepeated quality pervading it throughout. A flight of stairs, mechanical as it is, proceeds by individualized steps, not by undifferentiated progression, and an inclined plane is at least marked off from other things by abrupt discreteness.

Experience in this vital sense is defined by those situations and episodes that we spontaneously refer to as being "real experiences"; those things of which we say in recalling them, "that *was* an experience." It may have been something of tremendous importance—a quarrel with one who was once an intimate, a catastrophe finally averted by a hair's breadth. Or it may have been something that in comparison was slight—and which perhaps because of its very slightness illustrates all the better what is to be an experience. There is that meal in a Paris restaurant of which one says "that *was* an experience." It stands out as an enduring memorial of what food may be. Then there is that storm one went through in crossing the Atlantic—the storm that seemed in its fury, as it was experienced, to sum up in itself all that a storm can be, complete in itself, standing out because marked out from what went before and what came after.

In such experiences, every successive part flows freely, without seam and without unfilled blanks, into what ensues. At the same time there is no sacrifice of the self-identity of the parts. A river, as distinct from a pond, flows. But its flow gives a definiteness and interest to its successive portions greater than exist in the homogenous portions of a pond. In an experience, flow is from something to something. As one part leads into another and as one part carries on what went before, each gains distinctness in itself. The enduring whole is diversified by successive phases that are emphases of its varied colors.

Because of continuous merging, there are no holes, mechanical junctions, and dead centers when we have *an* experience. There are pauses, places of rest, but they punctuate and define the quality of movement. They sum up what has been undergone and prevent its dissipation and idle evaporation. Continued acceleration is breathless and prevents parts from gaining distinction. In a work of art, different acts, episodes, occurrences melt and fuse into unity, and yet do not disappear and lose their own character as they do so—just as in a genial conversation there is a continuous interchange and blending, and yet each speaker not only retains his own character but manifests it more clearly than is his wont.

An experience has a unity that gives it its name, *that* meal, that storm, that rupture of friendship. The existence of this unity is constituted by a single *quality* that pervades the entire experience in spite of the variation of its constituent parts. This unity is neither emotional, practical, nor intellectual, for these terms name distinctions that reflection can make within it. In discourse *about* an experience, we must make use of these adjectives of interpretation. In going over an experience in mind *after* its occurrence, we may find that one property rather than another was sufficiently dominant so that it characterizes the experience as a whole. There are absorbing inquiries and speculations which a scientific man and philosopher will recall as "experiences" in the emphatic sense. In final import they are intellectual. But in their actual occurrence they were emotional as well; they were purposive and volitional. Yet the experience was not a sum of these different characters; they were lost in it as distinctive traits.

No thinker can ply his occupation save as he is lured and rewarded by total integral experiences that are intrinsically worth while. Without them he would never know what it is really to think and would be completely at a loss in distinguishing real thought from the spurious article. Thinking goes on in trains of ideas, but the ideas form a train only because they are much more than what an analytic psychology calls ideas. They are phases, emotionally and practically distinguished, of a developing underlying quality; they are its moving variations, not separate and independent like Locke's and Hume's so-called ideas and impressions, but are subtle shadings of a pervading and developing hue.

We say of an experience of thinking that we reach or draw a conclusion. Theoretical formulation of the process is often made in such terms as to conceal effectually the similarity of "conclusion" to the consummating phase of every developing integral experience. These formulations apparently take their cue from the separate propositions that are premisses and the proposition that is the conclusion as they appear on the printed page. The impression is derived that there are first two independent and ready-made entities that are then manipulated so as to give rise to a third. In fact, in an experience of thinking, premisses emerge only as a conclusion becomes manifest. The experience, like that of watching a storm reach its height and gradually subside, is one of continuous movement of subject-matters. Like the ocean in the storm, there are a series of waves; suggestions reaching out and being broken in a clash, or being carried onwards by a coöperative wave. If a conclusion is reached, it is that of a movement of anticipation and cumulation, one that finally comes to completion. A "conclusion" is no separate and independent thing; it is the consummation of a movement.

Hence *an* experience of thinking has its own esthetic quality. It differs from those experiences that are acknowledged to be esthetic, but only in its materials. The material of the fine arts consists of qualities; that of experience having intellectual conclusion are signs or symbols having no intrinsic quality of their own, but standing for things that may in another experience be qualitatively experienced. The difference is enormous. It is one reason why the strictly intellectual art will never be popular as music is popular. Nevertheless, the experience itself has a satisfying emotional quality because it possesses internal integration and fulfillment reached through ordered and organized movement. This artistic structure may be immediately felt. In so far, it is esthetic. What is even more important is that not only is this quality a significant motive in undertaking intellectual inquiry and in keeping it honest, but that no intellectual activity is an integral event (is *an* experience), unless it is rounded out with this quality. Without it, thinking is inconclusive. In short, esthetic cannot be sharply marked off from intellectual experience since the latter must bear an esthetic stamp to be itself complete.

The same statement holds good of a course of action that is dominantly practical, that is, one that consists of overt doings. It is possible to be efficient in action and yet not have a conscious experience. The activity is too automatic to permit of a sense of what it is about and where it is going. It comes to an end but not to a close or consummation in consciousness. Obstacles are overcome by shrewd skill, but they do not feed experience. There are also those

who are wavering in action, uncertain and inconclusive like the shades in classic literature. Between the poles of aimlessness and mechanical efficiency, there lie those courses of action in which through successive deeds there runs a sense of growing meaning conserved and accumulating toward an end that is felt as accomplishment of a process. Successful politicians and generals who turn statesmen like Caesar and Napoleon have something of the showman about them. This of itself is not art, but it is, I think, a sign that interest is not exclusively, perhaps not mainly, held by the result taken by itself (as it is in the case of mere efficiency), but by it as the outcome of a process. There is interest in completing an experience. The experience may be one that is harmful to the world and its consummation undesirable. But it has esthetic quality.

The Greek identification of good conduct with conduct having proportion, grace, and harmony, the *kalon-agathon,* is a more obvious example of distinctive esthetic quality in moral action. One great defect in what passes as morality is its anesthetic quality. Instead of exemplifying wholehearted action, it takes the form of grudging piecemeal concessions to the demands of duty. But illustrations may only obscure the fact that any practical activity will, provided that it is integrated and moves by its own urge to fulfillment, have esthetic quality.

A generalized illustration may be had if we imagine a stone, which is rolling down hill, to have an experience. The activity is surely sufficiently "practical." The stone starts from somewhere, and moves, as consistently as conditions permit, toward a place and state where it will be at rest—toward an end. Let us add, by imagination, to these external facts, the ideas that it looks forward with desire to the final outcome; that it is interested in the things it meets on its way, conditions that accelerate and retard its movement with respect to their bearing on the end; that it acts and feels toward them according to the hindering or helping function it attributes to them; and that the final coming to rest is related to all that went before as the culmination of a continuous movement. Then the stone would have an experience, and one with esthetic quality.

If we turn from this imaginary case to our own experience, we shall find much of it is nearer to what happens to the actual stone than it is to anything that fulfills the conditions fancy just laid down. For in much of our experience we are not concerned with the connection of one incident with what went before and what comes after. There is no interest that controls attentive rejection or selection of what shall be organized into the developing experience. Things happen, but they are neither definitely included nor decisively excluded; we drift. We yield according to external pressure, or evade and compromise. There are beginnings and cessations, but no genuine initiations and concludings. One thing replaces another, but does not absorb it and carry it on. There is experience, but so slack and discursive that it is not *an* experience. Needless to say, such experiences are anesthetic.

Thus the non-esthetic lies within two limits. At one pole is the loose succession that does not begin at any particular place and that ends—in the sense of ceasing—at no particular place. At the other pole is arrest, constriction, proceeding from parts having only a mechanical connection with one another. There exists so much of one and the other of these two kinds of experience

that unconsciously they come to be taken as norms of all experience. Then, when the esthetic appears, it so sharply contrasts with the picture that has been formed of experience, that it is impossible to combine its special qualities with the features of the picture and the esthetic is given an outside place and status. The account that has been given of experience dominantly intellectual and practical is intended to show that there is no such contrast involved in having an experience: that, on the contrary, no experience of whatever sort is a unity unless it has esthetic quality.

The enemies of the esthetic are neither the practical nor the intellectual. They are the humdrum; slackness of loose ends; submission to convention in practice and intellectual procedure. Rigid abstinence, coerced submission, tightness on one side and dissipation, incoherence and aimless indulgence on the other, are deviations in opposite directions from the unity of an experience. Some such considerations perhaps induced Aristotle to invoke the "mean proportional" as the proper designation of what is distinctive of both virtue and the esthetic. He was formally correct. "Mean" and "proportion" are, however, not self-explanatory, nor to be taken over in a prior mathematical sense, but are properties belonging to an experience that has a developing movement toward its own consummation.

I have emphasized the fact that every integral experience moves toward a close, an ending, since it ceases only when the energies active in it have done their proper work. This closure of a circuit of energy is the opposite of arrest, of *stasis.* Maturation and fixation are polar opposites. Struggle and conflict may be themselves enjoyed, although they are painful, when they are experienced as means of developing an experience; members in that they carry it forward, not just because they are there. There is, as will appear later, an element of undergoing, of suffering in its large sense, in every experience. Otherwise there would be no taking in of what preceded. For "taking in" in any vital experience is something more than placing something on the top of consciousness over what was previously known. It involves reconstruction which may be painful. Whether the necessary undergoing phase is by itself pleasurable or painful is a matter of particular conditions. It is indifferent to the total esthetic quality, save that there are few intense esthetic experiences that are wholly gleeful. They are certainly not to be characterized as amusing, and as they bear down upon us they involve a suffering that is none the less consistent with, indeed a part of, the complete perception that is enjoyed.

I have spoken of the esthetic quality that rounds out an experience into completeness and unity as emotional. The reference may cause difficulty. We are given to thinking of emotions as things as simple and compact as are the words by which we name them. Joy, sorrow, hope, fear, anger, curiosity, are treated as if each in itself were a sort of entity that enters full-made upon the scene, an entity that may last a long time or a short time, but whose duration, whose growth and career, is irrelevant to its nature. In fact emotions are qualities, when they are significant, of a complex experience that moves and changes. I say, when they are *significant,* for otherwise they are but the outbreaks and eruptions of a disturbed infant. All emotions are qualifications of a drama and they change as the drama develops. Persons are sometimes said to fall in love at first sight. But what they fall into is not a thing of that instant.

What would love be were it compressed into a moment in which there is no room for cherishing and for solicitude? The intimate nature of emotion is manifested in the experience of one watching a play on the stage or reading a novel. It attends the development of a plot; and a plot requires a stage, a space, wherein to develop and time in which to unfold. Experience is emotional but there are no separate things called emotions in it.

By the same token, emotions are attached to events and objects in their movement. They are not, save in pathological instances, private. And even an "objectless" emotion demands something beyond itself to which to attach itself, and thus it soon generates a delusion in lack of something real. Emotion belongs of a certainty to the self. But it belongs to the self that is concerned in the movement of events toward an issue that is desired or disliked. We jump instantaneously when we are scared, as we blush on the instant when we are ashamed. But fright and shamed modesty are not in this case emotional states. Of themselves they are but automatic reflexes. In order to become emotional they must become parts of an inclusive and enduring situation that involves concern for objects and their issues. The jump of fright becomes emotional fear when there is found or thought to exist a threatening object that must be dealt with or escaped from. The blush becomes the emotion of shame when a person connects, in thought, an action he has performed with an unfavorable reaction to himself of some other person.

Physical things from far ends of the earth are physically transported and physically caused to act and react upon one another in the construction of a new object. The miracle of mind is that something similar takes place in experience without physical transport and assembling. Emotion is the moving and cementing force. It selects what is congruous and dyes what is selected with its color, thereby giving qualitative unity to materials externally disparate and dissimilar. It thus provides unity in and through the varied parts of an experience. When the unity is of the sort already described, the experience has esthetic character even though it is not, dominantly, an esthetic experience.

Two men meet; one is the applicant for a position, while the other has the disposition of the matter in his hands. The interview may be mechanical, consisting of set questions, the replies to which perfunctorily settle the matter. There is no experience in which the two men meet, nothing that is not a repetition, by way of acceptance or dismissal, of something which has happened a score of times. The situation is disposed of as if it were an exercise in bookkeeping. But an interplay may take place in which a new experience develops. Where should we look for an account of such an experience? Not to ledger-entries nor yet to a treatise on economics or sociology or personnel-psychology, but to drama or fiction. Its nature and import can be expressed only by art, because there is a unity of experience that can be expressed only as an experience. The *experience* is of material fraught with suspense and moving toward its own consummation through a connected series of varied incidents. The primary emotions on the part of the applicant may be at the beginning hope or despair, and elation or disappointment at the close. These emotions qualify the experience as a unity. But as the interview proceeds, secondary emotions are evolved as variations of the primary underlying one. It is even possible for each attitude and gesture, each sentence, almost every word, to

produce more than a fluctuation in the intensity of the basic emotion; to produce, that is, a change of shade and tint in its quality. The employer sees by means of his own emotional reactions the character of the one applying. He projects him imaginatively into the work to be done and judges his fitness by the way in which the elements of the scene assemble and either clash or fit together. The presence and behavior of the applicant either harmonize with his own attitudes and desires or they conflict and jar. Such factors as these, inherently esthetic in quality, are the forces that carry the varied elements of the interview to a decisive issue. They enter into the settlement of every situation, whatever its dominant nature, in which there are uncertainty and suspense.

There are, therefore, common patterns in various experiences, no matter how unlike they are to one another in the details of their subject matter. There are conditions to be met without which an experience cannot come to be. The outline of the common pattern is set by the fact that every experience is the result of interaction between a live creature and some aspect of the world in which he lives. A man does something; he lifts, let us say, a stone. In consequence he undergoes, suffers, something: the weight, strain, texture of the surface of the thing lifted. The properties thus undergone determine further doing. The stone is too heavy or too angular, not solid enough; or else the properties undergone show it is fit for the use for which it is intended. The process continues until a mutual adaptation of the self and the object emerges and that particular experience comes to a close. What is true of this simple instance is true, as to form, of every experience. The creature operating may be a thinker in his study and the environment with which he interacts may consist of ideas instead of a stone. But interaction of the two constitutes the total experience that is had, and the close which completes it is the institution of a felt harmony.

An experience has pattern and structure, because it is not just doing and undergoing in alternation, but consists of them in relationship. To put one's hand in the fire that consumes it is not necessarily to have an experience. The action and its consequence must be joined in perception. This relationship is what gives meaning; to grasp it is the objective of all intelligence. The scope and content of the relations measure the significant content of an experience. A child's experience may be intense, but, because of lack of background from past experience, relations between undergoing and doing are slightly grasped, and the experience does not have great depth or breadth. No one ever arrives at such maturity that he perceives all the connections that are involved. There was once written (by Mr. Hinton) a romance called "The Unlearner." It portrayed the whole endless duration of life after death as a living over of the incidents that happened in a short life on earth, in continued discovery of the relationships involved among them.

Experience is limited by all the causes which interfere with perception of the relations between undergoing and doing. There may be interference because of excess on the side of doing or of excess on the side of receptivity, of undergoing. Unbalance on either side blurs the perception of relations and leaves the experience partial and distorted, with scant or false meaning. Zeal for doing, lust for action, leaves many a person, especially in this hurried and

impatient human environment in which we live, with experience of an almost incredible paucity, all on the surface. No one experience has a chance to complete itself because something else is entered upon so speedily. What is called experience becomes so dispersed and miscellaneous as hardly to deserve the name. Resistance is treated as an obstruction to be beaten down, not as an invitation to reflection. An individual comes to seek, unconsciously even more than by deliberate choice, situations in which he can do the most things in the shortest time.

Experiences are also cut short from maturing by excess of receptivity. What is prized is then the mere undergoing of this and that, irrespective of perception of any meaning. The crowding together of as many impressions as possible is thought to be "life," even though no one of them is more than a flitting and a sipping. The sentimentalist and the day-dreamer may have more fancies and impressions pass through their consciousness than has the man who is animated by lust for action. But his experience is equally distorted, because nothing takes root in mind when there is no balance between doing and receiving. Some decisive action is needed in order to establish contact with the realities of the world and in order that impressions may be so related to facts that their value is tested and organized.

Because perception of relationship between what is done and what is undergone constitutes the work of intelligence, and because the artist is controlled in the process of his work by his grasp of the connection between what he has already done and what he is to do next, the idea that the artist does not think as intently and penetratingly as a scientific inquirer is absurd. A painter must consciously undergo the effect of his every brush stroke or he will not be aware of what he is doing and where his work is going. Moreover, he has to see each particular connection of doing and undergoing in relation to the whole that he desires to produce. To apprehend such relations is to think, and is one of the most exacting modes of thought. The difference between the pictures of different painters is due quite as much to differences of capacity to carry on this thought as it is to differences of sensitivity to bare color and to differences in dexterity of execution. As respects the basic quality of pictures, difference depends, indeed, more upon the quality of intelligence brought to bear upon perception of relations than upon anything else—though of course intelligence cannot be separated from direct sensitivity and is connected, though in a more external manner, with skill.

Any idea that ignores the necessary rôle of intelligence in production of works of art is based upon identification of thinking with use of one special kind of material, verbal signs and words. To think effectively in terms of relations of qualities is as severe a demand upon thought as to think in terms of symbols, verbal and mathematical. Indeed, since words are easily manipulated in mechanical ways, the production of a work of genuine art probably demands more intelligence than does most of the so-called thinking that goes on among those who pride themselves on being "intellectuals."

I have tried to show in these chapters that the esthetic is no intruder in experience from without, whether by way of idle luxury or transcendent ideality, but that it is the clarified and intensified development of traits that belong to

every normally complete experience. This fact I take to be the only secure basis upon which esthetic theory can build. It remains to suggest some of the implications of the underlying fact.

We have no word in the English language that unambiguously includes what is signified by the two words "artistic" and "esthetic." Since "artistic" refers primarily to the act of production and "esthetic" to that of perception and enjoyment, the absence of a term designating the two processes taken together is unfortunate. Sometimes, the effect is to separate the two from each other, to regard art as something superimposed upon esthetic material, or, upon the other side, to an assumption that, since art is a process of creation, perception and enjoyment of it have nothing in common with the creative act. In any case, there is a certain verbal awkwardness in that we are compelled sometimes to use the term "esthetic" to cover the entire field and sometimes to limit it to the receiving perceptual aspect of the whole operation. I refer to these obvious facts as preliminary to an attempt to show how the conception of conscious experience as a perceived relation between doing and undergoing enable us to understand the connection that art as production and perception and appreciation as enjoyment sustain to each other.

Art denotes a process of doing or making. This is as true of fine as of technological art. Art involves molding of clay, chipping of marble, casting of bronze, laying on of pigments, construction of buildings, singing of songs, playing of instruments, enacting rôles on the stage, going through rhythmic movements in the dance. Every art does something with some physical material, the body or something outside the body, with or without the use of intervening tools, and with a view to production of something visible, audible, or tangible. So marked is the active or "doing" phase of art, that the dictionaries usually define it in terms of skilled action, ability in execution. The Oxford Dictionary illustrates by a quotation from John Stuart Mill: "Art is an endeavor after perfection in execution" while Matthew Arnold calls it "pure and flawless workmanship."

The word "esthetic" refers, as we have already noted, to experience as appreciative, perceiving, and enjoying. It denotes the consumer's rather than the producer's standpoint. It is Gusto, taste; and, as with cooking, overt skillful action is on the side of the cook who prepares, while taste is on the side of the consumer, as in gardening there is a distinction between the gardener who plants and tills and the householder who enjoys the finished product.

These very illustrations, however, as well as the relation that exists in having an experience between doing and undergoing, indicate that the distinction between esthetic and artistic cannot be pressed so far as to become a separation. Perfection in execution cannot be measured or defined in terms of execution; it implies those who perceive and enjoy the product that is executed. The cook prepares food for the consumer and the measure of the value of what is prepared is found in consumption. Mere perfection in execution, judged in its own terms in isolation, can probably be attained better by a machine than by human art. By itself, it is at most technique, and there are great artists who are not in the first ranks as technicians (witness Cézanne), just as there are great performers on the piano who are not great esthetically, and as Sargent is not a great painter.

Craftsmanship to be artistic in the final sense must be "loving"; it must care deeply for the subject matter upon which skill is exercised. A sculptor comes to mind whose busts are marvelously exact. It might be difficult to tell in the presence of a photograph of one of them and of a photograph of the original which was of the person himself. For virtuosity they are remarkable. But one doubts whether the maker of the busts had an experience of his own that he was concerned to have those share who look at his products. To be truly artistic, a work must also be esthetic—that is, framed for enjoyed receptive perception. Constant observation is, of course, necessary for the maker while he is producing. But if his perception is not also esthetic in nature, it is a colorless and cold recognition of what has been done, used as a stimulus to the next step in a process that is essentially mechanical.

In short, art, in its form, unites the very same relation of doing and undergoing, outgoing and incoming energy, that makes an experience to be an experience. Because of elimination of all that does not contribute to mutual organization of the factors of both action and reception into one another, and because of selection of just the aspects and traits that contribute to their interpenetration of each other, the product is a work of esthetic art. Man whittles, carves, sings, dances, gestures, molds, draws and paints. The doing or making is artistic when the perceived result is of such a nature that *its* qualities *as perceived* have controlled the question of production. The act of producing that is directed by intent to produce something that is enjoyed in the immediate experience of perceiving has qualities that a spontaneous or uncontrolled activity does not have. The artist embodies in himself the attitude of the perceiver while he works.

Suppose, for the sake of illustration, that a finely wrought object, one whose texture and proportions are highly pleasing in perception, has been believed to be a product of some primitive people. Then there is discovered evidence that proves it to be an accidental natural product. As an external thing, it is now precisely what it was before. Yet at once it ceases to be a work of art and becomes a natural "curiosity." It now belongs in a museum of natural history, not in a museum of art. And the extraordinary thing is that the difference that is thus made is not one of just intellectual classification. A difference is made in appreciative perception and in a direct way. The esthetic experience—in its limited sense—is thus seen to be inherently connected with the experience of making.

The sensory satisfaction of eye and ear, when esthetic, is so because it does not stand by itself but is linked to the activity of which it is the consequence. Even the pleasures of the palate are different in quality to an epicure than in one who merely "likes" his food as he eats it. The difference is not of mere intensity. The epicure is conscious of much more than the taste of the food. Rather, there enter into the taste, as directly experienced, qualities that depend upon reference to its source and its manner of production in connection with criteria of excellence. As production must absorb into itself qualities of the product as perceived and be regulated by them, so, on the other side, seeing, hearing, tasting, becomes esthetic when relation to a distinct manner of activity qualifies what is perceived.

There is an element of passion in all esthetic perception. Yet when we are

overwhelmed by passion, as in extreme rage, fear, jealousy, the experience is definitely non-esthetic. There is no relationship felt to the qualities of the activity that has generated the passion. Consequently, the material of the experience lacks elements of balance and proportion. For these can be present only when, as in the conduct that has grace or dignity, the act is controlled by an exquisite sense of the relations which the act sustains—its fitness to the occasion and to the situation.

The process of art in production is related to the esthetic in perception organically—as the Lord God in creation surveyed his work and found it good. Until the artist is satisfied in perception with what he is doing, he continues shaping and reshaping. The making comes to an end when its result is experienced as good—and that experience comes not by mere intellectual and outside judgment but in direct perception. An artist, in comparison with his fellows, is one who is not only especially gifted in powers of execution but in unusual sensitivity to the qualities of things. This sensitivity also directs his doings and makings.

As we manipulate, we touch and feel, as we look, we see; as we listen, we hear. The hand moves with etching needle or with brush. The eye attends and reports the consequence of what is done. Because of this intimate connection, subsequent doing is cumulative and not a matter of caprice nor yet of routine. In an emphatic artistic-esthetic experience, the relation is so close that it controls simultaneously both the doing and the perception. Such vital intimacy of connection cannot be had if only hand and eye are engaged. When they do not, both of them, act as organs of the whole being, there is but a mechanical sequence of sense and movement, as in walking that is automatic. Hand and eye, when the experience is esthetic, are but instruments through which the entire live creature, moved and active throughout, operates. Hence the expression is emotional and guided by purpose.

Because of the relation between what is done and what is undergone, there is an immediate sense of things in perception as belonging together or as jarring; as reënforcing or as interfering. The consequences of the act of making as reported in sense show whether what is done carries forward the idea being executed or marks a deviation and break. In as far as the development of an experience is *controlled* through reference to these immediately felt relations of order and fulfillment, that experience becomes dominantly esthetic in nature. The urge to action becomes an urge to that kind of action which will result in an object satisfying in direct perception. The potter shapes his clay to make a bowl useful for holding grain; but he makes it in a way so regulated by the series of perceptions that sum up the serial acts of making, that the bowl is marked by enduring grace and charm. The general situation remains the same in painting a picture or molding a bust. Moreover, at each stage there is anticipation of what is to come. This anticipation is the connecting link between the next doing and its outcome for sense. What is done and what is undergone are thus reciprocally, cumulatively, and continuously instrumental to each other.

The doing may be energetic, and the undergoing may be acute and intense. But unless they are related to each other to form a whole in perception, the thing done is not fully esthetic. The making for example may be a display of

technical virtuosity, and the undergoing a gush of sentiment or a revery. If the artist does not perfect a new vision in his process of doing, he acts mechanically and repeats some old model fixed like a blue print in his mind. An incredible amount of observation and of the kind of intelligence that is exercised in perception of qualitative relations characterizes creative work in art. The relations must be noted not only with respect to one another, two by two, but in connection with the whole under construction; they are exercised in imagination as well as in observation. Irrelevancies arise that are tempting distractions; digressions suggest themselves in the guise of enrichments. There are occasions when the grasp of the dominant idea grows faint, and then the artist is moved unconsciously to fill in until his thought grows strong again. The real work of an artist is to build up an experience that is coherent in perception while moving with constant change in its development.

When an author puts on paper ideas that are already clearly conceived and consistently ordered, the real work has been previously done. Or, he may depend upon the greater perceptibility induced by the activity and its sensible report to direct his completion of the work. The mere act of transcription is esthetically irrelevant save as it enters integrally into the formation of an experience moving to completeness. Even the composition conceived in the head and, therefore, physically private, is public in its significant content, since it is conceived with reference to execution in a product that is perceptible and hence belongs to the common world. Otherwise it would be an aberration or a passing dream. The urge to express through painting the perceived qualities of a landscape is continuous with demand for pencil or brush. Without external embodiment, an experience remains incomplete; physiologically and functionally, sense organs are motor organs and are connected, by means of distribution of energies in the human body and not merely anatomically, with other motor organs. It is no linguistic accident that "building," "construction," "work," designate both a process and its finished product. Without the meaning of the verb that of the noun remains blank.

Writer, composer of music, sculptor, or painter can retrace, during the process of production, what they have previously done. When it is not satisfactory in the undergoing or perceptual phase of experience, they can to some degree start afresh. This retracing is not readily accomplished in the case of architecture—which is perhaps one reason why there are so many ugly buildings. Architects are obliged to complete their idea before its translation into a complete object of perception takes place. Inability to build up simultaneously the idea and its objective embodiment imposes a handicap. Nevertheless, they too are obliged to think out their ideas in terms of the medium of embodiment and the object of ultimate perception unless they work mechanically and by rote. Probably the esthetic quality of medieval cathedrals is due in some measure to the fact that their constructions were not so much controlled by plans and specifications made in advance as is now the case. Plans grew as the building grew. But even a Minerva-like product, if it is artistic, presupposes a prior period of gestation in which doings and perceptions projected in imagination interact and mutually modify one another. Every work of art follows the plan of, and pattern of, a complete experience, rendering it more intensely and concentratedly felt.

It is not so easy in the case of the perceiver and appreciator to understand the intimate union of doing and undergoing as it is in the case of the maker. We are given to supposing that the former merely takes in what is there in finished form, instead of realizing that this taking in involves activities that are comparable to those of the creator. But receptivity is not passivity. It, too, is a process consisting of a series of responsive acts that accumulate toward objective fulfillment. Otherwise, there is not perception but recognition. The difference between the two is immense. Recognition is perception arrested before it has a chance to develop freely. In recognition there is a beginning of an act of perception. But this beginning is not allowed to serve the development of a full perception of the thing recognized. It is arrested at the point where it will serve some *other* purpose, as we recognize a man on the street in order to greet or to avoid him, not so as to see him for the sake of seeing what is there.

In recognition we fall back, as upon a stereotype, upon some previously formed scheme. Some detail or arrangement of details serves as cue for bare identification. It suffices in recognition to apply this bare outline as a stencil to the present object. Sometimes in contact with a human being we are struck with traits, perhaps of only physical characteristics, of which we were not previously aware. We realize that we never knew the person before; we had not seen him in any pregnant sense. We now begin to study and to "take in." Perception replaces bare recognition. There is an act of reconstructive doing, and consciousness becomes fresh and alive. *This* act of seeing involves the cooperation of motor elements even though they remain implicit and do not become overt, as well as coöperation of all funded ideas that may serve to complete the new picture that is forming. Recognition is too easy to arouse vivid consciousness. There is not enough resistance between new and old to secure consciousness of the experience that is had. Even a dog that barks and wags his tail joyously on seeing his master return is more fully alive in his reception of his friend than is a human being who is content with mere recognition.

Bare recognition is satisfied when a proper tag or label is attached, "proper" signifying one that serves a purpose outside the act of recognition—as a salesman identifies wares by a sample. It involves no stir of the organism, no inner commotion. But an act of perception proceeds by waves that extend serially throughout the entire organism. There is, therefore, no such thing in perception as seeing or hearing *plus* emotion. The perceived object or scene is emotionally pervaded throughout. When an aroused emotion does not permeate the material that is perceived or thought of, it is either preliminary or pathological.

The esthetic or undergoing phase of experience is receptive. It involves surrender. But adequate yielding of the self is possible only through a controlled activity that may well be intense. In much of our intercourse with our surroundings we withdraw; sometimes from fear, if only of expending unduly our store of energy; sometimes from preoccupation with other matters, as in the case of recognition. Perception is an act of the going-out of energy in order to receive, not a withholding of energy. To steep ourselves in a subject-matter we have first to plunge into it. When we are only passive to a scene, it overwhelms us and, for lack of answering activity, we do not perceive that which bears us down. We must summon energy and pitch it at a responsive key in order to *take* in.

Every one knows that it requires apprenticeship to see through a microscope or telescope, and to see a landscape as the geologist sees it. The idea that esthetic perception is an affair for odd moments is one reason for the backwardness of the arts among us. The eye and the visual apparatus may be intact; the object may be physically there, the cathedral of Notre Dame, or Rembrandt's portrait of Hendrik Stoeffel. In some bald sense, the latter may be "seen." They may be looked at, possibly recognized, and have their correct names attached. But for lack of continuous interaction between the total organism and the objects, they are not perceived, certainly not esthetically. A crowd of visitors steered through a picture-gallery by a guide, with attention called here and there to some high point, does not perceive; only by accident is there even interest in seeing a picture for the sake of subject matter vividly realized.

For to perceive, a beholder must *create* his own experience. And his creation must include relations comparable to those which the original producer underwent. They are not the same in any literal sense. But with the perceiver, as with the artist, there must be an ordering of the elements of the whole that is in form, although not in details, the same as the process of organization the creator of the work consciously experienced. Without an act of recreation the object is not perceived as a work of art. The artist selected, simplified, clarified, abridged and condensed according to his interest. The beholder must go through these operations according to his point of view and interest. In both, an act of abstraction, that is of extraction of what is significant, takes place. In both, there is comprehension in its literal signification—that is, a gathering together of details and particulars physically scattered into an experienced whole. There is work done on the part of the percipient as there is on the part of the artist. The one who is too lazy, idle, or indurated in convention to perform this work will not see or hear. His "appreciation" will be a mixture of scraps of learning with conformity to norms of conventional admiration and with a confused, even if genuine, emotional excitation.

The considerations that have been presented imply both the community and the unlikeness, because of specific emphasis, of *an* experience, in its pregnant sense, and esthetic experience. The former has esthetic quality; otherwise its materials would not be rounded out into a single coherent experience. It is not possible to divide in a vital experience the practical, emotional, and intellectual from one another and to set the properties of one over against the characteristics of the others. The emotional phase binds parts together into a single whole; "intellectual" simply names the fact that the experience has meaning; "practical" indicates that the organism is interacting with events and objects which surround it. The most elaborate philosophic or scientific inquiry and the most ambitious industrial or political enterprise has, when its different ingredients constitute an integral experience, esthetic quality. For then its varied parts are linked to one another, and do not merely succeed one another. And the parts through their experienced linkage move toward a consummation and close, not merely to cessation in time. This consummation, moreover, does not wait in consciousness for the whole undertaking to be finished. It is anticipated throughout and is recurrently savored with special intensity.

Nevertheless, the experiences in question are dominantly intellectual or practical, rather than *distinctively* esthetic, because of the interest and purpose

that initiate and control them. In an intellectual experience, the conclusion has value on its own account. It can be extracted as a formula or as a "truth," and can be used in its independent entirety as factor and guide in other inquiries. In a work of art there is no such single self-sufficient deposit. The end, the terminus, is significant not by itself but as the integration of the parts. It has no other existence. A drama or novel is not the final sentence, even if the characters are disposed of as living happily ever after. In a distinctively esthetic experience, characteristics that are subdued in other experiences are dominant; those that are subordinate are controlling—namely, the characteristics in virtue of which the experience is an integrated complete experience on its own account.

In every integral experience there is form because there is dynamic organization. I call the organization dynamic because it takes time to complete it, because it is a growth. There is inception, development, fulfillment. Material is ingested and digested through interaction with that vital organization of the results of prior experience that constitutes the mind of the worker. Incubation goes on until what is conceived is brought forth and is rendered perceptible as part of the common world. An esthetic experience can be crowded into a moment only in the sense that a climax of prior long enduring processes may arrive in an outstanding movement which so sweeps everything else into it that all else is forgotten. That which distinguishes an experience as esthetic is conversion of resistance and tensions, of excitations that in themselves are temptations to diversion, into a movement toward an inclusive and fulfilling close.

Experiencing like breathing is a rhythm of intakings and outgivings. Their succession is punctuated and made a rhythm by the existence of intervals, periods in which one phase is ceasing and the other is inchoate and preparing. William James aptly compared the course of a conscious experience to the alternate flights and perchings of a bird. The flights and perchings are intimately connected with one another; they are not so many unrelated lightings succeeded by a number of equally unrelated hoppings. Each resting place in experience is an undergoing in which is absorbed and taken home the consequences of prior doing, and, unless the doing is that of utter caprice or sheer routine, each doing carries in itself meaning that has been extracted and conserved. As with the advance of an army, all gains from what has been already effected are periodically consolidated, and always with a view to what is to be done next. If we move too rapidly, we get away from the base of supplies—of accrued meanings—and the experience is flustered, thin, and confused. If we dawdle too long after having extracted a net value, experience perishes of inanition.

The *form* of the whole is therefore present in every member. Fulfilling, consummating, are continuous functions, not mere ends, located at one place only. An engraver, painter, or writer is in process of completing at every stage of his work. He must at each point retain and sum up what has gone before as a whole and with reference to a whole to come. Otherwise there is no consistency and no security in his successive acts. The series of doings in the rhythm of experience give variety and movement; they save the work from monotony and useless repetitions. The undergoings are the corresponding elements in

the rhythm, and they supply unity; they save the work from the aimlessness of a mere succession of excitations. An object is peculiarly and dominantly esthetic, yielding the enjoyment characteristic of esthetic perception, when the factors that determine anything which can be called *an* experience are lifted high above the threshold of perception and are made manifest for their own sake.

READING 7

INTRODUCTION

In "The Play of Art" (1973), Hans-Georg Gadamer, one of the leading figures in the hermeneutic tradition of philosophy, pursues a theme that is also to be found in the essay by Freud reprinted in this section: that of the "playful" character of art. However, the fact that Gadamer thinks that an understanding of art can usefully be sought by a consideration of play does not mean that he—any more than did Freud—thinks that art is frivolous or unimportant. On the contrary, Gadamer suggests that "our capacity for play is an expression of the highest seriousness." Gadamer's exploration of the ways in which art can be understood in terms of play lead him to consider questions about the ontology of artworks and the nature of aesthetic experience, as well as issues more narrowly focused on artistic creativity. But as his essay makes clear, the creative impulses that result in works of art cannot be fully understood without reflecting on the works themselves and on the experiences of those who engage with them.

"The Play of Art"

Hans-Georg Gadamer

Play is an elementary phenomenon that pervades the whole of the animal world and, as is obvious, it determines man as a natural being as well. Man shares a great deal with the other animals, whose enjoyment of play can astonish us—so much so that anyone who observes and studies animal behavior, in particular that of the higher mammals, is overcome by a feeling of delight coupled with horror. If animals and human beings resemble one another in so many respects, does not the borderline between them become blurred? The modern study of animal behavior has indeed made us more and more aware just how questionable such a distinction really is. Things are no longer as simple for us as they were made to seem in the seventeenth century. So overwhelming was the impact of Descartes' central insight at that time, that self-consciousness came to be seen as the mark of humanity, animals were simply considered to be automata, and man alone was distinguished among divinely created beings by his self-consciousness and free will.

This enthusiasm has utterly disappeared. For more than a century now, the suspicion has been growing that human behavior, on the part of both the

individual and especially of the group, is determined by natural conditions to a much greater degree than is appropriate for a being who is aware of choosing and acting freely. For it is by no means the case that everything accompanied by the conscious feeling of freedom is actually the result of a free decision. Unconscious factors, compulsive drives, and interests not only determine our behavior, but our consciousness as well.

We may well ask whether a great deal of what we claim to be the exercise of free and conscious human choice cannot be much better understood in terms of animal behavior and its controlling instincts. Is it not the case that in the final analysis, human play is also determined by nature, and that artistic creation itself is an expression of a play-drive?

To be sure, we always think that we play "at something," and believe that our behavior is thereby quite different from the playful behavior of small children and animals. They play "with something," it is true, but they do not really "intend" this or that game so much as simply the act of playing itself—the expression of superabundant life and movement. On the other hand, the game that someone begins, invents, or learns how to play, has a specificity of its own that is "intended" as such. Here we are conscious of the rules and conditions of play, whether we are talking about the sort of games we play together or about competitive sports, which possess the character of play in an indirect sense. Our playful behavior is sharply distinguished from all our other forms of behavior by this specificity—much more sharply than is the case in the animal world, where forms of play slip easily into other kinds of behavior. The playfulness of human games is constituted by the imposition of rules and regulations that only count as such within the closed world of play. Any player can avoid them simply by withdrawing from the game. Of course, within the game itself, the rules and regulations are binding in their own way and can no more be violated than any of the rules that determine and bind our lives together. What is the nature of the validity that both binds and limits in this way? Doubtless, the kind of directedness to the matter at hand that is unique to man also finds expression in the characteristic of human play to include binding rules. Philosophers refer to this as the intentionality of consciousness.

Now this is indeed so universal a structure of human existence that we might well consider the directedness of play to be characteristically human. We are used to talking about the element of play proper to all human culture. We discover forms of play in the most serious kinds of human activity: in ritual, in the administration of justice, in social behavior in general, where we even speak of roleplaying and so forth. A certain self-imposed limitation of our freedom seems to belong to the very structure of culture.

But does this mean that it is only in human culture that the act of play is objectified with the specificity of "intended" behavior? Play and seriousness seem to be interwoven in a still deeper sense. It is immediately apparent that any form of serious activity is shadowed by the possibility of playful behavior. "Acting as if" seems a particular possibility wherever the activity in question is not simply a case of instinctual behavior, but one that "intends" something. This "as if" modification is so universal that even the play of animals sometimes seems animated by a touch of freedom, especially when they playfully pretend to attack, to start back in fear, to bite, and so on. And what is

the significance of those gestures of submission that can be considered the con-clusive end of contests between animals? Here too, in all probability, it is a matter of observing the rules of the game. It is a remarkable fact that no vic-torious animal will actually continue the attack once the gesture of submission has been made. The execution of the action is here replaced by a symbolic one. How does this fit in with the claim that in the animal world, all behavior obeys instinctual imperatives, while in the case of man, everything follows from a freely made decision?

If we wish to avoid the interpretative framework of the dogmatic Carte-sian philosophy of self-consciousness, it seems to me methodologically advis-able to seek out just such transitional phenomena between human and animal life. Such borderline cases in the realm of play allow us to extend the com-parison into the realm not immediately accessible to us, but which we can approach only through the works that it produces: namely, the realm of art. In this connection, however, I do not think we have found a really convincing borderline case in the universal constructive force manifest in the forms of nature, and in whose formative play we see an excess over and above what is strictly necessary and purposive. The astonishing thing here is precisely not the drive of the "constructive force," but rather the suggestion of freedom that accompanies the forms it produces. That is why symbolic actions like those described are particularly interesting. For in human fabrication as well, the decisive moment of technical skill does not consist in the fact that something of extraordinary utility or superfluous beauty has emerged. It consists rather in the fact that human production of this kind can set itself various tasks and proceed according to plans that are characterized by an element of free vari-ability. Human production encounters an enormous variety of ways of trying things out, rejecting them, succeeding, or failing. "Art" begins precisely there, where we are able to do otherwise. Above all, where we are talking about art and artistic creation in the preeminent sense, the decisive thing is not the emer-gence of a product, but the fact that the product has a special nature of its own. It "intends" something, and yet it is not what it intends. It is not an item of equipment determined by its utility, as all such items or products of human work are. Certainly it is a product, that is, something produced by human activity that now stands there available for use. And yet the work of art refuses to be used in any way. That is not the way it is "intended." It has something of the "as if" character that we recognized as an essential feature of the nature of play. It is a "work" because it resembles something played. It is not encoun-tered in its own right, but stands for something else. Just as a symbolic ges-ture is not just itself but expresses something else through itself, so too the work of art is not itself simply *as* a product. It is defined precisely by not being a piece of work that has just been turned out and could be turned out again and again. On the contrary, it is something that has emerged in an unrepeat-able way and has manifested itself in a unique fashion. It seems to me, there-fore, that it would be more accurate to call it a creation *(Gebilde)* than a work. For the word *Gebilde* implies that the manifestation in question has in a strange way transcended the process in which it originated, or has relegated that process to the periphery. It is set forth in its own appearance as a self-suffi-cient creation.

Rather than referring back to the process of its formation, such creation demands to be apprehended in itself as pure manifestation. What this means can be grasped particularly clearly in the transitory arts. Poetry, music, and dance have none of the tangibility of a material thing, yet the transient and insubstantial stuff of which they are made does compose itself into the compact unity of a creation—one that always remains the same. For this reason, creations, texts, compositions, and dance forms are certainly spoken of as works of art as such, but their essential identity depends upon the act of reproduction. In the reproductive arts, the work of art must constantly be reconstituted as a creation. The transitory arts teach us most vividly that representation is required not only for the reproductive arts, but for any creation that we call a work of art. It demands to be constructed by the viewer to whom it is presented. In a sense, it is not simply what it is, but rather something that it is not—not something we can simply use for a particular purpose, nor a material thing from which we might fabricate some other thing. On the contrary, it is something that only manifests and displays itself when it is constituted in the viewer.

The act of reading is a peculiar borderline case that can illustrate this vividly. Strictly speaking, as long as we do not read aloud or recite, nothing is produced as it is in the reproductive arts. Although we do not generate a new independent reality, we nevertheless always seem to be moving in that direction.

There has always been a tendency to link the experience of art with the concept of play. Kant characterized the disinterested, nonpurposive, and nonconceptual quality of delight in the beautiful as an affective state of mind in which our faculties of understanding and imagination cooperate with one another in a kind of free play. Schiller then transposed this description onto the basis of Fichte's theory of drives, and ascribed aesthetic behavior to a play-drive that unfolds its own free potentialities in between the material drive on the one hand and the formal drive on the other. To this extent, modern aesthetic thought has fully recognized the "contribution of the subject" to the construction of aesthetic experience. Yet the experience of art also presents that other dimension in which the playlike character of the creation, the very fact of its being "played," comes to the fore. The proper basis for this is still to be found in the ancient Greek concept of mimesis.

The Greeks distinguished between two kinds of productive activity: manual production which fabricates utensils, and mimetic production which does not create anything "real" but simply offers a representation. Something of this second sense of production is preserved in our own language when we speak of mimicry. For it is not only when we want to describe someone's gestures or the play of expression on someone's face that we talk in this way, but particularly where the deliberate imitation of a person's whole manner of behavior is involved—be it the artistic assumption of a role by an actor or the impersonation of another outside the realm of art. The very idea of mimicry implies that one's own body is a vehicle for imitative expression and that, in the case of art, it represents itself as something that it is not. A role is "played," and this implies a unique ontological claim. The simulated astonishment or feigned sympathy that people play at in social intercourse is quite different from this.

Imitative representation is not the kind of play that deceives, but a play that communicates as play when it is taken in the way it wants to be taken: as pure representation. That is the precise difference between them. For example, the hypocritical sympathy that is merely a play wants to be believed, and this claim persists even when we are able to perceive that it is feigned and artificial. Mimetic imitation, on the other hand, does not intend to be "believed," but to be understood as imitation. Such imitation is not feigned, is not false show, but on the contrary is clearly a "true" showing, "true" as a show. It is perceived just as it is intended, namely *as show, as appearance.*

Even if we leave to one side the difficult problem concerning the *being* of appearance, it is clear in any case that wherever such "being played" is at issue, this manifest show belongs in the dimension of communication. The play of art as appearance is played out between us. The one takes the creation simply as a creation, just as the other does. Communication takes place when the other person takes part in what is imparted to him—and in such a way that he does not, as it were, only receive in part what is communicated, but shares in this knowledge of the whole matter that is fully possessed by both of them. This is obviously what distinguishes genuine communication from simulated participation. In the latter, the "appearance" is precisely not an appearance common to both partners, but a deception that is intended to appear simply for the other. An artistic creation is therefore a true show. So much is it common to all that even the artist enjoys no privileged status over those who experience his work. Precisely because he has expressed what he has to say, he keeps back nothing for himself, but communicates himself without reserve. His work speaks for him.

We must not lose sight of the ontological significance of mimicry and mimesis if we are to understand the essential sense in which art possesses the character of play. Mimicry is imitation. But this has nothing whatever to do with the relation between copy and original, or indeed with any theory for which art is supposed to be an imitation of "nature", that is, of that which exists in its own right. A little reflection on the essence of mimesis can save us from this crass naturalistic misunderstanding. The original mimetic relation is not an imitation in which we strive to approach an original by copying it as nearly as possible. On the contrary, it is a kind of showing. Here showing does not mean setting out something like a proof in which we demonstrate something that is not accessible in any other way. When we show something, we do not intend a relation between the one who shows and the thing shown. Showing points away from itself. We cannot show anything to the person who looks at the act of showing itself, like the dog that looks at the pointing hand. On the contrary, showing something means that the one to whom something is shown sees it correctly for himself. It is in this sense that imitation is a showing. For imitation enables us to see more than so-called reality. What is shown is, so to speak, elicited from the flux of manifold reality. Only what is shown is intended and nothing else. As intended, it is held in view, and thus elevated to a kind of ideality. It is no longer just this or that thing that we can see, but it is now shown and designated as something. An act of identification and, consequently, of recognition occurs whenever we see what it is that we are being shown.

Remarkably enough, even in the case of mechanical reproductions of art, this is often unmistakable. When we look at the frequently outstanding photographic reproductions in illustrated newspapers, it is remarkable how unerringly we are able to distinguish a photographic report of real events from the reproduction of a painting or even the most realistic of film scenes. That is not to say that the film is unnatural in any way, or that the realistic portrait is not painted realistically enough. Something else comes through here even when it is reproduced in a newspaper. Aristotle is quite right: poetry makes the universal more visible than that faithful narration of facts and actual events which we call history can ever do. The "as if" modification of poetic invention and the formative activity of sculpture or painting clearly make possible a form of participation that is beyond the reach of contingent reality with all its limitations and conditions. The photographic documentation of such contingent reality—the picture of a statesman, for example—only acquires its significance within a familiar context. The reproduction of a portrait painting has significance in its own right even when we do not know the identity of the person it represents. It not only allows us to recognize the universal, but thereby unites us by virtue of that which is common to us all. It is because what has been reproduced is not a "real" photograph, but only a painting that has the character of play, that it embraces us as participants. We know how it is intended and we take it as such.

From this perspective we can judge just how inappropriate the understanding and practice of art in the age of the culture industry have become. It is an industry that reduces participants to the level of exploited consumers. But a false self-understanding is thereby demanded of us. The mere onlooker who indulges in aesthetic or cultural enjoyment from a safe distance, whether in the theater, the concert hall, or the seclusion of solitary reading simply does not exist. Such a person misunderstands himself. For aesthetic selfunderstanding is indulging in escapism if it regards the encounter with the work of art as nothing but enchantment in the sense of liberation from the pressures of reality through the enjoyment of a spurious freedom.

The comparison between the forms of play discovered and created by men, and the uninhibited movement of play exhibited by superabundant life, can teach us that precisely what is at issue in the play of art is not some substitute dream-world in which we can forget ourselves. On the contrary, the play of art is a mirror that through the centuries constantly arises anew, and in which we catch sight of ourselves in a way that is often unexpected or unfamiliar: what we are, what we might be, and what we are about. In the last analysis, is it not an illusion to think that we can separate play from seriousness and only admit it to segregated areas peripheral to real life, like our leisure time which comes to resemble a relic of lost freedom? Play and seriousness, the exuberance and superabundance of life, on the one hand, and the tense power of vital energy on the other, are profoundly interwoven. They interact with one another, and those who have looked deeply into human nature have recognized that our capacity for play is an expression of the highest seriousness. For we read in Nietzsche, "Mature manhood: that means to have found again the seriousness one had as a child—in play." Nietzsche also knew the reverse of this as well, and celebrated the creative power of life—and of art—in the divine ease of play.

Insistence on the opposition between life and art is tied to the experience of an alienated world. And failure to recognize the universal scope and ontological dignity of play produces an abstraction that blinds us to the interdependence of both. Play is less the opposite of seriousness than the vital ground of spirit as nature, a form of restraint and freedom at one and the same time. It is precisely because what we encounter in the creative forms of art is not merely the freedom of caprice or of the blind superabundance of nature, that their play is capable of penetrating all the dimensions of our social life, through all classes, races, and levels of cultural attainment. For these our forms of play are forms of our freedom.

READING 8

INTRODUCTION

Christine Battersby teaches philosophy at the University of Warwick in England. The readings that follow are excerpted from her book *Gender and Genius: Towards a Feminist Aesthetics* (1989), a richly detailed study of how, throughout history, notions of artistic creativity, although they have undergone dramatic revision and evolution, have nonetheless always been cast in ways that deny the very possibility of genuine creativity in women. The concept of "genius," she argues, has from ancient times been bound up with that of "maleness." In her book, Battersby documents the history of "the gendering of genius"—as it is reflected in and indeed, she argues, furthered by the writings of Freud and Nietzsche, among others—and considers the effects that the gendering of genius has had on women creators. In the chapters reprinted here, she explores the controlling conceptions of "genius" in Romantic and Modernist theories of artistic creativity, and discusses the strategies that one woman artist, Anaïs Nin, was forced into by the success of those conceptions in denying the fact of her own artistic creativity. Battersby's work constitutes a concerted and powerful challenge to the other reflections on genius and artistic creativity reprinted in this section—a challenge that may undermine the very notion of "genius" itself.

From *Gender and Genius*

Christine Battersby

THE MALE GIFT

The Renaissance artist had aimed to *mirror* a universal truth that existed independently of his own self, and subjectivity was therefore a barrier rather than an aid to artistic invention. But for the Romantics individuality and particularity were no longer handicaps to artistic production. The artist offered his own inner landscape as one of the poles against which others could align the

compasses of their own minds. Coleridge theorised the new aesthetics in *Biographia Literaria* (1817); but the changes in taste that embraced artistic idio-syncrasy predated him, and occurred during the closing years of the eighteenth century. Thus Jean-Jacques Rousseau's autobiographical *Confessions* (1781) opens with a boast that a Renaissance author or artist would have scorned to make:

> *I have resolved on an enterprise which has no precedent, and which, once complete, will have no imitator. My purpose is to display to my kind a portrait in every way true to nature, and the man I shall portray will be myself.*
>
> *Simply myself. I know my own heart and understand my fellow man. But I am made unlike anyone I have ever met; I will even venture to say that I am like no one in the whole world. I may be no better, but at least I am different.*

These words of Rousseau's symbolise the new attitudes to the self: as an author he is proud of his uniqueness; he preens himself on his originality. His aim is to 'tell the truth'—sincerely, if not always accurately—by faithfully por-traying his own (very individual) soul, and the desires and needs of his own (very inadequate) body. Rousseau paints himself as a naïve, vain, impetuous, obsessive, fickle, fanciful, childlike creature—swayed more by strong emotions and sympathies than by reason. He is a charming monster: sometimes baf-flingly pure, but with a tendency to disease and madness. Rousseau projects himself, in other words, in very much the way that the Renaissance caricatured woman: as locked into his own very subjective and sexually disturbed psyche. Later, for the nineteenth-century Romantics, Rousseau's defence of the com-mon man—his attack on the institutional privileges of property, Church and urban society—came to symbolise the (lost) potential of revolutionary France . . . when all men had been declared equals and brothers in freedom. But Rousseau also symbolises the way that Romanticism made women Others rather than brothers. The free, imperfect man whose abasement and unique individuality was glorified remained a *hero* . . . heroines had, at best, a sup-portive role.

The 'feminine' Rousseau was anti-female . . . at least, anti-educated and creative females. In his *Letter to Mr d'Alembert* (1758), women are even denied the appropriate feelings to *appreciate* art properly, let alone *produce* it:

> *Women, in general, possess no artistic sensibility . . . nor genius. They can acquire a knowledge . . . of anything through hard work. But the celestial fire that emblazens and ignites the soul, the inspiration that consumes and devours . . . , these sublime ecstasies that reside in the depths of the heart are always lacking in women's writ-ings. These creations are as cold and pretty as women; they have an abundance of spirit but lack soul; they are a hundred times more reasoned than impassioned. (Quoted and trans. Citron, 1986, p. 225)*

In the Renaissance, it was males who possessed judgement and *ingenium* . . . and women who had too much in the way of feelings, too little in the way of reason to be real artists. For Rousseau the equations are reversed: woman has too much judgement, too little emotion. In the older tradition, fire was a phys-iological reality that was essentially bound up with the vital forces of male sex-uality . . . and women were, in general, too cold to be great artists. By the time

that Rousseau was writing, this physiology was out of date. But Rousseau's woman remains cold: still lacking the fires of sublime ecstasy and of divine inspiration. The accounts of maleness and femaleness have changed; but the old misogynistic vocabulary remains—reinterpreted in such a way as to represent women as metaphorically frigid and hence as creatively sterile.

Rousseau was by no means alone in maintaining this link between creative power and the psychic 'heat' of the heroic male. One of the most famous eighteenth-century descriptions of poetic genius was that of Shaftesbury: 'a poet is indeed a second *Maker; a just Prometheus under Jove*' (1711, i, p. 136). The idea that the genius is a Prometheus, who has stolen fire from the gods and brought it to earth as a gift to male-kind, is one that we find in many Romantic writings. In Percy Bysshe Shelley's 'Prometheus Unbound' (1820), for example, speech, civilisation and poetry are all gifts of Prometheus to mankind. Prometheus allies himself with Saturn—said by Shelley to be the true god of energy and power—rebels against Jupiter (Saturn's upstart son) and, through his heroic daring and extreme suffering, produces a revolution that makes all men (= males) quasi-divine.

When Shelley wrote about Prometheus, he did not go on to spell out the misogynistic implications of a mythology that made Woman (Pandora) part of the punishment meted out to male-kind for Prometheus's presumption in stealing fire from the gods. In a way appropriate to Mary Wollstonecraft's son-in-law, Shelley (quite consciously) tried to distance himself from the gender-stereotyping of his time—and especially of his great hero, Rousseau. Shelley was revolutionary enough to dream of extending freedom and equality to women. But, as McNiece remarks—thinking that this proves Shelley makes men and women 'transcendently equal'—for Shelley the heroine is always 'the beloved counterpart, shadow, other self, and ideal support of the hero' (1969, p. 180). She has instinctive knowledge of the truth . . . and her beauty (of spirit, as well as body) inspires the poetic hero to effective action. It is, however, always a *male* task to shape this truth into verse and, by so doing, to act as a charismatic leader of mankind.

As in the Galenic account of procreation, females could provide the matter—and assist the males in a kind of subsidiary way with the processes of (re)production—but it was a primarily *male* task to form that matter into art. The Romantics' muddling of the old categories of 'female', 'feminine' and 'male' did not fundamentally disturb the old sexual hierarchies—and produced, at best, a male ambivalence towards female authorship. On a personal level, for example, Shelley encouraged Mary Wollstonecraft Shelley to write . . . but also (apparently) found her writing threatening. We can see this in the original 'Preface' to *Frankenstein* (1818) which Percy wrote himself, assuming his wife's voice to explain the story's genesis in an informal competition set up in 1816 between Byron, himself and Mary (still, at that time, his wife-to-be). The idea, it seems, was to emulate the German ghost-stories that the three friends read to each other during wet evenings spent around Byron's Swiss fireside.

Percy's 'Preface' places the two male authors centre-stage—and not in the manner implied by the novel itself, as the models for Frankenstein's dream of divine omnipotence . . . and consequent monstrosity. Instead, Percy's voice

presents Byron and himself as Mary's authorial rivals: they, too, had super-
natural stories to recount. 'The weather, however, suddenly became serene',
and the two men set off on a comradely trek through the Alps, where they
'lost, in the magnificent scenes . . . all memory of their ghostly visions'. The
sun-lit visions of the males in the mountains were so vivid that they effaced
the fictions of the fire-lit darkness. Percy's 'Preface' implicitly ranks the nat-
ural sublimities of the two men's day-time world (which produced poetry)
above the hallucinations of Mary ('a most humble novelist') (pp. 58, 57). The
men transcend the enclosed space—and the horrors of domesticity—which
trap the woman in a world of shadows. In the Myth of the Cave in Plato's
Republic (one of Percy's favourite texts), sunlight represents Truth, whilst fire-
light only creates a ghostly imitation of reality for those imprisoned down
below, inside the Cave of Illusion. Appropriating Plato's imagery and the voice
of female modesty, Percy puts Mary in her authorial place. Ghost stories are
for women; Poetic Truth for men.

Shelley's anxieties about female authorship are further illustrated by one
of his own 'ghostly visions' during the weeks when Frankenstein was born.
We know from Byron's mistress and doctor—also full (writing) members of
the Gothic houseparty, despite Shelley's version of events—that during one of
the recitations, Percy retired, screaming . . . traumatised by a vision of Mary's
body with nipples transformed to eyes. Medical expertise was required before
the poet could recover his equilibrium.[1] Since the Romantic author creates the
world anew in the way that it presents itself to his own, unique angle of view,
Shelley's 'fit of phantasy' is symptomatic of a general male unease. As Gilbert
and Gubar show in the brilliant opening chapter of *The Madwoman in the Attic*
(1979), throughout the nineteenth century—and even today—the pen has been
represented as a metaphorical penis. The writer's watching eyes belong with
penises . . . not with female breasts.

In a letter to R. W. Dixon dated 1886, Gerard Manley Hopkins pithily
summarises this phallic view of art. For him the artist's 'most essential qual-
ity' is

> *masterly execution, which is a kind of male gift, and especially marks off men from
> women, the begetting of one's thoughts on paper, on verse, or whatever the matter is
> . . . [T]he mastery I speak of is not so much in the mind as a puberty in the life of
> that quality. The male quality is the creative gift.* (Madwoman, p. 3)

[1]For the diary entries of Dr Polidori and Claire Clairmont (Mary's step-sister, as well as Byron's
mistress), see Cameron (1974), pp. 92, 586. In her own 'Introduction' to *Frankenstein*, written for
the 1831 edition, Mary denies that she was ever in competition with Byron and her (dead) hus-
band (1817, p. 53). This has been interpreted by Poovey as a part of Mary's unwillingness to mea-
sure herself against her two intimidating male companions, and as an indication of her 'whole-
hearted acceptance of an essentially subordinate and passive role' (1984, pp. 141, 142). But such a
reading is suspect. We know that Percy Bysshe Shelley invented several details of the occasion:
that the writing was an exclusively nighttime activity, and that it involved only the three authors.
Why should we accept his account of the rest of the story? By refusing to slot herself into her dead
husband's mythologising of authorial competition—a mythologising that, in Mary's words, shows
the two men downgrading 'the platitude of prose'—Mary resisted the males' claim to superiority
of vision. As Poovey shows, Mary did herself internalise the social denigration of female author-
ship; but this does not make her a thoroughgoing conservative . . . even in later life.

The Jesuit poet has dressed in Victorian majesty the rather bathetic view of Timon, one of Rochester's characters: 'I . . . never Rhym'd, but for my Pintle's [penis's] sake' (quoted ibid., p. 6). The sexually chaste nineteenth-century Christian and the notorious seventeenth-century rake unite in making the poet's pen an extension of the male sexual organ.

We can find a similar perspective in twentieth-century poetics, after Romanticism has merged into Modernism. In 'The Figure of the Youth as Virile Poet' (1943), for example, Wallace Stevens remarked that 'The centuries have a way of being male', and says that this maleness comes 'in part, from their philosophers and poets' (p. 52). For Stevens this is appropriate, since 'There can be no poetry without the personality of the poet', and the definition of poetry has to start with character-sketches [p. 46]. The sketch he offers us is that of 'the genius, or, rather, the youth as virile poet' (p. 66). Stevens even denies that the Muse is female:

> No longer do I believe that there is a mystic muse, sister of the Minotaur. This is another of the monsters I had for nurse, whom I have wasted. I am myself a part of what is real, and it is my own speech and the strength of it, this only, that I hear or ever shall. (p. 60, original in italics)

All the poet's energies come from his own strong self, and that self is necessarily male. The poet, he claims, should write a poetry that 'satisfies both the reason and the imagination' (p. 42).

With the Muse (the imagination) incorporated within the male body, the poet remains male, virile and powerful. But

> if, for the poet, the imagination is paramount, and if he dwells apart in his imagination, as the philosopher dwells in his reason, and as the priest dwells in his belief, the masculine nature that we propose for one that must be the master of our lives will be lost as, for example, in the folds of the garments of the ghost or ghosts of Aristotle. (pp. 66–67)

Steven's poet is a male androgyne. Imagination is the feminine side of his mind; this is the Muse that must be incorporated into his virile male body. Stevens denies woman reason—and creativity. The final evocation of the ghost of Aristotle seems to suggest that he is aware of the sources of his beliefs. But whatever the metaphysical wrappings of this masculine poetics, Stevens seems to be agreeing with the anonymous eighteenth-century objector to Aphra Behn, who wrote in 1702:

> What a Pox have the Women to do with the Muses? I grant you the Poets call the Nine Muses by the Names of Women, but why so? not because the Sex had any thing to do with Poetry, but because in that Sex they're much fitter for prostitution. (Lock, 1976, p. 26)

The paintbrush and sculptor's chisel are also phallic signifiers. Renoir, for example, is alleged to have said 'that he painted his paintings with his prick' (quoted *Madwoman*, p. 6). He most certainly wrote that

> women are monsters who are authors, lawyers and politicians, like George Sand, Madame Adam, and other bores who are nothing more than five-legged beasts. The woman who is an artist is merely ridiculous, but I feel that it is acceptable for a woman

to be a singer or a dancer. In Antiquity and among simple people, women sing and dance and they do not therefore become less feminine. Gracefulness is a woman's domain and even her duty. (White, 1972, p. 171)

This is a common form of artistic misogyny. But in the fine arts there is another logic of sexual exclusion that is more prevalent than Renoir's . . . or even that underlying Ruskin's pronouncements about male and female roles in *Sesame and Lilies* (1867):

Now their separate characters are these. The man's power is active, progressive and defensive. He is eminently the doer, the creator, the discoverer. His intellect is for invention and speculation. But the woman's intellect is not for invention or creation but sweet ordering, arrangement and decision. Her great function is praise. (Parker and Pollock, 1981, p. 9)

For Renoir, woman's status as a beautiful object confines her to social roles that involve artistic *display*, rather than artistic *invention*. By contrast, Ruskin's woman is a born housekeeper. She tidies the house of art while man exercises his inventive muscles, and she applauds when he brings home the creative bacon. But many of the examples provided by Parker and Pollock in *Old Mistresses* (1981) provide a further position in the pornographic gymnastics of sexualised art criticism. Writing in 1871, John Jackson Jarves provides an illustration. He divides 'feminine' from non-feminine fields of art, suggesting that women '*Naturally*' pick artistic fields that involve 'the least expenditure of mental capital'. Crafts that appeal to women's 'nice feeling for form, quick perceptions' and 'mobile fancy' are allocated to the 'feminine'. He gives clay-modelling as his example, but adds that when women venture into the more masculine genre of sculpture, 'women by *nature* are likewise prompted . . . to motives of fancy and sentiment rather than realistic portraiture or absolute creative imagination' (ibid., p. 10, Parker and Pollock's emphases).

Male cultural supremacy is secured by such territorial divisions. Unlike Renoir and Ruskin, Jarves allows women inventive capacities—but only of inferior kinds. Absolute creative imagination is limited to certain sub-sections of subject-matter in certain privileged genres: such as realistic sculptures, oil paintings of (nude) human beings, group portraits or history paintings. Since women were deemed 'unsexed' by skill in these exclusively male fields of art, there could be no temptations to the truly 'feminine' psyche. Thus, although the 'feminine' is not consistently downgraded in phallic criticism, in these modes of *territorial* apartheid, 'feminine' and 'masculine' are synonymous with 'female' and 'male', and 'genius' becomes a kind of psychic beard—a secondary sexual characteristic of mature (European) males. In the words of Léon Legrange (1860):

Male genius has nothing to fear from female taste. Let men of genius conceive of great architectural projects, monumental sculpture, and elevated forms of painting. In a word, let men busy themselves with all that has to do with great art. Let women occupy themselves with those types of art they have always preferred, such as pastels, portraits or miniatures. Or the painting of flowers, those prodigies of grace and freshness which alone can compete with the grace and freshness of women themselves. (Trans. from French and quoted ibid., p. 13)

Such gendering of creative territories is much more common in the fine arts than in literature. But there are, of course, examples in literary criticism, too. Indeed, we saw Shelley implicitly gendering the ghost-story as female. And in Chapter 2 we observed Anthony Burgess employing similar devices to downgrade female novelists. Burgess (a novelist himself) is supercilious about novel-writing: this female genre does not represent True Art. It is an inferior form of literature . . . and literature itself is inferior to musical composition . . . an activity, apparently, that requires *male* sexuality. Significantly, in *The Independent* of 23 May 1988 Anthony Burgess reveals that he thinks of himself as 'primarily a composer' . . . which explains why he can use music as a truss to protect his own creative balls. But, of course, few male novelists view themselves as essentially musicians, and as such have had to opt for more subtle means of guarding their manhood. Historically, the novel has been less easy to marginalise from High Art than flower-painting, clay-modelling, watercolour landscapes and other 'crafts'. Male novelists have had to find ways of reassuring themselves of their virility whilst still recognising that 'feminine' qualities such as sensitivity, passivity, emotionality and introspective self-consciousness are also expected of them.

The Virility School of Creativity seems to have been particularly important in the middle years of this century. Its sires include Picasso, Jackson Pollock, and in literature Hemingway, Henry Miller and Mailer. It was by no means a cohesive school . . . but rather a variety of gut reactions to an ideology that credited a creator with a male sexual drive but a feminine psyche. It encompasses a variety of machismo stances. Jackson Pollock and Henry Miller, for example, stressed their maleness precisely in order to compensate for the essentially intuitive and passive nature of their own working methods. Pollock's famous 'drip' paintings started by liquid simply falling on to the huge unstretched canvases laid out on floors or walls: and then (he claimed) the paintings 'contacted' him as he walked round and 'in' them, and revealed to him the shapes that he must form (O'Hara, 1959, p. 32). Scale, size, aggression—and picture-titles drawn from the mythologies of patriarchal power—were employed to masculinise these 'drip' techniques into 'Action Painting.' Analogously, Henry Miller idealised authors as radio 'antennae', picking up currents and ideas from the pervading atmosphere (Plimpton, 1963, pp. 172–3). But Miller's prose is frantically insistent that the author is *not-female:* hence the excessively violent (and monotonous) details of sexual exploits with the Otherness of cunts.

The typical Hemingway hero, on the other hand, was very different: full of machismo, but sexually impotent. As Peter Schwenger notes in his analysis of a group of these Virile Novelists, in every case 'Beneath the blatant *machismo* one finds considerable ambivalence towards the traditional masculine role' (1984, p. 14). In his subsequent chapters, Schwenger expresses his puzzlement in reconciling feminist theory (with its analysis of the way the pen has been represented as a penis) with his own observations that the buddies of the Virility School are only too aware that it is 'sissy' to write novels. Like the feminist critics whose writings he cites, Schwenger fails to make a clear distinction between the 'feminine' and the 'female'. Indeed, the novelists he examines also

seem confused. Their texts stress maleness to counterbalance the effeminacy expected from members of their profession.

A kind of vulgar Freudianism was used to portray all creative activity as sublimated sexual libido . . . and as Freud himself indicated that only males could be really said to have libidos, Freudianism was very reassuring (see Chapter 14 of *Gender and Genius*). Via Freud the figure of the talented male melancholic (who transcends his melancholic madness) was transposed into that of the virile but neurotic artist (who sublimates his neurosis). Metaphors of male lust and male sexual sickness are thus scattered liberally through George Plimpton's third compilation of Paris Review Interviews, *Writers at Work* (1967). There James Jones talks about the writer's 'desire for self-expo-sure'. The writer wants to 'impose [his] personality upon the world', and the simile that follows excludes the woman writer. The author is 'like one of those guys who has a compulsion to take his thing out and show it on the street' (p. 250).

Cocteau, by contrast, seems to have male masturbation in mind when he asks. 'This sickness, to express oneself. What is it?' The query follows on from a remark that seems to resemble Rousseau's in excluding women from having even good taste in art. 'Appreciation of art is a moral erection; otherwise mere dilettantism. I believe sexuality is the basis of all friendship' (ibid., p. 81). For Norman Mailer, on the other hand, his own act of writing is like the desire of a man 'to perform the sexual act under every kind of condition, emotion, and mood available to him' (ibid., p. 275). The sexual performance fantasised must surely be that of a sexual bully . . . not the raped or sexually degraded victim! But just how mentally sick *is* Mailer? He would feel happier—more male—if he could persuade us that he is potentially very sick indeed, but has redirected his sickness into literature instead of deeds. As he famously brags elsewhere, 'a good novelist can do with everything but the remnant of his balls' (1961, p. 387).

Even contemporary male novelists who present themselves as sympathetic to feminism, like John Fowles, find themselves trapped within the spiritual pornography of the School of Virility. And I am not just thinking here of *Mantissa* (1982), Fowles 'comic' excursus into soft porn. This parody of male fantasies about women functions as just one more male fantasy, in which (between acting dirty) the male narrator talks dirty with a (sometimes femi-nist) Muse (Woodcock, 1984). Fowles caricatures feminism; but he has not sim-ply grown more conservative with age. Throughout his fiction, his alliance with the 'feminine' always co-existed with a double *male* perspective on women. On the one hand, his heroines are cyphers objectified by male desire. On the other hand, they are represented as having wants and needs which must be respected: otherwise female allure will be lost (*The Collector*, 1963); male happiness and the fabric of a patriarchal society will be threatened (*The French Lieutenant's Woman*, 1969); and men will be trapped in delusory fan-tasies about muses, goddesses and love (*The Magus*, 1966).

Fowles recognises that there never was a time in which males could sim-ply treat women as objects, and that this is a superficial conception of a male utopia. He tires to maintain authorial distance from the fetish that makes 'Mouse' the signifier for Woman—'the letter M and then, after a space' (in

which 'an O-shaped vulva' is inserted) 'the letters U, S, E' (1974, pp. 81–2). But what gives Fowles's fiction its power is his own attraction towards that zero: that mysterious O(therness) that completes the male creator and the male pro-creator. Like the narrator of 'The Ebony Tower' (1974), Fowles feels nostalgia for the old aesthetics of virility, that made great art emerge from " 'Balls. Spunk. Any spunk. Even Hitler's spunk. Or nothing' ", and which consigns the abstraction and intellectualisation of modern art to the " 'Triumph of the bloody eunuch' ". What is needed instead is " 'Cock. Not fundamentals. Fundaments . . . Pair of tits and a cunt. All that goes with them. That's reality' " (pp. 45–46). Although in Fowles's story there is a female creator (nicknamed 'Mouse')—and self-conscious echoes of Gwen John (and Rodin)—the woman's creativity emerges out of sexual perversion: 'the real repression must be of a normal sexuality, a femaleness that cried out for . . .' (p. 93). Fowles clings to the tradition that makes great creators male.[2] Like the other members of the Virility School, he makes art *dis*placed male sexuality . . . but *mis*placed female sexuality.

THE GREAT 'I AM'

'I am the author.' 'I am male.' 'I am God.' Romantic and modernist art binds these three sentences together into an unholy trinity. Post-structuralist fashion pretends that a post-modernist artist has no authority, and is far from god-like. But the convention that makes the artist a god was, as John Fowles notes in *The French Lieutenant's Woman* (1969), 'universally accepted' in the nineteenth century, and as long as we retain Romantic notions of artistic creativity, we retain the author as a pseudo-god.

> *The novelist is still a god, since he creates (and not even the most aleatory avant-garde modern novel has managed to extirpate its author completely); what has changed is that we are no longer the gods of the Victorian image, omniscient and decreeing; but in the new theological image, with freedom our first principle, not authority. (Fowles, 1969, p. 86)*

The twentieth century has re-defined God, and turned Him from an authoritarian and all-knowing Victorian patriarch into 'the freedom that allows other freedoms to exist' (p. 86). As a consequence, the 'once full, patriarchal beard' of the watching, modernist narrator-god 'has been trimmed down to something rather foppish and Frenchified'—as befits a God who is a respecter of existentialist freedoms (p. 394). But the author is still a god. He also still sports a beard. The new God of modernism is still (implicitly) male.

Romantic aesthetics built its theory of artistic creativity on epistemological foundations laid by the eighteenth-century German philosopher, Immanuel Kant. According to Kant, there are three levels of reality: the world of appearances (which includes everything we see, hear, smell or otherwise sense); the

[2] It is not just in his fiction that John Fowles associates great art with maleness. In one of his critical pieces, 'Hardy and the Hag' (1977), psychoanalytic theory is employed to rationalise the gendering of creativity. See Bruce Woodcock (1984), p. 21.

world of the noumena, or things-in-themselves, which are always unknowable and ungraspable by all men during their life on earth; and the world of transcendental objects and subjects, which is the world in which we live. Kantian man is, as it were, stuck behind spatio-temporal sunglasses that he can never remove from his head. Just as pink sunglasses make everything look pink, so these spatio-temporal sunglasses make everything appear to us in three-dimensional space and one-dimensional time. We can never remove them: so we can never see what things-in-themselves are really like. The only reality we have is one strung together out of perceptions by means of the imagination. And the first thing we construct for ourselves is a stable self (the transcendental ego) which constructs itself and a stable world (of transcendental objects) at the same time. We live our lives in a fiction constructed by the imagination.

Copernicus placed the sun, instead of the earth, at the centre of the universe. Kant thought of himself as equally revolutionary: locating the individual human being at the fulcrum of the knowable universe. The 'I am' of the Kantian self brings the world into existence. My 'I am' creates the world I (and you) live in. It's a pretty grandiose conception of the power of the imagination! And Kant modelled it on his Christian pietistic beliefs about the way that God created matter. Kant here was entirely inconsistent. He had said we can only know what we can string together out of sense experiences. On his account, therefore, we should not be able to know anything about whether God exists, or about how He might operate if, indeed, He does exist. But somehow Kant can guess this. He talks about beings with 'intellectual intuition' who don't just bring the world as it appears to be into existence, but also bring things-in-themselves into existence.

Kant seems to have in mind here the obscure verse from the Bible, Exodus 3:14, 'And God said unto Moses, I AM THAT I AM . . .' Kant is envisaging a Being who can literally think himself into existence, unlike a human being who can only think into existence the self he appears to himself to have. This is the metaphysical model that the Romantic theorists appropriated for art. In Coleridge's *Biographia Literaria*, for example, an author stands in the same relation to his work as does the Kantian self to the world of appearances . . . and God to the world of things-in-themselves. Coleridge's artist creates by means of the secondary imagination:

> *The Imagination then I consider either as primary, or secondary. The primary Imagination I hold to be the living power and prime agent of all human perception, and as a repetition in the finite mind of the eternal act of creation in the infinite I AM. The secondary Imagination I consider as an echo of the former . . . differing only in* **degree,** *and in the* **mode** *of its operation. (1817, p. 159)*

For the Romantics, then, art grows out of individuality. The Christian God is the great 'I am'; and the artist is the lesser 'I am'—God's son, who booms out 'I am' in a definitely male voice. As Anaïs Nin observes in her *Journals* for August 1937:

> *As to all that nonsense Henry [Miller] and Larry [Durrell] talked about, the necessity of 'I am God' in order to create (I suppose they mean 'I am God, I am not a woman') . . . But what neither Larry nor Henry understands is that woman's cre-*

ation far from being like man's must be exactly like her creation of children, that it must come out of her own blood, englobed by her womb, nourished with her own milk. It must be a human creation, of flesh, it must be different from man's abstractions. As to this 'I am God,' which makes creation an act of solitude and pride, this image of God alone making sky, earth, sea, it is this image which has confused woman. (Man too, because he thinks God did it all alone, and he thinks he did it all alone. And behind every achievement of man lies a woman, and I am sure God was helped too but never acknowledged it.) (vol. ii, pp. 233–4)

When Nin talks so dismissively about the 'nonsense' of Henry Miller and Lawrence Durrell—both close friends—she pretends not to know what they mean: 'I suppose they mean "I am God, I am not a woman." ' But, in fact, her diaries show that she is all too familiar with the type of Romantic aesthetic theory that her companions are drawing upon. She has not been fooled by the fact that Henry Miller thought of great authors as passive and egoless (even 'feminine') radio-antennae. She recognises that the model of creativity that underlies her colleague's work presupposes an individual and arrogant ego, so swollen with pride as to suppose that its own self encompasses the whole universe. And Nin is all too poignantly aware of the paradoxes that face the woman writer who internalises such a model of creativity.

Her *Journals* chart 'the guilt for creating which is strong in woman':

I tried to efface my creation with a sponge, to drown my creation because my concept of devotion and the roles I had to play clashed with my creative self. (January 1943, vol. iii, p. 258)

A male could be a fully sexual being and remain a creator. But, for a woman, choosing to be a professional writer, painter or a sculptor was not just a matter of choosing a career (what one *does* with one's life), it was also a matter of choosing what to *be:* a woman or a sexual pervert. A woman accepting that art requires *male* sexual energies would be likely to see herself as Renoir's George Sand: as an unsexed woman or a 'five-legged beast'. So Nin carries on:

*I did not want to be a man. Djuna Barnes was masculine. George Sand./I did not want to steal man's creation, his thunder./Creation and femininity seemed incompatible. The **aggressive** act of creation./ . . . I have a horror of the masculine 'career' woman./To create seemed such an assertion of the strongest part of me that I would no longer be able to give all those I love the feeling of their being stronger, and they would love me less./ . . . I have made myself less powerful, have concealed my powers./ . . . I have crippled myself./Dreams of Chinese women with bound feet. (ibid., pp. 259–60)*

Nin's own solution to this dilemma was to render herself invisible to herself in the history of high culture. She decides that Henry and Larry are artists; she is merely a writer. 'I know Henry is the artist because he does exactly what I do not do. He waits. He gets outside of himself. Until it becomes fiction . . . I am not interested in fiction. I want faithfulness' (August 1937, vol. ii, p. 233). The men are 'objective'; she as a woman could only be 'subjective'. It is the males who are associated with cultural creation, and the construction of an alternative, fictional reality. Females are necessarily linked to the body; to the 'real' world; to feeling, emotion and 'subjectivity'. She wishes to write in a way

that maintains its connections with the womb by a kind of navel-string. And so she opts for the first-person diary genre: 'a feminine activity, it is a personal and personified creation, the opposite of the masculine alchemy' (February 1937, p. 172).

In contemporary language what Nin aimed at was *écriture féminine* or 'writing the body'—a solution to the dilemmas of a phallic aesthetics that has attracted many later feminists. There is something to be said in favour of this type of answer. On one level, after all, it does negate the false either/or: *either* be a truly feminine woman, *or* be a writer and artist. Nin insists she is a woman; she will write; but she is not an 'artist'. However, by calling Henry 'the artist', and by stepping back from calling her own works 'art', Nin fails to challenge the notion that art itself is a male preserve. For all her creative courage, Nin at these moments adopts the coward's defence, and withdraws into a separate space marked 'women's work'. Nin *is* an artist, and sometimes she sees this—for example, whilst helping Henry Miller to structure his *Black Spring* (ibid., vol. i, p. 166). Her own journals are no more 'subjective' than Miller's novels. In any case, why should 'objectivity' be male and 'subjectivity' female? Why should a woman be more bound by her body than a man? Why should a woman be more emotional, a man more rational and more abstract? These are all dichotomies that Nin used at that time, and they all involve accepting the masculine perspective that views the female as lacking the psychic equipment that enables her to retain her sexuality and also be an artist.[3]

No woman can be blamed for getting trapped by the tradition that denies women the title of 'artist'. Historically the dialectics of exclusion have been so varied, and so inconsistent, that almost every move made by a woman creator will find her presented with another spurious argument that denies or misrepresents either her sexuality or her artistry. The aesthetics of Romanticism treats the woman artist as an isolated and exceptional freak and yet also—and often at the same time—as a sub-human incapable of having a strong and solitary ego. Although Nin talks of the way in which the male artist glorifies the solitary nature of the act of creation, it is in fact the woman artist who is the more isolated figure. The weight of cultural and artistic tradition presses on the shoulders of all writers in our culture who are male, and the male writer is likely to deny his ancestry and insist on his own individual creative power. Tradition, of course, also presses heavily on the shoulders of the woman artist. But it presses in a different way—as a discouragement to all artistic efforts. Dorothy Richardson put it poignantly in *Pilgrimage* (1915–38; vol. ii, ch. xxiv):

> If one could only burn all the volumes; stop the publication of them. But it was all books, all the literature in the world, right back to Juvenal . . . whatever happened, if it could all be avenged by somebody in some way, there was all that . . . the classics, the finest literature—'unsurpassed'. Education would always mean coming in contact with all that. Schoolboys got their first ideas . . . **How** could Newnham and Girton women endure it? How could they go on living and laughing and talking? (Original ellipses; extract in Goulianos, 1974, p. 270)

[3]For Nin's later views see her 'Diary versus Fiction', from her *The Novel of the Future* (1968), in Webber and Grumman (1978), pp. 39–45.

A lot of the metaphoric language of collectivity and the denial of creation as a solitary act that we find in texts and works by women artists is an expression of their need to find a group to which they feel they can belong. There are alternative traditions of women's art that, picked out, would promote a better understanding and appreciation of female creativity. But Romanticism does not bring these continuities into focus. Indeed, feminist critics are only just managing to peer round the edges of orthodox cultural histories to confront these distinctively female forms. In *The Madwoman in the Attic*, for example, Gilbert and Gubar have revealed a community of isolated female voices in which women creators are not second-class citizens. They show how, condemned to 'Otherness' by a phallic aesthetics that treats the female artist as a 'five-legged beast', nineteenth-century women writers are bonded into an alternative tradition. The characters these women writers create are (like themselves) presented as semi-human: their fictional witches, monsters, and madwomen are credited with fully human emotions and capacities that make them worthy of sympathy or empathy . . . whilst still (somehow) remaining thoroughly monstrous. This mode of ambivalence towards craziness, abnormality and terror—of authorial identification and simultaneous distance—constitutes a distinctively *female* genre.

Despite its subtitle 'The Modern Prometheus', Mary Shelley's *Frankenstein* (1818) helps create a tradition of female authorship that speaks with the voice of a modern Pandora. Like the first Pandora, these women are the offspring of a mythology that gifts to males the psychic fire and wisdom of the gods. Just as we could feel despair or anger at the way the first woman was blamed (instead of Prometheus) for introducing disease and suffering into the world, so also we could see the Romantic notion of genius in a purely negative light. It has, after all, obscured the alternative traditions of cultural achievement into which these individual female writers fit. But, as in the original myth, Hope lies concealed at the bottom of the jar of horrors opened up by the modern Pandora. Unfortunately, we have to fumble deep into the darkness of the jar of patriarchal myth before we can bring out Hope. But if we look deep enough we can find a continuum of women creators struggling to position themselves amongst the ancient and modern myths that bind together the concepts of male sexuality and of creativity. We find Another Otherness: as female writers, artists and musicians subvert the notion that artistic production is a *male* task.

Nin knew that she had been trapped into seeing creativity as a male attribute. But although she was aware of her own strength, she could not bring herself to 'want to steal man's creation, his thunder'. Her *Journals* show her trying to re-trace the route out of the maze that imprisons thoughts about creativity in the grounds of a male God. She rejects as 'confusing' the Old Testament version of the genesis of the universe and its paradigmatic status in accounts of artistic production. Creation cannot be 'an act of solitude and pride': rather, 'behind every achievement of man lies a woman, and I am sure God was helped too but never acknowledged it'. Nin's words here serve as a stunning illustration of the way that women artists, lacking easy access to the female traditions of creativity, have—on an individual basis—to re-establish those insights for themselves. Writing in the late 1930s and early '40s, Anaïs Nin could not have known of the buried texts that would be dug up just a few

years later, which also rejected the notion of a male god 'alone making sky, earth, sea'. Nin was unaware of the Gnostic cosmogony, condemned by the Church authorities to centuries of oblivion. So, instead, out of her own imagination, she re-invented part of the Gnostic alternative.

In December 1945, four months after the thunder of two explosions had brought to an end the Second World War, a jar containing thirteen ancient papyrus books was dug out of the cliffs edging the Egyptian desert by a local farmer collecting fertiliser. Amongst the fifty-two texts contained in the leather-bound books was a poem, called 'Thunder, Perfect Mind', written in the voice of a female divine power. The metaphoric language of omnipotence could not have been used of a male god; but neither did the power of this female creator stem simply from the specifically feminine tasks of motherhood.

> *For I am the first and the last.*
> *I am the honoured one and the scorned one.*
> *I am the whore and the holy one.*
> *I am the wife and the virgin . . .*
> 5 *I am the barren one,*
> * and many are her sons . . .*
> *I am the silence that is incomprehensible . . .*
> *I am the utterance of my name.*
> (Nag Hammadi Library, *1977, VI, 2; Pagels, pp. 16–17*)

In *The Gnostic Gospels* (1980), Elaine Pagels has exposed some of the detail of these early Christian works, translated into Coptic in AD *c.*350–400 from much earlier Greek texts, including some perhaps as old as—or even older than—those of Matthew, Mark, Luke and John. Pagels points out how much work remains to be done on the manuscripts, which (for reasons of greed and national and professional jealousy) only came fully into the public domain in the late 1970s. But from her account many things are already clear. Buried in Upper Egypt, condemned by the authority of the Fathers of the Church to the fate of unorthodoxy, is a rich tradition of writing and thinking about power and divinity that gives a different role to the female. Several of the texts provide Eve with a more positive part in the drama of the garden of Eden: she is associated with wisdom and the awakening of Adam to life and understanding. Mary Magdalene is also given a more central role, as a knowledgeable and perceptive apostle. A number of the gospels also present us with the prehistory of Genesis. God the Father of the Old Testament is made the self-promoting and boastful offspring of the female procreative force, Sophia (Wisdom). After he was created, the male God

> *became arrogant, saying, 'It is I who am God, and there is none other apart from me.'*
> *When he said this, he sinned against the Entirety. And a voice came forth from above the realm of absolute power, saying, 'You are mistaken, Samael'—which is, 'god of the blind.'*
> *And he said, 'If any other thing exists before me, let it become visible to me!' And immediately Sophia stretched forth her finger and introduced Light into Matter . . . ('The Hypostasis of the Archons,' Nag Hammadi II, 4, 94–5)*

These early Christian gospels thus undermine the orthodox understanding of the famous first verse of the Gospel of St John: 'In the beginning was

the Word, and the Word was with God, and the Word was God.' In the King James version of the New Testament, 'word' is used to render the untranslatable Greek term *logos*—glossed everywhere as 'speech', 'doctrine', 'measure', 'reason', 'principle' or even 'proportion'. This noun, so important in the metaphysics of ancient Greece, was associated with the capacity for rational discourse: that characteristic which, in Aristotelian metaphysics, is what makes human beings superior to the rest of the animal kingdom. But *logos* belonged to the males, in the sense that it was claimed that it was through the father that the attributes of the species were passed on from generation to generation. In the Stoic elaborations on this Aristotelian idea, *logos* was the formula contained within the male seed that enabled the father to reproduce his own likeness in his offspring. The *logos* was a kind of mystical (genetic) code, which only males carried.

Logos spermatikos—'the spermatic word'—was a central concept in ancient Greek and Roman Stoicism. Whether or not the writer of St John's Gospel was himself influenced by Stoicism is a matter of dispute. But it seems clear that the Fathers of the Christian Church read St John through the spectacles of Stoic cosmology, which traced the origin of the universe to the coding contained within the male seed. In Chapter 3 I argued that the Greek philosophers did not themselves have the concept of a self-creating God. Creation in Aristotle was procreation: the male principle was the active shaping force applied to the inert matter provided by the female. But, via Roman Stoicism, Christianity combined Judaic ideas of a self-creating God with Greek ideas of the origins of the universe. For the Church Fathers, God remained male—even though the Christian God was supposed to have created himself *out of nothing*, by processes utterly unlike those of biological reproduction. The 'I AM THAT I AM' was Father, Son and Holy *male* Spirit . . . as '*Genius*' was for the Stoics.

'*Genius*' was one of the key terms in the Stoics' spermatic cosmogony: it was used to conjoin (male) human beings with the universe and Jove (its personification and the father of the gods). The *logos spermatikos* made all three divine. Historians of ideas have, on the whole, pretended that it is the history of the Latin term *ingenium* that is important in the history of our modern concept of genius, and that the Latin word *genius* matters hardly at all. Anaïs Nin, quite instinctively, knew better. She recognised that the model of creation that her male companions drew on in thinking about genius used as its model God the Father. 'I am not a woman' is the whispered implication of the 'I am God' that Nin detects at the heart of Romantic and Modernist aesthetics.

In Chapter 1 we saw Carl Gustav Jung (1875–1961) confining the *logos spermatikos* to the males. Jung, the product of Romanticism, joined a patrilineal tradition that stretches back all the way to Aristotle, the Stoics, and the founding Fathers of the Western Church. Jung would have us believe that this tradition represents ancient wisdom. But the Gnostics knew better: they suggested that it is wilful male blindness that shapes this ancient prejudice. The Gnostics' primordial creative power is *bi*sexual: it is an androgynous voice which asserts, '[I] am the real Voice. I cry out in everyone, and they know that a seed dwells within' ('Trimorphic Protennoia', *Nag Hammadi* XIII, 1, 36; Pagels, p. 77). The Gnostic female is associated with that which underlies *logos*: with sound (out of which words are shaped), and with matter (out of which the seed itself is moulded). Matter was also female in Aristotle, but was downgraded in a way

quite foreign to many of these Gnostic texts. The Gnostic universe was formed by forces which include the psychic and reproductive powers of the female. 'Yahveh'—literally 'I am'—was one of the Old Testament names for the God. 'I am', 'I am', 'I am' thunders the counter-voice of the perfect female mind—adding, 'I am the silence that is incomprehensible . . . I am the utterance of my name.'

The Gnostic codices demonstrate that the Christian account of the creation of the universe could have severed the links between divinity and male pro-creativity. Christianity offered women the opportunity to be considered the spiritual equals of males. But instead of embracing women as 'brothers in Christ', the Christian Fathers closed ranks . . . and developed a canon that con-demned to the desert of forgetfulness the words of those who spoke out for female spiritual power. In much the same way, the Romantics' revaluation of all 'feminine' values should have given female artistic creators equality with males. But the Sons of Romanticism still represented creativity as bonded to male sexual energies, and hence as alien to women. An examination of the pagan worship of male virility—and the subsequent history of its uneasy alliance with Christian orthodoxy—will, I believe, cast light on the later ortho-doxies (of post-Romantic aesthetics, and even of some forms of feminism) that *still* represent *logos* as necessarily male. . . .

What I will be arguing is that, via Christianity, the (divine metaphysical) *genius* of male procreativity shrivelled into a (mundane, physical) penis . . . the pen was used as a kind of penis-extension (to re-establish male divinity on a new nonphysical level) . . . and then, eventually, via Romanticism, 'genius' was, once again, worshipped—although in an entirely different form. As Christian males grew ever more uneasy about the powers embodied in male flesh, 'genius' was excavated out of the classical past, and given an increas-ingly important role in the misogyny of Western culture. The Romantics re-worked the Roman and Christian myths that derided God the Mother, God the Daughter, and God the Holy *female* Spirit. We need the outlines of this his-tory to grasp the reasons why the mouths of women creators—like the mouths of the Gnostics' earthenware jars—should have been covered with rocks. I do not pretend that the sketch that follows is in any way complete. I am neither a classicist nor a medievalist, nor even a historian of religion. Specialists will have to go back and fill in more of the details of this narrative, with rather more awareness of the gender-implications of classical scholarship than I have found in much of the material that I have consulted. But the silhouettes of this history deserve to be established—however tentatively and however provi-sionally—to help us understand the processes whereby, in the nineteenth and twentieth centuries, the *logos* was once again decreed male.

References

Citron, Marcia J., 'Women and the Lied, 1775–1850', in *Women Making Music: The West-ern Art Tradition, 1150–1950,* eds. Jane Bowers and Judith Tick, London: Macmil-lan, 1986, pp. 224–48.

Coleridge, Samuel Taylor, *Biographia Literaria* [1817], Introduction by Arthur Symons, London: Dent, Everyman ed., n.d.

Fowles, John [1969], *The French Lieutenant's Woman*, London: Pan, 1987.

——— [1974], 'The Ebony Tower', in *The Ebony Tower*, London; New York: Panther, 1975.

Gilbert, Sandra M. and Gubar, Susan, *The Madwoman in the Attic: The Woman Writer and the Nineteenth-Century Literary Imagination*, Yale University Press, 1979.

Goulianos, Joan (ed.), *By a Woman Writt: Literature from Six Centuries by and about Women* [1973], London: New English Library, 1974.

Lock, F. P., 'Astraea's "Vacant Throne": The Successors of Aphra Behn', in Fritz and Morton [1976], pp. 25–36.

McNiece, Gerald, *Shelley and the Revolutionary Idea*, Harvard University Press, 1969.

The Nag Hammadi Library in English [1977], ed. James M. Robinson, trans. Coptic Gospel Library Project, Leiden: Brill, 2nd ed., 1984.

Nin, Anaïs, *The Journals of Anaïs Nin*, ed. Gunther Stuhlmann, 6 vols., London: Peter Owen, 1966–76.

O'Hara, Frank, *Jackson Pollock*, New York: George Braziller, Great American Artists Series, 1959.

Pagels, Elaine, *The Gnostic Gospels* [1980], Harmondsworth: Penguin, 1982.

Parker, Rozsika and Griselda Pollock [1981], *Old Mistresses: Women, Art and Ideology*, London: Routledge, 1981.

Plimpton, George [1963] (ed.), *Writers at Work: The Paris Review Interviews*, Harmondsworth: Penguin, 2nd series, 1977.

——— [1967], *Writers at Work: The Paris Review Interviews*, Harmondsworth: Penguin, 3rd series, 1977.

Rousseau, Jean-Jacques, *The Confessions* [1781], trans. J. M. Cohen, Harmondsworth: Penguin, 1953.

Schwenger, Peter, *Phallic Critiques: Masculinity and Twentieth-Century Literature*, London: Routledge, 1984.

Shaftesbury, Anthony Ashley Cooper, Third Earl of, *Characteristics of Men, Manners, Opinions, Times* [1711], ed. John M. Robertson, Indianapolis: Bobbs-Merrill, 1964.

Shelley, Mary [1818], *Frankenstein; or, The Modern Prometheus*, containing P.B. Shelley's 1818 'Preface' and the author's 1831 'Introduction', ed. Maurice Hindle. Harmondsworth: Penguin, 1985.

——— [1826], *The Last Man*, London: Hogarth Press, 1985.

Shelley, Percy Bysshe, 'Preface' to *Frankenstein* [1818], in Shelley, Mary [1818].

Stevens, Wallace, 'The Figure of the Youth as Virile Poet' [1943], reprinted in his *The Necessary Angel: Essays on Reality and the Imagination*, New York: Alfred A. Knopf Inc., Vintage ed. 1951.

White, Barbara Ehrlich, 'Renoir's Sensuous Women' [1972], in *Woman as Sex Object*, eds. Thomas B. Hess and Linda Nochlin, London: Allen Lane, 1973, pp. 166–81.

Woodcock, Bruce, *Male Mythologies, John Fowles and Masculinity*, Brighton: Harvester; New Jersey: Barnes and Noble, 1984.

2

ARTWORKS

FORM AND CONTENT

INTRODUCTION

Clive Bell (1881–1964) was a critic associated with the Bloomsbury Group of artists and writers. He is best known for his advocacy of modernism, and for his "formalist" theory of art. His theory of art is stated in the piece reprinted here, which is taken from his book *Art* (1914). Bell's central claim is that the subject matter, or represented content, of a work of art is aesthetically irrelevant. All that matters, according to him, is its "significant form." Indeed, the possession of "significant form" is, on this account, the distinctive and definitive feature of art. Thus to take an interest in a painting, say, for its subject matter would be to take an *un*aesthetic interest in it; and to value it for its subject matter would be to value it on grounds that had nothing to do with its aesthetic merit. It is easy to see how these views might fit with Bell's sympathy for modernism in general and for abstract art in particular. And the views themselves are not implausible. After all, an ill-balanced, poorly designed, gauchely colored portrait of your favorite person is still an aesthetic failure despite all the delightful qualities of its subject matter. But the notion of "significant form" upon which Bell's theory depends is a problematic one; and Bell could never explain it satisfactorily. Nonetheless, the thought that it is the formal properties of art which are of principal aesthetic significance is an interesting, influential, and perhaps even a pervasive position in the philosophy of art. It receives its classic statement here.

"The Aesthetic Hypothesis"

Clive Bell

It is improbable that more nonsense has been written about aesthetics than about anything else: the literature of the subject is not large enough for that. It is certain, however, that about no subject with which I am acquainted has so little been said that is at all to the purpose. The explanation is discoverable. He who would elaborate a plausible theory of aesthetics must possess two qualities—artistic sensibility and a turn for clear thinking. Without sensibility a man can have no aesthetic experience, and, obviously, theories not based on broad and deep aesthetic experience are worthless. Only those for whom art is a constant source of passionate emotion can possess the data from which profitable theories may be deduced; but to deduce profitable theories even from accurate data involves a certain amount of brain-work, and, unfortunately, robust intellects and delicate sensibilities are not inseparable. As often as not, the hardest thinkers have had no aesthetic experience whatever. I have a friend blessed with an intellect as keen as a drill, who, though he takes an interest in aesthetics, has never during a life of almost forty years been guilty of an aesthetic emotion. So, having no faculty for distinguishing a work of art from a handsaw, he is apt to rear up a pyramid of irrefragable argument on the hypothesis that a handsaw is a work of art. This defect robs his perspicuous and subtle reasoning of much of its value; for it has ever been a maxim that faultless logic can win but little credit for conclusions that are based on premises notoriously false. Every cloud, however, has its silver lining, and this insensibility, though unlucky in that it makes my friend incapable of choosing a sound basis for his argument, mercifully blinds him to the absurdity of his conclusions while leaving him in full enjoyment of his masterly dialectic. People who set out from the hypothesis that Sir Edwin Landseer was the finest painter that ever lived will feel no uneasiness about an aesthetic which proves that Giotto was the worst. So, my friend, when he arrives very logically at the conclusion that a work of art should be small or round or smooth, or that to appreciate fully a picture you should pace smartly before it or set it spinning like a top, cannot guess why I ask him whether he has lately been to Cambridge, a place he sometimes visits.

On the other hand, people who respond immediately and surely to works of art, though, in my judgment, more enviable than men of massive intellect but slight sensibility, are often quite as incapable of talking sense about aesthetics. Their heads are not always very clear. They possess the data on which any system must be based; but, generally, they want the power that draws correct inferences from true data. Having received aesthetic emotions from works of art, they are in a position to seek out the quality common to all that have moved them, but, in fact, they do nothing of the sort. I do not blame them. Why should they bother to examine their feelings when for them to feel is enough? Why should they stop to think when they are not very good at thinking? Why should they hunt for a common quality in all objects that move them in a particular way when they can linger over the many delicious and pecu-

liar charms of each as it comes? So, if they write criticism and call it aesthetics, if they imagine that they are talking about Art when they are talking about particular works of art or even about the technique of painting, if loving particular works they find tedious the consideration of art in general, perhaps they have chosen the better part. If they are not curious about the nature of their emotion, nor about the quality common to all objects that provoke it, they have my sympathy, and, as what they say is often charming and suggestive, my admiration too. Only let no one suppose that what they write and talk is aesthetics; it is criticism, or just "shop."

The starting-point for all systems of aesthetics must be the personal experience of a peculiar emotion. The objects that provoke this emotion we call works of art. All sensitive people agree that there is a peculiar emotion provoked by works of art. I do not mean, of course, that all works provoke the same emotion. On the contrary, every work produces a different emotion. But all these emotions are recognisably the same in kind; so far, at any rate, the best opinion is on my side. That there is a particular kind of emotion provoked by works of visual art, and that this emotion is provoked by every kind of visual art, by pictures, sculptures, buildings, pots, carvings, textiles, &c., &c., is not disputed, I think, by anyone capable of feeling it. This emotion is called the aesthetic emotion; and if we can discover some quality common and peculiar to all the objects that provoke it, we shall have solved what I take to be the central problem of aesthetics. We shall have discovered the essential quality in a work of art, the quality that distinguishes works of art from all other classes of objects.

For either all works of visual art have some common quality, or when we speak of "works of art" we gibber. Everyone speaks of "art," making a mental classification by which he distinguishes the class "works of art" from all other classes. What is the justification of this classification? What is the quality common and peculiar to all members of this class? Whatever it be, no doubt it is often found in company with other qualities; but they are adventitious—it is essential. There must be some one quality without which a work of art cannot exist; possessing which, in the least degree, no work is altogether worthless. What is this quality? What quality is shared by all objects that provoke our aesthetic emotions? What quality is common to St. Sophia and the windows at Chartres, Mexican sculpture, a Persian bowl, Chinese carpets, Giotto's frescoes at Padua, and the masterpieces of Poussin, Piero della Francesca, and Cézanne? Only one answer seems possible—significant form. In each, lines and colours combined in a particular way, certain forms and relations of forms, stir our aesthetic emotions. These relations and combinations of lines and colours, these aesthetically moving forms, I call "Significant Form"; and "Significant Form" is the one quality common to all works of visual art.

At this point it may be objected that I am making aesthetics a purely subjective business, since my only data are personal experiences of a particular emotion. It will be said that the objects that provoke this emotion vary with each individual, and that therefore a system of aesthetics can have no objective validity. It must be replied that any system of aesthetics which pretends to be based on some objective truth is so palpably ridiculous as not to be worth discussing. We have no other means of recognising a work of art than our feeling for it. The objects that provoke aesthetic emotion vary with each individ-

ual. Aesthetic judgments are, as the saying goes, matters of taste; and about tastes, as everyone is proud to admit, there is no disputing. A good critic may be able to make me see in a picture that had left me cold things that I had overlooked, till at last, receiving the aesthetic emotion, I recognise it as a work of art. To be continually pointing out those parts, the sum, or rather the combination, of which unite to produce significant form, is the function of criticism. But it is useless for a critic to tell me that something is a work of art; he must make me feel it for myself. This he can do only by making me see; he must get at my emotions through my eyes. Unless he can make me see something that moves me, he cannot force my emotions. I have no right to consider anything a work of art to which I cannot react emotionally; and I have no right to look for the essential quality in anything that I have not *felt* to be a work of art. The critic can affect my aesthetic theories only by affecting my aesthetic experience. All systems of aesthetics must be based on personal experience— that is to say, they must be subjective.

Yet, though all aesthetic theories must be based on aesthetic judgments, and ultimately all aesthetic judgments must be matters of personal taste, it would be rash to assert that no theory of aesthetics can have general validity. For, though A, B, C, D are the works that move me, and A, D, E, F the works that move you, it may well be that x is the only quality believed by either of us to be common to all the works in his list. We may all agree about aesthetics, and yet differ about particular works of art. We may differ as to the presence or absence of the quality x. My immediate object will be to show that significant form is the only quality common and peculiar to all the works of visual art that move me; and I will ask those whose aesthetic experience does not tally with mine to see whether this quality is not also, in their judgment, common to all works that move them, and whether they can discover any other quality of which the same can be said.

Also at this point a query arises, irrelevant indeed, but hardly to be suppressed: "Why are we so profoundly moved by forms related in a particular way?" The question is extremely interesting, but irrelevant to aesthetics. In pure aesthetics we have only to consider our emotion and its object: for the purposes of aesthetics we have no right, neither is there any necessity, to pry behind the object into the state of mind of him who made it. Later, I shall attempt to answer the question; for by so doing I may be able to develop my theory of the relation of art to life. I shall not, however, be under the delusion that I am rounding off my theory of aesthetics. For a discussion of aesthetics, it need be agreed only that forms arranged and combined according to certain unknown and mysterious laws do move us in a particular way, and that it is the business of an artist so to combine and arrange them that they shall move us. These moving combinations and arrangements I have called, for the sake of convenience and for a reason that will appear later, "Significant Form."

A third interruption has to be met.

"Are you forgetting about colour?" someone inquires. Certainly not; my term "significant form" included combinations of lines and of colours. The distinction between form and colour is an unreal one; you cannot conceive a colourless line or a colourless space; neither can you conceive a formless relation of colours. In a black and white drawing the spaces are all white and all are bounded by black lines; in most oil paintings the spaces are multi-coloured

and so are the boundaries; you cannot imagine a boundary line without any content, or a content without a boundary line. Therefore, when I speak of significant form, I mean a combination of lines and colours (counting white and black as colours) that moves me aesthetically.

Some people may be surprised at my not having called this "beauty." Of course, to those who define beauty as "combinations of lines and colours that provoke aesthetic emotion," I willingly concede the right of substituting their word for mine. But most of us, however strict we may be, are apt to apply the epithet "beautiful" to objects that do not provoke that peculiar emotion produced by works of art. Everyone, I suspect, has called a butterfly or a flower beautiful. Does anyone feel the same kind of emotion for a butterfly or a flower that he feels for a cathedral or a picture? Surely, it is not what I call an aesthetic emotion that most of us feel, generally, for natural beauty. I shall suggest, later, that some people may, occasionally, see in nature what we see in art, and feel for her an aesthetic emotion; but I am satisfied that, as a rule, most people feel a very different kind of emotion for birds and flowers and the wings of butterflies from that which they feel for pictures, pots, temples and statues. Why these beautiful things do not move us as works of art move is another, and not an aesthetic question. For our immediate purpose we have to discover only what quality is common to objects that do move us as works of art. In the last part of this chapter, when I try to answer the question—"Why are we so profoundly moved by some combinations of lines and colours?" I shall hope to offer an acceptable explanation of why we are less profoundly moved by others.

Since we call a quality that does not raise the characteristic aesthetic emotion "Beauty," it would be misleading to call by the same name the quality that does. To make "beauty" the object of the aesthetic emotion, we must give to the word an over-strict and unfamiliar definition. Everyone sometimes uses "beauty" in an unaesthetic sense; most people habitually do so. To everyone, except perhaps here and there an occasional aesthete, the commonest sense of the word is unaesthetic. Of its grosser abuse, patent in our chatter about "beautiful huntin'" and "beautiful shootin'," I need not take account; it would be open to the precious to reply that they never do so abuse it. Besides, here there is no danger of confusion between the aesthetic and the non-aesthetic use; but when we speak of a beautiful woman there is. When an ordinary man speaks of a beautiful woman he certainly does not mean only that she moves him aesthetically; but when an artist calls a withered old hag beautiful he may sometimes mean what he means when he calls a battered torso beautiful. The ordinary man, if he be also a man of taste, will call the battered torso beautiful, but he will not call a withered hag beautiful because, in the matter of women, it is not to the aesthetic quality that the hag may possess, but to some other quality that he assigns the epithet. Indeed, most of us never dream of going for aesthetic emotions to human beings, from whom we ask something very different. This "something," when we find it in a young woman, we are apt to call "beauty." We live in a nice age. With the man-in-the-street "beautiful" is more often than not synonymous with "desirable"; the word does not necessarily connote any aesthetic reaction whatever, and I am tempted to believe that in the minds of many the sexual flavour of the word is stronger than the aesthetic. I have noticed a consistency in those to whom the most beautiful

thing in the world is a beautiful woman, and the next most beautiful thing a picture of one. The confusion between aesthetic and sensual beauty is not in their case so great as might be supposed. Perhaps there is none; for perhaps they have never had an aesthetic emotion to confuse with their other emotions. The art that they call "beautiful" is generally closely related to the women. A beautiful picture is a photograph of a pretty girl; beautiful music, the music that provokes emotions similar to those provoked by young ladies in musical farces; and beautiful poetry, the poetry that recalls the same emotions felt, twenty years earlier, for the rector's daughter. Clearly the word "beauty" is used to connote the objects of quite distinguishable emotions, and that is a reason for not employing a term which would land me inevitably in confusions and misunderstandings with my readers.

On the other hand, with those who judge it more exact to call these combinations and arrangements of form that provoke our aesthetic emotions, not "significant form," but "significant relations of form," and then try to make the best of two worlds, the aesthetic and the metaphysical, by calling these relations "rhythm," I have no quarrel whatever. Having made it clear that by "significant form" I mean arrangements and combinations that move us in a particular way, I willingly join hands with those who prefer to give a different name to the same thing.

The hypothesis that significant form is the essential quality in a work of art has at least one merit denied to many more famous and more striking—it does help to explain things. We are all familiar with pictures that interest us and excite our admiration, but do not move us as works of art. To this class belongs what I call "Descriptive Painting"—that is, painting in which forms are used not as objects of emotion, but as means of suggesting emotion or conveying information. Portraits of psychological and historical value, topographical works, pictures that tell stories and suggest situations, illustrations of all sorts, belong to this class. That we all recognize the distinction is clear, for who has not said that such and such a drawing was excellent as illustration, but as a work of art worthless? Of course many descriptive pictures possess, amongst other qualities, formal significance, and are therefore works of art: but many more do not. They interest us; they may move us too in a hundred different ways, but they do not move us aesthetically. According to my hypothesis they are not works of art. They leave untouched our aesthetic emotions because it is not their forms but the ideas or information suggested or conveyed by their forms that affect us.

Few pictures are better known or liked than Frith's "Paddington Station"; certainly I should be the last to grudge it its popularity. Many a weary forty minutes have I whiled away disentangling its fascinating incidents and forging for each an imaginary past and an improbable future. But certain though it is that Frith's masterpiece, or engravings of it, have provided thousands with half-hours of curious and fanciful pleasure, it is not less certain that no one has experienced before it one half-second of aesthetic rapture—and this although the picture contains several pretty passages of colour, and is by no means badly painted. "Paddington Station" is not a work of art; it is an interesting and amusing document. In it line and colour are used to recount anecdotes, suggest ideas, and indicate the manners and customs of an age: they are not used to provoke aesthetic emotion. Forms and the relations of forms were

for Frith not objects of emotion, but means of suggesting emotion and conveying ideas.

The ideas and information conveyed by "Paddington Station" are so amusing and so well presented that the picture has considerable value and is well worth preserving. But, with the perfection of photographic processes and of the cinematograph, pictures of this sort are becoming otiose. Who doubts that one of those *Daily Mirror* photographers in collaboration with a *Daily Mail* reporter can tell us far more about "London day by day" than any Royal Academician? For an account of manners and fashions we shall go, in future, to photographs, supported by a little bright journalism, rather than to descriptive painting. Had the imperial academicians of Nero, instead of manufacturing incredibly loathsome imitations of the antique, recorded in fresco and mosaic the manners and fashions of their day, their stuff, though artistic rubbish, would now be an historical gold-mine. If only they had been Friths instead of being Alma Tademas! But photography has made impossible any such transmutation of modern rubbish. Therefore it must be confessed that pictures in the Frith tradition are grown superfluous; they merely waste the hours of able men who might be more profitably employed in works of a wider beneficence. Still, they are not unpleasant, which is more than can be said for that kind of descriptive painting of which "The Doctor" is the most flagrant example. Of course "The Doctor" is not a work of art. In it form is not used as an object of emotion, but as a means of suggesting emotions. This alone suffices to make it nugatory; it is worse than nugatory because the emotion it suggests is false. What it suggests is not pity and admiration but a sense of complacency in our own pitifulness and generosity. It is sentimental. Art is above morals, or, rather, all art is moral because, as I hope to show presently, works of art are immediate means to good. Once we have judged a thing a work of art, we have judged it ethically of the first importance and put it beyond the reach of the moralist. But descriptive pictures which are not works of art, and, therefore, are not necessarily means to good states of mind, are proper objects of the ethical philosopher's attention. Not being a work of art, "The Doctor" has none of the immense ethical value possessed by all objects that provoke aesthetic ecstasy; and the state of mind to which it is a means, as illustration, appears to me undesirable.

The works of those enterprising young men, the Italian Futurists, are notable examples of descriptive painting. Like the Royal Academicians, they use form, not to provoke aesthetic emotions, but to convey information and ideas. Indeed, the published theories of the Futurists prove that their pictures ought to have nothing whatever to do with art. Their social and political theories are respectable, but I would suggest to young Italian painters that it is possible to become a Futurist in thought and action and yet remain an artist, if one has the luck to be born one. To associate art with politics is always a mistake. Futurist pictures are descriptive because they aim at presenting in line and colour the chaos of the mind at a particular moment; their forms are not intended to promote aesthetic emotion but to convey information. These forms, by the way, whatever may be the nature of the ideas they suggest, are themselves anything but revolutionary. In such Futurist pictures as I have seen—perhaps I should except some by Severini—the drawing, whenever it becomes representative as it frequently does, is found to be in that soft and

common convention brought into fashion by Besnard some thirty years ago, and much affected by Beaux-Art students ever since. As works of art, the Futurist pictures are negligible; but they are not to be judged as works of art. A good Futurist picture would succeed as a good piece of psychology succeeds; it would reveal, through line and colour, the complexities of an interesting state of mind. If Futurist pictures seem to fail, we must seek an explanation, not in a lack of artistic qualities that they never were intended to possess, but rather in the minds the states of which they are intended to reveal.

Most people who care much about art find that of the work that moves them most the greater part is what scholars call "Primitive." Of course there are bad primitives. For instance, I remember going, full of enthusiasm, to see one of the earliest Romanesque churches in Poitiers (Notre-Dame-la-Grande), and finding it as ill-proportioned, over-decorated, coarse, fat and heavy as any better class building by one of those highly civilised architects who flourished a thousand years earlier or eight hundred later. But such exceptions are rare. As a rule primitive art is good—and here again my hypothesis is helpful—for, as a rule, it is also free from descriptive qualities. In primitive art you will find no accurate representation; you will find only significant form. Yet no other art moves us so profoundly. Whether we consider Sumerian sculpture or pre-dynastic Egyptian art, or archaic Greek, or the Wei and T'ang masterpieces,[1] or those early Japanese works of which I had the luck to see a few superb examples (especially two wooden Bodhisattvas) at the Shepherd's Bush Exhibition in 1910, or whether, coming nearer home, we consider the primitive Byzantine art of the sixth century and its primitive developments amongst the Western barbarians, or, turning far afield, we consider that mysterious and majestic art that flourished in Central and South America before the coming of the white men, in every case we observe three common characteristics— absence of representation, absence of technical swagger, sublimely impressive form. Nor is it hard to discover the connection between these three. Formal significance loses itself in preoccupation with exact representation and ostentatious cunning.[2]

[1]The existence of the Ku K'ai-chih makes it clear that the art of this period (fifth to eighth centuries), was a typical primitive movement. To call the great vital art of the Liang, Chen, Wei, and Tang dynasties a development out of the exquisitely refined and exhausted art of the Han decadence—from which Ku K'ai-chih is a delicate straggler—is to call Romanesque sculpture a development out of Praxiteles. Between the two something has happened to refill the stream of art. What had happened in China was the spiritual and emotional revolution that followed the onset of Buddhism.

[2]This is not to say that exact representation is bad in itself. It is indifferent. A perfectly represented form may be significant, only it is fatal to sacrifice significance to representation. The quarrel between significance and illusion seems to be as old as art itself, and I have little doubt that what makes most palaeolithic art so bad is a preoccupation with exact representation. Evidently palaeolithic draughtsmen had no sense of the significance of form. Their art resembles that of the more capable and sincere Royal Academicians: it is a little higher than that of Sir Edward Poynter and a little lower than that of the late Lord Leighton. That this is no paradox let the cave-drawings of Altamira, or such works as the sketches of horses found at Bruniquel and now in the British Museum, bear witness. If the ivory head of a girl from the Grotte du Pape, Brassempouy (*Musée St. Germain*) and the ivory torso found at the same place (*Collection St. Cric*), be, indeed, palaeolithic, then there were good palaeolithic artists who created and did not imitate form. Neolithic art is, of course, a very different matter.

Naturally, it is said that if there is little representation and less saltim-
bancery in primitive art, that is because the primitives were unable to catch a
likeness or cut intellectual capers. The contention is beside the point. There is
truth in it, no doubt, though, were I a critic whose reputation depended on a
power of impressing the public with a semblance of knowledge, I should be
more cautious about urging it than such people generally are. For to suppose
that the Byzantine masters wanted skill, or could not have created an illusion
had they wished to do so, seems to imply ignorance of the amazingly dexter-
ous realism of the notoriously bad works of that age. Very often, I fear, the
misrepresentation of the primitives must be attributed to what the critics call,
"willful distortion." Be that as it may, the point is that, either from want of
skill or want of will, primitives neither create illusions, nor make display of
extravagant accomplishment, but concentrate their energies on the one thing
needful—the creation of form. Thus have they created the finest works of art
that we possess.

Let no one imagine that representation is bad in itself; a realistic form may
be as significant, in its place as part of the design, as an abstract. But if a rep-
resentative form has value, it is as form, not as representation. The represen-
tative element in a work of art may or may not be harmful; always it is irrel-
evant. For, to appreciate a work of art we need bring with us nothing from
life, no knowledge of its ideas and affairs, no familiarity with its emotions. Art
transports us from the world of man's activity to a world of aesthetic exalta-
tion. For a moment we are shut off from human interests; our anticipations
and memories are arrested; we are lifted above the stream of life. The pure
mathematician rapt in his studies knows a state of mind which I take to be
similar, if not identical. He feels an emotion for his speculations which arises
from no perceived relation between them and the lives of men, but springs,
inhuman or super-human, from the heart of an abstract science. I wonder,
sometimes, whether the appreciators of art and of mathematical solutions are
not even more closely allied. Before we feel an aesthetic emotion for a combi-
nation of forms, do we not perceive intellectually the rightness and necessity
of the combination? If we do, it would explain the fact that passing rapidly
through a room we recognise a picture to be good, although we cannot say
that it has provoked much emotion. We seem to have recognised intellectually
the rightness of its forms without staying to fix our attention, and collect, as
it were, their emotional significance. If this were so, it would be permissible
to inquire whether it was the forms themselves or our perception of their right-
ness and necessity that caused aesthetic emotion. But I do not think I need
linger to discuss the matter here. I have been inquiring why certain combina-
tions of forms move us; I should not have travelled by other roads had I
enquired, instead, why certain combinations are perceived to be right and nec-
essary, and why our perception of their rightness and necessity is moving.
What I have to say is this: the rapt philosopher, and he who contemplates a
work of art, inhabit a world with an intense and peculiar significance of its
own; that significance is unrelated to the significance of life. In this world the
emotions of life find no place. It is a world with emotions of its own.

To appreciate a work of art we need bring with us nothing but a sense of
form and colour and a knowledge of three-dimensional space. That bit of

knowledge, I admit, is essential to the appreciation of many great works, since many of the most moving forms ever created are in three dimensions. To see a cube or a rhomboid as a flat pattern is to lower its significance, and a sense of three-dimensional space is essential to the full appreciation of most architectural forms. Pictures which would be insignificant if we saw them as flat patterns are profoundly moving because, in fact, we see them as related planes. If the representation of three-dimensional space is to be called "representation," then I agree that there is one kind of representation which is not irrelevant. Also, I agree that along with our feeling for line and colour we must bring with us our knowledge of space if we are to make the most of every kind of form. Nevertheless, there are magnificent designs to an appreciation of which this knowledge is not necessary: so, though it is not irrelevant to the appreciation of some works of art it is not essential to the appreciation of all. What we must say is that the representation of three-dimensional space is neither irrelevant nor essential to all art, and that every other sort of representation is irrelevant.

That there is an irrelevant representative or descriptive element in many great works of art is not in the least surprising. Why it is not surprising I shall try to show elsewhere. Representation is not of necessity baneful, and highly realistic forms may be extremely significant. Very often, however, representation is a sign of weakness in an artist. A painter too feeble to create forms that provoke more than a little aesthetic emotion will try to eke that little out by suggesting the emotions of life. To evoke the emotions of life he must use representation. Thus a man will paint an execution, and, fearing to miss with his first barrel of significant form, will try to hit with his second by raising an emotion of fear or pity. But if in the artist an inclination to play upon the emotions of life is often the sign of a flickering inspiration, in the spectator a tendency to seek, behind form, the emotions of life is a sign of defective sensibility always. It means that his aesthetic emotions are weak or, at any rate, imperfect. Before a work of art people who feel little or no emotion for pure form find themselves at a loss. They are deaf men at a concert. They know that they are in the presence of something great, but they lack the power of apprehending it. They know that they ought to feel for it a tremendous emotion, but it happens that the particular kind of emotion it can raise is one that they can feel hardly or not at all. And so they read into the forms of the work those facts and ideas for which they are capable of feeling emotion, and feel for them the emotions that they can feel—the ordinary emotions of life. When confronted by a picture, instinctively they refer back its forms to the world from which they came. They treat created form as though it were imitated form, a picture as though it were a photograph. Instead of going out on the stream of art into a new world of aesthetic experience, they turn a sharp corner and come straight home to the world of human interests. For them the significance of a work of art depends on what they bring to it; no new thing is added to their lives, only the old material is stirred. A good work of visual art carries a person who is capable of appreciating it out of life into ecstasy: to use art as a means to the emotions of life is to use a telescope for reading the news. You will notice that people who cannot feel pure aesthetic emotions remember pictures by their subjects; whereas people who can, as often as not, have no idea

what the subject of a picture is. They have never noticed the representative element, and so when they discuss pictures they talk about the shapes of forms and the relations and quantities of colours. Often they can tell by the quality of a single line whether or no a man is a good artist. They are concerned only with lines and colours, their relations and quantities and qualities; but from these they win an emotion more profound and far more sublime than any that can be given by the description of facts and ideas.

This last sentence has a very confident ring—over-confident, some may think. Perhaps I shall be able to justify it, and make my meaning clearer too, if I give an account of my own feelings about music. I am not really musical. I do not understand music well. I find musical form exceedingly difficult to apprehend, and I am sure that the profounder subtleties of harmony and rhythm more often than not escape me. The form of a musical composition must be simple indeed if I am to grasp it honestly. My opinion about music is not worth having. Yet, sometimes, at a concert, though my appreciation of the music is limited and humble, it is pure. Sometimes, though I have a poor understanding, I have a clean palate. Consequently, when I am feeling bright and clear and intent, at the beginning of a concert for instance, when something that I can grasp is being played, I get from music that pure aesthetic emotion that I get from visual art. It is less intense, and the rapture is evanescent; I understand music too ill for music to transport me far into the world of pure aesthetic ecstasy. But at moments I do appreciate music as pure musical form, as sounds combined according to the laws of a mysterious necessity, as pure art with a tremendous significance of its own and no relation whatever to the significance of life; and in those moments I lose myself in that infinitely sublime state of mind to which pure visual form transports me. How inferior is my normal state of mind at a concert. Tired or perplexed, I let slip my sense of form, my aesthetic emotion collapses, and I begin weaving into the harmonies, that I cannot grasp, the ideas of life. Incapable of feeling the austere emotions of art, I begin to read into the musical forms human emotions of terror and mystery, love and hate, and spend the minutes, pleasantly enough, in a world of turbid and inferior feeling. At such times, were the grossest pieces of onomatopoeic representation—the song of a bird, the galloping of horses, the cries of children, or the laughing of demons—to be introduced into the symphony, I should not be offended. Very likely I should be pleased; they would afford new points of departure for new trains of romantic feeling or heroic thought. I know very well what has happened. I have been using art as a means to the emotions of life and reading into it the ideas of life. I have been cutting blocks with a razor. I have tumbled from the superb peaks of aesthetic exaltation to the snug foothills of warm humanity. It is a jolly country. No one need be ashamed of enjoying himself there. Only no one who has ever been on the heights can help feeling a little crestfallen in the cosy valleys. And let no one imagine, because he has made merry in the warm tilth and quaint nooks of romance, that he can even guess at the austere and thrilling raptures of those who have climbed the cold, white peaks of art.

About music most people are as willing to be humble as I am. If they cannot grasp musical form and win from it a pure aesthetic emotion, they confess that they understand music imperfectly or not at all. They recognise quite

clearly that there is a difference between the feeling of the musician for pure music and that of the cheerful concertgoer for what music suggests. The latter enjoys his own emotions, as he has every right to do, and recognises their inferiority. Unfortunately, people are apt to be less modest about their powers of appreciating visual art. Everyone is inclined to believe that out of pictures, at any rate, he can get all that there is to be got; everyone is ready to cry "humbug" and "impostor" at those who say that more can be had. The good faith of people who feel pure aesthetic emotions is called in question by those who have never felt anything of the sort. It is the prevalence of the representative element, I suppose, that makes the man in the street so sure that he knows a good picture when he sees one. For I have noticed that in matters of architecture, pottery, textiles, &c., ignorance and ineptitude are more willing to defer to the opinions of those who have been blest with peculiar sensibility. It is a pity that cultivated and intelligent men and women cannot be induced to believe that a great gift of aesthetic appreciation is at least as rare in visual as in musical art. A comparison of my own experience in both has enabled me to discriminate very clearly between pure and impure appreciation. Is it too much to ask that others should be as honest about their feelings for pictures as I have been about mine for music? For I am certain that most of those who visit galleries do feel very much what I feel at concerts. They have their moments of pure ecstasy; but the moments are short and unsure. Soon they fall back into the world of human interests and feel emotions, good no doubt, but inferior. I do not dream of saying that what they get from art is bad or nugatory; I say that they do not get the best that art can give. I do not say that they cannot understand art; rather I say that they cannot understand the state of mind of those who understand it best. I do not say that art means nothing or little to them; I say they miss its full significance. I do not suggest for one moment that their appreciation of art is a thing to be ashamed of; the majority of the charming and intelligent people with whom I am acquainted appreciate visual art impurely; and, by the way, the appreciation of almost all great writers has been impure. But provided that there be some fraction of pure aesthetic emotion, even a mixed and minor appreciation of art is, I am sure, one of the most valuable things in the world—so valuable, indeed, that in my giddier moments I have been tempted to believe that art might prove the world's salvation.

Yet, though the echoes and shadows of art enrich the life of the plains, her spirit dwells on the mountains. To him who woos, but woos impurely, she returns enriched what is brought. Like the sun, she warms the good seed in good soil and causes it to bring forth good fruit. But only to the perfect lover does she give a new strange gift—a gift beyond all price. Imperfect lovers bring to art and take away the ideas and emotions of their own age and civilisation. In twelfth-century Europe a man might have been greatly moved by a Romanesque church and found nothing in a T'ang picture. To a man of a later age, Greek sculpture meant much and Mexican nothing, for only to the former could he bring a crowd of associated ideas to be the objects of familiar emotions. But the perfect lover, he who can feel the profound significance of form, is raised above the accidents of time and place. To him the problems of archaeology, history, and hagiography are impertinent. If the forms of a work are

significant its provenance is irrelevant. Before the grandeur of those Sumerian figures in the Louvre he is carried on the same flood of emotion to the same aesthetic ecstasy as, more than four thousand years ago, the Chaldean lover was carried. It is the mark of great art that its appeal is universal and eternal.[3] Significant form stands charged with the power to provoke aesthetic emotion in anyone capable of feeling it. The ideas of men go buzz and die like gnats; men change their institutions and their customs as they change their coats; the intellectual triumphs of one age are the follies of another; only great art remains stable and unobscure. Great art remains stable and unobscure because the feelings that it awakens are independent of time and place, because its kingdom is not of this world. To those who have and hold a sense of the significance of form what does it matter whether the forms that move them were created in Paris the day before yesterday or in Babylon fifty centuries ago? The forms of art are inexhaustible; but all lead by the same road of aesthetic emotion to the same world of aesthetic ecstasy.

READING 10

INTRODUCTION

Clement Greenberg has been one of the most influential art critics in postwar America, and "Modernist Painting" (1960) is one of his most famous essays. In it, Greenberg declares that "the unique and proper area of competence of each art coincide[s] with all that [is] unique in the nature of its medium." Considerations about the formal properties of any given artistic medium, such as painting, determine the possibilities available to an artist working in that medium. Greenberg argues that modernist art developed as art obsessed with its own arthood—i.e., with its own limiting conditions and hence with its autonomy. Rather than attempting to transcend the limits of flatness, for example, modernist painting draws attention to those limits; it *shows* that those limits are of the essence of painting by making them the essence of particular paintings. Greenberg suggests that

[3]Mr. Roger Fry permits me to make use of an interesting story that will illustrate my view. When Mr. Okakura, the Government editor of *The Temple Treasures of Japan*, first came to Europe, he found no difficulty in appreciating the pictures of those who from want of will or want of skill did not create illusions but concentrated their energies on the creation of form. He understood immediately the Byzantine masters and the French and Italian Primitives. In the Renaissance painters, on the other hand, with their descriptive preoccupations, their literary and anecdotic interests, he could see nothing but vulgarity and muddle. The universal and essential quality of art, significant form, was missing, or rather had dwindled to a shallow stream, overlaid and hidden beneath weeds, so the universal response, aesthetic emotion, was not evoked. It was not till he came on to Henri-Matisse that he again found himself in the familiar world of pure art. Similarly, sensitive Europeans who respond immediately to the significant forms of great Oriental art, are left cold by the trivial pieces of anecdote and social criticism so lovingly cherished by Chinese dilettanti. It would be easy to multiply instances did not decency forbid the labouring of so obvious a truth.

one effect of modernist art is to show that we have often valued premodernist art for the wrong reasons. Although the Old Masters are indeed great art, their greatness lies not in their representational qualities or their realism, but in their *formal* qualities, the qualities that are specific to the medium of painting itself. In effect, Greenberg suggests, modernist painting is painting that exemplifies the aesthetic theory of formalism, outlined by Clive Bell in the previous reading. Bell's insistence on the autonomy of art, on the irrelevance of pictorial content to the value of painting, his insistence that all true art is concerned with the exploration of form, finds support in (and indeed, as a matter of historical fact, lent support to) the development of modernist art. Greenberg's description of the modernist program helps us to understand why that is.

"Modernist Painting"

Clement Greenberg

Modernism includes more than just art and literature. By now it includes almost the whole of what is truly alive in our culture. It happens, also, to be very much of a historical novelty. Western civilization is not the first to turn around and question its own foundations, but it is the civilization that has gone furthest in doing so. I identify Modernism with the intensification, almost the exacerbation of this self-critical tendency that began with the philosopher Kant. Because he was the first to criticize the means itself of criticism, I conceive of Kant as the first real Modernist.

The essence of Modernism lies, as I see it, in the use of the characteristic methods of a discipline to criticize the discipline itself—not in order to subvert it, but to entrench it more firmly in its area of competence. Kant used logic to establish the limits of logic, and while he withdrew much from its old jurisdiction, logic was left in all the more secure possession of what remained to it.

The self-criticism of Modernism grows out of but is not the same thing as the criticism of the Enlightenment. The Enlightenment criticized from the outside, the way criticism in its more accepted sense does; Modernism criticizes from the inside, through the procedures themselves of that which is being criticized. It seems natural that this new kind of criticism should have appeared first in philosophy, which is critical by definition, but as the nineteenth century wore on it made itself felt in many other fields. A more rational justification had begun to be demanded of every formal social activity, and "Kantian" self-criticism was called on eventually to meet and interpret this demand in areas that lay far from philosophy.

We know what has happened to an activity like religion that has not been able to avail itself of "Kantian" immanent criticism in order to justify itself. At first glance the arts might seem to have been in a situation like religion's. Having been denied by the Enlightenment all tasks they could take seriously, they looked as though they were going to be assimilated to entertainment pure and simple, and entertainment itself looked as though it were going to be assimilated, like religion, to therapy. The arts could save themselves from this leveling down only by demonstrating that the kind of experience they provided was valuable in its own right and not to be obtained from any other kind of activity.

Each art, it turned out, had to effect this demonstration on its own account. What had to be exhibited and made explicit was that which was unique and irreducible not only in art in general, but also in each particular art. Each art had to determine, through the operations peculiar to itself, the effects peculiar and exclusive to itself. By doing this each art would, to be sure, narrow its area of competence, but at the same time it would make its possession of this area all the more secure.

It quickly emerged that the unique and proper area of competence of each art coincided with all that was unique to the nature of its medium. The task of self-criticism became to eliminate from the effects of each art any and every effect that might conceivably be borrowed from or by the medium of any other art. Thereby each art would be rendered "pure," and in its "purity" find the guarantee of its standards of quality as well as of its independence. "Purity" meant self-definition, and the enterprise of self-criticism in the arts became one of self-definition with a vengeance.

Realistic, illusionist art had dissembled the medium, using art to conceal art. Modernism used art to call attention to art. The limitations that constitute the medium of painting—the flat surface, the shape of the support, the properties of pigment—were treated by the Old Masters as negative factors that could be acknowledged only implicitly or indirectly. Modernist painting has come to regard these same limitations as positive factors that are to be acknowledged openly. Manet's paintings became the first Modernist ones by virtue of the frankness with which they declared the surfaces on which they were painted. The Impressionists, in Manet's wake, abjured underpainting and glazing, to leave the eye under no doubt as to the fact that the colors used were made of real paint that came from pots or tubes. Cézanne sacrificed verisimilitude, or correctness, in order to fit drawing and design more explicitly to the rectangular shape of the canvas.

It was the stressing, however, of the ineluctable flatness of the support that remained most fundamental in the process by which pictorial art criticized and defined itself under Modernism. Flatness alone was unique and exclusive to that art. The inclosing shape of the support was a limiting condition, or norm, that was shared with the art of the theater; color was a norm or means shared with sculpture as well as the theater. Flatness, two-dimensionality, was the only condition painting shared with no other art, and so Modernist painting oriented itself to flatness as it did to nothing else.

The Old Masters had sensed that it was necessary to preserve what is called the integrity of the picture plane; that is, to signify the enduring presence of flatness under the most vivid illusion of three-dimensional space. The apparent contradiction involved—the dialectical tension, to use a fashionable but apt phrase—was essential to the success of their art, as it is indeed to the success of all pictorial art. The Modernists have neither avoided nor resolved this contradiction; rather, they have reversed its terms. One is made aware of the flatness of their pictures before, instead of after, being made aware of what the flatness contains. Whereas one tends to see what is *in* an Old Master before seeing it as a picture, one sees a Modernist painting as a picture first. This is, of course, the best way of seeing any kind of picture, Old Master or Modernist, but Modernism imposes it as the only and necessary way, and Modernism's success in doing so is a success of self-criticism.

It is not in principle that Modernist painting in its latest phase has abandoned the representation of recognizable objects. What it has abandoned in principle is the representation of the kind of space that recognizable, three-dimensional objects can inhabit. Abstractness, or the nonfigurative, has in itself still not proved to be an altogether necessary moment in the self-criticism of pictorial art, even though artists as eminent as Kandinsky and Mondrian have thought so. Representation, or illustration, as such does not abate the uniqueness of pictorial art; what does do so are the associations of the things represented. All recognizable entities (including pictures themselves) exist in three-dimensional space, and the barest suggestion of a recognizable entity suffices to call up associations of that kind of space. The fragmentary silhouette of a human figure, or of a teacup, will do so, and by doing so alienate pictorial space from the two-dimensionality which is the guarantee of painting's independence as an art. Three-dimensionality is the province of sculpture, and for the sake of its own autonomy painting has had above all to divest itself of everything it might share with sculpture. And it is in the course of its effort to do this, and not so much—I repeat—to exclude the representational or the "literary," that painting has made itself abstract.

At the same time Modernist painting demonstrates precisely in its resistance to the sculptural, that it continues tradition and the themes of tradition, despite all appearances to the contrary. For the resistance to the sculptural begins long before the advent of Modernism. Western painting, insofar as it strives for realistic illusion, owes an enormous debt to sculpture, which taught it in the beginning how to shade and model towards an illusion of relief, and even how to dispose that illusion in a complementary illusion of deep space. Yet some of the greatest feats of Western painting came as part of the effort it has made in the last four centuries to suppress and dispel the sculptural. Starting in Venice in the sixteenth century and continuing in Spain, Belgium, and Holland in the seventeenth, that effort was carried on at first in the name of color. When David, in the eighteenth century, sought to revive sculptural painting, it was in part to save pictorial art from the decorative flattening-out that the emphasis on color seemed to induce. Nevertheless, the strength of David's own best pictures (which are predominantly portraits) often lies as much in their color as in anything else. And Ingres, his pupil, though subordinating color far more consistently, executed pictures that were among the flattest, least sculptural done in the West by a sophisticated artist since the fourteenth century. Thus by the middle of the nineteenth century all ambitious tendencies in painting were converging (beneath their differences) in an antisculptural direction.

Modernism, in continuing this direction, made it more conscious of itself. With Manet and the Impressionists, the question ceased to be defined as one of color versus drawing, and became instead a question of purely optical experience as against optical experience modified or revised by tactile associations. It was in the name of the purely and literally optical, not in that of color, that the Impressionists set themselves to undermining shading and modeling and everything else that seemed to connote the sculptural. And in a way like that in which David had reacted against Fragonard in the name of the sculptural, Cézanne, and the Cubists after him, reacted against Impressionism. But once again, just as David's and Ingres' reaction had culminated in a kind of paint-

ing even less sculptural than before, so the Cubist counter-revolution eventuated in a kind of painting flatter than anything Western art had seen since before Cimabue—so flat indeed that it could hardly contain recognizable images.

In the meantime the other cardinal norms of the art of painting were undergoing an equally searching inquiry, though the results may not have been equally conspicuous. It would take me more space than is at my disposal to tell how the norm of the picture's inclosing shape or frame was loosened, then tightened, then loosened once again, and then isolated and tightened once more by successive generations of Modernist painters; or how the norms of finish, of paint texture, and of value and color contrast, were tested and retested. Risks have been taken with all these, not only for the sake of new expression, but also in order to exhibit them more clearly as norms. By being exhibited and made explicit they are tested for their indispensability. This testing is by no means finished, and the fact that it becomes more searching as it proceeds accounts for the radical simplifications, as well as radical complications, in which the very latest abstract art abounds.

Neither the simplifications nor the complications are matters of license. On the contrary, the more closely and essentially the norms of a discipline become defined the less apt they are to permit liberties (*liberation* has become a much abused word in connection with avant-garde and Modernist art). The essential norms or conventions of painting are also the limiting conditions with which a marked-up surface must comply in order to be experienced as a picture. Modernism has found that the further back these limits are pushed the more explicitly they have to be observed. The intersecting black lines and colored rectangles of a Mondrian may seem hardly enough to make a picture out of, yet by echoing the picture's inclosing shape so self-evidently they impose that shape as a regulating norm with a new force and new completeness. Far from incurring the danger of arbitrariness in the absence of a model in nature, Mondrian's art proves, with the passing of time, almost too disciplined, too convention-bound in certain respects; once we have gotten used to its utter abstractness we realize that it is more traditional in its color, as well as in its subservience to the frame, than the last paintings of Monet are.

It is understood, I hope, that in plotting the rationale of Modernist art I have had to simplify and exaggerate. The flatness towards which Modernist painting orients itself can never be an utter flatness. The heightened sensitivity of the picture plane may no longer permit sculptural illusion, or *trompe-l'oeil*, but it does and must permit optical illusion. The first mark made on a surface destroys its virtual flatness, and the configurations of a Mondrian still suggest a kind of illusion of a kind of third dimension. Only now it is a strictly pictorial, strictly optical third dimension. Where the Old Masters created an illusion of space into which one could imagine oneself walking, the illusion created by a Modernist is one into which one can only look, can travel through only with the eye.

One begins to realize that the Neo-Impressionists were not altogether misguided when they flirted with science. Kantian self-criticism finds its perfect expression in science rather than in philosophy, and when this kind of self-criticism was applied in art the latter was brought closer in spirit to scientific

method than ever before—closer than in the early Renaissance. That visual art should confine itself exclusively to what is given in visual experience, and make no reference to anything given in other orders of experience, is a notion whose only justification lies, notionally, in scientific consistency. Scientific method alone asks that a situation be resolved in exactly the same kind of terms as that in which it is presented—a problem in physiology is solved in terms of physiology, not in those of psychology; to be solved in terms of psychology, it has to be presented in, or translated into, these terms first. Analogously, Modernist painting asks that a literary theme be translated into strictly optical, two-dimensional terms before becoming the subject of pictorial art— which means its being translated in such a way that it entirely loses its literary character. Actually, such consistency promises nothing in the way of esthetic quality or esthetic results, and the fact that the best art of the past seventy or eighty years increasingly approaches such consistency does not change this; now as before, the only consistency that counts in art is esthetic consistency, which shows itself only in results and never in methods or means. From the point of view of art itself its convergence of spirit with science happens to be a mere accident, and neither art nor science gives or assures the other of anything more than it ever did. What their convergence does show, however, is the degree to which Modernist art belongs to the same historical and cultural tendency as modern science.

It should also be understood that the self-criticism of Modernist art has never been carried on in any but a spontaneous and subliminal way. It has been altogether a question of practice, immanent to practice and never a topic of theory. Much has been heard about programs in connection with Modernist art, but there has really been far less of the programmatic in Modernist art than in Renaissance or Academic art. With a few untypical exceptions, the masters of Modernism have betrayed no more of an appetite for fixed ideas about art than Corot did. Certain inclinations and emphases, certain refusals and abstinences seem to become necessary simply because the way to stronger, more expressive art seems to lie through them. The immediate aims of Modernist artists remain individual before anything else, and the truth and success of their work is individual before it is anything else. To the extent that it succeeds as art Modernist art partakes in no way of the character of a demonstration. It has needed the accumulation over decades of a good deal of individual achievement to reveal the self-critical tendency of Modernist painting. No one artist was, or is yet, consciously aware of this tendency, nor could any artist work successfully in conscious awareness of it. To this extent—which is by far the largest—art gets carried on under Modernism in the same way as before.

And I cannot insist enough that Modernism has never meant anything like a break with the past. It may mean a devolution, an unraveling of anterior tradition, but it also means its continuation. Modernist art develops out of the past without gap or break, and wherever it ends up it will never stop being intelligible in terms of the continuity of art. The making of pictures has been governed, since pictures first began to be made, by all the norms I have mentioned. The Paleolithic painter or engraver could disregard the norm of the frame and treat the surface in both a literally and a virtually sculptural way because he made images rather than pictures, and worked on a support whose

limits could be disregarded because (except in the case of small objects like a bone or horn) nature gave them to the artist in an unmanageable way. But the making of pictures, as against images in the flat, means the deliberate choice and creation of limits. This deliberateness is what Modernism harps on: that is, spells out the fact that the limiting conditions of art have to be made altogether human limits.

I repeat that Modernist art does not offer theoretical demonstrations. It could be said, rather, that it converts all theoretical possibilities into empirical ones, and in doing so tests, inadvertently, all theories about art for their relevance to the actual practice and experience of art. Modernism is subversive in this respect alone. Ever so many factors thought to be essential to the making and experiencing of art have been shown not to be so by the fact that Modernist art has been able to dispense with them and yet continue to provide the experience of art in all its essentials. That this "demonstration" has left most of our old *value* judgments intact only makes it the more conclusive. Modernism may have had something to do with the revival of the reputations of Uccello, Piero, El Greco, Georges de la Tour, and even Vermeer, and it certainly confirmed if it did not start other revivals like that of Giotto; but Modernism has not lowered thereby the standing of Leonardo, Raphael, Titian, Rubens, Rembrandt or Watteau. What Modernism has made clear is that, though the past did appreciate masters like these justly, it often gave wrong or irrelevant reasons for doing so.

Still, in some ways this situation has hardly changed. Art criticism lags behind Modernist as it lagged behind pre-Modernist art. Most of the things that get written about contemporary art belong to journalism rather than criticism properly speaking. It belongs to journalism—and to the millennial complex from which so many journalists suffer in our day—that each new phase of Modernism should be hailed as the start of a whole new epoch of art making a decisive break with all the customs and conventions of the past. Each time, a kind of art is expected that will be unlike previous kinds of art, and so "liberated" from norms of practice or taste, that everybody, regardless of how informed or uninformed, will be able to have his say about it. And each time, this expectation is disappointed, as the phase of Modernism in question takes its place, finally, in the intelligible continuity of taste and tradition, and as it becomes clear that the same demands as before are made on artist and spectator.

Nothing could be further from the authentic art of our times than the idea of a rupture of continuity. Art is, among many other things, continuity. Without the past of art, and without the need and compulsion to maintain past standards of excellence, such a thing as Modernist art would be impossible.

POSTSCRIPT

The above appeared first in 1960 as a pamphlet in a series published by the Voice of America. It had been broadcast over that agency's radio in the spring of the same year. With some minor verbal changes it was reprinted in the spring 1963 number of *Art & Literature* in Paris, and then in Gregory Battcock's

anthology *The New Art* (1966), where its date of publication in *Art & Literature* was erroneously given as 1965.

I want to take this chance to correct another error, one of interpretation and not of fact. Many readers, though by no means all, seem to have taken the "rationale" of Modernist art outlined here as representing a position adopted by the writer himself: that is, that what he describes he also advocates. This may be a fault of the writing or the rhetoric. Nevertheless, a close reading of what he writes will find nothing at all to indicate that he subscribes to, believes in, the things that he adumbrates. (The quotation marks around *pure* and *purity* should have been enough to show that.) The writer is trying to account in part for how most of the very best art of the last hundred-odd years came about, but he's not implying that that's how it *had* to come about, much less that that's how the best art still has to come about. "Pure" art was a useful illusion, but this doesn't make it any the less an illusion. Nor does the possibility of its continuing usefulness make it any the less an illusion.

There have been some further constructions of what I wrote that go over into preposterousness: That I regard flatness and the inclosing of flatness not just as the limiting conditions of pictorial art, but as criteria of esthetic quality in pictorial art; that the further a work advances the self-definition of an art, the better that work is bound to be. The philosopher or art historian who can envision me—or anyone at all—arriving at esthetic judgments in this way reads shockingly more into himself or herself than into my article.

R E A D I N G 1 1

INTRODUCTION

R. G. Collingwood was born in 1889, spent most of his life in Oxford, and died of a brain tumor in 1943. Toward the end of his life, he wrote important books on the philosophies of nature and history and on metaphysics, as well as an oddly strident autobiography. But perhaps his most significant book was *The Principles of Art* (1938). Drawing some of his inspiration from the work of the Italian aesthetician Benedetto Croce, Collingwood develops an "expression theory" of art which is the most interesting such theory since Tolstoy's (*see* Section 4). Proceeding by way of a set of fascinating distinctions between the concept of art and the concept of craft, Collingwood elaborates the view that the purpose, and the distinctive feature, of art is the expression of emotion. Collingwood has many insights to offer on the nature and the process of expression, and on the nature of emotional experience, which later theorists have ignored at their peril. But a separate strand in Collingwood's thought leads him to the problematic view that the work of art itself is really an idea in the artist's head, of which a particular painting or novel, for instance, is only the outward manifestation. This is the so-called "ideal theory" of art; and this theory has sometimes distracted attention from the genuine achievements of Collingwood's aesthetics. The "ideal theory" is unsustainable for any

number of reasons, but Collingwood's expression theory does not depend upon it (in fact, it contradicts it); and it is for his expression theory that Collingwood remains an imposing figure in the philosophy of art. Anyone who has ever been moved by a work of art will recognize at once the power of Collingwood's account.

From *The Principles of Art*

R. G. Collingwood

INTRODUCTION

§1. *The Two Conditions of an Aesthetic Theory*

The business of this book is to answer the question: What is art?

A question of this kind has to be answered in two stages. First, we must make sure that the key word (in this case 'art') is a word which we know how to apply where it ought to be applied and refuse where it ought to be refused. It would not be much use beginning to argue about the correct definition of a general term whose instances we could not recognize when we saw them. Our first business, then, is to bring ourselves into a position in which we can say with confidence 'this and this and this are art; that and that and that are not art'.

This would be hardly worth insisting upon, but for two facts: that the word 'art' is a word in common use, and that it is used equivocally. If it had not been a word in common use, we could have decided for ourselves when to apply it and when to refuse it. But the problem we are concerned with is not one that can be approached in that way. It is one of those problems where what we want to do is to clarify and systematize ideas we already possess; consequently there is no point in using words according to a private rule of our own, we must use them in a way which fits on to common usage. This again would have been easy, but for the fact that common usage is ambiguous. The word 'art' means several different things; and we have to decide which of these usages is the one that interests us. Moreover, the other usages must not be simply jettisoned as irrelevant. They are very important for our inquiry; partly because false theories are generated by failure to distinguish them, so that in expounding one usage we must give a certain attention to others; partly because confusion between the various senses of the word may produce bad practice as well as bad theory. We must therefore review the improper senses of the word 'art' in a careful and systematic way; so that at the end of it we can say not only 'that and that and that are not art', but 'that is not art because it is pseudo-art of kind A; that, because it is pseudo-art of kind B; and that, because it is pseudo-art of kind C'.

Secondly, we must proceed to a definition of the term 'art'. This comes second, and not first, because no one can even try to define a term until he has settled in his own mind a definite usage of it: no one can define a term in common use until he has satisfied himself that his personal usage of it harmonizes with the common usage. Definition necessarily means defining one thing in

terms of something else; therefore, in order to define any given thing, one must have in one's head not only a clear idea of the thing to be defined, but an equally clear idea of all the other things by reference to which one defines it. People often go wrong over this. They think that in order to construct a definition or (what is the same thing) a 'theory' of something, it is enough to have a clear idea of that one thing. That is absurd. Having a clear idea of the thing enables them to recognize it when they see it, just as having a clear idea of a certain house enables them to recognize it when they are there; but defining the thing is like explaining where the house is or pointing out its position on the map; you must know its relations to other things as well, and if your ideas of these other things are vague, your definition will be worthless. . . .

ART AND CRAFT

§ 1. *The Meaning of Craft*

The first sense of the word 'art' to be distinguished from art proper is the obsolete sense in which it means what in this book I shall call craft. This is what *ars* means in ancient Latin, and what τέχνη means in Greek: the power to produce a preconceived result by means of consciously controlled and directed action. In order to take the first step towards a sound aesthetic, it is necessary to disentangle the notion of craft from that of art proper. In order to do this, again, we must first enumerate the chief characteristics of craft.

1. Craft always involves a distinction between means and end, each clearly conceived as something distinct from the other but related to it. The term 'means' is loosely applied to things that are used in order to reach the end, such as tools, machines, or fuel. Strictly, it applies not to the things but to the actions concerned with them: manipulating the tools, tending the machines, or burning the fuel. These actions (as implied by the literal sense of the word means) are passed through or traversed in order to reach the end, and are left behind when the end is reached. This may serve to distinguish the idea of means from two other ideas with which it is sometimes confused: that of part, and that of material. The relation of part to whole is like that of means to end, in that the part is indispensable to the whole, is what it is because of its relation to the whole, and may exist by itself before the whole comes into existence; but when the whole exists the part exists too, whereas, when the end exists, the means have ceased to exist. As for the idea of material, we shall return to that in (4) below.
2. It involves a distinction between planning and execution. The result to be obtained is preconceived or thought out before being arrived at. The craftsman knows what he wants to make before he makes it. This foreknowledge is absolutely indispensable to craft: if something, for example stainless steel, is made without such foreknowledge, the making of it is not a case of craft but an accident. Moreover, this foreknowledge is not vague but precise. If a person sets out to make a table, but conceives the table only vaguely, as somewhere between two by four feet and three by six, and between two and three feet high, and so forth, he is no craftsman.

3. Means and end are related in one way in the process of planning; in the opposite way in the process of execution. In planning the end is prior to the means. The end is thought out first, and afterwards the means are thought out. In execution the means come first, and the end is reached through them.
4. There is a distinction between raw material and finished product or artifact. A craft is always exercised upon something, and aims at the transformation of this into something different. That upon which it works begins as raw material and ends as finished product. The raw material is found ready made before the special work of the craft begins.
5. There is a distinction between form and matter. The matter is what is identical in the raw material and the finished product; the form is what is different, what the exercise of the craft changes. To describe the raw material as raw is not to imply that it is formless, but only that it has not yet the form which it is to acquire through 'transformation' into finished product.
6. There is a hierarchical relation between various crafts, one supplying what another needs, one using what another provides. There are three kinds of hierarchy: of materials, of means, and of parts.

 The raw material of one craft is the finished product of another. Thus the silviculturist propagates trees and looks after them as they grow, in order to provide raw material for the felling-men who transform them into logs; these are raw material for the saw-mill which transforms them into planks; and these, after a further process of selection and seasoning, become raw material for a joiner.

 In the hierarchy of means, one craft supplies another with tools. Thus the timber-merchant supplies pit-props to the miner; the miner supplies coal to the blacksmith; the blacksmith supplies horseshoes to the farmer; and so on.

 In the hierarchy of parts, a complex operation like the manufacture of a motor-car is parcelled out among a number of trades: one firm makes the engine, another the gears, another the chassis, another the tyres, another the electrical equipment, and so on; the final assembling is not strictly the manufacture of the car but only the bringing together of these parts. In one or more of these ways every craft has a hierarchical character; either as hierarchically related to other crafts, or as itself consisting of various heterogeneous operations hierarchically related among themselves.

Without claiming that these features together exhaust the notion of craft, or that each of them separately is peculiar to it, we may claim with tolerable confidence that where most of them are absent from a certain activity that activity is not a craft, and, if it is called by that name, is so called either by mistake or in a vague and inaccurate way.

§ 2. *The Technical Theory of Art*

It was the Greek philosophers who worked out the idea of craft, and it is in their writings that the above distinctions have been expounded once for all.

The philosophy of craft, in fact, was one of the greatest and most solid achievements of the Greek mind, or at any rate of that school, from Socrates to Aristotle, whose work happens to have been most completely preserved.

Great discoveries seem to their makers even greater than they are. A person who has solved one problem is inevitably led to apply that solution to others. Once the Socratic school had laid down the main lines of a theory of craft, they were bound to look for instances of craft in all sorts of likely and unlikely places. To show how they met this temptation, here yielding to it and there resisting it, or first yielding to it and then laboriously correcting their error, would need a long essay. Two brilliant cases of successful resistance may, however, be mentioned: Plato's demonstration (*Republic,* 330 D–336 A) that justice is not a craft, with the pendant (336 E–354 A) that injustice is not one either; and Aristotle's rejection (*Metaphysics,* Λ) of the view stated in Plato's *Timaeus,* that the relation between God and the world is a case of the relation between craftsman and artifact.

When they came to deal with aesthetic problems, however, both Plato and Aristotle yielded to the temptation. They took it for granted that poetry, the only art which they discussed in detail, was a kind of craft, and spoke of this craft as ποιητικὴ τέχνη, poet-craft. What kind of craft was this?

There are some crafts, like cobbling, carpentering, or weaving, whose end is to produce a certain type of artifact; others, like agriculture or stock-breeding or horse-breaking, whose end is to produce or improve certain non-human types of organism; others again, like medicine or education or warfare, whose end is to bring certain human beings into certain states of body or mind. But we need not ask which of these is the genus of which poet-craft is a species, because they are not mutually exclusive. The cobbler or carpenter or weaver is not simply trying to produce shoes or carts or cloth. He produces these because there is a demand for them; that is, they are not ends to him, but means to the end of satisfying a specific demand. What he is really aiming at is the production of a certain state of mind in his customers, the state of having these demands satisfied. The same analysis applies to the second group. Thus in the end these three kinds of craft reduce to one. They are all ways of bringing human beings into certain desired conditions.

The same description is true of poet-craft. The poet is a kind of skilled producer; he produces for consumers; and the effect of his skill is to bring about in them certain states of mind, which are conceived in advance as desirable states. The poet, like any other kind of craftsman, must know what effect he is aiming at, and must learn by experience and precept, which is only the imparted experience of others, how to produce it. This is poet-craft, as conceived by Plato and Aristotle and, following them, such writers as Horace in his *Ars Poetica.* There will be analogous crafts of painting, sculpture, and so forth; music, at least for Plato, is not a separate art but is a constituent part of poetry.

I have gone back to the ancients, because their thought, in this matter as in so many others, has left permanent traces on our own, both for good and for ill. There are suggestions in some of them, especially in Plato, of a quite different view; but this is the one which they have made familiar, and upon which both the theory and the practice of the arts has for the most part rested

down to the present time. Present-day fashions of thought have in some ways even tended to reinforce it. We are apt nowadays to think about most problems, including those of art, in terms either of economics or of psychology; and both ways of thinking tend to subsume the philosophy of art under the philosophy of craft. To the economist, art presents the appearance of a specialized group of industries; the artist is a producer, his audience consumers who pay him for benefits ultimately definable in terms of the states of mind which his productivity enables them to enjoy. To the psychologist, the audience consists of persons reacting in certain ways to stimuli provided by the artist; and the artist's business is to know what reactions are desired or desirable, and to provide the stimuli which will elicit them.

The technical theory of art is thus by no means a matter of merely antiquarian interest. It is actually the way in which most people nowadays think of art; and especially economists and psychologists, the people to whom we look (sometimes in vain) for special guidance in the problems of modern life.

But this theory is simply a vulgar error, as anybody can see who looks at it with a critical eye. It does not matter what kind of craft in particular is identified with art. It does not matter what the benefits are which the artist is regarded as conferring on his audience, or what the reactions are which he is supposed to elicit. Irrespectively of such details, our question is whether art is any kind of craft at all. It is easily answered by keeping in mind the half-dozen characteristics of craft enumerated in the preceding section, and asking whether they fit the case of art. And there must be no chopping of toes or squeezing of heels; the fit must be immediate and convincing. It is better to have no theory of art at all, than to have one which irks us from the first.

§ 3. Break-down of the Theory

1. The first characteristic of craft is the distinction between means and end. Is this present in works of art? According to the technical theory, yes. A poem is means to the production of a certain state of mind in the audience, as a horseshoe is means to the production of a certain state of mind in the man whose horse is shod. And the poem in its turn will be an end to which other things are means. In the case of the horseshoe, this stage of the analysis is easy: we can enumerate lighting the forge, cutting a piece of iron off a bar, heating it, and so on. What is there analogous to these processes in the case of a poem? The poet may get paper and pen, fill the pen, sit down and square his elbows; but these actions are preparatory not to composition (which may go on in the poet's head) but to writing. Suppose the poem is a short one, and composed without the use of any writing materials; what are the means by which the poet composes it? I can think of no answer, unless comic answers are wanted, such as 'using a rhyming dictionary', 'pounding his foot on the floor or wagging his head or hand to mark the metre', or 'getting drunk'. If one looks at the matter seriously, one sees that the only factors in the situation are the poet, the poetic labour of his mind, and the poem. And if any supporter of the technical theory says 'Right: then the poetic labour is the means, the poem the end', we shall ask him to find a blacksmith who can make a horseshoe by sheer labour, without forge, anvil, hammer, or tongs. It is because nothing

corresponding to these exists in the case of the poem that the poem is not an end to which there are means.

Conversely, is a poem means to the production of a certain state of mind in an audience? Suppose a poet had read his verses to an audience, hoping that they would produce a certain result; and suppose the result were different; would that in itself prove the poem a bad one? It is a difficult question; some would say yes, others no. But if poetry were obviously a craft, the answer would be a prompt and unhesitating yes. The advocate of the technical theory must do a good deal of toe-chopping before he can get his facts to fit his theory at this point.

So far, the prospects of the technical theory are not too bright. Let us proceed.

2. The distinction between planning and executing certainly exists in some works of art, namely those which are also works of craft or artifacts; for there is, of course, an overlap between these two things, as may be seen by the example of a building or a jar, which is made to order for the satisfaction of a specific demand, to serve a useful purpose, but may none the less be a work of art. But suppose a poet were making up verses as he walked; suddenly finding a line in his head, and then another, and then dissatisfied with them and altering them until he had got them to his liking: what is the plan which he is executing? He may have had a vague idea that if he went for a walk he would be able to compose poetry; but what were, so to speak, the measurements and specifications of the poem he planned to compose? He may, no doubt, have been hoping to compose a sonnet on a particular subject specified by the editor of a review; but the point is that he may not, and that he is none the less a poet for composing without having any definite plan in his head. Or suppose a sculptor were not making a Madonna and child, three feet high, in Hoptonwood stone, guaranteed to placate the chancellor of the diocese and obtain a faculty for placing it in the vacant niche over a certain church door; but were simply playing about with clay, and found the clay under his fingers turning into a little dancing man: is this not a work of art because it was done without being planned in advance?

All this is very familiar. There would be no need to insist upon it, but that the technical theory of art relies on our forgetting it. While we are thinking of it, let us note the importance of not over-emphasizing it. Art as such does not imply the distinction between planning and execution. But (a) this is a merely negative characteristic, not a positive one (we must not erect the absence of plan into a positive force and call it inspiration, or the unconscious, or the like) and (b) it is a permissible characteristic of art, not a compulsory one. If unplanned works of art are possible, it does not follow that no planned work is a work of art. That is the logical fallacy[1]

[1]It is an example of what I have elsewhere called the fallacy of precarious margins. Because art and craft overlap, the essence of art is sought not in the positive characteristics of all art, but in the characteristics of those works of art which are not works of craft. Thus the only things which are allowed to be works of art are those marginal examples which lie outside the overlap of art and craft. This is a precarious margin because further study may at any moment reveal the characteristics of craft in some of these examples. See *Essay on Philosophical Method*.

that underlies one, or some, of the various things called romanticism. It may very well be true that the only works of art which can be made altogether without a plan are trifling ones, and that the greatest and most serious ones always contain an element of planning and therefore an element of craft. But that would not justify the technical theory of art.

3. If neither means and end nor planning and execution can be distinguished in art proper, there obviously can be no reversal of order as between means and end, in planning and execution respectively.

4. We next come to the distinction between raw material and finished product. Does this exist in art proper? If so, a poem is made out of certain raw material. What is the raw material out of which Ben Jonson made *Queene and Huntresse, chaste, and faire?* Words, perhaps. Well, what words? A smith makes a horseshoe not out of all the iron there is, but out of a certain piece of iron, cut off a certain bar that he keeps in the corner of the smithy. If Ben Jonson did anything at all like that, he said: 'I want to make a nice little hymn to open Act v, Scene vi of *Cynthia's Revels.* Here is the English language, or as much of it as I know; I will use *thy* five times, *to* four times, *and, bright, excellently,* and *goddesse* three times each, and so on.' He did nothing like this. The words which occur in the poem were never before his mind as a whole in an order different from that of the poem, out of which he shuffled them till the poem, as we have it, appeared. I do not deny that by sorting out the words, or the vowel sounds, or the consonant sounds, in a poem like this, we can make interesting and (I believe) important discoveries about the way in which Ben Jonson's mind worked when he made the poem; and I am willing to allow that the technical theory of art is doing good service if it leads people to explore these matters; but if it can only express what it is trying to do by calling these words or sounds the materials out of which the poem is made, it is talking nonsense.

But perhaps there is a raw material of another kind: a feeling or emotion, for example, which is present to the poet's mind at the commencement of his labour, and which that labour converts into the poem. 'Aus meinem grossen Schmerzen mach' ich die kleinen Lieder', said Heine; and he was doubtless right; the poet's labour can be justly described as converting emotions into poems. But this conversion is a very different kind of thing from the conversion of iron into horseshoes. If the two kinds of conversion were the same, a blacksmith could make horseshoes out of his desire to pay the rent. The something more, over and above that desire, which he must have in order to make horseshoes out of it, is the iron which is their raw material. In the poet's case that something more does not exist.

5. In every work of art there is something which, in some sense of the word, may be called form. There is, to be rather more precise, something in the nature of rhythm, pattern, organization, design, or structure. But it does not follow that there is a distinction between form and matter. Where that distinction does exist, namely, in artifacts, the matter was there in the shape of raw material before the form was imposed upon it, and the form was there in the shape of a preconceived plan before being imposed upon the matter; and as the two coexist in the finished product we can see how the matter might have accepted a different form, or the form have been

imposed upon a different matter. None of these statements applies to a work of art. Something was no doubt there before a poem came into being; there was, for example, a confused excitement in the poet's mind; but, as we have seen, this was not the raw material of the poem. There was also, no doubt, the impulse to write; but this impulse was not the form of the unwritten poem. And when the poem is written, there is nothing in it of which we can say, 'this is a matter which might have taken on a different form', or 'this is a form which might have been realized in a different matter'.

When people have spoken of matter and form in connexion with art, or of that strange hybrid distinction, form and content, they have in fact been doing one of two things, or both confusedly at once. Either they have been assimilating a work of art to an artifact, and the artist's work to the craftsman's; or else they have been using these terms in a vaguely metaphorical way as means of referring to distinctions which really do exist in art, but are of a different kind. There is always in art a distinction between what is expressed and that which expresses it; there is a distinction between the initial impulse to write or paint or compose and the finished poem or picture or music; there is a distinction between an emotional element in the artist's experience and what may be called an intellectual element. All these deserve investigation; but none of them is a case of the distinction between form and matter.

6. Finally, there is in art nothing which resembles the hierarchy of crafts, each dictating ends to the one below it, and providing either means or raw materials or parts to the one above. When a poet writes verses for a musician to set, these verses are not means to the musician's end, for they are incorporated in the song which is the musician's finished product, and it is characteristic of means, as we saw, to be left behind. But neither are they raw materials. The musician does not transform them into music; he sets them to music; and if the music which he writes for them had a raw material (which it has not), that raw material could not consist of verses. What happens is rather that the poet and musician collaborate to produce a work of art which owes something to each of them; and this is true even if in the poet's case there was no intention of collaborating.

Aristotle extracted from the notion of a hierarchy of crafts the notion of a supreme craft, upon which all hierarchical series converged, so that the various 'goods' which all crafts produce played their part, in one way or another, in preparing for the work of this supreme craft, whose product could, therefore, be called the 'supreme good'.[2] At first sight, one might fancy an echo of this in Wagner's theory of opera as the supreme art, supreme because it combines the beauties of music and poetry and drama, the arts of time and the arts of space, into a single whole. But, quite apart from the question whether Wagner's opinion of opera as the greatest of the arts is justified, this opinion does not really rest on the idea of a hierarchy of arts. Words, gestures, music, scenery are not means to opera, nor yet raw materials of it, but parts of it; the hierarchies of means and mate-

[2]*Nicomachean Ethics*, beginning: 1094 a 1–b 10.

rials may therefore be ruled out, and only that of parts remains. But even this does not apply. Wagner thought himself a supremely great artist because he wrote not only his music but his words, designed his scenery, and acted as his own producer. This is the exact opposite of a system like that by which motorcars are made, which owes its hierarchical character to the fact that the various parts are all made by different firms, each specializing in work of one kind.

§ 4. *Technique*

As soon as we take the notion of craft seriously, it is perfectly obvious that art proper cannot be any kind of craft. Most people who write about art to-day seem to think that it is some kind of craft; and this is the main error against which a modern aesthetic theory must fight. Even those who do not openly embrace the error itself, embrace doctrines implying it. One such doctrine is that of artistic technique.

The doctrine may be stated as follows. The artist must have a certain specialized form of skill, which is called technique. He acquires his skill just as a craftsman does, partly through personal experience and partly through sharing in the experience of others who thus become his teachers. The technical skill which he thus acquires does not by itself make him an artist; for a technician is made, but an artist is born. Great artistic powers may produce fine works of art even though technique is defective; and even the most finished technique will not produce the finest sort of work in their absence; but all the same, no work of art whatever can be produced without some degree of technical skill, and, other things being equal, the better the technique the better will be the work of art. The greatest artistic powers, for their due and proper display, demand a technique as good in its kind as they are in their own.

All this, properly understood, is very true; and, as a criticism of the sentimental notion that works of art can be produced by any one, however little trouble he has taken to learn his job, provided his heart is in the right place, very salutary. And since a writer on art is for the most part addressing himself not to artists, but to amateurs of art, he does well to insist on what every artist knows, but most amateurs do not: the vast amount of intelligent and purposeful labour, the painful and conscientious self-discipline, that has gone to the making of a man who can write a line as Pope writes it, or knock a single chip off a single stone like Michelangelo. It is no less true, and no less important, that the skill here displayed (allowing the word skill to pass for the moment unchallenged), though a necessary condition of the best art, is not by itself sufficient to produce it. A high degree of such skill is shown in Ben Jonson's poem; and a critic might, not unfruitfully, display this skill by analysing the intricate and ingenious patterns of rhythm and rhyme, alliteration, assonance, and dissonance, which the poem contains. But what makes Ben Jonson a poet, and a great one, is not his skill to construct such patterns but his imaginative vision of the goddess and her attendants, for whose expression it was worth his while to use that skill, and for whose enjoyment it is worth our while to study the patterns he has constructed. Miss Edith Sitwell, whose distinction both as poet and critic needs no commendation, and whose analyses of sound-

pattern in poetry are as brilliant as her own verse, has analysed in this way the patterns constructed by Mr. T. S. Eliot, and has written warmly of the skill they exemplify; but when she wishes conclusively to compare his greatness with the littleness of certain other poets who are sometimes ridiculously fancied his equals, she ceases to praise his technique, and writes, 'here we have a man who has talked with fiery angels, and with angels of a clear light and holy peace, and who has "walked amongst the lowest of the dead" '.[3] It is this experience, she would have us understand, that is the heart of his poetry; it is the 'enlargement of our experience' by his own (a favourite phrase of hers, and one never used without illumination to her readers) that tells us he is a true poet; and however necessary it may be that a poet should have technical skill, he is a poet only in so far as this skill is not identified with art, but with something used in the service of art.

This is not the old Greco-Roman theory of poet-craft, but a modified and restricted version of it. When we examine it, however, we shall find that although it has moved away from the old poet-craft theory in order to avoid its errors, it has not moved far enough.

When the poet is described as possessing technical skill, this means that he possesses something of the same nature as what goes by that name in the case of a technician proper or craftsman. It implies that the thing so called in the case of a poet stands to the production of his poem as the skill of a joiner stands to the production of a table. If it does not mean this, the words are being used in some obscure sense; either an esoteric sense which people who use them are deliberately concealing from their readers, or (more probably) a sense which remains obscure even to themselves. We will assume that the people who use this language take it seriously, and wish to abide by its implications.

The craftsman's skill is his knowledge of the means necessary to realize a given end, and his mastery of these means. A joiner making a table shows his skill by knowing what materials and what tools are needed to make it, and being able to use these in such a way as to produce the table exactly as specified.

The theory of poetic technique implies that in the first place a poet has certain experiences which demand expression; then he conceives the possibility of a poem in which they might be expressed; then this poem, as an unachieved end, demands for its realization the exercise of certain powers or forms of skill, and these constitute the poet's technique. There is an element of truth in this. It is true that the making of a poem begins in the poet's having an experience which demands expression in the form of a poem. But the description of the unwritten poem as an end to which his technique is means is false; it implies that before he has written his poem he knows, and could state, the specification of it in the kind of way in which a joiner knows the specification of a table he is about to make. This is always true of a craftsman; it is therefore true of an artist in those cases where the work of art is also a work of craft. But it is wholly untrue of the artist in those cases where the work of art is not a work of craft; the poet extemporizing his verses, the sculptor playing with his clay, and so forth. In these cases (which after all are cases of art, even though pos-

[3]*Aspects of Modern Poetry,* ch. v and p. 251.

sibly of art at a relatively humble level) the artist has no idea what the experience is which demands expression until he has expressed it. What he wants to say is not present to him as an end towards which means have to be devised; it becomes clear to him only as the poem takes shape in his mind, or the clay in his fingers.

Some relic of this condition survives even in the most elaborate, most reflective, most highly planned works of art. That is a problem to which we must return in another chapter: the problem of reconciling the unreflective spontaneity of art in its simplest forms with the massive intellectual burden that is carried by great works of art such as the *Agamemnon* or the *Divina Commedia*. For the present, we are dealing with a simpler problem. We are confronted with what professes to be a theory of art in general. To prove it false we need only show that there are admitted examples of art to which it does not apply.

In describing the power by which an artist constructs patterns in words or notes or brush-marks by the name of technique, therefore, this theory is misdescribing it by assimilating it to the skill by which a craftsman constructs appropriate means to a preconceived end. The patterns are no doubt real; the power by which the artist constructs them is no doubt a thing worthy of our attention; but we are only frustrating our study of it in advance if we approach it in the determination to treat it as if it were the conscious working-out of means to the achievement of a conscious purpose, or in other words technique.

§ 5. *Art as a Psychological Stimulus*

The modern conception of artistic technique, as stated or implied in the writings of critics, may be unsuccessful; but it is a serious attempt to overcome the weaknesses of the old poet-craft theory, by admitting that a work of art as such is not an artifact, because its creation involves elements which cannot be subsumed under the conception of craft; while yet maintaining that there is a grain of truth in that theory, because among the elements involved in the creation of a work of art there is one which can be thus subsumed, namely, the artist's technique. We have seen that this will not do; but at least the people who put it forward have been working at the subject.

The same cannot be said about another attempt to rehabilitate the technical theory of art, namely, that of a very large school of modern psychologists, and of critics who adopt their way of speaking. Here the entire work of art is conceived as an artifact, designed (when a sufficient degree of skill is present to justify the word) as means to the realization of an end beyond it, namely, a state of mind in the artist's audience. In order to affect his audience in a certain way, the artist addresses them in a certain manner, by placing before them a certain work of art. In so far as he is a competent artist, one condition at least is fulfilled: the work of art does affect them as he intends it should. There is a second condition which may be fulfilled: the state of mind thus aroused in them may be in one way or another a valuable state of mind; one that enriches their lives, and thus gives him a claim not only on their admiration but also on their gratitude.

The first thing to notice about this stimulus-and-reaction theory of art is

that it is not new. It is the theory of the tenth book of Plato's *Republic,* of Aristotle's *Poetics,* and of Horace's *Ars Poetica.* The psychologists who make use of it have, knowingly or unknowingly, taken over the poet-craft doctrine bodily, with no suspicion of the devastating criticism it has received at the hands of aestheticians in the last few centuries.

This is not because their views have been based on a study of Plato and Aristotle, to the neglect of more modern authors. It is because, like good inductive scientists, they have kept their eye on the facts, but (a disaster against which inductive methods afford no protection) the wrong facts. Their theory of art is based on a study of art falsely so called.

There are numerous cases in which somebody claiming the title of artist deliberately sets himself to arouse certain states of mind in his audience. The funny man who lays himself out to get a laugh has at his command a number of well-tried methods for getting it; the purveyor of sob-stuff is in a similar case; the political or religious orator has a definite end before him and adopts definite means for achieving it, and so on. We might even attempt a rough classification of these ends.[4] First, the 'artist's' purpose may be to arouse a certain kind of emotion. The emotion may be of almost any kind; a more important distinction emerges according as it is aroused simply for its own sake, as an enjoyable experience, or for the sake of its value in the affairs of practical life. The funny man and the sob-stuff monger fall on one side in this division, the political and religious orator on the other. Secondly, the purpose may be to stimulate certain intellectual activities. These again may be of very various kinds, but they may be stimulated with either of two motives: either because the objects upon which they are directed are thought of as worth understanding, or because the activities themselves are thought of as worth pursuing, even though they lead to nothing in the way of knowledge that is of importance. Thirdly, the purpose may be to stimulate a certain kind of action; here again with two kinds of motive: either because the action is conceived as expedient, or because it is conceived as right.

Here are six kinds of art falsely so called; called by that name because they are kinds of craft in which the practitioner can by the use of his skill evoke a desired psychological reaction in his audience, and hence they come under the obsolete, but not yet dead and buried, conception of poet-craft, painter-craft, and so forth; falsely so called, because the distinction of means and end, upon which every one of them rests, does not belong to art proper.

Let us give the six their right names. Where an emotion is aroused for its own sake, as an enjoyable experience, the craft of arousing it is amusement; where for the sake of its practical value, magic (the meaning of that word will be explained in chapter IV). Where intellectual faculties are stimulated for the mere sake of their exercise, the work designed to stimulate them is a puzzle; where for the sake of knowing this or that thing, it is instruction. Where a cer-

[4]The reason why I call it a rough classification is because you cannot really 'stimulate intellectual activities', or 'stimulate certain kinds of action', in a man. Anybody who says you can, has not thought about the conditions under which alone these things can arise. Foremost among these conditions is this: that they must be absolutely spontaneous. Consequently they cannot be responses to stimulus.

tain practical activity is stimulated as expedient, that which stimulates it is advertisement or (in the current modern sense, not the old sense) propaganda; where it is stimulated as right, exhortation.

These six between them, singly or in combination, pretty well exhaust the function of whatever in the modern world wrongfully usurps the name of art. None of them has anything to do with art proper. This is not because (as Oscar Wilde said, with his curious talent for just missing a truth and then giving himself a prize for hitting it) 'all art is quite useless', for it is not; a work of art may very well amuse, instruct, puzzle, exhort, and so forth, without ceasing to be art, and in these ways it may be very useful indeed. It is because, as Oscar Wilde perhaps meant to say, what makes it art is not the same as what makes it useful. Deciding what psychological reaction a so-called work of art produces (for example, asking yourself how a certain poem 'makes you feel') has nothing whatever to do with deciding whether it is a real work of art or not. Equally irrelevant is the question what psychological reaction it is meant to produce.

The classification of psychological reactions produced by poems, pictures, music, or the like is thus not a classification of kinds of art. It is a classification of kinds of pseudo-art. But the term 'pseudo-art' means something that is not art but is mistaken for art; and something that is not art can be mistaken for it only if there is some ground for the mistake: if the thing mistaken for art is akin to art in such a way that the mistake easily arises. What must this kinship be? We have already seen in the last chapter that there may be a combination of, for example, art with religion, of such a kind that the artistic motive, though genuinely present, is subordinated to the religious. To call the result of such a combination art, *tout court,* would be to invite the reply, 'it is not art but religion'; that is, the accusation that what is simply religion is being mistaken for art. But such a mistake could never in fact be made. What happens is that a combination of art and religion is elliptically called art, and then characteristics which it possesses not as art but as religion are mistakenly supposed to belong to it as art.

So here. These various kinds of pseudo-art are in reality various kinds of use to which art may be put. In order that any of these purposes may be realized, there must first be art, and then a subordination of art to some utilitarian end. Unless a man can write, he cannot write propaganda. Unless he can draw, he cannot become a comic draughtsman or an advertisement artist. These activities have in every case developed through a process having two phases. First, there is writing or drawing or whatever it may be, pursued as an art for its own sake, going its own way and developing its own proper nature, caring for none of these things. Then this independent and self-sufficient art is broken, as it were, to the plough, forced aside from its own original nature and enslaved to the service of an end not its own. Here lies the peculiar tragedy of the artist's position in the modern world. He is heir to a tradition from which he has learnt what art should be; or at least, what it cannot be. He has heard its call and devoted himself to its service. And then, when the time comes for him to demand of society that it should support him in return for his devotion to a purpose which, after all, is not his private purpose but one among the purposes of modern civilization, he finds that his living is

guaranteed only on condition that he renounces his calling and uses the art which he has acquired in a way which negates its fundamental nature, by turning journalist or advertisement artist or the like; a degradation far more frightful than the prostitution or enslavement of the mere body.

Even in this denatured condition the arts are never mere means to the ends imposed upon them. For means rightly so called are devised in relation to the end aimed at; but here, there must first be literature, drawing, and so forth, before they can be turned to the purposes described. Hence it is a fundamental and fatal error to conceive art itself as a means to any of these ends, even when it is broken to their service. It is an error much encouraged by modern tendencies in psychology, and influentially taught at the present day by persons in a position of academic authority; but after all, it is only a new version, tricked out in the borrowed plumage of modern science, of the ancient fallacy that the arts are kinds of craft.

If it can deceive even its own advocates, that is only because they waver from one horn of a dilemma to the other. Their theory admits of two alternatives. Either the stimulation of certain reactions in its audience is the essence of art, or it is a consequence arising out of its essence in certain circumstances. Take the first alternative. If art is art only so far as it stimulates certain reactions, the artist as such is simply a purveyor of drugs, noxious or wholesome; what we call works of art are nothing but a section of the Pharmacopoeia.[5] If we ask on what principle that branch can be distinguished from others, there can be no answer.

This is not a theory of art. It is not an aesthetic but an anti-aesthetic. If it is presented as a true account of its advocates' experience, we must accept it as such; but with the implication that its advocates have no aesthetic experience whatever, or at least none so robust as to leave a mark on their minds deep enough to be discernible when they turn their eyes inward and try to recognize its main features.[6] It is, of course, quite possible to look at pictures, listen to music, and read poetry without getting any aesthetic experience from these things; and the exposition of this psychological theory of art may be illustrated by a great deal of talk about particular works of art; but if this is really connected with the theory, it is no more to be called art-criticism or aesthetic theory than the annual strictures in *The Tailor and Cutter* on the ways in which Academy portrait-painters represent coats and trousers. If it attempts to develop itself as a method of art-criticism, it can only (except when it forgets its own principles) rely on anti-aesthetic standards, as when it tries to estimate the objective merits of a given poem by tabulating the 'reactions' to it of persons from whom the poet's name has been concealed, irrespective of their skill or experience in the difficult business of criticizing poetry; or by the number of emotions, separately capable of being recorded by the psychologist and severally regarded by him as valuable, which it evokes in a single hearer.

On this horn of the dilemma art disappears altogether. The alternative pos-

[5]Cf. D. G. James, *Scepticism and Poetry* (1937).
[6]Dr. I. A. Richards is at present the most distinguished advocate of the theory I am attacking. I should never say of him that he has no aesthetic experience. But in his writings he does not discuss it; he only reveals it from time to time by things he lets slip.

sibility is that the stimulating of certain reactions should be regarded not as the essence of art but as a consequence arising in certain conditions out of the nature of that essence. In that case, art survives the analysis, but only at the cost of making it irrelevant, as a pharmacologist's account of the effect of a hitherto unanalysed drug would be irrelevant to the question of its chemical composition. Granted that works of art in certain conditions do stimulate certain reactions in their audience, which is a fact; and granted that they do so not because of something other than their nature as works of art, but because of that nature itself, which is an error; it will even so not follow that light is thrown on that nature itself by the study of these reactions.

Psychological science has in fact done nothing towards explaining the nature of art, however much it has done towards explaining the nature of certain elements of human experience with which it may from time to time be associated or confused. The contribution of psychology to pseudo-aesthetic is enormous; to aesthetic proper it is nil. . . .

ART AS AMUSEMENT

§ 1. *Amusement Art*

If an artifact is designed to stimulate a certain emotion, and if this emotion is intended not for discharge into the occupations of ordinary life, but for enjoyment as something of value in itself, the function of the artifact is to amuse or entertain. Magic is useful, in the sense that the emotions it excites have a practical function in the affairs of every day; amusement is not useful but only enjoyable, because there is a watertight bulkhead between its world and the world of common affairs. The emotions generated by amusement run their course within this watertight compartment.

Every emotion, dynamically considered, has two phases in its existence: charge or excitation, and discharge. The discharge of an emotion is some act done at the prompting of that emotion, by doing which we work the emotion off and relieve ourselves of the tension which, until thus discharged, it imposes upon us. The emotions generated by an amusement must be discharged, like any others; but they are discharged within the amusement itself. This is in fact the peculiarity of amusement. An amusement is a device for the discharge of emotions in such a way that they shall not interfere with the concerns of practical life. But since practical life is only definable as that part of life which is not amusement, this statement, if meant for a definition, would be circular. We must therefore say: to establish a distinction between amusement and practical life[7] is to divide experience into two parts, so related that the emotions generated in the one are not allowed to discharge themselves in the other. In the one, emotions are treated as ends in themselves; in the other, as forces whose operation achieves certain ends beyond them. The first part is now called amusement, the second part practical life.

[7]Aestheticians who discuss the relation between two mutually exclusive things called 'Art' and 'Life' are really discussing this distinction.

In order that emotion may be discharged without affecting practical life, a make-believe situation must be created in which to discharge it. This situation will of course be one which 'represents' (cf. Chapter III, § 4) the real situation in which the emotion would discharge itself practically. The difference between the two, which has been indicated by calling them respectively real and make-believe, is simply this: the so-called make-believe situation is one in which it is understood that the emotion discharged shall be 'earthed', that is, shall not involve the consequences which it would involve under the conditions of practical life. Thus, if one man expresses hatred for another by shaking his fist at him, threatening him, and so forth, he will ordinarily be regarded as a dangerous character, dangerous in particular to the man he has threatened, who will therefore take steps of one kind or another to protect himself: perhaps by appeasing the first, perhaps by attacking him and overpowering him, perhaps by obtaining police protection. If it is understood that nothing of this sort is to be done, that life is to go on exactly as if nothing had happened, then the situation in which the anger was expressed is called a make-believe situation.

Situations of this kind resemble those created by magic in being representative, that is, in evoking emotions like those evoked by the situations they are said to represent. They differ in being 'unreal' or 'make-believe'; that is, in that the emotions they evoke are intended to be earthed instead of overflowing into the situations represented. This element of make-believe is what is known as (theatrical) 'illusion', an element peculiar to amusement art, and never found either in magic or in art proper. If in a magical ritual one says of a painting 'this is a bison', or of a wax figure 'this is my enemy', there is no illusion. One knows perfectly well the difference between the two things. The make-believe of amusement art differs radically, again, from the so-called make-believe of childish games, which is not amusement but a very serious kind of work, which we call make-believe by way of assimilating it to something that occurs in our adult experience. Calling it by that misdescriptive name, we patronizingly license the child to go on with it; so that the child can work at the really urgent problems of its own life unhampered by the interference which would certainly be forthcoming if adults knew what it was doing.

Comparisons have often been made, sometimes amounting to identification, between art and play. They have never thrown much light on the nature of art, because those who have made them have not troubled to think what they meant by play. If playing means amusing oneself, as it often does, there is no important resemblance between play and art proper; and none between play and representative art in its magical form; but there is more than a mere resemblance between play and amusement art. The two things are the same. If playing means taking part in ritual games, art proper bears little resemblance to that, and amusement art even less; but such games, as we have already seen, not only resemble magic, they are magic. But there is another thing we call play: that mysterious activity which occupies the waking and working lives of children. It is not amusement, though we adults may amuse ourselves by imitating it, and even on privileged occasions taking part in it. It is not magic, though in some ways rather like it. Perhaps it is a good deal like art proper.

Giambattista Vico, who knew a lot both about poetry and about children, said that children were 'sublime poets', and he may have been right. But no one knows what children are doing when they play; it is far easier to find out what poets are doing when they write, difficult though that is; and even if art proper and children's play are the same thing, no light is thrown for most of us on art proper by saying so.[8]

There is a hedonistic theory of art: open, like all forms of hedonism, to the objection that even if the function of art is to give 'delight' (as many good artists have said), still this delight is not pleasure in general but pleasure of a particular kind. When this objection has been met, the theory is a fair enough account of amusement art. The artist as purveyor of amusement makes it his business to please his audience by arousing certain emotions in them and providing them with a make-believe situation in which these emotions can be harmlessly discharged.

The experience of being amused is sought not for the sake of anything to which it stands as means, but for its own sake. Hence, while magic is utilitarian, amusement is not utilitarian but hedonistic. The work of art, so called, which provides the amusement, is, on the contrary, strictly utilitarian. Unlike a work of art proper, it has no value in itself; it is simply means to an end. It is as skilfully constructed as a work of engineering, as skilfully compounded as a bottle of medicine, to produce a determinate and preconceived effect, the evocation of a certain kind of emotion in a certain kind of audience; and to discharge this emotion within the limits of a make-believe situation. When the arts are described in terms implying that they are essentially forms of skill, the reference, as the terms are ordinarily used nowadays, is to this utilitarian character of amusement art. When the spectator's reception of them is described in psychological terms as a reaction to stimulus, the reference is the same. Theoretically, in both cases, the reference might be to the magical type of representation; but in the modern world that is generally ignored. For the student of modern aesthetic, it is a good rule, whenever he hears or reads statements about art which seem odd or perverse or untrue, to ask whether their oddity (or apparent oddity) may not be due to a confusion between art proper and amusement; a confusion either in the mind of their authors, or in his own. . . .

ART PROPER: (1) AS EXPRESSION

§ 1. *The New Problem*

We have finished at last with the technical theory of art, and with the various kinds of art falsely so called to which it correctly applies. We shall return to it

[8]Dr. Margaret Lowenfeld (*Play in Childhood,* 1935) has devised a method for exploring the unknown world of children's play, and has made strange discoveries about the relation of this play to the child's health. My own interpretation of her discoveries may be expressed by saying that they suggest an identity between 'play' in children and art proper. On the relation between art and health of mind (involving health of body so far as psychological causes may impair or improve bodily health), I shall have something to say later on (Chapter X, § 7; Chapter XII, § 3).

in the future only so far as it forces itself upon our notice and threatens to impede the development of our subject.

That subject is art proper. It is true that we have already been much concerned with this; but only in a negative way. We have been looking at it so far as was necessary in order to exclude from it the various things which falsely claimed inclusion in it. We must now turn to the positive side of this same business, and ask what kinds of things they are to which the name rightly belongs. . . .

§ 2. *Expressing Emotion and Arousing Emotion*

Our first question is this. Since the artist proper has something to do with emotion, and what he does with it is not to arouse it, what is it that he does? It will be remembered that the kind of answer we expect to this question is an answer derived from what we all know and all habitually say; nothing original or recondite, but something entirely commonplace.

Nothing could be more entirely commonplace than to say he expresses them. The idea is familiar to every artist, and to every one else who has any acquaintance with the arts. To state it is not to state a philosophical theory or definition of art; it is to state a fact or supposed fact about which, when we have sufficiently identified it, we shall have later to theorize philosophically. For the present it does not matter whether the fact that is alleged, when it is said that the artist expresses emotion, is really a fact or only supposed to be one. Whichever it is, we have to identify it, that is, to decide what it is that people are saying when they use the phrase. Later on, we shall have to see whether it will fit into a coherent theory.

They are referring to a situation, real or supposed, of a definite kind. When a man is said to express emotion, what is being said about him comes to this. At first, he is conscious of having an emotion, but not conscious of what this emotion is. All he is conscious of is a perturbation or excitement, which he feels going on within him, but of whose nature he is ignorant. While in this state, all he can say about his emotion is: 'I feel . . . I don't know what I feel.' From this helpless and oppressed condition he extricates himself by doing something which we call expressing himself. This is an activity which has something to do with the thing we call language: he expresses himself by speaking. It has also something to do with consciousness: the emotion expressed is an emotion of whose nature the person who feels it is no longer unconscious. It has also something to do with the way in which he feels the emotion. As unexpressed, he feels it in what we have called a helpless and oppressed way; as expressed, he feels it in a way from which this sense of oppression has vanished. His mind is somehow lightened and eased.

This lightening of emotions which is somehow connected with the expression of them has a certain resemblance to the 'catharsis' by which emotions are earthed through being discharged into a make-believe situation; but the two things are not the same. Suppose the emotion is one of anger. If it is effectively earthed, for example by fancying oneself kicking some one down stairs, it is thereafter no longer present in the mind as anger at all: we have worked it off and are rid of it. If it is expressed, for example by putting it into hot and

bitter words, it does not disappear from the mind; we remain angry; but instead of the sense of oppression which accompanies an emotion of anger not yet recognized as such, we have that sense of alleviation which comes when we are conscious of our own emotion as anger, instead of being conscious of it only as an unidentified perturbation. This is what we refer to when we say that it 'does us good' to express our emotions.

The expression of an emotion by speech may be addressed to some one; but if so it is not done with the intention of arousing a like emotion in him. If there is any effect which we wish to produce in the hearer, it is only the effect which we call making him understand how we feel. But, as we have already seen, this is just the effect which expressing our emotions has on ourselves. It makes us, as well as the people to whom we talk, understand how we feel. A person arousing emotion sets out to affect his audience in a way in which he himself is not necessarily affected. He and his audience stand in quite different relations to the act, very much as physician and patient stand in quite different relations towards a drug administered by the one and taken by the other. A person expressing emotion, on the contrary, is treating himself and his audience in the same kind of way; he is making his emotions clear to his audience, and that is what he is doing to himself.

It follows from this that the expression of emotion, simply as expression, is not addressed to any particular audience. It is addressed primarily to the speaker himself, and secondarily to any one who can understand. Here again, the speaker's attitude towards his audience is quite unlike that of a person desiring to arouse in his audience a certain emotion. If that is what he wishes to do, he must know the audience he is addressing. He must know what type of stimulus will produce the desired kind of reaction in people of that particular sort; and he must adapt his language to his audience in the sense of making sure that it contains stimuli appropriate to their peculiarities. If what he wishes to do is to express his emotions intelligibly, he has to express them in such a way as to be intelligible to himself; his audience is then in the position of persons who overhear[9] him doing this. Thus the stimulus-and-reaction terminology has no applicability to the situation.

The means-and-end, or technique, terminology too is inapplicable. Until a man has expressed his emotion, he does not yet know what emotion it is. The act of expressing it is therefore an exploration of his own emotions. He is trying to find out what these emotions are. There is certainly here a directed process: an effort, that is, directed upon a certain end; but the end is not something foreseen and preconceived, to which appropriate means can be thought out in the light of our knowledge of its special character. Expression is an activity of which there can be no technique.

§ 3. *Expression and Individualization*

Expressing an emotion is not the same thing as describing it. To say 'I am angry' is to describe one's emotion, not to express it. The words in which it is

[9]Further development of the ideas expressed in this paragraph will make it necessary to qualify this word and assert a much more intimate relation between artist and audience.

expressed need not contain any reference to anger as such at all. Indeed, so far as they simply and solely express it, they cannot contain any such reference. The curse of Ernulphus, as invoked by Dr. Slop on the unknown person who tied certain knots, is a classical and supreme expression of anger; but it does not contain a single word descriptive of the emotion it expresses.

This is why, as literary critics well know, the use of epithets in poetry, or even in prose where expressiveness is aimed at, is a danger. If you want to express the terror which something causes, you must not give it an epithet like 'dreadful'. For that describes the emotion instead of expressing it, and your language becomes frigid, that is inexpressive, at once. A genuine poet, in his moments of genuine poetry, never mentions by name the emotions he is expressing.

Some people have thought that a poet who wishes to express a great variety of subtly differentiated emotions might be hampered by the lack of a vocabulary rich in words referring to the distinctions between them; and that psychology, by working out such a vocabulary, might render a valuable service to poetry. This is the opposite of the truth. The poet needs no such words at all; the existence or nonexistence of a scientific terminology describing the emotions he wishes to express is to him a matter of perfect indifference. If such a terminology, where it exists, is allowed to affect his own use of language, it affects it for the worse.

The reason why description, so far from helping expression, actually damages it, is that description generalizes. To describe a thing is to call it a thing of such and such a kind: to bring it under a conception, to classify it. Expression, on the contrary, individualizes. The anger which I feel here and now, with a certain person, for a certain cause, is no doubt an instance of anger, and in describing it as anger one is telling truth about it; but it is much more than mere anger: it is a peculiar anger, not quite like any anger that I ever felt before, and probably not quite like any anger I shall ever feel again. To become fully conscious of it means becoming conscious of it not merely as an instance of anger, but as this quite peculiar anger. Expressing it, we saw, has something to do with becoming conscious of it; therefore, if being fully conscious of it means being conscious of all its peculiarities, fully expressing it means expressing all its peculiarities. The poet, therefore, in proportion as he understands his business, gets as far away as possible from merely labelling his emotions as instances of this or that general kind, and takes enormous pains to individualize them by expressing them in terms which reveal their difference from any other emotion of the same sort.

This is a point in which art proper, as the expression of emotion, differs sharply and obviously from any craft whose aim it is to arouse emotion. The end which a craft sets out to realize is always conceived in general terms, never individualized. However accurately defined it may be, it is always defined as the production of a thing having characteristics that could be shared by other things. A joiner, making a table out of these pieces of wood and no others, makes it to measurements and specifications which, even if actually shared by no other table, might in principle be shared by other tables. A physician treating a patient for a certain complaint is trying to produce in him a condition which might be, and probably has been, often produced in others, namely, the

condition of recovering from that complaint. So an 'artist' setting out to produce a certain emotion in his audience is setting out to produce not an individual emotion, but an emotion of a certain kind. It follows that the means appropriate to its production will be not individual means but means of a certain kind: that is to say, means which are always in principle replaceable by other similar means. As every good craftsman insists, there is always a 'right way' of performing any operation. A 'way' of acting is a general pattern to which various individual actions may conform. In order that the 'work of art' should produce its intended psychological effect, therefore, whether this effect be magical or merely amusing, what is necessary is that it should satisfy certain conditions, possess certain characteristics: in other words be, not this work and no other, but a work of this kind and of no other.

This explains the meaning of the generalization which Aristotle and others have ascribed to art. We have already seen that Aristotle's *Poetics* is concerned not with art proper but with representative art, and representative art of one definite kind. He is not analysing the religious drama of a hundred years before, he is analysing the amusement literature of the fourth century, and giving rules for its composition. The end being not individual but general (the production of an emotion of a certain kind) the means too are general (the portrayal, not of this individual act, but of an act of this sort; not, as he himself puts it, what Alcibiades did, but what anybody of a certain kind would do). Sir Joshua Reynolds's idea of generalization is in principle the same; he expounds it in connexion with what he calls 'the grand style', which means a style intended to produce emotions of a certain type. He is quite right; if you want to produce a typical case of a certain emotion, the way to do it is to put before your audience a representation of the typical features belonging to the kind of thing that produces it: make your kings very royal, your soldiers very soldierly, your women very feminine, your cottages very cottagesque, your oak-trees very oakish, and so on.

Art proper, as expression of emotion, has nothing to do with all this. The artist proper is a person who, grappling with the problem of expressing a certain emotion, says, 'I want to get this clear.' It is no use to him to get something else clear, however like it this other thing may be. Nothing will serve as a substitute. He does not want a thing of a certain kind, he wants a certain thing. This is why the kind of person who takes his literature as psychology, saying 'How admirably this writer depicts the feelings of women, or bus-drivers, or homosexuals . . .', necessarily misunderstands every real work of art with which he comes into contact, and takes for good art, with infallible precision, what is not art at all.

§ 4. *Selection and Aesthetic Emotion*

It has sometimes been asked whether emotions can be divided into those suitable for expression by artists and those unsuitable. If by art one means art proper, and identifies this with expression, the only possible answer is that there can be no such distinction. Whatever is expressible is expressible. There may be ulterior motives in special cases which make it desirable to express some emotions and not others; but only if by 'express' one means express pub-

licly, that is, allow people to overhear one expressing oneself. This is because one cannot possibly decide that a certain emotion is one which for some reason it would be undesirable to express thus publicly, unless one first becomes conscious of it; and doing this, as we saw, is somehow bound up with expressing it. If art means the expression of emotion, the artist as such must be absolutely candid; his speech must be absolutely free. This is not a precept, it is a statement. It does not mean that the artist ought to be candid, it means that he is an artist only in so far as he is candid. Any kind of selection, any decision to express this emotion and not that, is inartistic not in the sense that it damages the perfect sincerity which distinguishes good art from bad, but in the sense that it represents a further process of a non-artistic kind, carried out when the work of expression proper is already complete. For until that work is complete one does not know what emotions one feels; and is therefore not in a position to pick and choose, and give one of them preferential treatment.

From these considerations a certain corollary follows about the division of art into distinct arts. Two such divisions are current: one according to the medium in which the artist works, into painting, poetry, music, and the like; the other according to the kind of emotion he expresses, into tragic, comic, and so forth. We are concerned with the second. If the difference between tragedy and comedy is a difference between the emotions they express, it is not a difference that can be present to the artist's mind when he is beginning his work; if it were, he would know what emotion he was going to express before he had expressed it. No artist, therefore, so far as he is an artist proper, can set out to write a comedy, a tragedy, an elegy, or the like. So far as he is an artist proper, he is just as likely to write any one of these as any other; which is the truth that Socrates was heard expounding towards the dawn, among the sleeping figures in Agathon's dining-room.[10] These distinctions, therefore, have only a very limited value. They can be properly used in two ways. (1) When a work of art is complete, it can be labelled *ex post facto* as tragic, comic, or the like, according to the character of the emotions chiefly expressed in it. But understood in that sense the distinction is of no real importance. (2) If we are talking about representational art, the case is very different. Here the so-called artist knows in advance what kind of emotion he wishes to excite, and will construct works of different kinds according to the different kinds of effect they are to produce. In the case of representational art, therefore, distinctions of this kind are not only admissible as an *ex post facto* classification of things to which in their origin it is alien; they are present from the beginning as a determining factor in the so-called artist's plan of work.

The same considerations provide an answer to the question whether there is such a thing as a specific 'aesthetic emotion'. If it is said that there is such an emotion independently of its expression in art, and that the business of

[10]Plato, *Symposium*, 223 D. But if Aristodemus heard him correctly, Socrates was saying the right thing for the wrong reason. He is reported as arguing, not that a tragic writer as such is also a comic one, but that ὁ τέχνη τραγῳΔοποιός is also a comic writer. Emphasis on the word τέχνη is obviously implied; and this, with a reference to the doctrine (*Republic*, 333 E—334 A) that craft is what Aristotle was to call a potentiality of opposites, i.e. enables its possessor to do not one kind of thing only, but that kind and the opposite kind too, shows that what Socrates was doing was to assume the technical theory of art and draw from it the above conclusion.

artists is to express it, we must answer that such a view is nonsense. It implies, first, that artists have emotions of various kinds, among which is this peculiar aesthetic emotion; secondly, that they select this aesthetic emotion for expression. If the first proposition were true, the second would have to be false. If artists only find out what their emotions are in the course of finding out how to express them, they cannot begin the work of expression by deciding what emotion to express.

In a different sense, however, it is true that there is a specific aesthetic emotion. As we have seen, an unexpressed emotion is accompanied by a feeling of oppression; when it is expressed and thus comes into consciousness the same emotion is accompanied by a new feeling of alleviation or easement, the sense that this oppression is removed. It resembles the feeling of relief that comes when a burdensome intellectual or moral problem has been solved. We may call it, if we like, the specific feeling of having successfully expressed ourselves; and there is no reason why it should not be called a specific aesthetic emotion. But it is not a specific kind of emotion pre-existing to the expression of it, and having the peculiarity that when it comes to be expressed it is expressed artistically. It is an emotional colouring which attends the expression of any emotion whatever.

§ 5. *The Artist and the Ordinary Man*

I have been speaking of 'the artist', in the present chapter, as if artists were persons of a special kind, differing somehow either in mental endowment or at least in the way they use their endowment from the ordinary persons who make up their audience. But this segregation of artists from ordinary human beings belongs to the conception of art as craft; it cannot be reconciled with the conception of art as expression. If art were a kind of craft, it would follow as a matter of course. Any craft is a specialized form of skill, and those who possess it are thereby marked out from the rest of mankind. If art is the skill to amuse people, or in general to arouse emotions in them, the amusers and the amused form two different classes, differing in their respectively active and passive relation to the craft of exciting determinate emotions; and this difference will be due, according to whether the artist is 'born' or 'made', either to a specific mental endowment in the artist, which in theories of this type has gone by the name of 'genius', or to a specific training.

If art is not a kind of craft, but the expression of emotion, this distinction of kind between artist and audience disappears. For the artist has an audience only in so far as people hear him expressing himself, and understand what they hear him saying. Now, if one person says something by way of expressing what is in his mind, and another hears and understands him, the hearer who understands him has that same thing in his mind. The question whether he would have had it if the first had not spoken need not here be raised; however it is answered, what has just been said is equally true. If some one says 'Twice two is four' in the hearing of some one incapable of carrying out the simplest arithmetical operation, he will be understood by himself, but not by his hearer. The hearer can understand only if he can add two and two in his own mind. Whether he could do it before he heard the speaker say those words

makes no difference. What is here said of expressing thoughts is equally true of expressing emotions. If a poet expresses, for example, a certain kind of fear, the only hearers who can understand him are those who are capable of experiencing that kind of fear themselves. Hence, when some one reads and understands a poem, he is not merely understanding the poet's expression of his, the poet's, emotions, he is expressing emotions of his own in the poet's words, which have thus become his own words. As Coleridge put it, we know a man for a poet by the fact that he makes us poets. We know that he is expressing his emotions by the fact that he is enabling us to express ours.

Thus, if art is the activity of expressing emotions, the reader is an artist as well as the writer. There is no distinction of kind between artist and audience. This does not mean that there is no distinction at all. When Pope wrote that the poet's business was to say 'what all have felt but none so well express'd', we may interpret his words as meaning (whether or no Pope himself consciously meant this when he wrote them) that the poet's difference from his audience lies in the fact that, though both do exactly the same thing, namely express this particular emotion in these particular words, the poet is a man who can solve for himself the problem of expressing it, whereas the audience can express it only when the poet has shown them how. The poet is not singular either in his having that emotion or in his power of expressing it; he is singular in his ability to take the initiative in expressing what all feel, and all can express. . . .

§ 7. *Expressing Emotion and Betraying Emotion*

Finally, the expressing of emotion must not be confused with what may be called the betraying of it, that is, exhibiting symptoms of it. When it is said that the artist in the proper sense of that word is a person who expresses his emotions, this does not mean that if he is afraid he turns pale and stammers; if he is angry he turns red and bellows; and so forth. These things are no doubt called expressions; but just as we distinguish proper and improper senses of the word 'art', so we must distinguish proper and improper senses of the word 'expression', and in the context of a discussion about art this sense of expression is an improper sense. The characteristic mark of expression proper is lucidity or intelligibility; a person who expresses something thereby becomes conscious of what it is that he is expressing, and enables others to become conscious of it in himself and in them. Turning pale and stammering is a natural accompaniment of fear, but a person who in addition to being afraid also turns pale and stammers does not thereby become conscious of the precise quality of his emotion. About that he is as much in the dark as he would be if (were that possible) he could feel fear without also exhibiting these symptoms of it.

Confusion between these two senses of the word 'expression' may easily lead to false critical estimates, and so to false aesthetic theory. It is sometimes thought a merit in an actress that when she is acting a pathetic scene she can work herself up to such an extent as to weep real tears. There may be some ground for that opinion if acting is not an art but a craft, and if the actress's object in that scene is to produce grief in her audience; and even then the conclusion would follow only if it were true that grief cannot be produced in the

audience unless symptoms of grief are exhibited by the performer. And no doubt this is how most people think of the actor's work. But if his business is not amusement but art, the object at which he is aiming is not to produce a preconceived emotional effect on his audience but by means of a system of expressions, or language, composed partly of speech and partly of gesture, to explore his own emotions: to discover emotions in himself of which he was unaware, and, by permitting the audience to witness the discovery, enable them to make a similar discovery about themselves. In that case it is not her ability to weep real tears that would mark out a good actress; it is her ability to make it clear to herself and her audience what the tears are about.

This applies to every kind of art. The artist never rants. A person who writes or paints or the like in order to blow off steam, using the traditional materials of art as means for exhibiting the symptoms of emotion, may deserve praise as an exhibitionist, but loses for the moment all claim to the title of artist. Exhibitionists have their uses; they may serve as an amusement, or they may be doing magic. The second category will contain, for example, those young men who, learning in the torment of their own bodies and minds what war is like, have stammered their indignation in verses, and published them in the hope of infecting others and causing them to abolish it. But these verses have nothing to do with poetry.

Thomas Hardy, at the end of a fine and tragic novel in which he has magnificently expressed his sorrow and indignation for the suffering inflicted by callous sentimentalism on trusting innocence, spoils everything by a last paragraph fastening his accusation upon 'the president of the immortals'. The note rings false, not because it is blasphemous (it offends no piety worthy of the name), but because it is rant. The case against God, so far as it exists, is complete already. The concluding paragraph adds nothing to it. All it does is to spoil the effect of the indictment by betraying a symptom of the emotion which the whole book has already expressed; as if a prosecuting counsel, at the end of his speech, spat in the prisoner's face.

The same fault is especially common in Beethoven. He was confirmed in it, no doubt, by his deafness; but the cause of it was not his deafness but a temperamental inclination to rant. It shows itself in the way his music screams and mutters instead of speaking, as in the soprano part of the Mass in D, or the layout of the opening page in the *Hammerklavier* Sonata. He must have known his failing and tried to overcome it, or he would never have spent so many of his ripest years among string quartets, where screaming and muttering are almost, one might say, physically impossible. Yet even there, the old Adam struts out in certain passages of the *Grosse Fuge*.

It does not, of course, follow that a dramatic writer may not rant in character. The tremendous rant at the end of *The Ascent of F6*, like the Shakespearian[11] ranting on which it is modelled, is done with tongue in cheek. It is not the author who is ranting, but the unbalanced character he depicts; the

[11]Shakespeare's characters rant (1) when they are characters in which he takes no interest at all, but which he uses simply as pegs on which to hang what the public wants, like Henry V; (2) when they are meant to be despicable, like Pistol; or (3) when they have lost their heads, like Hamlet in the graveyard.

emotion the author is expressing is the emotion with which he contemplates that character; or rather, the emotion he has towards that secret and disowned part of himself for which the character stands.

ART PROPER: (2) AS IMAGINATION

§ 1. *The Problem Defined*

The next question in the programme laid down at the beginning of the preceding chapter was put in this way: What is a work of art, granted that there is something in art proper (not only in art falsely so called) to which that name is applied, and that, since art is not craft, this thing is not an artifact? It is something made by the artist, but not made by transforming a given raw material, nor by carrying out a preconceived plan, nor by way of realizing the means to a preconceived end. What is this kind of making?

Here are two questions which, however closely they are connected, we shall do well to consider separately. We had better begin with the artist, and put the second question first. I shall therefore begin by asking: What is the nature of this making which is not technical making, or, if we want a one-word name for it, not fabrication? It is important not to misunderstand the question. When we asked what expression was, in the preceding chapter, it was pointed out that the writer was not trying to construct an argument intended to convince the reader, nor to offer him information, but to remind him of what (if he is a person whose experience of the subject-matter has been sufficient to qualify him for reading books of this kind) he knows already. So here. We are not asking for theories but for facts. And the facts for which we are asking are not recondite facts. They are facts well known to the reader. The order of facts to which they belong may be indicated by saying that they are the ways in which all of us who are concerned with art habitually think about it, and the ways in which we habitually express our thoughts in ordinary speech.

By way of making this clearer, I will indicate the kind of way in which our question cannot be answered. A great many people who have put to themselves the question 'What is this making, characteristic of the artist, which is not a fabrication?' have sought an answer in some such way as the following: 'This non-technical making is plainly not an accidental making, for works of art could not be produced by accident.[12] Something must be in control. But if this is not the artist's skill, it cannot be his reason or will or consciousness. It

[12]I am talking of quite sensible people. There are others; some of them have denied this proposition, pointing out that if a monkey played with a typewriter for long enough, rattling the keys at random, there is a calculable probability that within a certain time he would produce, purely by accident, the complete text of Shakespeare. Any reader who has nothing to do can amuse himself by calculating how long it would take for the probability to be worth betting on. But the interest of the suggestion lies in the revelation of the mental state of a person who can identify the 'works' of Shakespeare with the series of letters printed on the pages of a book bearing that phrase as its title; and thinks, if he can be said to think at all, that an archaeologist of 10,000 years hence, recovering a complete text of Shakespeare from the sands of Egypt but unable to read a single word of English, would possess Shakespeare's dramatic and poetic works.

must therefore be something else; either some controlling force outside the artist, in which case we may call it inspiration, or something inside him but other than his will and so forth. This must be either his body, in which case the production of a work of art is at bottom a physiological activity, or else it is something mental but unconscious, in which case the productive force is the artist's unconscious mind.'

Many imposing theories of art have been built on these foundations. The first alternative, that the artist's activity is controlled by some divine or at least spiritual being that uses him as its mouthpiece, is out of fashion to-day, but that is no reason why we should refuse it a hearing. It does at least fit the facts better than most of the theories of art nowadays current. The second alternative, that the artist's work is controlled by forces which, though part of himself and specifically part of his mind, are not voluntary and not conscious, but work in some mental cellar unseen and unbidden by the dwellers in the house above, is extremely popular; not among artists, but among psychologists and their numerous disciples, who handle the theory with a great deal of confidence and seem to believe that by its means the riddle of art has at last been solved.[13] The third alternative was popular with the physiological psychologists of the last century, and Grant Allen still remains its best exponent.

It would be waste of time to criticize these theories. The question about them is not whether they are good or bad, considered as examples of theorizing; but whether the problem which they are meant to solve is one that calls for theorizing in order to solve it. A person who cannot find his spectacles on the table may invent any number of theories to account for their absence. They may have been spirited away by a benevolent deity, to prevent him from overworking, or by a malicious demon, to interfere with his studies, or by a neighbouring mahatma, to convince him that such things can be done. He may have unconsciously made away with them himself, because they unconsciously remind him of his oculist, who unconsciously reminds him of his father, whom he unconsciously hates. Or he may have pushed them off the table while moving a book. But these theories, however ingenious and sublime, are premature if the spectacles should happen to be on his nose.

Theories professing to explain how works of art are constructed by means of hypotheses like these are based on recollecting that the spectacles are not on the table, and overlooking the fact that they are on the nose. Those who put them forward have not troubled to ask themselves whether we are in point of fact familiar with a kind of activity productive of results and under the agent's voluntary control, which has none of the special characteristics of craft. If they had asked the question, they must have answered it in the affirmative. We are perfectly familiar with activities of this kind; and our ordinary name for them is creation. . . .

[13]Mr. Robert Graves (*Poetic Unreason*, 1925) is almost the only practising man of letters or artist in this country who has come forward to back up the psychologists. Generally speaking, the judgement of literary men on the qualifications of the people who advocate this theory is sufficiently represented by Dr. I. A. Richards: 'To judge by the published work of Freud upon Leonardo da Vinci or of Jung upon Goethe (e.g. *The Psychology of the Unconscious*, p. 305) psycho-analysts tend to be peculiarly inept as critics' (*Principles of Literary Criticism*, ed. 5, 1934, pp. 29–30).

§ 3. *Creation and Imagination*

We must proceed to a further distinction. All the things taken above as examples of things created are what we ordinarily call real things. A work of art need not be what we should call a real thing. It may be what we call an imaginary thing. A disturbance, or a nuisance, or a navy, or the like, is not created at all until it is created as a thing having its place in the real world. But a work of art may be completely created when it has been created as a thing whose only place is in the artist's mind.

Here, I am afraid, it is the metaphysician who will take offence. He will remind me that the distinction between real things and things that exist only in our minds is one to which he and his fellows have given a great deal of attention. They have thought about it so long and so intently that it has lost all meaning. Some of them have decided that the things we call real are only in our minds; others that the things we describe as being in our minds are thereby implied to be just as real as anything else. These two sects, it appears, are engaged in a truceless war, and any one who butts in by using the words about which they are fighting will be set upon by both sides and torn to pieces.

I do not hope to placate these gentlemen. I can only cheer myself up by reflecting that even if I go on with what I was saying they cannot eat me. If an engineer has decided how to build a bridge, but has not made any drawings or specifications for it on paper, and has not discussed his plan with any one or taken any steps towards carrying it out, we are in the habit of saying that the bridge exists only in his mind, or (as we also say) in his head. When the bridge is built, we say that it exists not only in his head but in the real world. A bridge which 'exists only in the engineer's head' we also call an imaginary bridge; one which 'exists in the real world' we call a real bridge.

This may be a silly way of speaking; or it may be an unkind way of speaking, because of the agony it gives to metaphysicians; but it is a way in which ordinary people do speak, and ordinary people who speak in that way know quite well what kind of things they are referring to. The metaphysicians are right in thinking that difficult problems arise from talking in that way; and I shall spend the greater part of Book II in discussing these problems. Meanwhile, I shall go on 'speaking with the vulgar'; if metaphysicians do not like it they need not read it.

The same distinction applies to such things as music. If a man has made up a tune but has not written it down or sung it or played it or done anything which could make it public property, we say that the tune exists only in his mind, or only in his head, or is an imaginary tune. If he sings or plays it, thus making a series of audible noises, we call this series of noises a real tune as distinct from an imaginary one.

When we speak of making an artifact we mean making a real artifact. If an engineer said that he had made a bridge, and when questioned turned out to mean that he had only made it in his head, we should think him a liar or a fool. We should say that he had not made a bridge at all, but only a plan for one. If he said he had made a plan for a bridge and it turned out that he had put nothing on paper, we should not necessarily think he had deceived us. A plan is a kind of thing that can only exist in a person's mind. As a rule, an

engineer making a plan in his mind is at the same time making notes and sketches on paper; but the plan does not consist of what we call the 'plans', that is, the pieces of paper with these notes and sketches on them. Even if he has put complete specifications and working drawings on paper, the paper with these specifications and drawings on it is not the plan; it only serves to tell people (including himself, for memory is fallible) what the plan is. If the specifications and drawings are published, for example in a treatise on civil engineering, any one who reads the treatise intelligently will get the plan of that bridge into his head. The plan is therefore public property, although by calling it public we mean only that it can get into the heads of many people; as many as read intelligently the book in which the specifications and drawings are published.

In the case of the bridge there is a further stage. The plan may be 'executed' or carried out; that is to say, the bridge may be built. When that is done, the plan is said to be 'embodied' in the built bridge. It has begun to exist in a new way, not merely in people's heads but in stone or concrete. From being a mere plan existing in people's heads, it has become the form imposed on certain matter. Looking back from that point of view, we can now say that the engineer's plan was the form of the bridge without its matter, or that when we describe him as having the plan in his mind we might equally have described him as having in mind the form of the finished bridge without its matter.

The making of the bridge is the imposing of this form on this matter. When we speak of the engineer as making the plan, we are using the word 'make' in its other sense, as equivalent to create. Making a plan for a bridge is not imposing a certain form on a certain matter; it is a making that is not a transforming, that is to say, it is a creation. It has the other characteristics, too, that distinguish creating from fabricating. It need not be done as means to an end, for a man can make plans (for example, to illustrate a text-book of engineering) with no intention of executing them. In such a case the making of the plan is not means to composing the text-book, it is part of composing the textbook. It is not means to anything. Again, a person making a plan need not be carrying out a plan to make that plan. He may be doing this; he may for instance have planned a text-book for which he needs an example of a reinforced concrete bridge with a single span of 150 feet, to carry a two-track railway with a roadway above it, and he may work out a plan for such a bridge in order that it may occupy that place in the book. But this is not a necessary condition of planning. People sometimes speak as if everybody had, or ought to have, a plan for his whole life, to which every other plan he makes is or ought to be subordinated; but no one can do that.

Making an artifact, or acting according to craft, thus consists of two stages. (1) Making the plan, which is creating. (2) Imposing that plan on certain matter, which is fabricating. Let us now consider a case of creating where what is created is not a work of art. A person creating a disturbance need not be, though of course he may be, acting on a plan. He need not be, though of course he may be, creating it as means to some ulterior end, such as causing a government to resign. He cannot be transforming a pre-existing material, for there

is nothing out of which a disturbance can be made; though he is able to create it only because he already stands, as a finite being always does stand, in a determinate situation; for example, at a political meeting. But what he creates cannot be something that exists only in his own mind. A disturbance is something in the minds of the people disturbed.

Next, let us take the case of a work of art. When a man makes up a tune, he may and very often does at the same time hum it or sing it or play it on an instrument. He may do none of these things, but write it on paper. Or he may both hum it or the like, and also write it on paper at the same time or afterwards. Also he may do these things in public, so that the tune at its very birth becomes public property, like the disturbance we have just considered. But all these are accessories of the real work, though some of them are very likely useful accessories. The actual making of the tune is something that goes on in his head, and nowhere else.

I have already said that a thing which 'exists in a person's head' and nowhere else is alternatively called an imaginary thing. The actual making of the tune is therefore alternatively called the making of an imaginary tune. This is a case of creation, just as much as the making of a plan or a disturbance, and for the same reasons, which it would be tedious to repeat. Hence the making of a tune is an instance of imaginative creation. The same applies to the making of a poem, or a picture, or any other work of art.

The engineer, as we saw, when he made his plan in his own head, may proceed to do something else which we call 'making his plans'. His 'plans', here, are drawings and specifications on paper, and these are artifacts made to serve a certain purpose, namely to inform others or remind himself of the plan. The making of them is accordingly not imaginative creation; indeed, it is not creation at all. It is fabrication, and the ability to do it is a specialized form of skill, the craft of engineer's draughtsmanship.

The artist, when he has made his tune, may go on to do something else which at first sight seems to resemble this: he may do what is called publishing it. He may sing or play it aloud, or write it down, and thus make it possible for others to get into their heads the same thing which he has in his. But what is written or printed on music-paper is not the tune. It is only something which when studied intelligently will enable others (or himself, when he has forgotten it) to construct the tune for themselves in their own heads.

The relation between making the tune in his head and putting it down on paper is thus quite different from the relation, in the case of the engineer, between making a plan for a bridge and executing that plan. The engineer's plan is embodied in the bridge: it is essentially a form that can be imposed on certain matter, and when the bridge is built the form is there, in the bridge, as the way in which the matter composing it is arranged. But the musician's tune is not there on the paper at all. What is on the paper is not music, it is only musical notation. The relation of the tune to the notation is not like the relation of the plan to the bridge; it is like the relation of the plan to the specifications and drawings; for these, too, do not embody the plan as the bridge embodies it, they are only a notation from which the abstract or as yet unembodied plan can be reconstructed in the mind of a person who studies them.

§ 4. *Imagination and Make-believe*

Imagination, like art itself, is a word with proper and improper meanings. For our present purpose it will be enough to distinguish imagination proper from one thing that is often improperly so called: a thing already referred to under the name of make-believe.

Make-believe involves a distinction between that which is called by this name and that which is called real; and this distinction is of such a kind that the two exclude one another. A make-believe situation can never be a real situation, and vice versa. If, being hungry, I 'imagine' myself to be eating, this 'bare imagination of a feast' is a make-believe situation which I may be said to create for myself imaginatively; but this imaginative creation has nothing to do with art proper, though it has much to do with certain kinds of art falsely so called. It is the motive of all those sham works of art which provide their audiences or addicts with fantasies depicting a state of things in which their desires are satisfied. Dreaming consists to a great extent (some psychologists say altogether) of make-believe in which the dreamer's desires are thus satisfied; day-dreaming even more obviously so; and the sham works of art of which I am speaking are perhaps best understood as an organized and commercialized development of day-dreaming. A story is told of a psychologist who issued a questionnaire to all the girl students in a college, asking them how they spent their time, and learnt from their replies that I forget what vast percentage of it was spent in day-dreaming. He is said to have come to the conclusion that great results could be achieved if all this day-dreaming could be co-ordinated. Quite right; but he overlooked the fact that the thing had already been done, and that Hollywood was there to prove it.

Imagination is indifferent to the distinction between the real and the unreal. When I look out of the window, I see grass to right and left of the mullion that stands immediately before me; but I also imagine the grass going on where this mullion hides it from my sight. It may happen that I also imagine a lawn-mower standing on that part of the lawn. Now, the hidden part of the lawn is really there, the lawnmower is not; but I can detect nothing, either in the way in which I imagine the two things, or in the ways in which they respectively appear to my imagination, which at all corresponds to this distinction. The act of imagining is of course an act really performed; but the imagined object or situation or event is something which need not be real and need not be unreal, and the person imagining it neither imagines it as real or unreal, nor, when he comes to reflect on his act of imagining, thinks of it as real or unreal. Make-believe, too, is a thing which can be done without reflecting on it. When it is so done, the person who does it is unaware that he is constructing for himself unreal objects or situations or events; but when he reflects, he either discovers that these things are unreal, or else falls into the error of taking them for realities.

There is probably always a motive behind any act of make-believe, namely, the desire for something which we should enjoy or possess if the make-believe were truth. It implies a felt dissatisfaction with the situation in which one actually stands, and an attempt to compensate for this dissatisfaction not by prac-

tical means, by bringing a more satisfactory state of things into existence, but by imagining a more satisfactory state of things and getting what satisfaction one can out of that. For imagination proper there is no such motive. It is not because I am dissatisfied with the match-box lying before me on the table that I imagine its inside, whether as full or as empty; it is not because I am dissatisfied with an interrupted grass-plot that I imagine it as continuing where the mullion hides it from my view. Imagination is indifferent, not only to the distinction between real and unreal, but also to the distinction between desire and aversion.

Make-believe presupposes imagination, and may be described as imagination operating in a peculiar way under the influence of peculiar forces. Out of the numerous things which one imagines, some are chosen, whether consciously or unconsciously, to be imagined with peculiar completeness or vividness or tenacity, and others are repressed, because the first are things whose reality one desires, and the second things from whose reality one has an aversion. The result is make-believe, which is thus imagination acting under the censorship of desire; where desire means not the desire to imagine, nor even the desire to realize an imagined situation, but the desire that the situation imagined were real.

A good deal of damage has been done to aesthetic theory by confusing these two things. The connexion between art and imagination has been a commonplace for at least two hundred years;[14] but the confusion between art and amusement has been both reflected and reinforced by a confusion between imagination and make-believe, which culminates in the attempt of the psycho-analysts to subsume artistic creation under their theory (certainly a true theory) of 'fantasies' as make-believe gratifications of desire. This attempt is admirably successful so long as it deals with the art, falsely so called, of the ordinary popular novel or film; but it could not conceivably be applied to art proper. When the attempt is made to base an aesthetic upon it (a thing which has happened lamentably often) the result is not an aesthetic but an anti-aesthetic. This may be because the psychologists who have tried to explain artistic creation by appeal to the notion of 'fantasy' have no idea that there is any such distinction as that between amusement art and art proper, but are merely perpetuating in their own jargon a vulgar misconception, common in the nineteenth century, according to which the artist is a kind of dreamer or day-dreamer, constructing in fancy a make-believe world which if it existed would be, at least in his own opinion, a better or more pleasant one than that in which we live. Competent artists and competent aestheticians have again and again protested against this misconception; but the protest has naturally had no effect on the many people whose experience of so-called art, being limited to the 'art' of organized and commercialized day-dreaming, it faithfully describes. And to this class it would seem that our psycho-analyst aestheticians belong. Or perhaps it is their patients that belong to it. An excessive indulgence in day-dreaming would certainly tend to produce moral diseases like those from which their patients suffer.

[14]The habit of calling aesthetic experience 'the pleasures of the imagination' dates back, I think, to Addison; the philosophical theory of art as imagination, to his contemporary Vico.

§ 5. *The Work of Art as Imaginary Object*

If the making of a tune is an instance of imaginative creation, a tune is an imaginary thing. And the same applies to a poem or a painting or any other work of art. This seems paradoxical; we are apt to think that a tune is not an imaginary thing but a real thing, a real collection of noises; that a painting is a real piece of canvas covered with real colours; and so on. I hope to show, if the reader will have patience, that there is no paradox here; that both these propositions express what we do as a matter of fact say about works of art; and that they do not contradict one another, because they are concerned with different things.

When, speaking of a work of art (tune, picture, &c.), we mean by art a specific craft, intended as a stimulus for producing specific emotional effects in an audience, we certainly mean to designate by the term 'work of art' something that we should call real. The artist as magician or purveyor of amusement is necessarily a craftsman making real things, and making them out of some material according to some plan. His works are as real as the works of an engineer, and for the same reason.

But it does not at all follow that the same is true of an artist proper. His business is not to produce an emotional effect in an audience, but, for example, to make a tune. This tune is already complete and perfect when it exists merely as a tune in his head, that is, an imaginary tune. Next, he may arrange for the tune to be played before an audience. Now there comes into existence a real tune, a collection of noises. But which of these two things is the work of art? Which of them is the music? The answer is implied in what we have already said: the music, the work of art, is not the collection of noises, it is the tune in the composer's head. The noises made by the performers, and heard by the audience, are not the music at all; they are only means by which the audience, if they listen intelligently (not otherwise), can reconstruct for themselves the imaginary tune that existed in the composer's head.

This is not a paradox. It is not something παρὰ Δόξαυ, contrary to what we ordinarily believe and express in our ordinary speech. We all know perfectly well, and remind each other often enough, that a person who hears the noises the instruments make is not thereby possessing himself of the music. Perhaps no one can do that unless he does hear the noises; but there is something else which he must do as well. Our ordinary word for this other thing is listening; and the listening which we have to do when we hear the noises made by musicians is in a way rather like the thinking we have to do when we hear the noises made, for example, by a person lecturing on a scientific subject. We hear the sound of his voice; but what he is doing is not simply to make noises, but to develop a scientific thesis. The noises are meant to assist us in achieving what he assumes to be our purpose in coming to hear him lecture, that is, thinking this same scientific thesis for ourselves. The lecture, therefore, is not a collection of noises made by the lecturer with his organs of speech; it is a collection of scientific thoughts related to those noises in such a way that a person who not only hears but thinks as well becomes able to think these thoughts for himself. We may call this the communication of thought by means of speech, if we like; but if we do, we must think of communication

not as an 'imparting' of thought by the speaker to the hearer, the speaker somehow planting his thought in the hearer's receptive mind, but as a 'repro-duction' of the speaker's thought by the hearer, in virtue of his own active thinking.

The parallel with listening to music is not complete. The two cases are sim-ilar at one point, dissimilar at another. They are dissimilar in that a concert and a scientific lecture are different things, and what we are trying to 'get out of' the concert is a thing of a different kind from the scientific thoughts we are trying to 'get out of' the lecture. But they are similar in this: that just as what we get out of the lecture is something other than the noises we hear proceed-ing from the lecturer's mouth, so what we get out of the concert is something other than the noises made by the performers. In each case, what we get out of it is something which we have to reconstruct in our own minds, and by our own efforts; something which remains for ever inaccessible to a person who cannot or will not make efforts of the right kind, however completely he hears the sounds that fill the room in which he is sitting.

This, I repeat, is something we all know perfectly well. And because we all know it, we need not trouble to examine or criticize the ideas of aestheti-cians (if there are any left to-day—they were common enough at one time) who say that what we get out of listening to music, or looking at paintings, or the like, is some peculiar kind of sensual pleasure. When we do these things, we certainly may, in so far as we are using our senses, enjoy sensual pleasures. It would be odd if we did not. A colour, or a shape, or an instrumental tim-bre may give us an exquisite pleasure of a purely sensual kind. It may even be true (though this is not so certain) that no one would become a lover of music unless he were more susceptible than other people to the sensual plea-sure of sound. But even if a special susceptibility to this pleasure may at first lead some people towards music, they must, in proportion as they are more susceptible, take the more pains to prevent that susceptibility from interfering with their power of listening. For any concentration on the pleasantness of the noises themselves concentrates the mind on hearing, and makes it hard or impossible to listen. There is a kind of person who goes to concerts mainly for the sensual pleasure he gets from the sheer sounds; his presence may be good for the box-office, but it is as bad for music as the presence of a person who went to a scientific lecture for the sensual pleasure he got out of the tones of the lecturer's voice would be for science. And this, again, everybody knows.

It is unnecessary to go through the form of applying what has been said about music to the other arts. We must try instead to make in a positive shape the point that has been put negatively. Music does not consist of heard noises, paintings do not consist of seen colours, and so forth. Of what, then, do these things consist? Not, clearly, of a 'form', understood as a pattern or a system of relations between the various noises we hear or the various colours we see. Such 'forms' are nothing but the perceived structures of bodily 'works of art', that is to say, 'works of art' falsely so called; and these formalistic theories of art, popular though they have been and are, have no relevance to art proper and will not be further considered in this book. The distinction between form and matter, on which they are based, is a distinction belonging to the philos-ophy of craft, and not applicable to the philosophy of art.

The work of art proper is something not seen or heard, but something imagined. But what is it that we imagine? We have suggested that in music the work of art proper is an imagined tune. Let us begin by developing this idea.

Everybody must have noticed a certain discrepancy between what we actually see when looking at a picture or statue or play and what we see imaginatively; what we actually see when listening to music or speech and what we imaginatively hear. To take an obvious example: in watching a puppet-play we could (as we say) swear that we have seen the expression on the puppets' faces change with their changing gestures and the puppet-man's changing words and tones of voice. Knowing that they are only puppets, we know that their facial expression cannot change; but that makes no difference; we continue to see imaginatively the expressions which we know that we do not see actually. The same thing happens in the case of masked actors like those of the Greek stage.

In listening to the pianoforte, again, we know from evidence of the same kind that we must be hearing every note begin with a *sforzando,* and fade away for the whole length of time that it continues to sound. But our imagination enables us to read into this experience something quite different. As we seem to see the puppets' features move, so we seem to hear a pianist producing a *sostenuto* tone, almost like that of a horn; and in fact notes of the horn and the pianoforte are easily mistaken one for the other. Still stranger, when we hear a violin and pianoforte playing together in the key, say, of G, the violin's F sharp is actually played a great deal sharper than the pianoforte's. Such a discrepancy would sound intolerably out of tune except to a person whose imagination was trained to focus itself on the key of G, and silently corrected every note of the equally tempered pianoforte to suit it. The corrections which imagination must thus carry out, in order that we should be able to listen to an entire orchestra, beggar description. When we listen to a speaker or singer, imagination is constantly supplying articulate sounds which actually our ears do not catch. In looking at a drawing in pen or pencil, we take a series of roughly parallel lines for the tint of a shadow. And so on.

Conversely, in all these cases imagination works negatively. We disimagine, if I may use the word, a great deal which actually we see and hear. The street noises at a concert, the noises made by our breathing and shuffling neighbours, and even some of the noises made by the performers, are thus shut out of the picture unless by their loudness or in some other way they are too obtrusive to be ignored. At the theatre, we are strangely able to ignore the silhouettes of the people sitting in front of us, and a good many things that happen on the stage. Looking at a picture, we do not notice the shadows that fall on it or, unless it is excessive, the light reflected from its varnish.

All this is commonplace. And the conclusion has already been stated by Shakespeare's Theseus: 'the best in this kind ['works of art', as things actually perceived by the senses] are but shadows, and the worst are no worse if imagination amend them.' The music to which we listen is not the heard sound, but that sound as amended in various ways by the listener's imagination, and so with the other arts. . . .

In the light of this discussion let us recapitulate and summarize our attempt to answer the question, what is a work of art? What, for example, is a piece of music?

1. In the pseudo-aesthetic sense for which art is a kind of craft, a piece of music is a series of audible noises. The psychological and 'realistic' aestheticians, as we can now see, have not got beyond this pseudo-aesthetic conception.
2. If 'work of art' means work of art proper, a piece of music is not something audible, but something which may exist solely in the musician's head (§ 3).
3. To some extent it must exist solely in the musician's head (including, of course, the audience as well as the composer under that name), for his imagination is always supplementing, correcting, and expurgating what he actually hears (§ 4).
4. The music which he actually enjoys as a work of art is thus never sensuously or 'actually' heard at all. It is something imagined.
5. But it is not imagined sound (in the case of painting, it is not imagined colour-patterns, &c.). It is an imagined experience of total activity (§ 5).
6. Thus a work of art proper is a total activity which the person enjoying it apprehends, or is conscious of, by the use of his imagination.

READING 12

INTRODUCTION

In "Aesthetic Theory and the Experience of Art" (1967), R. K. Elliott, who taught philosophy at the University of London Institute of Education, argues that theories of aesthetic experience which hold that the appreciation of works of art is essentially a matter of perceiving their objective phenomenal qualities fail to provide us with an adequate understanding of the nature of our experience of art. Instead, he suggests, in order to understand aesthetic experience we need to appeal to something like the expression theories of Wordsworth, Collingwood, and Tolstoy (see Sections 1, 2, and 4). The version of expression theory that Elliott develops, however, is significantly different from theirs. Elliott's version of the theory turns on a distinction that he draws between experiencing a work of art "from within" and experiencing that work "from without." Admitting that it is not easy to give a precise characterization of these modes of experience, he endeavors, instead, to show their significance by discussing some of the ways in which we can experience a number of particular poems, pieces of music, and paintings. His discussion suggests that no matter how damaging may be the objections to expression theory as a general theory of art, that theory nonetheless—at any rate in the hands of a thinker as sensitive and as subtle as Elliott—captures something vital about the ways in which we think about, respond to, and value works of art.

"Aesthetic Theory and the Experience of Art"

R. K. Elliott

I wish to maintain that in some important respects a version of Expression Theory provides a better account of our experience of art and of the nature of a work of art than does an aesthetic theory outlined by the following five points. (i) The work of art, *qua* aesthetic object or object of criticism, is a complex of phenomenally objective qualities, including aesthetic qualities. (ii) Aesthetic perception is understood chiefly as the perception of aesthetic qualities, but "perception" is here used in an extended sense, so that an aesthetic quality may be a content of thought or imagination rather than of sight or hearing. (iii) Emotional qualities like joy or sadness are phenomenally objective qualities of the form or *gestalt* character of a work or of a part of a work, and since in order to appreciate the work it is necessary only to sense or recognise these qualities, not to feel them, they are not treated as logically distinct from the other qualities commonly attributed to works of art. (iv) But since a work may be exciting, soothing or disgusting, it must be allowed that arousal of emotion has some aesthetic significance. (v) In aesthetic experience attention is firmly directed upon the aesthetic object or upon some part of it, and it is always possible to distinguish this object from our response to it.[1] For Expression Theory, in its classical or "refined" form, the arousal of emotion as by the operation of a cause was a sign either of bad art or lack of taste. Aesthetic experience was not a matter of recognising that the object possesses emotional (and other) qualities, but required the reader to transfer himself into the poet's mind, re-enact his creative expression and thereby allow his clarified emotion to be manifested in him. According to Gentile, in aesthetic experience every duality between ourselves and the poet is transcended; when we have entered into the poet's feeling we feel ourselves to be looking upon the same world as he looked upon, with the same heart and eyes.[2]

The exaggerations of Expression Theory, especially the belief that in experiencing a poem aesthetically we reproduce in ourselves the creative activity of the poet, may have obscured its less spectacular but more genuine insight, namely, that some works of art are capable of being experienced as if they were human expression and that we do not experience expression exactly as we perceive objects or ordinary objective qualities. By "expression" I mean only that expression which is perceived as qualifying or issuing from the person, especially gesture, speech and such internal activities as thinking and imagining. I do not intend the term to cover any object perceived as made by a person and existing independently of him. The Expression Theorists recog-

[1]This composite 'theory' does not do justice to the views of any of the philosophers who advanced any of the theses contained in it, but is meant as a statement of a set of opinions which are currently sometimes expressed or presupposed. I have taken the components of the theory from the work of Professors Beardsley, Bouwsma, Dickie and Margolis, and from that of Prof. Hepburn.

[2]See Merle E. Brown, *Neo-Idealist Aesthetics: Croce-Gentile-Collingwood*, Detroit (1966), pp. 168–169.

nised that a poem can be perceived not as an object bearing an impersonal meaning but as if it were the speech or thought of another person and that it is possible for us to make this expression our own. A work may be experienced "from within" or "from without". I cannot define these terms but hope that this paper will elucidate their meaning. So far as poetry and painting are concerned, experiencing a work from within is, roughly speaking, experiencing it as if one were the poet or the artist. If a work is experienced as expression, experiencing it from within involves experiencing this expression after a certain imaginative manner as one's own. Experiencing it from without is experiencing it as expression, but not experiencing this expression as if it were one's own. When I say that a work "expresses emotion" I mean that if it is perceived as or as if it were expression it may be perceived as or as if it were the expression of an emotion.

In so far as experiencing a lyric poem differs from hearing someone actually speaking to us, in general these differences make it easier rather than more difficult for us to experience the poem from within. The poet is not visibly before us as another individual; the poem itself may rapidly and lucidly acquaint us with all that is necessary for us to understand the situation in which the poet (*qua* "speaker" of the poem) is represented as experiencing an emotion; and to experience the poem at all we have to give it a real or virtual reading in which we embody the poet's expression in our own voice. Consequently, the lyric "I" functions as an invitation to the reader to place himself, in imagination, at the point from which the poet is related to the situation given in the poem. *Qua* maker, the poet may employ devices which tend to inhibit this communion, but in many cases the reader is able, eventually if not immediately, to take up the lyric "I", invest himself imaginatively with the poet's situation, and experience the poet's expression and the emotion expressed from the place of the expressing subject rather than from the place of one who hears and understands the expression from without.

When we experience an emotion in this way, through an imaginative assumption of the expression and situation of another person (real or imaginary) we need not and commonly do not experience it as we would if the situation were unequivocally our own. In the *Lysis*, Plato distinguishes between the ignorance which is both present in and predictable of a man and that which though it is present in him is not predictable of him.[3] Emotion is subject to a similar distinction: the emotion that I feel in experiencing a work of art from within (and that which I feel as another person's in real life) may be present in me without being predictable of me. It is present in me because I do not merely recognise that the poet is expressing, for example, sadness, but actually feel this sadness; yet the emotion I feel is not predictable of me, *i.e.*, it would be false to say that I *am* sad or even, unqualifiedly, that I feel sad. Edith Stein describes emotion felt in this way (in our experience of other persons) as "primordial" for the other subject, "non-primordial" for me: it is "there for me in him".[4] The

[3]217C–218B.
[4]*On the Problem of Empathy*, trans. W. Stein, The Hague (1964), pp. 11, 16. Edith Stein distinguishes three grades of "empathic" experience (*i.e.*, experience of the consciousness of another person): (1) recognition that the other is, *e.g.*, joyful, (2) living in his joy, (3) objectification of this experience.

emotion expressed in a lyric poem may be "there for me in the speaker of the poem", even if the speaker is a fiction and even if the emotion was never experienced by the historical poet.

In experiencing a poem from within, the reader keeps more or less explicit contact with the poet. Sometimes he seems to be there together with the poet, as if they inhabited the same body and as if the poet were speaking or thinking with the reader's voice; sometimes the reader seems to be there in place of the poet, expressing and experiencing the poet's emotion as it were on the poet's behalf; sometimes the reader seems even to have supplanted the poet, but still without experiencing the expressed emotion as the product of his own fantasy. On occasions, as Longinus recognised, the experience is so vivid that it seems almost as if the reader were actually in the poet's situation. He has to return to himself, rather as if he were waking from a dream. As a rule, however, the reader is aware of his ability to relinquish the imagined situation and break off his communion with the poet immediately and without effort. We rarely experience a poem entirely from within, but are drawn into the world of the poem at certain points and later once more experience it from without, usually without noticing these changes in our point of view.

I have spoken of "experiencing" a poem from within and from without, but these are very like alternative manners of performing a work as well as alternative modes of experiencing it. The word "poem" is correctly applied not only to the text but also to that which may be constructed and experienced on the basis of the text, rather as the musical work is both the score and that which is present for perception when the work is performed. A poem is "realised" by a process in which understanding and imagination supplement and progressively correct each other. An initial understanding of the words of the text enables us to begin to represent the work in imagination, and these same words appear also in the imaginative representation. Through the representation, which at this stage is the partial intuitive fulfilment of a meaning as yet only tentatively grasped, we become aware of new significances which lead in turn to the modification of the representation. This process continues indefinitely. Not every poem need be represented according to either of the modes that I have described, but where it is possible to experience a work according to these modes (*i.e.*, when it can be experienced as expression) it is not immaterial which of them we adopt, for the perception of aesthetic qualities begins almost as soon as we begin to realise the poem, and these qualities will differ according to the mode of representation. Two critics may find the same poem to be vivid and unified, but for one it has the vividness and unity of an observed event, for the other, a vividness and unity more like those of an experience in which he actively participates. Even the aesthetic qualities of the rhythm and word-music will differ in some degree. Although for a particular poem one mode of representation may be more appropriate than the other, there is no ground for declaring either mode to be in general "unaesthetic". In so far as psychical distance is taken to be the absence of merely personal feeling and practical concern, it may be maintained or lost whichever mode is adopted. Each is a way of making the work available to aesthetic awareness. In one case the poem arises as a complex content entirely at the objective pole of consciousness; in the other it is realised as an experience, the description of

which involves a reference not simply to an objective content but also to the subject. In the first case aesthetic perception is awareness of certain qualities of an objective content; in the second it also includes a reflexive awareness of certain aspects of the experience as such.

It is difficult not to experience Donne's first *Holy Sonnet* ("Thou hast made me") from within. If after having experienced the poem in this way the reader were asked what his attention had been fixed upon, he could only answer that it had been fixed upon death and damnation—not upon death and damnation in general, however, nor his own, nor yet the poet's. He could not say exactly what it had been fixed upon unless he could describe his own situation relative to the poet and the world of the poem. If he is a person of critical temperament, the poem *qua* experience will become more and more comprehensively an object of reflection so that at some stage it will be appropriate to say that he is related to the poem as to an objective content. But the object so contemplated is one which cannot be described without reference to the subject. So long as the full extent of the equivocality of "work of art" and of all its specifications is not clearly recognised, such assertions as "Aesthetic experience is experience of the work" and "The critic's task is to talk about the work, not about himself" have the sort of ambivalence which allows them to be misused as instruments or persuasion. Except in so far as he reflects upon his own experience, a person who experiences a poem from within does not concentrate his attention on any objective content which can be identified with the poem *qua* aesthetic object. He does not even fix his attention on the words of the poem, for when we speak or think from deep feeling, although we are aware of our words, of their adequacy or the lack of it, and even of the quality of their sound, it is scarcely correct to say that our attention is concentrated upon them. When experiencing a poem from within we do not fix our attention upon it but live it according to a certain imaginative mode. This is not sufficient from the aesthetic point of view, but it is not in any way aesthetically improper.

Hölderlin's elegy *Homecoming* shows the development of the poet's mood from serene expectation to loving reflection on the homeland, from this to the flowering of his joy in actual perception, then to serenity once more in an attitude of benediction. This much may be understood, after a fashion, through experiencing the poem from without, but the emotion experienced is of an extreme kind, and if we experience it only from without we can understand it only in its peculiarity as Hölderlin's—as the particular state of a decidedly unusual person. This, together with the idiosyncrasy of some of the poet's ideas, his generalised vocabulary and fastidious craftsmanship, makes the poem seem for us a strange though extremely beautiful object. Once we are able to experience it from within, however, it retains this character only as an inessential and misleading aspect. It appears instead as a sublime expression of a great human emotion which it enables us to experience eminently, though non-primordially. At the same time we know the emotion to be one which we have felt in real life in a more ordinary fashion. The difference in what the poem means to us could hardly be greater, yet it would not be wrong to say that we understood its meaning when we experienced it only from without. The inability to experience such a poem from within is a deprivation for which no exquisiteness of taste can compensate. When we experience Donne's poem

The Sunne Rising from without, we hear the poet, represented as lying in bed with his mistress, address the sun with good-humoured but violently expressed contempt. We are shocked by his impiety and impressed by the brilliance of his wit. When we experience the poem from within, the poet's expression is reproduced in us at a level which is prior to the distinction between what is spoken aloud and what is merely thought. As a result the dramatic character of the poem is appreciably softened, and what appeared from without as aggressively clever conceit now seems at once more playful and more serious. The lyrical aspect of the poem is experienced more convincingly, and we feel a sense of the power and glory of sensual love—the same emotion which is experienced with such splendour in the *Song of Solomon*. Now it seems to us that the poet diminished the sun only to glorify a greater god, one whose power we ourselves feel in experiencing the poem from within. But in this case the understanding obtained through experiencing the poem from within does not establish its authority absolutely. This poem has two faces, and the critic must experience it according to both modes if he is to evaluate it justly.

There is a sense in which a poem can be said to provide an adequate "objective correlative" of an emotion if the poem is experienced from within. It does this to the extent that it displays or "imitates" the emotion, and to the extent in which it enables us to experience it when we realise the poem from within. A poem like Hölderlin's elegy *Homecoming* or Donne's *The Sunne Rising* accomplishes this by deploying a situation around the reader as he realises the poem, by representing the structure of a developing mood, and by enabling him to reproduce in imagination, from the place of the experiencing subject, modes of speech, changes in the direction, tempo and pressure of thought, movements of fancy, and even the modifications of perception through which the emotion manifests itself. The reader must himself contribute the appropriate feelings and emotional tone, but his feeling will be appropriate not only to the imagined situation but also to the expression he has made his own. Under this guidance the emotion comes into being in him.

In his article "The Expression Theory of Art",[5] Professor Bouwsma argues that we can perceive or sense the sadness of sad music without feeling sad ourselves, and that to attempt to elucidate the application of "emotional" predicates to music by reference to expression is only to invite confusion. When we say "The music is sad" we may mean that it makes us sad, but for the good critic, at least, "The music is sad" means that the form or *gestalt* character of the music has a certain audible quality which we call "sad" because the music has some of the characteristics of sad persons. "The sadness is to the music rather like the redness to the apple, than it is like the burp to the cider." We do apply emotional predicates to sounds according to the two criteria Bouwsma mentions, but we also apply them because we perceive sounds as or as if they were expressing emotion. Bouwsma maintains that once a poem is born it has character as surely as a cry in the night, but a cry in the night, because it is so unexpected, can at first be heard not as human expression but as pure sound. It may have an emotional quality: not grief or fear but eeriness, the power through strangeness to cause fear. An intermediate stage would be

[5]In Elton, W. (ed.), *Aesthetics and Language*, Oxford (1954), pp. 73–99.

hearing that the cry has a certain emotional quality, judging it to be a sad sound, but still not perceiving it as an expression of sadness. We call some sounds "happy" or "merry" in this way, because they have some of the characteristics of happy persons, and we perceive these emotional qualities as *gestalt* characters without hearing the sounds as if they were expression. But in such cases we have to judge that it is appropriate to apply the emotional predicate. To perceive music as *expressing* emotion we have to perceive the sounds *as if* they were expression. When I watch the foliage of a tree blown hither and thither in a strong wind, at first I see only a multiplicity of movements. Then this multitude becomes a unity, and I see a restless and fearful agitation on the brink of frenzy. But to see the foliage in this way is to see it as if it were a person and to grasp its movement as if it were expression. If I am to continue perceiving this vividly explicit fearfulness I must remain under the spell. As soon as I concentrate upon the movements simply as movements, I cease to see the tree as if it were a person and drop back into a more ordinary mode of perception. Similarly, the humming of telegraph wires may be heard as the contented murmuring of a number of "voices", but if one concentrates upon the sound the voices disappear and the inhuman noise of the wire returns. If I listen to a passage of "sad" music to discover whether I perceive an emotional quality or an expression of sadness, I hear sounds with an emotional quality. But the conditions of the experiment preclude me from hearing anything else. Music is eminently expressive but the musical sounds are very different from the sound of the human voice. Consequently, when attention is fixed on the sounds, one hears something inhuman having an intense emotional quality. For it to be possible for us to hear the music as expressing emotion, we must not be concentrating too keenly upon the qualities of the sounds themselves but listening to the music in a more relaxed and "natural" way. Then we find ourselves hearing some passage as if someone were expressing his emotion in and through the sounds as a person does in and through his voice, but although we hear the sounds rather as if they were a voice, in listening to pure music we seldom if ever hear them as the ordinary human voice. But there is a different manner in which we may hear the music as if it were expressing emotion, namely, by hearing it as our own expression. We value these experiences because the emotion in the music is realised most definitely and most vividly in these ways. Hearing the music as expressing emotion, whether from without or from within, is an instance of imaginatively enriched perception, one of many which we encounter in the experience of art.

That the expression and the emotion it expresses "belong" to nobody is no more a hindrance to our understanding the expression and experiencing the emotion than it is with poetry. We sometimes attribute the expressed emotion to the composer, but very often we do not attribute it to anyone definite: it is merely "his" emotion which is being expressed. On occasions, perhaps, although we hear the music as expression we do not attribute the expression to anyone at all, perceiving expression without an expressor, as no doubt we once did in early childhood. The emotion expressed in a song or aria is usually referred to the character the singer is personating. Perceiving anything as if it were expression of emotion involves a reference to feeling, but we can per-

ceive the music as expressing sadness without being made sad by it. Whether we are made sad by it or not, experiencing it simply as the expression of someone else's sadness is experiencing it from without. Often, however, we are able to experience the music from within, in which case we experience it as if it were our own expression and may feel the expressed emotion non-primordially. The hearer does not have to perform the music as the reader has to perform the poem, but in a certain way he can appropriate the stream of musical sound as his own expression. An extreme experience of emotionally expressive music from within is very like a real-life experience of, say, joy, when the emotion has no definite object and when we express it by voice or gesture. In this case we begin by directing an ordinary attention on the musical sounds, but, as if in a single movement, the music is received by us and, as it were, reissues from us as if it were our own expression, not exactly as if it were our own voice but as a mode of expression *sui generis*. Once the mood or emotion is present in us the experience is usually extremely pleasing, for to the extent that emotion is not tied to any external state of affairs or dependent in any other way upon the subject's representing anything to himself by means of concepts, music is an incomparably lucid and powerful means of expression.[6] It is as if in feeling joy or sadness we were at the same time conscious of an adequacy of expression far beyond anything we could have imagined.

Coming to understand a musical work is not simply a matter of frequently exercising concentration upon an object for the purpose of discerning its aesthetic qualities. In experiencing a work for the first time it appears to us chiefly, perhaps, as a sonorous object, but in places as someone else's expression. As we grow more familiar with it, however, some phrases and melodies no longer seem to be directed at us from a source outside us. We may not experience them as if they were issuing from us, on an analogy with the voice, but as coming into being in us, an analogy with a process of thought. We may become aware of this when at some time we feel ourselves to be inwardly articulating or "containing" a passage which we remember had previously seemed to be directed at us from without. Slow reflective passages lend themselves readily to an appropriation of this sort; vehement passages may seem to be "thought" by us or to issue from us as external expression. This is not *mere* familiarity with the work, for instead of causing our interest in the music to slacken it enables us to experience the mood or emotional tone rather than merely recognise its emotional quality. That is, having made the expression our own, we contribute the element of feeling, as we do in experiencing a lyric poem from within. When we seem to be expressing the music externally, it seems as if it is flowing forth from the mood, though often the mood seems inadequate to the expression—it may seem as if the expression were sustaining the mood, rather than *vice versa*. When we seem to be "thinking" the music, it often seems as if we are at the same time feeling it. In many cases hearing the music from within *is* feeling the emotion or feeling expressed. Sometimes we find ourselves not only "thinking" or otherwise "expressing" the music, but thinking or expressing it powerfully, as if our own resources were equal to the music. It is firmly appropriated and we are expressing it as if from the

[6]See Kierkegaard: *Either/Or,* trans. David and Lillian Swenson, London (1946), pp. 35–110.

heart. This is feeling the expressed emotion. On other occasions, feeling the emotion involves more than this. For example, there is a difference between recognising the intense and narrow concentration of extremely sad music and living in this concentration in experiencing the music from within. Sometimes, feeling the emotion amounts to accompanying the music with internal gestures. In hearing the conclusion of the first movement of *La Mer* from within, we may enjoy a glorious expansion of spirit, assuming in imagination something of the stature, zest and majesty of a sea-god. From without, some such being seems to tower over us, regal and threatening. Both tendencies can be inhibited by concentrating on the music as pure sound. We may feel an expressed emotion, however, without feeling it primordially. Joyful music tends to make us joyful when we experience it from within, but often we know that the joy we are feeling is only present in us and does not qualify the self. The passage from *La Mer* is exhilarating, but does not induce the state it expresses. Nevertheless, in so far as hearing music from within involves the appropriation of the musical expression the musical work is an experience, not an object. We cannot, by reflecting on our experience, discover a content exactly like that which we would have had if we had experienced the work from without. We discover instead "sounds suffused with feeling".

Whether we experience some passages from within or from without or as pure sound may well make a difference to our evaluation of a musical work. Sometimes, when we fail to experience them as expression we regard the hearing as abortive and consider that the work's aesthetic qualities have not been properly experienced. In other cases we may value a work without having experienced certain passages from within, and one day be surprised to find that someone else values it, as we think, excessively, but gives very much the same reasons for its merit as we do. In extreme cases, there is complete aesthetic disagreement. This is understandable, since a passage which seems banal if it and other passages have been experienced as pure sound may seem almost unhearably poignant if it and certain earlier passages have been experienced as expression. A case in point is the "hurdy gurdy" passage in the finale of Bartok's 5th String Quartet. Some critics value it for its expressiveness, others can see it only as an appalling error of judgment. Some passages in some of Wordsworth's poems present criticism with a similar problem, seeming on one reading wholly banal, on another wholly sublime. Where emotionally expressive music is found within a literary context, as in opera, the significance of the music may differ very considerably according to the mode of perception we adopt. There is a passage of presentation music in Bartok's opera *Bluebeard's Castle* which occurs when Bluebeard is showing Judith his vast domain, and we naturally experience this music as Bluebeard's expression. When we experience it from without, it gives an impression of vanity, even pomposity, in a character of great force; but we can hardly avoid experiencing it also from within, whereupon it seems to express a somewhat naïve pride and strength with which it is easy to sympathise. This ambivalence is in keeping with Bluebeard's character as we know it from the rest of the opera. The music is complex, and I suspect that some features are more prominent when it is experienced from without, others when it is experienced from within, and that this is enough to change the significance of the music as delin-

eating Bluebeard's character. But like Donne's poem, this passage must be experienced according to both modes if one is to grasp its full significance.

There are many pictures before which ordinary aesthetic contemplation can be transformed into a mode of perception in which the percipient seems to see the reality of what is represented in the representation. A picture like Rouault's *Flight into Egypt* would be quite insignificant if it did not have the power suddenly to make it seem that we are actually there, in an unbounded landscape, with the sky extending over us in a chill dawn. Our point of view shifts spontaneously from a point outside the world of the work to a point within it. If we value a work because it offers us such an experience we may be inclined, for want of a better word, to call it "vivid" or "realistic", but the relevant aesthetic property cannot be adequately described except by reference to the shift in the subject's point of view. The movement from seeing the picture as representing a chill dawn to the imaginative experience of such a dawn as if real, is of the same kind as the movement from experiencing a lyric poem from without to experiencing it from within, for it is the assumption of "the painter's" point of view and of his relation to his world. The historical painter may not have painted from life, as the historical poet may not have actually experienced the events he describes in his poem, but as the poem is given as verbal expression, so the representational picture is given as a visual field— that of an "observer" who is analogous with the poet *qua* "speaker" of the poem, as it is possible to make the poet's expression one's own, so the picture may cease to be an object in the percipient's visual field, become itself the visual field, and be experienced as if the objects in it were real. Ordinarily we see the represented dawn as such, either simply as a represented dawn or as the representation of a dawn seen by Rouault. In the experience I am describing we are shifted suddenly from one of these more ordinary modes of perception to a mode which is like the extreme kind of poetic experience of which Longinus writes.[7] Both in the experience of a poem and of a picture from within, an emotional character is realised through an imaginative response to the work, but in the experience of the picture this realisation is accomplished rather through an imaginative extension and modification of what is actually seen than through what is merely imagined, so that the experience of the picture from within has an aspect of illusion. Nevertheless the difference between the poetic and pictorial experiences is chiefly that between what activates imagination in each case, whether words or things seen. In neither case is what activates imagination transcended: the words are not superseded in the poetic experience, nor is perception supplanted by imagination in the experience of the picture. Words or things seen are taken up into a more comprehensive experience in the constitution of which imagination plays a vital part.

A perfect analogy between the experience of a picture and that of a lyric poem from within, has not yet been established, however, for it has not been shown that a picture, when experienced from within, can be an adequate "objective correlative" of an emotion. Before Rouault's *Flight into Egypt* we experience "the dawn-feeling", but the picture relies upon our providing a

[7]See Ruby Meager "The Sublime and the Obscene", *The British Journal of Aesthetics*, July 1964.

general human response and does little to determine this response any further. Here the painter is at a disadvantage. In experiencing a lyric poem it is normally quite easy to distinguish the objects of the poet's world from his attitude towards them: if he speaks of the sun as an officious court dignitary we do not have to imagine it as wearing a ruff or as appropriately grey-bearded. But whatever means the painter adopts to determine our attitude must be visible in the picture. If he distorts the image of the object of the emotion he wishes to communicate, it is this distorted image which we experience as if real when we experience the work from within its world, so that we respond not to the object of the emotion but rather to the emotion itself as objectified in the image. If on contemplating a picture of Rouault's I feel myself to be in the real presence of one of his monstrous judges, this experience will not directly deliver either the emotion that the artist intended to convey or its object. But if the painter does not obviously distort the image the percipient is left free to adopt what attitude he pleases: it is a matter of temperament whether he feels pity or contempt for the unattractive elder members of Goya's royal family. Yet in some pictures even this difficulty has been surmounted. One's first impression of Bonnard's *Nude before a Mirror* are of its brilliant colour and of its decorative character. The nude is in the centre of the picture-space and is more sharply and emphatically drawn than anything at the sides of the picture or in the background. All the rest is an extravagant décor for the central figure. The mirror which occupies much of the left margin of the picture, reflects a curtain as a long narrow area of brilliantly coloured patches and spots. The window glistens. The corner of the bedspread in the right foreground is richly coloured and formally pleasing. One recognises almost immediately that this is a good picture, but the judgment is made with reservations. The central figure seems a little awkwardly related to the background, the sensuous charm of which is perhaps excessive. But even while he is contemplating the picture in this way, the percipient's mode of perception may be transformed, and it is as if he were in the very room, looking at a real woman standing before a mirror, not with the neutral attitude of someone looking at something in a picture but with an affectionate, even a loving glance. It is as if he has assumed not only the artist's visual field but his very glance, and is gazing upon the same world with the same heart and eyes. He is no longer aware of the exaggerated colour or of the decorative aspect of the picture. It is as if these features had helped to create the attitude appropriate for the perception of the central figure—a technique common in religious painting—and in accomplishing this had given up their own prominence. I do not maintain that it is the function of painting to produce experiences of this kind, but it is in such experiences that Expression Theory's dream of a communion which is temporarily an identity seems most nearly to be realised. Less intense or less complete experiences of pictures from within, involving only a part of a picture or a momentary sense of the real presence of the object represented, are not uncommon. Imaginatively enhanced perception of these and other kinds have nothing to do with skill or taste, but this does not suffice to establish their irrelevance from the aesthetic point of view.

A somewhat clearer indication of what it means, in general, to experience a work "from within" can now be given. Music is perceived as expression, but

does not deliver a situation. Painting delivers a situation but is not perceived as expression. Poetry both delivers a situation and is perceived as expression. In each case there is the possibility of an imaginative movement whereby the percipient enters into a more intimate relation with the work, either by appropriating the musical expression, or by allowing the world of the picture to become as if it were his world instead of contemplating it as an object in his world, or by taking up the poetic expression and constructing the world of the poem as if it were his world. But expression and world are relative to a subject, and the percipient is often explicitly aware that the expression or world that he has made or allowed to become his is not in fact his own. Hence he may well feel a sense of identity or close communion with someone else, whom he is likely to identify as the artist. These, I believe, are the features of our experience of art which provide a certain limited justification for Expression Theory. At the same time they cast doubt on the adequacy of any exclusively objectivist aesthetic theory.

The theory I have been criticising restricts the application of 'aesthetic' to one aspect or region of our experience of art, perhaps in the belief that this is necessary if aesthetic judgment is to have objective validity. By this impoverishment of the concept of aesthetic experience Aesthetics becomes the philosophy of a scarcely practicable aestheticism which it has itself created. Yet even the problem of the objectivity of aesthetic judgment could be clarified by a more catholic understanding of our actual experience of art, in particular of the creative contribution made by the subject. Our experience of art, like our religious or moral experience, has its own character but is not yet transparent to us. It is this, in all its variety and complexity and with all the problems it presents, that Aesthetics should exhibit and examine, not only for the sake of remaining in contact with ordinary lovers of art but in order that through Aesthetics we may attain a better understanding of ourselves. A version of aesthetic experience adapted in a comparatively simple manner to our intellectualist preferences is not an acceptable substitute.

READING 13

INTRODUCTION

Like R. K. Elliott, Guy Sircello, who was professor of philosophy at the University of California at Irvine, believes that in order to do justice to the ways in which we experience, understand, and appreciate works of art we need to explore the concept of expression. His concern in "Expressive Properties of Art" (1972) is with the question "What makes art expressive?" His answer to this question is that the expressiveness of a work of art is not simply a matter of its having certain "anthropomorphic" properties, such as the properties of being "sad" or "austere." The crucial issue in understanding the expressiveness of art, he claims, is understanding *how* works of art come to *have* properties such as those of being "sad" or "austere."

In Sircello's view, works of art come to have such properties because of what he calls "artistic acts." It is because of what artists *do* that we think of works of art as expressive, not because of what artists actually feel as they create, and not because of what spectators (or listeners or readers or whatever) feel as they experience the work. It is his delicate handling of the role played by "artistic acts" in artistic expression that makes Sircello's discussion distinctive. He focuses on issues that any persuasive version of expression theory must take into account. But he also raises issues which have wider ramifications: issues about the nature of aesthetic properties (also raised in essays by Sibley and Walton in Section 3, "The Logic of Taste"), for example, and about the respects in which knowledge of artistic intention can be crucial to the interpretation of works of art (an issue raised in many of the essays on "Intention and Interpretation" in Section 3).

"Expressive Properties of Art"

Guy Sircello

Romantic ideas about mind and its relation to art did not receive their clearest expression until the twentieth century. Then philosophers like Croce, Collingwood, Cassirer, Dewey, and Langer tried to spell out exactly how it is that art can be expressive. But to many other twentieth-century philosophers, especially to those working in the various "analytical" styles whose intellectual ancestry was anything but Romantic, those philosophical discussions of expression in art were puzzling. This puzzlement can best be seen in the work of Monroe Beardsley and O. K. Bouwsma, philosophers who represent two distinct strains in recent analytical philosophy.

I think it is fair to understand the puzzlement of both Beardsley and Bouwsma in the following way. We understand relatively well what it is for a *person* to express such things as feelings, emotions, attitudes, moods, etc. But if we say that sonatas, poems, or paintings also express those sorts of things either we are saying something patently false or we are saying something true in an uninformative, misleading, and therefore pointless way. For to say of works of art that they express those sorts of things seems to imply that they are very much like persons. Therefore, unless we believe that philosophers who think of art as expression believe the unbelievable, that is, that art has feelings, attitudes, and moods and can express them, we must believe that such philosophers are trying, however inadequately, to come to grips with genuine truths about art.

Furthermore, there is such an obvious disparity between the nature of art and the thesis that art can express the same sorts of things that people do that we cannot understand that thesis as simply a clumsy and inept way of stating some truths about art. We must understand it, rather, as a kind of *theoretical* statement, that is, as a deliberately contrived and elaborated way of construing some simple facts about art. Both Beardsley and Bouwsma thus speak of the "Expression *Theory*" of art.

What are the facts which the Expression Theory is meant to interpret? Although Beardsley and Bouwsma differ slightly in the way they put the point,

they agree that works of art have "anthropomorphic" properties. That is, we may often properly characterize works of art as, for example, gay, sad, witty, pompous, austere, aloof, impersonal, sentimental, etc. A "theory" of art as expression, therefore, can say no more than that art works have properties designated by the same words which designate feelings, emotions, attitudes, moods, and personal characteristics of human beings.

The nature of these properties has not been probed very deeply by analytical critics of the Expression Theory. Beardsley calls them "qualities." Bouwsma prefers to call them "characters," pointing out their affinity with the "characters" of a number of things like sounds, words, numerals, and faces. In case this suggestion is unhelpful, Bouwsma further invites us to conceive the relation of the "character" to the art work in terms of the relation of redness to the apple in a red apple. At this point he is exactly in line with Beardsley, who mentions a red rose instead of a red apple.[1]

The Bouwsma-Beardsley position on the question of expression in art is currently rather widely accepted. Indeed, John Hospers, writing in the *Encyclopedia of Philosophy* has, in effect, canonized the view.[2] Accordingly, I shall refer to it henceforth as the Canonical Position. Now despite the fact that it has illuminated the concept of expression in art, the Canonical Position is false in some respects and inadequate in others. In this [essay], I shall argue (1) that attributions of "characters," or "anthropomorphic qualities," to works of art come in a number of different varieties, (2) that the simple thing-property relation is not an adequate model for understanding any of those varieties, [and] (3) that there are far better reasons for calling art "expressive" than are allowed by the Canonical interpretation of Expression Theory . . .

The Canonical Position has two incorrect presuppositions. The first is that works of art are very much like such natural objects as roses and apples as well as, I suppose, such natural quasi- and non-objects as hills, brooks, winds, and skies. The second is that the anthropomorphic predicates of art are not essentially different from simple color terms like "red" and "yellow." No one has seriously argued, as far as I know, that any art work is *just* like some natural "object." Everyone admits that there are basic differences between art and nature, most of them related to the fact that art is made by human beings and natural things are not. What the first presupposition of the Canonical Position amounts to, therefore, is that as far as the anthropomorphic predicates are concerned works of art are not different from natural objects.[3]

It is fairly easy to show that this presupposition is false by the following strategy. Anthropomorphic predicates are applied to natural things in virtue of certain non-anthropomorphic properties of those things. Of course these properties vary, depending on the particular predicate as well as on the thing

[1]Cf. Monroe Beardsley, *Aesthetics: Problems in the Philosophy of Criticism* (New York: Harcourt, Brace, 1958), pp. 321–332; and O. K. Bouwsma, "The Expression Theory of Art," in *Philosophical Analysis*, ed. Max Black (Ithaca: Cornell University Press, 1950), pp. 75–101.

[2]*The Encyclopedia of Philosophy*, ed. Paul Edwards (New York: Macmillan and The Free Press, 1967), I, 47.

[3]I hope it is clear that throughout this discussion the emphasis is on "natural," not on "object." But I will, for convenience, use the terms "object" and "thing" to cover non-objects and non-things as well.

to which it applied. Hills, for example, may be austere in virtue of their color, their vegetation (or lack of it), or their contours; an ocean may be angry in virtue of its sound and the force and size of its waves; a tree may be sad in virtue of the droop and shape of its branches. With respect to a number of art works to which anthropomorphic predicates are applied, I shall inquire what it is about those works in virtue of which the predicates are applicable. This strategy will yield categorical features of art which do not belong to natural things.

1. Like most of Raphael's Madonna paintings, the one called *La Belle Jardinière* can be described as calm and serene. It is fairly clear what there is about this painting which makes it calm and serene: the regular composition based on an equilateral triangle, the gentle and loving expressions on the faces of the Mother, the Child, and the infant John the Baptist, the placid landscape, the delicate trees, the soft blue of the sky, the gentle ripples in the Mother's garments blown by a slight breeze, and, finally, the equanimity and quiet with which the artist views his subject and records the details of the scene.
2. We might reasonably describe Hans Hofmann's *The Golden Wall* as an aggressive abstract painting. But in this painting there is no representational content in the usual sense and therefore nothing aggressive is depicted. What is aggressive is the color scheme, which is predominantly red and yellow. Blue and green are also used as contrasting colors, but even these colors, especially the blue, are made to look aggressive because of their intensity. Furthermore, by the way they are juxtaposed, the patches of color are made to appear as though they were rushing out towards the observer and even as though they were competing with one another in this rush towards the observer.
3. We might say of Poussin's *The Rape of the Sabine Women* (either version, but especially the one in the Metropolitan Museum of Art in New York City) that it is calm and aloof. Yet it is quite clear that the depicted scene is *not* calm and that no one in it, with the possible exception of Romulus, who is directing the attack, is aloof. It is rather, as we say, that Poussin calmly observes the scene and paints it in an aloof, detached way.
4. Breughel's painting called *Wedding Dance in the Open Air* can be aptly if superficially described as gay and happy. In this case however it is surely the occasion and the activities of the depicted peasants which are happy. Perhaps the prominent red used throughout the painting can be called "gay." The faces of the peasants however are neither happy nor gay. They are bland, stupid, and even brutal. It is this fact which makes the painting ironic rather than gay or happy. Yet there is certainly nothing about a peasant wedding, the dull peasants, or their heavy dance which is ironic. The irony lies in the fact that the painter "views," "observes," or depicts the happy scene ironically.
5. John Milton's "L'Allegro" is not only "about" high spirits, but it is surely a high-spirited, i.e. gay and joyful, poem. The gaiety and joy are evident in several ways. First, the scenes and images are gay and joyful: Zephir playing with Aurora, maids and youths dancing and dallying, the poet

himself living a life of "unreproved" pleasure with Mirth. Second, the diction and rhythms are light-hearted: "Haste thee nymphs and bring with thee / Jest and youthful Jollity, / Quips and Cranks, and wanton Wiles, / Nods, and Becks and Wreathed Smiles."

6. Another sort of example entirely is William Wordsworth's sentimental poem "We Are Seven." This poem is quite obviously not *about* sentimentality. It purports simply to record the conversation between the poet and a child. Neither the child nor the poet (that is, the "character" in the poem), moreover, is sentimental. The child matter-of-factly reports her firm conviction there are still seven members of her family despite the fact that two of them are dead. The poet is trying, in a rather obtuse and hard-headed sort of way, to get her to admit that there are only five. But the little girl is made to win the point by having the last word in the poem. She is thus made to seem "right" even though no explicit authorization is given to her point of view. By presenting the little girl's case so sympathetically, Wordsworth (the poet who wrote the poem, not the "character" in the poem) treats the attitude of the little girl, as well as the death of her siblings, sentimentally.

7. The case of "The Dungeon" by Coleridge is different again. At least the first half of this poem is angry. But it is not about anger or angry persons. It is a diatribe in verse (and certainly not a poor poem on that account) against the cruelty, injustice, and wasteful ineffectiveness of prisons.

8. T. S. Eliot's "The Lovesong of J. Alfred Prufrock" can, with considerable justice, be called a compassionate poem. In this case it is quite clear that the compassion exists in the way in which the character Prufrock is portrayed as a gentle and sensitive, if weak, victim of ugly and sordid surroundings.

9. Suppose that we say that the second movement of Beethoven's "Eroica" symphony is sad with a dignified and noble sadness characteristic of Beethoven. In this case the sadness is in the slowness of the tempo, and the special quality of the sadness comes from the stateliness of the march rhythm, from the use of "heavy" instruments like horns and tympani and from the sheer length of the movement.

10. A somewhat different case is presented by Mozart's music for Papageno, which is gay, carefree, light-headed and light-hearted like Papageno himself. What differentiates this case from (9), of course, is that the Mozart music is intended to suit a certain kind of character, whereas the Beethoven has no clear and explicit "representational" content. Despite this difference, however, the "anthropomorphic qualities" of the Mozart music are, like those of the Beethoven, audible in properties of the sound: in the simple harmonies, tripping rhythms, and lilting melodies of Papageno songs.

11. A slightly different case from either (9) or (10) is that presented by the first movement of Vivaldi's "Spring" Concerto. The first lilting, happy theme represents the joyful advent of spring. This is followed by the gentle music of the winds and waters of spring. Next, this pleasantness is interrupted by the angry music representing a thunder shower, after which the happy, gentle music returns. In this music the "programmatic" content is clear

and explicit because we know the poetry from which Vivaldi composed the music.

12. Quite different from the three cases immediately preceding is the witty Grandfather theme from Prokoviev's *Peter and the Wolf*. Grandfather's music, played by a bassoon, is large, lumbering, and pompous like Grandfather himself. But what makes it witty is that it portrays a dignified old man as just a bit ridiculous. Through the music Prokoviev pokes gentle fun at the old man, fun which is well-motivated by the story itself. For in the end Peter turns out to be more than equal to the danger which Grandfather has ordered him to avoid.

13. Finally, there is music like the utterly impersonal and detached music of John Cage, exemplified in *Variations II* played by David Tudor on (with) the piano. But where can we locate the "qualities" of impersonality and detachment in Cage's music? They do not seem to be "properties" of the sounds and sound-sequences in the way that gaiety is a property of Papageno's music or sadness is a property of Beethoven's. Indeed, we feel that these "anthropomorphic qualities" of Cage's music depend on the very fact that the sounds themselves are completely lacking in "human" properties. They are as characterless as any of a thousand random noises we hear every day. In fact, *Variations II* does have the apparent randomness and disorganization of mere noise. But we would not be inclined to call *any* random sequences of noises "impersonal" and "detached," even if they sounded very much like the sounds of *Variations II*. The predicates "impersonal" and "detached" are not applied to Cage's music simply in virtue of some features of its sounds. These "qualities" of *Variations II* arise rather from the fact that the composer presents what sounds like mere noise as music. Cage offers this "noise" for us to attend to and concentrate upon. Moreover, he offers it to us without "comment," and with no intention that it evoke, represent, or suggest anything beyond itself. That is to say, Cage offers these noise-like sounds in a totally uninvolved, detached, impersonal way, seeking in no way to touch our emotional life.

From the preceding examples we can see that there are some respects in which anthropomorphic predicates are applied to works of art in virtue of features of those works which they share or could share with some natural things. In the Raphael it is the composition of the painting which accounts in part for the "calm" of the painting. But "composition" here refers simply to the configuration of lines and shapes, which sorts of features can of course be shared by natural objects. Similarly, the aggressiveness of Hofmann's painting is due to its colors and their arrangement. In the Beethoven and Mozart examples the anthropomorphic qualities are traceable to features of sound which can be present in natural phenomena. The ocean crashing on the shore, a twig tapping against a windowpane, the gurgle of a stream—all of these can have "tempi," "rhythms," and even "tone color." Natural "melodies" are present in the rustle of trees and the howl of winds as well as in the songs of birds. Even the anthropomorphic qualities of verbal art can be like properties of natural things. For, as the example of "L'Allegro" shows, such qualities can be attributed to poetry at least partly in virtue of the tempo and rhythm of its verses.

Some of the above examples of anthropomorphic qualities applied to art, however, show that such qualities sometimes belong to works of art in virtue of what those works represent, describe, depict, or portray. Thus the calm and serenity of the Raphael is due in part to the countryside, the sky, the garments, and the faces depicted; the gaiety of the Breughel comes from the gaiety of the depicted scene, and the high spirits of Milton's poem are due to the gay, happy scenes and images described and presented. In cases of this sort, neither paintings nor poems are comparable to natural things with respect to the way they bear their anthropomorphic qualities. And the situation is similar with respect to all other forms of representational art, whether prose fiction, drama, ballet, opera, or sculpture. Only architecture and music are generally incapable of bearing anthropomorphic qualities in this way. This is true, moreover, even for music with a sort of representational content such as the Mozart music mentioned in (10) above. For it is not due to the fact that Mozart's songs are written for a gay, lighthearted character that they are properly described as gay and lighthearted. It is rather that the songs suit Papageno precisely in virtue of the gaiety and lightheartedness of their "sound" and are thereby capable of portraying him musically.

There is a second way in which anthropomorphic predicates may be applied to art works which is unlike the ways in which such predicates apply to natural things. In the discussion of (1) through (13) above, we discovered the following:

(a) *La Belle Jardinière* is calm and serene partly because Raphael *views* his subject calmly and quietly.
(b) *The Rape of the Sabine Women* is aloof and detached because Poussin calmly *observes* the violent scene and *paints* it in an aloof, detached way.
(c) *Wedding Dance in the Open Air* is an ironic painting because Breughel *treats* the gaiety of the wedding scene ironically.
(d) "We Are Seven" is a sentimental poem because Wordsworth *treats* his subject matter sentimentally.
(e) "The Dungeon" is an angry poem because in it the poet angrily *inveighs* against the institution of imprisonment.
(f) "The Lovesong of J. Alfred Prufrock" is a compassionate poem because the poet compassionately *portrays* the plight of his "hero."
(g) Prokoviev's Grandfather theme is witty because the composer wittily *comments* on the character in his ballet.
(h) Cage's *Variations II* is impersonal because the composer *presents* his noise-like sounds in an impersonal, uninvolved way.

I have italicized the verbs in the above in order to point up the fact that the respective anthropomorphic predicate is applied to the work of art in virtue of what the artist *does* in that work. In order to have a convenient way of referring to this class of anthropomorphic predicates, I shall henceforth refer to what verbs of the sort italicized above designate as "artistic acts." I do not intend this bit of nomenclature to have any metaphysical import. That is, I do not mean that the viewings, observings, paintings, presentings, portrayings, and treatings covered by the term "artistic acts" all belong to a category properly called "acts." Nor do I mean that all activities properly called "artistic"

are covered by my term "artistic act." As shall come out later, many artistic activities are neither identical with, constituents of, nor constituted by "artistic acts." Furthermore, I do not want to suggest that "artistic acts" have anything more in common than what I have already pointed out and what I shall go on to specify. To do a complete metaphysics of artistic acts might be an interesting philosophical job but one which would distract me from my main purpose [here].

What the preceding discussion has shown is that the view of art presupposed by the Canonical Position ignores complexities in works of art which are essential in understanding how they can bear anthropomorphic predicates. Even more significant is the discovery that anthropomorphic predicates apply to art works in virtue of "artistic acts" in these works. For, as I shall argue presently at length, it is precisely this feature of art works which enables them to be *expressions* and which thereby shows that the Canonical Position has missed a great deal of truth in classical Expression Theory.

 As far as I know, no adherent of the Canonical Position, with one exception to be noted below, has recognized the existence of what I call "artistic acts," much less seen their relevance to expression in art. But it is not difficult to anticipate the first defensive move a proponent of the Canonical Position would likely make against the threat posed by "artistic acts." It would go somewhat as follows. What the "discovery" of "artistic acts" shows is merely that not all applications of anthropomorphic predicates to art works attribute qualities to those works. They merely *seem* to do so because of their grammatical form. But in fact statements of this sort say nothing at all about the art work; they describe the artist. After all, "artistic acts" are acts of the artists, and they cannot possibly be acts of (i.e. performed by) the art works themselves.

 However superficially plausible this objection is, it can be shown to have little force. First, the objection presupposes a false dichotomy: a statement must be descriptive either of a work of art *or* of its artist. On the contrary, there seems to be no reason why when we talk in the above examples of the painting's aloofness, the poem's sentimentality, etc., we cannot be talking *both* about the painting or poem and about how Poussin painted or how Wordsworth treated his subject. And it is in fact the case that we are talking about both. The best proof of this is that the *grounds* for the truth of the descriptions of artistic acts in *(a)* through *(g)* above can come from the art work in question. One knows by looking at Poussin's painting that he has painted the scene in an aloof, detached way. The cold light, the statuesque poses, the painstaking linearity are all visible in the work. Similarly, we recognize by reading Wordsworth's poem that he treats his subject sentimentally. That is just what it is to give the child, who believes that the dead are present among the living, the advantage over the matter-of-fact adult. We can also recognize the impersonality of *Variations II* by listening to its neutral, noise-like sounds. A test for statements describing art in anthropomorphic terms is always and quite naturally a scrutiny of the art, even when the terms are applied in virtue of "artistic acts."

 Moreover it is not as if this sort of attention to the work of art were merely a second-best way of testing such statements. One does not look, listen, or read

in order to *infer* something about the aloof way Poussin painted, the compassionate way Eliot portrayed his hero, etc. We must not imagine that had we actually been with the artist at work, we could *really*, i.e. immediately and indubitably, have seen his aloofness, compassion, sentimentality, etc. How absurd to think that when Poussin's way of painting is described as aloof, what is meant is that Poussin arched his eyebrows slightly, maintained an impassive expression on his face, and moved his arms slowly and deliberately while he painted the picture. Or that because Eliot portrays Prufrock compassionately, he penned the manuscript of his poem with tears in his eyes. Not only would such facts not be needed to support statements about Poussin's aloofness or Eliot's compassion, but they are totally irrelevant to such statements. For even if we knew the way Poussin looked and moved when he was painting the Sabine picture or the way Eliot's face looked when he penned "Prufrock," we could not infer that the painting and poem were, respectively, aloof and compassionate in the ways we are discussing.

The foregoing considerations do not mean that the "artistic acts" in question are not truly acts of the artists, that is, are not truly something which the artists have done. Nor do they imply that these artistic acts are phantom acts, airy nothings existing mysteriously in works of art and disembodied from any agents.[4] They simply mean that these acts are not identifiable or describable independently of the works "in" which they are done. Probably nothing makes this point clearer than the fact that descriptions of artistic acts of this sort can be known to be true even when little or nothing is known about the author, much less what he looked like and what his behavior was like at the precise time that he was making his art. It can be truly said, for example, that Homer describes with some sentimentality the meeting of the returned Odysseus and aged dog Argos. And yet it would be absurd to say that the truth of that statement waits upon some detailed knowledge about Homer, even the existence of whom is a matter of considerable dispute.

Artistic acts are peculiar in that descriptions of them are at once and necessarily descriptions of art works. They are in this way distinguishable from other sorts of acts of artists which contribute to the production of works of art, e.g. looking at the canvas, chiseling marble, penning words, applying paint, revising a manuscript, thinking to oneself, etc. But artistic acts, for all their peculiarity, are not entirely alone in the universe; there are other sorts of things which people do which are analogous to artistic acts in significant ways. Note the following: A person may scowl angrily, and thereby have an angry scowl on his face; he may smile sadly and thereby have a sad smile on his face; he may gesture impatiently and thus make an impatient gesture; he may shout defiantly and produce thereby a defiant shout; he may pout sullenly and a sullen pout will appear on his face; his eyes may gleam happily and there will

[4]Nor are they "virtual," i.e. unreal, acts, as I have maintained in another place. Cf. my "Perceptual Acts and Pictorial Art: A Defense of Expression Theory," *Journal of Philosophy*, LXII (1965), 669–677. Giving these acts a separate and unusual metaphysical status not only complicates the universe needlessly, it is unfaithful to the commonsense facts of the situation. There are no good reasons to deny what our ways of talking implicitly affirm, namely, that "artistic acts," perceptual and otherwise, are "acts" of the artist.

be a happy gleam in his eyes; he may tug at his forelock shyly or give a shy tug at this forelock. What is interesting about these clauses is that they show how an anthropomorphic term can be applied either adverbially to "acts" or adjectivally to "things" without a difference in the sense of the term or of the sentences in which it is used. This sort of shift in the grammatical category of a term is clearly analogous to what is possible with respect to those anthropomorphic predicates applied to works of art in virtue of their artistic acts. Thus one may, without change of meaning, say either that Eliot's "Prufrock" is a compassionate poem or that Eliot portrays Prufrock compassionately in his poem; that Poussin paints his violent scene in an aloof, detached way or that the Sabine picture is an aloof, detached painting.[5]

This grammatical shift is possible in both sorts of cases because of the inseparability of the "act" and the "thing." One does not *infer* from a smile on a person's face that he is smiling any more than one *infers* that Eliot portrayed Prufrock compassionately from his compassionate poem, and for analogous reasons. The "acts" of smiling, pouting, shouting, tugging are not even describable without also and at once describing the smile, pout, shout, or tug. Smiling, after all, is not an act which produces or results in a smile so that something could interfere to prevent the smiling from bringing off the smile. "Smiling" and "smile," we are inclined to say, are simply two grammatically different ways of referring to the same "thing."[6]

Now the parallel I want to point out is not between smile-smiling, pout-pouting, tug-tugging, on the one hand, and poem-portraying, picture-(act of) painting, music-presenting, on the other. For clearly Poussin's Sabine painting is more than (is not simply identical with) Poussin's aloof way of painting the violent scene; Eliot's poem is more than his compassionate way of portraying its title character; Cage's music is more than his impersonal presentation of noise-like sounds. When we have described these artistic acts we have not by any means completely described the respective art works. The analogy rather is between smile-smiling and portrayal-portraying, presentation-presenting, treatment-treating, view-viewing, etc. Therefore, when we designate artistic acts by a noun term, those acts seem to be "parts" or "moments" of the works of art to which they pertain. We may then more properly understand the way in which an anthropomorphic adjective applies to an art work in virtue of such a "part" in something like the way in which a person's whole face is called sad in virtue merely of his sad smile or his sad gaze, or in which a person's behavior is generally angry in virtue (merely) of his quick movements and angry tone of voice. In these cases, too, it is not as if the terms "sad" and

[5]Of course it is true that sometimes when anthropomorphic terms are predicated of art works, they apply to subject matters and to "material" aspects of the work such as lines, colors, sounds, masses, etc., as well as to "artistic acts." My point above is only that anthropomorphic adjectives may be applied to a work only in virtue of an artistic act, in which case it is, without change of meaning, immediately applicable in adverbial form to that act.

[6]It is no objection to this assertion that in virtue of the natural lay of their faces some people have perpetual "smiles," "smirks," "pouts," etc., on their faces even when they do not smile, smirk, or pout. Of course, a "smile" of this sort is different from a smile; that is what the scare quotes signify. But even though a person with such a "smile" on his face is not thereby smiling, he is, significantly, "smiling."

"angry" *completely* described the face or the behavior or even all parts and aspects of the face and behavior even though they can *generally* characterize the face and the behavior.

The foregoing comparison points out that not only is it the case that anthropomorphic predicates do not always apply to art works the way predicates, anthropomorphic or not, apply to natural objects, but that sometimes anthropomorphic predicates apply to works of art rather like the way that they apply to verbal, gestural, and facial *expressions*. For sad smiles are characteristic expressions of sadness in a person; angry scowls, of anger; shy tugs at forelocks, of diffidence; sullen pouts, of petulance. And this is an all-important point which the Canonical Position has missed in its interpretation of the Expression Theory of Art. Had proponents of the Canonical Position pursued their inquiry into anthropomorphic predicates further, they would have been forced to question whether such predicates apply to art in the way they apply to objects or in the way they apply to common human expressions.

Instead of pursuing this line of questioning, however, they were misled by the noun-adjective form of their favorite example—sad music—into their object-quality interpretation of Expression Theory, an interpretation which of course makes that "theory" seem very far removed indeed from the "facts" which were alleged to have motivated it. Small wonder that Beardsley's final judgment on Expression Theory is that it "renders itself obsolete" after it has reminded us that anthropomorphic predicates may reasonably be applied to art works. Even O. K. Bouwsma, who of all the proponents of the Canonical Position comes closest to the point I am maintaining, was not able to see quite where his comparison between sad music and sad faces leads. For instead of making a transition from sad faces to sad *expressions* on faces, he takes the (rather longer) way from sad faces to red apples.

There is more to the comparison between artistic acts and facial, vocal, and gestural expressions than the formal or grammatical similarities just noted. Even more important are the parallels between the "significance" of things like sad smiles and angry scowls and the "significance" of aloofness or irony in paintings, sentimentality or compassion in poems, and impersonality or wittiness in music. For there are parallels between what facial, gestural and vocal expressions, on the one hand, and artistic acts, on the other, can tell us about the persons responsible for them. In order to draw out these parallels explicitly I shall use the cases of an angry scowl and a compassionate portrayal in the mode of Eliot's "Prufrock."

First, it is obvious that an angry scowl on a person's face might well mean that the person is angry. It might be more than simply an expression of anger; it might be an expression of *his* anger. Now it should need very little argument to show that a compassionate poem like "Prufrock" might be an expression of the poet's own compassion. He might be a person with a generally sympathetic and pitying attitude towards modern man and his situation. In that case, a poem like "Prufrock," at least a poem with "Prufrock's" kind of compassion, is precisely what one could expect from the poet, just as one could expect an angry man to scowl angrily. But just as we cannot reasonably expect that *every* time a person is angry he scowls angrily, we cannot expect that every man who is a poet and who has compassion towards his fellows will produce

poetry with the compassion of "Prufrock." If a man can keep his anger from showing in his face, a poet can, with whatever greater difficulties and whatever more interesting implications for himself and his poetry, keep his compassion from showing in his poetry.

Moreover, just as there is no necessity that a man's anger show in his face, there is no necessity that an angry scowl betoken anger in the scowler. There is a looseness of connection between anger and angry expressions which is matched by a looseness between compassion and compassionate poems. One reason that a man might have an angry scowl on his face is that he is *affecting* anger, for any of a number of reasons. Now although the range of reasons for affecting compassion in his poetry might be different from the range of reasons for affecting anger in his face, it is nevertheless possible that a corpus of poetry with "Prufrock's" sort of compassion might betoken nothing more than an affectation of compassion. This might be the case if, for example, the poet is extremely "hard" and sarcastic but thinks of these traits as defects. He might then quite deliberately write "compassionate" poetry in order to mask his true self and present himself to the world as the man he believes he should be.

On the other hand, both angry scowls and compassionate poetry might be the result simply of a desire to imitate. Children especially will often imitate expressions on people's faces, but even adults sometimes have occasion to imitate such expressions, e.g. in relating an anecdote. A poet might write poems with Eliot's sort of compassion in them in imitation of Eliot's early attitude. This imitation might be executed by a clever teacher in order to show more vividly than by merely pointing them out the means Eliot used to convey his special sympathy in "Prufrock." Or Eliot might be imitated because his techniques and style, together with the attitudes they imply, have become fashionable among serious poets or because these attitudes strike a responsive chord among serious poets. The latter sorts of imitation are rather like the imitations which a child might make of a person whom he regards as a model. It is not unusual for a girl who admires a female teacher, say, to practice smiling in that teacher's kind, gentle way or for a very young boy at play to "get angry" in the same way he has seen his father get angry.

A poet might write poems with the compassion of "Prufrock," not because he is either affecting or imitating the attitude of that poem, but because he is *practicing* writing poetry in different styles and different "moods." This may be just something like a technical exercise for him, or it may be part of a search for a characteristic attitude or stance which seems to be truly "his own." He thus "tries on" a number of different poetic "masks," so to speak, to see how they fit him. In a similar way, an adolescent girl grimacing before her mirror might "try on" various facial expressions to see how they "look on her" and to discover which is her "best," or perhaps her most characteristic face: innocent, sullen, sultry, haughty, or even angry.

Finally, an angry scowl on a face might be there when the person is portraying an angry person on the stage. There is a similar sort of situation in which compassionate poetry might be written not as betokening a characteristic of the poem's real author but as betokening the traits of a *character* in a play or novel who is *represented* as having written the poem. No actual examples of such a character come immediately to mind; but we surely have no

trouble imagining a master of stylistic imitation writing a novelized account of modern literature in which he exhibits examples of the "Prufrock"-like poetry of an Eliot-like figure.

What I have argued so far is not that all art is expression, nor even that all art works with artistic acts anthropomorphically qualified are expressions. My argument shows only that artistic acts in works of art are remarkably like common facial, vocal, and gestural expressions. It also demonstrates that precisely in virtue of their artistic acts and of the similarity they bear to common kinds of expressions, works of art may serve as expressions of those feelings, emotions, attitudes, moods, and/or personal characteristics of their creators which are designated by the anthropomorphic predicates applicable to the art works themselves. And it thereby demonstrates that one presupposition of the Canonical Position is clearly wrong: namely, that art works, insofar as they allow of anthropomorphic predicates, are essentially like natural things untouched by man.

But the second presupposition of the Canonical Position, to wit, that anthropomorphic predicates of art are like simple color words, is also false. It is false with respect to all of the three ways, distinguished earlier, that anthropomorphic predicates can be applied to works of art. And it is *a fortiori* false with respect to those predicates which are applied to art in two or three ways at once, as most of them are. The falsity of the presupposition can be brought out in an interesting way by showing how the three ways of applying anthropomorphic predicates to art bear a certain resemblance to color attributions which are rather unlike simply calling a (clearly) red rose red or an (indubitably) green hill green.

Suppose that a sign painter is painting a sign in three colors: yellow, red, and blue. Since the sign is large, he is required to move his equipment several times during the job. Suppose that he employs an assistant to attend to this business. Now we can imagine that the painter will have occasion to give directions to his assistant. He might say, "Bring me the red bucket, but leave the blue and yellow ones there, since I'll need them on that side later." Now if we suppose that the color of all the paint containers is black, when the painter calls for the "red bucket," he must mean "the bucket of red paint," and would surely be so understood by his assistant. In the context the phrase "red bucket" only *appears* to have the same grammatical form as "red rose." I suggest that to the extent that a painting or other representational work of art is called "gay" or "sad" solely in virtue of its subject matter or parts thereof, the latter terms function *more* like "red" in "red bucket" than in "red rose."

It is a common opinion that "sad" in "sad smile" and "gay" in "gay laughter" function metaphorically.[7] There may well be a use of "metaphor" such

[7]Nelson Goodman's recent theory of expression seems to depend rather heavily on the opinion that such uses of anthropomorphic predicates are metaphorical. As far as I can tell, however, Goodman merely asserts and does not argue for this opinion. Nor does he offer anything more than the briefest sketch of a theory of metaphor, which could be used to support his assertion. See his *Languages of Art: An Approach to a Theory of Symbols* (Indianapolis: Bobbs-Merrill, 1968), pp. 50–51, 80–95.

that the opinion is true. Whether there is such a use will not be determined until there exists a thorough philosophical study of metaphor; and I do not intend to offer one here. But even if it turns out to be true that such uses of anthropomorphic words are metaphorical, it cannot be very useful simply to say it. For such uses *appear* not to be metaphorical at all. After all, it is not as if calling a smile sad were representing the smile as, as it were, feeling sad, acting sad, weeping and dragging its feet. To see a smile's sadness is not to discern the tenuous and subtle "likeness" between the smile and a sad person. It is much more straightforward to think that a smile is sad because it is a smile *characteristic* of a sad person who smiles; that laughter is gay because such laughter is *characteristic* laughter of persons who are gay. In this respect "sad smile" is rather like "six-year-old behavior" or "Slavic cheekbones." These phrases do not indirectly point to unexpected similarities between a sort of behavior and six-year-old children or between cheekbones and persons. They designate, respectively, behavior which is *characteristic* of six-year-old children and cheekbones *characteristic* of Slavs. And there is no inclination at all to call these phrases "metaphorical."

Yet to say that a sad smile is a smile characteristic of sad people is not to deny what the Canonical Position affirms, namely, that "sad" designates a "property" or "character" of the smile. Surely there is something about the smile which marks it as sad: its droopiness, its weakness, its wanness. But the term "sad" still has a different import from "droopy," "weak," or "wan" when applied to smiles, even though all the latter terms are also characteristic smiles of sad persons. The difference is that the term "sad" *explicitly* relates the character of the smile to sadness of persons. A comparable sort of color term might be "cherry red." "Cherry red" is like the term "bright red with bluish undertones" in that they both designate roughly the same shade of red, which is characteristic of cherries. But the former term is unlike the latter in that it *explicitly* relates the color to cherries.

It might seem that the Canonical Position would be correct in its interpretation of anthropomorphic terms as they apply to those features of works of art which they can share with natural things. For the term "sad" applied to the second movement of the "Eroica" and to a weeping willow must surely denote some properties of the music and of the tree. And they do: drooping branches in the tree; slow rhythm and "heavy" sound in the Beethoven. But "sad" differs from "drooping," "slow," and "heavy" as in the preceding case; it immediately relates the properties of the sounds and the branches to properties of other things which are sad. In these cases "sad" does function metaphorically, harboring, as it were, a comparison within itself. To find an analogy among color words, this use of "sad" is like "reddish." Like "reddish," which quite self-consciously does not denote true redness, "sad" in "sad tree" does not denote true sadness but only a kind of likeness of it. This use of "sad" is also arguably analogous to the use of "red" in "His face turned red with shame." But whether "sad tree" and "sad rhythm" are closer to "reddish clay" or to "red face" is, if determinable at all, unimportant for my point. For "reddish clay" and "red face" are equally unlike "red rose" and "red apple" when the latter refer to a full-blown American Beauty and a ripe Washington Delicious.

In this section I have argued that anthropomorphic terms, when applied to art, are *more* like "red" in "red bucket (of paint)," "cherry red" in "cherry red silk," or "reddish" in "reddish clay" than like "red" in "red rose." But, in truth, anthropomorphic predicates of art are not *very* much like any of these. The reason is that what all anthropomorphic predicates ultimately relate to are human emotions, feelings, attitudes, moods, and personal traits, none of which are very much at all like colors. But there is point in drawing out the comparison between anthropomorphic predicates and color-terms more complicated than "red" in "red rose." The point is that "red" as applied to bucket, "cherry red," and "reddish" are all in some way relational terms in ways that "red" said of a rose is not. "Red bucket" means "bucket *of* red paint"; "cherry red" means "the red *characteristic of* cherries"; and "reddish" means "of a color *rather like* red." Had proponents of the Canonical Position troubled to refine their comparison between anthropomorphic predicates and color predicates, they might have been forced to recognize the relational aspects of the former. Eventually they might have been led to see that anthropomorphic terms finally relate to various forms of the "inner lives" of human beings. And *that* is where Expression Theory begins. The Canonical model of the red rose (or apple) ultimately fails to help us understand how anthropomorphic predicates apply to art because such predicates are not very much like simple quality-words and what they apply to are not very much like natural objects.

In spite of all the above arguments, the Canonical Position is not left utterly defenseless. Although it is the notion of "artistic acts" which is most threatening to the Canonical Position, proponents of that position have been almost totally unaware of this threat. Not totally unaware, however. There is a brief passage in Monroe Beardsley's book *Aesthetics: Problems in the Philosophy of Criticism* in which he mentions an artist's "treatment" and "handling," two examples of what I have called "artistic acts." Beardsley does not relate them, however, to the analysis of anthropomorphic terms. He discusses them under the rubric "misleading idioms," and he suggests that all talk about art concerning "handling" and "treatment" not only can be but should be translated into talk which makes no mention of these sorts of acts.[8]

These are meager clues, but from them it is possible to excogitate an objection to my notion of "artistic arts" which a defender of the Canonical Position might raise. We should first note a remark which Beardsley makes elsewhere in his book when he is concluding his interpretation of Expression Theory. He states that all remarks about the expressiveness of an art work can be "translated" into statements about the anthropomorphic qualities either of the subject matter or of the "design," i.e., roughly the properties which the work could share with natural things.[9] A defense against the notion of "artistic acts" might thus run as follows: Any statement which describes an artistic act anthropomorphically can be "translated" into a statement which describes features of the work of art other than its artistic acts. So stated, however, the defense is ambiguous; it has two plausible and interesting interpretations. First, it might

[8]Beardsley, *Aesthetics*, pp. 80 ff.
[9]*Ibid.*, p. 332.

mean that any anthropomorphic description of an artistic act in a work can be replaced, without loss of meaning, by a description of the subject matter and/or design of the work in terms of the same anthropomorphic predicate. Or it might mean that there are descriptions, of whatever sort, of the subject matter and/or design of a work which, given any true anthropomorphic description of an artistic act in that work, entail that description.

The first interpretation of the objection is easily shown to be false. All that is required is that some examples of art be adduced in which anthropomorphic predicates are applicable with some plausibility to an "artistic act" but which are in no other way plausibly attributable to the work. Let us look again at the works of Poussin, Eliot, and Prokoviev discussed earlier in this chapter.

In the Poussin painting of the rape of the Sabines there is nothing about the violent subject matter which could be called "aloof." Certainly the attackers and the attacked are not aloof. Romulus, the general in charge, is a relatively *calm* surveyor of the melee, but he cannot be called aloof, partly because we cannot see him well enough to tell what his attitude is. "Aloof" does not apply with regard to the formal elements of the Poussin painting either. It is difficult even to imagine what "aloof" lines, masses, colors, or an "aloof" arrangement thereof might be. The light in the painting is rather cold, and that feature does indeed contribute to the aloofness of the work. "Cold light" is not, however, the same as "aloof light," which does not even appear to be a sensible combination of words.

A similar analysis is possible with respect to Eliot's "Prufrock." If we consider first the "material" elements of the poem—its rhythm, meter, sound qualities, etc.—we realize that "compassionate" simply cannot apply to those features meaningfully. Moreover, there is nothing about the subject matter of "Prufrock" which is compassionate. Certainly Prufrock himself is not compassionate; he is simply confused, a victim of his own fears and anxieties, and of the meanness and triviality of his routinized life and soulless companions.

Finally, the wittiness of Prokoviev's Grandfather theme cannot be supposed to be a "property" of the music the way its comic qualities are. The music is amusing, or comic, because the wheeziness of the bassoon is funny and because the melody imitates the "structure" of a funny movement (one *must* move in an amusing way to that melody). Moreover, although Grandfather himself is funny, he is definitely not witty. What is comical, amusing, or funny is not always witty. To be witty is generally to make, say, or do something comical, amusing, or funny "on purpose." That is why Prokoviev's musical *portrayal* of a comical grandfather is witty. Similar analyses of the Breughel painting, the Wordsworth poem and the Cage music mentioned previously could obviously be carried out. But the point, I take it, is already sufficiently well made.

The second interpretation of the hypothetical attack on the importance of artistic acts borrows any initial plausibility it possesses from the fact that anthropomorphic descriptions of artistic acts can be "explained" or "justified" in terms which neither mention artistic acts nor use any of the terms which describe them. For example, one might point out the irony in the Breughel painting discussed above by noting the combination of the gay scene and the dull faces of its participants. Or one might justify the "aloofness" he sees in

the Poussin by remarking on the cold light, clear lines, and statuesque poses in a scene of violence and turmoil. And in discussing the impersonality of *Variations II* it is necessary to mention that the Cage work sounds like accidentally produced noise, which is senseless and emotionally neutral, but that this noise-like sound is to all *other* appearances music, i.e. it is scored, it is performed on a musical instrument, it is even reproduced on recordings. From these facts about the way in which anthropomorphic descriptions are justified, it might seem plausible that the statements which figure in the justification *entail* the original description. But such is not the case, as the following will show.

It has been suggested that the reason that Breughel's peasant faces are dull and stupid-looking is that the painter was simply unable to paint faces which were happy. Whether the suggestion is true or well supported by the evidence is not an issue here. What is important is that were there any reason for believing Breughel to have been incompetent in that way, then there might be (not necessarily "would be") that much less reason for believing that there is irony in Breughel's *Wedding Dance.* That is because Breughel's incompetence and Breughel's irony *can* in this case function as mutually exclusive ways of accounting for a "discrepancy" in the picture. Of course, there are ways of admitting both the incompetence and the irony. It is possible to suppose, for example, that Breughel used his particular incompetence in making an ironic "statement" about peasant existence. Such a supposition would imply that Breughel was aware of his limitation and made use of it in his work. However, were it *known* that the *only* reason for the discrepancy in the painting was Breughel's incompetence, the "irony" would disappear. It makes no difference, incidentally, that such a thing could probably *never* be known. I am making a logical point regarding the way an attribution of a certain sort to an "artistic act" relates to other aspects of a painting like the Breughel. In short, certain facts about the painting's subject matter do indeed "ground" the attribution but by no means logically entail that attribution. And that is so for the good reason that the same facts about the subject matter are consistent with a supposition about Breughel which might be incompatible with the description of the painting as ironic.

A similar point can be illustrated in Poussin's Sabine painting. In that work there is a discrepancy between the violent scene, on the one hand, and the "still," clear figures, on the other. Two persons might agree about the character of the figures and the character of the depicted scene, however, and yet disagree whether these facts entail that Poussin painted the rape of the Sabines in an aloof, reserved way. One viewer might think simply that the work is incoherent, that Poussin's coldly classical means are not suited to the end he had in mind, namely, to depict the violence of the event. In this quite reasonable view, the discrepancy makes the painting "fall apart" rather than "add up" to an aloof and reserved point of view. Here then are two incompatible descriptions of a work which are equally well grounded on facts which allegedly "entail" one of the descriptions. I am mindful that it might be objected that there are other features of the Sabine painting than the ones mentioned which preclude the judgment of "incoherence" and necessitate the judgment of "aloofness." The best I can say is that there seem to me to be no

such additional features contributing to the "aloofness" of the painting and that the burden of proof is upon those who disagree.[10]

Finally, let us suppose that a devoted listener of traditional Western music scoffs at the description of Cage's *Variations II* as "impersonal music." He insists that it is nothing but what it sounds like—meaningless noise. He charges that Cage is a fraud whose "music" is a gigantic hoax, a put-on, and that Cage is laughing up his sleeve at those who take him seriously, perform his "scores," record the performances, and listen gravely to his nonsense. He has, the traditional listener says, read some of Cage's "ideological" material relating to his "music" but he has noted how laden with irony it is. To him that shows that Cage is not to be taken seriously because he does not take himself seriously. Now such a doubter does not disagree with the description of *Variations II* which is used to justify calling it "impersonal." The disagreement concerns rather the way we are to assess John Cage. Are we to judge him to be a responsible and serious, albeit radically innovative, composer of music or not? It is only when Cage's seriousness is assumed that the term "impersonality" applies to his music. Otherwise, the aforementioned justification for calling it impersonal is equally justification for calling it nonsense.

What the above three cases demonstrate is that a true anthropomorphic description of an artistic act might presuppose conditions having nothing necessarily to do with the way the formal elements and/or subject matter are describable. The conditions mentioned are (1) the competence of the artist, (2) the coherence of the work, (3) the seriousness of the artist. But there are surely other examples which would bring light to other conditions of this sort. With sufficient ingenuity one could likely discover and/or construct examples of art in which anthropomorphic descriptions of artistic acts would or would not be applicable depending upon how one assessed the artist with respect to, say, his maturity, his sanity, his self-consciousness, his sensitivity, or his intelligence.

Now it is probably too rigid to regard "competence," "coherence," "seriousness," "maturity," "sanity," and the rest as denoting necessary *conditions* for the legitimate description of all artistic arts. It is probably not true that the artist *must* be serious, competent, sane, etc., and that the work *must* be coherent in order for any anthropomorphic description (of an artistic act) to apply to any work. What these terms should be taken as denoting are "parameters" according to which an artist or a work can be measured in whatever respect is relevant in a particular case. To do so would be to admit that there is probably not a single set of particular conditions of these sorts presupposed in *all* descriptions of artistic acts. Naming these parameters simply points out the *sorts* of considerations which *might* be relevant in particular descriptions of artistic acts, leaving it an open question which of these parameters are relevant, and to what degree, in particular cases.

In any event, what the recognition of such parameters means is that any

[10]These statements commit me to the position that a positive judgment about the Poussin cannot be deduced from any descriptions of the painting of the sort which "ground" its aloofness. For arguments in favor of this general position see my "Subjectivity and Justification in Aesthetic Judgments," *Journal of Aesthetics and Art Criticism*, XXVII (1968), 3–12.

attempt to save the Canonical Position by "eliminating" descriptions of artistic acts in favor of "logically equivalent" descriptions of formal elements and/or represented subject matter is doomed to fail. For the description of artistic acts in anthropomorphic terms does presuppose something about the artist which cannot be known *simply* by attending to his art. A similar point holds with respect to common expressions. The look of a sullen pout on a person's face does not mean that the person is pouting sullenly if we discover that the look results from the natural lay of his face. And thus it is that no description simply of the configuration of the person's face can *entail* the statement that the person is pouting sullenly.

But it is equally true that the assertion that a person is pouting sullenly is incompatible with the claim that the person's face has the same configuration as it does when he is not pouting sullenly. The sullen pout *must* make a difference visible on the face. Analogously, for an anthropomorphic predicate of an artistic act to be applicable to a work of art there *must* be *some* features of the material elements and/or the subject of the work which *justify* the attribution of the term, even though they do not *entail* that attribution. One thing, however, is never presupposed or implied when an anthropomorphic predicate is truly applied to a work, namely, that the predicate is truly applicable to the *artist*. In this, too, works of art are like expressions.

THE PROJECT OF DEFINITION

READING 14

INTRODUCTION

Morris Weitz's essay "The Role of Theory in Aesthetics" (1956) is one of the most important statements of "anti-essentialism" in the philosophy of art. In this essay, Weitz argues that the traditional project of attempting to define art, represented for example in the work of Bell and Collingwood, is radically misconceived. Weitz's argument was influenced by the writings of Ludwig Wittgenstein. In his *Philosophical Investigations* (Oxford, 1953), Wittgenstein considers the concept "game" and argues that there is no one feature or set of features common to all games which *makes* them games. That is, Wittgenstein suggests, the concept "game" is not one we apply to activities by appeal to necessary and sufficient conditions. Rather, when we look at the variety of activities that we call "games," we find "a complicated network of similarities overlapping and criss-crossing"—and it is by appeal to such similarities and resemblances that we call these different activities "games." In "The Role of Theory in Aesthetics," Weitz applies Wittgenstein's ideas to the concept "art," drawing the conclusion that "art" (as well as concepts such as "novel" and "tragedy") is, like "game," an *open* concept; a concept the application of which is not fixed by appeal to necessary and sufficient conditions, but which is always open to change as we are struck by new resemblances and similarities between the things that we *do* call art and the things that we *might* call art. Weitz concludes, then, that art cannot be defined; but he does not thereby conclude that all the theories which have attempted to define art are useless. Instead, he suggests that we should understand them "as serious and argued-for recommendations to concentrate on certain criteria of excellence in art."

"The Role of Theory in Aesthetics"

Morris Weitz

Theory has been central in aesthetics and is still the preoccupation of the philosophy of art. Its main avowed concern remains the determination of the nature of art which can be formulated into a definition of it. It construes definition as the statement of the necessary and sufficient properties of what is being defined, where the statement purports to be a true or false claim about the essence of art, what characterizes and distinguishes it from everything else. Each of the great theories of art—Formalism, Voluntarism, Emotionalism,

Intellectualism, Intuitionism, Organicism—converges on the attempt to state the defining properties of art. Each claims that it is the true theory because it has formulated correctly into a real definition the nature of art; and that the others are false because they have left out some necessary or sufficient property. Many theorists contend that their enterprise is no mere intellectual exercise but an absolute necessity for any understanding of art and our proper evaluation of it. Unless we know what art is, they say, what are its necessary and sufficient properties, we cannot begin to respond to it adequately or to say why one work is good or better than another. Aesthetic theory, thus, is important not only in itself but for the foundations of both appreciation and criticism. Philosophers, critics, and even artists who have written on art, agree that what is primary in aesthetics is a theory about the nature of art.

Is aesthetic theory, in the sense of a true definition or set of necessary and sufficient properties of art, possible? If nothing else does, the history of aesthetics itself should give one enormous pause here. For, in spite of the many theories, we seem no nearer our goal today than we were in Plato's time. Each age, each art-movement, each philosophy of art, tries over and over again to establish the stated ideal only to be succeeded by a new or revised theory, rooted, at least in part, in the repudiation of preceding ones. Even today, almost everyone interested in aesthetic matters is still deeply wedded to the hope that the correct theory of art is forthcoming. We need only examine the numerous new books on art in which new definitions are proffered; or, in our own country especially, the basic textbooks and anthologies to recognize how strong the priority of a theory of art is.

In this essay I want to plead for the rejection of this problem. I want to show that theory—in the requisite classical sense—is *never* forthcoming in aesthetics, and that we would do much better as philosophers to supplant the question, "What is the nature of art?," by other questions, the answers to which will provide us with all the understanding of the arts there can be. I want to show that the inadequacies of the theories are not primarily occasioned by any legitimate difficulty such, e.g., as the vast complexity of art, which might be corrected by further probing and research. Their basic inadequacies reside instead in a fundamental misconception of art. Aesthetic theory—all of it—is wrong in principle in thinking that a correct theory is possible because it radically misconstrues the logic of the concept of art. Its main contention that "art" is amenable to real or any kind of true definition is false. Its attempt to discover the necessary and sufficient properties of art is logically misbegotten for the very simple reason that such a set and, consequently, such a formula about it, is never forthcoming. Art, as the logic of the concept shows, has no set of necessary and sufficient properties; hence a theory of it is logically impossible and not merely factually difficult. Aesthetic theory tries to define what cannot be defined in its requisite sense. But in recommending the repudiation of aesthetic theory I shall not argue from this, as too many others have done, that its logical confusions render it meaningless or worthless. On the contrary, I wish to reassess its role and its contribution primarily in order to show that it is of the greatest importance to our understanding of the arts.

Let us now survey briefly some of the more famous extant aesthetic theories in order to see if they do incorporate correct and adequate statements about the nature of art. In each of these there is the assumption that it is the

true enumeration of the defining properties of art, with the implication that previous theories have stressed wrong definitions. Thus, to begin with, consider a famous version of Formalist theory, that propounded by Bell and Fry. It is true that they speak mostly of painting in their writings but both assert that what they find in that art can be generalized for what is "art" in the others as well. The essence of painting, they maintain, are the plastic elements in relation. Its defining property is significant form, i.e., certain combinations of lines, colors, shapes, volumes—everything on the canvas except the representational elements—which evoke a unique response to such combinations. Painting is definable as plastic organization. The nature of art, what it *really* is, so their theory goes, is a unique combination of certain elements (the specifiable plastic ones) in their relations. Anything which is art is an instance of significant form; and anything which is not art has no such form.

To this the Emotionalist replies that the truly essential property of art has been left out. Tolstoy, Ducasse, or any of the advocates of this theory, find that the requisite defining property is not significant form but rather the expression of emotion in some sensuous public medium. Without projection of emotion into some piece of stone or words or sounds, etc., there can be no art. Art is really such embodiment. It is this that uniquely characterizes art, and any true, real definition of it, contained in some adequate theory of art, must so state it.

The Intuitionist disclaims both emotion and form as defining properties. In Croce's version, for example, art is identified not with some physical, public object but with a specific creative, cognitive and spiritual art. Art is really a first stage of knowledge in which certain human beings (artists) bring their images and intuitions into lyrical clarification or expression. As such, it is an awareness, non-conceptual in character, of the unique individuality of things; and since it exists below the level of conceptualization or action, it is without scientific or moral content. Croce singles out as the defining essence of art this first stage of spiritual life and advances its identification with art as a philosophically true theory or definition.

The Organicist says to all of this that art is really a class of organic wholes consisting of distinguishable, albeit inseparable, elements in their causally efficacious relations which are presented in some sensuous medium. In A. C. Bradley, in piece-meal versions of it in literary criticism, or in my own generalized adaptation of it in my *Philosophy of the Arts,* what is claimed is that anything which is a work of art is in its nature a unique complex of interrelated parts—in painting, for example, lines, colors, volumes, subjects, etc., all interacting upon one another on a paint surface of some sort. Certainly, at one time at least it seemed to me that this organic theory constituted the one true and real definition of art.

My final example is the most interesting of all, logically speaking. This is the Voluntarist theory of Parker. In his writings on art, Parker persistently calls into question the traditional simple-minded definitions of aesthetics. "The assumption underlying every philosophy of art is the existence of some common nature present in all the arts."[1] "All the so popular brief definitions of

[1]D. Parker, "The Nature of Art," reprinted in E. Vivas and M. Krieger, *The Problems of Aesthetics* (N.Y., 1953), p. 90.

art—'significant form,' 'expression,' 'intuition,' 'objectified pleasure'—are fallacious, either because, while true of art, they are also true of much that is not art, and hence fail to differentiate art from other things; or else because they neglect some essential aspect of art."[2] But instead of inveighing against the attempt at definition of art itself, Parker insists that what is needed is a complex definition rather than a simple one. "The definition of art must therefore be in terms of a complex of characteristics. Failure to recognize this has been the fault of all the well-known definitions."[3] His own version of Voluntarism is the theory that art is essentially three things: embodiment of wishes and desires imaginatively satisfied, language, which characterizes the public medium of art, and harmony, which unifies the language with the layers of imaginative projections. Thus, for Parker, it is a true definition to say of art that it is ". . . the provision of satisfaction through the imagination, social significance, and harmony. I am claiming that nothing except works of art possesses all three of these marks."[4]

Now, all of these sample theories are inadequate in many different ways. Each purports to be a complete statement about the defining features of all works of art and yet each of them leaves out something which the others take to be central. Some are circular, e.g., the Bell-Fry theory of art as significant form which is defined in part in terms of our response to significant form. Some of them, in their search for necessary and sufficient properties, emphasize too few properties, like (again) the Bell-Fry definition, which leaves out subject-representation in painting, or the Croce theory, which omits inclusion of the very important feature of the public, physical character, say, of architecture. Others are too general and cover objects that are not art as well as works of art. Organicism is surely such a view since it can be applied to *any* causal unity in the natural world as well as to art.[5] Still others rest on dubious principles, e.g., Parker's claim that art embodies imaginative satisfactions, rather than real ones; or Croce's assertion that there is nonconceptual knowledge. Consequently, even if art has one set of necessary and sufficient properties, none of the theories we have noted, or, for that matter, no aesthetic theory yet proposed, has enumerated that set to the satisfaction of all concerned.

Then there is a different sort of difficulty. As real definitions, these theories are supposed to be factual reports on art. If they are, may we not ask, Are they empirical and open to verification or falsification? For example, what would confirm or disconfirm the theory that art is significant form or embodiment of emotion or creative synthesis of images? There does not even seem to be a hint of the kind of evidence which might be forthcoming to test these theories; and indeed one wonders if they are perhaps honorific definitions of "art," that is, proposed redefinitions in terms of some *chosen* conditions for applying the concept of art, and not true or false reports on the essential properties of art at all.

[2]*Ibid.*, pp. 93–94.
[3]*Ibid.*, p. 94.
[4]*Ibid.*, p. 104.
[5]See M. Macdonald's review of my *Philosophy of the Arts, Mind*, Oct. 1951, pp. 561–564, for a brilliant discussion of this objection to the Organic theory.

But all these criticisms of traditional aesthetic theories—that they are circular, incomplete, untestable, pseudo-factual, disguised proposals to change the meaning of concepts—have been made before. My intention is to go beyond these to make a much more fundamental criticism, namely, that aesthetic theory is a logically vain attempt to define what cannot be defined, to state the necessary and sufficient properties of that which has no necessary and sufficient properties, to conceive the concept of art as closed when its very use reveals and demands its openness.

The problem with which we must begin is not "What is art?," but "What sort of concept is 'art'?" Indeed, the root problem of philosophy itself is to explain the relation between the employment of certain kinds of concepts and the conditions under which they can be correctly applied. If I may paraphrase Wittgenstein, we must not ask, What is the nature of any philosophical x?, or even, according to the semanticist, What does "x" mean?, a transformation that leads to the disastrous interpretation of "art" as a name for some specifiable class of objects; but rather, What is the use or employment of "x"? What does "x" do in the language? This, I take it, is the initial question, the begin-all if not the end-all of any philosophical problem and solution. Thus, in aesthetics, our first problem is the elucidation of the actual employment of the concept of art, to give a logical description of the actual functioning of the concept, including a description of the conditions under which we correctly use it or its correlates.

My model in this type of logical description or philosophy derives from Wittgenstein. It is also he who, in his refutation of philosophical theorizing in the sense of constructing definitions of philosophical entities, has furnished contemporary aesthetics with a starting point for any future progress. In his new work, *Philosophical Investigations*,[6] Wittgenstein raises as an illustrative question, What is a game? The traditional philosophical, theoretical answer would be in terms of some exhaustive set of properties common to all games. To this Wittgenstein says, let us consider what we call "games": "I mean board-games, card-games, ball-games, Olympic games, and so on. What is common to them all?—Don't say: 'there *must* be something common, or they would not be called "games" ' but *look and see* whether there is anything common to all.—For if you look at them you will not see something that is common to *all*, but similarities, relationships, and a whole series of them at that. . . ."

Card games are like board games in some respects but not in others. Not all games are amusing, nor is there always winning or losing or competition. Some games resemble others in some respects—that is all. What we find are no necessary and sufficient properties, only "a complicated network of similarities overlapping and crisscrossing," such that we can say of games that they form a family with family resemblances and no common trait. If one asks what a game is, we pick out sample games, describe these, and add, "This and *similar things* are called 'games.' " This is all we need to say and indeed all any of

[6]L. Wittgenstein, *Philosophical Investigations* (Oxford, 1953), tr. E. Anscombe; see esp. Part I, Sec. 65–75. All quotations are from these sections.

us knows about games. Knowing what a game is is not knowing some real definition or theory but being able to recognize and explain games and to decide which among imaginary and new examples would or would not be called "games."

The problem of the nature of art is like that of the nature of games, at least in these respects: If we actually look and see what it is that we call "art," we will also find no common properties—only strands of similarities. Knowing what art is not apprehending some manifest or latent essence but being able to recognize, describe, and explain those things we call "art" in virtue of these similarities.

But the basic resemblance between these concepts is their open texture. In elucidating them, certain (paradigm) cases can be given, about which there can be no question as to their being correctly described as "art" or "game," but no exhaustive set of cases can be given. I can list some cases and some conditions under which I can apply correctly the concept of art but I cannot list all of them, for the all-important reason that unforeseeable or novel conditions are always forthcoming or envisageable.

A concept is open if its conditions of application are emendable and corrigible; i.e., if a situation or case can be imagined or secured which would call for some sort of *decision* on our part to extend the use of the concept to cover this, or to close the concept and invent a new one to deal with the new case and its new property. If necessary and sufficient conditions for the application of a concept can be stated, the concept is a closed one. But this can happen only in logic or mathematics where concepts are constructed and completely defined. It cannot occur with empirically-descriptive and normative concepts unless we arbitrarily close them by stipulating the ranges of their uses.

I can illustrate this open character of "art" best by examples drawn from its sub-concepts. Consider questions like "Is Dos Passos' *U.S.A.* a novel?," "Is V. Woolf's *To the Lighthouse* a novel?" "Is Joyce's *Finnegan's Wake* a novel?" On the traditional view, these are construed as factual problems to be answered yes or no in accordance with the presence or absence of defining properties. But certainly this is not how any of these questions is answered. Once it arises, as it has many times in the development of the novel from Richardson to Joyce (e.g., "Is Gide's *The School for Wives* a novel or a diary?"), what is at stake is no factual analysis concerning necessary and sufficient properties but a decision as to whether the work under examination is similar in certain respects to other works, already called "novels," and consequently warrants the extension of the concept to cover the new case. The new work is narrative, fictional, contains character delineation and dialogue but (say) it has no regular time-sequence in the plot or is interspersed with actual newspaper reports. It is like recognized novels, A, B, C . . . , in some respects but not like them in others. But then neither were B and C like A in some respects when it was decided to extend the concept applied to A to B and C. Because work N + 1 (the brand new work) is like A, B, C, . . . N in certain respects—has strands of similarity to them—the concept is extended and a new phase of the novel engendered. "Is N + 1 a novel?," then, is no factual, but rather a decision problem, where the verdict turns on whether or not we enlarge our set of conditions for applying the concept.

What is true of the novel is, I think, true of every sub-concept of art: "tragedy," "comedy," "painting," "opera," etc., of "art" itself. No "Is X a novel, painting, opera, work of art, etc.?" question allows of a definitive answer in the sense of a factual yes or no report. "Is this *collage* a painting or not?" does not rest on any set of necessary and sufficient properties of painting but on whether we decide—as we did!—to extend "painting" to cover this case.

"Art," itself, is an open concept. New conditions (cases) have constantly arisen and will undoubtedly constantly arise; new art forms, new movements will emerge, which will demand decisions on the part of those interested, usually professional critics, as to whether the concept should be extended or not. Aestheticians may lay down similarity conditions but never necessary and sufficient ones for the correct application of the concept. With "art" its conditions of application can never be exhaustively enumerated since new cases can always be envisaged or created by artists, or even nature, which would call for a decision on someone's part to extend or to close the old or to invent a new concept. (E.g., "It's not a sculpture, it's a mobile.")

What I am arguing, then, is that the very expansive, adventurous character of art, its ever-present changes and novel creations, makes it logically impossible to ensure any set of defining properties. We can, of course, choose to close the concept. But to do this with "art" or "tragedy" or "portraiture," etc., is ludicrous since it forecloses on the very conditions of creativity in the arts.

Of course there are legitimate and serviceable closed concepts in art. But these are always those whose boundaries of conditions have been drawn for a *special* purpose. Consider the difference, for example, between "tragedy" and "(extant) Greek tragedy." The first is open and must remain so to allow for the possibility of new conditions, e.g., a play in which the hero is not noble or fallen or in which there is no hero but other elements that are like those of plays we already call "tragedy." The second is closed. The plays it can be applied to, the conditions under which it can be correctly used are all in, once the boundary, "Greek," is drawn. Here the critic can work out a theory or real definition in which he lists the common properties at least of the extant Greek tragedies. Aristotle's definition, false as it is as a theory of all the plays of Aeschylus, Sophocles, and Euripides, since it does not cover some of them,[7] properly called "tragedies," can be interpreted as a real (albeit incorrect) definition of this closed concept; although it can also be, as it unfortunately has been, conceived as a purported real definition of "tragedy," in which case it suffers from the logical mistake of trying to define what cannot be defined— of trying to squeeze what is an open concept into an honorific formula for a closed concept.

What is supremely important, if the critic is not to become muddled, is to get absolutely clear about the way in which he conceives his concepts; otherwise he goes from the problem of trying to define "tragedy," etc., to an arbitrary closing of the concept in terms of certain preferred conditions or characteristics which he sums up in some linguistic recommendation that he mistakenly thinks is a real definition of the open concept. Thus, many critics

[7]See H. D. F. Kitto, *Greek Tragedy* (London, 1939), on this point.

and aestheticians ask, "What is tragedy?," choose a class of samples for which they may give a true account of its common properties, and then go on to construe this account of the chosen closed class as a true definition or theory of the whole open class of tragedy. This, I think, is the logical mechanism of most of the so-called theories of the sub-concepts of art: "tragedy," "comedy," "novel," etc. In effect, this whole procedure, subtly deceptive as it is, amounts to a transformation of correct criteria for *recognizing* members of certain legitimately closed classes of works of art into recommended criteria for *evaluating* any putative member of the class.

The primary task of aesthetics is not to seek a theory but to elucidate the concept of art. Specifically, it is to describe the conditions under which we employ the concept correctly. Definition, reconstruction, patterns of analysis are out of place here since they distort and add nothing to our understanding of art. What, then, is the logic of "X is a work of art"?

As we actually use the concept, "Art" is both descriptive (like "chair") and evaluative (like "good"); i.e., we sometimes say, "This is a work of art," to describe something and we sometimes say it to evaluate something. Neither use surprises anyone.

What, first, is the logic of "X is a work of art," when it is a descriptive utterance? What are the conditions under which we would be making such an utterance correctly? There are no necessary and sufficient conditions but there are the strands of similarity conditions, i.e., bundles of properties, none of which need be present but most of which are, when we describe things as works of art. I shall call these the "criteria of recognition" of works of art. All of these have served as the defining criteria of the individual traditional theories of art; so we are already familiar with them. Thus, mostly, when we describe something as a work of art, we do so under the conditions of there being present some sort of artifact, made by human skill, ingenuity, and imagination, which embodies in its sensuous, public medium—stone, wood, sounds, words, etc.—certain distinguishable elements and relations. Special theorists would add conditions like satisfaction of wishes, objectification or expression of emotion, some act of empathy, and so on; but these latter conditions seem to be quite adventitious, present to some but not to other spectators when things are described as works of art. "X is a work of art and contains *no* emotion, expression, act of empathy, satisfaction, etc.," is perfectly good sense and may frequently be true. "X is a work of art and . . . was made by no one," or ". . . exists only in the mind and not in any publicly observable thing," or ". . . was made by accident when he spilled the paint on the canvas," in each case of which a normal condition is denied, are also sensible and capable of being true in certain circumstances. None of the criteria of recognition is a defining one, either necessary or sufficient, because we can sometimes assert of something that it is a work of art and go on to deny any one of these conditions, even the one which has traditionally been taken to be basic, namely, that of being an artifact: Consider, "This piece of driftwood is a lovely piece of sculpture." Thus, to say of anything that it is a work of art is to commit oneself to the presence of *some* of these conditions. One would scarcely describe X as a work of art if X were not an artifact, or a collection of elements

sensuously presented in a medium, or a product of human skill, and so on. If none of the conditions were present, if there were no criteria present for recognizing something as a work of art, we would not describe it as one. But, even so, no one of these or any collection of them is either necessary or sufficient.

The elucidation of the descriptive use of "Art" creates little difficulty. But the elucidation of the evaluative use does. For many, especially theorists, "This is a work of art" does more than describe; it also praises. Its conditions of utterance, therefore, include certain preferred properties or characteristics of art. I shall call these "criteria of evaluation." Consider a typical example of this evaluative use, the view according to which to say of something that it is a work of art is to imply that it is a *successful* harmonization of elements. Many of the honorific definitions of art and its sub-concepts are of this form. What is at stake here is that "Art" is construed as an evaluative term which is either identified with its criterion or justified in terms of it. "Art" is defined in terms of its evaluative property, e.g., successful harmonization. On such a view, to say "X is a work of art" is (1) to say something which is taken *to mean* "X is a successful harmonization" (e.g., "Art *is* significant form") or (2) to say something praiseworthy *on the basis* of its successful harmonization. Theorists are never clear whether it is (1) or (2) which is being put forward. Most of them, concerned as they are with this evaluative use, formulate (2), i.e., that feature of art that *makes* it art in the praise-sense, and then go on to state (1), i.e., the definition of "Art" in terms of its art-making feature. And this is clearly to confuse the conditions under which we say something evaluatively with the meaning of what we say. "This is a work of art," said evaluatively, cannot mean "This is a successful harmonization of elements"—except by stipulation—but at most is said in virtue of the art-making property, which is taken as a (the) criterion of "Art," when "Art" is employed to assess. "This is a work of art," used evaluatively, serves to praise and not to affirm the reason why it is said.

The evaluative use of "Art," although distinct from the conditions of its use, relates in a very intimate way to these conditions. For, in every instance of "This is a work of art" (used to praise), what happens is that the criterion of evaluation (e.g., successful harmonization) for the employment of the concept of art is converted into a criterion of recognition. This is why, on its evaluative use, "This is a work of art" implies "This has P," where "P" is some chosen art-making property. Thus, if one chooses to employ "Art" evaluatively, as many do, so that "This is a work of art and not (aesthetically) good" makes no sense, he uses "Art" in such a way that he refuses to *call* anything a work of art unless it embodies his criterion of excellence.

There is nothing wrong with the evaluative use; in fact, there is good reason for using "Art" to praise. But what cannot be maintained is that theories of the evaluative use of "Art" are true and real definitions of the necessary and sufficient properties of art. Instead they are honorific definitions, pure and simple, in which "Art" has been redefined in terms of chosen criteria.

But what makes them—these honorific definitions—so supremely valuable is not their disguised linguistic recommendations; rather it is the *debates* over the reasons for changing the criteria of the concept of art which are built into

the definitions. In each of the great theories of art, whether correctly understood as honorific definitions or incorrectly accepted as real definitions, what is of the utmost importance are the reasons proffered in the argument for the respective theory, that is, the reasons given for the chosen or preferred criterion of excellence and evaluation. It is this perennial debate over these criteria of evaluation which makes the history of aesthetic theory the important study it is. The value of each of the theories resides in its attempt to state and to justify certain criteria which are either neglected or distorted by previous theories. Look at the Bell-Fry theory again. Of course, "Art is significant form" cannot be accepted as a true, real definition of art; and most certainly it actually functions in their aesthetics as a redefinition of art in terms of the chosen condition of significant form. But what gives it its aesthetic importance is what lies behind the formula: In an age in which literary and representational elements have become paramount in painting, *return* to the plastic ones since these are indigenous to painting. Thus, the role of the theory is not to define anything but to use the definitional form, almost epigrammatically, to pinpoint a crucial recommendation to turn our attention once again to the plastic elements in painting.

Once we, as philosophers, understand this distinction between the formula and what lies behind it, it behooves us to deal generously with the traditional theories of art; because incorporated in every one of them is a debate over and argument for emphasizing or centering upon some particular feature of art which has been neglected or perverted. If we take the aesthetic theories literally, as we have seen, they all fail; but if we reconstrue them, in terms of their function and point, as serious and argued-for recommendations to concentrate on certain criteria of excellence in art, we shall see that aesthetic theory is far from worthless. Indeed, it becomes as central as anything in aesthetics, in our understanding of art, for it teaches us what to look for and how to look at it in art. What is central and must be articulated in all the theories are their debates over the reasons for excellence in art—debates over emotional depth, profound truths, natural beauty, exactitude, freshness of treatment, and so on, as criteria of evaluation—the whole of which converges on the perennial problem of what makes a work of art good. To understand the role of aesthetic theory is not to conceive it as definition, logically doomed to failure, but to read it as summaries of seriously made recommendations to attend in certain ways to certain features of art.

READING 15

INTRODUCTION

In "Family Resemblances and Generalizations Concerning the Arts" (1965), Maurice Mandelbaum takes issue with the argument offered by Weitz in the previous reading. The notion of "family-resemblance," Mandelbaum suggests, is not particularly helpful in explaining how we come to apply concepts. Wildly different sorts

of things resemble each other in any number of ways, and those resemblances do not entitle us to apply the same concept to all of those things. For example, what a fortune-teller does with cards may look very much like what a solitaire player does with cards; yet it would surely be a mistake to think of the two activities as activities of the same sort. Furthermore, says Mandelbaum, Weitz's pessimism about the possibility of defining art is unjustified. In asking whether there are any features that all works of art have in common, it is not enough to look at the "manifest" features of works, or at features that the works can be seen to have when inspected in isolation. Rather, we should ask whether there may be "relational" features that works of art have in common. For example, he suggests, works of art may have in common the relational feature of "having been created by someone for some actual or possible audience." Mandelbaum does not attempt to specify precisely what the relational feature definitive of art might be. However, his remarks here foreshadow more recent attempts, such as those of Dickie and Levinson (*see* this section), to define art in institutional terms.

"Family Resemblances and Generalizations Concerning the Arts"

Maurice Mandelbaum

In 1954 William Elton collected and published a group of essays under the title *Aesthetics and Language*. As his introduction made clear, a common feature of these essays was the application to aesthetic problems of some of the doctrines characteristic of recent British linguistic philosophy.[1] While this mode of philosophizing has not had as pervasive an influence on aesthetics as it has had on most other branches of philosophy,[2] there have been a number of important articles which, in addition to those contained in the Elton volume, suggest the direction in which this influence runs. Among these articles one might mention "The Task of Defining a Work of Art" by Paul Ziff,[3] "The Role of Theory in Aesthetics" by Morris Weitz,[4] Charles L. Stevenson's "On 'What is a Poem' "[5] and W. E. Kennick's "Does Traditional Aesthetics Rest on a Mistake?"[6] In each of them one finds a conviction which was also present in most of the essays in the Elton volume: that it is a mistake to offer generalizations concerning the arts, or to put the matter in a more provocative manner, that it is a mistake to attempt to discuss what art, or beauty, or the aesthetic, or a poem, *essentially* is. In partial support of this contention, some writers have

[1]See William Elton (ed.), *Aesthetics and Language* (Oxford, Basil Blackwell, 1954), p. 1, no. 1 and 2.
[2]A discussion of this fact is to be found in Jerome Stolnitz, "Notes on Analytic Philosophy and Aesthetics," *British Journal of Aesthetics*, vol. 3 (1961), pp. 210–222.
[3]*Philosophical Review*, vol. 62 (1953), pp. 58–78.
[4]Reprinted in this volume.
[5]*Philosophical Review*, vol. 66 (1957), pp. 329–362.
[6]*Mind*, vol. 67 (1958), pp. 317–334. In addition to the articles already referred to, I might mention "The Uses of Works of Art" by Teddy Brunius in *Journal of Aesthetics and Art Criticism*, vol. 22 (1963), pp. 123–133, which refers to both Weitz and Kennick, but raises other questions with which I am not here concerned.

made explicit use of Wittgenstein's doctrine of *family resemblances;* Morris Weitz, for example, has placed it in the forefront of his discussion. However, in that influential and frequently anthologized article, Professor Weitz made no attempt to analyze, clarify, or defend the doctrine itself. Since its use with respect to aesthetics has provided the means by which others have sought to escape the need of generalizing concerning the arts, I shall begin my discussion with a consideration of it.

The *locus classicus* for Wittgenstein's doctrine of family resemblances is in Part I of *Philosophical Investigations,* sections 65–77.[7] In discussing what he refers to as language-games, Wittgenstein says:

> Instead of producing something common to all that we call language, I am saying that these phenomena have no one thing in common which makes us use the same word for all—but they are *related* to one another in many different ways. And it is because of this relationship, or these relationships, that we call them all "language." ([Section] 65)

He then illustrates his contention by citing a variety of *games,* such as board games, card games, ball games, etc., and concludes:

> We see a complicated network of similarities overlapping and criss-crossing: sometimes overall similarities of detail. ([Section] 66)
> I can think of no better expression to characterize these similarities than "family resemblances"; for the various resemblances between members of a family: build, features, colour of eyes, gait, temperment, etc., etc. overlap and criss-cross in the same way.—And I shall say: "games" form a family. ([Section] 67)

In short, what Wittgenstein aims to establish is that one need not suppose that all instances of those entities to which we apply a common name do in fact possess any one feature in common. Instead, the use of a common name is grounded in the criss-crossing and overlapping of resembling features among otherwise heterogeneous objects and activities.

Wittgenstein's concrete illustrations of the diversity among various types of games may at first make his doctrine of family resemblances extremely plausible. For example, we do not hesitate to characterize tennis, chess, bridge, and solitaire as games, even though a comparison of them fails to reveal any specific feature which is the same in each of them. Nonetheless, I do not believe that his doctrine of family resemblances, as it stands, provides an adequate analysis of why a common name, such as "a game," is in all cases applied or withheld.

Consider first the following case. Let us assume that you know how to play that form of solitaire called "Canfield"; suppose also that you are acquainted with a number of other varieties of solitaire (Wittgenstein uses "patience," i.e., "solitaire," as one instance of a form of game). Were you to

[7]Ludwig Wittgenstein, *Philosophical Investigations,* translated by G. E. M. Anscombe (New York, Macmillan, 1953), pp. 31–36. A parallel passage is to be found in "The Blue Book": see *Preliminary Studies for the "Philosophical Investigations," Generally Known as The Blue and Brown Books* (Oxford, Basil Blackwell, 1958), pp. 17–18.

see me shuffling a pack of cards, arranging the cards in piles, some face up and some face down, turning cards over one-by-one, sometimes placing them in one pile, then another, shifting piles, etc., you might say: "I see you are playing cards. What game are you playing?" However, to this I might answer: "I am not playing a game; I am telling (or reading) fortunes." Will the resemblances between what you have seen me doing and the characteristics of card games with which you are familiar permit you to contradict me and say that I am indeed playing some sort of game? Ordinary usage would not, I believe, sanction our describing fortune-telling as an example of playing a game, no matter how striking may be the resemblances between the ways in which cards are handled in playing solitaire and in telling fortunes. Or, to choose another example, we may say that while certain forms of wrestling contests are sometimes characterized as games (Wittgenstein mentions *"Kampfspiele"*)[8] an angry struggle between two boys, each trying to make the other give in, is not to be characterized as a game. Yet one can find a great many resembling features between such a struggle and a wrestling match in a gymnasium. What would seem to be crucial in our designation of an activity as a game is, therefore, not merely a matter of noting a number of specific resemblances between it and other activities which we denote as games, but involves something further.

To suggest what sort of characteristic this "something further" might possibly be, it will be helpful to pay closer attention to the notion of what constitutes a family resemblance. Suppose that you are shown ten or a dozen photographs and you are then asked to decide which among them exhibit strong resemblances.[9] You might have no difficulty in selecting, say, three of the photographs in which the subjects were markedly round-headed, had a strongly prognathous profile, rather deep-set eyes, and dark curly hair.[10] In some extended, metaphorical sense you might say that the similarities in their fea-

[8]Ludwig Wittgenstein, *Philosophical Investigations*, §66, p. 31. For reasons which are obscure, Miss Anscombe translates *"Kampfspiele"* as "Olympic games."

[9]In an article which is closely related to my discussion, but which uses different arguments to support a similar point, Haig Khatchadourian has shown that Wittgenstein is less explicit than he should have been with respect to the levels of determinateness at which these resemblances are significant for our use of common names. See "Common Names and 'Family Resemblances'," *Philosophy and Phenomenological Research*, vol. 18 (1957–1958), pp. 341–358. (For a related, but less closely relevant, article by Professor Khatchadourian, see "Art-Names and Aesthetic Judgments," *Philosophy*, vol. 36 [1961], pp. 30–48.)

[10]It is to be noted that this constitutes a closer resemblance than that involved in what Wittgenstein calls "family resemblances," since in my illustration the specific similarities all pertain to a single set of features, with respect to each one of which all three of the subjects directly resemble one another. In Wittgenstein's use of the notion of family resemblances there is, however, no one set of resembling features common to each member of the "family"; there is merely a criss-crossing and overlapping among the elements which constitute the resemblances among the various persons. Thus, in order to conform to his usage, my illustration would have to be made more complicated, and the degree of resemblance would become more attenuated. For example, we would have to introduce the photographs of other subjects in which, for example, recessive chins would supplant prognathous profiles among those who shared the other characteristics; some would have blond instead of dark hair, and protruberant instead of deep-set eyes, but would in each case resemble the others in other respects, etc. However, if what I say concerning family resemblances holds of the stronger similarities present in my illustration, it should hold *a fortiori* of the weaker form of family resemblances to which Wittgenstein draws our attention.

tures constituted a family resemblance among them. The sense, however, would be metaphorical, since in the absence of a biological kinship of a certain degree of proximity we would be inclined to speak only of resemblances, and not of a *family* resemblance. What marks the difference between a literal and a metaphorical sense of the notion of "family resemblances" is, therefore, the existence of a genetic connection in the former case and not the latter. Wittgenstein, however, failed to make explicit the fact that the literal, root notion of a family resemblance includes this genetic connection no less than it includes the existence of noticeable physiognomic resemblances.[11] Had the existence of such a *twofold* criterion been made explicit by him, he would have noted that there is in fact an attribute common to all who bear a family resemblance to each other: they are related through a common ancestry. Such a relationship is not, of course, one among the specific features of those who share a family resemblance; it nonetheless differentiates them from those who are not to be regarded as members of a single family.[12] If, then, it is possible that the analogy of family resemblances could tell us something about how games may be related to one another, one should explore the possibility that, in spite of their great dissimilarities, games may possess a common attribute which, like biological connection, is not itself one among their directly exhibited characteristics. Unfortunately, such a possibility was not explored by Wittgenstein.

[11]Although Wittgenstein failed to make explicit the fact that a genetic connection was involved in his notion of "family resemblances," I think that he did in fact presuppose such a connection. If I am not mistaken, the original German makes this clearer than does the Anscombe translation. The German text reads:

> Ich kann diese Ähnlichkeiten nicht besser charakterisieren, als durch das Wort "Familienähnlichkeiten"; denn so übergreifen und kreuzen sich die verschiedenen Ähnlichkeiten, die zwischen den Gliedern einer Familie bestehen: Wuchs, Gesichtszüge, Augenfarbe, Gang, Temperament, etc., etc. (§67).

Modifying Miss Anscombe's translation in as few respects as possible, I suggest that a translation of this passage might read:

> I can think of no better expression to characterize these similarities than "family resemblances," since various similarities which obtain among the members of a family—their build, features, color of eyes, gait, temperament, etc., etc.—overlap and criss-cross in the same way.

This translation differs from Miss Anscombe's (which has been quoted above) in that it makes more explicit the fact that the similarities are similarities among the members of a single family, and are not themselves definitive of what constitutes a *family* resemblance.

[12]Were this aspect of the twofold criterion to be abandoned, and were our use of common names to be solely determined by the existence of overlapping and criss-crossing relations, it is difficult to see how a halt would ever be called to the spread of such names. Robert J. Richman has called attention to the same problem in "Something Common," *Journal of Philosophy*, vol. 59 (1962), pp. 821–830. He speaks of what he calls "the Problem of Wide-Open Texture," and says: "the notion of family resemblances may account for our extending the application of a given general term, but it does not seem to place any limit on this process" (p. 829).

In an article entitled "The Problem of the Model-Language Game in Wittgenstein's Later Philosophy," *Philosophy*, vol. 36 (1961), pp. 333–351, Helen Hervey also calls attention to the fact that "a family is so-called by virtue of its common ancestry" (p. 334). She also mentions (p. 335) what Richman referred to as the problem of "the wide-open texture."

To be sure, Wittgenstein does not explicitly state that the resemblances which are correlated with our use of common names must be a sort that are directly exhibited. Nonetheless, all of his illustrations in the relevant passages involve aspects of games which would be included in a description of how a particular game is to be played; that is, when he commands us to "look and see" whether there is anything common to all games,[13] the "anything" is taken to represent precisely the sort of manifest feature that is described in rule-books, such as Hoyle. However, as we have seen in the case of family resemblances, what constitutes a *family* is not defined in terms of the manifest features of a random group of people; we must first characterize the *family* relationship in terms of genetic ties, and then observe to what extent those who are connected in this way *resemble* one another.[14] In the case of games, the analogue to genetic ties might be the purpose for the sake of which various games were formulated by those who invented or modified them, e.g., the potentiality of a game to be of absorbing non-practical interest to either participants or spectators. If there were any such common feature one would not expect it to be defined in a rule book, such as Hoyle, since rule books only attempt to tell us how to play a particular game: our interest in playing a game, and our understanding of what constitutes a game, is already presupposed by the authors of such books.

It is not my present concern to characterize any feature common to most or all of those activities which we call games, nor would I wish to argue on the analogy of family resemblances that there *must be* any such feature. If the question is to be decided, it must be decided by an attempt to "look and see." However, it is important that we look in the right place and in the right ways if we are looking for a common feature; we should not assume that any feature common to all games must be some manifest characteristic, such as whether they are to be played with a ball or with cards, or how many players there must be in order for the game to be played. If we were to rely exclusively on such features we should, as I have suggested, be apt to link solitaire with fortune-telling, and wrestling matches with fights, rather than (say) linking solitaire with cribbage and wrestling matches with weight-lifting. It is, then, my contention that Wittgenstein's emphasis on directly exhibited resemblances, and his failure to consider other possible similarities, led to a failure on his part to provide an adequate clue as to what—in some cases at least—governs our use of common names.[15]

If the foregoing remarks are correct, we are now in a position to see that the radical denigration of generalization concerning the arts, which has come

[13]Ludwig Wittgenstein, *Philosophical Investigations*, §66, p. 31.

[14]Although I have only mentioned the existence of genetic connections among members of a family, I should of course not wish to exclude the effects of habitual association in giving rise to some of the resemblances which Wittgenstein mentions. I have stressed genetic connection only because it is the simplest and most obvious illustration of the point I have wished to make.

[15]I do not deny that directly exhibited resemblances often play a part in our use of common names; this is a fact explicitly noted at least as long ago as by Locke. However, similarities in origin, similarities in use, and similarities in intention may also play significant roles. It is such factors that Wittgenstein overlooks in his specific discussions of family resemblances and of games.

to be almost a hallmark of the writings of those most influenced by recent British philosophy, may involve serious errors, and may not constitute a notable advance.

In turning from Wittgenstein's statements concerning family resemblances to the use to which his doctrine has been put by writers on aesthetics, we must first note what these writers are *not* attempting to do. In the first place, they are not seeking to clarify the relationships which exist among the many different senses in which the word "art" is used. Any dictionary offers a variety of such senses (e.g., the art of navigation, art as a guile, art as the craft of the artist, etc.), and it is not difficult to find a pattern of family resemblances existing among many of them. However, an analysis of such resemblances, and of their differences, has not, as a matter of fact, been of interest to the writers of the articles with which we are concerned. In the second place, these writers have not been primarily interested in analyzing how words such as "work of art" or "artist" or "art" are ordinarily used by those who are neither aestheticians nor art critics; their concern has been with the writings which make up the tradition of "aesthetic theory." In the third place, we must note that the concern of these writers has not been to show that family resemblances do in fact exist among the various arts, or among various works of art; on the contrary, they have used the doctrine of family resemblances in a *negative* fashion. In this, they have of course followed Wittgenstein's own example. The position which they have sought to establish is that traditional aesthetic theory has been mistaken in assuming that there is any essential property or defining characteristic of works of art (or any set of such properties or characteristics); as a consequence, they have contended that most of the questions which have been asked by those engaged in writing on aesthetics are mistaken sorts of questions.

However, as the preceding discussion of Wittgenstein should have served to make clear, one cannot assume that if there is any one characteristic common to all works of art it must consist in some specific, directly exhibited feature. Like the biological connections among those who are connected by family resemblances, or like the intentions on the basis of which we distinguish between fortune-telling and card games, such a characteristic might be a relational attribute, rather than some characteristic at which one could directly point and say: "It is this particular feature of the object which leads me to designate it as a work of art." A relational attribute of the required sort might, for example, only be apprehended if one were to consider specific art objects as having been created by someone for some actual or possible audience.

The suggestion that the essential nature of art is to be found in such a relational attribute is surely not implausible when one recalls some of the many traditional theories of art. For example, art has sometimes been characterized as being one special form of communication or of expression, or as being a special form of wish-fulfillment, or as being a presentation of truth in sensuous form. Such theories do not assume that in each poem, painting, play, and sonata there is a specific ingredient which identifies it as a work of art; rather, that which is held to be common to these otherwise diverse objects is a relationship which is assumed to have existed, or is known to have existed,

between certain of their characteristics and the activities and the intentions of those who made them.[16]

While we may acknowledge that it is difficult to find any set of attributes—whether relational or not—which can serve to characterize the nature of a work of art (and which will not be as vulnerable to criticism as many other such characterizations have been),[17] it is important to note that the difficulties inherent in this task are not really avoided by those who appeal to the notion of family resemblances. As soon as one attempts to elucidate how the term "art" is in fact used in the context of art criticism, most of the same problems which have arisen in the history of aesthetic theory will again make their appearance. In other words, linguistic analysis does not provide a means of escape from the issues which have been of major concern in traditional aesthetics. . . .

In "The Role of Theory in Aesthetics" Professor Weitz places his primary emphasis on the fact that art forms are not static. From this fact he argues that it is futile to attempt to state the conditions which are necessary and sufficient for an object to be a work of art. What he claims is that the concept "art" must be treated as an open concept, since new art forms have developed in the past, and since any art form (such as the novel) may undergo radical transforma-

[16]I know of no passage in which Wittgenstein takes such a possibility into account. In fact, if the passage from "The Blue Book" to which I have already alluded may be regarded as representative, we may say that Wittgenstein's view of traditional aesthetic theories was quite without foundation. In that passage he said:

> The idea of a general concept being a common property of its particular instances connects up with other primitive, too simple, ideas of the structure of language. It is comparable to the idea that *properties* are *ingredients* of the things which have the properties; e.g., that beauty is an ingredient of all beautiful things as alcohol is of beer and wine, and that we therefore could have pure beauty, unadulterated by anything that is beautiful (p. 17).

I fail to be able to identify any aesthetic theory of which such a statement would be true. It would not, for example, be true of Clive Bell's doctrine of "significant form," nor would it presumably be true of G. E. Moore's view of beauty, since both Bell and Moore hold that beauty depends upon the specific nature of the other qualities which characterize that which is beautiful.

However, it may be objected that when I suggest that what is common to works of art involves reference to "intentions," I overlook "the intentional fallacy" (see W. K. Wimsatt, Jr., and Monroe C. Beardsley, "The "Intentional Fallacy," reprinted in this volume.

This is not the case. The phrase "the intentional fallacy" originally referred to a particular method of criticism, that is, to a method of interpreting and evaluating given works of art; it was not the aim of Wimsatt and Beardsley to distinguish between art and non-art. These two problems are, I believe, fundamentally different in character. However, I do not feel sure that Professor Beardsley has noted this fact, for in a recent article in which he set out to criticize those who have been influenced by the doctrine of family resemblances he apparently felt himself obliged to define art *solely* in terms of some characteristic in the object itself (see "The Definition of the Arts," *Journal of Aesthetics and Art Criticism*, vol. 20 [1961], pp. 175–187). Had he been willing to relate this characteristic to the activity and intention of those who make objects having such a characteristic, his discussion would not, I believe, have been susceptible to many of the criticisms leveled against it by Professor Douglas Morgan and Mary Mothersill (ibid., pp. 187–198).

[17]I do not say *"all"* such definitions, for I think that one can find a number of convergent definitions of art, each of which has considerable merit, though each may differ slightly from the others in its emphasis.

tions from generation to generation. One brief statement from Professor Weitz's article can serve to summarize this view:

> What I am arguing, then, is that the very expansive, adventurous character of art, its ever-present changes and novel creations, makes it logically impossible to ensure any set of defining properties. We can, of course, choose to close the concept. But to do this with "art" or "tragedy" or portraiture, etc. is ludicrous since it forecloses the very conditions of creativity in the arts.

Unfortunately, Professor Weitz fails to offer any cogent argument in substantiation of this claim. The lacuna in his discussion is to be found in the fact that the question of whether a particular concept is open or closed (i.e., whether a set of necessary and sufficient conditions can be offered for its use) is not identical with the question of whether future instances to which the very same concept is applied may or may not possess genuinely novel properties. In other words, Professor Weitz has not shown that every novelty in the instances to which we apply a term involves a stretching of the term's connotation.

By way of illustration, consider the classificatory label "representational painting." One can assuredly define this particular form of art without defining it in such a way that it will include only those paintings which depict either a mythological event or a religious scene. Historical paintings, interiors, fête-champêtres, and still life can all count as "representational" according to any adequate definition of this mode of painting, and there is no reason why such a definition could not have been formulated prior to the emergence of any of these novel species of the representational mode. Thus, to define a particular form of art—and to define it truly and accurately—is not necessarily to set one's self in opposition to whatever new creations may arise within that particular form.[18] Consequently, it would be mistaken to suppose that all attempts to state the defining properties of various art forms are prescriptive in character and authoritarian in their effect.

This conclusion is not confined to cases in which an established form of art, such as representational painting, undergoes changes; it can also be shown to be compatible with the fact that radically new art forms arise. For example, if the concept "a work of art" had been carefully defined prior to the invention of cameras, is there any reason to suppose that such a definition would have proved an obstacle to viewing photography or the movies as constituting new art forms? To be sure, one can imagine definitions which might have done so. However, it was not Professor Weitz's aim to show that one or another definition of art had been a poor definition; he wished to establish the

[18]To be sure, if no continuing characteristic is to be found, the fact of change will demand that the concept be treated as having been an open one. This was precisely the position taken by Max Black in a discussion of the concept "science." (See "The Definition of Scientific Method," in *Science and Civilization*, edited by Robert C. Stauffer [Madison, Wisconsin, 1949].) Paul Ziff refers to the influence of Professor Black's discussion upon his own views, and the views of Morris Weitz are assuredly similar. However, even if Professor Black's view of the changes in the concept "science" is a correct one (as I should be prepared to think that it may be), it does not follow that the same argument applies in the case of art. Nor does the fact that the meaning of "science" has undergone profound changes in the past imply that further analogous changes will occur in the future.

general thesis that there was a necessary incompatibility, which he denoted as a logical impossibility, between allowing for novelty and creativity in the arts and stating the defining properties of a work of art. He failed to establish this thesis since he offered no arguments to prove that new sorts of instantiation of a previously defined concept will necessarily involve us in changing the definition of that concept.

To be sure, if neither photography nor the movies had developed along lines which satisfied the same sort of interest that the other arts satisfied, and if the kinds of standards which were applied in the other arts were not seen to be relevant when applied to photography and to the movies, then the antecedently formulated definition of art would have functioned as a closed concept, and it would have been used to exclude all photographers and all motion-picture makers from the class of those who were to be termed "artists." However, what would the defender of the openness of concepts hold that one should have done under these circumstances? Suppose, for example, that all photographers had in fact been the equivalent of passport photographers, and that they had been motivated by no other interests and controlled by no other standards than those which govern the making of photographs for passports and licenses: would the defender of open concepts be likely to have expanded the concept of what is to count as an art in order to have included photography? The present inclusion of photography among the arts is justified, I should hold, precisely because photography arises out of the same sorts of interest, and can satisfy the same sorts of interest, and our criticism of it employs the same sorts of standards, as is the case with respect to the other arts.

READING 16

INTRODUCTION

Arthur C. Danto is Johnsonian professor emeritus of philosophy at Columbia University. In "The Artworld" (1964), he argues that "To see something as art requires something that the eye cannot descry—an atmosphere of artistic theory, a knowledge of the history of art: an artworld." Danto agrees with Weitz and with Mandelbaum that what makes something a work of art is not to be found by looking at its "manifest" features. In Danto's view, what "makes the difference between a Brillo box and a work of art consisting of a Brillo Box is a certain theory of art. It is the theory that takes it up into the world of art, and keeps it from collapsing into the real object which it is." On the one hand, his emphasis on the role of art theory and the artworld in making art can be seen, given the evolving nature of art theory and hence of the artworld, as supporting and adding substance to Weitz's claim that the concept of "art" is not fixed by necessary and sufficient conditions but is subject to evolution and open to revision. On the other hand, his exploration of the relations between art, art theory, and the artworld can be seen as part of an attempt to characterize the kind of existence that art has in something

like the relational manner that Mandelbaum recommends. For its subtlety and its responsiveness to the complexities of the evolution of art, Danto's essay has become a classic of contemporary aesthetic theory.

"The Artworld"

Arthur C. Danto

HAMLET: *Do you see nothing there?*
THE QUEEN: *Nothing at all; yet all that is I see.*
 —Shakespeare: Hamlet, Act III, Scene IV

Hamlet and Socrates, though in praise and deprecation respectively, spoke of art as a mirror held up to nature. As with many disagreements in attitude, this one has a factual basis. Socrates saw mirrors as but reflecting what we can already see; so art, insofar as mirrorlike, yields idle accurate duplications of the appearances of things, and is of no cognitive benefit whatever. Hamlet, more acutely, recognized a remarkable feature of reflecting surfaces, namely that they show us what we could not otherwise perceive—our own face and form—and so art, insofar as it is mirrorlike, reveals us to ourselves, and is, even by socratic criteria, of some cognitive utility after all. As a philosopher, however, I find Socrates' discussion defective on other, perhaps less profound grounds than these. If a mirror-image of o is indeed an imitation of o, then, if art is imitation, mirror-images are art. But in fact mirroring objects no more is art than returning weapons to a madman is justice; and reference to mirror-ings would be just the sly sort of counterinstance we would expect Socrates to bring forward in rebuttal of the theory he instead uses them to illustrate. If that theory requires us to class *these* as art, it thereby shows its inadequacy: "is an imitation" will not do as a sufficient condition for "is art." Yet, perhaps because artists *were* engaged in imitation, in Socrates' time and after, the insuf-ficiency of the theory was not noticed until the invention of photography. Once rejected as a sufficient condition, mimesis was quickly discarded as even a nec-essary one; and since the achievement of Kandinsky, mimetic features have been relegated to the periphery of critical concern, so much so that some works survive in spite of possessing those virtues, excellence in which was once cel-ebrated as the essence of art, narrowly escaping demotion to mere illustrations.

It is, of course, indispensable in socratic discussion that all participants be masters of the concept up for analysis, since the aim is to match a real defin-ing expression to a term in active use, and the test for adequacy presumably consists in showing that the former analyzes and applies to all and only those things of which the latter is true. The popular disclaimer notwithstanding, then, Socrates' auditors purportedly knew what art was as well as what they liked; and a theory of art, regarded here as a real definition of 'Art,' is accord-ingly not to be of great use in helping men to recognize instances of its appli-cation. Their antecedent ability to do this is precisely what the adequacy of the theory is to be tested against, the problem being only to make explicit what they already know. It is *our* use of the term that the theory allegedly means to capture, but we are supposed able, in the words of a recent writer, "to sepa-

rate those objects which are works of art from those which are not, because
. . . we know how correctly to use the word 'art' and to apply the phrase 'work
of art.' " Theories, on this account, are somewhat like mirror-images on
Socrates' account, showing forth what we already know, wordy reflections of
the actual linguistic practice we are masters in.

But telling artworks from other things is not so simple a matter, even for
native speakers, and these days one might not be aware he was on artistic ter-
rain without an artistic theory to tell him so. And part of the reason for this
lies in the fact that terrain is constituted artistic in virtue of artistic theories, so
that one use of theories, in addition to helping us discriminate art from the
rest, consists in making art possible. Glaucon and the others could hardly have
known what was art and what not: otherwise they would never have been
taken in by mirror-images.

I

Suppose one thinks of the discovery of a whole new class of artworks as some-
thing analogous to the discovery of a whole new class of facts anywhere, viz.,
as something for theoreticians to explain. In science, as elsewhere, we often
accommodate new facts to old theories via auxiliary hypotheses, a pardonable
enough conservatism when the theory in question is deemed too valuable to
be jettisoned all at once. Now the Imitation Theory of Art (IT) is, if one but
thinks it through, an exceedingly powerful theory, explaining a great many
phenomena connected with the causation and evaluation of artworks, bring-
ing a surprising unity into a complex domain. Moreover, it is a simple matter
to shore it up against many purported counterinstances by such auxiliary
hypotheses as that the artist who deviates from mimeticity is perverse, inept,
or mad. Ineptitude, chicanery, or folly are, in fact, testable predications. Sup-
pose, then, tests reveal that these hypotheses fail to hold, that the theory, now
beyond repair, must be replaced. And a new theory is worked out, capturing
what it can of the old theory's competence, together with the heretofore recal-
citrant facts. One might, thinking along these lines, represent certain episodes
in the history of art as not dissimilar to certain episodes in the history of sci-
ence, where a conceptual revolution is being effected and where refusal to
countenance certain facts, while in part due to prejudice, inertia, and self-inter-
est, is due also to the fact that a well-established, or at least widely credited
theory is being threatened in such a way that all coherence goes.

Some such episode transpired with the advent of post-impressionist paint-
ings. In terms of the prevailing artistic theory (IT), it was impossible to accept
these as art unless inept art: otherwise they could be discounted as hoaxes,
self-advertisements, or the visual counterparts of madmen's ravings. So to get
them accepted *as* art, on a footing with the *Transfiguration* (not to speak of a
Landseer stag), required not so much a revolution in taste as a theoretical revi-
sion of rather considerable proportions, involving not only the artistic enfran-
chisement of these objects, but an emphasis upon newly significant features of
accepted artworks, so that quite different accounts of their status as artworks
would now have to be given. As a result of the new theory's acceptance, not
only were post-impressionist paintings taken up as art, but numbers of objects

(masks, weapons, etc.) were transferred from anthropological museums (and heterogeneous other places) to *musées des beaux arts,* though, as we would expect from the fact that a criterion for the acceptance of a new theory is that it account for whatever the older one did, nothing had to be transferred out of the *musée des beaux arts*—even if there were internal rearrangements as between storage rooms and exhibition space. Countless native speakers hung upon suburban mantelpieces innumerable replicas of paradigm cases for teaching the expression 'work of art' that would have sent their Edwardian forebears into linguistic apoplexy.

To be sure, I distort by speaking of a theory: historically, there were several, all, interestingly enough, more or less defined in terms of the IT. Art-historical complexities must yield before the exigencies of logical exposition, and I shall speak as though there were one replacing theory, partially compensating for historical falsity by choosing one which was actually enunciated. According to it, the artists in question were to be understood not as unsuccessfully imitating real forms but as successfully creating new ones, quite as real as the forms which the older art had been thought, in its best examples, to be creditably imitating. Art, after all, had long since been thought of as creative (Vasari says that God was the first artist), and the post-impressionists were to be explained as genuinely creative, aiming, in Roger Fry's words, "not at illusion but reality." This theory (RT) furnished a whole new mode of looking at painting, old and new. Indeed, one might almost interpret the crude drawing in Van Gogh and Cézanne, the dislocation of form from contour in Rouault and Dufy, the arbitrary use of color planes in Gauguin and the Fauves, as so many ways of drawing attention to the fact that these were *non-imitations,* specifically intended not to deceive. Logically, this would be roughly like printing "Not Legal Tender" across a brilliantly counterfeited dollar bill, the resulting object (counterfeit *cum* inscription) rendered incapable of deceiving anyone. It is not an illusory dollar bill, but then, just because it is non-illusory it does not automatically become a real dollar bill either. It rather occupies a freshly opened area between real objects and real facsimiles of real objects: it is a non-facsimile, if one requires a word, and a new contribution to the world. Thus, Van Gogh's *Potato Eaters,* as a consequence of certain unmistakable distortions, turns out to be a non-facsimile of real-life potato eaters; and inasmuch as these are not facsimiles of potato eaters, Van Gogh's picture, as a non-imitation, had as much right to be called a real object as did its putative subjects. By means of this theory (RT), artworks re-entered the thick of things from which socratic theory (IT) had sought to evict them: if no *more* real than what carpenters wrought, they were at least no *less* real. The Post-Impressionist won a victory in ontology.

It is in terms of RT that we must understand the artworks around us today. Thus Roy Lichtenstein paints comic-strip panels, though ten or twelve feet high. These are reasonably faithful projections onto a gigantesque scale of the homely frames from the daily tabloid, but it is precisely the scale that counts. A skilled engraver might incise *The Virgin and the Chancellor Rollin* on a pinhead, and it would be recognizable as such to the keen of sight, but an engraving of a Barnett Newman on a similar scale would be a blob, disappearing in

the reduction. A *photograph* of a Lichtenstein is indiscernible from a photo-graph of a counterpart panel from *Steve Canyon;* but the photograph fails to capture the scale, and hence is as inaccurate a reproduction as a black-and-white engraving of Botticelli, scale being essential here as color there. Licht-ensteins, then, are not imitations but *new entities,* as giant whelks would be. Jasper Johns, by contrast, paints objects with respect to which questions of scale are irrelevant. Yet his objects cannot be imitations, for they have the remarkable property that any intended copy of a member of this class of objects is automatically a member of the class itself, so that these objects are logically inimitable. Thus, a copy of a numeral just *is* that numeral: a painting of 3 is a 3 made of paint. Johns, in addition, paints targets, flags, and maps. Finally, in what I hope are not unwitting footnotes to Plato, two of our pioneers—Robert Rauschenberg and Claes Oldenburg—have made genuine beds.

Rauschenberg's bed hangs on a wall, and is streaked with some desultory housepaint. Oldenburg's bed is a rhomboid, narrower at one end than the other, with what one might speak of as a built-in perspective: ideal for small bedrooms. As beds, these sell at singularly inflated prices, but one *could* sleep in either of them: Rauschenberg has expressed the fear that someone might just climb into his bed and fall asleep. Imagine, now, a certain Testadura—a plain speaker and noted philistine—who is not aware that these are art, and who takes them to be reality simple and pure. He attributes the paintstreaks on Rauschenberg's bed to the slovenliness of the owner, and the bias in the Oldenburg bed to the ineptitude of the builder or the whimsy, perhaps, of whoever had it "custom-made." These would be mistakes, but mistakes of rather an odd kind, and not terribly different from that made by the stunned birds who pecked the sham grapes of Zeuxis. They mistook art for reality, and so has Testadura. But it was meant to *be* reality, according to RT. Can one have mistaken reality for reality? How shall we describe Testadura's error? What, after all, prevents Oldenburg's creation from being a misshapen bed? This is equivalent to asking what makes it art, and with this query we enter a domain of conceptual inquiry where native speakers are poor guides: *they* are lost themselves.

II

To mistake an artwork for a real object is no great feat when an artwork is the real object one mistakes it for. The problem is how to avoid such errors, or to remove them once they are made. The artwork is a bed, and not a bed-illu-sion; so there is nothing like the traumatic encounter against a flat surface that brought it home to the birds of Zeuxis that they had been duped. Except for the guard cautioning Testadura not to sleep on the artworks, he might never have discovered that this was an artwork and not a bed; and since, after all, one cannot discover that a bed is not a bed, how is Testadura to realize that he has made an error? A certain sort of explanation is required, for the error here is a curiously philosophical one, rather like, if we may assume as correct some well-known views of P. F. Strawson, mistaking a person for a material

body when the truth is that a person *is* a material body in the sense that a whole class of predicates, sensibly applicable to material bodies, are sensibly, and by appeal to no different criteria, applicable to persons. So you cannot *discover* that a person is not a material body.

We begin by explaining, perhaps, that the paintstreaks are not to be explained away, that they are *part* of the object, so the object is not a mere bed with—as it happens—streaks of paint spilled over it, but a complex object fabricated out of a bed and some paintstreaks: a paint-bed. Similarly, a person is not a material body with—as it happens—some thoughts superadded, but is a complex entity made up of a body and some conscious states: a conscious-body. Persons, like artworks, must then be taken as irreducible to *parts* of themselves, and are in that sense primitive. Or, more accurately, the paintstreaks are not part of the real object—the bed—which happens to be part of the artwork, but are, *like* the bed, part of the artwork as such. And this might be generalized into a rough characterization of artworks that happen to contain real objects as parts of themselves: not every part of an artwork *A* is part of a real object *R* when *R* is part of *A* and can, moreover, be detached from *A* and seen *merely* as *R*. The mistake thus far will have been to mistake *A* for *part* of itself, namely *R*, even though it would not be incorrect to say that *A* is *R*, that the artwork is a bed. It is the 'is' which required clarification here.

There is an *is* that figures prominently in statements concerning artworks which is not the *is* of either identity or predication; nor is it the *is* of existence, of identification, or some special *is* made up to serve a philosophic end. Nevertheless, it is in common usage, and is readily mastered by children. It is the sense of *is* in accordance with which a child, shown a circle and a triangle and asked which is him and which his sister, will point to the triangle saying "That is me"; or, in response to my question, the person next to me points to the man in purple and says "That one is Lear"; or in the gallery I point, for my companion's benefit, to a spot in the painting before us and say "That white dab is Icarus." We do not mean, in these instances, that whatever is pointed to stands for, or represents, what it is said to be, for the *word* 'Icarus' stands for or represents Icarus: yet I would not in the same sense of *is* point to the word and say "That is Icarus." The sentence "That *a* is *b*" is perfectly compatible with "That *a* is not *b*" when the first employs this sense of *is* and the second employs some other, though *a* and *b* are used nonambiguously throughout. Often, indeed, the truth of the first *requires* the truth of the second. The first, in fact, is incompatible with "That *a* is not *b*" only when the *is* is used nonambiguously throughout. For want of a word I shall designate this the *is of artistic identification;* in each case in which it is used, the *a* stands for some specific physical property of, or physical part of, an object; and, finally, it is a necessary condition for something to be an artwork that some part or property of it be designable by the subject of a sentence that employs this special *is*. It is an *is*, incidentally, which has near-relatives in marginal and mythical pronouncements. (Thus, one *is* Quetzalcoatl; those *are* the Pillars of Hercules.)

Let me illustrate. Two painters are asked to decorate the east and west walls of a science library with frescoes to be respectively called *Newton's First Law* and *Newton's Third Law*. These paintings, when finally unveiled, look, scale apart, as follows:

A B

As objects I shall suppose the works to be indiscernible: a black, horizontal
line on a white ground, equally large in each dimension and element. *B*
explains his work as follows: a mass, pressing downward, is met by a mass
pressing upward: the lower mass reacts equally and oppositely to the upper
one. *A* explains his work as follows: the line through the space is the path of
an isolated particle. The path goes from edge to edge, to give the sense of its
going beyond. If it ended or began within the space, the line would be curved:
and it is parallel to the top and bottom edges, for if it were closer to one than
to another, there would have to be a force accounting for it, and this is incon-
sistent with its being the path of an *isolated* particle.

Much follows from these artistic identifications. To regard the middle line
as an edge (mass meeting mass) imposes the need to identify the top and bot-
tom half of the picture as rectangles, and as two distinct parts (not necessar-
ily as two masses, for the line could be the edge of *one* mass jutting up—or
down—into empty space). If it is an edge, we cannot thus take the entire area
of the painting as a single space: it is rather composed of two forms, or one
form and a non-form. We could take the entire area as a single space only by
taking the middle horizontal as a *line* which is not an edge. But this almost
requires a three-dimensional identification of the whole picture: the area can
be a flat surface which the line is *above (Jetflight)*, or *below (Submarine-path)*, or
on (Line), or *in (Fissure)*, or *through (Newton's First Law)*—though in this last
case the area is not a flat surface but a transparent cross section of absolute
space. We could make all these prepositional qualifications clear by imagining
perpendicular cross sections to the picture plane. Then, depending upon the
applicable prepositional clause, the area is (artistically) interrupted or not by
the horizontal element. If we take the line as *through* space, the edges of the
picture are not really the edges of the space: the space goes beyond the picture
if the line itself does; and we are in the same space as the line is. As *B*, the
edges of the picture can be *part* of the picture in case the masses go right to
the edges, so that the edges of the picture are *their* edges. In that case, the ver-

tices of the picture would be the vertices of the masses, except that the masses have four vertices more than the picture itself does: here four vertices would be part of the artwork which were not part of the real object. Again, the faces of the masses could be the face of the picture, and in looking at the picture, we are looking at these faces: but *space* has no face, and on the reading of *A* the work has to be read as faceless, and the face of the physical object would not be part of the artwork. Notice here how one artistic identification engenders another artistic identification, and how, consistently with a given identification, we are *required* to give others and *precluded* from still others: indeed, a given identification determines how many elements the work is to contain. These different identifications are incompatible with one another, or generally so, and each might be said to make a different artwork, even though each artwork contains the identical real object as part of itself—or at least parts of the identical real object as parts of itself. There are, of course, senseless identifications: no one could, I think, sensibly read the middle horizontal as *Love's Labour's Lost* or *The Ascendency of St. Erasmus*. Finally, notice how acceptance of one identification rather than another is in effect to exchange one *world* for another. We could, indeed, enter a quiet poetic world by identifying the upper area with a clear and cloudless sky, reflected in the still surface of the water below, whiteness kept from whiteness only by the unreal boundary of the horizon.

And now Testadura, having hovered in the wings throughout this discussion, protests that *all he sees is paint:* a white painted oblong with a black line painted across it. And how right he really is: that is all he sees or that anybody can, we aesthetes included. So, if he asks us to show him what there is further to see, to demonstrate through pointing that this is an artwork *(Sea and Sky)*, we cannot comply, for he has overlooked nothing (and it would be absurd to suppose he had, that there was something tiny we could point to and he, peering closely, say "So it is! A work of art after all!"). We cannot help him until he has mastered the *is of artistic identification* and so *constitutes* it a work of art. If he cannot achieve this, he will never look upon artworks: he will be like a child who sees sticks as sticks.

But what about pure abstractions, say something that looks just like *A* but is entitled *No. 7*? The 10th Street abstractionist blankly insists that there is nothing here but white paint and black, and none of our literary identifications need apply. What then distinguishes him from Testadura, whose philistine utterances are indiscernible from his? And how can it be an artwork for him and not for Testadura, when they agree that there is nothing that does not meet the eye? The answer, unpopular as it is likely to be to purists of every variety, lies in the fact that this artist has returned to the physicality of paint through an atmosphere compounded of artistic theories and the history of recent and remote painting, elements of which he is trying to refine out of his own work; and as a consequence of this his work belongs in this atmosphere and is part of this history. He has achieved abstraction through rejection of artistic identifications, returning to the real world from which such identifications remove us (he thinks), somewhat in the mode of Ch'ing Yuan, who wrote:

Before I had studied Zen for thirty years, I saw mountains as mountains and waters as waters. When I arrived at a more intimate knowledge, I came to the

> point where I saw that mountains are not mountains, and waters are not
> waters. But now that I have got the very substance I am at rest. For it is just
> that I see mountains once again as mountains, and waters once again as waters.

His identification of what he has made is logically dependent upon the theo-
ries and history he rejects. The difference between his utterance and Tes-
tadura's "This is black paint and white paint and nothing more" lies in the fact
that he is still using the *is* of artistic identification, so that his use of "That black
paint is black paint" is not a tautology. Testadura is not at that stage. To see
something as art requires something the eye cannot decry—an atmosphere of
artistic theory, a knowledge of the history of art: an artworld.

III

Mr. Andy Warhol, the Pop artist, displays facsimiles of Brillo cartons, piled
high, in neat stacks, as in the stockroom of the supermarket. They happen to
be of wood, painted to look like cardboard, and why not? To paraphrase the
critic of the *Times,* if one may make the facsimile of a human being out of
bronze, why not the facsimile of a Brillo carton out of plywood? The cost of
these boxes happens to be 2×10^3 that of their homely counterparts in real
life—a differential hardly ascribable to their advantage in durability. In fact
the Brillo people might, at some slight increase in cost, make their boxes out
of plywood without these becoming artworks, and Warhol might make *his* out
of cardboard without their ceasing to be art. So we may forget questions of
intrinsic value, and ask why the Brillo people cannot manufacture art and why
Warhol cannot *but* make artworks. Well, his are made by hand, to be sure.
Which is like an insane reversal of Picasso's strategy in pasting the label from
a bottle of Suze onto a drawing, saying as it were that the academic artist, con-
cerned with exact imitation, must always fall short of the real thing: so why
not just *use* the real thing? The Pop artist laboriously reproduces machine-
made objects by hand, e.g., painting the labels on coffee cans (one can hear the
familiar commendation "Entirely made by hand" falling painfully out of the
guide's vocabulary when confronted by these objects). But the difference can-
not consist in craft: a man who carved pebbles out of stones and carefully con-
structed a work called *Gravel Pile* might invoke the labor theory of value to
account for the price he demands; but the question is, What makes it art? And
why need Warhol *make* these things anyway? Why not just scrawl his signa-
ture across one? Or crush one up and display it as *Crushed Brillo Box* ("A
protest against mechanization . . .") or simply display a Brillo carton as
Uncrushed Brillo Box ("A bold affirmation of the plastic authenticity of indus-
trial . . .")? Is this man a kind of Midas, turning whatever he touches into the
gold of pure art? And the whole world consisting of latent artworks waiting,
like the bread and wine of reality, to be transfigured, through some dark mys-
tery, into the indiscernible flesh and blood of the sacrament? Never mind that
the Brillo box may not be good, much less great art. The impressive thing is
that it is art at all. But if it is, why are not the indiscernible Brillo boxes that
are in the stockroom? Or *has* the whole distinction between art and reality bro-
ken down?

Suppose a man collects objects (ready-mades), including a Brillo carton; we praise the exhibit for variety, ingenuity, what you will. Next he exhibits nothing but Brillo cartons, and we criticize it as dull, repetitive, self-plagiarizing—or (more profoundly) claim that he is obsessed by regularity and repetition, as in *Marienbad*. Or he piles them high, leaving a narrow path; we tread our way through the smooth opaque stacks and find it an unsettling experience, and write it up as the closing in of consumer products, confining us as prisoners: or we say he is a modern pyramid builder. True, we don't say these things about the stockboy. But then a stockroom is not an art gallery, and we cannot readily separate the Brillo cartons from the gallery they are in, any more than we can separate the Rauschenberg bed from the paint upon it. Outside the gallery, they are pasteboard cartons. But then, scoured clean of paint, Rauschenberg's bed is a bed, just what it was before it was transformed into art. But then if we think this matter through, we discover that the artist has failed, really and of necessity, to produce a mere real object. He has produced an artwork, his use of real Brillo cartons being but an expansion of the resources available to artists, a contribution to *artists' materials,* as oil paint was, or *tuche*.

What in the end makes the difference between a Brillo box and a work of art consisting of a Brillo Box is a certain theory of art. It is the theory that takes it up into the world of art, and keeps it from collapsing into the real object which it is (in a sense of *is* other than that of artistic identification). Of course, without the theory, one is unlikely to see it as art, and in order to see it as part of the artworld, one must have mastered a good deal of artistic theory as well as a considerable amount of the history of recent New York painting. It could not have been art fifty years ago. But then there could not have been, everything being equal, flight insurance in the Middle Ages, or Etruscan typewriter erasers. The world has to be ready for certain things, the artworld no less than the real one. It is the role of artistic theories, these days as always, to make the artworld, and art, possible. It would, I should think, never have occurred to the painters of Lascaux that they were producing *art* on those walls. Not unless there were neolithic aestheticians.

IV

The artworld stands to the real world in something like the relationship in which the City of God stands to the Earthly City. Certain objects, like certain individuals, enjoy a double citizenship, but there remains, the RT notwithstanding, a fundamental contrast between artworks and real objects. Perhaps this was already dimly sensed by the early framers of the IT who, inchoately realizing the nonreality of art, were perhaps limited only in supposing that the sole way objects had of being other than real is to be sham, so that artworks necessarily had to be imitations of real objects. This was too narrow. So Yeats saw in writing "Once out of nature I shall never take / My bodily form from any natural thing." It is but a matter of choice: and the Brillo box of the artworld may be just the Brillo box of the real one, separated and united by the *is* of artistic identification. But I should like to say some final words

about the theories that make artworks possible, and their relationship to one another. In so doing, I shall beg some of the hardest philosophical questions I know.

I shall now think of pairs of predicates related to each other as "opposites," conceding straight off the vagueness of this *demodé* term. Contradictory predicates are not opposites, since one of each of them must apply to every object in the universe, and neither of a pair of opposites need apply to some objects in the universe. An object must first be of a certain kind before either of a pair of opposites applies to it, and then at most and at least one of the opposites must apply to it. So opposites are not contraries, for contraries may both be false of some objects in the universe, but opposites cannot both be false; for of some objects, neither of a pair of opposites cannot both be false; for of some objects, neither of a pair of opposites *sensibly* applies, unless the object is of the right sort. Then, if the object is of the required kind, the opposites behave as contradictories. If F and non-F are opposites, an object o must be of a certain kind K before either of these sensibly applies; but if o is a member of K, then o either is F or non-F, to the exclusion of the other. The class of pairs of opposites that sensibly apply to the $(ô)Ko$ I shall designate as the class of *K-relevant predicates.* And a necessary condition for an object to be of a kind K is that at least one pair of K-relevant opposites be sensibly applicable to it. But, in fact, if an object is of kind K, at least and at most one of each K-relevant pair of opposites applies to it.

I am now interested in the K-relevant predicates for the class K of artworks. And let F and non-F be an opposite pair of such predicates. Now it might happen that, throughout an entire period of time, every artwork is non-F. But since nothing thus far is both an artwork and F, it might never occur to anyone that non-F is an artistically relevant predicate. The non-F-ness of artworks goes unmarked. By contrast, all works up to a given time might be G, it never occurring to anyone until that time that something might both be an artwork and non-G; indeed, it might have been thought that G was a *defining trait* of artworks when in fact something might first have to be an artwork before G is sensibly predicable of it—in which case non-G might also be predicable of artworks, and G itself then could not have been a defining trait of this class.

Let G be 'is representational' and let F be 'is expressionist.' At a given time, these and their opposites are perhaps the only art-relevant predicates in critical use. Now letting '+' stand for a given predicate P and '−' for its opposite non-P, we may construct a style matrix more or less as follows:

F	G
+	+
+	−
−	+
−	−

The rows determine available styles, given the active critical vocabulary: representational expressionistic (e.g., Fauvism); representational nonexpressionistic (Ingres); nonrepresentational expressionistic (Abstract Expressionism); nonrepresentational nonexpressionist (hard-edge abstraction). Plainly, as we add art-relevant predicates, we increase the number of available styles at the rate of 2^n. It is, of course, not easy to see in advance which predicates are going to be added or replaced by their opposites, but suppose an artist determines that H shall henceforth be artistically relevant for his paintings. Then, in fact, both H and non-H become artistically relevant for *all* painting, and if his is the first and only painting that is H, every other painting in existence becomes non-H, and the entire community of paintings is enriched, together with a doubling of the available style opportunities. It is this retroactive enrichment of the entities in the artworld that makes it possible to discuss Raphael and De Kooning together, or Lichtenstein and Michelangelo. The greater the variety of artistically relevant predicates, the more complex the individual members of the artworld become; and the more one knows of the entire population of the artworld, the richer one's experience with any of its members.

In this regard, notice that, if there are m artistically relevant predicates, there is always a bottom row with m minuses. This row is apt to be occupied by purists. Having scoured their canvasses clear of what they regard as inessential, they credit themselves with having distilled out the essence of art. But this is just their fallacy: exactly as many artistically relevant predicates stand true of their square monochromes as stand true of any member of the Artworld, and they can *exist* as artworks only insofar as "impure" paintings exist. Strictly speaking, a black square by Reinhardt is artistically as rich as Titian's *Sacred and Profane Love*. This explains how less is more.

Fashion, as it happens, favors certain rows of the style matrix: museums, connoisseurs, and others are makeweights in the Artworld. To insist, or seek to, that all artists become representational, perhaps to gain entry into a specially prestigious exhibition, cuts the available style matrix in half: there are then $2^n / 2$ ways of satisfying the requirement, and museums then can exhibit all these "approaches" to the topic they have set. But this is a matter of almost purely sociological interest: one row in the matrix is as legitimate as another. An artistic breakthrough consists, I suppose, in adding the possibility of a column to the matrix. Artists then, with greater or less alacrity, occupy the positions thus opened up: this is a remarkable feature of contemporary art, and for those unfamiliar with the matrix, it is hard, and perhaps impossible, to recognize certain positions as occupied by artworks. Nor would these things be artworks without the theories and the histories of the Artworld.

Brillo boxes enter the artworld with that same tonic incongruity the *commedia dell'arte* characters bring into *Ariadne auf Naxos*. Whatever is the artistically relevant predicate in virtue of which they gain their entry, the rest of the Artworld becomes that much the richer in having the opposite predicate available and applicable to its members. And, to return to the views of Hamlet with which we began this discussion, Brillo boxes may reveal us to ourselves as well as anything might: as a mirror held up to nature, they might serve to catch the conscience of our kings.

READING 17

INTRODUCTION

George Dickie, who teaches philosophy at the University of Illinois at Chicago, has
made a number of important contributions to contemporary aesthetics. But he is
best known for his "institutional theory" of art, of which the essay reprinted here,
"The New Institutional Theory of Art" (1984), is a recent statement. Inspired by
considerations similar to those noted by Mandelbaum and Danto (*see* the previous
two readings), Dickie seeks to give a definition of art that identifies the essential
property of art as a non-exhibited property. The non-exhibited property that Dickie
believes an object must have if it is to count as art is the property of having been
"created to be presented to an artworld public." The notion that works such as Carl
Andre's *Equivalent VIII* and Duchamp's *Fountain* are works of art is one which more
traditional theories find it difficult to account for. But, given his appeal to the role
of the artworld in making something art, that notion can be accommodated by
Dickie's institutional theory. In other words, Dickie's theory seems tailor-made to the
complex character of the contemporary artworld—exactly as it was intended to be.
The price it pays for the capacity to explain much that traditional theories of art
seem unable to explain, however, is quite high. For Dickie's theory, in focusing on
the context and background against which we understand and appreciate works of
art, says little about artworks themselves, or about what it is to understand and
appreciate works of art. And some have argued that his theory leaves it unclear
why we should *care* whether or not a given object does or does not count as art.

"The New Institutional Theory of Art"

George Dickie

The version of the institutional theory that I worked out in 1974 in *Art and the
Aesthetic*[1] was defective in several respects, but the institutional approach is, I
think, still viable. By an institutional approach I mean the idea that works of
art are art as the result of the position they occupy within an institutional
framework or context. I have tried in a forthcoming book, *The Art Circle*, to
work out a revised version of the theory. In this paper, I shall attempt to give
a summary account of the new version of the institutional theory of art.

It should be made clear here at the beginning that the theory of art I am
trying to work out is a classificatory one. Some theories of art have assumed
that a work of art is necessarily a good thing, but this assumption would leave
unaccounted for all the mediocre, bad, and worthless art. It is the wider class
of objects which contain the worthless, the indifferent, the mediocre, the good,
and the masterpieces about which I am concerned to theorize.

Traditional theories of art place works of art within simple and narrowly-
focused networks of relations. The imitation theory, for example, suspends the
work of art in a three-place network between artist and subject matter, and the
expression theory places the work of art in a two-place network of artist and

[1]Dickie, G., *Art and the Aesthetic* (Ithaca and London, 1974).

work. The institutional theory attempts to place the work of art within a multi-placed network of greater complexity than anything envisaged by the various traditional theories. The networks or contexts of the traditional theories are too "thin" to be sufficient. The institutional theory attempts to provide a context which is "thick" enough to do the job. The network of relations or context within which a theory places works of art I shall call "the framework" of that theory.

Despite my reservations about the traditional theories of art, they were, I believe, on the right track about the group of objects they focus on. All of the traditional theories assume that works of art are artifacts, although they differ about the nature of the artifacts. There is, then, a sense in which the institutional approach is a return to the traditional way of theorizing about art for it too maintains that works of art are artifacts. By the way, what is meant by "artifact" here is the ordinary dictionary definition: "an object made by man, especially with a view to subsequent use." Furthermore, although many are, an artifact need not be a physical object: for example a poem is not a physical object, but it is, nevertheless, an artifact. Still further, things such as performances, for example, improvised dances, are also "made by man" and are, therefore, artifacts.

In the 1950s, first Paul Ziff and then Morris Weitz challenged the assumption of artifactuality, claiming that being an artifact is not a necessary condition of art. Although Ziff's and Weitz's views differ somewhat, they have in common the claim that there is no necessary condition for something's being art, not even artifactuality. Their common view can be called "the new conception of art." This new view conceives of the members of the class of works of art as having no common feature of any theoretical significance. The members of the class are related only by means of similarities: work of art A resembles work of art B and work of art B resembles work of art C, but A does not have to resemble C. According to the new view, an object becomes a work of art by sufficiently resembling a prior-established work of art.

The new conception speaks of sufficient resemblance as the only way that a work of art can come into being. An examination of the new view reveals, however, that it entails that there must be another way than sufficient resemblance to a prior-established work of art for a work of art to come into being. That two ways of becoming art are required by the new conception of art can be shown in the following way. Suppose that work of art A had become art by sufficiently resembling prior-established work of art B. Work of art B would have had to become art by sufficiently resembling an earlier prior-established work of art, call it C. If resemblance to a prior-established work of art is the only way of becoming art, then the way back in time from work of art A to work of art B to work of art C generates an infinite regress of works of art receding into the past. If resemblance to a prior-established work of art were the only way of becoming art, there could be no first work of art and, consequently, there could not be any art at all. Some way of becoming art other than resemblance to a prior-established work is required for resemblance to a prior-established work to function as a way of becoming art. Works of art which become art by sufficiently resembling prior-established works may be called "similarity art." In order for there to be similarity art there must be at least

one work of art which did not become art in virtue of its similarity to a prior-established work of art. Consequently, the new conception of art really requires two ways of becoming art: the similarity way and some nonsimilarity way. The new conception is an unacknowledged "double" theory of art.

What is the nature of the nonsimilarity art required by the new conception? Since neither Ziff nor Weitz was aware that their view requires nonsimilarity art, it is not surprising that they said nothing about it. The nature of nonsimilarity art will have to be inferred from the stated theory. First, nonsimilarity art is primary within the theory—there could not be similarity art unless there is first nonsimilarity art. Second, the class of works of art, according to the new conception, consists of two distinct subsets of which one (nonsimilarity art) is more basic than the other (similarity art). Finally, there is nothing in the new conception of art or outside of it which requires nonsimilarity art to be a one-time sort of thing the only function of which is to block the regress and get the art process going. Although nothing in the new conception entails that it is, the only plausible account of the nature of nonsimilarity art that I can think of is that it is art which is art as the result of someone's creating an artifact. This, of course, does not prove that nonsimilarity art is to be identified with what may be called "artifactual art," but artifactual art seems to be the only real contender. The new conception of art involves two distinct kinds of art—artifactual art and similarity art—with the former being primary. Artifactual art is clearly not confined to the beginning of the art process, because such art is being created at the present and has been created throughout the history of art.

Ziff and Weitz demand that if one is to theorize about art, one must produce a theory which encompasses all members of the class of works of art. And according to their view, the members of the class have no common feature or features. Consequently, they claim that one cannot theorize about art in the traditional manner of discovering necessary and sufficient features. The closest they can come to theorizing about art is to say that there is a class of objects to which the terms "art" and "work of art" meaningfully apply and that this class cannot be theoretically characterized further.

The earlier examination of the new conception of art has shown that the class of objects to which the terms "art" and "work of art" meaningfully apply divides into two distinct subclasses of art. This division shows that the class can be theoretically characterized further. The first thing to be noted about the subclasses is that the two activities which generate the two subclasses are very different. Artifactual art is generated by the human activity of making. Similarity art is generated by the human activity of noticing similarities. The strikingly different activities which generate the two subclasses suggest that the two classes are not literally subclasses of a single class. The two classes seem more like a class picked out by the literal use of a term and a derivative class picked out by the metaphorical uses of the same term. I will not, however, pursue this point here.

Even if one were to agree with Ziff and Weitz that artifactual art and similarity art are both literally art, why should this persuade philosophers to abandon their traditional concern with theorizing about what is in effect artifactual art? From Plato's time forward, philosophers of art have been con-

cerned to theorize about the class of objects which is generated by a particular kind of human making. Philosophers have been interested in these objects precisely because they are human artifacts. The fact that there is another class of objects which is in some way derivative by means of similarities from the class of objects they have traditionally been interested in is not surprising and is no reason to divert philosophers of art from their traditional activity. That traditional activity is the attempt to describe correctly the nature of the making of artifactual art and, consequently, the nature of the objects made. Artifactuality is, in effect, a "built-in" characteristic of the interest of philosophers in works of art.

On the surface anyway, there is no mystery about the making of the great bulk of works of artifactual art; they are crafted in various traditional ways—painted, sculpted, and the like. (Later, I will attempt to go below the surface a bit.) There is, however, a puzzle about the artifactuality of some relatively recent works of art: Duchamp's readymades, found art, and the like. Some deny that such things are art because, they claim, they are not artifacts made by artists. It can, I think, be shown that they are the artifacts of artists. (In *Art and the Aesthetic* I claimed, I now think, mistakenly, that artifactuality is *conferred* on things such as Duchamp's *Fountain* and found art, but I will not discuss this here.)

Typically an artifact is produced by altering some preexisting material: by joining two pieces of material, by cutting some material, by sharpening some material, and so on. This is typically done so that the altered material can be used to do something. When materials are so altered, one has clear cases which neatly fit the dictionary definition of "artifact"—"An object made by man, especially with a view to subsequent use." There are other cases which are less clear-cut. Suppose one picks up a piece of driftwood and without altering it in any way digs a hole or brandishes it at a threatening dog. The unaltered driftwood has been *made* into a digging tool or a weapon by the use to which it is put. These two cases do not conform to the nonnecessary clause of the definition "especially with a view to subsequent use" because they are pressed into service on the spot. There does seem to be a sense in which something is made in these cases, but what is it that has been made if the driftwood is unaltered? In the clear cases in which material is altered, a complex object is produced: the original material is for present purposes a simple object and its being altered produces the complex object—altered material. In the two less clear-cut cases, complex objects have also been made—the wood used as a digging tool and the wood used as a weapon. In neither of the two less clear-cut cases is the driftwood alone the artifact; the artifact in both cases is the driftwood manipulated and used in a certain way. The two cases in question are exactly like the sort of thing that anthropologists have in mind when they speak of unaltered stones found in conjunction with human or human-like fossils as artifacts. The anthropologists assume that the stones were used in some way. The anthropologists have in mind the same notion of a complex object made by the use of a simple (i.e., unaltered) object.

A piece of driftwood may be used in a similar way within the context of the artworld, i.e., picked up and displayed in the way that a painting or a sculpture is displayed. Such a piece of driftwood would be being used as an

artistic medium and thereby would become part of the more complex object—the-driftwood-used-as-an-artistic-medium. This complex object would be an artifact of an artworld system. Duchamp's *Fountain* can be understood along the same lines. The urinal (the simple object) is being used as an artistic medium to make *Fountain* (the complex object) which is an artifact within the artworld—Duchamp's artifact. The driftwood would be being used and the urinal was used as artistic media in the way that pigments, marble, and the like are used to make more conventional works of art.

Thus far, I have talked of artifactuality as a necessary condition of art, but this discussion does not distinguish the institutional theory from the traditional theories, as the latter have assumed or implied that being an artifact is a necessary condition of art. In the last paragraph, however, I introduced without explanation the notion of the *artworld*, and it is now time to turn to a discussion of the artworld, for it is this notion which lies at the heart of the institutional theory.

Perhaps the best way to begin a discussion of the artworld is to quote the now-abandoned definition of "work of art" from the earlier version of the institutional theory. "A work of art in the classificatory sense is (1) an artifact (2) a set of the aspects of which has had conferred upon it the status of a candidate for appreciation by some person or persons acting on behalf of a certain social institution (the artworld)."[2] Monroe Beardsley has observed that in the discussion which surrounds the definition in the earlier version of the theory I characterized the artworld as an "established practice" which is to say, an informal kind of activity. He then goes on to point out that the quoted definition makes use of such phrases as "conferred status" and "acting on behalf of." Such phrases typically have application within formal institutions such as states, corporations, universities, and the like. Beardsley correctly notes that it is a mistake to use the language of formal institutions to try to describe an informal institution as I conceive the artworld to be. Beardsley queries, ". . . does it make sense to speak of acting on behalf of a practice? Status-awarding authority can center in [a formal institution], but practices, as such, seem to lack the requisite source of authority."[3]

Accepting Beardsley's criticism, I have abandoned as too formal the notions of *status conferral* and *acting on behalf of* as well as those aspects of the earlier version which connect up with these notions. Being a work of art is a status all right, that is, it is the occupying of a position within the human activity of the artworld. Being a work of art is not, however, a status which is conferred but is rather a status which is achieved as the result of creating an artifact within or against the background of the artworld.

The claim is then that works of art are art as the result of the position or place they occupy within an established practice, namely, the artworld. There are two crucial questions about the claim. (1) Is the claim true and (2) if the claim is true, how is the artworld to be described?

The claim is a claim about the existence of a human institution, and the

[2]Ibid., p. 34.
[3]"Is Art Essentially Institutional?," in: *Culture and Art,* Lars Aagaard-Mogensen (ed.) (Atlantic Highlands, N.J. 1976), p. 202.

test of its truth is the same as for any other claim about human organization—the test of observation. "Seeing" the artworld and the works of art embedded in its structures, however, is not as easy as "seeing" some of the other human institutions which we are more accustomed to thinking about.

Arthur Danto has invented an argument which helps somewhat in "seeing" the structure in which works of art are embedded. (I must note, however, that what Danto himself "sees" with the use of his argument is quite different from what I "see," but I will not here attempt to rebut Danto's theory.) My version of Danto's argument runs as follows. Consider a painting and another object which looks exactly like it but which was produced accidentally and is, therefore, not a work of art. Or consider *Fountain* and a urinal which is its twin but is not a work of art. Here are two pairs of objects with visually indistinguishable elements, but the first element in each pair is a work of art and the second element is not. The fact that the first element of each pair is a work of art and the second element is not although the elements of each pair are visually indistinguishable shows that the first object in each pair must be enmeshed in some sort of framework or network of relations in which the second element is not. It is the first element's being enmeshed in the framework which accounts for its being a work of art, and it is the second element's not being enmeshed in the framework which accounts for its not being a work of art. The framework in question is not, of course, visible to the eye in the way that the colors of the two objects are.

Some will argue that the *Fountain*/urinal pair does not show anything because *Fountain* is not a work of art. Fortunately, the other hypothetical pair is sufficient to get the argument off the ground. The *Fountain*/urinal pair, however, can also be shown to suffice even if *Fountain* is not a work of art. *Fountain* does not actually have to be a work of art to show the necessity of a context or framework. It is sufficient for the argument that at some time some person mistakenly thought *Fountain* to be a work of art. The framework within which *Fountain* apparently had a place would in this case explain the mistake. And, some persons have thought *Fountain* to be a work of art.

Danto's argument shows that works of art exist within a context or framework, but it does not reveal the nature of the elements which make up the framework. Moreover, many different frameworks are possible. Each of the traditional theories of art, for example, implies its own particular framework. For one example, Susanne Langer's view that "Art is the creation of forms symbolic of human feeling" implies a framework of artist (one who creates) and a specific kind of subject matter (human feeling). And as I noted at the beginning of the paper, the imitation theory and the expression theory each implies a particular framework. Langer's theory and the other traditional theories, however, fall easy prey to counterexamples, and, consequently, none of the frameworks they imply can be the right one. The reason that the traditional theories are easy prey for counterexamples is that the frameworks implied by the theories are too narrowly focused on the artist and various differences of the more obvious characteristics which works of art may have rather than on *all* the framework elements which surround works of art. The result is that it is all too easy to find works of art which lack the properties seized upon by a particular traditional theory as universal and defining.

The frameworks of the traditional theories do lead in the right direction in one respect. Each of the traditional theories conceives of the making of art as a human practice, as an established way of behaving. The framework of each of these theories is conceived of, then, as a cultural phenomenon which persists through time and is repeatable. The persistence of a framework as a cultural practice is enough, I think, to make the traditional theories themselves quasi-institutional. That is to say, each of the traditional theories purports to describe an established cultural practice. In every one of the traditional theories, however, there is only one established role envisioned and that is the role of the artist or the maker of artifacts. And in every case, the artist is seen as the creator of an artifact with a property such as being representative, being symbolic, or being an expression. For the traditional theories the artist role is envisaged as simply that of producing representations, producing symbolic forms, producing expressions, or some such thing. It is this narrow conception of the artist role which is responsible for the ease with which counterexamples can be produced. Since the traditional theories are inadequate, there must be more to the artist role than the producing of any, or even all, of these kinds of things which the traditional theories envisage. What an artist understands and does when he creates a work of art far exceeds the simple understanding and doing entailed by the traditional theories.

Whenever art is created there is, then, an artist who creates it, but an artist always creates for a *public* of some sort. Consequently, the framework must include a role for a *public* to whom art is presented. Of course, for a variety of reasons many works of art are never in fact presented to any public. Some works just never reach their public although their makers intended for them to do so. Some works are withheld from their publics by their creators because they judge them to be in some way inferior and unworthy of presentation. The fact that artists withhold some of their works because they judge them unworthy of presentation shows that the works are things of a *kind* to be presented, otherwise, it would be pointless to judge them unworthy of presentation. Thus, even art not intended for public presentation presupposes a public, for not only is it possible to present it to a public (as sometimes happens), it is a thing of a type which has as a goal presentation to a public. The notion of a public hovers always in the background, even when a given artist refuses to present his work. In those cases in which works of art are withheld from a public, there is what might be called a "double intention"—there is an intention to create a thing of a kind which is presented, but there is also an intention not to actually present it.

But what is an artworld public? Such a public is not just a collection of people. The members of an artworld public are such because they know how to fulfill a role which requires knowledge and understanding similar in many respects to that required of an artist. There are as many different publics as there are different arts, and the knowledge required for one public is different from that required by another public. An example of one bit of knowledge required of the public of stage plays is the understanding of what it is for someone to act a part. Any given member of a public would have a great many such bits of information.

The artist and public roles are the minimum framework for the creation

of art, and the two roles in relation may be called "the presentation group." The role of artist has two central aspects: first, a general aspect characteristic of all artists, namely, the awareness that what is created for presentation is art, and, second, the ability to use one or more of a wide variety of art techniques which enable one to create art of a particular kind. Likewise, the role of a public has two central aspects: first, a general aspect characteristic of all publics, namely, the awareness that what is presented to it is art and, second, the abilities and sensitivities which enable one to perceive and understand the particular kind of art with which one is presented.

In almost every actual society which has an institution of art-making, in addition to the roles of artist and public, there will be a number of supplementary artworld roles such as those of critic, art teacher, director, curator, conductor, and many more. The presentation group, i.e., the roles of artist and public in relation, however, constitutes the essential framework for art-making.

Among the more frequent criticisms of *Art and the Aesthetic* was that it failed to show that art-making is institutional because it failed to show that art-making is rule-governed. The underlying assumption of the criticism is that it is rule-governedness which distinguishes institutional practices such as, say, promising from noninstitutional ones such as, say, dog-walking. And it is true that *Art and the Aesthetic* did not bring out the rule-governedness of art-making and this requires correcting. There are rules implicit in the theory developed in the earlier book, but unfortunately, I failed to make them explicit. There is no point in discussing the rules governing art-making implicit in the earlier theory, but those of the present revised theory can be stated. Earlier in this paper I argued that artifactuality is a necessary condition for being a work of art. This claim of necessity implies one rule of art-making: if one wishes to make a work of art, one must do so by creating an artifact. Also earlier in this paper I claimed that being a thing of a kind which is presented to an artworld public is a necessary condition for being a work of art. This claim of necessity implies another rule of art-making: if one wishes to create a work of art, one must do so by creating a thing of a kind which is presented to an artworld public. These two rules are jointly sufficient for making works of art.

The question naturally arises as to why the framework described as the institutional one is the correct essential framework rather than some other framework. The framework of the traditional theories is clearly inadequate, but its inadequacy does not prove the correctness of the framework of the present version of the institutional theory. Proving that a theory is true is notoriously difficult to do, although proving that a theory is false is sometimes easy to do. It can be said of the present version of the institutional theory that it is a conception of a framework in which works of art are clearly embedded and that no other plausible framework is in the offing. For lack of a more conclusive argument that the institutional theory's framework is the right one, I shall have to rely on the description of it I have given to function as an argument as to its rightness. If the description is correct, or approximately so, then it should evoke a "that's right" experience in the listener. In the remainder of the paper I shall, in effect, continue my description of the essential framework for the creation of art.

In *Art and the Aesthetic* I talked a great deal about conventions and how they are involved in the institution of art. In that book, I tried to distinguish between what I called "the primary convention" and other "secondary conventions" which are involved in the creation and presentation of art. One example of the so-called secondary conventions discussed there is the Western theatrical convention of concealing stagehands behind the scenery. This Western convention was there contrasted with that of classical Chinese theater in which the stagehand (called the property man) appears on stage during the action of the play and rearranges props and scenery. These two different theatrical solutions for the same task, namely, the employment of stagehands, brings out an essential feature of conventions. Any conventional way of doing something could have been done in a different way.

The failure to realize that things of the kind just discussed are conventions can result in confused theory. For example, it is another convention of Western theater that spectators do not participate in the action of a play. Certain aesthetic-attitude theorists failed to realize that this particular convention is a convention and concluded that the nonparticipation of spectators is a rule derived from aesthetic consciousness and that the rule must not be violated. Such theorists are horrified by Peter Pan's request for the members of the audience to applaud to save Tinkerbell's life. The request, however, merely amounts to the introduction of a new convention which small children, but not some aestheticians, catch on to right away.

There are innumerable conventions involved in the creation and presentation of art, but there is not, as I claimed in my earlier book, a *primary* convention to which all the other conventions are secondary. In effect, in *Art and the Aesthetic* I claimed that not only are there many conventions involved in the creation and presentation of art, but that at bottom the whole activity is completely conventional. But theater, painting, sculpting, and the like, are not ways of doing something which could be done in another way, and, therefore, they are not conventional. If, however, there is no *primary* convention, there is a primary *something* within which the innumerable conventions that there are have a place. What is primary is the understanding shared by all involved that they are engaged in an established activity or practice within which there is a variety of roles: artist roles, public roles, critic roles, director roles, curator roles, and so on. Our artworld consists of the totality of such roles with the roles of artist and public at its core. Described in a somewhat more structured way, the artworld consists of a set of individual artworld systems, each of which contains its own specific artist and public roles plus other roles. For example, painting is one artworld system, theater is another, and so on.

The institution of art, then, involves rules of very different kinds. There are conventional rules which derive from the various conventions employed in presenting and creating art. These rules are subject to change. There are more basic rules which govern the engaging in an activity, and these rules are not conventional. The artifact rule—if one wishes to make a work of art, one must do so by creating an artifact—is not a conventional rule, it states a condition for engaging in a certain kind of practice.

As I remarked earlier, the artifact rule and the other nonconventional rule

are sufficient for the creating of art. And, as each rule is necessary, they can be used to formulate a definition of "work of art."

A work of art is an artifact of a kind created to be presented to an artworld public.

This definition explicitly contains the terms "artworld" and "public," both of which have been discussed but not defined in this paper. The definition also involves the notions of *artist* and *artworld system,* both of which have been discussed but not definitionally characterized in this paper. I shall not attempt to define either "artist," "public," "artworld," or "artworld system" here, as I do in my book manuscript, but the definition of "work of art" given here and the definitions of these other four central terms provide the leanest possible description of the institutional theory of art.

To forestall an objection to the definition, let me acknowledge that there are artifacts which are created for presentation to the artworld publics which are not works of art: for example, playbills. Such things are, however, parasitic or secondary to works of art. Works of art are artifacts of a primary kind in this domain, and playbills and the like which are dependent on works of art are artifacts of a secondary kind within this domain. The word "artifact" in the definition should be understood to be referring to artifacts of a primary kind.

The definition of "work of art" given in *Art and the Aesthetic* was, as I affirmed there, circular, although not viciously so. The definition of "work of art" just given is also circular, although again not viciously so. In fact, the definitions of the five central terms constitute a logically circular set of terms.

There is an ideal of noncircular definition which assumes that the meaning of terms used in a definition ought not to lead back to the term originally defined, but rather ought to be or lead to terms which are more basic. The ideal of noncircular definition also assumes that we ought to be able to arrive at terms which are primitive in the sense that they can be known in some nondefinitional way, say, by direct sensory experience or by rational intuition. There may be some sets of definitions which satisfy this ideal, but the definitions of the five central terms of the institutional theory do not. Does this mean that the institutional theory involves a vicious circularity? The circularity of the definitions shows the interdependency of the central notions. These central notions are *inflected,* that is, that they bend in on, presuppose, and support one another. What the definitions reveal is that art-making involves an intricate, correlative structure which cannot be described in the straightforward, linear way envisaged by the ideal of noncircular definition. The inflected nature of art is reflected in the way we learn about art. This learning is sometimes approached through being taught how to be an artist—learning how to draw pictures which can be displayed, for example. This learning is sometimes approached through being taught how to be a member of an artworld public—learning how to look at pictures which are presented as the intentional products of artists. Both approaches teach us about artists, works, and publics all at the same time, for these notions are not independent of one another. I suspect that many areas within the cultural domain also have the same kind

of inflected nature that the institution of art has. For example, the area which involves the notions of *law, legislative, executive,* and *judiciary.*

The ideal of noncircular definition holds also that sets of circular definitions cannot be informative. This may be true of some sets of definitions, but it is not, I think, true of the definitions of the institutional theory. For these definitions just mirror the mutually dependent items which constitute the art enterprise, and, thereby, informs us of its inflected nature.

READING 18

INTRODUCTION

Jerrold Levinson, professor of philosophy at the University of Maryland, has written widely on aesthetics. Much of his work is characterized by a concern for the historical dimensions of art; and nowhere is this more obvious than in the piece reprinted here. In "Defining Art Historically" (1979), Levinson seeks to give a definition of art in terms of one of its non-exhibited properties. The attempt to define art in terms of such properties is usually associated with Dickie's institutional theory of art; but Levinson's theory is distinct from Dickie's. The non-exhibited property that Levinson believes to be definitive of art is the property of having been made with the intention of being regarded in one (or more) of the ways in which previous works of art have standardly been regarded. That this property is non-exhibited is clear: You certainly couldn't tell whether an object had such a property by inspecting it in isolation. In order to determine whether the object does have Levinson's property, it is necessary to find out, or to deduce, what relation the object bears to its maker's intentions. If the object was intended for some appropriate kind of regard, then it is art. If it wasn't, then it isn't. Levinson's definition thus presents art and the creation of art as essentially historical phenomena. The creation—indeed the very possibility—of art depends upon the existence of earlier art and of traditions of regarding that earlier art in particular ways. All of this, of course, like any evolutionary account, prompts the question: But how did it all begin, how did the ball get rolling in the first place? This question is a perfectly legitimate one. But its answer, if Levinson's theory is correct, is much more likely to come from archaeology or anthropology than from philosophy.

"Defining Art Historically"

Jerrold Levinson

The question of what makes something art is probably the most venerable in aesthetics. What is the artness of an artwork? Wherein does it reside? We would certainly like to know. We would certainly be interested to learn what ties together Dickens's *Oliver Twist,* Tallis's *Spem in alium,* Flavin's *Pink and Gold,* Balanchine's *Variations for a Door and a Sigh,* Wilson and Glass's *Einstein*

on the Beach, the Parthenon, and countless other unknown and unsung objects under the common banner of art. After rejecting the many proposals made by philosophers from Plato to the present on grounds of narrowness, tendentiousness, inflexibility, vagueness, or circularity, one would appear to be left with no answer to the question at all, and perhaps a suspicion that it is unanswerable. Nevertheless, the question has been taken up in recent years and given a new sort of answer: the institutional theory of art, adumbrated by Arthur Danto and propounded explicitly by George Dickie. In short, the theory is that artworks are artworks because they occupy a certain place, which they must be given, in a certain institution, that of Art.[1]

I

In this essay I would like to begin to develop an alternative to the institutional theory of art, albeit one that is clearly inspired by it. What I will retain from that theory is the crucial idea that artworkhood is not an intrinsic exhibited property of a thing, but rather a matter of being related in the right way to human activity and thought. However, I propose to construe this relation solely in terms of the *intention* of an *independent individual* (or individuals)—as opposed to an overt *act* (that of conferring the status of a candidate for appreciation) performed in an *institutional setting* constituted by many individuals— where the intention makes reference (either transparently or opaquely) to the *history of art* (what art has been) as opposed to that murky and somewhat exclusive institution, the *artworld*. The core of my proposal will be an account of what it is to regard-as-a-work-of-art, an account that gives this an essential historicity.[2] It is this which will do the work in my theory which the notion of artworld is supposed to do in the institutional theory. That art is necessarily backward-looking (though in some cases not consciously so) is a fact that the definition of art must recognize. To ignore it is to miss the only satisfying explanation of the unity of art across time and of its inherently continuous evolution—the manner in which art of a given moment must *involve*, as opposed to merely *follow*, that which has preceded it.

II

Before sketching my view in some detail, I want to remark on two major difficulties with the institutional theory. (I pass over the oftenmade charges that

[1]Dickie's definition of art runs as follows: "A work of art in the classificatory sense is (I) an artifact (2) a set of the aspects of which has had conferred upon it the status of candidate for appreciation by some person or persons acting on behalf of a certain social institution (the art-world)" *Art and the Aesthetic* (Ithaca: Cornell University Press, 1974), p. 34.

[2]The suggestions that regarding-as-a-work-of-art may be a primary notion and that the nature of art must be located in its historical development can be found in Richard Wollheim's *Art and Its Objects* (New York: Harper & Row, 1971), sections 40 and 60–63, respectively. It is those remarks that first prompted me to work out the view I am trying to present. I might add here that I use 'regard' in this essay as a broad term covering whatever is done in relation to an object so as to experience or interact with it.

the theory is uninformative, and that the key notions of 'artworld' and 'conferral of status' are vague and artificial.)[3] The first problem is the implication that art making must involve a certain *cultural performance,* a ceremony or quasi ceremony, a kind of hand waving that draws into the fold. One must do something outwardly, and one must do it in relation to a certain social institution. On the contrary, I would urge that there can be private, isolated art that is constituted as art in the mind of the artist—and on no one's behalf but his or her own and that of *potential* experiencers of it. (I assume that *just that* is not enough to make the artworld, or else the notion becomes trivial and otiose.) Although in my scheme an art maker will *typically* have art and an existing society of art consumers in mind when producing an art object, this is not necessary. In no case *must* one invoke or accord with the shadowy infrastructure of the artworld to make what one makes into art. Consider the farmer's wife at a Nebraska country fair who sets an assemblage of egg shells and white glue down on the corner of a table for folks to look at. Isn't it possible that she has created art? Yet she and the artworld exist in perfect mutual oblivion. Consider a solitary Indian along the Amazon who steals off from his nonartistic tribe to arrange colored stones in a clearing, not outwardly investing them with special position in the world. Might not this also be art (and, note, before any future curator decides that it is)? The institutional theory comes close to conflating art and *self-conscious* art, art and *socially situated* art, art and *declared* art.

The second and main problem I find with the institutional theory is that the artworld must do all the work in specifying the *way* in which an object has to be presented or treated in order for it to be a work of art, whereas the notion of *appreciation* (the point of the enterprise) is not specified at all or only in the most general terms.[4] That is to say, we are not told enough about what the art maker must envisage must be done with his or her object by potential spectators. It seems, though, that some kind of specification of this must be essayed if making art is to be distinguished from making nonart. I believe the key to an adequate and revealing definition of art is to specify what the art object must be *intended for,* what sort of *regard* the spectator must be asked to extend to the object—rather than designate an *institution* on behalf of which some such request can be made. The trick, of course, is to do so without describing an intended way of regard given by fixed characteristics (e.g., with full attention, contemplatively, giving special notice to appearance, with emotional openness). It has been sufficiently shown that *that* sort of definition is doomed to

[3]For useful criticism of the institutional theory see R. Sclafani, "Art as a Social Institution: Dickie's New Definitions," *Journal of Aesthetics and Art Criticism,* 32 (1973); R. Sclafani, "Art Works, Art Theory, and the Artworld," *Theoria,* 39 (1973); T. Cohen, "The Possibility of Art: Remarks on a Proposal by Dickie," *Philosophical Review,* 82 (1973); A. Silvers, "The Artworld Discarded," *Journal of Aesthetics and Art Criticism,* 34 (1976); K. Walton, "Review: Dickie: *Art and the Aesthetic,*" *Philosophical Review* (January 1977); M. Beardsley, "Is Art Essentially Institutional?" in *Culture and Art,* ed. L. Aagaard-Mogensen (Atlantic Highlands, N.J.: Humanities Press, 1976). I share many of the misgivings expressed by these authors.

[4]Which even then may be subject to counterexamples, as well as being unilluminating in any case (cf. Cohen, "Possibility of Art"). Dickie's extremely general suggestion for the meaning of 'appreciation' is: "in experiencing the qualities of a thing one finds them worthy or valuable" (Dickie, *Art and the Aesthetic,* pp. 40–41).

failure, given the impossibility of locating a single unitary aesthetic attitude or regard common to all the ways we approach and have approached works of art, and given the ways unthought of in which we will undoubtedly be approaching some works in the future. The definition I will offer does not hamstring the kinds of regard that may eventually be given to artworks, yet gives the art-making intention the content it sorely needs.

III

The above-mentioned content is to be found in the actual historical development of art. My idea is roughly this: a work of art is a thing intended for regard-as-a-work-of-art, regard in any of the ways works of art existing prior to it have been correctly regarded. In the absence of any identifiable 'aesthetic attitude', how else can 'regard-as-a-work-of-art' be understood? Obviously, in adopting this proposal we are not analyzing art completely in nonart terms. Rather, what we are doing is explicating what it is for an object to be art at a given time with reference to the body of past art taken as unproblematic. But what it is for a thing to be art at any time can eventually be exhibited in this manner, by starting with the present and working backward. New art is art because of this relation to past art, art of the recent past is art because of this relation to art of the not-so-recent past, art of the not-so-recent past is art because of this relation to art of the distant past . . . until one arrives presumably at the *ur*-arts of our tradition—those to which the mantle of *art* can be initially attached, but which are art *not* in virtue of any relation to preceding objects. (I will return to the *ur*-arts in section VII.) Before stating a more careful definition, let me further attempt to explain the motives for its introduction.

The concept of artwork is unlike that of other sorts of things that surround us—e.g., cars, chairs, persons. *Artwork* seems to lack antecedently defined limits in terms of intrinsic features, even flexible ones—as opposed to car, chair, person. There is no question of determining in all cases that something is art by weighing it against some archetype or other. The *only* clue one has is the particular, concrete, and multifarious population that art has acquired at any point (that is, assuming, as I do, the nebulousness and/or inessentiality of that institution, the artworld). It appears almost obvious, then, that for a prospective object to count as art must be for it to be related in some way to those objects that have already been decided or determined. For a thing to be art it must be linked by its creator to the repository of art existing at the time, as opposed to being aligned by him with some abstracted template of required characteristics. What I am saying is that currently the concept of art has no content beyond what art *has been*. It is this content that must figure in a successful definition.

Let me focus on the central case of art-aware art makers. In such cases making an artwork is a conscious act involving a conception of art. But what conception of art can all such art makers, existing at different times and places, have in common? It seems the only possibility is a conception of art tantamount to all or anything that has been art until now—a concrete conception not equivalent to any abstract principle or generalization drawn from a survey of art's past. Art-aware art makers are thus those who connect their cre-

ations to such a conception and, in so doing, make them art. If they do not do this—if their activities involve no reference whatsoever to the body of artworks preceding them—then I think we fail to understand in what sense they are consciously or knowingly producing art. Given the abandonment of special aesthetic attitudes and/or artistic purposes, some connection of some sort between current artworks and earlier ones must logically be demanded of the putative art maker. It looks as if there are three likely ways in which the connection might be established: (i) by making something that will be externally similar to previous art works; (ii) by making something that is intended to afford the same kind of pleasure/experience that previous artworks have afforded; (iii) by making something that is intended for regard or treatment as previous artworks have been regarded or treated.

The first suggestion, while the simplest, clearly will not do. It is useless unless respects of similarity are indicated, since just about anything would be externally similar to some past artwork in some respect. But aside from that, artworks are just not to any great extent bound together by external similarity. For example, certain welded iron sculptures resemble portions of junkyards more closely than they do the sculptures that were their predecessors. External similarity to artworks is neither necessary nor sufficient for being an artwork. The second suggestion is more promising, but it fails too. There are two reasons for this: (I) the pleasures/experiences derived from art are not necessarily unique to art; (2) it is the *manner* in which artworks afford their pleasures/experiences, the *ways* in which one approaches or engages them *so that* they give those pleasures/experiences, which characterize them as art. To illustrate these points, imagine a drug that when ingested would provide a pleasure/experience akin to what one can have by listening intently to Beethoven's Quartet in C-sharp Minor, op. 131. Such a drug would not thereby be an artwork, although it would be a handy thing to have around. Furthermore, to focus on the pleasures derived from artworks is to emphasize the passive and resultant in the situation, as opposed to the active and causative—i.e., the way of taking the object. It is more reasonable to hold that an artist directing an object toward potential spectators is concerned intentionally with what is to be *done* with the object, as opposed to what might be *got* out of it, since spectators can only *directly* adjust themselves or behave with respect to the former. So I think we are left with the third suggestion as the only one around with which to build an account of what it is to be art.

IV

A definition that preserves my basic idea, but adds certain qualifications, is the following:

> (I) X is an artwork = df X is an object that a person or persons, having the appropriate proprietary right over X, nonpassingly intends for regard-as-a-work-of-art, i.e. regard in any way (or ways) in which prior artworks are or were correctly (or standardly) regarded.

Several comments on this initial definition are in order. First, there is the phrase 'intends for'. This is to be understood as short for 'makes, appropriates

or conceives for the purpose of', so as to comprehend fashioned, found, and conceptual art. Second, there is the notion that the intent must be fairly stable ('nonpassing'), as opposed to merely transient. In other words, it is not enough to turn an object into art that one momentarily considers it for regard-as-a-work-of-art. Third, I have construed regard-as-a-work-of-art as equivalent to ways of regarding past art only in so far as they are or were *correct* (or *standard*) ways. If one omits this qualification, or appeals instead to *common* ways of regard, or even *rewarding* ways of regard, the definition will go awry. The following case illustrates this point.

Italian Renaissance portraits are presumably artworks. Suppose they come to be regarded in a new and unprecedented way—viz., they begin to be used as thermal insulation, and are found to be quite suitable for this. And suppose, through an amazing decline in taste or an unparalleled need for insulation, this manner of regard becomes the rule. If we omit 'correctly' from our definition, or replace it by 'commonly' or 'rewardingly', then given the case as described, it follows from our definition that anything subsequently intended by its maker for use as insulation (e.g., a sheet of Fiberglas) would be an artwork. Why? Because Renaissance portraits are past artworks that are regarded, are commonly regarded, and are rewardingly regarded as insulation. This must be wrong. It can't be possible to turn all tomorrow's Fiberglas production into art simply through general misuse today of a certain class of portraits. To avoid this unwanted consequence, we *must* appeal to some notion of *correct* regarding for artworks.[5] Using Renaissance portraits as insulation is manifestly not a correct way of regarding them, no matter how widespread or satisfactory such a use might be. And so on our definition nothing can become art through intentional reference to such a prior way of regarding artworks.

Fourth, the definition includes a proprietary-right condition. What this amounts to is basically *ownership*—you cannot 'artify' what you do not own and thus have no right to dispose of. All your intentions will not avail in such a case, because another person's intention, that of the owner, has priority over yours. (Of course, if owners are not opposed to your intention, they can grant you permission to make their possessions into artworks.) One standardly attains the right in question by creating an object, but notice that this will not always suffice—for example, if the object is created under contract during working hours while in the employ of a metal tubing company. (On the other hand, neither is it necessary to create something in order to have the right to 'artify' it, as witnessed by found art.) It might be thought that the proprietary-

[5]The notion of correct regard for an artwork is a difficult one to make out, but surely relevant to it are the following considerations: (1) how the artist *intended* his work to be regarded; (2) what manner of regarding the work is *most* rewarding; (3) the kinds of regard *similar* objects have enjoyed; (4) what way of regarding the work is optimum for realizing the *ends* (e.g., certain pleasures, moods, awarenesses) which the artist envisaged in connection with appreciation; (5) what way of regarding the work makes for the most satisfying or coherent picture of its place in the *development* of art. (For an illuminating discussion of some of these factors, see Walton, "Categories of Art," reprinted in this volume.) Nothing in the present paper depends on the exact analysis of 'correct regard', however. To understand my account of art one only has to grant that *there are* correct ways of regarding past artworks, whatever that might amount to.

right condition would rule out varieties of conceptual art, but this is not so. One must just avoid the mistake of taking the art object in such cases to be simply and solely what the artist has described or pointed to (e.g., Marilyn Monroe, the Empire State Building, a slice of the life of a family in Queens—things that the artist clearly has no proprietary right over), rather than a directed complex of the description and the object.

Given a proprietary-right condition, it is somewhat problematic whether curators, promoters, exhibitors can turn nonart objects of the past into art objects of the present as blithely as is usually allowed. Imagine an art museum having mounted for regard-as-a-work-of-art a strange ornate receptacle whose original purpose is unknown. The object comes from an ancient Mexican culture thought to have died out. However, a well-documented descendant of the tribe, armed with full knowledge of its customs and practices, appears and successfully demands the removal of the receptacle from public view (it is apparently a sacred ritual object, used for nocturnal royal baptisms, and not in any sense for appreciation). I maintain that the object in question does not just revert to being nonart—it never was art at all, because our present art establishment unknowingly lacked the right to make it such. This sort of case may be more prevalent than is generally imagined.

It will be useful to distinguish three kinds of intention which can realize the condition expressed in the definition: *intending for regard-as-a-work-of-art*. The first would be the *specific art-conscious* intention: intending for regard in the specific way or ways some particular past artworks (or class of artworks) have been correctly regarded. An example of this would be intending for regard in the way wire sculptures are to be regarded. The second is the *non-specific art-conscious* intention: intending for regard in whatever ways any past artworks have been correctly regarded, having no particular ones in mind. The third is the *art-unconscious* intention: intending for regard in some specific way ϕ characterized in terms of intrinsic features, where ϕ is *in fact* a way in which some past artworks have been correctly regarded, though this fact is not known to the intender. An example of this might be intending for listening to with attention to timbre.

The first and second kinds realize *intending for regard-as-a-work-of-art* on a referentially *opaque* interpretation of that notion, whereas the third kind satisfies a *transparent* interpretation of it. Given the notion as readable in both modes, my definition thus allows (via the art-unconscious intention) for art makers ignorant of all artworks, all art activities, and all institutions of art. Such persons can be seen to make art if they intend their objects for regard in ways that *happen to be*, unbeknown to them, in the repertory of aesthetic regards established at that time. In such a case there is the requisite link to the prior history of art, but it is one such art makers are unaware of, though they have in fact forged it.

So cases of naïve activity can be cases of art making if they accord with the development of art at that point in the manner sketched. And I would insist that a theory must account for these cases. From where we stand such persons (e.g., the Amazon Indian mentioned before) are clearly making art—and it is not our recognition that makes it so.

V

The definition presented in the preceding section conveys in a fairly perspic-
uous fashion what I believe it now means for something to be an artwork.
however, at the expense of some perspicuity but in the name of greater preci-
sion and flexibility, I offer a second definition that makes explicit the time-
dependence of the status of 'artwork', clarifies the interpretation of 'prior art-
works', and indicates more exactly what sort of definition of art I am giving.

> (I_t) X is an artwork at t = df X is an object of which it is true at t that some
> person or persons having the appropriate proprietary right over X, nonpass-
> ingly intends (or intended) X for regard-as-a-work-of-art—i.e., regard in any
> way (or ways) in which artworks existing prior to t are or were correctly (or
> standardly) regarded.

An object can be an artwork at one time and not another. This definition rec-
ognizes that an object may not be an artwork from the moment of its physical
creation, but may only become an artwork at some *later* date. It also allows for
an object that becomes an artwork even subsequent to its creator's intending
it for a certain regard, and even subsequent to the death of its creator.[6]

The first sort of case is relatively common. Any piece of found art serves
as an example. The snow shovel involved in Duchamp's *Snow Shovel,* or the
bottle rack in his *Bottle Rack,* became works of art at a certain time owing to
Duchamp's appropriating them with a certain intention, whereas they existed
but were not works of art before that time. The same goes for driftwood
mounted and displayed in someone's living room, or potsherds and door han-
dles touched by curatorial intent in a museum of primitive art. Another kind
of example would be a canvas that is undertaken and completed merely as a
technical exercise but which after a few days' reflection is then viewed by its
creator as for regarding-as-a-work-of-art. These things are art only *after* a cer-
tain intentional decision has taken place. Definition I_t makes this plain.

The second sort of case is less common, but I think a completely adequate
definition of art must be capable of handling it. An example would be the fol-
lowing: A naïve or art-unaware creator makes an object Z at t, which he
intends for a kind of treatment or regard that is not a correct way of regard-
ing any artworks existing prior to t_1. However, it is a kind of treatment or
regard that *will be* correct for certain artworks θ existing 200 years after t_1. I
think we want to say that the naïve creator's work is art beginning around t_2
(= t_1 + 200) but not before. That is to say, Z becomes art 200 years after its inten-
tioned creation, when the history of art, so to speak, catches up with what Z's
creator was engaged in. It would be hard to deny at t_2 that Z was art; for, after
all, it was created and intended for just the sort of treatment that θ's, which

[6]There are three times of importance that should be distinguished if we are to get clear on this
issue. One is the time of physical creation of the object, t_p. A second is the time of intentioned-
object creation, t_i—i.e., the time at which the brute object is structured or transformed by a cer-
tain intention concerning it. Every artwork is, strictly speaking, an intentioned object. A third is
the time of art-becoming, t_a. In the typical or normal case of art production $t_p = t_i = t_a$; in the case
of found art, t_p is earlier than t_i, and $t_i = t_a$; in the case of the naïve creator ahead of his time (dis-
cussed below), $t_p = t_i$ and t_a is later than t_i.

are recognized artworks at t_2, are correctly accorded. Z is art at t_2 because it was intended for a kind of regard which (unknown to its creator) turns out to be in the stock of standard regards for artworks at t_2. Z at t_2 can be seen as projected for a kind of appreciative activity which had become part of artistic tradition. However, before t_2 this cannot be seen. There is no plausible ground for considering Z to be art prior to t_2. Something cannot be art from the outset *just* in virtue of its future redemption by the evolution of art—only actual redemption will turn the trick then and there.

Definition I_t handles this case as desired. Z is an artwork at t_2 (and thereafter) because it is an object of which it is true at t_2 that someone rightfully and nonpassingly intended it (at t_1) for regard in a way in which some artworks existing prior to t_2 are correctly regarded. However, Z is *not*, according to I_t, an artwork at t_1.

So what sort of definition of art have we given? In short, a definition that explains what it is to be art at a given time in terms of what is art at previous times. To be art at t is to be intentionally related in the required way to something that is art prior to t. The present state of art shows us that certainly nothing more can be required. On the other hand, nothing less than this can be required if we are to locate a conception of art which will cover equally Donatello's *David* and Carl Andre's *Lever*, Mozart's *Jupiter* Symphony and Stockhausen's *Momente*, Shelley's "Ode to the West Wind" and John Berryman's *Dream Songs*. If there is now a univocal sense of 'art' in which all six items count as art, and count as such from the time of their creation, then I believe this sense is given (more or less) by definition I_t.

I can almost see readers shake their heads at this point and ask: But does this definition *really tell* me what art is? Doesn't it seem that I have to *know* what art is in order to use it? In fact, isn't the definition simply *circular*, in that it defines art in terms of art? This response is perfectly understandable, but it is nonetheless mistaken. True, there is something reflexive about the definition, in that it exhibits art as essentially referring to itself. But to eliminate this reflexiveness would be to eviscerate the term 'art' of the only universal content it now retains. If artworks at one time are essentially intentionally related to artworks at an earlier time, then on the assumption that definitions attempt to give essences, how could a definition of art fail to explicate artworks—to put it bluntly—in terms of artworks? Thus the *appearance* of circularity.

But, strictly speaking, I_t is *not* circular. What it does is define the *concept: being art at a given time* by reference to the *actual body of things* that are art prior to that time. True, one cannot tell what counts as art at t without its being granted what things count as art prior to t—but this is in fact just the way art itself works. Furthermore, and this also conforms to the reality of art, to the extent that it is unclear which objects *prior to t* are artworks, it will be equally unclear which objects *at t* count as art. True, one cannot use the definition to tell, all at once, what has, does, and will count as art at all times, but this is because the applicability of 'art' at any stage is always tied to its concrete, historical realization at that stage. That the definition is not circular if properly understood can be seen by reflecting that one doesn't have to know what 'artwork at t' *means* in order for I_t to *tell* you; one only has to grant that there is a

set of things which are artworks prior to *t*—*whatever* they are and *whatever* that (viz., 'artwork') might mean.

The last point suggests another way of expressing the analysis of art that I offer, a way I think that removes any lingering suspicion of circularity. Basically, what I have proposed is that the *meaning* of 'art now' involves the extension of 'art previously'—that the *meaning* of 'art at *t*' is to be given in terms of the *extension* of 'art prior to *t*'. Formulating a variant of I_t to make this explicit, we have:

> (I'_t) X is an artwork at *t* = df X is an object of which it is true at *t* that some person or persons, having the appropriate proprietary right over X, nonpassingly intends (or intended) X for regard-as-a-work-of-art—i.e., regard in any way (or ways) in which objects in the extension of 'artwork' prior to *t* are or were correctly (or standardly) regarded.[7]

It is clear that the *meaning* of 'artwork' is not involved in the righthand side of this definition, but only its past *extension* at some point. Thus, I maintain that I'_t or I_t captures our present concept of art—and without presupposing that concept in doing so.

VI

On the view I have presented, which makes art a necessarily backward-looking affair, one may wonder how the *revolutionary* aspect of art can be accommodated. Surely, one might say, if art is continually looking to the rear, how can it change or advance? Won't it always remain the same? To begin to answer this let me first distinguish revolutionary from merely new or original art. A new artwork is simply one nonidentical to any previously existing artwork. An original artwork is a new one significantly different in structural or aesthetic properties from any previously existing artwork. The production of original art could continue indefinitely without there being any additions to the stock of ways in which artworks are regarded. But by a revolutionary artwork I mean one for which any of the past ways of approaching art seems inadequate, inappropriate, pointless, or impossible; a revolutionary artwork appears to be ultimately calling for a kind of regard which is totally *unprecedented*. It is plainly only revolutionary art that poses any difficulty for my analysis.[8]

Art that is revolutionary because it demands or requires a new approach to yield up its fruits to spectators is not per se a problem. A problem only arises for artworks—e.g., Dadaist ones—which are *intended* as revolutionary

[7]Note in this definition that when I speak of the extension of the term 'art work' at a time *t* this means the extension of the term at *t* as it is understood *now*—i.e., in its current usage.

[8]Most movements in art are revolutionary in a *weak* sense, in that they ask for or involve *some* specific new ways of taking art objects, but few such movements (perhaps none before Dadaism) deny the applicability of *all* past ways of taking art objects. For example, Impressionist paintings certainly are and were to be approached in specific ways (e.g., synoptic vision from a distance) which were not in practice for previous paintings (e.g., those of the Neo-classicists). But there clearly remained ways in common in which they were to be regarded. Thus, weakly revolutionary art does not challenge the historicity of the art-making intention.

by their artists, that is to say, intended for treatment in a manner completely distinct from what has gone before. (Whether all intentionally revolutionary art is thereby revolutionary *simpliciter* is a complicated question I will not go into here.) Two strategies suggest themselves for reconciling my proposal to this important and characteristic mode of art making. One is to maintain that although consciously revolutionary artists desire that eventually their objects will be dealt with in unprecedented ways, to make them *art* they must initially direct their audiences to take them (or try taking them) in some way that art *has* been taken—otherwise, what can we make of the claim that they have given us *art*, as opposed to something else? The art-making intention of consciously revolutionary artists may thus have to be a covertly disingenuous one, somewhat along these lines: 'My object is for regarding in any way artworks have been regarded in the past (but with the expectation that this will prove frustrating or unrewarding, thus prodding the spectator to adopt some other point of view—this being my ultimate intention)'. The secondary intention embodies the true *aim* of such art, but the primary intention must be present to make it *art* at all.

A second strategy for dealing with this issue perhaps does less violence to the outward stance of the consciously revolutionary artist. This requires a liberalization of what regard-as-a-work-of-art amounts to. Instead of construing it as restricted to past correct ways of regarding artworks, broaden it to include completely unheralded types of regard so long as one is directed to adopt such regards in conscious opposition to those past correct ways. The liberalized version of regard-as-a-work-of-art then reads as follows: regard in any way (or ways) in which prior artworks are or were correctly (or standardly) regarded, or *in some other way in contrast to and against the* background of those ways. (Call this 'regard-as-a-work-of-art*'.) If this second strategy is adopted, one simply substitutes 'regard-as-a-work-of-art*' for 'regard-as-a-work-of-art' in I, I_t, and I'_t to get definitions adequate to revolutionary art. Whereas the idea of the first strategy was that self-aware revolutionary artists must on one level intend the existing correct art regards, freeing them to intend on another level some entirely new regard, the present strategy does not insist that they should directly intend the existing ways at all, but only that they should project the new way *in relation* (albeit antagonistic relation) to its predecessors. If they fail to do even that, I think there are no grounds on which one could deny that they fail to make art. Of course it is open at that point for some other member of the art community, assuming they have the proprietary right, to appropriate the would-be artist's work at a later date with the right intention, and so bring it into the sphere of art. The point is, to get a revolutionary mode of activity to *be* art it is necessary that its creator (or the creator's subsequent proxy) should consciously nod in the direction of past artistic activity.

Which of the two strategies is ultimately preferable as a way of accommodating the historical definition of art to revolutionary art making is a question I will not attempt to settle here. However, for the sake of simplifying succeeding discussion, I will assume for the remainder of this essay the workability of the first strategy and tentatively adopt it. This means that definition I, I_t, I'_t, properly understood, will be viewed as adequate to revolutionary (as well as evolutionary) art.

VII

The view presented so far suggests the following picture of art's evolution. Artworks are objects projected for regard, at least in part, in ways past artworks have been standardly regarded. These artworks, if at all original, will differ from those of the past more or less markedly, and will therefore optimally call for ways of regard (which the artist has usually envisaged) somewhat different from ones already in practice. But then *those* ways will become part of the tradition of art appreciation, allowing for newer works to be constituted as art by reference to *them,* and so on. There is thus a deeper continuity in the development of art than is generally noted. Artworks of a given period do more than *follow* their predecessors. They are even more than causally *descended* from them, more even than testimonies to the influence of style, medium, and subject matter. Rather, those predecessors are *necessarily involved* (via the ways in which they have been regarded) in the intentional structure which determines their successors as art. What art becomes depends conceptually, not just causally, on what art has been.

Definition I_t analyzes being art at a given time in terms of what is art prior to that time. The definition can be applied at the present time, and then at as many times back into the past as one chooses, until one at last reaches the origins of art[9] itself (i.e., the *ur*-arts). Having reached that terminus, however, we could then use it as the starting point of another kind of definition of art, one that begins with the hypothesized origins of art and yields serially all that has sprung from it up to the present. This would be a *recursive* definition and would reveal art as a recursive domain. Before giving one, let me tell a somewhat oversimplified tale.

The time predates the beginning of art. Certain societies are thriving in which various activities are going on. In some of these activities objects (including events) are produced and then treated in a certain manner. These activities can be identified retrospectively as the *ur*-arts of our tradition. At some point, new activities arise wherein objects of a different sort are produced which are intended for treatment as objects of some *ur*-art are. The new activity then becomes associated with that of the *ur*-art, under a wider category, that of *art.* At this stage, an activity of object making can only become art by relating itself to the purposes of some (or possibly more than one) *ur*-art; the objects of the activity can only be artworks by being thought of in connection with the ends toward which the objects of some *ur*-art were directed. Once a new activity and its objects are established as art, *further* activities and objects now enter the realm of art through intentional connection with *them.* Eventually one arrives at art as we find it today.[10] Let me state the definition suggested by this tale:

[9]That is, *art* as understood in present-day Western culture.

[10]The story I tell here is consonant with a remark made in passing by Walton, "Review: Dickie," concerning the historical development of art. I should also emphasize that the story is told from the point of view of art as the production of artworks for appreciation by spectators, and not from the point of view of art as the release of psychic energy or the expression of artistic impulses by creators. As should be apparent, it is only the former idea of art that this essay is concerned to elucidate.

(II) Initial Step: Objects of the *ur*-arts are artworks at t_o (and thereafter).[11] Recursive Step: If X is an artwork prior to t, then Y is an artwork at t if it is true at t that some person or persons, having the appropriate proprietary right over Y, nonpassingly intends (or intended), Y for regard in any way (or ways) in which X is or was correctly regarded.

I believe this definition very nearly generates all and only those things that have been, are, or could be artworks, given the concept of art we presently have.[12] And yet, it is easy to understand how the definition might strike one as inoperative or incomplete. For recursion depends on the initial step, the initial step speaks of the *ur*-arts—but one has not been told what the *ur*-arts *are!* I would be happy to supply their description if I knew what they were, but I don't. Nor does anyone. Is there, then, a way to save II from this charge of having merely programmatic status?

I think there is. Our explanation of the *idea* of an *ur*-art given earlier in this section can be turned to provide a method in principle for *actually identifying* the *ur*-arts. Basically, one just has to ask, of objects at points successively farther into the past, and until the questioning process terminates, "What makes this count as art?" More formally, and relying on definition I for simplicity of exposition, the procedure would be as follows: Begin with a group of related recent artworks, A. Then by I, A consists of objects that were *intended* for regard R, where R is the manner of regard *in fact* standardly accorded certain earlier artworks, A'. Now focus on A'. By I, A' consists of objects that were intended for regard R', R' being the regard in fact standardly given an even earlier set of artworks, A''. A, A', A'' . . . thus form a backward-reaching series of artworks whose principle of continuation should be clear. Eventually one arrives at a set of objects, A_o, which are such that objects succeeding them are intended for regard as A_o's are standardly regarded, but there are no objects X preceding A_o such that A_o's were intended to be regarded as X's in fact standardly were. A_o is then one set of *ur*-artworks. Of course to put this method into practice would be exceedingly difficult. It would require a great deal of knowledge of artists' intentions and actual appreciative practices of societies to perform successfully the backward trace on an initial sample. And one would have to do

[11]Let t_o be the time roughly at which the *ur*-arts begin spawning non-*ur*-art artworks.

[12]Wollheim, in section 60 of *Art and Its Objects*, mentions the possibility of a general *method* of identifying all works of art which would be recursive in form. He concludes that as a method of identification it would not work, the reason being the inability to formulate rules of transformation adequate to the concrete evolution of art in the distant and also the recent past. He has in mind rules that would operate on given structures or styles and spew out altered ones according with the direction taken by art at a given juncture. The problem is especially acute for the modern period: "whereas earlier changes in art affected only the more or less detailed properties of a work of art, e.g., painterly vs. linear, in the art of our day one work of art generates another by the supersession of its most general properties . . . e.g., hard-edge painting as the successor of abstract expressionism" (p. 126).

Granted that Wollheim is right about this, I think the possibility of a definition such as I propose is unaffected. The definition does not depend on rules of stylistic change but, rather, simply on the rule I have argued for as constraining the intention that makes something art. The definition, unlike Wollheim's projected method, does not of course generate all works of art in terms of their intrinsic observable features, but only in terms of certain external intentional relations they bear to other objects.

this for many such samples in order to unearth all the *ur*-arts of Western culture. However, *if* one did carry out this procedure for a wide, well-chosen variety of current paradigm artworks, one would have pretty good reason to be confident that all of the *ur*-arts had been ferreted out from their historical hiding places. At that point, if one liked, one could substitute for the place-holder '*ur*-arts' in II a specification in *intrinsic* terms of the activities that archaeological investigation had revealed to be *in fact* the roots of Western art. This would in effect 'complete' the recursive definition of art.

It is important to note that while the basic definition (I_t) is put forward as capturing the general concept of art which we now employ, the recursive definition aims only at displaying in a revealing way the *extension* of that concept. The basic definition explains the shared sense in which Donatello's *David* is art in 1420, Shelley's "Ode to the West Wind" is art in 1820, and Stockhausen's *Momente* is art in 1970. The recursive definition, though, does *not* explain the sense of 'artwork'. It would be implausible to maintain that our conception of artwork entails that all such things have ultimate ancestors of the sort that the *ur*-arts are. Surely the notion of *ur*-arts, whether characterized positionally or intrinsically, is not part of the content of a judgement that something is an artwork. What the recursive definition does, though, is to generate all artworks by a method that closely parallels and illuminates the actual historical process of the evolution of art.[13]

VIII

Having spelled out the theory I have to offer, in which the concrete history of art replaces the institutional network of art at center stage, I wish to remark further on certain issues over which my theory and the reigning institutional one differ. In particular, two issues that can be put in the form of questions: (I) Is art making in essence an *internal* (intention) or *external* (conferral) matter? (2) Need a person have a special *position* in the artworld to create certain sorts of artwork? I will consider these briefly in turn.

1. Consider an object made by an artist, and intended for regard-as-a-work-of-art, but not offered, not placed, not mounted, not circumscribed, adver-

[13]The recursive definition justifies perhaps more strongly than the basic definition my titular claim to be 'defining art historically.' Of course, I am not defining art simply as that which has a history; just about any activity has a history. But neither am I defining it simply as that activity whose historical source is the *ur*-arts. For some of the ultimate ancestors of art (viz., the *ur*-arts) may in fact also be ultimate ancestors of activities other than art. If that is so, does our recursive definition unwantedly generate those nonart activities as well as that of art? No, because in order to be art something must not only have an *ur*-art as ancestor but must also be descended from it in a particular fashion—namely, via intentional relations invoking previous standard regards. It is a good bet that even if there *are* other activities which have *ur*-arts as ultimate ancestors, they do not exhibit *that* principle of descent.

Now that we have concluded our discussion of the *ur*-arts as they figure in the recursive definition, it might be observed that objects of the *ur*-arts are artworks that do *not* conform to our basic definition of the meaning of 'artwork', namely I_t (or I'_t). For there are no artworks and correct regards prior to the *ur*-arts. I_t (or I'_t) thus strictly speaking only tell one what it means for any thing *apart from an ur-art object* to be an artwork. Objects of the *ur*-arts are, by contrast, simply stipulated to be artworks.

tised, or sold—in short, not 'done with' in any way. Isn't this still an artwork? The institutionalist might argue that having the intention *just is* conferring a certain status, and no other 'action' is necessary. But if having the intention is always *thereby* conferring status, while any overt conferring must *anyway* include the requisite intention (or else it is mere sham, 'playing the artist'), then this seems to me tantamount to admitting that intention is really all that is essential to art making. This is not to say that art makers are very *likely* to *just* intend an object for regard-as-a-work-of-art. It is highly unlikely that they will fail to act so as to draw attention to their works. Artists naturally try to increase the chances of their works getting the regard they intend (both for their benefit and for ours).

On the other hand, the fear that taking everything outward away from the essentials of art making would mean a world pullulating with artworks of the unfashioned kind, generated at every turn of thought—that fear is groundless. It is relatively easy, natural, and common to summon the requisite nonpassing intention in connection with an object one has made, but difficult, unnatural, and rare to form such an intention in connection with an object one has not made—it takes a certain courage and occasionally perversity to convince oneself of the right or point of so appropriating what nature or another person has already fashioned. Only if one overlooks the fact that these intentions are not going to arise in many people will one suppose the need for an art maker to perform an action on behalf of the artworld, in order to account for the observation that not one person in a hundred has transformed his or her kitchen stove into a work of art.

2. Arthur Danto gives an answer to question two in speaking of 'the making of artworks out of real things'—i.e., the appropriation/minimal-fashioning mode of art. "It is analytically true that artworks can only be *by* artists, so that an object, however much (or exactly) it may resemble an artwork is not *by* whoever is responsible for its existence, unless he is an artist. The mere object [e.g., a brass bushing] perhaps does not lie outside their [viz., non artists'] powers. But as an artwork it does."[14] If 'artist' in these remarks meant only 'person who at some time makes an artwork' then I would have no trouble agreeing that an artwork can be brought into being by nobody other than an artist. However, the context makes it clear that 'artist' means there something more like 'person with an established position in the artworld, one of whose main concerns is the making of artworks' (call this 'artist*'). Danto believes that tracing a 'real thing' to someone who is not an artist* defeats any claim it might have to be art. I cannot accept this. I do not believe the 'conventions of ascribing'[15] the predicate 'is art' are like that at all. The only reason I see why one would maintain they are is based on confusing *established* or *professional* art with *all* art. I am willing to admit that commanding a special position or having a certain background may be relevant to making brass bushings into *recognized* art, or making them into *significant* art, or into artworks that will affect the *development* of art—but *not* to making them into art *simpliciter*. The witti-

[14]A. Danto, "Artworks and Real Things," *Theoria*, 39 (1973): 14.
[15]Ibid., p. 12.

est riposte of the season is presumably utterable *only* by a member of high society; art per se no more operates on this level than philosophy does.

IX

The concept of art has certainly changed over time. There is no doubt of that. It is thus worth emphasizing in this final section that my analysis is aimed just at capturing what the concept of art is *at present*—that is, what it *now* means for an object created *at any time* (past, present, or future) to count as art at that time, rather than what it meant at the time of the object's creation.[16] Claiming that the analysis indicates what it means, say, for something created in 1777 to be an artwork thus does not entail or require that the concept-of-art$_{1977}$ is identical with concept-of-art$_{1777}$. Presumably these two concepts would classify the field of objects into art and nonart somewhat differently. And calling Rembrandt's *Night Watch* a work of art in 1777 undoubtedly meant something different from what is meant by calling it that in 1977. However, given my analysis of it, I think the only part of concept-of-art$_{1977}$ that could unarguably be held to have been *missing* from concept-of-art$_{1777}$ is the permissibility of objects as art which are unfashioned or only minimally fashioned by their creators.[17] Whereas concept-of-art$_{1977}$ associates *The Night Watch* with former stainless steel bars, coat racks, cardboard cartons, and goats' heads, concept-of-art$_{1977}$ served in part to differentiate *The Night Watch* from such things. This major conceptual changeover occurred, as we know, around 1920 as a result of the Dadaist movement.

I have already noted that the historical definition of art provides a powerful and direct explanation of the inherent unity and continuity of the development of art. In short, for something to be an artwork at any time is for it to be intentionally related to artworks that precede it—no more and no less. And the historical definition, if accepted, helps to dispel the lingering effects of the so-called 'intentional fallacy' understood as a claim about the irrelevance of artists' intentions to correct or full appreciation of their works. For if artists' intentions are recognized as central to the difference between art and nonart, they are not so likely to be offhandedly declared irrelevant to an understanding of artworks once seen as so constituted. In particular, the historical definition indicates the overwhelming importance for appreciation of those past artworks/genres/ways of regard/modes of treatment which artists connect to their current productions through their art-making intentions.

The historical definition of art also casts a useful light on the fact that in art anything goes, but not everything works. The reason anything goes is that

[16]This is the distinction, difficult to grasp firmly, between: (i) what it *means at present* for something to *be art at the time of its creation,* and (ii) what it *meant at the time of its creation* for something to *be art at that time.*

[17]On the other hand, it seems clear that there was much in the concept-of-art$_{1777}$ that is missing from the concept-of-art$_{1977}$. Concept-of-art$_{1777}$ was surely more restrictive than its 1977 counterpart; one could reasonably maintain that it included specification of structural features, technical requirements, purposes, ends, and even minimum aesthetic effectiveness. Thus, to get from concept-of-art$_{1777}$ to concept-of-art$_{1977}$ one must delete all such artistic specifications, while broadening the sphere of creation beyond that of fashioning; what is retained throughout is the common thread of reference by art at any time to the sort of treatment earlier art was accorded.

there are no clear limits to the sorts of things people may seriously intend us to regard-as-a-work-of-art. The reason not everything works is that regarding-something-as-a-work-of-art necessarily involves bringing the past of art to bear on what is being offered as art in the present. That the present object and past regards will mesh is not guaranteed.[18] The interaction of the two sometimes satisfies immediately, sometimes only after an interval. Sometimes we are shocked and unsettled, but recover and are illuminated. Sometimes we are forcibly impelled to adopt new modes of regard, leaving old ones aside. But sometimes we are simply bewildered, bored, bothered—or all three—and in a manner that is never transcended. In such cases we have artworks, all right, but such works don't work.

In conclusion, let me say that I do not mean to deny that there is a common practice of art, and a group of people bound together under that umbrella, nor do I deny that artworks need to be understood in relation to their cultural situation. What I do deny is that the institutions of art in a society are essential to art, and that an analysis of arthood must therefore involve them. The making of art is primary; the social frameworks and conventions that grow up around it are not. While the sociology of art is of great interest, the essence of art does not lie there but instead in art's relation to its contingent history. The theory I offer sketches in its main outlines what this relation is.[19]

READING 19

INTRODUCTION

Richard Eldridge teaches philosophy at Swarthmore College. The essay reprinted here, "Form and Content: An Aesthetic Theory of Art" (1985), contains one of the very few recent attempts to define art in a nonrecursive way. Dickie's institutional theory, for instance, defines art in terms of the "artworld"; Levinson's theory defines art in terms of earlier art. Thus both theories define art recursively—i.e., they both define art in terms, ultimately, of art. But Eldridge bucks this trend. He suggests that what makes something art is the "satisfying appropriateness" of its form to its content. Eldridge therefore seeks to give an *informative*, rather than a merely recursive, account of art. And he argues in some detail that his definition can help to make sense of a variety of artistic and critical practices in a way that other definitions are unable to. If he is right about this, then it certainly adds to the plausibility of an already attractive theory of art.

[18]Thus it is clear that the historical theory of art leaves room for the sense of 'conceptual strain' accompanying some works of art (e.g., *Bottle Rack*) that Anita Silvers ("The Artworld Discarded") accuses the institutional theory of eliminating. The strain arises from the clash between the *nature* of the object and the *kinds of regard* typically accorded earlier artworks, which regards had to be invoked in making the object in question art.

[19]For further discussion and defense of the ideas presented here, see Jerrold Levinson, "Refining Art Historically," *Journal of Aesthetics and Art Criticism* 47 (1989): 21–33, reprinted in Levinson, *Music, Art and Metaphysics* (Ithaca, NY: Cornell University Press, 1990); and "Extending Art Historically," *Journal of Aesthetics and Art Criticism* 52 (1993): 411–423.

"Form and Content: An Aesthetic Theory of Art"

Richard Eldridge

I

In the senses in which 'aesthetics' and 'the philosophy of art' are not synonymous expressions, aesthetics treats the natures and conditions of occurrence of various human experiences such as the experiences of the beautiful, the garish, and the cute, while the philosophy of art in contrast treats the nature of works of art. Throughout the eighteenth century and recurrently thereafter, these two disciplines were often held to be identical, for works of art were often taken to be just those artefacts which, when confronted, engender in us a particular aesthetic experience, generally called the experience of the beautiful. An examination of the capacity to have aesthetic experiences—that is, of the faculty of taste—was often held to constitute nearly the whole of a properly directed philosophy of art.

Nowadays, however, aesthetics has come to seem to many to be peripheral to the philosophy of art. There seem to be many objects—the works of Duchamp are the ones most often mentioned—which fail to provide us with an experience of the beautiful but which none the less are called works of art. Marxists, structuralists, and so-called post-modernists have insisted that the experience of a thing's beauty and its consequent canonization as art are little more than conditioned responses induced by a prevailing bourgeois cultural ideology which is maintained through such conditioning. Prevailing taste, rather than recording discoveries of works of inherent value, is simply an outgrowth of the fact that a certain group has acquired economic and cultural power and is concerned to impose its views about art and value on others. When art is seen in this light, 'everything is equal, the good and the evil. The farcical and the sublime—the beautiful and the ugly—the insignificant and the typical, *they all become an exaltation of the statistical*'.[1] If this is what taste is— an exaltation of the statistical—then, as Douglas Crimp has argued, 'Art as ontological essence, created not by men in their historical contingencies, but by Man in his very being, [and identified through the aesthetic experience it provides] . . . is [a] deception'.[2] Art is to be studied sociologically, not philosophically. There is no essence of art and there are no inherent bearers of aesthetic or artistic value. Thus, for post-modernists, 'a poem or picture is not necessarily privileged and the artifact is likely to be treated less as a *work* in modernist terms—unique, symbolic, visionary—than as a *text* in a post-mod-

[1]Gustave Flaubert, *Bouvard and Pécuchet*, quoted in Douglas Crimp, 'On the Museum's Ruins', in *The Anti-Aesthetic: Essays on Post-Modern Culture*, ed. Hal Foster (Port Townsend, Washington: Bay Press, 1983), p. 45. Emphasis added. Crimp quotes Flaubert from Eugenio Donato's 'The Museum's Furnace: Notes Toward a Contextual Reading of *Bouvard and Pécuchet*', in *Textual Strategies*, ed. Josue V. Harari (Ithaca: Cornell University Press, 1979), p. 214.
[2]Crimp, 'On the Museum's Ruins', p. 51.

ernist sense—"already written", allegorical, contingent',[3] and to be understood sociologically.

The moral to be drawn from all this is, it seems, that aesthetics should not be confused with the philosophy of art. Aestheticians, together with other varieties of psychologists, should of course be allowed to study whatever human experiences interest them, but they should not suppose that the experiences they study have anything to do with what makes some things art, for, seemingly, nothing does.

Beyond the apparent heterogeneity of works of art, four further philosophical reasons encourage the idea that aesthetic theories of art are hopeless: (I) anti-essentialism, inspired by Wittgenstein, about either things generally or especially theory-laden phenomena such as art; (2) scepticism, comparable to scepticism about the existence of so-called moral intuitions, about the existence of a special aesthetic sense and its verdicts; (3) the by now standard twentieth-century rejection of the epistemic priority of judgements about mental objects and states to judgements about physical objects and states; and (4) a desire to uphold the cognitive significance of art, coupled with the intuition that art could not be cognitively significant if its essence were merely the power to provoke a certain feeling.

Yet despite all this, somehow in most of us the conviction persists that the experience of art matters uniquely or has a particular value that the experiences of, say, acquiring knowledge or having one's class solidarity reinforced do not have. A description of the religious attitude towards nature evident in Eliot's later work is no substitute for reading *Four Quartets*; a physicist's account of the optics of colour and depth space and a sociologist's account of class affiliations, however helpful they might be, will not replace the experiences of looking at Louis's unfurleds or Rothko's *Orange, Yellow, Orange*. It is thought worth while to set children and to encourage adults to read, listen to, and peer at various works of art, generally no matter how many other sorts of experiences and bits of knowledge they have. And not only does there seem to be a special value to experiencing works of art, the experience so valued also seems to have something to do with the nature of art; the production of such experiences seems to serve as the ambition of artmaking and the criterion of its success. Even post-modernist relativists about art often attempt to impugn simultaneously the objectivity of both judgements about what is art and judgements about the abilities of various works to move us in certain ways, thereby seemingly conceding that the former could be shown to be objective if the latter could be. Pre-theoretically, these facts provide an impetus for resisting anti-essentialism and relativism about art and for taking aesthetic theories of art seriously.

Moreover, the overtly philosophical reasons generally urged against aesthetic theories of art are not obviously fully compelling. Anti-essentialism as a philosophical doctrine can be understood in at least two distinct ways, one of which is plausibly true but not damaging to any philosophy of art that remains engaged with artistic and critical practice, and one of which is plausibly false. As an attack on the business of characterizing essences supposed

[3]Hal Foster, 'Postmodernism: A Preface', in *The Anti-Aesthetic,* ed. Foster, pp. x–xi.

to exist, at least potentially, apart from all human practice, anti-essentialism is successful. There is neither any point to nor any possibility of plausibly framing definitions of concepts that are not deployed in the practical life of human culture or that potentially lack any instances whatsoever. There are no criteria (even criteria the satisfaction of which we cannot ascertain) for the correctness of claims about what art (or knowledge or education or baseball) is in itself, apart from our cultural life. As Wittgenstein insisted, we fix the criteria for our talk in our talk and practice. Understood, however, as an attack on the making of all claims about what our criteria are anti-essentialism is less successful (and less Wittgensteinian). Certain practices, among them the production and the appreciation of art, are especially liable to mockery, posturing, abuse, decay, and confusion. In light of such threats, claims about what we do, claims that serve as reminders of what our practices have been and as pointers to their further extension, revision, or termination—hence claims that are simultaneously descriptive of our practices and normative for them—are appropriate. There are criteria for the correctness of such criterial claims about what we do and say: namely, not whether an abstract essence has been correctly characterized, but rather whether a practice is made intelligibly extendable or modifiable by such claims. (Thus such claims are always confirmed, when they are, after they have been issued, in the effects they have in furthering or altering what we do, and in reducing our alienation from our practices.)[4] The production, interpretation, and appreciation of art are, at present, practices about which such criterial claims, such reminders and pointers, are in order, and it is possible that they will be accepted.

The other, more special objections to specifically aesthetic theories of art require the articulation of a new model of aesthetic judgement, distinct from the Hutchesonian-Humean model in which the making of an aesthetic judgement is mistakenly assimilated to the having of a sensation. It is true that not all art works produce anything much like sensible pleasure, and it is true that there is no aesthetic sense.[5] But it is none the less not at all implausible to suppose that art works characteristically repay critical investigation and that critical investigation is in large measure the elucidation of the meanings of objects of feeling—as though art and criticism together help us to recover and assess the engagement of various of our feelings in the experience of objects that mean things to us. Criticism seems to be inspired by a fitness between the form and content of a thing, a fitness uncovered through an audience's felt satisfaction in their relation. Criticism accounts for this satisfaction through the

[4]I offer an account of the *ex post facto* confirmation of such criterial claims and of the relation between alienation and the need for criterial claims in my 'The Normal and the Normative: Wittgenstein's Legacy, Kripke, and Cavell', *Philosophy and Phenomenological Research,* forthcoming (Spring 1986).

[5]Ted Cohen, in 'Aesthetic/Nonaesthetic and the Concept of Taste: A Critique of Sibley's Position', reprinted in *Aesthetics: A Critical Anthology,* eds. George Dickie and Richard Sclafani (New York: St Martin's Press, 1977), pp. 838–66, criticizes the idea that there is a special isolated, aesthetic sense and emphasizes the superiority of Kant's view that our capacity for aesthetic response is compounded of other capacities we all possess to the views of such eighteenth-century figures as Hutcheson and Hume and such twentieth-century theorists of taste as Sibley and Hungerland.

investigation of its occasioning, elucidating the form and content that do this work. No special aesthetic capacities or abilities not exercised elsewhere are called for here in responding to art and in finding criticism in order. All that is needed are the capacities to identify forms, to understand contents, and to have feelings of satisfaction. Judgements about mental states need not be held to be epistemically prior to other judgements: indeed, judgements about the forms and contents of various physical objects can help us to understand the characters of our feelings, enabling us to distinguish between the satisfaction, which has certain sorts of objects, characteristic of art and other phenomenologically similar but differently occasioned feelings. Works of art can be held to be cognitively significant in having content.

Aesthetic theories of art are thus not obviously ill-conceived. The immediate philosophical objections to them can be met, and they promise to illuminate critical practice and our pre-theoretic sense of the irreducible and irreplaceable value characteristic of art. But the construction of a satisfactory aesthetic theory of art requires more than this. It requires showing that there are shared critical and interpretative practices that can be made sense of in light of the claim that we do call something art if and only if it is able to induce a particular feeling in us. Until shared practices have been so illuminated, feelings in the presence of objects will seem private and particular to individuals, and relativism about art will seem plausible, simply given the apparent heterogeneity of things called art. What must be shown is that this heterogeneity is only apparent, or, better, that underlying some genuine heterogeneity there are common ways of interpreting and appreciating a great many (though not necessarily all) of the things called art, ways which depend upon ascribing to these genuine works of art a capacity for inducing feelings in us. Can a claim about what art is be put to work to show that there are such common practices?

II

Any aesthetic theorist must concede first of all that there are many more aesthetic qualities than beauty and ugliness. Things are properly accounted dainty, unsettling, horrible, or witty relative to our experience of them in very much the same way that things are properly accounted beautiful. (It does not follow that there is a sharp distinction to be drawn between aesthetic and non-aesthetic qualities.) Eighteenth-century art works perhaps share many more aesthetic qualities than twentieth-century art works share with them or with one another. The aestheticians of the eighteenth century were probably wrong to think that all art works are beautiful. 'Beautiful' is not a predicate one would normally apply to Hitchcock's *North by Northwest* with its lurid technicolour or to Pynchon's hectic narratives interspersed with snatches of songs, and it is difficult to deny that such things are works of art.

But that does not show that there is no aesthetic quality that all art works share. It does show that, if there is any such quality, it is not very much like natural beauty and that probably it is unwise to talk of beauty as essential to art. There are works of art by which, as Arthur Danto puts it, 'we are repelled,

disgusted, even sickened'.[6] But that does not show that there is not some further, distinct aesthetic quality characteristic of all and only works of art.

Secondly, the variety of aesthetic qualities possessed by works of art suggests that if all art works share some aesthetic quality, then that quality might well be a complex context and category relative one. In particular, both Danto[7] and Kendall Walton[8] have shown that there can be perceptually indistinguishable objects which have quite different aesthetic qualities, so that they are either quite different works of art (one is dramatic while one is boring) or one is a work of art and one is not. Our sensibilities and capacities for having feelings seem to be responsive not simply to overt perceptible features evident independently of knowledge of the subject-matter, history of production, and so forth of a work. That is to say, some aesthetic qualities seem to depend in part on the subject-matter and category memberships of things. Anyone who wishes to discover what is art by attending to the aesthetic qualities of things will presumably have to be someone who knows the relevant context and is patient in the contextual study of things. An aesthetic theory of art is well advised to take this fact into account.

Thirdly, any theorist of art must concede that taste *is* ideologized, in the sense that many of the judgements about beauty, coherence, harmony and so forth which people explicitly make are best understood as having been caused through social conditioning. This of course does not *show* that these judgements lack universal truth-values, that they are properly speaking more reflexes than genuine judgements open to criticism and correction; it is, however, a piece of evidence in favour of this conclusion. To counter this evidence, if it can be countered, what is needed are examples of good (though not necessarily absolutely conclusive) arguments in favour of some judgements about what is art and an account of both what makes these arguments good and the assumptions upon which their being taken to be good rest. Considering whether there are such arguments requires an investigation of critical reflective judgement about what art is. The denial that there are such arguments is not entailed by (though it is perhaps made plausible by) the quite evident heterogeneity and social conditioning of explicit pronouncements about art. Thus, while the relativists are right about the causes of many explicit judgements of taste and about the wide variations in such judgements, these facts alone do not conclusively show either that there are no good arguments about what is art or, more specifically, that there are no such arguments which contain premises ascribing aesthetic qualities to things. Whether there are such arguments depends on what we find in the criticism of art, not on the obvious facts of mass culture.

In order to resist relativism about art and to show that, despite the heterogeneity of what is called art, there *are* good arguments, with premises ascribing aesthetic qualities to things, about what is art, the particular art-

[6]Arthur C. Danto, *The Transfiguration of the Commonplace* (Cambridge, Mass.: Harvard University Press, 1981), p. 92.
[7]See Danto, *The Transfiguration of the Commonplace,* especially Chapters 1–4, for his most recent development of this idea.
[8]Kendall Walton, 'Categories of Art', reprinted in this volume.

making aesthetic quality must be a quality about the presence of which it is possible to make a mistake. Judging the presence of an artmaking aesthetic quality must be less like sensing and more like judging generally than is sometimes supposed. Only in that case will one be able to offer a diagnosis of what has gone wrong in the making of some explicit judgements of taste and pronouncements about what is art, to say that in calling *that* art so-and-so has mistakenly ascribed an aesthetic quality to a thing and that in denying that *that* is art so-and-so has overlooked the presence of a genuine and objective aesthetic quality.

In fact, there is a glimmer of truth in the sort of relativism about art which is inspired by the heterogeneity of what is called art. *Realism* about both art and aesthetic qualities, in the sense in which Richard Wollheim has distinguished *realism* about the evaluation of art from *objectivism, relativism,* and *subjectivism,*[9] does seem implausible. The rough intuition here is that nothing would be beautiful or gauche and nothing would be art were it not for the relations of things to human beings and their sensory and cognitive faculties. Relativists are on good ground in resisting realism about art and aesthetic qualities.

But this fact points us as much towards an objectivist, and indeed an aesthetic, theory of art as much as towards relativism. It can be maintained that attributions of both aesthetic qualities and arthood are not 'totally independent of the psychological properties of human beings, though . . . not dependent . . . on the psychological properties of specific human beings or specific groups of human beings' either.[10] Rather such attributions 'may be held to depend upon the experience of humanity at large'.[11] Objectivists about aesthetic qualities and arthood affirm this thesis, while relativists deny it.

The only way to settle the issue between objectivists and relativists is to turn to analyses of the assumptions underlying critical arguments and of what, if anything, makes some of these arguments good. (As Wollheim notes, widespread agreement in judgements about art and in judgements about an artmaking aesthetic quality is compatible with, but not entailed by, both objectivism and relativism, so that neither such agreement nor the lack of it immediately cuts either way.)[12] When we interpret, appreciate, and talk about putative works of art, is it our practice to treat them as having a particular aesthetic quality? When we call something art, do we mean that it can move us in a certain way? Do we have common practices in dealing with art, the coherence and intelligibility of which depend upon our meaning this?

III

The aesthetic theory of art to be proposed is not a novel one. What is novel about it is the account of how it makes sense of the arguments critics put for-

[9]Richard Wollheim, 'Art and Evaluation' in *Art and Its Objects,* 2nd ed. Cambridge: Cambridge University Press, 1980), pp. 227–40.
[10]Ibid., p. 232.
[11]Ibid.
[12]Ibid., pp. 240, 238.

ward and of our experience of art; in light of this theory, considerable reaches of shared artistic, critical, and appreciative practices *can* be shown to be coherent and intelligible as they cannot be in light of other theories. The aesthetic quality possession of which is necessary and sufficient for a thing's being art is the satisfying appropriateness to one another of a thing's form and content. The idea that the possession of this feature is necessary and sufficient for art is common among English and German Romantics, most notably Wordsworth, who criticizes 'the gaudiness and inane phraseology of many modern writers' which he proposes to replace with language evocative of feelings appropriate to the situation described,[13] and Hegel, who criticized as 'a defective combination' and hence non-art, works with 'a matter . . . driven to make the best it can of a mode of presentation which is antagonistic to its nature'.[14] The remarkable thing is how much sense this theory makes of artistic and critical activity and of the experience of art.

1. The proposed aesthetic theory explains why art evolves. In the first place, as the rest of culture develops, new contents—steam engines, modern factories, baseball—emerge and require new forms of artistic expression, and so there are Turners and Chaplins and Robert Coovers. Secondly, when a given content has been embodied in certain forms of expression, the forms of expression used are themselves altered (Eliot's insight). It becomes known that certain forms of expression—certain cadences or patterns of orchestration in music, certain ways of restricting or deepening pictorial space or of treating the relation between the centre and edge of a canvas, certain techniques of narration and plot development—are apt for the satisfying rendering of certain contents, and this alters the place these forms of expression have in the language of art, just as novel metaphors can freeze into literal expressions in natural languages. The use of forms of expression which have been already established to be apt to certain contents becomes, like quoting, effective in its place but not an independent artistic achievement. Equalling the achievement of an artistic precursor requires not imitations, which are often mannered, but the development conjointly of new contents and new forms of expression which have the same satisfying appropriateness to one another as the forms and contents of the work of the precursor.[15]

2. The proposed aesthetic theory explains why there are no rules for artistic creation and why experimentation in artistic creation is necessary. What counts as satisfying appropriateness to one another of a new form and new content? Not simply the co-embodiment in a thing of any new form and new content. There are failed attempts to produce works of art, 'inane phraseologies' and 'defective combinations'. Nor can what will succeed be predicted, since which forms and contents are satisfyingly appropriate to one another depends upon what contents are ascribed to things and the

[13]William Wordsworth, 'Preface to Lyrical Ballads' (1802), reprinted in this volume.

[14]G. W. F. Hegel, 'The Evolution and Completion of Art History', from *The Philosophy of Fine Art*, Ch. 5, trans. F. P. B. Osmaston, in *Aesthetics*, eds., Dickie and Sclafani, p. 520.

[15]See Timothy Gould, 'The Audience of Originality: Kant and Wordsworth on the Reception of Genius', in *Essays in Kant's Aesthetics*, eds. Ted Cohen and Paul Guyer (Chicago: The University of Chicago Press, 1982), pp. 179–93.

ascribing of contents to things is *not* causally determined. Rather, contents are ascribed to things, whether works or ordinary sentences, just in so far as things are judged to have a certain role in the life of a people, and such judgements are always in principle open to revision, not causally fixed, as one's acquaintance with the people whose commerce one is assessing deepens.[16]

3. The proposed aesthetic theory of art explains why music and abstract painting are the most phenomenal and least representational of the arts, why there is consequently a temptation to treat works of music in particular as phenomenal objects, and why none the less music and abstract painting each have significant histories which must be understood before one is able properly to ascribe aesthetic qualities to works of these kinds. Works of music and abstract paintings typically seem not to have content, in that they are not about perceptible objects or events. But what they are rather about are the structures or forms which are capable of provoking absorption on the part of the audience. Their contents are the relations between certain musical forms or structures (which include orchestration, harmonies, rhythms, amplitude, etc.) and certain forms or arrangements of colours (which include hue, intensity, size, complementarities, etc.) on the one hand, and human experiences of absorption on the other. Human capacities for absorption evolve as sensibilities become jaded to certain forms. Musicians and abstract painters explore such evolutions of sensibility, hoping to match the structures of their works to the capacities of their audiences. There is no reason not to think of such explorations as the contents of many works of music and abstract paintings, and there is every reason to do so. Both musical structures and structures of colour are real objects of human experience and stand in real relations to human experience, so that such structures and relations are fit subjects of works of art. Attempts to produce significant works of music and abstract painting are plausibly construed as attempts to discover the structures of sound and colour capable of absorbing sensibility in its current state, and success in such attempts as making such a discovery. Given that attention to structures of sound and colour in the hope of becoming absorbed, once the structures are understood (which includes understanding their place in a history of absorbing structures), is, according to the proposed aesthetic theory, the appropriate mode of reaction on the part of the audiences of works of music and abstract painting, the proposed theory also captures what truth there is in phenomenalist theories of the aesthetic object and in theories of art works as things which require aesthetic contemplation.

4. The proposed aesthetic theory of art points to an account of why art matters to us. Authentic works of art, works whose forms and contents are appropriate to one another against the background of the history of forms and content, make new sense.[17] They show that even as both the contents

[16]I do not mean to propose a full-blooded theory of meaning here, but rather only to invoke the criticism to be found in Wittgenstein, Quine, and Davidson of the idea that semantic relations can be reduced to causal relations.
[17]See Gould, 'The Audience of Originality', pp. 180ff.

of works of art (things in the world) and sensibilities change it is possible for us to make sense of the world and sense to one another. It is plausibly important to us as human beings to know that sense and community are possible. This idea is the insight at the heart of Kant's talk of the harmony of the cognitive faculties in free play, and the proposed aesthetic theory of art makes room for it. The fact that our feelings are invested in meaningful objects, because of the forms of those objects, accounts for the senses of both deep understanding of one's interlocutors and unbridgeable alienation from them that can sometimes inhabit conversations about works of art.

5. The proposed aesthetic theory explains why critics spend so much of their energy on both the interpretation of works and the analysis of their formal structures. Consider these few lines of Geoffrey Hartman's on 'Tintern Abbey':

> The halting of the traveler in 'Tintern Abbey' is felt more in the slowed rhythm and meditative elaboration of its first lines than as part of the casual frame. We begin with 'Five years have passed,' a phrase as quietly elegiac as 'There was a Boy,' and again a countervailing movement is felt at once. It is expressed by a peculiar type of redundance ['Five years have passed; five summers with the length of five long winters!'] and indicates resistance to abrupt progression. . . . I am tempted to say that in the opening verses of 'Tintern Abbey,' as well as in other sections, there is a *wave effect* of rhythm whose characteristic is that while there is internal acceleration, the feeling of climax is avoided. . . .
>
> I connect this rhythm with the shying from peripety or abrupt illumination, here as in other poems. On the thematic level, however, it is linked in 'Tintern Abbey' to a vacillating calculus of gain and loss, of hope and doubt.[18]

Here it is clear that Hartman's effort is both to figure out what sort of experience the poet is describing, what he is saying, and to show that the words used, engender, by their sounds and rhythms as well as their meanings, a similar experience of meditative halting in us, thus confirming their appropriateness to their content. Interpretation and formal analysis of this sort are not trivial exercises. They aim at accounting for a work's effect on us, its satisfyingness or its ability to give us the sense that it is true. As John Stuart Mill puts it, 'poetry . . . is the delineation of the deeper and more secret workings of human emotions . . . it stirs up [others] to conceive what they could feel, or what they might have been able to feel, had their outward circumstances been different. Poetry, when it really is such, is truth'.[19] The aim of interpretation is to discover such truths, if they are present in a work, to show that the content of a work (for example, what one would feel in certain circumstances) and its form (for example, the words of a poem, considered as having both meanings and aural properties) are appropriate to one another in such a way that it is clear that the content has been rightly captured.

[18]Geoffrey H. Hartman, *Wordsworth's Poetry 1787–1814*, 2nd ed. (New Haven: Yale University Press, 1971), pp. 26–7.
[19]John Stuart Mill, 'What is Poetry?' in *The Norton Anthology of English Literature*, Vol. 2, p. 969.

6. The proposed aesthetic theory of art explains why the theory of art is both affiliated with psychology and not reducible to empirical laboratory psychology. Art works are, according to the theory, things which produce a certain sort of human response in which cognition plays a role. Types of response in which cognition plays a role are subjects of interest to psychologists. But causes of the response in question—satisfaction in the appropriateness to one another of the form and content of a work—cannot be understood through laboratory procedures alone. In order for a laboratory inquiry into the causes of this response to be appropriate, it would have to be established both that the artefact confronted in the laboratory is a genuine work of art which possesses the required appropriateness and that the subject producing the response both understands the structures and significance of the work and is attending to them. It is to begin with difficult to imagine that subjects could ever do this in a laboratory. Moreover it is clear that any such psychological causal inquiry which aimed at reducing aesthetic questions about what is art to psychological questions about the causes of a certain response would presuppose answers to the very question—what causes the relevant response?—supposedly under consideration, for one would have to know that one is dealing with works of art, objects with certain aesthetic qualities, in order to begin any experiments.

7. The proposed aesthetic theory of art explains the kind of objectivity without conclusiveness possessed by critical arguments. Relativism is inevitable within an aesthetic theory of art only as long as the art-relevant aesthetic response is regarded as caused by works under examination in concert with *passive* human sensibilities. If art-relevant aesthetic responses are assumed to be so caused, then the wide variation in sincere explicit reports of art-relevant aesthetic responses will count heavily against objectivism about art. A rearguard action in favour of objectivism could be fought by trying to distinguish *normal* passive aesthetic sensibilities from *abnormal* ones. This was Hume's aim in taking the joint verdict of persons with strong sense and delicate imagination, without prejudice, and who have practised and made comparisons as the standard of taste. Hume claims that this joint verdict practically approximates the verdict of a faculty of taste 'in a sound state' and is our only way of estimating it. Yet, as Peter Kivy has noted, Hume gives no reason for his supposition that these five features are makers of normality in the having of aesthetic experience.[20] Thus judgements about what is art would have truth-values only when indexed to groups of people who agreed with one or another in their choices of normal perceivers. The truth of relativism would have to be conceded, and arguments about what is art could not be objective, for their conclusions could not have truth-values except in so far as indexed to a social group.

The situation is entirely altered, however, as soon as the engagement of sensibility with a work is taken to be active, in particular dependent upon the activity of interpreting. The fact that satisfaction in the appro-

[20]Peter Kivy, 'A Logic of Taste—The First Fifty Years' in *Aesthetics*, eds. Dickie and Sclafani, p. 639.

priateness to one another of the form and content of a work is, so to speak, inhabited by interpretative activity makes it clear why there is no single standard perceiver or identifier of works of art and why this doesn't matter to the objectivity of judgements about what is art. Competence at interpretation, rather than normality, is required to make objective identifications of works of art. Through training and experience, different people are competent in the interpretation of different things, although competences in interpreting things of various kinds, genres, and eras (unlike either normality or a mysterious unanalysable ability to taste) are skills which it is open to anyone to acquire.

The claim that a given object is a work of art can thus be taken to have a truth-value without being indexed to a social group. Such a claim will be true just in case a competent interpreter finds satisfaction in the appropriateness to one another of the object's form and content, and claims of this kind will be objective as long as interpreters competent with respect to a given object do not disagree in their response to it. It is not altogether clear that there has been such disagreement among competent interpreters. Many arguments among critics involve disagreements about interpretation, but not about the status as art of what is interpreted. Genuine disagreements about whether something is a work of art often hinge on conflicting interpretations and are often resolved when an interpretation is settled on. To the extent that there are outstanding disagreements which have not been so resolved, it is possible that one or another of the contending parties is incompetent at the interpretation of the work in question. The striking fact here is that, as Clement Greenberg puts it,

The people who look, listen or read hard enough come to agree largely about art over the course of time—and not only within a given cultural tradition but also across differences of cultural tradition (as the experience of the last hundred years teaches us).[21]

And consider how much more likely it is that disagreements will continue to be resolved once we are able to say more than Greenberg does about what competent interpreters are on the lookout for—the satisfying appropriateness of form and content—and what interpretative competence is like.

Some disagreements about what is art may remain unresolved and some arguments about what is art may remain inconclusive to the extent that a conclusive interpretation of a work has not yet been settled on. None the less, interpretation will be objective, though not a science of causal relations, as long as the interests of human beings in interpreting remain suitably similar. There are always better and worse interpretations and likely, at any given moment, a single best one. But interpretation is an ongoing enterprise requiring practical judgement,[22] and this fact leads to the incon-

[21]Clement Greenberg, 'Can Taste Be Objective?', *Artnews* 72 (February 1973), p. 23a.
[22]Here again there are issues in the theory of meaning which cannot be gone into fully. See footnote 21 and my 'Deconstruction and Its Alternatives', *Man and World,* forthcoming.

clusiveness of some interpretative arguments, yet does so in a way that does not compromise their objectivity.

8. The proposed aesthetic theory of art explains how it is that artistic identifications are, so to speak, socially mediated. Things have contents to be interpreted only in the context of a form of life. Membership in a form of life, which can be acquired either naturally through birth and upbringing or artificially through explicit study, is necessary in order to know a thing's content. Just as there cannot be meanings except where there is social life, there cannot be either works of art or identifications of them except where there is social life.

9. The proposed aesthetic theory explains why art can be politically and morally important. Characteristically *artistic* expressiveness on the part of a representation depends on three things: *(a)* the representation's form or particular way of manipulating the materials (words, sounds, colours, lines, images, etc.) of its medium; *(b)* the representation's semantic content or what it is about (how a certain character develops, the memorability of an image, the roles that can be played at certain historical moments by certain chords within certain structures of consonances and dissonances, etc.); and *(c)* the attitude expressed towards the semantic content. (Both *b* and *c* are aspects of the content, broadly speaking, of the work.) When these three things are satisfyingly appropriate to one another, the work in which they are embodied is *artistically* expressive and a work of art.

Art's political and moral power stems from the facts, first of all, that this satisfyingness is experienced in part as a sort of appropriateness of the attitude expressed to the semantic content and, secondly, that our discovery that there are certain appropriate attitudes towards phenomena can change our understanding of and response to phenomena. Works of art, through the appropriateness to one another of their forms and contents, can bring us to feel that it is appropriate to regard certain phenomena—including such things as human actions or political systems or social policies—with horror or exultation, and such feelings can be politically important.

That art has this power is confirmed by the fact that moralizing and propagandizing are modes of failure into which potential works of art are prone to enter or perennial possibilities of artistic failure. In propaganda, the attitude expressed is not appropriate to what the work is about. The representer declaims or harangues or panders, rather than expressing himself artistically.[23] Representers, attempting to fit attitudes to contents, are naturally tempted to do such things. The proposed theory explains both what makes artistic achievement naturally threatened by propagandizing tendencies and why genuine art can none the less be morally and politically important.

10. The proposed aesthetic theory of art enables us to make sense of the relation between the good art/bad art distinction and the art/non-art distinc-

[23]Compare Collingwood's remarks on the tendencies of Hardy and Beethoven sometimes to declaim and harangue, *The Principles of Art*, reprinted in this volume.

tion. It is a frequently remarked characteristic of modern art that it has tended to conflate these two distinctions as bad art is taken to be fraudulent, to have broken a rule, and all genuine art is thought to be worth our attention and hence in some sense good. Yet we retain a residual sense that there must be a difference between these two distinctions. The proposed theory allows us to say that bad works of art are genuine works, works in which the form and content are satisfyingly appropriate to one another, but also works with insipid or uninteresting contents. Insipid contents can often seem like no contents at all (muddled but quite voluble speakers are sometimes said not to have a thing to say), and that accounts for the tendency of bad art to collapse into non-art. Yet we are also able to make sense of the difference.

Or we can say that a given work possesses a rather low degree of satisfying appropriateness of its form and content, so that it is almost, but not quite, a fully defective combination, and is hence bad, but genuine, art. Here it is useful to compare the degrees of quality that art works can possess with the degrees of education that persons can have. The exact lines between good art and bad art and between well-educated and badly educated persons, as well as the lines between art and non-art and between the educated and the non-educated, are fuzzy but real. The proposed theory of art explains how this can be so.

11. The proposed theory explains why it is that, as Wollheim has suggested, in identifying particular works of art we employ something like a recursive method. Wollheim's idea is that in attempting to identify particular works 'we should, first, pick out certain objects as original or primary works of art . . . and then set up some rules which, successively applied to the original works of art, will give us (within certain rough limits) all subsequent or derivative works of art.'[24] Of course there will not be strict rules. Innovation and creativity in finding artistic forms appropriate to new contents will always be required. But it seems right to insist that new works of art can be identified only by comparing new works with acknowledged works of art.

According to the proposed theory, it is clear why this should be so. The aesthetic experience, the provoking of which is necessary and sufficient for a thing's being a work of art—satisfaction in the appropriateness to one another of a thing's form and content—does not have a particular phenomenologically identifiable feel or character. Phenomenologically, it's just satisfaction, just as Kant's pleasure owing to the harmony of the faculties is, phenomenologically, just pleasure. The only way to identify instances of this particular kind of satisfaction is through attention to its causes. By hypothesis, all and only art works cause in us experiences of this kind of satisfaction. Thus, whether we are dealing with old works or new ones, we must, in order to discover whether we have had an experience of this kind of satisfaction, engage in interpretation, which requires a grasp of the language of the forms of artistic expression and hence acquaintance with a number of works of art.

[24]Wollheim, p. 143.

IV

Works of art have a particular kind of complex aesthetic quality, the ability to satisfy us in virtue of the appropriateness of their forms to their contents. Once we appreciate that this is what art is, we become able to understand a good deal about how artists create, why art evolves, why art matters to us, and what arguments about art are like, and so on. The attempt of artists to produce things with this aesthetic quality is an examination of our nature and our capacities for both interpretative and sensible responses, capacities whose exercise is essential to human community and sanity. Or, as Stanley Cavell has put it:

> One might rather think of [the enterprise of art] as the exploration or educa-tion or enjoyment or chastisement of taste and of decision and of intuition, an exploration of the kind of creature in whom capacities are exercised. Artists are people who know how to do such things, i.e., how to make objects in response to which we are enabled, but also fated, to explore and educate and enjoy and chastise our capacities as they stand. Underlying the tyranny of con-vention is the tyranny of nature.[25]

[25]Stanley Cavell, *The Claim of Reason* (New York: Oxford University Press, 1979), p. 123. T. J. Dif-fey provided helpful comments on an earlier draft of this paper.

3

AUDIENCES

THE LOGIC OF TASTE

INTRODUCTION

David Hume was born in Edinburgh, Scotland, in 1711 and died in the same city in 1776. He was a diplomat and a historian, but is best known for his philosophical works *A Treatise of Human Nature, An Enquiry Concerning Human Understanding,* and *An Enquiry Concerning the Principles of Morals.* Much of his work is dedicated to showing how limited is the role of reason in the lives of human beings. In Hume's view, "Reason is, and ought only to be the slave of the passions." In his moral theory, this made Hume a subjectivist of sorts: He held that our distinctions between, and judgments about, right and wrong, good and bad, are based not on reason but on feelings. When he came to think about art, he was inclined to take the same approach; that is, to think that our aesthetic judgments, like our moral judgments, are based on personal feelings. As he puts it, common sense tells us that "Beauty is no quality in things themselves: It exists merely in the mind which contemplates them; and each mind perceives a different beauty." Beauty, then, is in the eye of the beholder. However, as Hume points out, common sense pulls us in two directions here. However commonsensical the view that "beauty is in the eye of the beholder" may be, it seems equally a matter of common sense to insist that some aesthetic judgments may be more accurate than others; indeed, that some aesthetic judgments may simply be mistaken, "absurd" or "ridiculous." As Hume says, "Whoever would assert an equality of genius and elegance between

254

Ogilby and Milton, or Bunyan and Addison, would be thought to defend no less an extravagance, than if he had maintained a mole-hill to be as high as Teneriffe, or a pond as extensive as the ocean." In effect, Hume's essay "Of the Standard of Taste" (1757) is his attempt to reconcile these conflicting intuitions of common sense. (As we shall see, Kant undertook the same task.) The essay, then, is an attempt to show how aesthetic judgments can be based on personal feelings and nonetheless be true or false, right or wrong. In the course of the attempt, Hume makes some penetrating remarks on what makes a critic a *great* critic. Whether or not he succeeds in the task he sets himself in this essay, there is no doubt that "Of the Standard of Taste" is one of the most important and influential pieces of writing in the philosophy of art. (Footnotes to Hume's essay were provided by the editor, Eugene F. Miller.)

Of the Standard of Taste

David Hume

The great variety of Taste, as well as of opinion, which prevails in the world, is too obvious not to have fallen under every one's observation.[1] Men of the most confined knowledge are able to remark a difference of taste in the narrow circle of their acquaintance, even where the persons have been educated under the same government, and have early imbibed the same prejudices. But those, who can enlarge their view to contemplate distant nations and remote ages, are still more surprised at the great inconsistence and contrariety. We are apt to call *barbarous* whatever departs widely from our own taste and apprehension: But soon find the epithet of reproach retorted on us. And the highest arrogance and self-conceit is at last startled, on observing an equal assurance on all sides, and scruples, amidst such a contest of sentiment, to pronounce positively in its own favour.

As this variety of taste is obvious to the most careless enquirer; so will it be found, on examination, to be still greater in reality than in appearance. The sentiments of men often differ with regard to beauty and deformity of all kinds, even while their general discourse is the same. There are certain terms in every language, which import blame, and others praise; and all men, who use the same tongue, must agree in their application of them. Every voice is united in applauding elegance, propriety, simplicity, spirit in writing; and in blaming fustian, affectation, coldness, and a false brilliancy: But when critics come to particulars, this seeming unanimity vanishes; and it is found, that they had affixed a very different meaning to their expressions. In all matters of opin-

[1]Taste, according to Hume, is the source of our judgments of natural and of moral beauty. We rely on taste, and not on reason, when we judge a work of art to be beautiful or an action to be virtuous. Taste "gives the sentiments of beauty and deformity, vice and virtue" (*Enquiry Concerning the Principles of Morals,* App. 1). Taste is thus the foundation of both morals and criticism. Hume's initial plan was to discuss moral taste and critical taste within the framework of the *Treatise,* but he abandoned the plan of the *Treatise* before this could be accomplished. His *Enquiry Concerning Morals* gives his fullest account of how moral taste or sentiment can serve as the foundation of the science of morals. The present essay is concerned mainly with critical taste, and it represents Hume's primary contribution to what he calls "criticism."

ion and science, the case is opposite: The difference among men is there oftener found to lie in generals than in particulars; and to be less in reality than in appearance. An explanation of the terms commonly ends the controversy; and the disputants are surprised to find, that they had been quarrelling, while at bottom they agreed in their judgment.

Those who found morality on sentiment, more than on reason, are inclined to comprehend ethics under the former observation, and to maintain, that, in all questions, which regard conduct and manners, the difference among men is really greater than at first sight it appears. It is indeed obvious, that writers of all nations and all ages concur in applauding justice, humanity, magnanimity, prudence, veracity; and in blaming the opposite qualities. Even poets and other authors, whose compositions are chiefly calculated to please the imagination, are yet found from HOMER down to FENELON,[2] to inculcate the same moral precepts, and to bestow their applause and blame on the same virtues and vices. This great unanimity is usually ascribed to the influence of plain reason; which, in all these cases, maintains similar sentiments in all men, and prevents those controversies, to which the abstract sciences are so much exposed. So far as the unanimity is real, this account may be admitted as satisfactory: But we must also allow that some part of the seeming harmony in morals may be accounted for from the very nature of language. The word *virtue*, with its equivalent in every tongue, implies praise; as that of *vice* does blame: And no one, without the most obvious and grossest impropriety, could affix reproach to a term, which in general acceptation is understood in a good sense; or bestow applause, where the idiom requires disapprobation. HOMER'S general precepts, where he delivers any such, will never be controverted; but it is obvious, that, when he draws particular pictures of manners, and represents heroism in ACHILLES and prudence in ULYSSES, he intermixes a much greater degree of ferocity in the former, and of cunning and fraud in the latter, than FENELON would admit of. The sage ULYSSES in the GREEK poet seems to delight in lies and fictions, and often employs them without any necessity or even advantage: But his more scrupulous son, in the FRENCH epic writer, exposes himself to the most imminent perils, rather than depart from the most exact line of truth and veracity.

The admirers and followers of the ALCORAN[3] insist on the excellent moral precepts interspersed throughout that wild and absurd performance. But it is to be supposed, that the ARABIC words, which correspond to the ENGLISH, equity, justice, temperance, meekness, charity, were such as, from the constant use of that tongue, must always be taken in a good sense; and it would have argued the greatest ignorance, not of morals, but of language, to have mentioned them with any epithets, besides those of applause and approbation. But would we know, whether the pretended prophet had really attained a just sentiment of morals? Let us attend to his narration; and we shall soon find, that

[2]François de Salignac de la Mothe-Fénelon (1651–1715), *Les Aventures de Télémaque, fils d'Ulysse* (1699), translated as *The Adventures of Telemachus the Son of Ulysses* (1699–1700). Ulysses is the Latin name for Odysseus, the hero of Homer's *Odyssey*.

[3]Or the Koran, the holy book of Islam, which Muslims regard as the true word of God as it was revealed to the prophet Muhammad.

he bestows praise on such instances of treachery, inhumanity, cruelty, revenge, bigotry, as are utterly incompatible with civilized society. No steady rule of right seems there to be attended to; and every action is blamed or praised, so far only as it is beneficial or hurtful to the true believers.

The merit of delivering true general precepts in ethics is indeed very small. Whoever recommends any moral virtues, really does no more than is implied in the terms themselves. That people, who invented the word *charity,* and used it in a good sense, inculcated more clearly and much more efficaciously, the precept, *be charitable,* than any pretended legislator or prophet, who should insert such a *maxim* in his writings. Of all expressions, those, which, together with their other meaning, imply a degree either of blame or approbation, are the least liable to be perverted or mistaken.

It is natural for us to seek a *Standard of Taste;* a rule, by which the various sentiments of men may be reconciled; at least, a decision, afforded, confirming one sentiment, and condemning another.

There is a species of philosophy, which cuts off all hopes of success in such an attempt, and represents the impossibility of ever attaining any standard of taste. The difference, it is said, is very wide between judgment and sentiment. All sentiment is right; because sentiment has a reference to nothing beyond itself, and is always real, wherever a man is conscious of it. But all determinations of the understanding are not right; because they have a reference to something beyond themselves, to wit, real matter of fact; and are not always conformable to that standard. Among a thousand different opinions which different men may entertain of the same subject, there is one, and but one, that is just and true; and the only difficulty is to fix and ascertain it. On the contrary, a thousand different sentiments, excited by the same object, are all right: Because no sentiment represents what is really in the object. It only marks a certain conformity or relation between the object and the organs or faculties of the mind; and if that conformity did not really exist, the sentiment could never possibly have being. Beauty is no quality in things themselves: It exists merely in the mind which contemplates them; and each mind perceives a different beauty. One person may even perceive deformity, where another is sensible of beauty; and every individual ought to acquiesce in his own sentiment, without pretending to regulate those of others. To seek the real beauty, or real deformity, is as fruitless an enquiry, as to pretend to ascertain the real sweet or real bitter. According to the disposition of the organs, the same object may be both sweet and bitter; and the proverb has justly determined it to be fruitless to dispute concerning tastes. It is very natural, and even quite necessary, to extend this axiom to mental, as well as bodily taste; and thus common sense, which is so often at variance with philosophy, especially with the sceptical kind, is found, in one instance at least, to agree in pronouncing the same decision.

But though this axiom, by passing into a proverb, seems to have attained the sanction of common sense; there is certainly a species of common sense which opposes it, at least serves to modify and restrain it. Whoever would assert an equality of genius and elegance between OGILBY[4] and MILTON, or

[4]John Ogilby (1600–76) published verse translations of Homer and Virgil and of *Aesop's Fables.*

BUNYAN[5] and ADDISON, would be thought to defend no less an extravagance, than if he had maintained a mole-hill to be as high as TENERIFFE,[6] or a pond as extensive as the ocean. Though there may be found persons, who give the preference to the former authors; no one pays attention to such a taste; and we pronounce without scruple the sentiment of these pretended critics to be absurd and ridiculous. The principle of the natural equality of tastes is then totally forgot, and while we admit it on some occasions, where the objects seem near an equality, it appears an extravagant paradox, or rather a palpable absurdity, where objects so disproportioned are compared together.

It is evident that none of the rules of composition are fixed by reasonings *a priori,* or can be esteemed abstract conclusions of the understanding, from comparing those habitudes and relations of ideas, which are eternal and immutable. Their foundation is the same with that of all the practical sciences, experience; nor are they any thing but general observations, concerning what has been universally found to please in all countries and in all ages. Many of the beauties of poetry and even of eloquence are founded on falsehood and fiction, on hyperboles, metaphors, and an abuse or perversion of terms from their natural meaning. To check the sallies of the imagination, and to reduce every expression to geometrical truth and exactness, would be the most contrary to the laws of criticism; because it would produce a work, which, by universal experience, has been found the most insipid and disagreeable. But though poetry can never submit to exact truth, it must be confined by rules of art, discovered to the author either by genius or observation. If some negligent or irregular writers have pleased, they have not pleased by their transgressions of rule or order, but in spite of these transgressions: They have possessed other beauties, which were conformable to just criticism; and the force of these beauties has been able to overpower censure, and give the mind a satisfaction superior to the disgust arising from the blemishes. ARIOSTO pleases; but not by his monstrous and improbable fictions, by his bizarre mixture of the serious and comic styles, by the want of coherence in his stories, or by the continual interruptions of his narration. He charms by the force and clearness of his expression, by the readiness and variety of his inventions, and by his natural pictures of the passions, especially those of the gay and amorous kind: And however his faults may diminish our satisfaction, they are not able entirely to destroy it. Did our pleasure really arise from those parts of his poem, which we denominate faults, this would be no objection to criticism in general: It would only be an objection to those particular rules of criticism, which would establish such circumstances to be faults, and would represent them as universally blameable. If they are found to please, they cannot be faults; let the pleasure, which they produce, be ever so unexpected and unaccountable.

But though all the general rules of art are founded only on experience and on the observation of the common sentiments of human nature, we must not imagine, that, on every occasion, the feelings of men will be conformable to

[5]John Bunyan (1628–88) was author of theological and devotional literature, including *The Pilgrim's Progress from this World to that which is to come* (1678).
[6]Tenerife, the principal of the Canary Islands, is a volcanic formation whose peak exceeds twelve thousand feet above sea level.

these rules. Those finer emotions of the mind are of a very tender and delicate nature, and require the concurrence of many favourable circumstances to make them play with facility and exactness, according to their general and established principles. The least exterior hindrance to such small springs, or the least internal disorder, disturbs their motion, and confounds the operation of the whole machine. When we would make an experiment of this nature, and would try the force of any beauty or deformity, we must choose with care a proper time and place, and bring the fancy to a suitable situation and disposition. A perfect serenity of mind, a recollection of thought, a due attention to the object; if any of these circumstances be wanting, our experiment will be fallacious, and we shall be unable to judge of the catholic and universal beauty. The relation, which nature has placed between the form and the sentiment, will at least be more obscure; and it will require greater accuracy to trace and discern it. We shall be able to ascertain its influence not so much from the operation of each particular beauty, as from the durable admiration, which attends those works, that have survived all the caprices of mode and fashion, all the mistakes of ignorance and envy.

The same HOMER, who pleased at ATHENS and ROME two thousand years ago, is still admired at PARIS and at LONDON. All the changes of climate, government, religion, and language, have not been able to obscure his glory. Authority or prejudice may give a temporary vogue to a bad poet or orator; but his reputation will never be durable or general. When his compositions are examined by posterity or by foreigners, the enchantment is dissipated, and his faults appear in their true colours. On the contrary, a real genius, the longer his works endure, and the more wide they are spread, the more sincere is the admiration which he meets with. Envy and jealousy have too much place in a narrow circle; and even familiar acquaintance with his person may diminish the applause due to his performances: But when these obstructions are removed, the beauties, which are naturally fitted to excite agreeable sentiments, immediately display their energy; and while the world endures, they maintain their authority over the minds of men.

It appears then, that, amidst all the variety and caprice of taste, there are certain general principles of approbation or blame, whose influence a careful eye may trace in all operations of the mind. Some particular forms or qualities, from the original structure of the internal fabric, are calculated to please, and others to displease; and if they fail of their effect in any particular instance, it is from some apparent defect or imperfection in the organ. A man in a fever would not insist on his palate as able to decide concerning flavours; nor would one, affected with the jaundice, pretend to give a verdict with regard to colours. In each creature, there is a sound and a defective state; and the former alone can be supposed to afford us a true standard of taste and sentiment. If, in the sound state of the organ, there be an entire or a considerable uniformity of sentiment among men, we may thence derive an idea of the perfect beauty; in like manner as the appearance of objects in day-light, to the eye of a man in health, is denominated their true and real colour, even while colour is allowed to be merely a phantasm of the senses.

Many and frequent are the defects in the internal organs, which prevent or weaken the influence of those general principles, on which depends our sen-

timent of beauty or deformity. Though some objects, by the structure of the mind, be naturally calculated to give pleasure, it is not to be expected, that in every individual the pleasure will be equally felt. Particular incidents and situations occur, which either throw a false light on the objects, or hinder the true from conveying to the imagination the proper sentiment and perception.

One obvious cause, why many feel not the proper sentiment of beauty, is the want of that *delicacy* of imagination, which is requisite to convey a sensibility of those finer emotions. This delicacy every one pretends to: Every one talks of it; and would reduce every kind of taste or sentiment to its standard. But as our intention in this essay is to mingle some light of the understanding with the feelings of sentiment, it will be proper to give a more accurate definition of delicacy, than has hitherto been attempted. And not to draw our philosophy from too profound a source, we shall have recourse to a noted story in DON QUIXOTE.[7]

It is with good reason, says SANCHO to the squire with the great nose, that I pretend to have a judgment in wine: This is a quality hereditary in our family. Two of my kinsmen were once called to give their opinion of a hogshead, which was supposed to be excellent, being old and of a good vintage. One of them tastes it; considers it; and after mature reflection pronounces the wine to be good, were it not for a small taste of leather, which he perceived in it. The other, after using the same precautions, gives also his verdict in favour of the wine; but with the reserve of a taste of iron, which he could easily distinguish. You cannot imagine how much they were both ridiculed for their judgment. But who laughed in the end? On emptying the hogshead, there was found at the bottom, an old key with a leathern thong tied to it.

The great resemblance between mental and bodily taste will easily teach us to apply this story. Though it be certain, that beauty and deformity, more than sweet and bitter, are not qualities in objects, but belong entirely to the sentiment, internal or external; it must be allowed, that there are certain qualities in objects, which are fitted by nature to produce those particular feelings. Now as these qualities may be found in a small degree, or may be mixed and confounded with each other, it often happens, that the taste is not affected with such minute qualities, or is not able to distinguish all the particular flavours, amidst the disorder, in which they are presented. Where the organs are so fine, as to allow nothing to escape them; and at the same time so exact as to perceive every ingredient in the composition: This we call delicacy of taste, whether we employ these terms in the literal or metaphorical sense. Here then the general rules of beauty are of use; being drawn from established models, and from the observation of what pleases or displeases, when presented singly and in a high degree: And if the same qualities, in a continued composition and in a smaller degree, affect not the organs with a sensible delight or uneasiness, we exclude the person from all pretensions to this delicacy. To produce these general rules or avowed patterns of composition is like finding the key with the leathern thong; which justified the verdict of SANCHO's kinsmen, and confounded those pretended judges who had condemned them. Though the hogshead had never been emptied, the taste of the one was still equally deli-

[7]Cervantes, *Don Quixote,* pt. 2, chap. 13.

cate, and that of the other equally dull and languid: But it would have been more difficult to have proved the superiority of the former, to the conviction of every by-stander. In like manner, though the beauties of writing had never been methodized, or reduced to general principles; though no excellent models had ever been acknowledged; the different degrees of taste would still have subsisted, and the judgment of one man been preferable to that of another; but it would not have been so easy to silence the bad critic, who might always insist upon his particular sentiment, and refuse to submit to his antagonist. But when we show him an avowed principle of art; when we illustrate this principle by examples, whose operation, from his own particular taste, he acknowledges to be conformable to the principle; when we prove, that the same principle may be applied to the present case, where he did not perceive or feel its influence: He must conclude, upon the whole, that the fault lies in himself, and that he wants the delicacy, which is requisite to make him sensible of every beauty and every blemish, in any composition or discourse.

It is acknowledged to be the perfection of every sense or faculty, to perceive with exactness its most minute objects, and allow nothing to escape its notice and observation. The smaller the objects are, which become sensible to the eye, the finer is that organ, and the more elaborate its make and composition. A good palate is not tried by strong flavours; but by a mixture of small ingredients, where we are still sensible of each part, notwithstanding its minuteness and its confusion with the rest. In like manner, a quick and acute perception of beauty and deformity must be the perfection of our mental taste; nor can a man be satisfied with himself while he suspects, that any excellence or blemish in a discourse has passed him unobserved. In this case, the perfection of the man, and the perfection of the sense or feeling, are found to be united. A very delicate palate, on many occasions, may be a great inconvenience both to a man himself and to his friends: But a delicate taste of wit or beauty must always be a desirable quality; because it is the source of all the finest and most innocent enjoyments, of which human nature is susceptible. In this decision the sentiments of all mankind are agreed. Wherever you can ascertain a delicacy of taste, it is sure to meet with approbation; and the best way of ascertaining it is to appeal to those models and principles, which have been established by the uniform consent and experience of nations and ages.

But though there be naturally a wide difference in point of delicacy between one person and another, nothing tends further to encrease and improve this talent, than *practice* in a particular art, and the frequent survey or contemplation of a particular species of beauty. When objects of any kind are first presented to the eye or imagination, the sentiment, which attends them, is obscure and confused; and the mind is, in a great measure, incapable of pronouncing concerning their merits or defects. The taste cannot perceive the several excellencies of the performance; much less distinguish the particular character of each excellency, and ascertain its quality and degree. If it pronounce the whole in general to be beautiful or deformed, it is the utmost that can be expected; and even this judgment, a person, so unpractised, will be apt to deliver with great hesitation and reserve. But allow him to acquire experience in those objects, his feeling becomes more exact and nice: He not only perceives the beauties and defects of each part, but marks the distinguishing species of each quality, and

assigns it suitable praise or blame. A clear and distinct sentiment attends him through the whole survey of the objects; and he discerns that very degree and kind of approbation or displeasure, which each part is naturally fitted to produce. The mist dissipates, which seemed formerly to hang over the object: The organ acquires greater perfection in its operations; and can pronounce, without danger of mistake, concerning the merits of every performance. In a word, the same address and dexterity, which practice gives to the execution of any work, is also acquired by the same means, in the judging of it.

So advantageous is practice to the discernment of beauty, that, before we can give judgment on any work of importance, it will even be requisite, that that very individual performance be more than once perused by us, and be surveyed in different lights with attention and deliberation. There is a flutter or hurry of thought which attends the first perusal of any piece, and which confounds the genuine sentiment of beauty. The relation of the parts is not discerned: The true characters of style are little distinguished: The several perfections and defects seem wrapped up in a species of confusion, and present themselves indistinctly to the imagination. Not to mention, that there is a species of beauty, which, as it is florid and superficial, pleases at first; but being found incompatible with a just expression either of reason or passion, soon palls upon the taste, and is then rejected with disdain, at least rated at a much lower value.

It is impossible to continue in the practice of contemplating any order of beauty, without being frequently obliged to form *comparisons* between the several species and degrees of excellence, and estimating their proportion to each other. A man, who has had no opportunity of comparing the different kinds of beauty, is indeed totally unqualified to pronounce an opinion with regard to any object presented to him. By comparison alone we fix the epithets of praise or blame, and learn how to assign the due degree of each. The coarsest daubing contains a certain lustre of colours and exactness of imitation, which are so far beauties, and would affect the mind of a peasant or Indian with the highest admiration. The most vulgar ballads are not entirely destitute of harmony or nature; and none but a person, familiarized to superior beauties, would pronounce their numbers harsh, or narration uninteresting. A great inferiority of beauty gives pain to a person conversant in the highest excellence of the kind, and is for that reason pronounced a deformity: As the most finished object, with which we are acquainted, is naturally supposed to have reached the pinnacle of perfection, and to be entitled to the highest applause. One accustomed to see, and examine, and weigh the several performances, admired in different ages and nations, can alone rate the merits of a work exhibited to his view, and assign its proper rank among the productions of genius.

But to enable a critic the more fully to execute this undertaking, he must preserve his mind free from all *prejudice,* and allow nothing to enter into his consideration, but the very object which is submitted to his examination. We may observe, that every work of art, in order to produce its due effect on the mind, must be surveyed in a certain point of view, and cannot be fully relished by persons, whose situation, real or imaginary, is not conformable to that which is required by the performance. An orator addresses himself to a particular audience, and must have a regard to their particular genius, interests,

opinions, passions, and prejudices; otherwise he hopes in vain to govern their resolutions, and inflame their affections. Should they even have entertained some prepossessions against him, however unreasonable, he must not overlook this disadvantage; but, before he enters upon the subject, must endeavour to conciliate their affection, and acquire their good graces. A critic of a different age or nation, who should peruse this discourse, must have all these circumstances in his eye, and must place himself in the same situation as the audience, in order to form a true judgment of the oration. In like manner, when any work is addressed to the public, though I should have a friendship or enmity with the author, I must depart from this situation; and considering myself as a man in general, forget, if possible, my individual being and my peculiar circumstances. A person influenced by prejudice, complies not with this condition; but obstinately maintains his natural position, without placing himself in that point of view, which the performance supposes. If the work be addressed to persons of a different age or nation, he makes no allowance for their peculiar views and prejudices; but, full of the manners of his own age and country, rashly condemns what seemed admirable in the eyes of those for whom alone the discourse was calculated. If the work be executed for the public, he never sufficiently enlarges his comprehension, or forgets his interest as a friend or enemy, as a rival or commentator. By this means, his sentiments are perverted; nor have the same beauties and blemishes the same influence upon him, as if he had imposed a proper violence on his imagination, and had forgotten himself for a moment. So far his taste evidently departs from the true standard; and of consequence loses all credit and authority.

It is well known, that in all questions, submitted to the understanding, prejudice is destructive of sound judgment, and perverts all operations of the intellectual faculties: It is no less contrary to good taste; nor has it less influence to corrupt our sentiment of beauty. It belongs to *good sense* to check its influence in both cases; and in this respect, as well as in many others, reason, if not an essential part of taste, is at least requisite to the operations of this latter faculty. In all the nobler productions of genius, there is a mutual relation and correspondence of parts; nor can either the beauties or blemishes be perceived by him, whose thought is not capacious enough to comprehend all those parts, and compare them with each other, in order to perceive the consistence and uniformity of the whole. Every work of art has also a certain end or purpose, for which it is calculated; and is to be deemed more or less perfect, as it is more or less fitted to attain this end. The object of eloquence is to persuade, of history to instruct, of poetry to please by means of the passions and the imagination. These ends we must carry constantly in our view, when we peruse any performance; and we must be able to judge how far the means employed are adapted to their respective purposes. Besides, every kind of composition, even the most poetical, is nothing but a chain of propositions and reasonings; not always, indeed, the justest and most exact, but still plausible and specious, however disguised by the colouring of the imagination. The persons introduced in tragedy and epic poetry, must be represented as reasoning, and thinking, and concluding, and acting, suitably to their character and circumstances; and without judgment, as well as taste and invention, a poet can never hope to succeed in so delicate an undertaking. Not to mention, that the

same excellence of faculties which contributes to the improvement of reason, the same clearness of conception, the same exactness of distinction, the same vivacity of apprehension, are essential to the operations of true taste, and are its infallible concomitants. It seldom, or never happens, that a man of sense, who has experience in any art, cannot judge of its beauty; and it is no less rare to meet with a man who has a just taste without a sound understanding.

Thus, though the principles of taste be universal, and nearly, if not entirely the same in all men; yet few are qualified to give judgment on any work of art, or establish their own sentiment as the standard of beauty. The organs of internal sensation are seldom so perfect as to allow the general principles their full play, and produce a feeling correspondent to those principles. They either labour under some defect, or are vitiated by some disorder; and by that means, excite a sentiment, which may be pronounced erroneous. When the critic has no delicacy, he judges without any distinction, and is only affected by the grosser and more palpable qualities of the object: The finer touches pass unnoticed and disregarded. Where he is not aided by practice, his verdict is attended with confusion and hesitation. Where no comparison has been employed, the most frivolous beauties, such as rather merit the name of defects, are the object of his admiration. Where he lies under the influence of prejudice, all his natural sentiments are perverted. Where good sense is wanting, he is not qualified to discern the beauties of design and reasoning, which are the highest and most excellent. Under some or other of these imperfections, the generality of men labour; and hence a true judge in the finer arts is observed, even during the most polished ages, to be so rare a character: Strong sense, united to delicate sentiment, improved by practice, perfected by comparison, and cleared of all prejudice, can alone entitle critics to this valuable character; and the joint verdict of such, wherever they are to be found, is the true standard of taste and beauty.

But where are such critics to be found? By what marks are they to be known? How distinguish them from pretenders? These questions are embarrassing; and seem to throw us back into the same uncertainty, from which, during the course of this essay, we have endeavoured to extricate ourselves.

But if we consider the matter aright, these are questions of fact, not of sentiment. Whether any particular person be endowed with good sense and a delicate imagination, free from prejudice, may often be the subject of dispute, and be liable to great discussion and enquiry: But that such a character is valuable and estimable will be agreed in by all mankind. Where these doubts occur, men can do no more than in other disputable questions, which are submitted to the understanding: They must produce the best arguments, that their invention suggests to them; they must acknowledge a true and decisive standard to exist somewhere, to wit, real existence and matter of fact; and they must have indulgence to such as differ from them in their appeals to this standard. It is sufficient for our present purpose, if we have proved, that the taste of all individuals is not upon an equal footing, and that some men in general, however difficult to be particularly pitched upon, will be acknowledged by universal sentiment to have a preference above others.

But in reality the difficulty of finding, even in particulars, the standard of taste, is not so great as it is represented. Though in speculation, we may readily

avow a certain criterion in science and deny it in sentiment, the matter is found in practice to be much more hard to ascertain in the former case than in the latter. Theories of abstract philosophy, systems of profound theology, have prevailed during one age: In a successive period, these have been universally exploded: Their absurdity has been detected: Other theories and systems have supplied their place, which again gave place to their successors: And nothing has been experienced more liable to the revolutions of chance and fashion than these pretended decisions of science. The case is not the same with the beauties of eloquence and poetry. Just expressions of passion and nature are sure, after a little time, to gain public applause, which they maintain for ever. ARISTOTLE,[8] and PLATO, and EPICURUS,[9] and DESCARTES, may successively yield to each other: But TERENCE and VIRGIL maintain an universal, undisputed empire over the minds of men. The abstract philosophy of CICERO has lost its credit: The vehemence of his oratory is still the object of our admiration.

Though men of delicate taste be rare, they are easily to be distinguished in society, by the soundness of their understanding and the superiority of their faculties above the rest of mankind. The ascendant, which they acquire, gives a prevalence to that lively approbation, with which they receive any productions of genius, and renders it generally predominant. Many men, when left to themselves, have but a faint and dubious perception of beauty, who yet are capable of relishing any fine stroke, which is pointed out to them. Every convert to the admiration of the real poet or orator is the cause of some new conversion. And though prejudices may prevail for a time, they never unite in celebrating any rival to the true genius, but yield at last to the force of nature and just sentiment. Thus, though a civilized nation may easily be mistaken in the choice of their admired philosopher, they never have been found long to err, in their affection for a favourite epic or tragic author.

But notwithstanding all our endeavors to fix a standard of taste, and reconcile the discordant apprehensions of men, there still remain two sources of variation, which are not sufficient indeed to confound all the boundaries of beauty and deformity, but will often serve to produce a difference in the degrees of our approbation or blame. The one is the different humours of particular men; the other, the particular manners and opinions of our age and country. The general principles of taste are uniform in human nature: Where men vary in their judgments, some defect or perversion in the faculties may commonly be remarked; proceeding either from prejudice, from want of practice, or want of delicacy; and there is just reason for approving one taste, and condemning another. But where there is such a diversity in the internal frame or external situation as is entirely blameless on both sides, and leaves no room to give one the preference above the other; in that case a certain degree of diversity in judgment is unavoidable, and we seek in vain for a standard, by which we can reconcile the contrary sentiments.

A young man, whose passions are warm, will be more sensibly touched

[8]Aristotle (384–322 B.C.), a Greek philosopher, was the main source of medieval scholastic philosophy.
[9]Epicurus (341–270 B.C.), a Greek moral philosopher, professed hedonism, or the view that pleasure is the good for man. See Hume's essay entitled "The Epicurean."

with amorous and tender images, than a man more advanced in years, who takes pleasure in wise, philosophical reflections concerning the conduct of life and moderation of the passions. At twenty, OVID may be the favourite author; HORACE at forty; and perhaps TACITUS at fifty. Vainly would we, in such cases, endeavour to enter into the sentiments of others, and divest ourselves of those propensities, which are natural to us. We choose our favourite author as we do our friend, from a conformity of humour and disposition. Mirth or passion, sentiment or reflection; whichever of these most predominates in our temper, it gives us a peculiar sympathy with the writer who resembles us.

One person is more pleased with the sublime; another with the tender; a third with raillery. One has a strong sensibility to blemishes, and is extremely studious of correctness: Another has a more lively feeling of beauties, and pardons twenty absurdities and defects for one elevated or pathetic stroke. The ear of this man is entirely turned towards consciousness and energy; that man is delighted with a copious, rich, and harmonious expression. Simplicity is affected by one; ornament by another. Comedy, tragedy, satire, odes, have each its partizans, who prefer that particular species of writing to all others. It is plainly an error in a critic, to confine his approbation to one species or style of writing, and condemn all the rest. But it is almost impossible not to feel a predilection for that which suits our particular turn and disposition. Such preferences are innocent and unavoidable, and can never reasonably be the object of dispute, because there is no standard, by which they can be decided.

For a like reason, we are more pleased, in the course of our reading, with pictures and characters, that resemble objects which are found in our own age or country, than with those which describe a different set of customs. It is not without some effort, that we reconcile ourselves to the simplicity of ancient manners, and behold princesses carrying water from the spring, and kings and heroes dressing their own victuals. We may allow in general, that the representation of such manners is no fault in the author, nor deformity in the piece; but we are not so sensibly touched with them. For this reason, comedy is not easily transferred from one age or nation to another. A FRENCHMAN or ENGLISHMAN is not pleased with the ANDRIA of TERENCE,[10] or CLITIA of MACHIAVEL;[11] where the fine lady, upon whom all the play turns, never once appears to the spectators, but is always kept behind the scenes, suitably to the reserved humour of the ancient GREEKS and modern ITALIANS. A man of learning and reflection can make allowance for these peculiarities of manners; but a common audience can never divest themselves so far of their usual ideas and sentiments, as to relish pictures which no wise resemble them.

But here there occurs a reflection, which may, perhaps, be useful in examining the celebrated controversy concerning ancient and modern learning; where we often find the one side excusing any seeming absurdity in the ancients from the manners of the age, and the other refusing to admit this excuse, or at least, admitting it only as an apology for the author, not for the performance. In my opinion, the proper boundaries in this subject have sel-

[10]Terence, *Andria* (The lady of Andros). Glycerium, the young woman around whom the play revolves, is a *muta persona;* i.e., she says nothing on the stage.
[11]In Machiavelli's *Clizia,* which was staged in 1525, the young woman Clizia does not appear but is the center of the action.

dom been fixed between the contending parties. Where any innocent pecu-
liarities of manners are represented, such as those above mentioned, they
ought certainly to be admitted; and a man, who is shocked with them, gives
an evident proof of false delicacy and refinement. The poet's *monument more
durable than brass*,[12] must fall to the ground like common brick or clay, were
men to make no allowance for the continual revolutions of manners and cus-
toms, and would admit of nothing but what was suitable to the prevailing
fashion. Must we throw aside the pictures of our ancestors, because of their
ruffs and farthingales? But where the ideas of morality and decency alter from
one age to another, and where vicious manners are described, without being
marked with the proper characters of blame and disapprobation; this must be
allowed to disfigure the poem, and to be a real deformity. I cannot, nor is it
proper I should, enter into such sentiments; and however I may excuse the
poet, on account of the manners of his age, I never can relish the composition.
The want of humanity and of decency, so conspicuous in the characters drawn
by several of the ancient poets, even sometimes by HOMER and the GREEK
tragedians, diminishes considerably the merit of their noble performances, and
gives modern authors an advantage over them. We are not interested in the
fortunes and sentiments of such rough heroes: We are displeased to find the
limits of vice and virtue so much confounded: And whatever indulgence we
may give to the writer on account of his prejudices, we cannot prevail on our-
selves to enter into his sentiments, or bear an affection to characters, which we
plainly discover to be blameable.

 The case is not the same with moral principles, as with speculative opin-
ions of any kind. These are in continual flux and revolution. The son embraces
a different system from the father. Nay, there scarcely is any man, who can
boast of great constancy and uniformity in this particular. Whatever specula-
tive errors may be found in the polite writings of any age or country, they
detract but little from the value of those compositions. There needs but a cer-
tain turn of thought or imagination to make us enter into all the opinions,
which then prevailed, and relish the sentiments or conclusions derived from
them. But a very violent effort is requisite to change our judgment of manners,
and excite sentiments of approbation or blame, love or hatred, different from
those to which the mind from long custom has been familiarized. And where
a man is confident of the rectitude of that moral standard, by which he judges,
he is justly jealous of it, and will not pervert the sentiments of his heart for a
moment, in complaisance to any writer whatsoever.

 Of all speculative errors, those, which regard religion, are the most excus-
able in compositions of genius; nor is it ever permitted to judge of the civility
or wisdom of any people, or even of single persons, by the grossness or refine-
ment of their theological principles. The same good sense, that directs men in
the ordinary occurrences of life, is not hearkened to in religious matters, which
are supposed to be placed altogether above the cognizance of human reason.
On this account, all the absurdities of the pagan system of theology must be
overlooked by every critic, who would pretend to form a just notion of ancient
poetry; and our posterity, in their turn, must have the same indulgence to their
forefathers. No religious principles can ever be imputed as a fault to any poet,

[12]Horace, *Carmina* (Odes) 3.30.1.

while they remain merely principles, and take not such strong possession of his heart, as to lay him under the imputation of *bigotry* or *superstition*. Where that happens, they confound the sentiments of morality, and alter the natural boundaries of vice and virtue. They are therefore eternal blemishes, according to the principle abovementioned; nor are the prejudices and false opinions of the age sufficient to justify them.

It is essential to the ROMAN catholic religion to inspire a violent hatred of every other worship, and to represent all pagans, mahometans, and heretics as the objects of divine wrath and vengeance. Such sentiments, though they are in reality very blameable, are considered as virtues by the zealots of that communion, and are represented in their tragedies and epic poems as a kind of divine heroism. This bigotry has disfigured two very fine tragedies of the FRENCH theatre, POLIEUCTE and ATHALIA;[13] where an intemperate zeal for particular modes of worship is set off with all the pomp imaginable, and forms the predominant character of the heroes. "What is this," says the sublime JOAD to JOSABET, finding her in discourse with MATHAN, the priest of BAAL, "Does the daughter of DAVID speak to this traitor? Are you not afraid, lest the earth should open and pour forth flames to devour you both? Or lest these holy walls should fall and crush you together? What is his purpose? Why comes that enemy of God hither to poison the air, which we breathe, with his horrid presence?" Such sentiments are received with great applause on the theatre of PARIS; but at LONDON the spectators would be full as much pleased to hear ACHILLES tell AGAMEMNON, that he was a dog in his forehead, and a deer in his heart, or JUPITER threaten JUNO with a sound drubbing, if she will not be quiet.[14]

RELIGIOUS principles are also a blemish in any polite composition, when they rise up to superstition, and intrude themselves into every sentiment, however remote from any connection with religion. It is no excuse for the poet, that the customs of his country had burthened life with so many religious ceremonies and observances, that no part of it was exempt from that yoke. It must for ever be ridiculous in PETRARCH to compare his mistress, LAURA, to JESUS CHRIST.[15] Nor is it less ridiculous in that agreeable libertine, BOCCACE, very seriously to give thanks to GOD ALMIGHTY and the ladies, for their assistance in defending him against his enemies.[16]

[13]*Polyeucte* (1641–1642), a tragedy by Corneille, is the story of an Armenian nobleman whose conversion to Christianity and martyrdom lead to the conversion of his wife, Pauline, and of his father-in-law, Felix, the Roman governor, who had sentenced Polyeucte to death for betraying the Roman gods. *Athalie* (1691), a tragedy by Racine, is based on the biblical account (2 *Kings* 11 and 2 *Chronicles* 22–23) of the victory of God's priest over Athaliah, queen of Judah and a worshiper of Baal. The scene described below by Hume is from *Athalie*, act 3, sc. 5.

[14]See Homer, *Iliad* 1.225, for Achilles's insult to Agamemnon and 1.56–67 for Zeus's (or Jupiter's) threat to Hera (or Juno).

[15]Hume probably refers to the collection of 366 poems by Francesco Petrarca (1304–74), which has no definite title but is known in Italian as *Canzoniere* or *Rima*. Most of the poems are about Petrarch's love for Laura, which began when he first saw her in church in the year 1327 and continued after her death in 1348. It seems that Laura was beyond Petrarch's reach and that he loved her from afar. In the poems, Petrarch's love for Laura becomes a symbol for his own quest for salvation, and Laura herself, after her physical death, is resurrected as a sublime ideal with divine qualities.

[16]See Boccaccio, *Decameron*, Introduction to "The Fourth Day."

READING 21

INTRODUCTION

Immanuel Kant (1724–1804) is one of the most important philosophers of the Western tradition. He developed a massive and complex philosophical system, covering many of the most difficult issues of metaphysics, epistemology, and the philosophy of mind. The third of his three great Critiques is *The Critique of Judgment* (1790), of which "Analytic of the Beautiful" is the opening section. Here Kant, like Hume, is concerned to show that the subjective nature of aesthetic judgments, or judgments of taste, does not imply skepticism about aesthetic judgments, or the view that in matters of aesthetics any judgment is as good as any other. Kant is clear that judgments of taste are indeed judgments "whose determining bias cannot be other than subjective." If judgments of taste were *objective,* then there would be *principles* of taste; that is to say, one would be able to prove that such judgments were objectively true or false. And it seems clear that this is not the case: We cannot enumerate principles of taste, nor can we prove (in any ordinary sense of the word) that a judgment of taste is true or false. So what are we to make of such judgments? In exploring their nature, Kant states some views that have been extremely influential. One of the most striking of these is his contention that although judgments of taste are subjective, they nevertheless make a sort of universal claim. As Kant says, "If it merely pleases *him,* he must not call it *beautiful. . . .* When he puts a thing on a pedestal and calls it beautiful, he demands the same delight from others. He judges not merely for himself, but for all men." But how is this possible? How can judgments that are based on purely subjective feelings claim or command universal assent? This is the question that motivated Hume in "Of the Standard of Taste." But Kant rejects Hume's answer. His own answer lies in a distinctive theory of mind and, particularly, in a theory of the ways in which the faculties of imagination and understanding work together. Kant's discussion of the logic of taste is far from transparent; but it is one of the most influential and one of the most debated discussions in the philosophy of art.

Analytic of the Beautiful

Immanuel Kant

First Moment
Of the Judgement of Taste:[1] Moment of Quality

1. The Judgement of Taste Is Aesthetic If we wish to discern whether anything is beautiful or not, we do not refer the representation of it to the Object

[1] The definition of taste here relied upon is that it is the faculty of estimating the beautiful. But the discovery of what is required for calling an object beautiful must be reserved for the analysis of judgements of taste. In my search for the moments to which attention is paid by this judgement in its reflection, I have followed the guidance of the logical functions of judging (for a judgement of taste always involves a reference to understanding). I have brought the moment of quality first under review, because this is what the aesthetic judgement on the beautiful looks to in the first instance.

by means of understanding with a view to cognition, but by means of the imagination (acting perhaps in conjunction with understanding) we refer the representation to the Subject and its feeling of pleasure or displeasure. The judgement of taste, therefore, is not a cognitive judgement, and so not logical, but is aesthetic—which means that it is one whose determining ground *cannot be other than subjective.* Every reference of representations is capable of being objective, even that of sensations (in which case it signifies the real in an empirical representation). The one exception to this is the feeling of pleasure or displeasure. This denotes nothing in the object, but is a feeling which the Subject has of itself and of the manner in which it is affected by the representation.

To apprehend a regular and appropriate building with one's cognitive faculties, be the mode of representation clear or confused, is quite a different thing from being conscious of this representation with an accompanying sensation of delight. Here the representation is referred wholly to the Subject, and what is more to its feeling of life—under the name of the feeling of pleasure or displeasure—and this forms the basis of a quite separate faculty of discriminating and estimating, that contributes nothing to knowledge. All it does is to compare the given representation in the Subject with the entire faculty of representations of which the mind is conscious in the feeling of its state. Given representations in a judgement may be empirical, and so aesthetic; but the judgement which is pronounced by their means is logical, provided it refers them to the Object. Conversely, be the given representations even rational, but referred in a judgement solely to the Subject (to its feeling), they are always to that extent aesthetic.

2. The Delight Which Determines the Judgement of Taste Is Independent of All Interest The delight which we connect with the representation of the real existence of an object is called interest. Such a delight, therefore, always involves a reference to the faculty of desire, either as its determining ground, or else as necessarily implicated with its determining ground. Now, where the question is whether something is beautiful, we do not want to know, whether we, or any one else, are, or even could be, concerned in the real existence of the thing, but rather what estimate we form of it on mere contemplation (intuition or reflection). If any one asks me whether I consider that the palace I see before me is beautiful, I may, perhaps, reply that I do not care for things of that sort that are merely made to be gaped at. Or I may reply in the same strain as that Iroquois *sachem* who said that nothing in Paris pleased him better than the eating-houses. I may even go a step further and inveigh with the vigour of a *Rousseau* against the vanity of the great who spend the sweat of the people on such superfluous things. Or, in fine, I may quite easily persuade myself that if I found myself on an uninhabited island, without hope of ever again coming among men, and could conjure such a palace into existence by a mere wish, I should still not trouble to do so, so long as I had a hut there that was comfortable enough for me. All this may be admitted and approved; only it is not the point now at issue. All one wants to know is whether the mere representation of the object is to my liking, no matter how indifferent I may be to the real existence of the object of this representation. It is quite plain that in order to say that the object *is beautiful,* and to show that I have taste, every-

thing turns on the meaning which I can give to this representation, and not on any factor which makes me dependent on the real existence of the object. Every one must allow that a judgement on the beautiful which is tinged with the slightest interest, is very partial and not a pure judgement of taste. One must not be in the least prepossessed in favour of the real existence of the thing, but must preserve complete indifference in this respect, in order to play the part of judge in matters of taste.

This proposition, which is of the utmost importance, cannot be better explained than by contrasting the pure disinterested[2] delight which appears in the judgement of taste with that allied to an interest—especially if we can also assure ourselves that there are no other kinds of interest beyond those presently to be mentioned.

3. Delight in the Agreeable Is Coupled with Interest That Is Agreeable Which the Senses Find Pleasing in Sensation

This at once affords a convenient opportunity for condemning and directing particular attention to a prevalent confusion of the double meaning of which the word 'sensation' is capable. All delight (as is said or thought) is itself sensation (of a pleasure). Consequently everything that pleases, and for the very reason that it pleases, is agreeable—and according to its different degrees, or its relations to other agreeable sensations, is attractive, charming, delicious, enjoyable, &c. But if this is conceded, then impressions of sense, which determine inclination, or principles of reason, which determine the will, or mere contemplated forms of intuition, which determine judgement, are all on a par in everything relevant to their effect upon the feeling of pleasure, for this would be agreeableness in the sensation of one's state; and since, in the last resort, all the elaborate work of our faculties must issue in and unite in the practical as its goal, we could credit our faculties with no other appreciation of things and the worth of things, than that consisting in the gratification which they promise. How this is attained is in the end immaterial; and, as the choice of the means is here the only thing that can make a difference, men might indeed blame one another for folly or imprudence, but never for baseness or wickedness; for they are all, each according to his own way of looking at things, pursuing one goal, which for each is the gratification in question.

When a modification of the feeling of pleasure or displeasure is termed sensation, this expression is given quite a different meaning to that which it bears when I call the representation of a thing (through sense as a receptivity pertaining to the faculty of knowledge) sensation. For in the latter case the representation is referred to the Object, but in the former it is referred solely to the Subject and is not available for any cognition, not even for that by which the Subject *cognizes* itself.

Now in the above definition the word sensation is used to denote an objective representation of sense; and, to avoid continually running the risk of mis-

[2]A judgement upon an object of our delight may be wholly *disinterested* but withal very *interesting*, i.e. it relies on no interest, but it produces one. Of this kind are all pure moral judgements. But, of themselves, judgements of taste do not even set up any interest whatsoever. Only in society is it *interesting* to have taste—a point which will be explained in the sequel.

interpretation, we shall call that which must always remain purely subjective, and is absolutely incapable of forming a representation of an object, by the familiar name of feeling. The green colour of the meadows belongs to *objective* sensation, as the perception of an object of sense; but its agreeableness to *subjective* sensation, by which no object is represented: i.e. to feeling, through which the object is regarded as an Object of delight (which involves no cognition of the object).

Now, that a judgement on an object by which its agreeableness is affirmed, expresses an interest in it, is evident from the fact that through sensation it provokes a desire for similar objects, consequently the delight presupposes, not the simple judgement about it, but the bearing its real existence has upon my state so far as affected by such an Object. Hence we do not merely say of the agreeable that it *pleases*, but that it *gratifies*. I do not accord it a simple approval, but inclination is aroused by it, and where agreeableness is of the liveliest type a judgement on the character of the Object is so entirely out of place, that those who are always intent only on enjoyment (for that is the word used to denote intensity of gratification) would fain dispense with all judgement.

4. Delight in the Good Is Coupled with Interest That is *good* which by means of reason commends itself by its mere concept. We call that *good for something* (useful) which only pleases as a means; but that which pleases on its own account we call *good in itself*. In both cases the concept of an end is implied, and consequently the relation of reason to (at least possible) willing, and thus a delight in the *existence* of an Object or action, i.e. some interest or other.

To deem something good, I must always know what sort of a thing the object is intended to be, i.e. I must have a concept of it. That is not necessary to enable me to see beauty in a thing. Flowers, free patterns, lines aimlessly intertwining—technically termed foliage,—have no signification, depend upon no definite concept, and yet please. Delight in the beautiful must depend upon the reflection on an object precursory to some (not definitely determined) concept. It is thus also differentiated from the agreeable, which rests entirely upon sensation.

In many cases, no doubt, the agreeable and the good seem convertible terms. Thus it is commonly said that all (especially lasting) gratification is of itself good; which is almost equivalent to saying that to be permanently agreeable and to be good are identical. But it is readily apparent that this is merely a vicious confusion of words, for the concepts appropriate to these expressions are far from interchangeable. The agreeable, which, as such, represents the object solely in relation to sense, must in the first instance be brought under principles of reason through the concept of an end, to be, as an object of will, called good. But that the reference to delight is wholly different where what gratifies is at the same time called *good*, is evident from the fact that with the good the question always is whether it is mediately or immediately good, i.e. useful or good in itself; whereas with the agreeable this point can never arise, since the word always means what pleases immediately—and it is just the same with what I call beautiful.

Even in everyday parlance a distinction is drawn between the agreeable and the good. We do not scruple to say of a dish that stimulates the palate with spices and other condiments that it is agreeable—owning all the while that it is not good: because, while it immediately *satisfies* the senses, it is mediately displeasing, i.e. in the eye of reason that looks ahead to the consequences. Even in our estimate of health this same distinction may be traced. To all that possess it, it is immediately agreeable—at least negatively, i.e. as remoteness of all bodily pains. But, if we are to say that it is good, we must further apply to reason to direct it to ends, that is, we must regard it as a state that puts us in a congenial mood for all we have to do. Finally, in respect of happiness every one believes that the greatest aggregate of the pleasures of life, taking duration as well as number into account, merits the name of a true, nay even of the highest, good. But reason sets its face against this too. Agreeableness is enjoyment. But if this is all that we are bent on, it would be foolish to be scrupulous about the means that procure it for us—whether it be obtained passively by the bounty of nature or actively and by the work of our own hands. But that there is any intrinsic worth in the real existence of a man who merely lives for *enjoyment,* however busy he may be in this respect, even when in so doing he serves others—all equally with himself intent only on enjoyment—as an excellent means to that one end, and does so, moreover, because through sympathy he shares all their gratifications,—this is a view to which reason will never let itself be brought round. Only by what a man does heedless of enjoyment, in complete freedom and independently of what he can procure passively from the hand of nature, does he give to his existence, as the real existence of a person, an absolute worth. Happiness, with all its plethora of pleasures, is far from being an unconditioned good.[3]

But, despite all this difference between the agreeable and the good, they both agree in being invariably coupled with an interest in their object. This is true, not alone of the agreeable, § 3, and of the mediately good, i.e. the useful, which pleases as a means to some pleasure, but also of that which is good absolutely and from every point of view, namely the moral good which carries with it the highest interest. For the good is the Object of will, i.e. of a rationally determined faculty of desire. But to will something, and to take a delight in its existence, i.e. to take an interest in it, are identical.

5. Comparison of the Three Specifically Different Kinds of Delight Both the Agreeable and the Good involve a reference to the faculty of desire, and are thus attended, the former with a delight pathologically conditioned (by stimuli), the latter with a pure practical delight. Such delight is determined not merely by the representation of the object, but also by the represented bond of connexion between the Subject and the real existence of the object. It is not merely the object, but also its real existence, that pleases. On the other hand

[3]An obligation to enjoyment is a patent absurdity. And the same, then, must also be said of a supposed obligation to actions that have merely enjoyment for their aim, no matter how spiritually this enjoyment may be refined in thought (or embellished), and even if it be a mystical, so-called heavenly, enjoyment.

the judgement of taste is simply *contemplative,* i.e. it is a judgement which is indifferent as to the existence of an object, and only decides how its character stands with the feeling of pleasure and displeasure. But not even is this contemplation itself directed to concepts; for the judgement of taste is not a cognitive judgement (neither a theoretical one nor a practical), and hence, also, is not *grounded* on concepts, nor yet *intentionally directed* to them.

The agreeable, the beautiful, and the good thus denote three different relations of representations to the feeling of pleasure and displeasure, as a feeling in respect of which we distinguish different objects or modes of representation. Also, the corresponding expressions which indicate our satisfaction in them are different. The *agreeable* is what GRATIFIES a man; the *beautiful* what simply PLEASES him; the *good* what is ESTEEMED *(approved),* i.e. that on which he sets an objective worth. Agreeableness is a significant factor even with irrational animals; beauty has purport and significance only for human beings, i.e. for beings at once animal and rational (but not merely for them as rational— intelligent beings—but only for them as at once animal and rational); whereas the good is good for every rational being in general;—a proposition which can only receive its complete justification and explanation in the sequel. Of all these three kinds of delight, that of taste in the beautiful may be said to be the one and only disinterested and *free* delight; for, with it, no interest, whether of sense or reason, extorts approval. And so we may say that delight, in the three cases mentioned, is related to *inclination,* to *favour,* or to *respect.* For FAVOUR is the only free liking. An object of inclination, and one which a law of reason imposes upon our desire, leaves us no freedom to turn anything into an object of pleasure. All interest presupposes a want, or calls one forth; and, being a ground determining approval, deprives the judgement on the object of its freedom.

So far as the interest of inclination in the case of the agreeable goes, every one says: Hunger is the best sauce; and people with a healthy appetite relish everything, so long as it is something they can eat. Such delight, consequently, gives no indication of taste having anything to say to the choice. Only when men have got all they want can we tell who among the crowd has taste or not. Similarly there may be correct habits (conduct) without virtue, politeness without good-will, propriety without honour, &c. For where the moral law dictates, there is, objectively, no room left for free choice as to what one has to do; and to show taste in the way one carries out these dictates, or in estimating the way others do so, is a totally different matter from displaying the moral frame of one's mind. For the latter involves a command and produces a need of something, whereas moral taste only plays with the objects of delight without devoting itself sincerely to any.

Definition of the Beautiful Derived from the First Moment

Taste is the faculty of estimating an object or a mode of representation by means of a delight or aversion *apart from any interest.* The object of such a delight is called *beautiful.*

Second Moment
Of the Judgement of Taste: Moment of Quantity

6. The Beautiful Is That Which, Apart from Concepts, Is Represented as the Object of a Universal Delight This definition of the beautiful is deducible from the foregoing definition of it as an object of delight apart from any interest. For where any one is conscious that his delight in an object is with him independent of interest, it is inevitable that he should look on the object as one containing a ground of delight for all men. For, since the delight is not based on any inclination of the Subject (or on any other deliberate interest), but the Subject feels himself completely *free* in respect of the liking which he accords to the object, he can find as reason for his delight no personal conditions to which his own subjective self might alone be party. Hence he must regard it as resting on what he may also presuppose in every other person; and therefore he must believe that he has reason for demanding a similar delight from every one. Accordingly he will speak of the beautiful as if beauty were a quality of the object and the judgement logical (forming a cognition of the Object by concepts of it); although it is only aesthetic, and contains merely a reference of the representation of the object to the Subject;—because it still bears this resemblance to the logical judgement, that it may be presupposed to be valid for all men. But this universality cannot spring from concepts. For from concepts there is no transition to the feeling of pleasure or displeasure (save in the case of pure practical laws, which, however, carry an interest with them; and such an interest does not attach to the pure judgement of taste). The result is that the judgement of taste, with its attendant consciousness of detachment from all interest, must involve a claim to validity for all men, and must do so apart from universality attached to Objects, i.e. there must be coupled with it a claim to subjective universality.

7. Comparison of the Beautiful with the Agreeable and the Good by Means of the Above Characteristic As regards the *agreeable* every one concedes that his judgement, which he bases on a private feeling, and in which he declares that an object pleases him, is restricted merely to himself personally. Thus he does not take it amiss if, when he says that Canary-wine is agreeable, another corrects the expression and reminds him that he ought to say: It is agreeable *to me*. This applies not only to the taste of the tongue, the palate, and the throat, but to what may with any one be agreeable to eye or ear. A violet colour is to one soft and lovely: to another dull and faded. One man likes the tone of wind instruments, another prefers that of string instruments. To quarrel over such points with the idea of condemning another's judgement as incorrect when it differs from our own, as if the opposition between the two judgements were logical, would be folly. With the agreeable, therefore, the axiom holds good: *Every one has his own taste* (that of sense).

The beautiful stands on quite a different footing. It would, on the contrary, be ridiculous if any one who plumed himself on his taste were to think of justifying himself by saying: This object (the building we see, the dress that person has on, the concert we hear, the poem submitted to our criticism) is beau-

tiful *for me*. For if it merely pleases *him*, he must not call it *beautiful*. Many things may for him possess charm and agreeableness—no one cares about that; but when he puts a thing on a pedestal and calls it beautiful, he demands the same delight from others. He judges not merely for himself, but for all men, and then speaks of beauty as if it were a property of things. Thus he says the *thing* is beautiful; and it is not as if he counted on others agreeing in his judgement of liking owing to his having found them in such agreement on a number of occasions, but he *demands* this agreement of them. He blames them if they judge differently, and denies them taste, which he still requires of them as something they ought to have; and to this extent it is not open to men to say: Every one has his own taste. This would be equivalent to saying that there is no such thing at all as taste, i.e. no aesthetic judgement capable of making a rightful claim upon the assent of all men.

Yet even in the case of the agreeable we find that the estimates men form do betray a prevalent agreement among them, which leads to our crediting some with taste and denying it to others, and that, too, not as an organic sense but as a critical faculty in respect of the agreeable generally. So of one who knows how to entertain his guests with pleasures (of enjoyment through all the senses) in such a way that one and all are pleased, we say that he has taste. But the universality here is only understood in a comparative sense; and the rules that apply are, like all empirical rules, *general* only, not *universal*,—the latter being what the judgement of taste upon the beautiful deals or claims to deal in. It is a judgement in respect of sociability so far as resting on empirical rules. In respect of the good it is true that judgements also rightly assert a claim to validity for every one; but the good is only represented as an Object of universal delight *by means of a concept,* which is the case neither with the agreeable nor the beautiful.

8. In a Judgement of Taste the Universality of Delight Is Only Represented as Subjective

This particular form of the universality of an aesthetic judgement, which is to be met with in a judgement of taste, is a significant feature, not for the logician certainly, but for the transcendental philosopher. It calls for no small effort on his part to discover its origin, but in return it brings to light a property of our cognitive faculty which, without this analysis, would have remained unknown.

First, one must get firmly into one's mind that by the judgement of taste (upon the beautiful) the delight in an object is imputed to *every one*, yet without being founded on a concept (for then it would be the good), and that this claim to universality is such an essential factor of a judgement by which we describe anything as *beautiful,* that were it not for its being present to the mind it would never enter into any one's head to use this expression, but everything that pleased without a concept would be ranked as agreeable. For in respect of the agreeable every one is allowed to have his own opinion, and no one insists upon others agreeing with his judgement of taste, which is what is invariably done in the judgement of taste about beauty. The first of these I may call the taste of sense, the second, the taste of reflection: the first laying down judgements merely private, the second, on the other hand, judgements ostensibly of general validity (public), but both alike being aesthetic (not practical)

judgements about an object merely in respect of the bearings of its representation on the feeling of pleasure or displeasure. Now it does seem strange that while with the taste of sense it is not alone experience that shows that its judgement (of pleasure or displeasure in something) is not universally valid, but every one willingly refrains from imputing this agreement to others (despite the frequent actual prevalence of a considerable consensus of general opinion even in these judgements), the taste of reflection, which, as experience teaches, has often enough to put up with a rude dismissal of its claims to universal validity of its judgement (upon the beautiful), can (as it actually does) find it possible for all that, to formulate judgements capable of demanding this agreement in its universality. Such agreement it does in fact require from every one for each of its judgements of taste,—the persons who pass these judgements not quarrelling over the possibility of such a claim, but only failing in particular cases to come to terms as to the correct application of this faculty.

First of all we have here to note that a universality which does not rest upon concepts of the Object (even though these are only empirical) is in no way logical, but aesthetic, i.e. does not involve any objective quantity of the judgement, but only one that is subjective. For this universality I use the expression *general validity*, which denotes the validity of the reference of a representation, not to the cognitive faculties, but to the feeling of pleasure or displeasure for every Subject. (The same expression, however, may also be employed for the logical quantity of the judgement, provided we add *objective* universal validity, to distinguish it from the merely subjective validity which is always aesthetic.)

Now a judgement that has *objective universal validity* has always got the subjective also, i.e. if the judgement is valid for everything which is contained under a given concept, it is valid also for all who represent an object by means of this concept. But from a *subjective universal validity*, i.e. the aesthetic, that does not rest on any concept, no conclusion can be drawn to the logical; because judgements of that kind have no bearing upon the Object. But for this very reason the aesthetic universality attributed to a judgement must also be of a special kind, seeing that it does not join the predicate of beauty to the concept of the *Object* taken in its entire logical sphere, and yet does extend this predicate over the whole sphere of *judging Subjects*.

In their logical quantity all judgements of taste are *singular* judgements. For, since I must present the object immediately to my feeling of pleasure or displeasure, and that, too, without the aid of concepts, such judgements cannot have the quantity of judgements with objective general validity. Yet by taking the singular representation of the Object of the judgement of taste, and by comparison converting it into a concept according to the conditions determining that judgement, we can arrive at a logically universal judgement. For instance, by a judgement of taste I describe the rose at which I am looking as beautiful. The judgement, on the other hand, resulting from the comparison of a number of singular representations: Roses in general are beautiful, is no longer pronounced as a purely aesthetic judgement, but as a logical judgement founded on one that is aesthetic. Now the judgement, 'The rose is agreeable' (to smell) is also, no doubt, an aesthetic and singular judgement, but then it is not one of taste but of sense. For it has this point of difference from a judge-

ment of taste, that the latter imports an *aesthetic quantity* of universality, i.e. of validity for every one which is not to be met with in a judgement upon the agreeable. It is only judgements upon the good which, while also determining the delight in an object, possess logical and not mere aesthetic universality; for it is as involving a cognition of the Object that they are valid of it, and on that account valid for every one.

In forming an estimate of Objects merely from concepts, all representation of beauty goes by the board. There can, therefore, be no rule according to which any one is to be compelled to recognize anything as beautiful. Whether a dress, a house, or a flower is beautiful is a matter upon which one declines to allow one's judgement to be swayed by any reasons or principles. We want to get a look at the Object with our own eyes, just as if our delight depended on sensation. And yet, if upon so doing, we call the object beautiful, we believe ourselves to be speaking with a universal voice, and lay claim to the concurrence of every one, whereas no private sensation would be decisive except for the observer alone and *his* liking.

Here, now, we may perceive that nothing is postulated in the judgement of taste but such a *universal voice* in respect of delight that is not mediated by concepts; consequently, only the *possibility* of an aesthetic judgement capable of being at the same time deemed valid for every one. The judgement of taste itself does not *postulate* the agreement of every one (for it is only competent for a logically universal judgement to do this, in that it is able to bring forward reasons); it only *imputes* this agreement to every one, as an instance of the rule in respect of which it looks for confirmation, not from concepts, but from the concurrence of others. The universal voice is, therefore, only an idea—resting upon grounds the investigation of which is here postponed. It may be a matter of uncertainty whether a person who thinks he is laying down a judgement of taste is, in fact, judging in conformity with that idea; but that this idea is what is contemplated in his judgement, and that, consequently, it is meant to be a judgement of taste, is proclaimed by his use of the expression 'beauty'. For himself he can be certain on the point from his mere consciousness of the separation of everything belonging to the agreeable and the good from the delight remaining to him; and this is all for which he promises himself the agreement of every one—a claim which, under these conditions, he would also be warranted in making, were it not that he frequently sinned against them, and thus passed an erroneous judgement of taste.

9. Investigation of the Question of the Relative Priority in a Judgement of Taste of the Feeling of Pleasure and the Estimating of the Object The solution of this problem is the key to the Critique of taste, and so is worthy of all attention.

Were the pleasure in a given object to be the antecedent, and were the universal communicability of this pleasure to be all that the judgement of taste is meant to allow to the representation of the object, such a sequence would be self-contradictory. For a pleasure of that kind would be nothing but the feeling of mere agreeableness to the senses, and so, from its very nature, would possess no more than private validity, seeing that it would be immediately dependent on the representation through which the object *is given*.

Hence it is the universal capacity for being communicated incident to the mental state in the given representation which, as the subjective condition of the judgement of taste, must be fundamental, with the pleasure in the object as its consequent. Nothing, however, is capable of being universally communicated but cognition and representation so far as appurtenant to cognition. For it is only as thus appurtenant that the representation is objective, and it is this alone that gives it a universal point of reference with which the power of representation of every one is obliged to harmonize. If, then, the determining ground of the judgement as to this universal communicability of the representation is to be merely subjective, that is to say, is to be conceived independently of any concept of the object, it can be nothing else than the mental state that presents itself in the mutual relation of the powers of representation so far as they refer a given representation *to cognition in general.*

The cognitive powers brought into play by this representation are here engaged in a free play, since no definite concept restricts them to a particular rule of cognition. Hence the mental state in this representation must be one of a feeling of the free play of the powers of representation in a given representation for a cognition in general. Now a representation, whereby an object is given, involves, in order that it may become a source of cognition at all, *imagination* for bringing together the manifold of intuition, and *understanding* for the unity of the concept uniting the representations. This state of *free play* of the cognitive faculties attending a representation by which an object is given must admit of universal communication: because cognition, as a definition of the Object with which given representations (in any Subject whatever) are to accord, is the one and only representation which is valid for every one.

As the subjective universal communicability of the mode of representation in a judgement of taste is to subsist apart from the presupposition of any definite concept, it can be nothing else than the mental state present in the free play of imagination and understanding (so far as these are in mutual accord, as is requisite for *cognition in general*): for we are conscious that this subjective relation suitable for a cognition in general must be just as valid for every one, and consequently as universally communicable, as is any determinate cognition, which always rests upon that relation as its subjective condition.

Now this purely subjective (aesthetic) estimating of the object, or of the representation through which it is given, is antecedent to the pleasure in it, and is the basis of this pleasure in the harmony of the cognitive faculties. Again, the above-described universality of the subjective conditions of estimating objects forms the sole foundation of this universal subjective validity of the delight which we connect with the representation of the object that we call beautiful.

That an ability to communicate one's mental state, even though it be only in respect of our cognitive faculties, is attended with a pleasure, is a fact which might easily be demonstrated from the natural propensity of mankind to social life, i.e. empirically and psychologically. But what we have here in view calls for something more than this. In a judgement of taste the pleasure felt by us is exacted from every one else as necessary, just as if, when we call something beautiful, beauty was to be regarded as a quality of the object forming part of its inherent determination according to concepts; although beauty is for itself,

apart from any reference to the feeling of the Subject, nothing. But the discussion of this question must be reserved until we have answered the further one of whether, and how, aesthetic judgements are possible *a priori*.

At present we are exercised with the lesser question of the way in which we become conscious, in a judgement of taste, of a reciprocal subjective common accord of the powers of cognition. Is it aesthetically by sensation and our mere internal sense? Or is it intellectually by consciousness of our intentional activity in bringing these powers into play?

Now if the given representation occasioning the judgement of taste were a concept which united understanding and imagination in the estimate of the object so as to give a cognition of the Object, the consciousness of this relation would be intellectual (as in the objective schematism of judgement dealt with in the Critique). But, then, in that case the judgement would not be laid down with respect to pleasure and displeasure, and so would not be a judgement of taste. But, now, the judgement of taste determines the Object, independently of concepts, in respect of delight and of the predicate of beauty. There is, therefore, no other way for the subjective unity of the relation in question to make itself known than by sensation. The quickening of both faculties (imagination and understanding) to an indefinite, but yet, thanks to the given representation, harmonious activity, such as belongs to cognition generally, is the sensation whose universal communicability is postulated by the judgement of taste. An objective relation can, of course, only be thought, yet in so far as, in respect of its conditions, it is subjective, it may be felt in its effect upon the mind, and, in the case of a relation (like that of the powers of representation to a faculty of cognition generally) which does not rest on any concept, no other consciousness of it is possible beyond that through sensation of its effect upon the mind—an effect consisting in the more facile play of both mental powers (imagination and understanding) as quickened by their mutual accord. A representation which is singular and independent of comparison with other representations, and, being such, yet accords with the conditions of the universality that is the general concern of understanding, is one that brings the cognitive faculties into that proportionate accord which we require for all cognition and which we therefore deem valid for every one who is so constituted as to judge by means of understanding and sense conjointly (i.e. for every man).

Definition of the Beautiful Drawn from the Second Moment

The *beautiful* is that which, apart from a concept, pleases universally.

Third Moment
Of Judgements of Taste: Moment of the *Relation* of the Ends Brought Under Review in Such Judgements

10. Finality in General Let us define the meaning of 'an end' in transcendental terms (i.e. without presupposing anything empirical, such as the feel-

ing of pleasure). An end is the object of a concept so far as this concept is regarded as the cause of the object (the real ground of its possibility); and the causality of a *concept* in respect of its *Object* is finality *(forma finalis)*. Where, then, not the cognition of an object merely, but the object itself (its form or real existence) as an effect, is thought to be possible only through a concept of it, there we imagine an end. The representation of the effect is here the determining ground of its cause and takes the lead of it. The consciousness of the causality of a representation in respect of the state of the Subject as one tending *to preserve a continuance* of that state, may here be said to denote in a general way what is called pleasure; whereas displeasure is that representation which contains the ground for converting the state of the representations into their opposite (for hindering or removing them).

The faculty of desire, so far as determinable only through concepts, i.e. so as to act in conformity with the representation of an end, would be the will. But an Object, or state of mind, or even an action may, although its possibility does not necessarily presuppose the representation of an end, be called final simply on account of its possibility being only explicable and intelligible for us by virtue of an assumption on our part of a fundamental causality according to ends, i.e. a will that would have so ordained it according to a certain represented rule. Finality, therefore, may exist apart from an end, in so far as we do not locate the causes of this form in a will, but yet are able to render the explanation of its possibility intelligible to ourselves only by deriving it from a will. Now we are not always obliged to look with the eye of reason into what we observe (i.e. to consider it in its possibility). So we may at least observe a finality of form, and trace it in objects—though by reflection only—without resting it on an end (as the material of the *nexus finalis*).

11. The Sole Foundation of the Judgement of Taste Is the Form of Finality of an Object (or Mode of Representing It) Whenever an end is regarded as a source of delight it always imports an interest as determining ground of the judgement on the object of pleasure. Hence the judgement of taste cannot rest on any subjective end as its ground. But neither can any representation of an objective end, i.e. of the possibility of the object itself on principles of final connexion, determine the judgement of taste, and, consequently, neither can any concept of the good. For the judgement of taste is an aesthetic and not a cognitive judgement, and so does not deal with any *concept* of the nature or of the internal or external possibility, by this or that cause, of the object, but simply with the relative bearing of the representative powers so far as determined by a representation.

Now this relation, present when an object is characterized as beautiful, is coupled with the feeling of pleasure. This pleasure is by the judgement of taste pronounced valid for every one; hence an agreeableness attending the representation is just as incapable of containing the determining ground of the judgement as the representation of the perfection of the object or the concept of the good. We are thus left with the subjective finality in the representation of an object, exclusive of any end (objective or subjective)—consequently the bare form of finality in the representation whereby an object is *given* to us, so far as we are conscious of it—as that which is alone capable of constituting the

delight which, apart from any concept, we estimate as universally communicable, and so of forming the determining ground of the judgement of taste.

12. The Judgement of Taste Rests upon a Priori Grounds To determine *a priori* the connexion of the feeling of pleasure or displeasure as an effect, with some representation or other (sensation or concept) as its cause, is utterly impossible; for that would be a causal relation which, (with objects of experience,) is always one that can only be cognized *a posteriori* and with the help of experience. True, in the Critique of Practical Reason we did actually derive *a priori* from universal moral concepts the feeling of respect (as a particular and peculiar modification of this feeling which does not strictly answer either to the pleasure or displeasure which we receive from empirical objects). But there we were further able to cross the border of experience and call in aid a causality resting on a supersensible attribute of the Subject, namely that of freedom. But even there it was not this *feeling* exactly that we deduced from the idea of the moral as cause, but from this was derived simply the determination of the will. But the mental state present in the determination of the will by any means is at once in itself a feeling of pleasure and identical with it, and so does not issue from it as an effect. Such an effect must only be assumed where the concept of the moral as a good precedes the determination of the will by the law; for in that case it would be futile to derive the pleasure combined with the concept from this concept as a mere cognition.

Now the pleasure in aesthetic judgements stands on a similar footing: only that here it is merely contemplative and does not bring about an interest in the Object; whereas in the moral judgement it is practical. The consciousness of mere formal finality in the play of the cognitive faculties of the Subject attending a representation whereby an object is given, is the pleasure itself, because it involves a determining ground of the Subject's activity in respect of the quickening of its cognitive powers, and thus an internal causality (which is final) in respect of cognition generally, but without being limited to a definite cognition, and consequently a mere form of the subjective finality of a representation in an aesthetic judgement. This pleasure is also in no way practical, neither resembling that from the pathological ground of agreeableness nor that from the intellectual ground of the represented good. But still it involves an inherent causality, that, namely, of *preserving a continuance* of the state of the representation itself and the active engagement of the cognitive powers without ulterior aim. We *dwell* on the contemplation of the beautiful because this contemplation strengthens and reproduces itself. The case is analogous (but analogous only) to the way we linger on a charm in the representation of an object which keeps arresting the attention, the mind all the while remaining passive.

13. The Pure Judgement of Taste Is Independent of Charm and Emotion Every interest vitiates the judgement of taste and robs it of its impartiality. This is especially so where instead of, like the interest of reason, making finality take the lead of the feeling of pleasure, it grounds it upon this feeling—which is what always happens in aesthetic judgements upon anything so far as it gratifies or pains. Hence judgements so influenced can either lay

no claim at all to a universally valid delight, or else must abate their claim in proportion as sensations of the kind in question enter into the determining grounds of taste. Taste that requires an added element of *charm* and *emotion* for its delight, not to speak of adopting this as the measure of its approval, has not yet emerged from barbarism.

And yet charms are frequently not alone ranked with beauty (which ought properly to be a question merely of the form) as supplementary to the aesthetic universal delight, but they have been accredited as intrinsic beauties, and consequently the matter of delight passed off for the form. This is a misconception which, like many others that have still an underlying element of truth, may be removed by a careful definition of these concepts.

A judgement of taste which is uninfluenced by charm or emotion, (though these may be associated with the delight in the beautiful,) and whose determining ground, therefore, is simply finality of form, is *a pure judgement of taste.*

14. Exemplification Aesthetic, just like theoretical (logical) judgements, are divisible into empirical and pure. The first are those by which agreeableness or disagreeableness, the second those by which beauty, is predicated of an object or its mode of representation. The former are judgements of sense (material aesthetic judgements), the latter (as formal) alone judgements of taste proper.

A judgement of taste, therefore, is only pure so far as its determining ground is tainted with no merely empirical delight. But such a taint is always present where charm or emotion have a share in the judgement by which something is to be described as beautiful.

Here now there is a recrudescence of a number of specious pleas that go the length of putting forward the case that charm is not merely a necessary ingredient of beauty, but is even of itself sufficient to merit the name of beautiful. A mere colour, such as the green of a plot of grass, or a mere tone (as distinguished from sound or noise), like that of a violin, is described by most people as in itself beautiful, notwithstanding the fact that both seem to depend merely on the matter of the representations—in other words, simply on sensation, which only entitles them to be called agreeable. But it will at the same time be observed that sensations of colour as well as of tone are only entitled to be immediately regarded as beautiful where, in either case, they are *pure.* This is a determination which at once goes to their form, and it is the only one which these representations possess that admits with certainty of being universally communicated. For it is not to be assumed that even the quality of the sensations agrees in all Subjects, and we can hardly take it for granted that the agreeableness of a colour, or of the tone of a musical instrument, which we judge to be preferable to that of another, is given a like preference in the estimate of every one.

Assuming with *Euler* that colours are isochronous vibrations (*pulsus*) of the aether, as tones are of the air set in vibration by sound, and, what is most important, that the mind not alone perceives by sense their effect in stimulating the organs, but also, by reflection, the regular play of the impressions, (and consequently the form in which different representations are united,)—which I, still, in no way doubt—then colour and tone would not be mere sensations.

They would be nothing short of formal determinations of the unity of a manifold of sensations, and in that case could even be ranked as intrinsic beauties.

But the purity of a simple mode of sensation means that its uniformity is not disturbed or broken by any foreign sensation. It belongs merely to the form; for abstraction may there be made from the quality of the mode of such sensation (what colour or tone, if any, it represents). For this reason all simple colours are regarded as beautiful so far as pure. Composite colours have not this advantage, because, not being simple, there is no standard for estimating whether they should be called pure or impure.

But as for the beauty ascribed to the object on account of its form, and the supposition that it is capable of being enhanced by charm, this is a common error and one very prejudicial to genuine, uncorrupted, sincere taste. Nevertheless charms may be added to beauty to lend to the mind, beyond a bare delight, an adventitious interest in the representation of the object, and thus to advocate taste and its cultivation. This applies especially where taste is as yet crude and untrained. But they are positively subversive of the judgement of taste, if allowed to obtrude themselves as grounds of estimating beauty. For so far are they from contributing to beauty, that it is only where taste is still weak and untrained, that, like aliens, they are admitted as a favour, and only on terms that they do not violate that beautiful form.

In painting, sculpture, and in fact in all the formative arts, in architecture and horticulture, so far as fine arts, the *design* is what is essential. Here it is not what gratifies in sensation but merely what pleases by its form, that is the fundamental prerequisite for taste. The colours which give brilliancy to the sketch are part of the charm. They may no doubt, in their own way, enliven the object for sensation, but make it really worth looking at and beautiful they cannot. Indeed, more often than not the requirements of the beautiful form restrict them to a very narrow compass, and, even where charm is admitted, it is only this form that gives them a place of honour.

All form of objects of sense (both of external and also, mediately, of internal sense) is either *figure* or *play*. In the latter case it is either play of figures (in space: mimic and dance), or mere play of sensations (in time). The *charm* of colours, or of the agreeable tones of instruments, may be added: but the *design* in the former and the *composition* in the latter constitute the proper object of the pure judgement of taste. To say that the purity alike of colours and of tones, or their variety and contrast, seem to contribute to beauty, is by no means to imply that, because in themselves agreeable, they therefore yield an addition to the delight in the form and one on a par with it. The real meaning rather is that they make this form more clearly, definitely, and completely intuitable, and besides stimulate the representation by their charm, as they excite and sustain the attention directed to the object itself.

Even what is called *ornamentation (parerga)*, i.e. what is only an adjunct, and not an intrinsic constituent in the complete representation of the object, in augmenting the delight of taste does so only by means of its form. Thus it is with the frames of pictures or the drapery on statues, or the colonnades of palaces. But if the ornamentation does not itself enter into the composition of the beautiful form—if it is introduced like a gold frame merely to win approval for the picture by means of its charm—it is then called *finery* and takes away from the genuine beauty.

Emotion—a sensation where an agreeable feeling is produced merely by means of a momentary check followed by a more powerful outpouring of the vital force—is quite foreign to beauty. Sublimity (with which the feeling of emotion is connected) requires, however, a different standard of estimation from that relied upon by taste. A pure judgement of taste has, then, for its determining ground neither charm nor emotion, in a word, no sensation as matter of the aesthetic judgement.

15. The Judgement of Taste Is Entirely Independent of the Concept of Perfection *Objective* finality can only be cognized by means of a reference of the manifold to a definite end, and hence only through a concept. This alone makes it clear that the beautiful, which is estimated on the ground of a mere formal finality, i.e. a finality apart from an end, is wholly independent of the representation of the good. For the latter presupposes an objective finality, i.e. the reference of the object to a definite end.

Objective finality is either external, i.e. the *utility*, or internal, i.e. the *perfection*, of the object. That the delight in an object on account of which we call it beautiful is incapable of resting on the representation of its utility, is abundantly evident from the two preceding articles; for in that case, it would not be an immediate delight in the object, which latter is the essential condition of the judgement upon beauty. But in an objective, internal finality, i.e. perfection, we have what is more akin to the predicate of beauty, and so this has been held even by philosophers of reputation to be convertible with beauty, though subject to the qualification: *where it is thought in a confused way*. In a Critique of taste it is of the utmost importance to decide whether beauty is really reducible to the concept of perfection.

For estimating objective finality we always require the concept of an end, and, where such finality has to be, not an external one (utility), but an internal one, the concept of an internal end containing the ground of the internal possibility of the object. Now an end is in general that, the *concept* of which may be regarded as the ground of the possibility of the object itself. So in order to represent an objective finality in a thing we must first have a concept of *what sort of a thing it is to be*. The agreement of the manifold in a thing with this concept (which supplies the rule of its synthesis) is the *qualitative perfection* of the thing. *Quantitative* perfection is entirely distinct from this. It consists in the completeness of anything after its kind, and is a mere concept of quantity (of totality). In its case the question of *what the thing is to be* is regarded as definitely disposed of, and we only ask whether it is possessed of *all* the requisites that go to make it such. What is formal in the representation of a thing, i.e. the agreement of its manifold with a unity (i.e. irrespective of what it is to be) does not, of itself, afford us any cognition whatsoever of objective finality. For since abstraction is made from this unity as *end* (what the thing is to be) nothing is left but the subjective finality of the representations in the mind of the Subject intuiting. This gives a certain finality of the representative state of the Subject, in which the Subject feels itself quite at home in its effort to grasp a given form in the imagination, but no perfection of any Object, the latter not being here thought through any concept. For instance, if in a forest I light upon a plot of grass, round which trees stand in a circle, and if I do not then form any representation of an end, as that it is meant to be used, say, for

country dances, then not the least hint of a concept of perfection is given by the mere form. To suppose a formal *objective* finality that is yet devoid of an end, i.e. the mere form of a *perfection* (apart from any matter or *concept* of that to which the agreement relates, even though there was the mere general idea of a conformity to law) is a veritable contradiction.

Now the judgement of taste is an aesthetic judgement, i.e. one resting on subjective grounds. No concept can be its determining ground, and hence not one of a definite end. Beauty, therefore, as a formal subjective finality, involves no thought whatsoever of a perfection of the object, as a would-be formal finality which yet, for all that, is objective: and the distinction between the concepts of the beautiful and the good, which represents both as differing only in their logical form, the first being merely a confused, the second a clearly defined, concept of perfection, while otherwise alike in content and origin, all goes for nothing: for then there would be no *specific* difference between them, but the judgement of taste would be just as much a cognitive judgement as one by which something is described as good—just as the man in the street, when he says that deceit is wrong, bases his judgement on confused, but the philosopher on clear grounds, while both appeal in reality to identical principles of reason. But I have already stated that an aesthetic judgement is quite unique, and affords absolutely no, (not even a confused,) knowledge of the Object. It is only through a logical judgement that we get knowledge. The aesthetic judgement, on the other hand, refers the representation, by which an Object is given, solely to the Subject, and brings to our notice no quality of the object, but only the final form in the determination of the powers of representation engaged upon it. The judgement is called aesthetic for the very reason that its determining ground cannot be a concept, but is rather the feeling (of the internal sense) of the concert in the play of the mental powers as a thing only capable of being felt. If, on the other hand, confused concepts, and the objective judgement based on them, are going to be called aesthetic, we shall find ourselves with an understanding judging by sense, or a sense representing its objects by concepts—a mere choice of contradictions. The faculty of concepts, be they confused or be they clear, is understanding; and although understanding has (as in all judgements) its rôle in the judgement of taste, as an aesthetic judgement, its rôle there is not that of a faculty for cognizing an object, but of a faculty for determining that judgement and its representation (without a concept) according to its relation to the Subject and its internal feeling, and for doing so in so far as that judgement is possible according to a universal rule.

16. A Judgement of Taste by Which an Object Is Described as Beautiful Under the Condition of a Definite Concept Is Not Pure There are two kinds of beauty: free beauty (*pulchritudo vaga*), or beauty which is merely dependent (*pulchritudo adhaerens*). The first presupposes no concept of what the object should be; the second does presuppose such a concept and, with it, an answering perfection of the object. Those of the first kind are said to be (self-subsisting) beauties of this thing or that thing; the other kind of beauty, being attached to a concept (conditioned beauty), is ascribed to Objects which come under the concept of a particular end.

Flowers are free beauties of nature. Hardly any one but a botanist knows

the true nature of a flower, and even he, while recognizing in the flower the reproductive organ of the plant, pays no attention to this natural end when using his taste to judge of its beauty. Hence no perfection of any kind—no internal finality, as something to which the arrangement of the manifold is related—underlies this judgement. Many birds (the parrot, the humming-bird, the bird of paradise), and a number of crustacea, are self-subsisting beauties which are not appurtenant to any object defined with respect to its end, but please freely and on their own account. So designs *à la grecque*, foliage for framework or on wall-papers, &c., have no intrinsic meaning; they represent nothing—no Object under a definite concept—and are free beauties. We may also rank in the same class what in music are called fantasias (without a theme), and, indeed, all music that is not set to words.

In the estimate of a free beauty (according to mere form) we have the pure judgement of taste. No concept is here presupposed of any end for which the manifold should serve the given Object, and which the latter, therefore, should represent—an incumbrance which would only restrict the freedom of the imagination that, as it were, is at play in the contemplation of the outward form.

But the beauty of man (including under this head that of a man, woman, or child), the beauty of a horse, or of a building (such as a church, palace, arsenal, or summer-house), presupposes a concept of the end that defines what the thing has to be, and consequently a concept of its perfection; and is therefore merely appendant beauty. Now, just as it is a clog on the purity of the judgement of taste to have the agreeable (of sensation) joined with beauty to which properly only the form is relevant, so to combine the good with beauty, (the good, namely, of the manifold to the thing itself according to its end,) mars its purity.

Much might be added to a building that would immediately please the eye, were it not intended for a church. A figure might be beautified with all manner of flourishes and light but regular lines, as is done by the New Zealanders with their tattooing, were we dealing with anything but the figure of a human being. And here is one whose rugged features might be softened and given a more pleasing aspect, only he has got to be a man, or is, perhaps, a warrior that has to have a warlike appearance.

Now the delight in the manifold of a thing, in reference to the internal end that determines its possibility, is a delight based on a concept, whereas delight in the beautiful is such as does not presuppose any concept, but is immediately coupled with the representation through which the object is given (not through which it is thought). If, now, the judgement of taste in respect of the latter delight is made dependent upon the end involved in the former delight as a judgement of reason, and is thus placed under a restriction, then it is no longer a free and pure judgement of taste.

Taste, it is true, stands to gain by this combination of intellectual delight with the aesthetic. For it becomes fixed, and, while not universal, it enables rules to be prescribed for it in respect of certain definite final Objects. But these rules are then not rules of taste, but merely rules for establishing a union of taste with reason, i.e. of the beautiful with the good—rules by which the former becomes available as an intentional instrument in respect of the latter, for the purpose of bringing that temper of the mind which is self-sustaining and of subjective universal validity to the support and maintenance of that mode

of thought which, while possessing objective universal validity, can only be preserved by a resolute effort. But, strictly speaking, perfection neither gains by beauty, nor beauty by perfection. The truth is rather this, when we compare the representation through which an object is given to us with the Object (in respect of what it is meant to be) by means of a concept, we cannot help reviewing it also in respect of the sensation in the Subject. Hence there results a gain to the *entire faculty* of our representative power when harmony prevails between both states of mind.

In respect of an object with a definite internal end, a judgement of taste would only be pure where the person judging either has no concept of this end, or else makes abstraction from it in his judgement. But in cases like this, although such a person should lay down a correct judgement of taste, since he would be estimating the object as a free beauty, he would still be found fault with by another who saw nothing in its beauty but a dependent quality (i.e. who looked to the end of the object) and would be accused by him of false taste, though both would, in their own way, be judging correctly: the one according to what he had present to his senses, the other according to what was present in his thoughts. This distinction enables us to settle many disputes about beauty on the part of critics; for we may show them how one side is dealing with free beauty, and the other with that which is dependent: the former passing a pure judgement of taste, the latter one that is applied intentionally.

17. The Ideal of Beauty There can be no objective rule of taste by which what is beautiful may be defined by means of concepts. For every judgement from that source is aesthetic, i.e. its determining ground is the feeling of the Subject, and not any concept of an Object. It is only throwing away labour to look for a principle of taste that affords a universal criterion of the beautiful by definite concepts; because what is sought is a thing impossible and inherently contradictory. But in the universal communicability of the sensation (of delight or aversion)—a communicability, too, that exists apart from any concept—in the accord, so far as possible, of all ages and nations as to this feeling in the representation of certain objects, we have the empirical criterion, weak indeed and scarce sufficient to raise a presumption, of the derivation of a taste, thus confirmed by examples, from grounds deep-seated and shared alike by all men, underlying their agreement in estimating the forms under which objects are given to them.

For this reason some products of taste are looked on as *exemplary*—not meaning thereby that by imitating others taste may be acquired. For taste must be an original faculty; whereas one who imitates a model, while showing skill commensurate with his success, only displays taste as himself a critic of this model.[4] Hence it follows that the highest model, the archetype of taste, is a

[4]Models of taste with respect to the arts of speech must be composed in a dead and learned language; the first, to prevent their having to suffer the changes that inevitably overtake living ones, making dignified expressions become degraded, common ones antiquated, and ones newly coined after a short currency obsolete; the second to ensure its having a grammar that is not subject to the caprices of fashion, but has fixed rules of its own.

mere idea, which each person must beget in his own consciousness, and according to which he must form his estimate of everything that is an Object of taste, or that is an example of critical taste, and even of universal taste itself. Properly speaking, an *idea* signifies a concept of reason, and an *ideal* the representation of an individual existence as adequate to an idea. Hence this archetype of taste—which rests, indeed, upon reason's indeterminate idea of a maximum, but is not, however, capable of being represented by means of concepts, but only in an individual presentation—may more appropriately be called the ideal of the beautiful. While not having this ideal in our possession, we still strive to beget it within us. But it is bound to be merely an ideal of the imagination, seeing that it rests, not upon concepts, but upon the presentation—the faculty of presentation being the imagination.—Now, how do we arrive at such an ideal of beauty? Is it *a priori* or empirically? Further, what species of the beautiful admits of an ideal?

First of all, we do well to observe that the beauty for which an ideal has to be sought cannot be a beauty that is *free and at large,* but must be one *fixed* by a concept of objective finality. Hence it cannot belong to the Object of an altogether pure judgement of taste, but must attach to one that is partly intellectual. In other words, where an ideal is to have place among the grounds upon which any estimate is formed, then beneath grounds of that kind there must lie some idea of reason according to determinate concepts, by which the end underlying the internal possibility of the object is determined *a priori.* An ideal of beautiful flowers, of a beautiful suite of furniture, or of a beautiful view, is unthinkable. But, it may also be impossible to represent an ideal of a beauty dependent on definite ends, e.g. a beautiful residence, a beautiful tree, a beautiful garden, &c., presumably because their ends are not sufficiently defined and fixed by their concept, with the result that their finality is nearly as free as with beauty that is quite *at large.* Only what has in itself the end of its real existence—only *man* that is able himself to determine his ends by reason, or, where he has to derive them from external perception, can still compare them with essential and universal ends, and then further pronounce aesthetically upon their accord with such ends, only he, among all objects in the world, admits, therefore, of an ideal of *beauty,* just as humanity in his person, as intelligence, alone admits of the ideal of *perfection.*

Two factors are here involved. *First,* there is the aesthetic *normal idea,* which is an individual intuition (of the imagination). This represents the norm by which we judge of a man as a member of a particular animal species. *Secondly,* there is the *rational idea.* This deals with the ends of humanity so far as capable of sensuous representation, and converts them into a principle for estimating his outward form, through which these ends are revealed in their phenomenal effect. The normal idea must draw from experience the constituents which it requires for the form of an animal of a particular kind. But the greatest finality in the construction of this form—that which would serve as a universal norm for forming an estimate of each individual of the species in question—the image that, as it were, forms an intentional basis underlying the technic of nature, to which no separate individual, but only the race as a whole, is adequate, has its seat merely in the idea of the judging Subject.

Yet it is, with all its proportions, an aesthetic idea, and, as such, capable of being fully presented *in concreto* in a model image. Now, how is this effected? In order to render the process to some extent intelligible (for who can wrest nature's whole secret from her?), let us attempt a psychological explanation.

It is of note that the imagination, in a manner quite incomprehensible to us, is able on occasion, even after a long lapse of time, not alone to recall the signs for concepts, but also to reproduce the image and shape of an object out of a countless number of others of a different, or even of the very same, kind. And, further, if the mind is engaged upon comparisons, we may well suppose that it can in actual fact, though the process is unconscious, super-impose as it were one image upon another, and from the coincidence of a number of the same kind arrive at a mean contour which serves as a common standard for all. Say, for instance, a person has seen a thousand full-grown men. Now if he wishes to judge normal size determined upon a comparative estimate, then imagination (to my mind) allows a great number of these images (perhaps the whole thousand) to fall one upon the other, and, if I may be allowed to extend to the case the analogy of optical presentation, in the space where they come most together, and within the contour where the place is illuminated by the greatest concentration of colour, one gets a perception of the *average size,* which alike in height and breadth is equally removed from the extreme limits of the greatest and smallest statures; and this is the stature of a beautiful man. (The same result could be obtained in a mechanical way, by taking the measures of all the thousand, and adding together their heights, and their breadths (and thicknesses), and dividing the sum in each case by a thousand.) But the power of imagination does all this by means of a dynam-ical effect upon the organ of internal sense, arising from the frequent appre-hension of such forms. If, again, for our average man we seek on similar lines for the average head, and for this the average nose, and so on, then we get the figure that underlies the normal idea of a beautiful man in the country where the comparison is instituted. For this reason a negro must necessarily (under these empirical conditions) have a different normal idea of the beauty of forms from what a white man has, and the Chinaman one different from the Euro-pean. And the process would be just the same with the *model* of a beautiful horse or dog (of a particular breed).—This *normal idea* is not derived from pro-portions taken from experience *as definite rules:* rather is it according to this idea that rules for forming estimates first become possible. It is an intermedi-ate between all singular intuitions of individuals, with their manifold varia-tions—a floating image for the whole genus, which nature has set as an arche-type underlying those of her products that belong to the same species, but which in no single case she seems to have completely attained. But the nor-mal idea is far from giving the complete *archetype* of *beauty* in the genus. It only gives the form that constitutes the indispensable condition of all beauty, and, consequently, only *correctness* in the presentation of the genus. It is, as the famous *Doryphorus* of *Polycletus* was called, the *rule* (and *Myron's* Cow might be similarly employed for its kind). It cannot, for that very reason, contain any-thing specifically characteristic; for otherwise it would not be the *normal idea*

for the genus. Further, it is not by beauty that its presentation pleases, but merely because it does not contradict any of the conditions under which alone a thing belonging to this genus can be beautiful. The presentation is merely academically correct.[5]

But the *ideal* of the beautiful is still something different from its *normal idea*. For reasons already stated it is only to be sought in the *human figure*. Here the ideal consists in the expression of the *moral*, apart from which the object would not please at once universally and positively (not merely negatively in a presentation academically correct). The visible expression of moral ideas that govern men inwardly can, of course, only be drawn from experience; but their combination with all that our reason connects with the morally good in the idea of the highest finality—benevolence, purity, strength, or equanimity, &c.—may be made, as it were, visible in bodily manifestation (as effect of what is internal), and this embodiment involves a union of pure ideas of reason and great imaginative power, in one who would even form an estimate of it, not to speak of being the author of its presentation. The correctness of such an ideal of beauty is evidenced by its not permitting any sensuous charm to mingle with the delight in its Object, in which it still allows us to take a great interest. This fact in turn shows that an estimate formed according to such a standard can never be purely aesthetic, and that one formed according to an ideal of beauty cannot be a simple judgement of taste.

Definition of the Beautiful Derived from the Third Moment

Beauty is the form of *finality* in an object, so far as perceived in it *apart from the representation of an end*.[6]

[5]It will be found that a perfectly regular face—one that a painter might fix his eye on for a model—ordinarily conveys nothing. This is because it is devoid of anything characteristic, and so the idea of the race is expressed in it rather than the specific qualities of a person. The exaggeration of what is characteristic in this way, i.e. exaggeration violating the normal idea (the finality of the race), is called *caricature*. Also experience shows that these quite regular faces indicate as a rule internally only a mediocre type of man; presumably—if one may assume that nature in its external form expresses the proportions of the internal—because, where none of the mental qualities exceed the proportion requisite to constitute a man free from faults, nothing can be expected in the way of what is called *genius,* in which nature seems to make a departure from its wonted relations of the mental powers in favour of some special one.

[6]As telling against this explanation, the instance may be adduced, that there are things in which we see a form suggesting adaptation to an end, without any end being cognized in them—as, for example, the stone implements frequently obtained from sepulchral tumuli and supplied with a hole, as if for [inserting] a handle; and although these by their shape manifestly indicate a finality, the end of which is unknown, they are not on that account described as beautiful. But the very fact of their being regarded as art-products involves an immediate recognition that their shape is attributed to some purpose or other and to a definite end. For this reason there is no immediate delight whatever in their contemplation. A flower, on the other hand, such as a tulip, is regarded as beautiful, because we meet with a certain finality in its perception, which, in our estimate of it, is not referred to any end whatever.

Fourth Moment
Of the Judgement of Taste: Moment of the Modality of
the Delight in the Object

18. Nature of the Modality in a Judgement of Taste I may assert in the case of every representation that the synthesis of a pleasure with the representation (as a cognition) is at least *possible*. Of what I call *agreeable* I assert that it *actually* causes pleasure in me. But what we have in mind in the case of the *beautiful* is a *necessary* reference on its part to delight. However, this necessity is of a special kind. It is not a theoretical objective necessity—such as would let us cognize *a priori* that every one *will feel* this delight in the object that is called beautiful by me. Nor yet is it a practical necessity, in which case, thanks to concepts of a pure rational will in which free agents are supplied with a rule, this delight is the necessary consequence of an objective law, and simply means that one ought absolutely (without ulterior object) to act in a certain way. Rather, being such a necessity as is thought in an aesthetic judgement, it can only be termed *exemplary*. In other words it is a necessity of the assent of *all* to a judgement regarded as exemplifying a universal rule incapable of formulation. Since an aesthetic judgement is not an objective or cognitive judgement, this necessity is not derivable from definite concepts, and so is not apodictic. Much less is it inferable from universality of experience (of a thorough-going agreement of judgements about the beauty of a certain object). For, apart from the fact that experience would hardly furnish evidences sufficiently numerous for this purpose, empirical judgements do not afford any foundation for a concept of the necessity of these judgements.

19. The Subjective Necessity Attributed to a Judgement of Taste Is Conditioned The judgement of taste exacts agreement from every one; and a person who describes something as beautiful insists that every one *ought* to give the object in question his approval and follow suit in describing it as beautiful. The *ought* in aesthetic judgements, therefore, despite an accordance with all the requisite data for passing judgement, is still only pronounced conditionally. We are suitors for agreement from every one else, because we are fortified with a ground common to all. Further, we would be able to count on this agreement, provided we were always assured of the correct subsumption of the case under that ground as the rule of approval.

20. The Condition of the Necessity Advanced by a Judgement of Taste Is the Idea of a Common Sense Were judgements of taste (like cognitive judgements) in possession of a definite objective principle, then one who in his judgement followed such a principle would claim unconditioned necessity for it. Again, were they devoid of any principle, as are those of the mere taste of sense, then no thought of any necessity on their part would enter one's head. Therefore they must have a subjective principle, and one which determines what pleases or displeases, by means of feeling only and not through concepts, but yet with universal validity. Such a principle, however, could only be regarded as a *common sense*. This differs essentially from common understanding, which is also sometimes called common sense *(sensus communis):* for

the judgement of the latter is not one by feeling, but always one by concepts, though usually only in the shape of obscurely represented principles.

The judgement of taste, therefore, depends on our presupposing the existence of a common sense. (But this is not to be taken to mean some external sense, but the effect arising from the free play of our powers of cognition.) Only under the presupposition, I repeat, of such a common sense, are we able to lay down a judgement of taste.

21. Have We Reason for Presupposing a Common Sense? Cognitions and judgements must, together with their attendant conviction, admit of being universally communicated; for otherwise a correspondence with the Object would not be due to them. They would be a conglomerate constituting a mere subjective play of the powers of representation, just as scepticism would have it. But if cognitions are to admit of communication, then our mental state, i.e. the way the cognitive powers are attuned for cognition generally, and, in fact, the relative proportion suitable for a representation (by which an object is given to us) from which cognition is to result, must also admit of being universally communicated, as, without this, which is the subjective condition of the act of knowing, knowledge, as an effect, would not arise. And this is always what actually happens where a given object, through the intervention of sense, sets the imagination at work in arranging the manifold, and the imagination, in turn, the understanding in giving to this arrangement the unity of concepts. But this disposition of the cognitive powers has a relative proportion differing with the diversity of the Objects that are given. However, there must be one in which this internal ratio suitable for quickening (one faculty by the other) is best adapted for both mental powers in respect of cognition (of given objects) generally; and this disposition can only be determined through feeling (and not by concepts). Since, now, this disposition itself must admit of being universally communicated, and hence also the feeling of it (in the case of a given representation), while again, the universal communicability of a feeling presupposes a common sense: it follows that our assumption of it is well founded. And here, too, we do not have to take our stand on psychological observations, but we assume a common sense as the necessary condition of the universal communicability of our knowledge, which is presupposed in every logic and every principle of knowledge that is not one of scepticism.

22. The Necessity of the Universal Assent that Is Thought in a Judgement of Taste, Is a Subjective Necessity Which, Under the Presupposition of a Common Sense, Is Represented as Objective In all judgements by which we describe anything as beautiful we tolerate no one else being of a different opinion, and in taking up this position we do not rest our judgement upon concepts, but only on our feeling. Accordingly we introduce this fundamental feeling not as a private feeling, but as a public sense. Now, for this purpose, experience cannot be made the ground of this common sense, for the latter is invoked to justify judgements containing an 'ought'. The assertion is not that every one *will* fall in with our judgement, but rather that every one *ought* to agree with it. Here I put forward my judgement of taste as an example of the judgement of common sense, and attribute to it on that account *exemplary*

validity. Hence common sense is a mere ideal norm. With this as presupposition, a judgement that accords with it, as well as the delight in an Object expressed in that judgement, is rightly converted into a rule for every one. For the principle, while it is only subjective, being yet assumed as subjectively universal (a necessary idea for every one), could, in what concerns the consensus of different judging Subjects, demand universal assent like an objective principle, provided we were assured of our subsumption under it being correct.

This indeterminate norm of a common sense is, as a matter of fact, presupposed by us; as is shown by our presuming to lay down judgements of taste. But does such a common sense in fact exist as a constitutive principle of the possibility of experience, or is it formed for us as a regulative principle by a still higher principle of reason, that for higher ends first seeks to beget in us a common sense? Is taste, in other words, a natural and original faculty, or is it only the idea of one that is artificial and to be acquired by us, so that a judgement of taste, with its demand for universal assent, is but a requirement of reason for generating such a *consensus*, and does the 'ought', i.e. the objective necessity of the coincidence of the feeling of all with the particular feeling of each, only betoken the possibility of arriving at some sort of unanimity in these matters, and the judgement of taste only adduce an example of the application of this principle? These are questions which as yet we are neither willing nor in a position to investigate. For the present we have only to resolve the faculty of taste into its elements, and to unite these ultimately in the idea of a common sense.

Definition of the Beautiful Drawn from the Fourth Moment

The beautiful is that which, apart from a concept, is cognized as object of a *necessary* delight.

General Remark on the First Section of the Analytic

The result to be extracted from the foregoing analysis is in effect this: that everything runs up into the concept of taste as a critical faculty by which an object is estimated in reference to the *free conformity to law* of the imagination. If, now, imagination must in the judgement of taste be regarded in its freedom, then, to begin with, it is not taken as reproductive, as in its subjection to the laws of association, but as productive and exerting an activity of its own (as originator of arbitrary forms of possible intuitions). And although in the apprehension of a given object of sense it is tied down to a definite form of this Object and, to that extent, does not enjoy free play, (as it does in poetry,) still it is easy to conceive that the object may supply ready-made to the imagination just such a form of the arrangement of the manifold, as the imagination, if it were left to itself, would freely project in harmony with the general *conformity to law of the understanding*. But that the *imagination* should be both *free* and *of itself conformable to law*, i.e. carry autonomy with it, is a contradiction. The understanding alone gives the law. Where, however, the imagination

is compelled to follow a course laid down by a definite law, then what the form of the product is to be is determined by concepts; but, in that case, as already shown, the delight is not delight in the beautiful, but in the good, (in perfection, though it be no more than formal perfection), and the judgement is not one due to taste. Hence it is only a conformity to law without a law, and a subjective harmonizing of the imagination and the understanding without an objective one—which latter would mean that the representation was referred to a definite concept of the object—that can consist with the free conformity to law of the understanding (which has also been called finality apart from an end) and with the specific character of a judgement of taste.

Now geometrically regular figures, a circle, a square, a cube, and the like, are commonly brought forward by critics of taste as the most simple and unquestionable examples of beauty. And yet the very reason why they are called regular, is because the only way of representing them is by looking on them as mere presentations of a determinate concept by which the figure has its rule (according to which alone it is possible) prescribed for it. One or other of these two views must, therefore, be wrong: either the verdict of the critics that attributes beauty to such figures, or else our own, which makes finality apart from any concept necessary for beauty.

One would scarce think it necessary for a man to have taste to take more delight in a circle than in a scrawled outline, in an equilateral and equiangular quadrilateral than in one that is all lob-sided, and, as it were, deformed. The requirements of common understanding ensure such a preference without the least demand upon taste. Where some purpose is perceived, as, for instance, that of forming an estimate of the area of a plot of land, or rendering intelligible the relation of divided parts to one another and to the whole, then regular figures, and those of the simplest kind, are needed; and the delight does not rest immediately upon the way the figure strikes the eye, but upon its serviceability for all manner of possible purposes. A room with the walls making oblique angles, a plot laid out in a garden in a similar way, even any violation of symmetry, as well in the figure of animals (e.g. being one-eyed) as in that of buildings, or of flower-beds, is displeasing because of its perversity of form, not alone in a practical way in respect of some definite use to which the thing may be put, but for an estimate that looks to all manner of possible purposes. With the judgement of taste the case is different. For, when it is pure, it combines delight or aversion immediately with the bare *contemplation* of the object irrespective of its use or of any end.

The regularity that conduces to the concept of an object is, in fact, the indispensable condition *(conditio sine qua non)* of grasping the object as a single representation and giving to the manifold its determinate form. This determination is an end in respect of knowledge; and in this connexion it is invariably coupled with delight (such as attends the accomplishment of any, even problematical, purpose). Here, however, we have merely the value set upon the solution that satisfies the problem, and not a free and indeterminately final entertainment of the mental powers with what is called beautiful. In the latter case understanding is at the service of imagination, in the former this relation is reversed.

With a thing that owes its possibility to a purpose, a building, or even an animal, its regularity, which consists in symmetry, must express the unity of the intuition accompanying the concept of its end, and belongs with it to cognition. But where all that is intended is the maintenance of a free play of the powers of representation (subject, however, to the condition that there is to be nothing for understanding to take exception to), in ornamental gardens, in the decoration of rooms, in all kinds of furniture that shows good taste, &c., regularity in the shape of constraint is to be avoided as far as possible. Thus English taste in gardens, and fantastic taste in furniture, push the freedom of imagination to the verge of what is grotesque—the idea being that in this divorce from all constraint of rules the precise instance is being afforded where taste can exhibit its perfection in projects of the imagination to the fullest extent.

All stiff regularity (such as borders on mathematical regularity) is inherently repugnant to taste, in that the contemplation of it affords us no lasting entertainment. Indeed, where it has neither cognition nor some definite practical end expressly in view, we get heartily tired of it. On the other hand, anything that gives the imagination scope for unstudied and final play is always fresh to us. We do not grow to hate the very sight of it. *Marsden* in his description of Sumatra observes that the free beauties of nature so surround the beholder on all sides that they cease to have much attraction for him. On the other hand he found a pepper garden full of charm, on coming across it in mid-forest with its rows of parallel stakes on which the plant twines itself. From all this he infers that wild, and in its appearance quite irregular beauty, is only pleasing as a change to one whose eyes have become surfeited with regular beauty. But he need only have made the experiment of passing one day in his pepper garden to realize that once the regularity has enabled the understanding to put itself in accord with the order that is its constant requirement, instead of the object diverting him any longer, it imposes an irksome constraint upon the imagination: whereas nature subject to no constraint of artificial rules, and lavish, as it there is, in its luxuriant variety can supply constant food for his taste.—Even a bird's song, which we can reduce to no musical rule, seems to have more freedom in it, and thus to be richer for taste, than the human voice singing in accordance with all the rules that the art of music prescribes; for we grow tired much sooner of frequent and lengthy repetitions of the latter. Yet here most likely our sympathy with the mirth of a dear little creature is confused with the beauty of its song, for if exactly imitated by man (as has been sometimes done with the notes of the nightingale) it would strike our ear as wholly destitute of taste.

Further, beautiful objects have to be distinguished from beautiful views of objects (where the distance often prevents a clear perception). In the latter case taste appears to fasten, not so much on what the imagination *grasps* in this field, as on the incentive it receives to indulge in poetic fiction, i.e. in the peculiar fancies with which the mind entertains itself as it is being continually stirred by the variety that strikes the eye. It is just as when we watch the changing shapes of the fire or of a rippling brook: neither of which are things of beauty, but they convey a charm to the imagination, because they sustain its free play.

READING 22

INTRODUCTION

In "Psychical Distance" (1912), Edward Bullough (1880–1934) presents an account of the sort of attitude that many have felt to be a necessary condition for the experience of aesthetic properties and for the recognition of aesthetic value. In some respects, Bullough's conception of "psychical distance" is a descendant of Kant's conception of the "disinterested" nature of judgments of taste. (Bullough's discussion of the difference between the beautiful and the agreeable, for example, invites comparison with Kant's discussion.) Bullough's suggestion is that in order properly to experience and appreciate the aesthetic qualities of a work of art, we must maintain the right "distance" from it. If we are either too little distanced, or overdistanced, from the work, then we lose the ability to treat it as an aesthetic object: We become unable to recognize the work as *art*. To adapt Bullough's own example: A jealous husband at a performance of *Othello* may be unable to disassociate his own predicament from Othello's, and hence unable to view the play as a work of art. The stagehand, by contrast, may be unable to respond aesthetically to the play for a different reason: He or she concentrates on the play only as a *production*. The jealous husband has too little distance, the stagehand has too much distance. It is important to notice that just as Kant's notion of "disinterestedness" does not suggest that when we engage with art we are *un*interested in it, so Bullough's argument about distance "does not imply an impersonal, purely intellectually interested relation. . . . On the contrary, it describes a *personal* relation, often highly emotionally colored, but *of a peculiar character*." Bullough's reflections on the nature of aesthetic experience illustrate the enormous influence that Kant has had on aesthetic theory, and have themselves been extremely influential.

Psychical Distance

Edward Bullough

I

1. The conception of 'Distance' suggests, in connexion with Art, certain trains of thought by no means devoid of interest or of speculative importance. Perhaps the most obvious suggestion is that of *actual spatial* distance, i.e. the distance of a work of Art from the spectator, or that of *represented spatial* distance, i.e. the distance represented within the work. Less obvious, more metaphorical, is the meaning of *temporal* distance. The first was noticed already by Aristotle in his *Poetics*; the second has played a great part in the history of painting in the form of perspective; the distinction between these two kinds of distance assumes special importance theoretically in the differentiation between sculpture in the round, and relief-sculpture. Temporal distance, remoteness from us in point of time, though often a cause of misconceptions, has been declared to be a factor of considerable weight in our appreciation.

It is not, however, in any of these meanings that 'Distance' is put forward

here, though it will be clear in the course of this essay that the above men-
tioned kinds of distance are rather special forms of the conception of Distance
as advocated here, and derive whatever *aesthetic* qualities they may possess
from Distance in its *general* connotation. This general connotation is 'Psychical
Distance.'

A short illustration will explain what is meant by 'Psychical Distance.'
Imagine a fog at sea: for most people it is an experience of acute unpleasant-
ness. Apart from the physical annoyance and remoter forms of discomfort such
as delays, it is apt to produce feelings of peculiar anxiety, fears of invisible
dangers, strains of watching and listening for distant and unlocalised signals.
The listless movements of the ship and her warning calls soon tell upon the
nerves of the passengers; and that special, expectant, tacit anxiety and ner-
vousness, always associated with this experience, make a fog the dreaded ter-
ror of the sea (all the more terrifying because of its very silence and gentle-
ness) for the expert seafarer no less than for the ignorant landsman.

Nevertheless, a fog at sea can be a source of intense relish and enjoyment.
Abstract from the experience of the sea fog, for the moment, its danger and
practical unpleasantness, just as every one in the enjoyment of a mountain-
climb disregards its physical labour and its danger (though, it is not denied,
that these may incidentally enter into the enjoyment and enhance it); direct the
attention to the features 'objectively' constituting the phenomenon—the veil
surrounding you with an opaqueness as of transparent milk, blurring the out-
line of things and distorting their shapes into weird grotesqueness; observe the
carrying-power of the air, producing the impression as if you could touch
some far-off siren by merely putting out your hand and letting it lose itself
behind that white wall; note the curious creamy smoothness of the water, hyp-
ocritically denying as it were any suggestion of danger; and, above all, the
strange solitude and remoteness from the world, as it can be found only on
the highest mountain tops: and the experience may acquire, in its uncanny
mingling of repose and terror, a flavour of such concentrated poignancy and
delight as to contrast sharply with the blind and distempered anxiety of its
other aspects. This contrast, often emerging with startling suddenness, is like
a momentary switching on of some new current, or the passing ray of a
brighter light, illuminating the outlook upon perhaps the most ordinary and
familiar objects—an impression which we experience sometimes in instants of
direct extremity, when our practical interest snaps like a wire from sheer over-
tension, and we watch the consummation of some impending catastrophe with
the marvelling unconcern of a mere spectator.

It is a difference of outlook, due—if such a metaphor is permissible—to
the insertion of Distance. This Distance appears to lie between our own self
and its affections, using the latter term in its broadest sense as anything which
affects our being, bodily or spiritually, e.g. as sensation, perception, emotional
state or idea. Usually, though not always, it amounts to the same thing to say
that the Distance lies between our own self and such objects as are the sources
or vehicles of such affections.

Thus, in the fog, the transformation by Distance is produced in the first
instance by putting the phenomenon, so to speak, out of gear with our prac-
tical, actual self; by allowing it to stand outside the context of our personal

needs and ends—in short, by looking at it 'objectively,' as it has often been called, by permitting only such reactions on our part as emphasise the 'objective' features of the experience, and by interpreting even our 'subjective' affections not as modes of *our* being but rather as characteristics of the phenomenon.

The working of Distance is, accordingly, not simple, but highly complex. It has a *negative,* inhibitory aspect—the cutting-out of the practical sides of things and of our practical attitude to them—and a *positive* side—the elaboration of the experience on the new basis created by the inhibitory action of Distance.

2. Consequently, this distanced view of things is not, and cannot be, our normal outlook. As a rule, experiences constantly turn the same side towards us, namely, that which has the strongest practical force of appeal. We are not ordinarily aware of those aspects of things which do not touch us immediately and practically, nor are we generally conscious of impressions apart from our own self which is impressed. The sudden view of things from their reverse, usually unnoticed, side, comes upon us as a revelation, and such revelations are precisely those of Art. In this most general sense, Distance is a factor in all Art.

3. It is, for this very reason, also an aesthetic principle. The aesthetic contemplation and the aesthetic outlook have often been described as 'objective.' We speak of 'objective' artists as Shakespeare or Velasquez, of 'objective' works or art forms as Homer's *Iliad* or the drama. It is a term constantly occurring in discussions and criticisms, though its sense, if pressed at all, becomes very questionable. For certain forms of Art, such as lyrical poetry, are said to be 'subjective'; Shelley, for example, would usually be considered a 'subjective' writer. On the other hand, no work of Art can be genuinely 'objective' in the sense in which this term might be applied to a work on history or to a scientific treatise; nor can it be 'subjective' in the ordinary acceptance of that term, as a personal feeling, a direct statement of a wish or belief, or a cry of passion is subjective. 'Objectivity' and 'subjectivity' are a pair of opposites which in their mutual exclusiveness when applied to Art soon lead to confusion.

Nor are they the only pair of opposites. Art has with equal vigour been declared alternately 'idealistic' and 'realistic,' 'sensual' and 'spiritual,' 'individualistic' and 'typical.' Between the defence of either terms of such antitheses most aesthetic theories have vacillated. It is one of the contentions of this essay that such opposites find their synthesis in the more fundamental conception of Distance.

Distance further provides the much needed criterion of the beautiful as distinct from the merely agreeable.

Again, it marks one of the most important steps in the process of artistic creation and serves as a distinguishing feature of what is commonly so loosely described as the 'artistic temperament.'

Finally, it may claim to be considered as one of the essential characteristics of the 'aesthetic consciousness,'—if I may describe by this term that special mental attitude towards, and outlook upon, experience, which finds its most pregnant expression in the various forms of Art.

II

Distance, as I said before, is obtained by separating the object and its appeal from one's own self, by putting it out of gear with practical needs and ends. Thereby the 'contemplation' of the object becomes alone possible. But it does not mean that the relation between the self and the object is broken to the extent of becoming 'impersonal.' Of the alternatives 'personal' and 'impersonal' the latter surely comes nearer to the truth; but here, as elsewhere, we meet the difficulty of having to express certain facts in terms coined for entirely different uses. To do so usually results in paradoxes, which are nowhere more inevitable than in discussions upon Art. 'Personal' and 'impersonal,' 'subjective' and 'objective' are such terms, devised for purposes other than aesthetic speculation, and becoming loose and ambiguous as soon as applied outside the sphere of their special meanings. In giving preference therefore to the term 'impersonal' to describe the relation between the spectator and a work of Art, it is to be noticed that it is not impersonal in the sense in which we speak of the 'impersonal' character of Science, for instance. In order to obtain 'objectively valid' results, the scientist excludes the 'personal factor,' i.e. his personal wishes as to the validity of his results, his predilection for any particular system to be proved or disproved by his research. It goes without saying that all experiments and investigations are undertaken out of a personal interest in the science, for the ultimate support of a definite assumption, and involve personal hopes of success; but this does not affect the 'dispassionate' attitude of the investigator, under pain of being accused of 'manufacturing his evidence.'

1. Distance does not imply an impersonal, purely intellectually interested relation of such a kind. On the contrary, it describes a *personal* relation, often highly emotionally coloured, but *of a peculiar character.* Its peculiarity lies in that the personal character of the relation has been, so to speak, filtered. It has been cleared of the practical, concrete nature of its appeal, without, however, thereby losing its original constitution. One of the best known examples is to be found in our attitude towards the events and characters of the drama: they appeal to us like persons and incidents of normal experience, except that that side of their appeal, which would usually affect us in a directly personal manner, is held in abeyance. This difference, so well known as to be almost trivial, is generally explained by reference to the knowledge that the characters and situations are 'unreal,' imaginary. In this sense Witasek, operating with Meinong's theory of *Annahmen,* has described the emotions involved in witnessing a drama as *Scheingefühle,* a term which has so frequently been misunderstood in discussions of his theories. But, as a matter of fact, the 'assumption' upon which the imaginative emotional reaction is based is not necessarily the condition, but often the consequence, of Distance; that is to say, the converse of the reason usually stated would then be true: viz. that Distance, by changing our relation to the characters, renders them seemingly fictitious, not that the fictitiousness of the characters alters our feelings toward them. It is, of course, to be granted that the actual and admitted unreality of the dramatic action reinforces the effect of Distance. But surely the proverbial unsophisticated yokel whose chivalrous interference in the play on behalf of the hapless heroine can only be prevented by impressing upon him that 'they are only pre-

tending,' is not the ideal type of theatrical audience. The proof of the seeming paradox that it is Distance which primarily gives to dramatic action the appearance of unreality and not *vice versâ*, is the observation that the same filtration of our sentiments and the same seeming 'unreality' of *actual* men and things occur, when at times, by a sudden change of inward perspective, we are overcome by the feeling that "all the world's a stage."

2. This personal, but 'distanced' relation (as I will venture to call this nameless character of our view) directs attention to a strange fact which appears to be one of the fundamental paradoxes of Art: it is what I propose to call 'the antinomy of Distance.'

It will be readily admitted that a work of Art has the more chance of appealing to us the better it finds us prepared for its particular kind of appeal. Indeed, without some degree of predisposition on our part, it must necessarily remain incomprehensible, and to that extent unappreciated. The success and intensity of its appeal would seem, therefore, to stand in direct proportion to the completeness with which it corresponds with our intellectual and emotional peculiarities and the idiosyncracies of our experience. The absence of such a concordance between the characters of a work and of the spectator is, of course, the most general explanation for differences of 'tastes.'

At the same time, such a principle of concordance requires a qualification, which leads at once to the antinomy of Distance.

Suppose a man, who believes that he has cause to be jealous about his wife, witnesses a performance of 'Othello.' He will the more perfectly appreciate the situation, conduct and character of Othello, the more exactly the feelings and experiences of Othello coincide with his own—at least he *ought* to on the above principle of concordance. In point of fact, he will probably do anything but appreciate the play. In reality, the concordance will merely render him acutely conscious of his own jealousy; by a sudden reversal of perspective he will no longer see Othello apparently betrayed by Desdemona, but himself in an analogous situation with his own wife. The reversal of perspective is the consequence of the loss of Distance.

If this be taken as a typical case, it follows that the qualification required is that the coincidence should be as complete as is compatible with maintaining Distance. The jealous spectator of 'Othello' will indeed appreciate and enter into the play the more keenly, the greater the resemblance with his own experience—*provided* that he succeeds in keeping the Distance between the action of the play and his personal feelings: a very difficult performance in the circumstances. It is on account of the same difficulty that the expert and the professional critic make a bad audience, since their expertness and critical professionalism are *practical* activities, involving their concrete personality and constantly endangering their Distance. [It is, by the way, one of the reasons why Criticism is an art, for it requires the constant interchange from the practical to the distanced attitude and *vice versâ*, which is characteristic of artists.]

The same qualification applies to the artist. He will prove artistically most effective in the formulation of an intensely *personal* experience, but he can formulate it artistically only on condition of a detachment from the experience *quâ personal*. Hence the statement of so many artists that artistic formulation was to them a kind of catharsis, a means of ridding themselves of feelings and

ideas the acuteness of which they felt almost as a kind of obsession. Hence, on the other hand, the failure of the average man to convey to others at all adequately the impression of an overwhelming joy or sorrow. His personal implication in the event renders it impossible for him to formulate and present it in such a way as to make others, like himself, feel all the meaning and fulness which it possesses for him.

What is therefore, both in appreciation and production, most desirable is the *utmost decrease of Distance without its disappearance.*

3. Closely related, in fact a presupposition to the 'antimony,' is the *variability of Distance.* Herein especially lies the advantage of Distance compared with such terms as 'objectivity' and 'detachment.' Neither of them implies a *personal* relation—indeed both actually preclude it; and the mere inflexibility and exclusiveness of their opposites render their application generally meaningless.

Distance, on the contrary, admits naturally of degrees, and differs not only according to the nature of the *object,* which may impose a greater or smaller degree of Distance, but varies also according to the *individual's capacity* for maintaining a greater or lesser degree. And here one may remark that not only do *persons differ from each other* in their habitual measure of Distance, but that the *same individual differs* in his ability to maintain it in the face of different objects and of different arts.

There exist, therefore, two different sets of conditions affecting the degree of Distance in any given case: those offered by the object and those realised by the subject. In their interplay they afford one of the most extensive explanations for varieties of aesthetic experience, since loss of Distance, whether due to the one or the other, means loss of aesthetic appreciation.

In short, Distance may be said to *be variable both according to the distancing-power of the individual, and according to the character of the object.*

There are two ways of losing Distance: either to 'under-distance' or to 'over-distance.' 'Under-distancing' is the commonest failing of the *subject,* an excess of Distance is a frequent failing of *Art,* especially in the past. Historically it looks almost as if Art had attempted to meet the deficiency of Distance on the part of the subject and had overshot the mark in this endeavour. It will be seen later that this is actually true, for it appears that over-distanced Art is specially designed for a class of appreciation which has difficulty to rise spontaneously to any degree of Distance. The consequence of a loss of Distance through one or other cause is familiar: the verdict in the case of under-distancing is that the work is 'crudely naturalistic,' 'harrowing,' 'repulsive in its realism.' An excess of Distance produces the impression of improbability, artificiality, emptiness or absurdity.

The individual tends, as I just stated, to under-distance rather than to lose Distance by over-distancing. *Theoretically* there is no limit to the decrease of Distance. In theory, therefore, not only the usual subjects of Art, but even the most personal affections, whether ideas, percepts or emotions, can be sufficiently distanced to be aesthetically appreciable. Especially artists are gifted in this direction to a remarkable extent. The average individual, on the contrary, very rapidly reaches his limit of decreasing Distance, his 'Distance-limit,' i.e.

that point at which Distance is lost and appreciation either disappears or changes its character.

In the *practice,* therefore, of the average person, a limit does exist which marks the minimum at which his appreciation can maintain itself in the aesthetic field, and this average minimum lies considerably higher than the Distance-limit of the artist. It is practically impossible to fix this average limit, in the absence of data, and on account of the wide fluctuations from person to person to which this limit is subject. But it is safe to infer that, in art practice, explicit references to organic affections, to the material existence of the body, especially to sexual matters, lie normally below the Distance-limit, and can be touched upon by Art only with special precautions. Allusions to social institutions of any degree of personal importance—in particular, allusions implying any doubt as to their validity—the questioning of some generally recognized ethical sanctions, references to topical subjects occupying public attention at the moment, and such like, are all dangerously near the average limit and may at any time fall below it, arousing, instead of aesthetic appreciation, concrete hostility or mere amusement.

This difference in the Distance-limit between artists and the public has been the source of much misunderstanding and injustice. Many an artist has seen his work condemned, and himself ostracized for the sake of so-called 'immoralities' which to him were *bonâ fide* aesthetic objects. His power of distancing, nay, the necessity of distancing feelings, sensations, situations which for the average person are too intimately bound up with his concrete existence to be regarded in that light, have often quite unjustly earned for him accusations of cynicism, sensualism, morbidness or frivolity. The same misconception has arisen over many 'problem plays' and 'problem novels' in which the public have persisted in seeing nothing but a supposed 'problem' of the moment, whereas the author may have been—and often has demonstrably been—able to distance the subject-matter sufficiently to rise above its practical problematic import and to regard it simply as a dramatically and humanly interesting situation.

The variability of Distance in respect to Art, disregarding for the moment the subjective complication, appears both as a general feature in Art, and in the differences between the special arts.

It has been an old problem why the 'arts of the eye and of the ear' should have reached the practically exclusive predominance over arts of other senses. Attempts to raise 'culinary art' to the level of a Fine Art have failed in spite of all propaganda, as completely as the creation of scent or liqueur 'symphonies.' There is little doubt that, apart from other excellent reasons of a partly psycho-physical, partly technical nature, the actual, *spatial distance* separating objects of sight and hearing from the subject has contributed strongly to the development of this monopoly. In a similar manner *temporal remoteness* produces Distance, and objects removed from us in point of time are *ipso facto* distanced to an extent which was impossible for their contemporaries. Many pictures, plays and poems had, as a matter of fact, rather an expository or illustrating significance—as for instance much ecclesiastical Art—or the force of a direct practical appeal—as the invectives of many satires or comedies—

which seem to us nowadays irreconcilable with their aesthetic claims. Such works have consequently profited greatly by lapse of time and have reached the level of Art only with the help of temporal distance, while others, on the contrary, often for the same reason have suffered a loss of Distance, through *over*-distancing.

Special mention must be made of a group of artistic conceptions which present excessive Distance in their form of appeal rather than in their actual presentation—a point illustrating the necessity of distinguishing between distancing an object and distancing the appeal of which it is the source. I mean here what is often rather loosely termed 'idealistic Art,' that is, Art springing from abstract conceptions, expressing allegorical meanings, or illustrating general truths. Generalisations and abstractions suffer under this disadvantage that they have too much general applicability to invite a personal interest in them, and too little individual concreteness to prevent them applying to us in all their force. They appeal to everybody and therefore to none. An axiom of Euclid belongs to nobody, just because it compels everyone's assent; general conceptions like Patriotism, Friendship, Love, Hope, Life, Death, concern as much Dick, Tom and Harry as myself, and I therefore either feel unable to get into any kind of personal relation to them or, if I do so, they become at once, emphatically or concretely, *my* Patriotism, *my* Friendship, *my* Love, *my* Hope, *my* Life and Death. By mere force of generalisation, a general truth or a universal ideal is so far distanced from myself that I fail to realise it concretely at all, or, when I do so, I can realise it only as part of my *practical actual being,* i.e. it falls below the Distance-limit altogether. 'Idealistic Art' suffers consequently under the peculiar difficulty that its excess of Distance turns generally into an *under*-distanced appeal—all the more easily, as it is the usual failing of the subject to *under*- rather than to *over*-distance. . . .

III

It remains to indicate the value of Distance as *an aesthetic principle:* as criterion in some of the standing problems of Aesthetics; as representing a phase of artistic creation; and as a characteristic feature of the 'aesthetic consciousness.'

1. The axiom of 'hedonistic Aesthetics' is that beauty is pleasure. Unfortunately for hedonism the formula is not reversible: not all pleasure is beauty. Hence the necessity of some limiting criterion to separate the beautiful within the 'pleasure-field' from the merely agreeable. This relation of the beautiful to the agreeable is the ever recurring crux of all hedonistic Aesthetics, as the problem of this relation becomes inevitable when once the hedonistic basis is granted. It has provoked a number of widely different solutions, some manifestly wrong, and all as little satisfactory as the whole hedonistic groundwork upon which they rest: the shareableness of beauty as opposed to the 'monopoly' of the agreeable (Bain), the passivity of beauty-pleasure (Grant Allen), or most recently, the 'relative permanence of beauty-pleasure in revival' (H. R. Marshall).

Distance offers a distinction which is as simple in its operation as it is fundamental in its importance: *the agreeable is a non-distanced pleasure.* Beauty in

the widest sense of aesthetic value is impossible without the insertion of Distance. The agreeable stands in precisely the same relation to the beautiful (in its narrower sense) as the sad stands to the tragic, as indicated earlier. Translating the above formula, one may say, that the agreeable is felt as an affection of our concrete, practical self; the centre of gravity of an agreeable experience lies in the self which experiences the agreeable. The aesthetic experience, on the contrary, has its centre of gravity in itself or in the object mediating it, not in the self which has been distanced out of the field of the inner vision of the experiencer: "not the fruit of experience, but experience itself, is the end." It is for this reason that to be asked in the midst of an intense aesthetic impression "whether one likes it," is like a somnambulist being called by name: it is a recall to one's concrete self, an awakening of practical consciousness which throws the whole aesthetic mechanism out of gear. One might almost venture upon the paradox that the more intense the aesthetic absorption, the less one 'likes," consciously, the experience. The failure to realise this fact, so fully borne out by all genuine artistic experience, is the fundamental error of hedonistic Aesthetics.

The problem of the relation of the beautiful and the agreeable has taken more definite shape in the question of the aesthetic value of the so-called 'lower senses' (comprising sensations of taste and temperature, muscular and tactile, and organic sensations). Sight and hearing have always been the 'aesthetic senses *par excellence.* Scent has been admitted to the status of an aesthetic sense by some, excluded by others. The ground for the rejection of the lower senses has always been that they mediate only agreeable sensations, but are incapable of conveying aesthetic experiences. Though true normally, this rigid distinction is theoretically unfair to the senses, and in practice often false. It is undoubtedly very difficult to reach an aesthetic appreciation through the lower senses, because the materialness of their action, their proximity and bodily connexion are great obstacles to their distancing. The aroma of coffee may be a kind of foretaste, taste etherialised, but still a taste. The sweetness of scent of a rose is usually felt more as a bodily caress than as an aesthetic experience. Yet poets have not hesitated to call the scents of flowers their "souls." Shelley has transformed the scent to an imperceptible sound. We call such conceptions 'poetical': they mark the transition from the merely agreeable to the beautiful by means of Distance.

M. Guyau has described the same transformation of a taste. Even muscular sensations may present aesthetic possibilities, in the free exercise of bodily movement, the swing of a runner, in the ease and certainty of the trained gymnast; nay, such diffuse organic sensations as the buoyancy of well-being, and the elasticity of bodily energy, can, in privileged moments, be aesthetically enjoyed. That they admit of no material fixation, such as objects of sight and hearing do, and for that reason form no part of Art in the narrower sense; that they exist as aesthetic objects only for the moment and for the single being that enjoys them, is no argument against their aesthetic character. Mere material existence and permanence is no aesthetic criterion.

This is all the more true, as even among the experience of lasting things, such as are generally accounted to yield aesthetic impressions, the merely agreeable occurs as frequently as the beautiful.

To begin with the relatively simple case of colour-appreciation. Most people imagine that because they are not colour-blind, physically or spiritually, and prefer to live in a coloured world rather than in an engraving, they possess an aesthetic appreciation of colour as such. This is the sort of fallacy which hedonistic art-theories produce, and the lack of an exchange of views on the subject only fosters. Everybody believes that he enjoys colour—and for that matter other things—just like anyone else. Yet rather the contrary is the case. By far the greater number, when asked why they like a colour, will answer, that they like it, because it strikes them as warm or cold, stimulating or soothing, heavy or light. They constitute a definite type of colour-appreciation and form about sixty per cent of all persons. The remainder assumes, for the greater part, a different attitude. Colours do not appeal to them as effects (largely organic) upon themselves. Their appreciation attributes to colours a kind of personality: colours are energetic, lively, serious, pensive, melancholic, affectionate, subtle, reserved, stealthy, treacherous, brutal, etc. These characters are not mere imaginings, left to the whim of the individual, romancing whatever he pleases into the colours, nor are they the work simply of accidental associations. They follow, on the contrary, definite rules in their applications; they are, in fact, the same organic effects as those of the former type, but transformed into, or interpreted as, attributes of the colour, instead of as affections of one's own self. In short, they are the result of the distancing of the organic effects: they form an aesthetic appreciation of colour, instead of a merely agreeable experience like those of the former kind.

A similar parallelism of the agreeable and the beautiful (in the widest sense of aesthetic value) occurs also within the sphere of recognised art-forms. I select for special notice *comedy* and *melodrama* (though the same observation can be made in painting, architecture and notably in music), firstly as counterparts to tragedy, secondly, because both represent admitted art-forms, in spite of their at least partially, inadequate claims to the distinction, and lastly because all these types, tragedy, comedy and melodrama, are usually grouped together as 'arts of the theatre' no less than as forms of 'literature.'

From the point of view of the present discussion, the case of *comedy* is particularly involved. What we mean by comedy as a class of theatrical entertainment covers several different kinds, which actually merge into each other and present historically a continuity which allows of no sharp lines of demarcation (a difficulty, by the way, which besets all distinctions of literary or artistic *species*, as opposed to artistic *genera*). The second difficulty is that the 'laughable' includes much more than the comic of comedy. It may enter, in all its varieties of the ridiculous, silly, naïve, brilliant, especially as the humorous, into comedy as ingredients, but the comic is not coextensive with the laughable as a whole.

The fact to be noted here is, that the different types of comedy, as well as the different kinds of the laughable, presuppose different degrees of Distance. Their tendency is to have none at all. Both to laugh and to weep are direct expressions of a thoroughly practical nature, indicating almost always a concrete personal affection. Indeed, given suitable circumstances and adequate distancing-power, both can be distanced, but only with great difficulty; nor is it possible to decide which of the two offers the greater difficulty. The balance

seems almost to incline in favour of tears as the easier of the two, and this would accord with the acknowledged difficulty of producing a really good comedy, or of maintaining a consistent aesthetic attitude in face of a comic situation. Certainly the tendency to *under*distance is more felt in comedy even than in tragedy; most types of the former presenting a *non-distanced*, practical and personal appeal, which precisely implies that their enjoyment is generally hedonic, not aesthetic. In its lower forms comedy consequently is a mere amusement and falls as little under the heading of Art as pamphleteering would be considered as *belles-lettres,* or a burglary as a dramatic performance. It may be spiritualised, polished and refined to the sharpness of a dagger-point or the subtlety of foil-play, but there still clings to it an atmosphere of amusement pure and simple, sometimes of a rude, often of a cruel kind. This, together with the admitted preference of comedy for generalised types rather than for individualised figures, suggests the conclusion that its point of view is the survival of an attitude which the higher forms of Art have outgrown. It is noteworthy that this tendency decreases with every step towards high comedy, character-comedy and drama, with the growing spiritualisation of the comic elements and the first appearance of Distance. Historically the development has been slow and halting. There is no doubt that the 17th century considered the *Misanthrope* as amusing. We are nowadays less harsh and less socially intolerant and *Alceste* appears to us no longer as frankly ridiculous. The supreme achievement of comedy is unquestionably that 'distanced ridicule' which we call *humour.* The self-contradiction of smiling at what we love, displays, in the light vein, that same perfect and subtle balance of the 'antinomy of Distance' which the truly tragic shows in the serious mood. The tragic and the humorous are the genuine aesthetic opposites; the tragic and the comic are contradictory in the matter of Distance, as aesthetic and hedonic objects respectively.

A similar hedonic opposition in the other direction is to be found between tragedy and *melodrama.* Whereas comedy tends to *under*distance, melodrama suffers from *over*distancing. For a cultivated audience its overcharged idealism, the crude opposition of vice and virtue, the exaggeration of its underlined moral, its innocence of *nuance,* and its sentimentality with violin-accompaniment are sufficient cause to stamp it as inferior Art. But perhaps its excessive distance is the least Distance obtainable by the public for which it is designed, and may be a great help to an unsophisticated audience in distancing the characters and events. For it is more than probable that we make a mistake in assuming an analogy between a cultivated audience at a serious drama, and a melodramatic audience. It is very likely that the lover of melodrama does not present that subtle balance of mind towards a play, implied in the 'antinomy of Distance.' His attitude is rather either that of a matter-of-fact adult or of a child: i.e. he is either in a frankly personal relation to the events of the play and would like to cudgel the villain who illtreats the innocent heroine, and rejoices loudly in his final defeat—just as he would in real life—or, he is completely lost in the excessive distance imposed by the work and watches naïvely the wonders he sees, as a child listens enchantedly to a fairy-tale. In neither case is his attitude aesthetic; in the one the object is *under-,* in the other *over*distanced; in the former he confuses it with the reality he *knows* (or thinks

he knows) to exist, in the other with a reality whose existence he does *not know, but accepts.* Neither bears the twofold character of the aesthetic state in which *we know* a thing *not* to exist, but *accept its existence.* From the point of view of moral advantage—in the absence of any aesthetic advantage—the former attitude might seem preferable. But even this may be doubted; for if he believes what he sees in a great spectacular melodrama, every marble-lined hall of the most ordinary London hotel that he passes after the play must appear to him as a veritable Hell, and every man or woman in evening-dress as the devil incarnate. On either supposition, the moral effect must be deplorable in the extreme, and the melodrama is generally a much more fitting object of the censor's attention than any usually censored play. For in the one case the brutal-ising effect of the obtrusively visible wickedness cannot possibly be out-weighed by any retaliatory poetic justice, which must seem to him singularly lacking in real life; in the other, the effect is purely negative and narcotic; in both his perspective of real life is hopelessly outfocussed and distorted.

2. The importance of Distance in artistic creation has already been briefly alluded to in connexion with the 'antinomy of Distance.'

Distancing might, indeed, well be considered as the especial and primary function of what is called the 'creative act' in artistic production: distancing is the *formal* aspect of creation in Art. The view that the artist 'copies nature' has already been dismissed. Since the 'imitation-of-nature' theory was officially discarded at the beginning of the 19th century, its place in popular fancy has been taken by the conception of the 'self-expression of the artist,' supported by the whole force of the Romantic Movement in Europe. Though true as a crude statement of the subjective origin of an artistic conception, though in many ways preferable to its predecessor and valuable as a corollary of such theories as that of the 'organic growth' of a work of Art, it is apt to lead to confusions and to one-sided inferences, to be found even in such deliberate and expert accounts of artistic production as that of Benedetto Croce. For, to start with, the 'self-expression' of an artist is not such as the 'self-expression' of a letter-writer or a public speaker: it is not the *direct* expression of the con-crete personality of the artist; it is not even an *indirect* expression of his con-crete personality, in the sense in which, for instance, Hamlet's 'self-expression' might be supposed to be the indirect reflexion of Shakespeare's ideas. Such a denial, it might be argued, runs counter to the observation that in the works of a literary artist, for example, are to be found echoes and mirrorings of his times and of his personal experiences and convictions. But it is to be noted that to find these *is* in fact impossible, unless you previously know what reflexions to look for. Even in the relatively most direct transference from personal expe-rience to their expression, viz. in lyrical poetry, such a connexion cannot be established backwards, though it is easy enough to prove it forwards: i.e. given the knowledge of the experiences, there is no difficulty in tracing their echoes, but it is impossible to infer biographical data of any detail or concrete value from an author's works alone. Otherwise Shakespeare's *Sonnets* would not have proved as refractory to biographical research as they have done, and end-less blunders in literary history would never have been committed. What proves so impossible in literature, which after all offers an exceptionally ade-quate medium to 'self-expression,' is *a fortiori* out of question in other arts, in

which there is not even an equivalence between the personal experiences and the material in which they are supposed to be formulated. The fundamental two-fold error of the 'self-expression' theory is to speak of 'expression' in the sense of 'intentional communication,' and to identify straightway the artist and the man. An intentional communication is as far almost from the mind of the true artist as it would be from that of the ordinary respectable citizen to walk about naked in the streets, and the idea has repeatedly been indignantly repudiated by artists. The second confusion is as misleading in its theoretical consequences, as it is mischievous and often exceedingly painful to the 'man' as well as to the 'artist.' The numberless instances in history of the astonishing difference, often the marked contrast between the *man* and his *work* is one of the most disconcerting riddles of Art, and should serve as a manifest warning against the popular illusion of finding the 'artist's mind' in his productions.

Apart from the complication of technical necessities, of conventional art-forms, of the requirements of unification and composition, all impeding the direct transference of an actual mental content into its artistic formulation, there is the interpolation of Distance which stands between the artist's conception and the man's. For the 'artist' himself is already distanced from the concrete, historical personality, who ate and drank and slept and did the ordinary business of life. No doubt here also are *degrees* of Distance, and the 'antinomy' applies to this case too. Some figures in literature and other arts are unquestionably self-portraits; but even self-portraits are not, and cannot be, the direct and faithful cast taken from the living soul. In short, so far from being 'self-expression,' *artistic production is the indirect formulation of a distanced mental content.*

I give a short illustration of this fact. A well-known dramatist described to me the process of production as taking place in his case in some such way as follows:

The starting-point of his production is what he described as an 'emotional idea,' i.e. some more or less general conception carrying with it a strong emotional tone. This idea may be suggested by an actual experience; anyhow the idea itself *is* an actual experience, i.e. it occurs within the range of his normal, practical being. Gradually it condenses itself into a situation made up of the interplay of certain characters, which may be of partly objective, partly imaginative descent. Then ensues what he described as a "life and death struggle" between the idea and the characters for existence: if the idea gains the upper hand, the conception of the whole is doomed. In the successful issue, on the contrary, the idea is, to use his phrase, "sucked up" by the characters as a sponge sucks up water, until no trace of the idea is left outside the characters. It is a process, which, he assured me, he is quite powerless to direct or even to influence. It is further of interest to notice that during this period the idea undergoes sometimes profound, often wholesale changes. Once the stage of complete fusion of the idea with the characters is reached, the conscious elaboration of the play can proceed. What follows after this, is of no further interest in this connexion.

This account tallies closely with the procedure which numerous dramatists are known to have followed. It forms a definite type. There are other types, equally well supported by evidence, which proceed along much less

definite lines of a semi-logical development, but rather show sudden flash-like illuminations and much more subconscious growth.

The point to notice is the "life and death struggle" between the idea and the characters. As I first remarked, the idea is the *'man's,'* it is the reflexion of the dramatist's concrete and practical self. Yet this is precisely the part which must "die." The paradox of just the germpart of the whole being doomed, particularly impressed my informant as a kind of life-tragedy. The 'characters' on the other hand belong to the imaginary world, to the 'artist's.' Though they may be partially suggested by actuality, their full-grown development is divorced from it. This process of the 'idea' being "sucked up" by the characters and being destroyed by it, is a phase of artistic production technically known as the 'objectivation' of the conception. In it the 'man' dies and the 'artist' comes to life, and with him the work of Art. It is a change of death and birth in which there is no overlapping of the lives of parent and child. The result is the distanced finished production. As elsewhere, the distancing means the separation of personal affections, whether idea or complex experience, from the concrete personality of the experiencer, its filtering by the extrusion of its personal aspects, the throwing out of gear of its personal potency and significance.

The same transformation through distance is to be noticed in *acting*. Here, even more than in the other arts, a lingering bias in favour of the 'imitation of nature' theory has stood in the way of a correct interpretation of the facts. Yet acting supplies in this and other respects exceptionally valuable information, owing to its medium of expression and the overlapping—at least in part—of the process of producing with the finished production, which elsewhere are separated in point of time. It illustrates, as no other art can, the cleavage between the concrete, normal person and the distanced personality. [The acting here referred to is, of course, not that style which consists in 'walking on.' What is meant here is 'creative' acting, which in its turn must be distinguished from 'reproductive' acting—two different types traceable through the greater part of theatrical history, which in their highest development are often outwardly indistinguishable, but nevertheless retain traces of differences, characteristic of their procedures and psychical mechanism.] This cleavage between the two streams or layers of consciousness is so obvious that it has led to increasing speculation from the time when acting first attracted intelligent interest, since the middle of the 18th century. From the time of Diderot's *Paradoxe sur le Comédien* (itself only the last of a series of French studies) down to Mr. William Archer's *Masks or Faces* (1888) and the controversy between Coquelin and Salvini (in the nineties), theory has been at pains to grapple with this phenomenon. Explanations have differed widely, going from the one extreme of an identification of the acting and the normal personality to the other of a separation so wide as to be theoretically inconceivable and contradicted by experience. It is necessary to offer some conception which will account for the difference as well as for the indirect connexion between the two forms of being, and which is applicable not merely to acting, but to other kinds of art as well. Distance, it is here contended, meets the requirement even in its subtlest shades. To show this in detail lies outside the scope of this essay, and forms rather the task of a special treatment of the psychology of acting. . . .

4. In this way Distance represents in aesthetic appreciation as well as in artistic production a quality inherent in the impersonal, yet *so* intensely personal, relation which the human being entertains with Art, either as mere beholder or as producing artist.

It is Distance which makes the aesthetic object 'an end in itself.' It is that which raises Art beyond the narrow sphere of individual interest and imparts to it that 'postulating' character which the idealistic philosophy of the 19th century regarded as a metaphysical necessity. It renders questions of origin, of influences, or of purposes almost as meaningless as those of marketable value, of pleasure, even of moral importance, since it lifts the work of Art out of the realm of practical systems and ends.

In particular, it is Distance, which supplies one of the special criteria of aesthetic values as distinct from practical (utilitarian), scientific, or social (ethical) values. All these are concrete values, either *directly* personal as utilitarian, or *indirectly* remotely personal, as moral values. To speak, therefore, of the 'pleasure value' of Art, and to introduce hedonism into aesthetic speculation, is even more irrelevant than to speak of moral hedonism in Ethics. Aesthetic hedonism is a compromise. It is the attempt to reconcile for public use utilitarian ends with aesthetic values. Hedonism, as a practical, personal appeal has no place in the distanced appeal of Art. Moral hedonism is even more to the point than aesthetic hedonism, since ethical values, *quâ* social values, lie on the line of prolongation of utilitarian ends, sublimating indeed the *directly* personal object into the realm of socially or universally valuable ends, often demanding the sacrifice of individual happiness, but losing neither its *practical* nor even its *remotely personal* character.

In so far, Distance becomes one of the distinguishing features of the 'aesthetic consciousness,' of that special mentality or outlook upon experience and life, which, as I said at the outset, leads in its most pregnant and most fully developed form, both appreciatively and productively, to Art.

READING 23

INTRODUCTION

A number of the readings in this section have focused on the conditions that govern our use of aesthetic terms. For example, both Hume and Kant were occupied with the question whether judgments involving such terms are subjective or objective. In his extremely influential study of the logic of aesthetic terms, Frank Sibley, emeritus professor of philosophy at the University of Lancaster in England, takes up many of the issues that concerned Hume and Kant. Sibley notes that we can distinguish between aesthetic concepts, such as "gracefulness" and "gaudiness," and non-aesthetic concepts, such as "weight" and "height." And he argues that although the aesthetic features of an object do in some sense depend on the object's non-aesthetic features, the aesthetic features are not *logically* dependent on the non-

aesthetic features. What this means, he suggests, is that recognizing the aesthetic features of an object demands more than merely recognizing its non-aesthetic features: The ability to recognize aesthetic features requires the exercise of *taste*. Sibley's remarks about the ways in which we exercise taste are illuminating and original. They also raise a number of questions which recall the issues that concerned Hume and Kant. For one thing, if aesthetic features such as gracefulness are not logically determined by non-aesthetic features such as physical shape, is there any *fact* of the matter about whether or not a particular object is graceful?

Aesthetic Concepts

Frank Sibley

The remarks we make about works of art are of many kinds. In this paper I wish to distinguish between two broad groups. We say that a novel has a great number of characters and deals with life in a manufacturing town; that a painting uses pale colours, predominantly blues and greens, and has kneeling figures in the foreground; that the theme in a fugue is inverted at such a point and that there is a stetto at the close; that the action of a play takes place in the span of one day and that there is a reconciliation scene in the fifth act. Such remarks may be made by, and such features pointed out to, anyone with normal eyes, ears, and intelligence. On the other hand, we also say that a poem is tightly-knit or deeply moving; that a picture lacks balance, or has a certain serenity and repose, or that the grouping of the figures sets up an exciting tension; that the characters in a novel never really come to life, or that a certain episode strikes a false note. It would be natural enough to say that the making of judgments such as these requires the exercise of taste, perceptiveness, or sensitivity, of aesthetic discrimination or appreciation; one would not say this of my first group. Accordingly, when a word or expression is such that taste or perceptiveness is required in order to apply it, I shall call it an *aesthetic* term or expression, and I shall, correspondingly, speak of *aesthetic* concepts or *taste* concepts.[1]

Aesthetic terms span a great range of types and could be grouped into various kinds and sub-species. But it is not my present purpose to attempt any such grouping; I am interested in what they all have in common. Their almost endless variety is adequately displayed in the following list: *unified, balanced, integrated, lifeless, serene, sombre, dynamic, powerful, vivid, delicate, moving, trite, sentimental, tragic.* The list of course is not limited to adjectives; expressions in artistic contexts like "telling contrast," "sets up a tension," "conveys a sense of," or "holds it together" are equally good illustrations. It includes terms used by both layman and critic alike, as well as some which are mainly the property of professional critics and specialists.

[1] I shall speak loosely of an "aesthetic term," even when, because the word sometimes has other uses, it would be more correct to speak of its *use* as an aesthetic term. I shall also speak of "non-aesthetic" words, concepts, features, and so on. None of the terms other writers use, "natural," "observable," "perceptual," "physical," "objective" (qualities), "neutral," "descriptive" (language), when they approach the distinction I am making, is really apt for my purpose.

I have gone for my examples of aesthetic expressions in the first place to critical and evaluative discourse about works of art because it is there particularly that they abound. But now I wish to widen the topic; we employ terms the use of which requires an exercise of taste not only when discussing the arts but quite liberally throughout discourse in everyday life. The examples given above are expressions which, appearing in critical contexts, most usually, if not invariably, have an aesthetic use; outside critical discourse the majority of them more frequently have some other use unconnected with taste. But many expressions do double duty even in everyday discourse, sometimes being used as aesthetic expressions and sometimes not. Other words again, whether in artistic or daily discourse, function only or predominantly as aesthetic terms; of this kind are *graceful, delicate, dainty, handsome, comely, elegant, garish.* Finally, to make the contrast with all the preceding examples, there are many words which are seldom used as aesthetic terms at all: *red, noisy, brackish, clammy, square, docile, curved, evanescent, intelligent, faithful, derelict, tardy, freakish.*

Clearly, when we employ words as aesthetic terms we are often making and using metaphors, pressing into service words which do not primarily function in this manner. Certainly also, many words *have come* to be aesthetic terms by some kind of metaphorical transference. This is so with those like "dynamic," "melancholy," "balanced," "tightly-knit" which, except in artistic and critical writings, are not normally aesthetic terms. But the aesthetic vocabulary must not be thought wholly metaphorical. Many words, including the most common *(lovely, pretty, beautiful, dainty, graceful, elegant),* are certainly not being used metaphorically when employed as aesthetic terms, the very good reason being that this is their primary or only use, some of them having no current non-aesthetic uses. And though expressions like "dynamic," "balanced," and so forth *have come* by a metaphorical shift to be aesthetic terms, their employment in criticism can scarcely be said to be more than quasi-metaphorical. Having entered the language of art description and criticism as metaphors they are now standard vocabulary in that language.[2]

The expressions I am calling aesthetic terms form no small segment of our discourse. Often, it is true, people with normal intelligence and good eyesight and hearing lack, at least in some measure, the sensitivity required to apply them; a man need not be stupid or have poor eyesight to fail to see that something is graceful. Thus taste or sensitivity is somewhat more rare than certain other human capacities; people who exhibit a sensitivity both wide-ranging and refined are a minority. It is over the application of aesthetic terms too that, notoriously, disputes and differences sometimes go helplessly unsettled. But almost everybody is able to exercise taste to some degree and in some matters. It is surprising therefore that aesthetic terms have been so largely neglected. They have received glancing treatment in the course of other aes-

[2]A contrast will reinforce this. If a critic were to describe a passage of music as chattering, carbonated, or gritty, a painter's colouring as vitreous, farinaceous, or effervescent, or a writer's style as glutinous, or abrasive, he *would* be using live metaphors rather than drawing on the more normal language of criticism. Words like "athletic," "vertiginous," "silken" may fall somewhere between.

thetic discussions; but as a broad category they have not received the direct attention they merit.

The foregoing has marked out the area I wish to discuss. One warning should perhaps be given. When I speak of taste in this paper, I shall not be dealing with questions which centre upon expressions like "a matter of taste" (meaning, roughly, a matter of personal preference or liking). It is with an ability to *notice* or *see* or *tell* that things have certain qualities that I am concerned.

I

In order to support our application of an aesthetic term, we often refer to features the mention of which involves other aesthetic terms: "it has an extraordinary vitality because of its free and vigorous style of drawing," "graceful in the smooth flow of its lines," "dainty because of the delicacy and harmony of its colouring." It is as normal to do this as it is to justify one mental epithet by other epithets of the same general type, *intelligent* by *ingenious, inventive, acute,* and so on. But often when we apply aesthetic terms, we explain why by referring to features which do *not* depend for their recognition upon an exercise of taste: "delicate because of its pastel shades and curving lines," or "it lacks balance because one group of figures is so far off to the left and is so brightly illuminated." When no explanation of this latter kind is offered, it is legitimate to ask or search for one. Finding a satisfactory answer is sometimes difficult, but one cannot ordinarily reject the question. When we cannot ourselves quite say what non-aesthetic features make something delicate or unbalanced or moving, the good critic often puts his finger on something which strikes us as the right explanation. In short, aesthetic terms always ultimately apply because of, and aesthetic qualities always ultimately depend upon, the presence of features which, like curving or angular lines, colour contrasts, placing of masses, or speed of movement, are visible, audible, or otherwise discernible without any exercise of taste or sensibility. Whatever kind of dependence this is, and there are various relationships between aesthetic qualities and non-aesthetic features, what I want to make clear in this paper is that there are no non-aesthetic features which serve in *any* circumstances as logically *sufficient conditions* for applying aesthetic terms. Aesthetic concepts are not in *this* respect condition-governed at all.

There is little temptation to suppose that aesthetic terms resemble words which, like "square," are applied in accordance with a set of necessary and sufficient conditions. For whereas each square is square in virtue of the *same* set of conditions, four equal sides and four right angles, aesthetic terms apply to widely varied objects; one thing is graceful because of these features, another because of those, and so on. Recently, philosophers have broken the spell of the strict necessary-and-sufficient model by showing that many everyday concepts are not of that type, but are governed only in a much looser way by conditions. However, since these newer models provide satisfactory accounts of many concepts, it might plausibly be thought that aesthetic concepts are of some such kind and that they similarly are governed in some looser way by conditions. I want to argue that aesthetic concepts differ radically from any of these other concepts.

Amongst these concepts to which attention has recently been paid are those for which no *necessary-and-sufficient* conditions can be provided, but for which there are a number of relevant features, A, B, C, D, E, such that the presence of some groups or combinations of these features is *sufficient* for the application of the concept. The list of relevant features may be an open one; that is, given A, B, C, D, E, we may not wish to close off the possible relevance of other unlisted features beyond E. Examples of such concepts might be "dilatory," "discourteous," "possessive," "capricious," "prosperous," "intelligent." . . . If we begin a list of features relevant to "intelligent" with, for example, ability to grasp and follow various kinds of instructions, ability to master facts and marshall evidence, ability to solve mathematical or chess problems, we might go on adding to this list almost indefinitely.

However, with concepts of this sort, although decisions may have to be made and judgment exercised, it is always possible to extract and state, from cases which have *already* clearly been decided, the sets of features or conditions which were regarded as sufficient in those cases. These relevant features which I am calling conditions are, it should be noted, features which, though not sufficient *alone* and needing to be combined with other similar features, nevertheless carry some weight and count only in one direction. Being a good chess player can count only *towards* and not *against* intelligence. Whereas mention of it may enter sensibly along with other remarks in expressions like "I say he is intelligent because . . ." or "the reason I call him intelligent is that . . . ," it cannot be used to complete such negative expressions as "I say he is *un*intelligent because. . . ." But what I want particularly to emphasize about features which function as conditions for a term is that *some* group or set of them is sufficient fully to ensure or warrant the application of that term. An individual characterized by some of these features may not yet qualify to be called lazy or intelligent, and so on, beyond all question, but all that is needed is to add some further (indefinite) number of such characterizations and a point is reached where we have enough. There are individuals possessing a number of such features of whom one cannot deny, cannot but admit, that they are intelligent. We have left necessary-and-sufficient conditions behind, but we are still in the realm of sufficient conditions.

But aesthetic concepts are not condition-governed even in this way. There are no sufficient conditions, no non-aesthetic features such that the presence of some set or number of them will beyond question logically justify or warrant the application of an aesthetic term. It is impossible . . . to make any statements corresponding to those we make for condition-governed words. We are able to say "If it is true he can do this, and that, and the other, then one just cannot deny that he is intelligent," or "if he does A, B, and C, I don't see how it can be denied that he is lazy," but we cannot make *any* general statement of the form "If the vase is pale pink, somewhat curving, lightly mottled, and so forth, it will be delicate, cannot but be delicate." Nor again can one say *any* such thing here as "Being tall and thin is not enough *alone* to ensure that a vase is delicate, but if it is, for example, slightly curving and pale coloured (and so forth) as well, it cannot be denied that it is." Things may be described to us in non-aesthetic terms as fully as we please but we are not thereby put

in the position of having to admit (or being unable to deny) that they are delicate or graceful or garish or exquisitely balanced.[3]

No doubt there are some respects in which aesthetic terms *are* governed by conditions or rules. For instance, it may be impossible that a thing should be garish if all its colours are pale pastels, or flamboyant if all its lines are straight. There may be, that is, descriptions using only non-aesthetic terms which are incompatible with descriptions employing certain aesthetic terms. If I am told that a painting in the next room consists solely of one or two bars of very pale blue and very pale grey set at right angles on a pale fawn ground, I can be sure that it cannot be fiery or garish or gaudy or flamboyant. A description of this sort may make certain aesthetic terms *in*applicable or *in*appropriate; and if from this description I inferred that the picture was, or even might be, fiery or gaudy or flamboyant, this might be taken as showing a failure to understand these words. I do not wish to deny therefore that taste concepts may be governed *negatively* by conditions.[4] What I am emphasizing is that they quite lack governing conditions of a sort many other concepts possess. Though on *seeing* the picture we might say, and rightly, that it is delicate or serene or restful or sickly or insipid, no *description* in non-aesthetic terms permits us to claim that these or any other aesthetic terms must undeniably apply to it.

I have said that if an object is characterized *solely* by certain sorts of features this may count decisively against the possibility of applying to it certain aesthetic terms. But of course the presence of *some* such features need not count decisively; other features may be enough to outweigh those which, on their own, would render the aesthetic term inapplicable. A painting might be garish even though much of its colour is pale. These facts call attention to a further feature of taste concepts. One *can* find general features or descriptions which in some sense count in one direction only, only *for* or only *against* the application of certain aesthetic terms. Angularity, fatness, brightness, or intensity of colour are typically *not* associated with delicacy or grace. Slimness, lightness, gentle curves, lack of intensity of colour are associated with delicacy, but not with flamboyance, majesty, grandeur, splendour or garishness. This is shown by the naturalness of saying, for example, that someone is graceful *because* she's so light, but in *spite of* being quite angular or heavily built; and by the corresponding oddity of saying that something is graceful *because* it is so heavy or angular, or delicate *because* of its bright and intense colouring. This may therefore sound quite similar to what I have said already about conditions in dis-

[3]In a paper reprinted in *Aesthetics and Language*, ed. by W. Elton (Oxford, 1954), pp. 131–46, Arnold Isenberg discusses certain problems about aesthetic concepts and qualities. Like others who approach these problems, he does not isolate them, as I do, from questions about verdicts on the *merits* of works of art, or from questions about *likings* and *preferences*. He says something parallel to my remarks above: "There is not in all the world's criticism a single purely descriptive statement concerning which one is prepared to say beforehand, 'if it is true, I shall *like* that work so much the better'" (p. 139, my italics). I should think *this* is highly questionable.

[4]Isenberg (op. cit., p. 132) makes a somewhat similar but mistaken point: "If we had been told that the colours of a certain painting are garish, it would be *astonishing* to find that they are *all* very pale and unsaturated" (my italics). But if we say "all" rather than "predominantly," then "astonishing" is the wrong word. The word that goes with "all" is "impossible"; "astonishing" might go with "predominantly."

cussing terms like "intelligent." There are nevertheless significant differences. Although there is this sense in which slimness, lightness, lack of intensity of colour, and so on, count only towards, not against, delicacy, these features, I shall say, at best count only *typically* or *characteristically* towards delicacy. They do not count towards in the same sense as condition-features count towards laziness or intelligence; that is, no group of them is ever logically sufficient.

One way of reinforcing this is to notice how features which are characteristically associated with one aesthetic term may also be similarly associated with other, rather different aesthetic terms. "Graceful" and "delicate" may be on the one hand sharply contrasted with terms like "violent," "grand," "fiery," "garish," or "massive" which have characteristic non-aesthetic features, quite unlike those for "delicate" and "graceful." But on the other hand they may also be contrasted with aesthetic terms which stand much closer to them, like "flaccid," "weakly," "washed out," "lanky," "anaemic," "wan," "insipid"; and the features characteristic of *these* qualities, pale colour, slimness, lightness, lack of angularity and contrast, are virtually identical with the range for "delicate" and "graceful." Similarly many features typically associated with "joyous," "fiery," "robust," or "dynamic" are identical with those associated with "garish," "strident," "turbulent," "gaudy," or "chaotic." Thus an object described very fully, but exclusively in terms of qualities characteristic of delicacy, may turn out on inspection to be not delicate at all, but anaemic or insipid. The failures of novices and the artistically inept prove that quite close similarity in line, colour, or technique gives no assurance of gracefulness or delicacy. A failure and a success in the manner of Degas may be generally more alike, so far as their non-aesthetic features go, than either is like a successful Fragonard. But I need not go even this far to make my main point. A painting which has only the kind of features one would associate with vigour and energy but which even so fails to be vigorous and energetic *need* not be instead, say, strident or chaotic. It may fail to have any particular character whatever. It may employ bright colours and the like without being particularly lively and vigorous at all; but one may feel unable to describe it as chaotic or strident or garish either. It is, rather, simply lacking in character (though of course this too is an aesthetic judgment; taste is exercised also in seeing that the painting has no character).

There are of course many features which do not in these ways characteristically count for (or against) particular aesthetic qualities. One poem has strength and power because of the regularity of its metre and rhyme; another is monotonous and lacks drive and strength because of its regular metre and rhyme. We do not feel the need to switch from "because of" to "in spite of." However, I have concentrated upon features characteristically associated with aesthetic qualities because, if one could maintain that taste concepts are in any way governed by sufficient conditions, these would seem to be the most promising candidates for governing conditions. But to say that features are associated only *characteristically* with an aesthetic term *is* to say that they can never amount to sufficient conditions; no description however full, even in terms characteristic of gracefulness, puts it beyond question that something is graceful in the way a description may put it beyond question that someone is lazy or intelligent.

It is important to observe, however, that I am not merely claiming that no sufficient conditions can be stated for taste concepts. For if this were all, they might not be after all really different from one kind of concept recently discussed. They could be accommodated perhaps with those concepts which Professor H. L. A. Hart has called "defeasible"; it is a characteristic of defeasible concepts that we cannot state sufficient conditions for them because, for any sets we offer, there is always an (open) list of defeating conditions any of which might rule out the application of the concept. The most we can say schematically for a defeasible concept is that, for example, A, B, and C together are sufficient for the concept to apply *unless* some feature is present which overrides or voids them. But, I want to emphasize, the very fact that we *can* say this sort of thing shows that we are still to the extent in the realm of conditions.[5] The features governing defeasible concepts can ordinarily count only one way, *either* for *or* against. To take Hart's example, "offer" and "acceptance" can count only towards the existence of a valid contract, and fraudulent misrepresentation, duress, and lunacy only against. And even with defeasible concepts, if we are told that there are *no* voiding features present, we can know that some set of conditions or features, A, B, C, . . ., is enough to ensure, for example, that there is a contract. The very notion of a defeasible concept seems to require that some group of features *would* be sufficient *in certain circumstances*, i.e. in the absence of voiding features. In a certain way, defeasible concepts lack sufficient conditions then, but they are still, in the sense described, condition-governed. My claim about taste concepts is stronger; that they are not, except negatively, governed by conditions at all. We could not conclude even in certain circumstances, e.g. if we were told of the absence of all "voiding" or uncharacteristic features (no angularities and the like), that an object *must* certainly be graceful, however fully it was described to us as possessing features characteristic of gracefulness.

My arguments and illustrations so far have been rather simply schematic. Many concepts, including most of the examples I have used . . . are much more thoroughly open and complex than my illustrations suggest. Not only may there be an open list of relevant conditions; it may be impossible to give precise rules telling how many features from the list are needed for a sufficient set or in which combinations; impossible similarly to give precise rules covering the extent or degree to which such features need to be present in those combinations. Indeed, we may have to abandon as futile any attempt to describe or formulate anything like a complete set of precise conditions or rules, and content ourselves with giving only a very general account of the concept, making reference to samples or cases or precedents. We cannot employ these concepts *simply* by being equipped with lists of conditions, readily applicable procedures or sets of rules, however complex. For to exhibit a mastery of one of those concepts we must be able to apply the word correctly to new individual cases, at least to central ones; and each new case may be a uniquely different object, just as each intelligent child or student may differ from others in relevant features and exhibit a unique combination of kinds and degrees of achievement and ability. In dealing with these new cases mechan-

[5]H. L. A. Hart, "The Ascription of Responsibility and Rights in *Logic and Language*," First Series, ed. by A. G. N. Flew (Oxford, 1951). Hart indeed speaks of "conditions" throughout, see p. 148.

ical rules and procedures would be useless; we have to exercise our judgment, guided by a complex set of examples and precedents. Here then there is a marked *superficial* similarity to aesthetic concepts. For in using aesthetic terms too we learn from samples and examples, not rules, and we have to apply them, likewise, without guidance by rules or readily applicable procedures, to new and unique instances. Neither kind of concept admits of a simply "mechanical" employment.

But this is *only* a superficial similarity. It is at least noteworthy that in applying words like "lazy" or "intelligent" to new and unique instances we say that we are required to exercise *judgment;* it would be indeed odd to say that we are exercising *taste.* In exercising judgment we are called upon to examine the pros and cons, and to decide whether a quite new feature is to be counted as weighing on one side or on the other. But this goes to show that, though we may learn from and rely upon samples and precedents rather than a set of stated conditions, we are not out of the realm of general conditions and guiding principles. These precedents necessarily embody, and are used by us to illustrate, a complex web of governing and relevant conditions which it is impossible to formulate completely. To profit by precedents we have to understand them; and we must argue consistently from case to case. This is the very function of precedents. Thus it is possible, even with these very loosely condition-governed concepts, to take clear or paradigm cases of X and to say "this is X because . . .," and follow it up with an account of features which logically clinch the matter.

Nothing like this is possible with aesthetic terms. Examples undoubtedly play a crucial role in giving us a grasp of these concepts; but we do not and cannot derive from these examples conditions and principles, however complex, which will enable us, if we are consistent, to apply the terms even to some new cases. When, with a clear case of something which is in fact graceful or balanced but which I have not seen, someone tells me what features make it so, it is always possible for me to wonder whether, in spite of these features, it really is graceful or balanced.

My point may be reinforced thus. A man who failed to realize the nature of aesthetic concepts, or who, knowing he lacked sensitivity in aesthetic matters, did not want to reveal this lack might by assiduous application and shrewd observation provide himself with some rules and generalizations; and by inductive procedures and intelligent guessing, he might frequently say the right things. But he could have no great confidence or certainty; a slight change in an object might at any time unpredictably ruin his calculations, and he might as easily have been wrong as right. No matter how careful he has been about working out a set of consistent principles and conditions, he is only in a position to think that the object is very possible delicate. With concepts like *lazy, intelligent,* or *contract,* someone who intelligently formulated rules that led him aright appreciably often *would* thereby show the beginning of a grasp of those concepts; but the person we are considering is not even beginning to show an awareness of what delicacy is. Though he sometimes says the right thing, he has not seen, but guessed, that the object is delicate. However intelligent he might be, we could easily tell him wrongly that something was delicate and "explain" why without his being able to detect the deception. (I am ignoring complications now about negative conditions.) But if we did the same

with, say, "intelligent" he could at least often uncover some incompatibility which would need explaining. In a world of beings like himself he would have no use for concepts like delicacy. As it is, these concepts would play a quite different role in his life. He would for himself, have no more reason to choose tasteful objects, pictures, and so on, than a deaf man would to avoid noisy places. He could not be praised for exercising taste; at best his ingenuity and intelligence might come in for mention. In "appraising" pictures, statuettes, poems, he would be doing something quite different from what other people do when they exercise taste.

At this point I want to notice in passing that there are times when it may look as if an aesthetic word could be applied according to a rule. These cases vary in type; I shall mention only one. One might say, in using "delicate" of glassware perhaps, that the thinner the glass, other things being equal, the more delicate it is. Similarly, with fabrics, furniture, and so on, there are perhaps times when the thinner or more smoothly finished or more highly polished something is, the more certainly some aesthetic term or other applies. On such occasions someone might formulate a rule and follow it in applying the word to a given range of articles. Now it may be that sometimes when this is so, the word being used is not really an aesthetic term at all; "delicate" applied to glass in this way may at times really mean no more than "thin" or "fragile." But this is certainly not always the case; people often *are* exercising taste even when they say that glass is very delicate because it is so thin, and know that it would be less so if thicker and more so if thinner. These instances where there appear to be rules are peripheral cases of the use of aesthetic terms. If someone did merely follow a rule we should not say he was exercising taste, and we should hesitate to admit that he had any real notion of delicacy until he satisfied us that he could discern it in other instances where no rule was available. In any event, these occasions when aesthetic words can be applied by rule are exceptional not central or typical, and there is still no reason to think we are dealing with a logical entailment.[6]

[6]I cannot in the compass of this paper discuss the other types of apparent exceptions to my thesis. Cases where a man *lacking* in sensitivity might learn and follow a rule, as above, ought to be distinguished from cases where someone who *possesses* sensitivity might know, from a non-aesthetic description, that an aesthetic term applies. I have stated my thesis as though this latter kind of case never occurs because I have had my eye on the logical features of *typical* aesthetic judgments and have preferred to over- rather than understate my view. But with certain aesthetic terms, especially negative ones, there may perhaps be some rare genuine exceptions when a description enables us to visualize very fully, and when what is described belongs to certain restricted classes of things, say human faces or animal forms. Perhaps a description like "One eye red and rheumy, the other missing, a wart-covered nose, a twisted mouth, a greenish pallor" may justify in a strong sense ("must be," "cannot but be") the judgments "ugly" or "hideous." If so, such cases are marginal, form a very small minority, and are uncharacteristic or atypical of aesthetic judgments in general. Usually, when, on hearing a description, we say "it *must* be very beautiful (graceful, or the like)," we mean no more than "it surely must be, it's only remotely possible that it isn't." Different again are situations, and these are very numerous, where we can move quite simply from "bright colours" to "gay," or from "reds and yellows" to "warm," but where we are as yet only on the borderline of anything that could be called an expression of taste or aesthetic sensibility. I have stressed the importance of this transitional and border area between non-aesthetic and obviously aesthetic judgments below.

It must not be thought that the impossibility of stating any conditions (other than negative) for the application of aesthetic terms results from an accidental poverty or lack of precision in language, or that it is simply a question of extreme complexity. It is true that words like "pink," "bluish," "curving," "mottled" do not permit of anything like a specific naming of each and every varied shade, curve, mottling, and blending. But if we were to give special names much more liberally than either we or even the specialists do (and no doubt there are limits beyond which we could not go), or even if, instead of names, we were to use vast numbers of specimens and samples of particular shades, shapes, mottlings, lines, and configurations, it would still be impossible, and for the same reasons, to supply any conditions.

We do indeed, in talking about a work of art, concern ourselves with its individual and specific features. We say that it is delicate not simply because it is in pale colours but because of *those* pale colours, that it is graceful not because its outline curves slightly but because of *that* particular curve. We use expressions like "because of its *pale* colouring," "because of *the* flecks of bright blue," "because of *the* way the lines converge" where it is clear we are referring not to the presence of general features but to very specific and particular ones. But it is obvious that even with the help of precise names, or even samples and illustrations, of particular shades of colour, contours and lines, any attempt to state conditions would be futile. After all, the very same feature, say a colour or shape or line of a particular sort, which helps make one work may quite spoil another. "It would be quite delicate if it were not for that pale colour there" may be said about the very colour which is singled out in another picture as being largely responsible for its delicate quality. No doubt one way of putting this is to say that the features which make something delicate or graceful, and so on, are combined in a peculiar and unique way; that the aesthetic quality depends upon exactly this individual or unique combination of just these specific colours and shapes so that even a slight change might make all the difference. Nothing is to be achieved by trying to single out or separate features and generalizing about them.

I have now argued that in certain ways aesthetic concepts are not and cannot be condition- or rule-governed.[7] Not to be so governed is one of their essential characteristics. In arguing this I first claimed in a general way that no non-aesthetic features are possible candidates for conditions, and then considered more particularly both the "characteristic" *general* features associated with aesthetic terms and the individual or *specific* features found in particular objects. I have not attempted to examine what relationship these specific fea-

[7]Helen Knight says (Elton, op. cit., p. 152) that "piquant" (one of my "aesthetic" terms) "depends on" various features (a *retroussé* nose, a pointed chin, and the like), and that these features are *criteria* for it; this second claim is what I am denying. She also maintains that "good," when applied to works of art, depends on *criteria* like balance, solidity, depth, profundity (my aesthetic terms again; I should place piquancy in this list). I would deny this too, though I regard it as a different question and do not consider it in this paper. The two questions need separating: the relation of nonaesthetic features (*retroussé*, pointed) to aesthetic qualities, and the relation of aesthetic qualities to "aesthetically good" (verdicts). Most writings which touch on the nature of aesthetic concepts have this other (verdict) question mainly in mind. Mrs. Knight blurs this difference when she says, for example, " 'piquant' is the same kind of word as 'good.' "

tures of a work do bear to its aesthetic qualities. An examination of the locutions we use when we refer to them in the course of explaining or supporting our application of an aesthetic term reinforces with linguistic evidence the fact that we are certainly not offering them as explanatory or justifying *conditions*. When we are asked why we say a certain person is lazy or intelligent or courageous, we are being asked in virtue of what we *call* him this; we reply with "because of the way he regularly leaves his work unfinished," or "because of the ease with which he handles such and such problems," and so on. But when we are asked to say why, in our opinion, a picture lacks balance or is sombre in tone, or why a poem is moving or tightly organized, we are doing a different kind of thing. We may use similar locutions: "his verse has strength and variety *because of the way* he handles the metre and employs the caesura," or "it is nobly austere *because* of the lack of detail and the restricted palette." But we can also express what we want to by using quite other expressions: "it is the handling of metre and caesura which is *responsible for* its strength and variety," "its nobly austere quality is *due to* the lack of detail and the use of a restricted palette," "its lack of balance *results from* the highlighting of the figures on the left," "those minor chords *make it* extremely moving," "those converging lines *give it* an extraordinary unity." These are locutions we cannot switch to with "lazy" or "intelligent"; to say what *makes* him lazy, is *responsible* for his laziness, what it is *due to,* is to broach another question entirely.

One after another, in recent discussions, writers have insisted that aesthetic judgments are not "mechanical": "Critics do not formulate general standards and apply these mechanically to all, or to classes of, works of art." "Technical points can be settled rapidly, by the application of rules," but aesthetic questions "cannot be settled by any mechanical method." Instead, these writers on aesthetics have emphasized that there is no "substitute for individual judgment" with its "spontaneity and speculation" and that "The final standard . . . [is] the judgment of personal taste."[8] What is surprising is that, though such things have been repeated again and again, no one seems to have said what is meant by "taste" or by the word "mechanical." There are many judgments besides those requiring taste which demand "spontaneity" and "individual judgment" and are not "mechanical." Without a detailed comparison we cannot see in what particular way *aesthetic* judgments are not "mechanical," or how they differ from those other judgments, nor can we begin to specify what taste is. This I have attempted. It is a characteristic and essential feature of judgments which employ an aesthetic term that they cannot be made by appealing, in the sense explained, to non-aesthetic conditions.[9] This, I believe is a logical feature of aesthetic or taste judgments in general though I have argued it here only as regards the more restricted range of judgments which employ aesthetic terms. It is part of what "taste" means.

[8]See articles by Margaret Macdonald and J. A. Passmore in Elton, op. cit., pp. 118, 41, 40, 119.
[9]As I indicated, . . . above. I have dealt only with the relation of *non-aesthetic* to aesthetic features. Perhaps a description in *aesthetic* terms may occasionally suffice for applying another aesthetic term. Johnson's Dictionary gives "handsome" as "beautiful with dignity"; Shorter O.E.D. gives "pretty" as "beautiful in a slight, dainty, or diminutive way."

II

A great deal of work remains to be done on aesthetic concepts. In the remainder of this paper I shall offer further suggestions which may help towards an understanding of them.

The realization that aesthetic concepts are governed only negatively by conditions is likely to give rise to puzzlement over how we manage to apply the words in our aesthetic vocabulary. If we are not following rules and there are no conditions to appeal to, how are we to know when they are applicable? One very natural way to counter this question is to point out that some other sorts of concepts also are not condition-governed. We do not apply simple colour words by following rules or in accordance with principles. We see that the book is red by looking, just as we tell that the tea is sweet by tasting it. So too, it might be said, we just see (or fail to see) that things are delicate, balanced, and the like. This kind of comparison between the exercise of taste and the use of the five senses is indeed familiar; our use of the word "taste" itself shows that the comparison is age-old and very natural. Yet whatever the similarities, there are great dissimilarities too. A careful comparison cannot be attempted here though it would be valuable; but certain differences stand out, and writers who have emphasized that aesthetic judgments are not "mechanical" have sometimes dwelt on and been puzzled by them.

In the first place, while our ability to discern aesthetic features is dependent upon our possession of good eyesight, hearing, and so on, people normally endowed with senses and understanding may nevertheless fail to discern them. "Those who listen to a concert, walk round a gallery, read a poem may have roughly similar sense perceptions, but some get a great deal more than others," Miss Macdonald says; but she adds that she is "puzzled by this feature 'in the object' which can be seen only by a specially qualified observer" and asks, "What is this 'something more'?"[10]

It is this difference between aesthetic and perceptual qualities which in part leads to the view that "works of art are esoteric objects . . . not simple objects of sense perception."[11] But there is no good reason for calling an object esoteric simply because we discern aesthetic qualities in it. The *objects* to which we apply aesthetic words are of the most diverse kinds and by no means esoteric: people and buildings, flowers and gardens, vases and furniture, as well as poems and music. Nor does there seem any good reason for calling the *qualities* themselves esoteric. It is true that someone with perfect eyes or ears might miss them, but we do after all say we *observe* or *notice* them ("Did you notice how very grateful she was?," "Did you observe the exquisite balance in all his pictures?"). In fact, they are very familiar indeed. We learn while quite young to use many aesthetic words, though they are, as one might expect from their dependence upon our ability to see, hear, distinguish colours, and the like, not the earliest words we learn: and our mastery and sophistication in using them

[10]Macdonald in Elton, op. cit., pp. 114, 119. See also pp. 120, 122.
[11]Macdonald, ibid., pp. 114, 120–3. She speaks of non-aesthetic properties here as "physical" or "observable" qualities, and distinguishes between "physical objects" and "work of art."

develop along with the rest of our vocabulary. They are not rarities; some ranges of them are in regular use in everyday discourse.

The second notable difference between the exercise of taste and the use of the five senses lies in the way we support those judgments in which aesthetics concepts are employed. Although we use these concepts without rules or conditions, we do defend or support our judgments, and convince others of their rightness, by talking; "disputation about art is not futile," as Miss Macdonald says, for critics do "attempt a certain kind of explanation of works of art with the object of establishing correct judgments."[12] Thus even though this disputation does not consist in "deductive or inductive inference" or "reasoning," its occurrence is enough to show how very different these judgments are from those of a simple perceptual sort.

Now the critic's talk, it is clear, frequently consists in mentioning or pointing out the features, including easily discernible non-aesthetic ones, upon which the aesthetic qualities depend. But the puzzling question remains how, by mentioning these features, the critic is thereby justifying or supporting his judgments. To this question a number of recent writers have given an answer. Stuart Hampshire, for example, says that "One engages in aesthetic discussion for the sake of what one might see on the way . . . if one has been brought to see what there is to be seen in the object, the purpose of discussion is achieved. . . . The point is to bring people to see these features."[13] The critic's talk, that is, often serves to support his judgments in a special way; it helps us to *see* what he has seen, namely, the aesthetic qualities of the object. But even when it is agreed that this is one of the main things that critics do, puzzlement tends to break out again over *how* they do it. How is it that by talking about features of the work (largely non-aesthetic ones) we can manage to bring others to see what they had not seen? "What sort of endowment is this which *talking* can modify? . . . Discussion does not improve eyesight and hearing" (my italics).[14]

Yet of course we do succeed in applying aesthetic terms, and we frequently do succeed by talking (and pointing and gesturing in certain ways) in bringing others to see what we see. One begins to suspect that puzzlement over how we can possibly do this, and puzzlement over the "esoteric" character of aesthetic qualities too, arises from bearing in mind inappropriate philosophical models. When someone is unable to see that the book on the table is brown, we cannot get him to see that it is by talking; consequently it seems puzzling that we might get someone to see that the vase is graceful by talking. If we are to dispel this puzzlement and recognize aesthetic concepts and qualities for what they are, we must abandon unsuitable models and investigate how we actually employ these concepts. With so much interest in and agreement about *what* the critic does, one might expect descriptions of *how* he does it to have been given. But little has been said about this, and what has been said is unsatisfactory.

[12]Ibid., pp. 115–116; cf. also John Holloway, *Proceedings of the Aristotelian Society*, Supplementary Vol. xxiii (1949), pp. 175–176.

[13]Stuart Hampshire in Elton, op. cit., p. 165. Cf. also remarks in Elton by Isenberg (pp. 142, 145), Passmore (p. 38), in *Philosophy and Psycho-analysis* by John Wisdom (Oxford, 1953), pp. 223–224, and in Holloway, op. cit., p. 175.

[14]Macdonald, op. cit., pp. 119–120.

Miss Macdonald,[15] for example, subscribes to this view of the critic's task as presenting "what is not obvious to casual or uninstructed inspection," and she does ask the question "What sort of considerations are involved, *and how*, to justify a critical verdict?" (my italics). But she does not in fact go on to answer it. She addresses herself instead to the different, though related, question of the interpretation of art works. In complex works different critics claim, often justifiably, to discern different features; hence Miss Macdonald suggests that in critical discourse the critic is bringing us to see what he sees by offering new interpretations. But if the question is "what [the critic] does and how he does it," he cannot be represented either wholly or even mainly as providing new interpretations. His task quite as often is simply to help us appreciate qualities which other critics have regularly found in the works he discusses. To put the stress upon *new* interpretations is to leave untouched the question how, by talking, he can help us to see *either* the newly appreciated aesthetic qualities *or* the old. In any case, besides complex poems or plays which may bear many interpretations, there are also relatively simple ones. There are also vases, buildings, and furniture, not to mention faces, sunsets, and scenery, about which no questions of "interpretation" arise but about which we talk in similar ways and make similar judgments. So the "puzzling" questions remain: how do we support these judgments and how do we bring others to see what we see?

Hampshire,[16] who likewise believes that the critic brings us "to see what there is to be seen in the object," does give some account of how the critic does this. "The greatest service of the critic" is to point out, isolate, and place in a frame of attention the "particular features of the particular object which *make it ugly or beautiful*"; for it is "difficult to see and hear all that there is to see and hear," and simply a prejudice to suppose that while "things really do have colours and shapes . . . there do not exist literally and objectively, concordances of colours and perceived rhythms and balances of shapes." However, these "extraordinary qualities" which the critic "may have seen (in the wider sense of 'see')" are "qualities which are of no direct practical interest." Consequently, to bring us to see them the critic employs "an unnatural use of words in description"; "the common vocabulary, being created for practical purposes, obstructs any disinterested perception of things"; and so these qualities "are normally described metaphorically by some transference of terms from the common vocabulary."

Much of what Hampshire says is right. But there is also something quite wrong in the view that the "common" vocabulary "obstructs" our aesthetic purposes, that it is "unnatural" to take it over and use it metaphorically, and that the critic "is under the necessity of building . . . a vocabulary *in opposition to the main tendency of his language*" (my italics). First, while we do often coin new metaphors in order to describe aesthetic qualities, we are by no means always under the necessity of wresting the "common vocabulary" from its "natural" uses to serve our purposes. There does exist, as I observed earlier, a

[15]Ibid., see pp. 127, 122, 125, 115. Other writers also place the stress on interpretation, cf. Holloway, op. cit., p. 173 ff.
[16]Op. cit., pp. 165–168.

large and accepted vocabulary of aesthetic terms some of which, whatever their metaphorical origins, are now not metaphors at all, others of which are at most quasi-metaphorical. Second, this view that our use of metaphor and quasi-metaphor for aesthetic purposes is unnatural or a makeshift into which we are forced by a language designed for other purposes misrepresents fundamentally the character of aesthetic qualities and aesthetic language. There is nothing unnatural about using words like "forceful," "dynamic," or "tightly-knit" in criticism; they do their work perfectly and are exactly the words needed for the purposes they serve. We do not want or need to replace them by words which lack the metaphorical element. In using them to describe works of art, the very point is that we are noticing aesthetic qualities related to their literal or common meanings. If we possessed a quite different word from "dynamic," one we could use to point out an aesthetic quality unrelated to the common meaning of "dynamic," it could not be used to describe that quality which "dynamic" does serve to point out. Hampshire pictures "a colony of aesthetes, disengaged from practical needs and manipulations" and says that "descriptions of aesthetic qualities, which for us are metaphorical, might seem to them to have an altogether literal and familiar sense"; they might use "a more directly descriptive vocabulary." But if they had a new and "directly descriptive" vocabulary lacking the links with non-aesthetic properties and interests which our vocabulary possesses, they would have to remain silent about many of the aesthetic qualities we can describe; further, if they were more completely "disengaged from practical needs" and other non-aesthetic awareness and interests, they would perforce be blind to many aesthetic qualities we can appreciate. The links between aesthetic qualities and non-aesthetic ones are both obvious and vital. Aesthetic concepts, all of them, carry with them attachments and in one way or another are tethered to or parasitic upon non-aesthetic features. The fact that many aesthetic terms are metaphorical or quasi-metaphorical in no way means that common language is an ill-adapted tool with which we have to struggle. When someone writes as Hampshire does, one suspects again that critical language is being judged against other models. To use language which is frequently metaphorical might be strange for some *other* purpose or from the standpoint of doing something else, but for the purpose and from the standpoint of making aesthetic observations it is not. To say it is an unnatural use of language for doing *this* is to imply there is or could be for this purpose some other and "natural" use. But these *are* natural ways of talking about aesthetic matters.

 To help understand what the critic does, then, how he supports his judgments and gets his audience to see what he sees, I shall attempt a brief description of the methods we use as critics.[17]

 (1) We may simply mention or point out non-aesthetic features: "Notice these flecks of colour, that dark mass there, those lines." By merely drawing attention to those easily discernible features which make the painting luminous or warm or dynamic, we often succeed in bringing someone to see these aesthetic qualities. We get him to see B by mentioning something different, A. Sometimes in doing this we are drawing attention to features which may have

[17]Holloway, op. cit., pp. 173–174, lists some of these very briefly.

gone unnoticed by an untrained or insufficiently attentive eye or ear: "Just listen for the repeated figure in the left hand," "Did you notice the figure of Icarus in the Breughel? It is very small." Sometimes they are features which have been seen or heard but of which the significance or purpose has been missed in any of a variety of ways: "Notice how much darker he has made the central figure, how much brighter these colours are than the adjacent ones," "Of course, you've observed the ploughman in the foreground; but had you considered how he, like everyone else in the picture, is going about his business without noticing the fall of Icarus?" In mentioning features which may be discerned by anyone with normal eyes, ears, and intelligence, we are singling out what may serve as a kind of key to grasping or seeing something else (and the key may not be the same for each person).

(2) On the other hand we often simply mention the very qualities we want people to see. We point to a painting and say, "Notice how nervous and delicate the drawing is," or "See what energy and vitality it has." The use of the aesthetic term itself may do the trick; we say what the quality or character is, and people who had not seen it before see it.

(3) Most often, there is a linking of remarks about aesthetic and non-aesthetic features: "Have you noticed this line and that, and the points of bright colour here and there . . . don't they give it vitality, energy?"

(4) We do, in addition, often make extensive and helpful use of similes and genuine metaphors: "It's as if there are small points of light burning," "as though he had thrown on the paint violently and in anger," "the light shimmers, the lines dance, everything is air, lightness and gaiety," "his canvasses are fires, they crackle, burn, and blaze, even at their most subdued always restlessly flickering, but often bursting into flame, great pyrotechnic displays," and so on.

(5) We make use of contrasts, comparisons, and reminiscences: "Suppose he had made that a lighter yellow, moved it to the right, how flat it would have been," "Don't you think it has something of the quality of a Rembrandt?," "Hasn't it the same serenity, peace, and quality of light of those summer evenings in Norfolk?" We use what keys we have to the known sensitivity, susceptibilities, and experience of our audience.

Critics and commentators may range, in their methods, from one extreme to the other, from painstaking concentration on points of detail, line and colour, vowels and rhymes, to more or less flowery and luxuriant metaphor. Even the enthusiastic biographical sketch decorated with suitable epithet and metaphor may serve. What is best depends on both the audience and the work under discussion. But this would not be a complete sketch unless certain other notes were added.

(6) Repetition and reiteration often play an important role. When we are in front of a canvas we may come back time and again to the same points, drawing attention to the same lines and shapes, repeating the same words, "swirling," "balance," "luminosity," or the same similes and metaphors, as if time and familiarity, looking harder, listening more carefully, paying closer attention may help. So again with variation; it often helps to talk round what we have said, to build up, supplement with more talk *of the same kind*. When someone misses the swirling quality, when one epithet or one metaphor does

not work, we throw in related ones; we speak of its wild movement, how it twists and turns, writhes and whirls, as though, failing to score a direct hit, we may succeed with a barrage of near-synonyms.

(7) Finally, besides our verbal performances, the rest of our behaviour is important. We accompany our talk with appropriate tones of voice, expression, nods, looks, and gesture. A critic may sometimes do more with a sweep of the arm than by talking. An appropriate gesture may make us see the violence in a painting or the character of a melodic line.

These ways of acting and talking are not significantly different whether we are dealing with a particular work, paragraph, or line, or speaking of an artist's work as a whole, or even drawing attention to a sunset or scenery. But even with the speaker doing all this, we may fail to see what he sees. There may be a point, though there need be no limit except that imposed by time and patience, at which he gives up and sets us (or himself) down as lacking in some way, defective in sensitivity. He may tell us to look or read again, or to read or look at other things and then come back again to this; he may suspect there are experiences in life we have missed. But these are the things he does. This is what succeeds if anything does; indeed it is all that can be done.

But realizing clearly that, whether we are dealing with art or scenery or people or natural objects, this is how we operate with aesthetic concepts, we may recognize this sphere of human activity for what it is. We operate with different kinds of concepts in different ways. If we want someone to agree that a colour is red we may take it into a good light and ask him to look; if it is viridian we may fetch a colour chart and make him compare; if we want him to agree that a figure is fourteen-sided we get him to count; and to bring him to agree that something is dilapidated or that someone is lazy we may do other things, citing features and reasoning and arguing about them. These are the methods appropriate to these various concepts. But the ways we get someone to see aesthetic qualities are different; they are of the kind I have described. With each kind of concept we can describe what we do and how we do it. But the methods suited to these other concepts will not do for aesthetic ones, or vice versa. We cannot prove by argument or by assembling a sufficiency of conditions that something is graceful; but this is no more puzzling than our inability to prove, by using the methods, metaphors, and gestures of the art critic, that it will be mate in ten moves. The questions raised admit of no answer beyond the sort of description I have given. To go on to ask, with puzzlement, how it is that *when* we do these things people come to see, is like asking how is it that, when we take the book into a good light, our companion agrees with us that it is red. There is no place for this kind of question or puzzlement. Aesthetic concepts are as natural, as little esoteric, as any others. It is against the background of different and philosophically more familiar models that they seem puzzling.

I have described how people justify aesthetic judgments and bring others to see aesthetic qualities in things. I shall end by showing that the methods I have outlined are the ones natural for and characteristic of taste concepts from the start. When someone tries to make me see that a painting is delicate or balanced, I have some understanding of these terms already and know in a sense what I am looking for. But if there is puzzlement over how, by talking, he can

bring me to see these qualities in this picture, there should be equal puzzle-
ment over how I learned to use aesthetic terms and discern aesthetic qualities
in the first place. We may ask, therefore, how we learn to do these things; and
this is to inquire (1) what natural potentialities and tendencies people have
and (2) how we develop and take advantage of these capacities in training and
teaching. Now for the second of these there is no doubt that our ability to
notice and respond to aesthetic qualities is cultivated and developed by our
contacts with parents and teachers from quite an early age. What is interest-
ing for my present purpose is that, while we are being taught in the presence
of examples what grace, delicacy and so on are, the methods used, the lan-
guage and behaviour, are of a piece with those of the critic as I have already
described them.

To pursue these two questions, consider first those words like "dynamic,"
"melancholy," "balanced," "taut," or "gay" the aesthetic use of which is quasi-
metaphorical. It has already been emphasized that we could not use them thus
without some experience of situations where they are used literally. The pre-
sent inquiry is how we shift from literal to aesthetic uses of them. For this it
is required that there be certain abilities and tendencies to link experiences, to
regard certain things as similar, and to see, explore, and be interested in these
similarities. It is a feature of human intelligence and sensitivity that we do
spontaneously do these things and that the tendency can be encouraged and
developed. It is no more baffling that we should employ aesthetic terms of this
sort than that we should make metaphors at all. Easy and smooth transitions
by which we shift to the use of these aesthetic terms are not hard to find. We
suggest to children that simple pieces of music are hurrying or running or skip-
ping or dawdling, from there we move to lively, gay, jolly, happy, smiling, or
sad, and, as their experiences and vocabulary broaden, to solemn, dynamic, or
melancholy. But the child also discovers for himself many of these parallels
and takes interest or delight in them. He is likely on his own to skip, march,
clap, or laugh with the music, and without this natural tendency our training
would get nowhere. In so far, however, as we do take advantage of this ten-
dency and help him by training, *we do just what the critic does.* We may merely
need to persuade the child to pay attention, to look or listen; or we may sim-
ply *call* the music jolly. But we are also likely to use, as the critic does, reiter-
ation, synonyms, parallels, contrasts, similes, metaphors, gestures, and other
expressive behavior.

Of course the recognition of similarities and simple metaphorical exten-
sions are not the only transitions to the aesthetic use of language. Others are
made in different ways; for instance, by the kind of peripheral cases I men-
tioned earlier. When our admiration is for something as simple as the thinness
of a glass or the smoothness of a fabric, it is not difficult to call attention to
such things, evoke a similar delight, and introduce suitable aesthetic terms.
These transitions are only the beginnings; it may often be questionable whether
a term is yet being used aesthetically or not. Many of the terms I have men-
tioned may be used in ways which are not straightforwardly literal but of
which we should hesitate to say that they demanded much yet by way of aes-
thetic sensitivity. We speak of warm and cool colours, and we may say of a
brightly coloured picture that at least it is gay and lively. When we have

brought someone to make this sort of metaphorical extension of terms, he has made one of the transitional steps from which he may move on to uses which more obviously deserve to be called aesthetic and demand a more obviously aesthetic appreciation. When I said at the outset that aesthetic sensitivity was rarer than some other natural endowments, I was not denying that it varies in degree from the rudimentary to the refined. Most people learn easily to make the kinds of remarks I am now considering. But when someone can call bright canvasses gay and lively without being able to spot the one which is really vibrant, or can recognize the obvious outward vigor and energy of a student composition played *con fuoco* while failing to see that it lacks inner fire and drive, we do not regard his aesthetic sensitivity in these areas as particularly developed. However, once these transitions from common to aesthetic uses are begun in the more obvious cases, the domain of aesthetic concepts may broaden out, and they become more subtle and even partly autonomous. The initial steps, however varied the metaphorical shifts and however varied the experiences upon which they are parasitic, are natural and easy.

Much the same is true when we turn to those words which have no standard non-aesthetic use, "lovely," "pretty," "dainty," "graceful," "elegant." We cannot say that these are learned by a metaphorical shift. But they still are linked to non-aesthetic features in many ways and the learning of them also is made possible by certain kinds of natural response, reaction, and ability. We learn them not so much by noticing similarities, but by our attention being caught and focused in other ways. Certain phenomena which are outstanding or remarkable or unusual catch the eye or ear, seize our attention and interest, and move us to surprise, admiration, delight, fear, or distaste. Children begin by reacting in these ways to spectacular sunsets, woods in autumn, roses, dandelions, and other striking and colourful objects, and it is in these circumstances that we find ourselves introducing general aesthetic words to them, like "lovely," "pretty," and "ugly." It is not an accident that the first lessons in aesthetic appreciation consist in drawing the child's attention to roses rather than to grass; nor is it surprising that we remark to him on the autumn colour rather than on the subdued tints of winter. We all of us, not only children, pay aesthetic attention more readily to such outstanding and easily noticeable things. We notice with pleasure early spring grass or the first snow, hills of notably marked and varied contours, scenery flecked with a great variety of colour or dappled variously with sun and shadow. We are struck and impressed by great size or mass, as with mountains or cathedrals. We are similarly responsive to unusual precision or minuteness or remarkable feats of skill, as with complex and elaborate filigree, or intricate wood carving and fan-vaulting. It is at these times, taking advantage of these natural interests and admirations, that we first teach the simpler aesthetic words. People of moderate aesthetic sensitivity and sophistication continue to exhibit aesthetic interest mainly on such occasions and to use only the more general words ("pretty," "lovely," and the like). But these situations may serve as a beginning from which we extend our aesthetic interests to wider and less obvious fields, mastering as we go the more subtle and specific vocabulary of taste. The principles do not change; the basis for learning more specific terms like "graceful," "delicate," and "elegant" is also our interest in and admiration for various non-

aesthetic natural properties ("She seems to move *effortlessly,* as if floating," "So very *thin* and *fragile,* as if a breeze might destroy it," "So *small* and yet so *intricate,*" "So *economical* and perfectly *adapted*").[18] And even with these aesthetic terms which are not metaphorical themselves ("graceful," "delicate," "elegant"), we rely in the same way upon the critic's methods, including comparison, illustration, and metaphor, to teach or make clear what they mean.

I have wished to emphasize in the latter part of this paper the natural basis of responses of various kinds without which aesthetic terms could not be learned. I have also outlined what some of the features are to which we naturally respond: similarities of various sorts, notable colours, shapes, scents, size, intricacy, and much else besides. Even the non-metaphorical aesthetic terms have significant links with all kinds of natural features by which our interest, wonder, admiration, delight, or distaste is aroused. But in particular I have wanted to urge that it should not strike us as puzzling that the critic supports his judgment and brings us to see aesthetic qualities by pointing out key features and talking about them in the way he does. It is by the very same methods that people helped us develop our aesthetic sense and master its vocabulary from the beginning. If we responded to those methods then, it is not surprising that we respond to the critic's discourse now. It would be surprising if, by using this language and behavior, people could *not* sometimes bring us to see the aesthetic qualities of things; for this would prove us lacking in one characteristically human kind of awareness and activity.

READING 24

INTRODUCTION

In "Categories of Art" (1970), Kendall L. Walton, professor of philosophy at the University of Michigan, takes up a number of issues raised by earlier readings in this section, and by Frank Sibley in particular. Sibley argues that we may distinguish between the aesthetic and the non-aesthetic properties of a thing and that the former depend on the latter. Thus we can, in principle, recognize an object's aesthetic properties simply by looking at it, listening to it, touching it, tasting it, or whatever. Walton disagrees. The aesthetic properties of a work, he argues, depend

[18]It is worth noticing that most of the words which in current usage are primarily or exclusively aesthetic terms had earlier non-aesthetic uses and gained their present use by some kind of metaphorical shift. Without reposing too great weight on these etymological facts, it can be seen that their history reflects connections with the responses, interests, and natural features I have mentioned as underlying the learning and use of aesthetic terms. These transitions suggest both the dependence of aesthetic upon other interests, and what some of these interests are. Connected with liking, delight, affection, regard, estimation, or choice—*beautiful, graceful, delicate, lovely, exquisite, elegant, dainty;* with fear or repulsion—*ugly;* with what notably catches the eye or attention—*garish, splendid, gaudy;* with what attracts by notable rarity, precision, skill, ingenuity, elaboration—*dainty, nice, pretty, exquisite;* with adaptation to function, suitability to ease of handling—*handsome.*

not only upon its non-aesthetic, perceptual properties, but also upon "which of its nonaesthetic properties are 'standard,' which 'variable,' and which 'contra-standard'." And recognizing which of these classes a particular non-aesthetic property falls into demands more than merely looking at (listening to, touching, tasting, etc.) the thing; it demands a knowledge of the history of the work and of the medium and/or genre to which it belongs; a knowledge, that is, of which "category of art" it belongs to. Only a person who has the relevant knowledge will be able to recognize which of the properties of a thing are aesthetically significant. This leads Walton to consider the question that so occupied Hume and Kant: the question of the objectivity of aesthetic judgment. If the aesthetic judgments that we make about a work depend on which category we happen to see it in, does this mean that all aesthetic judgments are subjective? No, answers Walton. For, although what aesthetic properties a work has does depend on which category it is seen in, there are criteria for deciding which category a work is *correctly* to be seen in. It is the person who sees the work in the correct category who is in a position to make correct aesthetic judgments about it.

Categories of Art

Kendall L. Walton

I. Introduction

> False judgments enter art history if we judge from the impression which pictures of different epochs, placed side by side, make on us. . . . They speak a different language.[1]

Paintings and sculptures are to be looked at; sonatas and songs are to be heard. What is important about such works of art is what can be seen or heard in them.[2] This apparent truism has inspired attempts by aesthetic theorists to purge from criticism of works of art supposedly extraneous excursions into matters not available to inspection of the works, and to focus attention narrowly on the works themselves. Circumstances connected with a work's origin, in particular, are frequently held to have no essential bearing on an assessment of its aesthetic nature. Thus critics are advised to ignore how and when a work was created, the artist's intentions in creating it, his philosophical views, psychological state, personal life, the artistic traditions and intellectual atmosphere of his society, and so forth. Once produced, it is argued, a work must stand or fall on its own; it must be judged for what it is, regardless of how it came to be as it is.

Arguments for this position need not involve the claim that how and in what circumstances a work comes about is not of "aesthetic" interest or importance. One might consider an artist's action of producing a work to be aes-

[1] Heinrich Wölfflin, *Principles of Art History*, trans. by M. D. Hottinger (7th ed.; New York, 1929), p. 228.
[2] "[W]e should all agree, I think . . . that any quality that cannot even in principle be heard in it [a musical composition] does not belong to it as music." Monroe Beardsley, *Aesthetics: Problems in the Philosophy of Criticism* (New York, 1958), pp. 31–32.

thetically interesting, an "aesthetic object" in its own right, while vehemently denying its relevance to an aesthetic investigation of the work. Robert Rauschenberg once carefully obliterated a drawing by de Kooning, titled the bare canvas *Erased de Kooning Drawing,* framed it, and exhibited it.[3] His doing this might be taken as symbolic or expressive (of an attitude toward art, or toward life in general, or whatever) in an "aesthetically" significant manner, and yet thought to have no bearing whatever on the aesthetic nature of the finished product. The issue I am here concerned with is how far critical questions about works of art can be *separated* from questions about their histories.[4]

One who wants to make a sharp separation may regard the basic facts of art along the following lines. Works of art are simply objects with various properties, of which we are primarily interested in perceptual ones—visual properties of paintings, audible properties of music, and so forth.[5] A work's perceptual properties include "aesthetic" as well as "non-aesthetic" ones—the sense of mystery and tension of a painting as well as its dark coloring and diagonal composition; the energy, exuberance, and coherence of a sonata, as well as its meters, rhythms, pitches, timbres; the balance and serenity of a Gothic cathedral as well as its dimensions, lines, and symmetries.[6] Aesthetic properties are features or characteristics of works of art just as much as non-aesthetic ones are.[7] They are *in* the works, to be seen, heard, or otherwise perceived there. Seeing a painting's sense of mystery or hearing a sonata's coherence might require looking or listening longer or harder than does perceiving colors and shapes, rhythms and pitches; it may even require special training or a special kind of sensitivity. But these qualities must be discoverable simply by examining the works themselves if they are discoverable at all. It is never even partly *in virtue of* the circumstances of a work's origin that it has a sense of mystery or is coherent or serene. Such circumstances sometimes provide hints concerning what to look for in a work, what we might reasonably expect to find by examining it. But these hints are always theoretically dispensable; a work's aesthetic properties must "in principle" be ascertainable without their help. Surely (it seems) a Rembrandt portrait does not have (or lack) a sense of mystery in virtue of the fact that Rembrandt intended it to have (or to lack) that quality, any more than a contractor's intention to make

[3]Cf. Calvin Tompkins, *The Bride and the Bachelors* (New York, 1965), pp. 210–211.

[4]Monroe Beardsley argues for a relatively strict separation (*op. cit.,* pp. 17–34). Some of the strongest recent attempts to enforce this separation are to be found in discussions of the so-called "intentional fallacy," beginning with William Wimsatt and Beardsley, "The Intentional Fallacy," reprinted in this volume. Despite the name of the "fallacy" these discussions are not limited to consideration of the relevance of artists' *intentions.*

[5]The aesthetic properties of works of literature are not happily called "perceptual." For reasons connected with this it is sometimes awkward to treat literature together with the visual arts and music. (The notion of perceiving a work in a category, to be introduced shortly, is not straightforwardly applicable to literary works.) Hence in this paper I will concentrate on visual and musical works, though I believe that the central points I make concerning them hold, with suitable modifications, for novels, plays, and poems as well.

[6]Frank Sibley distinguishes between "aesthetic" and "nonaesthetic" terms and concepts in "Aesthetic Concepts," reprinted in this volume.

[7]Cf. Paul Ziff, "Art and the 'Object of Art,'" in Ziff, *Philosophic Turnings* (Ithaca, N.Y., 1966), pp. 12–16 (originally published in *Mind,* N.S. LX [1951]).

a roof leakproof makes it so; nor is the portrait mysterious in virtue of any other facts about what Rembrandt thought or how he went about painting the portrait or what his society happened to be like. Such circumstances are important to the result only in so far as they had an effect on the pattern of paint splotches that became attached to the canvas, and the canvas can be examined without in any way considering how the splotches got there. It would not matter in the least to the aesthetic properties of the portrait if the paint had been applied to the canvas not by Rembrandt at all, but by a chimpanzee or a cyclone in a paint shop.

The view sketched above can easily seem very persuasive. But the tendency of critics to discuss the histories of works of art in the course of justifying aesthetic judgments about them has been remarkably persistent. This is partly because hints derived from facts about a work's history, however dispensable they may be "in principle," are often crucially important in practice. (One might not think to listen for a recurring series of intervals in a piece of music, until he learns that the composer meant the work to be structured around it.) No doubt it is partly due also to genuine confusions on the part of critics. But I will argue that certain facts about the origins of works of art have an *essential* role in criticism, that aesthetic judgments rest on them in an absolutely fundamental way. For this reason, and for another as well, the view that works of art should be judged simply by what can be perceived in them is seriously misleading. Nevertheless there is something right in the idea that what matters aesthetically about a painting or a sonata is just how it looks or sounds.

II. Standard, Variable, and Contra-Standard Properties

I will continue to call tension, mystery, energy, coherence, balance, serenity, sentimentality, pallidness, disunity, grotesqueness, and so forth, as well as colors and shapes, pitches and timbres *properties* of works of art, though "property" is to be construed broadly enough not to beg any important questions. I will also, following Sibley, call properties of the former sort "aesthetic" properties, but purely for reasons of convenience I will include in this category "representational" and "resemblance" properties, which Sibley excludes—for example, the property of representing Napoleon, that of depicting an old man stooping over a fire, that of resembling, or merely suggesting, a human face, claws (the petals of van Gogh's sunflowers), or (in music) footsteps or conversation. It is not essential for my purposes to delimit with any exactness the class of aesthetic properties (if indeed any such delimitation is possible), for I am more interested in discussing particular examples of such properties than in making generalizations about the class as a whole. It will be obvious, however, that what I say about the examples I deal with is also applicable to a great many other properties we would want to call aesthetic.

Sibley points out that a work's aesthetic properties depend on its nonaesthetic properties; the former are "emergent" or *"Gestalt"* properties based on the latter.[8] I take this to be true of all the examples of aesthetic properties we will be dealing with, including representational and resemblance ones. It is because of the configuration of colors and shapes on a painting, perhaps in

[8]"Aesthetic and Nonaesthetic," *Philosophical Review,* LXXII (1965).

particular its dark colors and diagonal composition, that it has a sense of mystery and tension, if it does. The colors and shapes of a portrait are responsible for its resembling an old man and its depicting an old man. The coherence or unity of a piece of music (for example, Beethoven's *Fifth Symphony*) may be largely due to the frequent recurrence of a rhythmic motive, and the regular meter of a song plus the absence of harmonic modulation and of large intervals in the voice part may make it serene or peaceful.

Moreover, a work *seems* or *appears* to us to have certain aesthetic properties because we observe in it, or it appears to us to have, certain nonaesthetic features (though it may not be necessary to notice consciously all the relevant nonaesthetic features). A painting depicting an old man may not look like an old man to someone who is color-blind, or when it is seen from an extreme angle or in bad lighting conditions which distort or obscure its colors or shapes. Beethoven's *Fifth Symphony* performed in such a sloppy manner that many occurrences of the four-note rhythmic motive do not sound similar may seem incoherent or disunified.

I will argue, however, that a work's aesthetic properties depend not only on its nonaesthetic ones, but also on which of its nonaesthetic properties are "standard," which "variable," and which "contra-standard," in senses to be explained. I will approach this thesis by way of the psychological point that what aesthetic properties a work seems to us to have depends not only on what nonaesthetic features we perceive in it, but also on which of them are standard, which variable, and which contra-standard *for us* (in a sense also to be explained).

It is necessary to introduce first a distinction between standard, variable, and contra-standard properties relative to perceptually distinguishable categories of works of art. A category is perceptually distinguishable if membership in it is determined solely by features of works that can be perceived in them when they are experienced in the normal manner. The categories of painting, cubist painting, Gothic architecture, classical sonatas, painting in the style of Cézanne, music in the style of late Beethoven, and most other media, genre, styles, and forms can be construed as perceptually distinguishable. If we do construe them this way, we must, for example, regard whether a piece of music was written in the eighteenth century as irrelevant to whether it belongs to the category of classical sonatas, and we must take whether or not a work was produced by Cézanne or Beethoven to have nothing essential to do with whether or not it is in the style of Cézanne or late Beethoven. The category of etchings as normally understood is not perceptually distinguishable in the requisite sense, for to be an etching is, I take it, to have been produced in a particular manner. But the category of *apparent* etchings, works which *look* like etchings from the quality of their lines, whether or not they are etchings, is perceptually distinguishable.[9]

A feature of a work of art is *standard* with respect to a (perceptually dis-

[9]A category will not count as perceptually distinguishable in my sense if in order to determine perceptually whether something belongs to it, it is necessary (in some or all cases) to determine, on the basis of nonperceptual considerations, which categories it is correctly perceived in. (See Section IV below.) This prevents the category of serene things, for example, from being perceptually distinguishable.

tinguishable) category just in case it is among those in virtue of which works in that category belong to that category—that is, just in case the absence of that feature would disqualify, or tend to disqualify, a work from that category. A feature is *variable* with respect to a category just in case it has nothing to do with works belonging to that category; the possession or lack of the feature is irrelevant to whether a work qualifies for the category. Finally, a *contra-standard* feature with respect to a category is the absence of a standard feature with respect to that category—that is, a feature whose presence tends to *disqualify* works as members of the category. Needless to say, it will not be clear in *all* cases whether a feature of a work is standard, variable, or contra-standard relative to a given category, since the criteria for classifying works of art are far from precise. But clear examples are abundant. The flatness of a painting and the motionlessness of its markings are standard, and its particular shapes and colors are variable, relative to the category of painting. A protruding three-dimensional object or an electrically driven twitching of the canvas would be contra-standard relative to this category. The straight lines in stick-figure drawings and squarish shapes in cubist paintings are standard with respect to those categories respectively, though they are variable with respect to the categories of drawing and painting. The exposition-development-recapitulation form of a classical sonata is standard, and its thematic material is variable, relative to the category of sonatas.

In order to explain what I mean by features being standard, variable, or contra-standard *for a person on a particular occasion,* I must introduce the notion of perceiving a work in, or as belonging to, a certain (perceptually distinguishable) category. To perceive a work in a certain category is to perceive the *"Gestalt"* of that category in the work. This needs some explanation. People familiar with Brahmsian music (music in the style of Brahms—notably, works of Johannes Brahms) or impressionist paintings can frequently recognize members of these categories by recognizing the Brahmsian or impressionist *Gestalt* qualities. Such recognition is dependent on perception of particular features that are standard relative to these categories, but it is not a matter of *inferring* from the presence of such features that a work is Brahmsian or impressionist. One may not notice many of the relevant features, and he may be very vague about which ones are relevant. If I recognize a work as Brahmsian by first noting its lush textures, its basically traditional harmonic and formal structure, its superimposition and alternation of duple and triple meters, and so forth, and recalling that these characteristics are typical of Brahmsian works, I have not recognized it by hearing the Brahmsian *Gestalt*. To do that is simply to recognize it by its Brahmsian *sound*, without necessarily paying attention to the features ("cues") responsible for it. Similarly, recognizing an impressionist painting by its impressionist *Gestalt* is recognizing the impressionist *look* about it, which we are familiar with from other impressionist paintings; not applying a rule we have learned for recognizing it from its features.

To *perceive* a *Gestalt* quality in a work—that is, to perceive it in a certain category—is not, or not merely, to *recognize* that *Gestalt* quality. Recognition is a momentary occurrence, whereas perceiving a quality is a continuous state which may last for a short or long time. (For the same reason, seeing the ambiguous duck-rabbit figure as a duck is not, or not merely, recognizing a property of it.) We perceive the Brahmsian or impressionist *Gestalt* in a work

when, and as long as, it *sounds* Brahmsian or *looks* impressionist to us. This involves perceiving (not necessarily being aware of) features standard relative to that category. But it is not *just* this, nor this plus the intellectual realization that these features make the work Brahmsian, or impressionist. These features are perceived combined into a single *Gestalt* quality.

We can of course perceive a work in several or many different categories at once. A Brahms sonata might be heard simultaneously as a piece of music, a sonata, a romantic work, and a Brahmsian work. Some pairs of categories, however, seem to be such that one cannot perceive a work as belonging to both at once, much as one cannot see the duck-rabbit both as a duck and as a rabbit simultaneously. One cannot see a photographic image simultaneously as a still photograph and as (part of) a film, nor can one see something both in the category of paintings and at the same time in the category (to be explained shortly) of *guernicas*.

It will be useful to point out some of the *causes* of our perceiving works in certain categories. (*a*) In which categories we perceive a work depends in part, of course, on what other works we are familiar with. The more works of a certain sort we have experienced, the more likely it is that we will perceive a particular work in that category. (*b*) What we have heard critics and others say about works we have experienced, how they have categorized them, and what resemblances they have pointed out to us is also important. If no one has ever explained to me what is distinctive about Schubert's style (as opposed to the styles of, say, Schumann, Mendelssohn, Beethoven, Brahms, Hugo Wolf), or even pointed out that there is such a distinctive style, I may never have learned to hear the Schubertian *Gestalt* quality, even if I have heard many of Schubert's works, and so I may not hear his works as Schubertian. (*c*) How we are introduced to the particular work in question may be involved. If a Cézanne painting is exhibited in a collection of French Impressionist works, or if before seeing it we are told that it is French Impressionist, we are more likely to see it as French Impressionist than we would be if it is exhibited in a random collection and we are not told anything about it beforehand.

I will say that a feature of a work is standard for a particular person on a particular occasion when, and only when, it is standard relative to some category in which he perceives it, and is not contra-standard relative to any category in which he perceives it. A feature is variable for a person just when it is variable relative to *all* of the categories in which he perceives it. And a feature is contra-standard for a person just when it is contra-standard relative to *any* of the categories in which he perceives it.[10]

[10]I am ignoring some considerations that might be important at a later stage of investigation. In particular, I think it would be important at some point to distinguish between different *degrees* or *levels* of standardness, variableness, and contra-standardness for a person; to speak, e.g., of features being *more* or *less* standard for him. At least two distinct sorts of grounds for such differences of degree should be recognized. (*a*) Distinctions between perceiving a work in a certain category to a greater and lesser extent should be allowed for, with corresponding differences of degree in the standardness for the perceiver of properties relative to that category. (*b*) A feature which is standard relative to more, and/or more specific, categories in which a person perceives the work should thereby count as more standard for him. Thus, if we see something as a painting and also as a French Impressionist painting, features standard relative to both categories are more standard for us than features standard relative only to the latter.

III. A Point About Perception

I turn now to my psychological thesis that what aesthetic properties a work seems to have, what aesthetic effect it has on us, how it strikes us aesthetically often depends (in part) on which of its features are standard, which variable, and which contra-standard for us. I offer a series of examples in support of this thesis.

(a) Representational and resemblance properties provide perhaps the most obvious illustration of this thesis. Many works of art look like or resemble other objects—people, buildings, mountains, bowls of fruit, and so forth. Rembrandt's *Titus Reading* looks like a boy, and in particular like Rembrandt's son; Picasso's *Les Demoiselles d'Avignon* looks like five women, four standing and one sitting (though not *especially* like any particular women). A portrait may even be said to be a *perfect* likeness of the sitter, or to capture his image *exactly*.

An important consideration in determining whether a work *depicts* or *represents* a particular object, or an object of a certain sort (for example, Rembrandt's son, or simply *a* boy), in the sense of being a picture, sculpture, or whatever of it[11] is whether the work resembles that object, or objects of that kind. A significant degree of resemblance is, I suggest, a necessary condition in most contexts for such representation or depiction,[12] though the resemblance need not be obvious at first glance. If we are unable to see a similarity between a painting purportedly of a woman and women, I think we would have to suppose either that there is such a similarity which we have not yet discovered (as one might fail to see a face in a maze of lines), or that it simply is not a picture of a woman. Resemblance is of course not a *sufficient* condition for representation, since a portrait (containing only one figure) might resemble both the sitter and his twin brother equally but is not a portrait of both of them. (The title might determine which of them it depicts.)[13]

It takes only a touch of perversity, however, to find much of our talk about resemblances between works of art and other things preposterous. Paintings and people are *very* different sorts of things. Paintings are pieces of canvas supporting splotches of paint, while people are live, three-dimensional, flesh-and-blood animals. Moreover, except rarely and under special conditions of observation paintings and people *look* very different. Paintings look like pieces of canvas (or anyway flat surfaces) covered with paint and people look like flesh-and-blood animals. There is practically no danger of confusing them. How, then, can anyone seriously hold that a portrait resembles the sitter to

[11]This excludes, e.g., the sense of "represent" in which a picture might represent justice or courage, and probably other senses as well.

[12]This does not hold for the special case of photography. A photograph is a photograph of a woman no matter what it looks like, I take it, if a woman was in front of the lens when it was produced.

[13]Nelson Goodman denies that resemblance is necessary for representation—and obviously not merely because of isolated or marginal examples of nonresembling representations (p. 5). I cannot treat his arguments here, but rather than reject *en masse* the common-sense beliefs that pictures do resemble significantly what they depict and that they depict what they do partly because of such resemblances, if Goodman advocates rejecting them, I prefer to recognize a sense of "resemblance" in which these beliefs are true. My disagreement with him is perhaps less sharp than it appears since, as will be evident, I am quite willing to grant that the relevant resemblances are "conventional." Cf. Goodman, *Languages of Art* (Indianapolis, 1968), p. 39, n. 31.

any significant extent, let alone that it is a perfect likeness of him? Yet it remains true that many paintings strike us as resembling people, sometimes very much or even exactly—despite the fact that they look so very different!

To resolve this paradox we must recognize that the resemblances we perceive between, for example, portraits and people, those that are relevant in determining what works of art depict or represent, are resemblances of a somewhat special sort, tied up with the categories in which we perceive such works. The properties of a work which are standard for us are ordinarily irrelevant to what we take it to look like or resemble in the relevant sense, and hence to what we take it to depict or represent. The properties of a portrait which make it *so* different from, so easily distinguishable from, a person—such as its flatness and its *painted* look—are standard for us. Hence these properties just do not count with regard to what (or whom) it looks like. It is only the properties which are variable for us, the colors and shapes on the work's surface, that make it look to us like what it does. And these are the ones which are relevant in determining what (if anything) the work represents.[14]

Other examples will reinforce this point. A marble bust of a Roman emperor seems to us to resemble a man with, say, an aquiline nose, a wrinkled brow, and an expression of grim determination, and we take it to represent a man with, or as having, those characteristics. But why don't we say that it resembles and represents a perpetually motionless man, of uniform (marble) color, who is severed at the chest? It is similar to such a man, it seems, and much more so than to a normally colored, mobile, and whole man. But we are not struck by the former similarity when we see the bust, obvious though it is on reflection. The bust's uniform color, motionlessness, and abrupt ending at the chest are standard properties relative to the category of busts, and since we see it as a bust they are standard for us. Similarly, black-and-white drawings do not look to us like colorless scenes and we do not take them to depict things as being colorless, nor do we regard stick-figure drawings as resembling and depicting only very thin people. A cubist work might look like a person with a cubical head to someone not familiar with the cubist style. But the standardness of such cubical shapes for people who see it as a cubist work prevents them from making that comparison.

The shapes of a painting or a still photograph of a high jumper in action are motionless, but these pictures do not look to us like a high jumper frozen in midair. Indeed, depending on features of the pictures which are variable for us (the exact positions of the figures, swirling brush strokes in the painting, slight blurrings of the photographic image) the athlete may seem in a frenzy of activity; the pictures may convey a vivid sense of movement. But if static images exactly like those of the two pictures occur in a motion picture, and we see it as a motion picture, they probably would strike us as resembling a static athlete. This is because the immobility of the images is standard relative to the category of still pictures and variable relative to that of motion pictures.

[14]The connection between features variable for us and what the work looks like is by no means a straightforward or simple one, however. It may involve "rules" which are more or less "conventional" (e.g., the "laws" of perspective). Cf. E. H. Gombrich, *Art and Illusion* (New York, 1960) and Nelson Goodman, *op cit.*

(Since we are so familiar with still pictures it might be difficult to see the static images as motion pictures for very long, rather than as [filmed] still pictures. But we could not help seeing them that way if we had no acquaintance at all with the medium of still pictures.) My point here is brought out by the tremendous aesthetic difference we are likely to experience between a film of a dancer moving *very* slowly and a still picture of him, even if "objectively" the two images are very nearly identical. We might well find the former studied, calm, deliberate, laborious, and the latter dynamic, energetic, flowing, or frenzied.

In general, then, what we regard a work as resembling, and as representing, depends on the properties of the work which are variable, and not on those which are standard for us.[15] The latter properties serve to determine what *kind* of a representation the work is, rather than what it represents or resembles. We take them for granted, as it were, in representations of that kind. This principle helps to explain also how clouds can look like elephants, how diatonic orchestral music can suggest a conversation or a person crying or laughing, and how a twelve-year-old boy can look like his middle-aged father.

We can now see how a portrait can be an *exact* likeness of the sitter, despite the huge differences between the two. The differences, in so far as they involve properties standard for us, simply do not count against likeness, and hence not against exact likeness. Similarly, a boy not only can resemble his father but can be his "spitting image," despite the boy's relative youthfulness. It is clear that the notions of resemblance and exact resemblance that we are concerned with are not even cousins of the notion of perceptual indistinguishability.

(*b*) The importance of the distinction between standard and variable properties is by no means limited to cases involving representation or resemblance. Imagine a society which does not have an established medium of painting, but does produce a kind of work of art called *guernicas*. Guernicas are like versions of Picasso's *Guernica* done in various bas-relief dimensions. All of them are surfaces with the colors and shapes of Picasso's *Guernica*, but the surfaces are molded to protrude from the wall like relief maps of different kinds of terrain. Some guernicas have rolling surfaces, others are sharp and jagged, still others contain several relatively flat planes at various angles to each other, and so forth. If members of this society should come across Picasso's *Guernica*, they would count it as a guernica—a perfectly flat one—rather than as a painting. Its flatness is variable, and the figures on its surface are standard relative to the category of guernicas. Thus the flatness, which is standard for us, would be variable for members of the other society, and the figures on the surface, which are variable for us, would be standard for them. This would make for a profound difference between our aesthetic reaction to *Guernica* and theirs. It seems violent, dynamic, vital, disturbing to us. But I imagine it would strike them as cold, stark, lifeless, or serene and restful, or perhaps bland, dull, boring—but in any case *not* violent, dynamic, and vital. We do not pay attention

[15]There is at least one group of exceptions to this. Obviously features of a work which are standard for us because they are standard relative to some *representational* category which we see it in—e.g., the category of nudes, still lifes, or landscapes—do help determine what the work looks like to us and what we take it to depict.

to or take note of *Guernica's* flatness; this is a feature we take for granted in paintings. But for the other society this is *Guernica's* most striking and noteworthy characteristic—what is *expressive* about it. Conversely, *Guernica's* color patches, which we find noteworthy and expressive, are insignificant to them.

It is important to notice that this difference in aesthetic response is not due *solely* to the fact that we are much more familiar with flat works of art than they are, and they are more familiar with *Guernica's* colors and shapes. Someone equally familiar with paintings and guernicas might, I think, see Picasso's *Guernica* as a painting on some occasions, and as a guernica on others. On the former occasions it will probably look dynamic, violent, and so forth to him, and on the latter cold, serene, bland, or lifeless. Whether he sees the work in a museum of paintings or a museum of guernicas, or whether he has been told that it is a painting or a guernica, may influence how he sees it. But I think he might be able to shift at will from one way of seeing it to the other, somewhat as one shifts between seeing the duck-rabbit as a duck and seeing it as a rabbit.

This example and the previous ones might give the impression that in general only features of a work that are variable for us are aesthetically important—that these are the expressive, aesthetically active properties, as far as we are concerned, whereas features standard for us are aesthetically inert. But this notion is quite mistaken, as the following examples will demonstrate. Properties standard for us are not aesthetically lifeless, though the life that they have, the aesthetic effect they have on us, is typically very different from what it would be if they were variable for us.

(c) Because of the very fact that features standard for us do not seem striking or noteworthy, that they are somehow expected or taken for granted, they can contribute to a work a sense of order, inevitability, stability, correctness. This is perhaps most notably true of large-scale structural properties in the time arts. The exposition-development-recapitulation form (including the typical key and thematic relationships) of the first movements of classical sonatas, symphonies, and string quartets is standard with respect to the category of works in sonata-allegro form, and standard for listeners, including most of us, who hear them as belonging to that category. So proceeding along the lines of sonata-allegro form seems *right* to us; to our ears that is how sonatas are *supposed* to behave. We feel that we know where we are and where we are going throughout the work—more so, I suggest, than we would if we were not familiar with sonata-allegro form, if following the strictures of that form were variable rather than standard for us.[16] Properties standard for us do not always have this sort of unifying effect, however. The fact that a piano sonata contains only piano sounds, or uses the Western system of harmony throughout, does not make it seem unified to us. The reason, I think, is that these properties are *too* standard for us in a sense that needs explicating (cf. note 10). Nevertheless, sonata form is unifying partly because it is standard rather than variable for us.

[16]The presence of clichés in a work sometimes allows it to contain drastically disorderly elements without becoming chaotic or incoherent. Cf. Anton Ehrenzweig, *The Hidden Order of Art* (London, 1967), pp. 114–116.

(*d*) That a work (or part of it) has a certain determinate characteristic (of size, for example, or speed, or length, or volume) is often variable relative to a particular category, when it is nevertheless standard for that category that the variable characteristic falls within a certain range. In such cases the aesthetic effect of the determinate variable property may be colored by the standard limits of the range. Hence these limits function as an aesthetic catalyst, even if not as an active ingredient.

Piano music is frequently marked *sostenuto, cantabile, legato,* or *lyrical.* But how can the pianist possibly carry out such instructions? Piano tones diminish in volume drastically immediately after the key is struck, becoming inaudible relatively promptly, and there is no way the player can prevent this. If a singer or violinist should produce sounds even approaching a piano's in suddenness of demise, they would be nerve-wrackingly sharp and percussive— anything but *cantabile* or lyrical! Yet piano music *can* be *cantabile, legato,* or lyrical nevertheless; sometimes it is extraordinarily so (for example, a good performance of the *Adagio Cantabile* movement of Beethoven's *Pathétique* sonata). What makes this possible is the very fact that the drastic diminution of piano tones cannot be prevented, and hence never is. It is a standard feature for piano music. A pianist can, however, by a variety of devices, control a tone's rate of diminution and length within the limits dictated by the nature of the instrument.[17] Piano tones may thus be *more or less* sustained within these limits, and *how* sustained they are, how quickly or slowly they diminish and how long they last, within the range of possibilities, is variable for piano music. A piano passage that sounds lyrical or *cantabile* to us is one in which the individual tones are *relatively* sustained, given the capabilities of the instrument. Such a passage sounds lyrical only because piano music is limited as it is, and we hear it as piano music; that is, the limitations are standard properties for us. The character of the passage is determined not merely by the "absolute" nature of the sounds, but by that in relation to the standard property of what piano tones can be like.[18]

This principle helps to explain the lack of energy and brilliance that we sometimes find even in very fast passages of electronic music. The energy and brilliance of a fast violin or piano passage derives not merely from the absolute speed of the music (together with accents, rhythmic characteristics, and so forth), but from the fact that it is fast *for that particular medium.* In electronic music different pitches can succeed one another at any frequency up to and

[17]The timing of the release of the key affects the tone's length. Use of the sustaining pedal can lessen slightly a tone's diminuendo by reinforcing its overtones with sympathetic vibrations from other strings. The rate of diminuendo is affected somewhat more drastically by the force with which the key is struck. The more forcefully it is struck the greater is the tone's relative diminuendo. (Obviously the rate of diminuendo cannot be controlled in this way independently of the tone's initial volume.) The successive tones of a melody can be made to overlap so that each tone's sharp attack is partially obscured by the lingering end of the preceding tone. A melodic tone may also be reinforced after it begins by sympathetic vibrations from harmonically related accompanying figures, contributed by the composer.

[18]"[T]he musical media we know thus far derive their whole character and their usefulness as musical media precisely from their limitations." Roger Sessions, "Problems and Issues Facing the Composer Today," in Paul Henry Lang, *Problems of Modern Music* (New York, 1960), p. 31.

including that at which they are no longer separately distinguishable. Because of this it is difficult to make electronic music *sound* fast (energetic, violent). For when we have heard enough electronic music to be aware of the possibilities we do not feel that the speed of a passage approaches a limit, no matter how fast it is.[19]

There are also visual correlates of these musical examples. A small elephant, one which is smaller than most elephants with which we are familiar, might impress us as charming, cute, delicate, or puny. This is not simply because of its (absolute) size, but because it is small *for an elephant.* To people who are familiar not with our elephants but with a race of mini-elephants, the same animal may look massive, strong, dominant, threatening, lumbering, if it is large for a mini-elephant. The size of elephants is variable relative to the class of elephants, but it varies only within a certain (not precisely specifiable) range. It is a standard property of elephants that they do fall within this range. How an elephant's size affects us aesthetically depends, since we see it as an elephant, on whether it falls in the upper, middle, or lower part of the range.

(*e*) Properties standard for a certain category which do not derive from physical limitations of the medium can be regarded as results of more or less conventional "rules" for producing works in the given category (for example, the "rules" of sixteenth-century counterpoint, or those for twelve-tone music). These rules may combine to create a dilemma for the artist which, if he is talented, he may resolve ingeniously and gracefully. The result may be a work with an aesthetic character very different from what it would have had if it had not been for those rules. Suppose that the first movement of a sonata in G major modulates to C-sharp major by the end of the development section. A rule of sonata form decrees that it must return to G for the recapitulation. But the keys of G and C-sharp are as unrelated as any two keys can be; it is difficult to modulate smoothly and quickly from one to the other. Suppose also that while the sonata is in C-sharp there are signs that, given other rules of sonata form, indicate that the recapitulation is imminent (motivic hints of the return, an emotional climax, a cadenza). Listeners who hear it as a work in sonata form are likely to have a distinct feeling of unease, tension, uncertainty, as the time for the recapitulation approaches. If the composer with a stroke of ingenuity accomplishes the necessary modulation quickly, efficiently, and naturally, this will give them a feeling of relief—one might say of deliverance. The movement to C-sharp, which may have seemed alien and brashly adventurous at the time will have proven to be quite appropriate, and the entire sequence will in retrospect have a sense of correctness and perfection about it. Our impression of it is likely, I think, to be very much like our impression of a "beautiful" or "elegant" proof in mathematics. (Indeed the composer's task in this example is not unlike that of producing such a proof.)

But suppose that the rule for sonatas were that the recapitulation must be *either* in the original key *or* in the key one half-step below it. Thus in the example above the recapitulation could have been in F-sharp major rather than G major. This possibility removes the sense of tension from the occurrence of C-

[19]One way to make electronic music sound fast would be to make it sound like some traditional instrument, thereby trading on the limitations of that instrument.

sharp major in the development section, for a modulation from C-sharp to F-sharp is as easy as any modulation is (since C-sharp is the dominant of F-sharp). Of course, there would also be no special *release* of tension when the modulation to G is effected, there being no tension to be released. In fact, that modulation probably would be rather surprising, since the permissible modulation to F-sharp would be much more natural.

Thus the effect that the sonata has on us depends on which of its properties are dictated by "rules," which ones are standard relative to the category of sonatas and hence standard for us.

(*f*) I turn now to features which are contra-standard for us—ones which have a tendency to disqualify a work from a category in which we nevertheless perceive it. We are likely to find such features shocking, or disconcerting, or startling, or upsetting, just because they are contra-standard for us. Their presence may be so obtrusive that they obscure the work's variable properties. Three-dimensional objects protruding from a canvas and movement in a sculpture are contra-standard relative to the categories of painting and (traditional) sculpture respectively. These features are contra-standard for us, and probably shocking, if despite them we perceive the works possessing them in the mentioned categories. The monochromatic paintings of Yves Klein are disturbing to us (at least at first) for this reason: we see them as paintings, though they contain the feature contra-standard for paintings of being one solid color.[20] Notice that we find other similarly monochromatic surfaces—walls of living rooms, for example—not in the least disturbing, and indeed quite unnoteworthy.

If we are exposed frequently to works containing a certain kind of feature which is contra-standard for us, we ordinarily adjust our categories to accommodate it, making it contra-standard for us no longer. The first painting with a three-dimensional object glued to it was no doubt shocking. But now that the technique has become commonplace we are not shocked. This is because we no longer see these works as *paintings,* but rather as members of either (*a*) a new category—*collages*—in which case the offending feature has become standard rather than contra-standard for us, or (*b*) an expanded category which includes paintings both with and without attached objects, in which case that feature is variable for us.

But it is not just the rarity, unusualness, or unexpectedness of a feature that makes it shocking. If a work differs *too* significantly from the norms of a certain category we do not perceive it in that category and hence the difference is not contra-standard for us, even if we have not previously experienced works differing from that category in that way. A sculpture which is constantly and vigorously in motion would be so obviously and radically different from traditional sculptures that we probably would not perceive it as one even if it is the first moving sculpture we have come across. We would either perceive it as a *kinetic* sculpture, or simply remain confused. In contrast, a sculpted bust which is traditional in every respect except that one ear twitches slightly every thirty seconds would be perceived as an ordinary sculpture. So the twitching ear would be contra-standard for us, and it would be considerably more unsettling than the much greater movement of the other kinetic sculpture. Similarly,

[20]This example was suggested by Göran Hermerén.

a very small colored area of an otherwise entirely black-and-white drawing would be very disconcerting. But if enough additional color is added to it we will see it as a colored rather than a black-and-white drawing, and the shock will vanish.

This point helps to explain a difference between the harmonic aberrations of Wagner's *Tristan and Isolde* and those of Debussy's *Pelléas et Mélisande* and Schoenberg's *Pierrot Lunaire* as well as Schoenberg's later twelve-tone works. The latter are not merely *more* aberrant, *less* tonal, than *Tristan*. They differ from traditional tonal music in such respects and to such an extent that they are not heard as tonal at all. *Tristan,* however, retains enough of the apparatus of tonality, despite its deviations, to be heard as a tonal work. For this reason its lesser deviations are often the more shocking.[21] *Tristan* plays on harmonic traditions by selectively following and flaunting them, while *Pierrot Lunaire* and the others simply ignore them.

Shock then arises from features that are not just rare or unique, but ones that are contra-standard relative to categories in which objects possessing them are perceived. But it must be emphasized that to be contra-standard relative to a certain category is not merely to be rare or unique *among things of that category.* The melodic line of Schubert's song *"Im Walde"* is probably unique; it probably does not occur in any other songs, or other works of any sort. But it is not contra-standard relative to the category of songs, because it does not tend to disqualify the work from that category. Nor is it contra-standard relative to any other category to which we hear the work as belonging. And clearly we do not find this melodic line at all upsetting. What is important is not the rarity of a feature, but its connection with the classification of the work. Features contra-standard for us are perceived as misfits in a category which the work strikes us as belonging to, as doing *violence* to such a category. Being rare in a category is not the same thing as being a misfit in it.

It should be clear from the above examples that how a work affects us aesthetically—what aesthetic properties it seems to us to have and what ones we are inclined to attribute to it—depends in a variety of important ways on which of its features are standard, which variable, and which contra-standard for us. Moreover, this is obviously not an isolated or exceptional phenomenon, but a pervasive characteristic of aesthetic perception. I should emphasize that my purpose has not been to establish general principles about how each of the three sorts of properties affects us. How any particular feature affects us depends also on many variables I have not discussed. The important point is that in many cases whether a feature is standard, variable, or contra-standard for us has a great deal to do with what effect it has on us. We must now begin to assess the theoretical consequences of this.

IV. Truth and Falsity

The fact that what aesthetic properties a thing seems to have may depend on what categories it is perceived in raises a question about how to determine what aesthetic properties it really does have. If *Guernica* appears dynamic

[21]Cf. William W. Austin, *Music in the 20th Century* (New York, 1966), pp. 205–206; and Eric Salzman, *Twentieth-Century Music: An Introduction* (Englewood Cliffs, N.J., 1967), pp. 5, 8, 19.

when seen as a painting, and not dynamic when seen as a guernica, is it dynamic or not? Can one way of seeing it be ruled correct, and the other incorrect? One way of approaching this problem is to deny that the apparently conflicting aesthetic judgments of people who perceive a work in different categories actually do conflict.[22]

Judgments that works of art have certain aesthetic properties, it might be suggested, implicitly involve reference to some particular set of categories. Thus our claim that *Guernica* is dynamic really amounts to the claim that it is dynamic *as a painting,* or for people who see it as a painting. The judgment that it is not dynamic made by people who see it as a guernica amounts simply to the judgment that it is not dynamic *as a guernica.* Interpreted in these ways, the two judgments are of course quite compatible. Terms like "large" and "small" provide a convenient model for this interpretation. An elephant might be both small as an elephant and large as a mini-elephant, and hence it might be called truly either "large" or "small," depending on which category is implicitly referred to.

I think that aesthetic judgments are in *some* contexts amenable to such category-relative interpretations, especially aesthetic judgments about natural objects (clouds, mountains, sunsets) rather than works of art. (It will be evident that the alternative account suggested below is not readily applicable to most judgments about natural objects.) But most of our aesthetic judgments can be forced into this mold only at the cost of distorting them beyond recognition.

My main objection is that category-relative interpretations do not allow aesthetic judgments to be mistaken often enough. It would certainly be natural to consider a person who calls *Guernica* stark, cold, or dull, because he sees it as a guernica, to be *mistaken;* he misunderstands the work because he is looking at it in the wrong way. Similarly, one who asserts that a good performance of the *Adagio Cantabile* of Beethoven's *Pathétique* is percussive, or that a Roman bust looks like a unicolored, immobile man severed at the chest and depicts one as such, is simply wrong, even if his judgment is a result of his perceiving the work in different categories from those in which we perceive it. Moreover, we do not accord a status any more privileged to our own aesthetic judgments. We are likely to regard cubist paintings, or Japanese *gagaku* music, as formless, incoherent, or disturbing on our first contact with these forms largely because, I suggest, we would not be perceiving the works as cubist paintings, or as *gagaku* music. But after becoming familiar with these kinds of art we would probably *retract* our previous judgments, admit that they were mistaken. It would be quite inappropriate to protest that what we meant previously was merely that the works were formless or disturbing for the categories in which we then perceived them, while admitting that they are not for the categories of cubist paintings, or *gagaku* music. The conflict between

[22]I am ruling out the view that the notions of truth and falsity are not applicable to aesthetic judgments, on the ground that it would force us to reject so much of our normal discourse and common-sense intuitions about art that theoretical aesthetics, conceived as attempting to understand the institution of art, would hardly have left a recognizable subject matter to investigate. (Cf. the quotation from Wölfflin, above.)

apparently incompatible aesthetic judgments made while perceiving a work in different categories does not simply evaporate when the difference of categories is pointed out, as does the conflict between the claims that an animal is large and that it is small, when it is made clear that the person making the first claim regarded it as a mini-elephant and the one making the second regarded it as an elephant. The latter judgments do not (necessarily) reflect a real disagreement about the size of the animal, but the former do reflect a real disagreement about the aesthetic nature of the work.

Thus it seems that, at least in some cases, it is *correct* to perceive a work in certain categories, and *incorrect* to perceive it in certain others; that is, our judgments of it when we perceive it in the former are likely to be true, and those we make when perceiving it in the latter false. This provides us with absolute senses of "standard," "variable," and "contra-standard": features of a work are standard, variable, or contra-standard absolutely just in case they are standard, variable, or contra-standard (respectively) for people who perceive the work correctly. (Thus an absolutely standard feature is standard relative to some category in which the work is correctly perceived and contra-standard relative to none, an absolutely variable feature is variable relative to all such categories, and an absolutely contra-standard feature is contra-standard relative to at least one such category.)

How is it to be determined in which categories a work is correctly perceived? There is certainly no very precise or well-defined procedure to be followed. Different criteria are emphasized by different people and in different situations. But there are several fairly definite considerations which typically figure in critical discussions and which fit our intuitions reasonably well. I suggest that the following circumstances count toward its being correct to perceive a work, *W*, in a given category, *C:*

(*i*) The presence in *W* of a relatively large number of features standard with respect to *C*. The correct way of perceiving a work is likely to be that in which it has a minimum of contra-standard features for us. I take the relevance of this consideration to be obvious. It cannot be correct to perceive Rembrandt's *Titus Reading* as a kinetic sculpture, if this is possible, just because that work has too few of the features which make kinetic sculptures kinetic sculptures. But of course this does not get us very far. *Guernica*, for example, qualifies equally well on this count for being perceived as a painting and as a guernica.

(*ii*) The fact that *W* is better, or more interesting or pleasing aesthetically, or more worth experiencing, when perceived in *C* than it is when perceived in alternative ways. The correct way of perceiving a work is likely to be the way in which it comes off best.

(*iii*) The fact that the artist who produced *W* intended or expected it to be perceived in *C*, or thought of it as a *C*.

(*iv*) The fact that *C* is well established in and recognized by the society in which *W* was produced. A category is well established in and recognized by a society if the members of the society are familiar with works in that category, consider a work's membership in it a fact worth mentioning, exhibit works of that category together, and so forth—that is, roughly if that category figures importantly in their way of classifying works of art. The categories of impressionist painting and Brahmsian music are well established and recog-

nized in our society; those of guernicas, paintings with diagonal composition containing green crosses, and pieces of music containing between four and eight F-sharps and at least seventeen quarter notes every eight bars are not. The categories in which a work is correctly perceived, according to this condition, are generally the ones in which the artist's contemporaries did perceive or would have perceived it.

In certain cases I think the mechanical process by which a work was produced, or (for example, in architecture) the nonperceptible physical characteristics or internal structure of a work, is relevant. A work is probably correctly perceived as an apparent etching rather than, say, an apparent woodcut or line drawing, if it was produced by the etching process. The strengths of materials in a building or the presence of steel girders inside wooden or plaster columns counts (not necessarily conclusively) toward the correctness of perceiving it in the category of buildings with visual characteristics typical of buildings constructed in that manner. I will not discuss these considerations further here.

What can be said in support of the relevance of conditions (*ii*), (*iii*), and (*iv*)? In the examples mentioned above, the categories in which we consider a work correctly perceived probably meet all of these conditions. I would suppose that *Guernica* is better seen as a painting than it would be seen as a guernica (though this would be hard to prove). In any case, Picasso certainly intended it to be seen as a painting rather than a guernica, and the category of paintings is well established in his (that is, our) society, whereas that of guernicas is not. But this of course does not show that (*ii*), (*iii*), and (*iv*) *each* is relevant. It tends to indicate only that one or other of them, or some combination, is relevant.

The difficulty of assessing each of the three conditions individually is complicated by the fact that by and large they can be expected to coincide, to yield identical conclusions. Since an artist usually intends his works for his contemporaries he is likely to intend them to be perceived in categories established in and recognized by his society. Moreover, it is reasonable to expect works to come off better when perceived in the intended categories than when perceived in others. An artist tries to produce works which are well worth experiencing when perceived in the intended way and, unless we have reason to think he is totally incompetent, there is some presumption that he succeeded at least to some extent. But it is more or less a matter of chance whether the work comes off well when perceived in some unintended way. The convergence of the three conditions, however, at the same time diminishes the *practical* importance of justifying them individually, since in most cases we can decide how to judge particular works of art without doing so. But the theoretical question remains.

I will begin with (*ii*). If we are faced with a choice between two ways of perceiving a work, and the work is very much better perceived in one way than it is perceived in the other, I think that, at least in the absence of contrary considerations, we would be strongly inclined to settle on the former way of perceiving it as the *correct* way. The process of trying to determine what is in a work consists partly in casting around among otherwise plausible ways of perceiving it for one in which the work is good. We feel we are coming to a

correct understanding of a work when we begin to like or enjoy it; we are find-ing what is really there when it seems worth experiencing.

But if (*ii*) is relevant, it is quite clearly not the *only* relevant consideration. Take any work of art we can agree is of fourth- or fifth- or tenth-rate quality. It is very possible that if this work were perceived in some far-fetched set of categories that someone might dream up, it would appear to be first-rate, a masterpiece. Finding such *ad hoc* categories obviously would require talent and ingenuity on the order of that necessary to produce a masterpiece in the first place. But we can sketch how one might begin searching for them. (*a*) If the mediocre work suffers from some disturbingly prominent feature that distracts from whatever merits the work has, this feature might be toned down by choosing categories with respect to which it is standard, rather than variable or contra-standard. When the work is perceived in the new way the offending feature may be no more distracting than the flatness of a painting is to us. (*b*) If the work suffers from an overabundance of clichés it might be livened up by choosing categories with respect to which the clichés are variable or con-tra-standard rather than standard. (*c*) If it needs ingenuity we might devise a set of rules in terms of which the work finds itself in a dilemma from which it ingeniously escapes, and we might build these rules into a set of categories. Surely, however, if there are categories waiting to be discovered which would transform a mediocre work into a masterpiece, it does not follow that the work really is a hitherto unrecognized masterpiece. The fact that when perceived in such categories it would appear exciting, ingenious, and so forth, rather than grating, cliché-ridden, pedestrian, does not make it so. It *cannot* be correct, I suggest, to perceive a work in categories which are totally foreign to the artist and his society, even if it comes across as a masterpiece in them.[23]

This brings us to the historical conditions (*iii*) and (*iv*). I see no way of avoiding the conclusion that one or the other of them at least is relevant in determining in what categories a work is correctly perceived. I consider both relevant, but I will not argue here for the independent relevance of (*iv*). (*iii*) merits special attention in light of the prevalence of disputes about the impor-tance of artists' intentions. To test the relevance of (*iii*) we must consider a case in which (*iii*) and (*iv*) diverge. One such instance occurred during the early days of the twelve-tone movement in music. Schoenberg no doubt intended even his earliest twelve-tone works to be heard as such. But this category was certainly not then well established or recognized in his society: virtually none of his contemporaries (except close associates such as Berg and Webern), even musically sophisticated ones, would have (or could have) heard these works in that category. But it seems to me that even the very first twelve-tone com-positions are correctly heard as such, that the judgments one who hears them otherwise would make of them (for example, that they are chaotic, formless) are mistaken. I think this would be so even if Schoenberg had been working entirely alone, if *none* of his contemporaries had any inkling of the twelve-tone

[23]To say that it is incorrect (in my sense) to perceive a work in certain categories is not necessar-ily to claim that one *ought not* to perceive it that way. I heartily recommend perceiving mediocre works in categories that make perceiving them worthwhile whenever possible. The point is that one is not likely to *judge* the work correctly when he perceives it incorrectly.

system. No doubt the first twelve-tone compositions are much better when heard in the category of twelve-tone works than when they are heard in any other way people might be likely to hear them. But as we have seen this cannot *by itself* account for the correctness of hearing them in the former way. The only other feature of the situation which could be relevant, so far as I can see, is Schoenberg's intention.

The above example is unusual in that Schoenberg was extraordinarily self-conscious about what he was doing, having explicitly formulated rules—that is, specified standard properties—for twelve-tone composition. Artists are not often so self-conscious, even when producing revolutionary works of art. Their intentions as to which categories their works are to be perceived in are not nearly as clear as Schoenberg's were, and often they change their minds during the process of creation. In such cases (as well as ones in which the artists' intentions are unknown) the question of what categories a work is correctly perceived in is left by default to condition (*iv*), together with (*i*) and (*ii*). But it seems to me that in almost all cases at least one of the historical conditions, (*iii*) and (*iv*), is of crucial importance.

My account of the rules governing decisions about what categories works are correctly perceived in leaves a lot undone. There are bound to be a large number of undecidable cases on my criteria. Artists' intentions are frequently unclear, variable, or undiscoverable. Many works belong to categories which are borderline cases of being well established in the artists' societies (perhaps, for example, the categories of rococo music—for instance, C.P.E. Bach—of music in the style of early Mozart, and of very thin metal sculpted figures of the kind that Giacometti made). Many works fall between well-established categories (for example, between impressionist and cubist paintings), possessing *some* of the standard features relative to each, and so neither clearly qualify nor clearly fail to qualify on the basis of condition (*i*) to be perceived in either. There is, in addition, the question of what relative weights to accord the various conditions when they conflict.

It would be a mistake, however, to try to tighten up much further the rules for deciding how works are correctly perceived. To do so would be simply to legislate gratuitously, since the intuitions and precedents we have to go on are highly variable and often confused. But it is important to notice just where these intuitions and precedents are inconclusive, for doing so will expose the sources of many critical disputes. One such dispute might well arise concerning Giacometti's thin metal sculptures. To a critic who sees them simply as sculptures, or sculptures of people, they look frail, emaciated, wispy, or wiry. But that is not how they would strike a critic who sees them in the category of thin metal sculptures of that sort (just as stick figures do not strike us as wispy or emaciated). He would be impressed not by the thinness of the sculptures, but by the expressive nature of the positions of their limbs, and so forth, so he would no doubt attribute very different aesthetic properties to them. Which of the two ways of seeing these works is correct is, I suspect, undecidable. It is not clear whether enough such works have been made and have been regarded sufficiently often as constituting a category for that category to be deemed well established in Giacometti's society. And I doubt whether any of the other conditions settle the issue conclusively. So perhaps the dispute

between the two critics is essentially unresolvable. The most that we can do is to point out just what sort of a difference of perception underlies the dispute, and why it is unresolvable.

The occurrence of impasses like this is by no means something to be regretted. Works may be fascinating precisely because of shifts between equally permissible ways of perceiving them. And the enormous richness of some works is due in part to the variety of permissible, and worthwhile, ways of perceiving them. But it should be emphasized that even when my criteria do not clearly specify a *single* set of categories in which a work is correctly perceived, there are bound to be possible ways of perceiving it (which we may or may not have thought of) that they definitely rule out.

The question posed at the outset of this section was how to determine what aesthetic properties a work has, given that which ones it seems to have depends on what categories it is perceived in, on which of its properties are standard, which variable, and which contra-standard for us. I have sketched in rough outline rules for deciding in what categories a work is *correctly* perceived (and hence which of its features are absolutely standard, variable, and contra-standard). The aesthetic properties it actually possesses are those that are to be found in it when it is perceived correctly.[24]

V. Conclusion

I return now to the issues raised in Section I. (I will adopt for the remainder of this paper the simplifying assumption that there is only one correct way of perceiving any work. Nothing important depends on this.) If a work's aesthetic properties are those that are to be found in it when it is perceived correctly, and the correct way to perceive it is determined partly by historical facts about the artist's intention and/or his society, no examination of the work itself, however thorough, will by itself reveal those properties.[25] If we are confronted by a work about whose origins we know absolutely nothing (for example, one lifted from the dust at an as yet unexcavated archaeological site on Mars), we would simply not be in a position to judge it aesthetically. We could not possibly tell by staring at it, no matter how intently and intelligently, whether it is coherent, or serene, or dynamic, for by staring we cannot tell whether it is

[24]This is a considerable oversimplification. If there are two equally correct ways of perceiving a work, and it appears to have a certain aesthetic property perceived in one but not the other of them, does it actually possess this property or not? There is no easy general answer. Probably in some such cases the question is undecidable. But I think we would sometimes be willing to say that a work is, e.g., touching or serene if it seems so when perceived in one acceptable way (or, more hesitantly, that there is "something very touching, or serene, about it"), while allowing that it does not seem touching, or serene, when perceived in another way which we do not want to rule incorrect. In some cases works have aesthetic properties (e.g., intriguing, subtle, alive, interesting, deep) which are not apparent on perceiving it in any *single* acceptable way, but which depend on the multiplicity of acceptable ways of perceiving it and relations between them. None of these complications relieves the critic of the responsibility for determining in what way or ways it is correct to perceive a work.

[25]But this, plus a general knowledge of what sorts of works were produced when and by whom, might.

to be seen as a sculpture, a guernica, or some other exotic or mundane kind of work of art. (We could attribute aesthetic properties to it in the way we do to natural objects, which of course does not involve consideration of historical facts about artists or their societies. [Cf. section IV.] But to do this would not be to treat the object as a *work* of art.)

It should be emphasized that the relevant historical facts are not merely useful aids to aesthetic judgment; they do not simply provide hints concerning what might be found in the work. Rather they help to *determine* what aesthetic properties a work has; they, together with the work's nonaesthetic features, *make* it coherent, serene, or whatever. If the origin of a work which is coherent and serene had been different in crucial respects, the work would not have had these qualities; we would not merely have lacked a means for *discovering* them. And of two works which differ *only* in respect of their origins— ones which are perceptually indistinguishable—one might be coherent or serene, and the other not. Thus, since artists' intentions are among the relevant historical considerations, the "intentional fallacy" is not a fallacy at all. I have of course made no claims about the relevance of artists' intentions as to the aesthetic properties that their works should have. I am willing to agree that whether an artist intended his work to be coherent or serene has nothing essential to do with whether it is coherent or serene. But this must not be allowed to seduce us into thinking that *no* intentions are relevant.

Aesthetic properties, then, are not to be found in works themselves in the straightforward way that colors and shapes or pitches and rhythms are. But I do not mean to deny that we perceive aesthetic properties in works of art. I *see* the serenity of a painting and *hear* the coherence of a sonata, despite the fact that the presence of these qualities in the works depends partly on circumstances of their origin which I cannot (now) perceive. Jones's marital status is part of what makes him a bachelor, if he is one, and we cannot tell his marital status just by looking at him, though we can thus ascertain his sex. Hence, I suppose, his bachelorhood is not a property we can be said to perceive in him. But the aesthetic properties of a work do not depend on historical facts about it in anything like the way Jones's bachelorhood depends on his marital status. The point is not that the historical facts function as *grounds* in any ordinary sense for aesthetic judgments. By themselves they do not, in general, count either for or against the presence of any particular aesthetic property. And they are not part of a larger body of information (also including data about the work derived from an examination of it) from which conclusions about the works' aesthetic properties are to be deduced or inferred. We must learn to *perceive* the work in the correct categories, as determined in part by the historical facts, and judge it by what we then perceive in it. The historical facts help to determine whether a painting is coherent or serene *only* (as far as my arguments go) by affecting what way of perceiving the painting must reveal these qualities if they are truly attributable to the work.

We must not, however, expect to judge a work simply by setting ourselves to perceive it correctly, once it is determined what the correct way of perceiving it is. For one cannot, in general, perceive a work in a given set of categories simply by setting himself to do it. I could not possibly, merely by an act of

will, see *Guernica* as a guernica rather than as a painting, nor could I hear a succession of street sounds in any arbitrary category one might dream up, even if the category has been explained to me in detail. Indeed, I cannot even imagine except in a rather vague way what it would be like, for example, to see *Guernica* as a guernica. One cannot merely decide to respond appropriately to a work—to be shocked or unnerved or surprised by its (absolutely) contrastandard features, to find its standard features familiar or mundane, and to react to its variable features in other ways—once one knows the correct categories. Perceiving a work in a certain category or set of categories is a skill that must be acquired by training, and exposure to a great many other works of the category or categories in question is ordinarily, I believe, an essential part of this training. (But an effort of will may facilitate the training, and once the skill is acquired one may be able to decide at will whether or not to perceive it in that or those categories.) This has important consequences concerning how best to approach works of art of kinds that are new to us—contemporary works in new idioms, works from foreign cultures, or newly resurrected works from the ancient past. It is no use just immersing ourselves in a particular work, even with the knowledge of what categories it is correctly perceived in, for that alone will not enable us to perceive it in those categories. We must become familiar with a considerable variety of works of similar sorts.

When dealing with works of more familiar kinds it is not generally necessary to undertake deliberately the task of training ourselves to perceive them in the correct categories (except perhaps when those categories include relatively subtle ones). But this is, I think, only because we have been trained unwittingly. Even the ability to see paintings as paintings had to be acquired, it seems to me, by repeated exposure to a great many paintings. The critic must thus go beyond the work before him in order to judge it aesthetically, not only to discover what the correct categories are, but also to be able to perceive it in them. The latter does not require consideration of historical facts, or consideration of facts at all, but it requires directing one's attention nonetheless to things other than the work in question.

Probably no one would deny that *some* sort of perceptual training is necessary, in many if not all instances, for apprehending a work's serenity or coherence, or other aesthetic properties. And of course it is not only *aesthetic* properties whose apprehension by the senses requires training. But the kind of training required in the aesthetic cases (and perhaps some others as well) has not been properly appreciated. In order to learn how to recognize gulls of various kinds, or the sex of chicks, or a certain person's handwriting, one must have gulls of those kinds, or chicks of the two sexes, or examples of that person's handwriting pointed out to him, practice recognizing them himself, and be corrected when he makes mistakes. But the training important for discovering the serenity or coherence of a work of art that I have been discussing is not of this sort. Acquiring the ability to perceive a serene or coherent work in the correct categories is not a matter of having had serene or coherent things pointed out to one, or having practiced recognizing them. What is important is not (or not merely) experience with other serene and coherent things, but experience with other things of the appropriate categories.

Much of the argument in this paper has been directed against the seemingly common-sense notion that aesthetic judgments about works of art are to be based solely on what can be perceived in them, how they look or sound. That notion is seriously misleading, I claim, on two different counts. I do not deny that paintings and sonatas are to be judged solely by what can be seen or heard in them—when they are perceived correctly. But examining a work with the senses can by itself reveal neither how it is correct to perceive it, nor how to perceive it that way.

READING 25

INTRODUCTION

Stanley Cavell is professor of philosophy at Harvard University. In "Aesthetic Judgment and a Philosophical Claim," which is excerpted from his essay "Aesthetic Problems of Modern Philosophy" (1969), he addresses what he calls "the familiar lack of conclusiveness in aesthetic arguments." Arguments about whether something is beautiful, for example, can often appear to be irresolvable; they may seem to be arguments where there is no possibility of either side convincingly proving its claim. This leads many to think of arguments about aesthetic matters as somehow pointless, or even irrational; to wonder whether such arguments are really *arguments* at all. But Cavell suggests that the inconclusiveness of argument about aesthetic qualities, "rather than showing up an irrationality, shows the kind of rationality it has, and needs." Like Hume and Kant, whose work he discusses, Cavell shows that the questions surrounding "the logic of taste" have important ramifications both within and beyond the philosophy of art.

Aesthetic Judgment and a Philosophical Claim

Stanley Cavell

Another good cause for stumbling over the procedures of ordinary language philosophy lies in its characteristic appeal to what "we" say and mean, or cannot or must say or mean. A good cause, since it is a very particular, not to say peculiar appeal, and one would expect philosophers dependent upon it themselves to be concerned for its investigation. I will suggest that the aesthetic judgment models the sort of claim entered by these philosophers, and that the familiar lack of conclusiveness in aesthetic argument, rather than showing up an irrationality, shows the kind of rationality it has, and needs.

Hume is always a respectable place to begin. Near the middle of his essay "Of the Standard of Taste," he has recourse to a story from *Don Quixote* which is to illustrate that "delicacy" of taste said to be essential to those critics who are to form our standard of it.

It is with good reason, says Sancho to the squire with the great nose, that I pretend to have a judgment in wine: This is a quality hereditary in our family. Two of my kinsmen were once called in to give their opinion of a hogshead, which was supposed to be excellent, being old and of a good vintage. One of them tastes it; considers it; and after mature reflection pronounces the wine to be good, were it not for a small taste of leather, which he perceived in it. The other, after using the same precautions, gives also his verdict in favour of the wine; but with the reserve of a taste of iron, which he could easily distinguish. You cannot imagine how much they were both ridiculed for their judgment. But who laughed in the end? On emptying the hogshead, there was found at the bottom, an old key with a leathern thong tied to it.

First of all, the fine drama of this gesture is greater than its factual decisiveness—a bit quixotic, so to say: for the taste may have been present and the object not, or the object present and the taste not. Second, and more important, the gesture misrepresents the efforts of the critic and the sort of vindication to which he aspires. It dissociates the exercise of taste from the discipline of accounting for it: but *all* that makes the critic's expression of taste worth more than another man's is his ability to produce for himself the thong and key of his response; and his vindication comes not from his pointing out that it is, or was, in the barrel, but in getting us to taste it there. Sancho's ancestors, he tells us, in each case after the precautions of reflection, both pronounced in favor of the wine; but he does not tell us what those reflections were, nor whether they were vindicated in their favorable verdict. Hume's essay, I take it, undertakes to explore just such questions, but in his understandable difficulty in directing us to the genuine critic and distinguishing him from the pretender, he says about him just what he, or anyone, says about art itself: that he is valuable, that we may disagree about his merits in a particular case, and that some, in the long run, "will be acknowledged by universal sentiment to have a preference above others." But this seems to put the critic's worth at the mercy of the history of taste; whereas his value to us is that he is able to make that history a part of his data, knowing that in itself, as it stands, it proves nothing—except popularity. His value to art and culture is not that he agrees with its taste—which would make him useful for guiding one's investments in the art market—but that he sets the terms in which our tastes, whatever they happen to be, may be protected or overcome. Sancho's descendants would, by the eighteenth century, have risen to gentlemen, exercising distinction in a world which knew what was right, and not needing to make their tastes their own. But it is Quixote who is the patron saint of the critic, desperate to preserve the best of his culture against itself, and surviving any failure but that of his honesty and his expression of it.

The idea of the agreement or "reconciliation" of taste controls Hume's argument; it is agreement that the standard of taste is to provide, so far as that is attainable. Hume's descendants, catching the assumption that agreement provides the vindication of judgment, but no longer able to hope for either, have found that aesthetic (and moral and political) judgments lack something: the arguments that support them are not conclusive the way arguments in logic are, nor rational the way arguments in science are. Indeed they are not,

and if they were there would be no such subject as art (or morality) and no such art as criticism. It does not follow, however, that such judgments are not conclusive and rational.

Let us turn to Kant on the subject, who is, here as elsewhere, deeper and obscurer. Universal agreement, or as he also calls it, the "harmony of sentiment" or "a common sense of mankind," makes its appearance in the *Critique of Judgment* not as an empirical problem—which is scarcely surprising about Kant's procedure—but as an a priori requirement setting the (transcendental) conditions under which such judgments as we call aesthetic could be made *überhaupt*. Kant begins by saying that aesthetic judgment is not "theoretical," not "logical," not "objective," but one "whose determining ground can be *no other than subjective*."[1] Today, or anyway the day before yesterday, and largely under his influence, we would have said it is not cognitive; which says so little that it *might* have been harmless enough. Kant goes on immediately to distinguish two kinds of "aesthetical judgments," or, as he also calls them, judgments of taste; and here, unfortunately, his influence trickled out. The first kind he calls the taste of sense, the second the taste of reflection; the former concerns merely what we find pleasant, the latter must—logically must, some of us would say—concern and claim more than that. And it is only the second whose topic is the beautiful, whose role, that is, would be aesthetic in its more familiar sense. The something more these judgments must do is to "demand" or "impute" or "claim" general validity, universal agreement with them; and when we make such judgments we go on claiming this agreement even though we know from experience that they will not receive it. (Are we, then, just willful or stupid in going on making them?) Kant also describes our feeling or belief when we make such judgments—judgments in which we demand "the assent of everyone," although we cannot "postulate" this assent as we could in making an ordinary empirical judgment—as one of "[speaking] with a universal voice." That is the sort of thing that we are likely nowadays to call a piece of psychology, which is no doubt right enough. But we would take that to mean that it marks an accidental accompaniment of such judgments; whereas Kant says about this claim to universal validity, this voice, that it "so essentially belongs to a judgment by which we describe anything as *beautiful* that, if this were not thought in it, it would never come into our thoughts to use the expression at all, but everything which pleases without a concept would be counted as pleasant."[2] The possibility of stupidity here is not one of continuing to demand agreement in the face of the fact that we won't attain it; but the stupidity of going on making aesthetic judgments at all (or moral or political ones) in the face of what they cost us, the difficulties of finding them for ourselves and the risk of explicit isolation.

Kant seems to be saying that apart from a certain spirit in which we make judgments we could have no concepts of the sort we think of as aes-

[1]All quotations from Kant are from sections 7 and 8 of the *Critique of Judgment,* reprinted in this volume.

[2]One might compare with this Wittgenstein's question: "What gives us *so much as the idea* that living beings, things, can feel?" (*Investigations,* §283).

thetic.[3] What can the basis for such a claim be? Let us look at the examples he gives of his two kinds of aesthetic judgments.

> [Someone] is quite contented that if he says, "Canary wine is pleasant," another man may correct his expression and remind him that he ought to say, "It is pleasant *to me*." And this is the case not only as regards the taste of the tongue, the palate, and the throat, but for whatever is pleasant to anyone's eyes and ears. . . . To strive here with the design of reproving as incorrect another man's judgment which is different from our own, as if the judgments were logically opposed, would be folly. . . .
>
> The case is quite different with the beautiful. It would (on the contrary) be laughable if a man who imagined anything to his own taste thought to jus-tify himself by saying: "This object (the house we see, the coat that person wears, the concert we hear, the poem submitted to our judgment) is beautiful *for me*." For he must not call it *beautiful* if it merely pleases him.

What are these examples supposed to show? That using a form of expression in one context is all right, and using it in another is not all right. But what I wish to focus upon is the kind of rightness and wrongness invoked: it is not a matter of factual rectitude, nor of formal indiscretion but of saying some-thing laughable, or which would be folly. It is such consequences that are taken to display a difference in the kind of judgment in question, in the nature of the concepts employed, and even in the nature of the reality the concepts cap-ture. One hardly knows whether to call this a metaphysical or a logical dif-ference. Kant called it a transcendental difference; Wittgenstein would call it a grammatical difference. And how can psychological differences like finding something laughable or foolish (which perhaps not *every* person would) be thought to betray such potent, or anyway different, differences?

Here we hit upon what is, to my mind, the most sensitive index of mis-understanding and bitterness between the positivist and the post-positivist components of analytical philosophy: the positivist grits his teeth when he hears an analysis given out as a logical one which is so painfully remote from formality, so obviously a question of how you happen to feel at the moment, so psychological; the philosopher who proceeds from everyday language stares back helplessly, asking, "Don't you feel the difference? Listen: you *must* see it." Surely, both know what the other knows, and each thinks the other is perverse, or irrelevant, or worse. (Here I must appeal to the experience of

[3]Another way of describing this assumption or demand, this thing of speaking with a universal voice, of judging "not merely for himself, but for all men," Kant also describes as "[speaking] of beauty as if it were a property of things." Only "as if" because it cannot be an ordinary property of things: its presence or absence cannot be established in the way ordinary properties are; that is, they cannot be established publicly, and we don't know (there aren't any) causal conditions, or usable rules, for producing, or altering, or erasing, or increasing this "property." Then why not just say it *isn't* a property of an object? I suppose there would be no reason not to say this, if we could find another way of recording our conviction that it is one, anyway that what we are point-ing to is *there*, in the object; and our knowledge that men make objects that create this response in us, and make them exactly with the idea that they will create it; and the fact that, while we know not everyone will agree with us when we say it is present, we think they are *missing some-thing* if they don't.

anyone who has been engaged in such encounters.) Any explanation of this is going to be hard to acquire. I offer the following guess, not because it can command much attention in itself, but as a way of suggesting the level I would expect a satisfying explanation to reach, a way of indicating why we lack as yet the concepts, even the facts, which must form a serious accommodation.

We know of the efforts of such philosophers as Frege and Husserl to undo the "psychologizing" of logic (like Kant's undoing Hume's psychologizing of knowledge): now, the shortest way I might describe such a book as the *Philosophical Investigations* is to say that it attempts to undo the psychologizing of psychology, to show the necessity controlling our application of psychological and behavioral categories; even, one could say, show the necessities in human action and passion themselves.[4] And at the same time it seems to turn all of philosophy into psychology—matters of what we call things, how we treat them, what their role is in our lives.

For one last glance, let us adapt Kant's examples to a form which is more fashionable, and think of the sort of reasons we offer for such judgments:

1. A: Canary wine is pleasant.
 B: How can you say that? It tastes like canary droppings.
 A: Well, I like it.
2. A: He plays beautifully doesn't he?
 B_1: Yes; too beautifully. Beethoven is not Chopin.

Or he may answer:

 B_2: How can you say that? There was no line, no structure, no idea what the music was about. He's simply an impressive colorist.

Now, how will A reply? Can he now say: "Well, I liked it"? Of course he *can;* but don't we feel that here that would be a feeble rejoinder, a *retreat* to personal taste? Because B's reasons are obviously relevant to the evaluation of performance, and because they are *arguable,* in ways that anyone who knows about such things will know how to pursue. A *doesn't have* to pursue them; but if he doesn't, there is a price he will have to pay in our estimate of him. Is that enough to show it is a different kind of judgment? We are still in the realm of the psychological. But I wish to say that the price is necessary, and specific to the sorts of judgments we call aesthetic.

Go back to my saying "he doesn't have to pursue" the discussion, and compare the following case:

A: There is a goldfinch in the garden.
B: How do you know?
A: From the color of its head.

[4]Consider, for example, the question: "Could someone have a feeling of ardent love or hope for the space of one second—*no matter what* preceded or followed this second?" (*Investigations,* §583). We shall not wish to say that this is logically impossible, or that it can in no way be imagined. But we might say: given our world this cannot happen; it is not, in our language, what "love" or "hope" mean; necessary in our world that this is not what love and hope are. I take it that our most common philosophical understanding of such notions as necessity, contingency, synthetic and analytic statements, will not know what to make of our saying such things.

B: But goldcrests also have heads that color.
A: Well, *I* think it's a goldfinch (it's a goldfinch to me).

This is no longer a feeble rejoinder, a retreat to personal opinion: and the price that would be paid here is not, as it would be in the former case, that he is not very articulate, or not discriminating, or has perverse tastes: the price here is that he is either mad, or doesn't know what the word "know" means, or is in some other way unintelligible to us. That is, *we rule him out* as a competent interlocutor in matters of knowledge (about birds?): whatever is going on, he *doesn't* know there is a goldfinch in the garden, whatever (else) he thinks he "knows." But we do not, at least not with the same flatness and good conscience, and not with the same consequences, rule out the person who liked the performance of the Beethoven: he still has a claim upon us, however attenuated; he *may* even have reasons for his judgment, or counters to your objections, which for some reason he can't give (perhaps because you've browbeaten him into amnesia).

Leaving these descriptions so cruelly incomplete, I think one can now imagine the familiar response: "But you admit that arguments in the aesthetic case may go on, may perhaps never end, and that they needn't go on, perhaps can't go on in some cases, and that they may have different 'prices' (what-ever that may mean), presumably depending on where they stop. How do you get logic out of that? What you cannot claim is that either party to the dispute, whether in the case Kant calls the taste of sense or the case he calls the taste of reflection, can *prove* his judgment. And would he want to, even if he could? Isn't that, indeed, what all your talk about criticism was about: The person accounts for his own feelings, and then, at best 'proves' them *to* another, shows them to whomever he wants to know them, the best way he can, the most effective way. That's scarcely logic; and how can you deny that it is psychology?"

It may help to reply to this: You call it psychology just because it so obviously is not logic, and it must be one or the other. (I do think that is the *entire* content of "psychology" in such objections. Such a person knows what he means by logic: how to do it, how to recognize it when he sees it done, what he can expect from it, etc. But who knows any of this about the "psychology" in question?) Contrariwise, I should admit that I call it "logic" mostly because it so obviously is not "psychology" in the way I think you mean it. I do not really think it is either of those activities, in the senses we attach to them now; but I cannot describe to anyone's satisfaction *what* it is. Wittgenstein called it "grammar"; others might call it "phenomenology."

Those of us who keep finding ourselves wanting to call such differences "logical" are, I think, responding to a sense of necessity we feel in them, together with a sense that necessity is, partly, a matter of the *ways* a judgment is supported, the ways in which conviction in it is produced: it is only by virtue of these recurrent patterns of support that a remark will count as—will be—aesthetic, or a mere matter of taste, or moral, propagandistic, religious, magical, scientific, philosophical. . . . It is essential to making an aesthetic judgment that at some point we be prepared to say in its support: don't you see, don't you hear, don't you dig? The best critic will know the best points. Because if you do not see *something*, without explanation, then there is nothing further to discuss.

Which does not mean that the critic has no recourse: he can start training and instructing you and preaching at you—a direction in which criticism invariably will start to veer. (A critic like Ruskin can be a bit eager in seizing this direction, but it is a measure of his honesty, and his devotion to art, never to shrink from it; as it is part of the permanence of his writing to exemplify that moral passion which is a *natural* extension of the critical task.) At some point, the critic will have to say: This is what I see. Reasons—at definite points, for definite reasons, in different circumstances—come to an end. (Cf. *Investigations*, §217.)

Those who refuse the term "logic" are responding to a sense of arbitrariness in these differences, together with a sense that "logic" is a matter of arriving at conviction in such a way that anyone who can follow the argument must, unless he finds something definitely wrong with it, *accept the conclusion*, agree with it. I do not know what the gains or disadvantages would be of unfastening the term "logic" from that constant pattern of support or justification whose peculiarity is that it leads those competent at it to this kind of agreement, and extending it to patterns of justification having other purposes and peculiarities. All I am arguing for is that *pattern* and *agreement* are distinct features of the notion of logic.

If we say that the *hope* of agreement motivates our engaging in these various patterns of support, then we must also say, what I take Kant to have seen, that even were agreement in fact to emerge, our judgments, so far as aesthetic, would remain as essentially subjective, in his sense, as they ever were. Otherwise, art and the criticism of art would not have their special importance nor elicit their own forms of distrust and of gratitude. The problem of the critic, as of the artist, is not to discount his subjectivity, but to include it; not to overcome it in agreement, but to master it in exemplary ways. Then his work outlasts the fashions and arguments of a particular age. That is the beauty of it.

Kant's "universal voice" is, with perhaps a slight shift of accent, what we hear recorded in the philosopher's claims about "what we say": such claims are at least as close to what Kant calls aesthetical judgments as they are to ordinary empirical hypotheses. Though the philosopher seems to claim, or depend upon, severer agreement than is carried by the aesthetic analogue, I wish to suggest that it is a claim or dependence of the same kind.

We should immediately notice an obvious failure in the analogy between aesthetic judgments and the philosophical claim to voice what we say. The philosophical claim seems clearly open to refutation by an empirical collection of data about what people in fact say, whereas it makes no obvious sense to confirm or disconfirm such a judgment as "The *Hammerklavier* Sonata is a perverse work" by collecting data to find out whether the Sonata is in fact perverse. It is out of the question to enter into this difficult range of problems now. But I cannot forbear mentioning several points which I have tried elsewhere to suggest, with, to judge from results, evident unsuccess.[5]

[5]See J. Fodor and J. Katz, "The Availability of What We Say," in the *Philosophical Review*, Vol. LXXII (1963), an attack, primarily, on my paper "Must We Mean What We Say?" which appears as the first essay in this book. [Added 1968. A paper by Professor Richard Henson ("What We Say," *American Philosophical Quarterly*, Vol. 2/No. 1, January 1965, pp. 52–62) includes specific rejoinders to a number of the points raised by Fodor and Katz.]

1. I take it to be a phenomenological fact about philosophizing from everyday language that one feels empirical evidence about one's language to be irrelevant to one's claims. If such philosophizing is to be understood, then that fact about it must be understood. I am not saying that evidence about how (other) people speak can never make an ordinary language philosopher withdraw his typical claims; but I find it important that the most characteristic pressure against him is applied by producing or deepening an example which shows him that *he* would not say what he says "we" say.

2. The appeal to "what we should say if . . ." requires that we imagine an example or story, sometimes one more or less similar to events which may happen any day, sometimes one unlike anything we have known. Whatever the difficulties will be in trying to characterize this procedure fully and clearly, this much can be said at once: if we find we disagree about what we should say, it would make no obvious sense to attempt to confirm or disconfirm one or other of our responses by collecting data to show which of us is in fact right. What we should do is either (*a*) try to determine why we disagree (perhaps we are imagining the story differently)—just as, if we agree in response we will, when we start philosophizing about this fact, want to know why we agree, what it shows about our concepts; or (*b*) we will, if the disagreement cannot be explained, either find some explanation for *that*, or else discard the example. Disagreement is not disconfirming: it is as much a datum for philosophizing as agreement is. At this stage philosophizing has, hopefully, not yet begun.

3. Such facts perhaps only amount to saying that the philosophy of ordinary language is not about language, anyway not in any sense in which it is not also about the world. Ordinary language philosophy is about whatever ordinary language is about.

The philosopher appealing to everyday language turns to the reader not to convince him without proof but to get him to prove something, test something, against himself. He is saying: Look and find out whether you can see what I see, wish to say what I wish to say. Of course he often seems to answer or beg his own question by posing it in plural form: "We say . . . ; We want to say . . . ; We can imagine . . . ; We feel as if we had to penetrate phenomena, repair a spider's web; We are under the illusion . . . ; We are dazzled . . . ; The idea now absorbs us . . . ; We are dissatisfied. . . ." But this plural is still first person: it does not, to use Kant's word, "postulate" that "we," you and I and he, say and want and imagine and feel and suffer together. If we do not, then the philosopher's remarks are irrelevant to us. Of course he doesn't think they are irrelevant, but the implication is that philosophy, like art, is, and should be, powerless to *prove* its relevance; and that says something about the kind of relevance it wishes to have. All the philosopher, this kind of philosopher, can do is to express, as fully as he can, his world, and attract our undivided attention to our own.

Kant's attention to the "universal voice" expressed in aesthetic judgment seems to me, finally, to afford some explanation of that air of dogmatism which

claims about what "we" say seem to carry for critics of ordinary language procedures, and which they find repugnant and intolerant. I think that air of dogmatism is indeed present in such claims; but if that is intolerant, that is because tolerance could only mean, as in liberals it often does, that the kind of claim in question is not taken seriously. It is, after all, a claim about *our lives*; it is differences, or oppositions, of these that tolerance, if it is to be achieved, must be directed toward. About what we should say when, we do not expect to have to tolerate much difference, believing that if we could articulate it fully we would have spoken for all men, found the necessities common to us all. Philosophy has always hoped for that; so, perhaps, has science. But philosophy concerns those necessities we cannot, being human, fail to know. Except that nothing is more human than to deny them.

R E A D I N G 2 6

INTRODUCTION

The essays in this section are all, in one way or another, concerned with the logic of taste, and with issues concerning the objectivity of aesthetic judgments. In effect, that is, they are concerned with the question: Can judgments about the aesthetic properties of a thing, or about its value, really be correct or incorrect? As Cavell suggests, one of the reasons that it might be held that such judgments cannot be objective, or that no aesthetic judgment has any more claim to correctness than any other, is that arguments about aesthetic value are often inconclusive, and may, as a result, seem irresolvable. In attempting to get clear about the logic of taste, then, it is important to examine the nature of argument about aesthetic properties and aesthetic value. In "Critical Communication" (1949), Arnold Isenberg, late professor of philosophy at Michigan State University, embarks on just such an examination. Once we have recognized what we take to be the aesthetically relevant properties of a work, what is involved in attempting to communicate our recognition to others? In particular, what is involved in our attempts to *justify* the value judgments that we make about a work on the basis of those recognitions? How are our evaluative judgments related to the reasons that we offer in support of them? Isenberg suggests that the reasons a critic offers in support of his or her evaluative judgments are never logically compelling: They cannot "designate any quality the perception of which might induce us to assent" to an evaluative judgment. Instead, he argues, the reasons a critic offers in support of his or her evaluative judgments serve to "clarify" and "alter" the experience that we have of a work. If they are successful in this, then we ourselves come to make evaluative judgments on the basis of our clarified or altered experience. Critical communication, he suggests, does not succeed by offering proofs of or even compelling evidence for the truth of a judgment. Rather, criticism enables a person to make his or her own educated judgments.

Critical Communication

Arnold Isenberg

That questions about meaning are provisionally separable, even if finally inseparable, from questions about validity and truth, is shown by the fact that meanings can be exchanged without the corresponding cognitive decisions.[1] What is imparted by one person to another in an act of communication is (typically) a certain idea, thought, content, meaning, or claim—not a belief, expectation, surmise, or doubt; for the last are dependent on factors, such as the checking process, which go beyond the mere understanding of the message conveyed. And there is a host of questions which have to do with this message: its simplicity or complexity, its clarity or obscurity, its tense, its mood, its modality, and so on. Now, the theory of art criticism has, I think, been seriously hampered by a kind of headlong assault on the question of validity. We have many doctrines about the objectivity of a critical judgment but few concerning its import, or claim to objectivity, though the settlement of the first of these questions probably depends on the clarification of the second. The following remarks are for the most part restricted to meeting such questions as: What is the content of the critic's argument? What claim does he transmit to us? How does he expect us to deal with this claim?

A good point to start from is a theory of criticism, widely held in spite of its deficiencies, which divides the critical process into three parts. There is the value judgment or *verdict* (V): "This picture or poem is good—." There is a particular statement or *reason* (R): "—because it has such-and-such a quality—." And there is a general statement or *norm* (N): "—and any work which has that quality is *pro tanto* good."[2]

V has been construed, and will be construed here, as an expression of feeling—an utterance manifesting praise or blame. But among utterances of that class it is distinguished by being in some sense conditional upon R. This is only another phrasing of the commonly noted peculiarity of aesthetic feeling: that it is "embodied" in or "attached" to an aesthetic content.

R is a statement describing the content of an art work; but not every such descriptive statement will be a case of R. The proposition, "There are just twelve flowers in that picture" (and with it nine out of ten descriptions in Crowe and Cavalcaselle), is without critical relevance; that is, without any bearing upon V. The description of a work of art is seldom attempted for its own sake. It is controlled by some purpose, some interest; and there are many interests by which it might be controlled other than that of reaching or defending a critical judgment. The qualities which are significant in relation to one purpose—dating, attribution, archaeological reconstruction, clinical diagnosis,

[1]The author is indebted to Mr. Herbert Bohnert for assistance with this paper.
[2]Cf. for instance, C. J. Ducasse, *Art, the Critics, and You* (p. 116): "The statement that a given work possesses a certain objective characteristic expresses at the same time a judgment of value if the characteristic is one that the judging person approves or, as the case may be, disapproves; and is thus one that he regards as conferring, respectively, positive or negative value on any object of the given kind that happens to possess it." See, further, pp. 117–120.

proving or illustrating some thesis in sociology—might be quite immaterial in relation to another. At the same time, we cannot be sure that there is any *kind* of statement about art, serving no matter what main interest, which cannot also act as R; or, in other words, that there is any *kind* of knowledge about art which cannot influence aesthetic appreciation.

V and R, it should be said, are often combined in sentences which are at once normative and descriptive. If we have been told that the colors of a certain painting are garish, it would be astonishing to find that they were all very pale and unsaturated; and to this extent the critical comment conveys information. On the other hand, we might find the colors bright and intense, as expected, without being thereby forced to admit that they are garish; and this reveals the component of valuation (that is, distaste) in the critic's remark. This feature of critical usage has attracted much notice and some study; but we do not discuss it here at all. We shall be concerned solely with the descriptive function of R.

Now if we ask what makes a description critically useful and relevant, the first suggestion which occurs is that it is *supported by N*. N is based upon an inductive generalization which describes a relationship between some aesthetic quality and someone's or everyone's system of aesthetic response. Notice: I do not say that N *is* an inductive generalization; for in critical evaluation N is being used not to predict or to explain anybody's reaction to a work of art but to vindicate that reaction, perhaps to someone who does not yet share it; and in this capacity N is a precept, a rule, a *generalized value statement*. But the *choice* of one norm, rather than another, when that choice is challenged, will usually be given some sort of inductive justification. We return to this question in a moment. I think we shall find that a careful analysis of N is unnecessary, because there are considerations which permit us to dismiss it altogether.

At this point it is well to remind ourselves that there is a difference between *explaining and justifying* a critical response. A psychologist who should be asked "why X likes the object y" would take X's enjoyment as a datum, a fact to be explained. And if he offers as explanation the presence in y of the quality Q, there is, explicit or latent in this causal argument, an appeal to some generalization which he has reason to think is true, such as "X likes any work which has that quality." But when we ask X as a critic "why he likes the object y," we want him to give us some reason to like it too and are not concerned with the causes of what we may so far regard as his bad taste. This distinction between genetic and normative inquiry, though it is familiar to all and acceptable to most of us, is commonly ignored in the practice of aesthetic speculation; and the chief reason for this—other than the ambiguity of the question "Why do you like this work?"—is the fact that some statements about the object will necessarily figure both in the explanation and in the critical defence of any reaction to it. Thus, if I tried to explain my feeling for the line

> But musical as is Apollo's lute,

I should certainly mention "the pattern of *u*'s and *l*'s which reinforces the meaning with its own musical quality"; for this quality of my sensations is doubtless among the conditions of my feeling response. And the same point

would be made in any effort to convince another person of the beauty of the line. The remark which gives a reason also, in this case, states a cause. But notice that, though as criticism this comment might be very effective, it is practically worthless as explanation; for we have no phonetic or psychological laws (nor any plausible "common-sense" generalizations) from which we might derive the prediction that such a pattern of u's and l's should be pleasing to me. In fact, the formulation ("pattern of u's and l's," etc.) is so vague that one could not tell just what general hypothesis it is that is being invoked or assumed; yet it is quite sharp enough for critical purposes. On the other hand, suppose that someone should fail to be "convinced" by my argument in favor of Milton's line. He might still readily admit that the quality of which I have spoken might have something to do with *my* pleasurable reaction, given my peculiar mentality. Thus the statement which is serving both to explain and to justify is not equally effective in the two capacities; and this brings out the difference between the two lines of argument. Coincident at the start, they diverge in the later stages. A *complete* explanation of any of my responses would have to include certain propositions about my nervous system, which would be irrelevant in any critical argument. And a critically relevant observation about some configuration in the art object might be useless for explaining a given experience, if only because the experience did not yet contain that configuration.[3]

Now it would not be strange if, among the dangers of ambiguity to which the description of art, like the rest of human speech, is exposed, there should be some which derive from the double purpose—critical and psychological—to which such description is often being put. And this is, as we shall see, the case.

The necessity for sound inductive generalizations in any attempt at aesthetic explanation is granted. We may now consider, very briefly, the parallel role in normative criticism which has been assigned to N. Let us limit our attention to those metacritical theories which *deny* a function in criticism to N. I divide these into two kinds, those which attack existing standards and those which attack the very notion of a critical standard.

(1) It is said that we know of no law which governs human tastes and preferences, no quality shared by any two works of art that makes those works attractive or repellent. The point might be debated; but it is more important to notice what it assumes. It assumes that if N *were* based on a sound induction, it would be (together with R) a real ground for the acceptance of V. In other words, it would be reasonable to accept V on the strength of the quality Q if it could be shown that works which possess Q tend to be pleasing. It follows

[3]I should like to add that when we speak of "justifying" or "giving reasons" for our critical judgments, we refer to something which patently does go on in the world and which is patently different from the causal explanation of tastes and preferences. We are not begging any question as to whether the critical judgment can "really" be justified; that is, established on an objective basis. Even if there were no truth or falsity in criticism, there would still be agreement and disagreement; and there would be argument which arises out of disagreement and attempts to resolve it. Hence, at the least there exists the purely "phenomenological" task of elucidating the import and intention of words like 'insight,' 'acumen,' 'obtuseness,' 'bad taste,' all of which have a real currency in criticism.

that criticism is being held back by the miserable state of aesthetic science. This raises an issue too large to be canvassed here. Most of us believe that the idea of progress applies to science, does not apply to art, applies, in some unusual and not very clear sense, to philosophy. What about criticism? Are there "discoveries" and "contributions" in this branch of thought? Is it reasonable to expect better evaluations of art after a thousand years of criticism than before? The question is not a simple one: it admits of different answers on different interpretations. But I do think that some critical judgments have been and are every day being "proved" as well as in the nature of the case they ever can be proved. I think we have already numerous passages which are not to be corrected or improved upon. And if this opinion is right, then it could not be the case that the validation of critical judgments waits upon the discovery of aesthetic laws. Let us suppose even that we had some law which stated that a certain color combination, a certain melodic sequence, a certain type of dramatic hero has everywhere and always a positive emotional effect. To the extent to which this law holds, there is of course that much less disagreement in criticism; but there is no better method for resolving disagreement. We are not more fully convinced in our own judgment because we know its explanation; and we cannot hope to convince an imaginary opponent by appeal to this explanation, which by hypothesis does not hold for him.

(2) The more radical arguments against critical standards are spread out in the pages of Croce, Dewey, Richards, Prall, and the great romantic critics before them. They need not be repeated here. In one way or another they all attempt to expose the absurdity of presuming to judge a work of art, the very excuse for whose existence lies in its *difference* from everything that has gone before, by its degree of *resemblance* to something that has gone before; and on close inspection they create at least a very strong doubt as to whether a standard of success or failure in art is either necessary or possible. But it seems to me that they fail to provide a positive interpretation of criticism. Consider the following remarks by William James on the criticism of Herbert Spencer: "In all his dealings with the art products of mankind he manifests the same curious dryness and mechanical literality of judgment. . . . Turner's painting he finds untrue in that the earth-region is habitually as bright in tone as the air-region. Moreover, Turner scatters his detail too evenly. In Greek statues the hair is falsely treated. Renaissance painting is spoiled by unreal illumination. Venetian Gothic sins by meaningless ornamentation." And so on. We should most of us agree with James that this is bad criticism. But *all* criticism is similar to this in that it cites, as reasons for praising or condemning a work, one or more of its qualities. If Spencer's reasons are descriptively true, how can we frame our objection to them except in some such terms as that "unreal illumination does not make a picture bad"; that is, by attacking his standards? What constitutes the relevance of a reason but its correlation with a norm? It is astonishing to notice how many writers, formally committed to an opposition to legal procedure in criticism, *seem* to relapse into a reliance upon standards whenever they give reasons for their critical judgments. The appearance is inevitable; for as long as we have no alternative interpretation of the import and function of R, we must assume *either* that R is perfectly arbitrary *or* that it presupposes and depends on some general claim.

With these preliminaries, we can examine a passage of criticism. This is Ludwig Goldscheider on *The Burial of Count Orgaz:*

> Like the contour of a violently rising and falling wave is the outline of the four illuminated figures in the foreground: steeply upwards and downwards about the grey monk on the left, in mutually inclined curves about the yellow of the two saints, and again steeply upwards and downwards about . . . the priest on the right. The depth of the wave indicates the optical centre; the double curve of the saints' yellow garments is carried by the greyish white of the shroud down still farther; in this lowest depth rests the bluish-grey armor of the knight.

This passage—which, we may suppose, was written to justify a favorable judgment on the painting—conveys to us the idea of a certain quality which, if we believe the critic, we should expect to find in a certain painting by El Greco. And we do find it: we can verify its presence by perception. In other words, there is a quality in the picture which agrees with the quality which we "have in mind"—which we have been led to think of by the critic's language. But the same quality ("a steeply rising and falling curve," etc.) would be found in any of a hundred lines one could draw on the board in three minutes. It could not be the critic's purpose to inform us of the presence of a quality as obvious as this. It seems reasonable to suppose that the critic is thinking of another quality, no idea of which is transmitted to us by his language, which he *sees* and which by his use of language he *gets us to see.* This quality is, of course, a wavelike contour; but it is not the quality designated by the *expression* 'wavelike contour.' Any object which has this quality will have a wavelike contour; but it is not true that any object which has a wavelike contour will have this quality. At the same time, the expression 'wavelike contour' *excludes* a great many things: if anything is a wavelike contour, it is not a color, it is not a mass, it is not a straight line. Now the critic, besides imparting to us the idea of a wavelike contour, gives us directions for perceiving, and does this *by means* of the idea he imparts to us, which narrows down the field of possible visual orientations and guides us in the discrimination of details, the organization of parts, the grouping of discrete objects into patterns. It is as if we found both an oyster and a pearl when we had been looking for a seashell because we had been told it was valuable. It *is* valuable, but not because it is a seashell.

I may be stretching usage by the senses I am about to assign to certain words, but it seems that the critic's *meaning* is "filled in," "rounded out," or "completed" by the act of perception, which is performed not to judge the truth of his description but in a certain sense to *understand* it. And if *communication* is a process by which a mental content is transmitted by symbols from one person to another, then we can say that it is a function of criticism to bring about communication at the level of the senses; that is, to induce a sameness of vision, of experienced content. If this is accomplished, it may or may not be followed by agreement, or what is called "communion"—a community of feeling which expresses itself in identical value judgments.

There is a contrast, therefore, between critical communication and what I may call normal or ordinary communication. In ordinary communication, symbols tend to acquire a footing relatively independent of sense-perception.

It is, of course, doubtful whether the interpretation of symbols is at any time completely unaffected by the environmental context. But there is a difference of degree between, say, an exchange of glances which, though it means "Shall we go home?" at one time and place, would mean something very different at another—between this and formal science, whose vocabulary and syntax have relatively fixed connotations. With a passage of scientific prose before us, we may be dependent on experience for the definition of certain simple terms, as also for the confirmation of assertions; but we are not dependent on experience for the interpretation of compound expressions. If we are, this exposes semantical defects in the passage—obscurity, vagueness, ambiguity, or incompleteness. (Thus: "Paranoia is marked by a profound egocentricity and deep-seated feelings of insecurity"—the kind of remark which makes every student think he has the disease—is suitable for easy comparison of notes among clinicians, who know how to recognize the difference between paranoia and other conditions; but it does not explicitly set forth the criteria which they employ). Statements about immediate experience, made in ordinary communication, are no exception. If a theory requires that a certain flame should be blue, then we have to report whether it is or is not blue—regardless of shades or variations which may be of enormous importance aesthetically. We are bound to the letters of our words. Compare with this something like the following:

"The expression on her face was delightful."

"What was delightful about it?"

"Didn't you see that smile?"

The speaker does not mean that there is something delightful about smiles as such; but he cannot be accused of not stating his meaning clearly, because the clarity of his language must be judged in relation to his purpose, which in this case is the *evaluation* of the immediate experience; and for that purpose the reference to the smile will be sufficient if it gets people to feel that they are "talking about the same thing." There is understanding and misunderstanding at this level; there are marks by which the existence of one or the other can be known; and there are means by which misunderstanding can be eliminated. But these phenomena are not identical with those that take the same names in the study of ordinary communication.

Reading criticism, otherwise than in the presence, or with direct recollection, of the objects discussed is a blank and senseless employment—a fact which is concealed from us by the cooperation, in our reading, of many non-critical purposes for which the information offered by the critic is material and useful. There is not in all the world's criticism a single purely descriptive statement concerning which one is prepared to say beforehand, "If it is true, I shall like that work so much the better"—and *this* fact is concealed by the play of memory, which gives the critic's language a quite different, more specific, meaning than it has as ordinary communication. The point is not at all similar to that made by writers who maintain that value judgments have no objective basis because the reasons given to support them are not logically derivable from the value judgments themselves. I do not ask that R be related *logically* to V. In ethical argument you have someone say, "Yes, I would condemn that policy if it really did cause a wave of suicides, as you maintain." Suppose that the two clauses are here only psychologically related—still, this

is what you never have in criticism. *The truth of R never adds the slightest weight to V*, because R does not designate any quality the perception of which might induce us to assent to V. But if it is not R, or what it designates, that makes V acceptable, then R cannot possibly require the support of N. The critic is not committed to the general claim that the quality named Q is valuable because he never makes the particular claim that a work is good in virtue of the presence of Q.

But he, or his readers, can easily be misled into *thinking* that he has made such a claim. You have, perhaps, a conflict of opinion about the merits of a poem; and one writer defends his judgment by mentioning vowel sounds, metrical variations, consistent or inconsistent imagery. Another critic, taking this language at its face value in ordinary communication, points out that "by those standards" one would have to condemn famous passages in *Hamlet* or *Lear* and raise some admittedly bad poems to a high place. He may even attempt what he calls an "experiment" and, to show that his opponent's grounds are irrelevant, construct a travesty of the original poem in which its plot or its meter or its vowels and consonants, or whatever other qualities have been cited with approval, are held constant while the rest of the work is changed. This procedure, which takes up hundreds of the pages of our best modern critics, is a waste of time and space; for it is the critic abandoning his own function to pose as a scientist—to assume, in other words, that criticism explains experiences instead of clarifying and altering them. If he saw that the *meaning* of a word like 'assonance'—the quality which it leads our perception to discriminate in one poem or another—is in critical usage never twice the same, he would see no point in "testing" any generalization about the relationship between assonance and poetic value.

Some of the foregoing remarks will have reminded you of certain doctrines with which they were not intended to agree. The fact that criticism does not actually designate the qualities to which it somehow directs our attention has been a ground of complaint by some writers, who tell us that our present critical vocabulary is woefully inadequate.[4] This proposition clearly looks to an eventual improvement in the language of criticism. The same point, in a stronger form and with a different moral, is familiar to readers of Bergson and Croce, who say that it is impossible by means of concepts to "grasp the essence" of the artistic fact; and this position has seemed to many people to display the ultimate futility of critical analysis. I think that by returning to the passage I quoted from Goldscheider about the painting by El Greco we can differentiate the present point of view from both of these. Imagine, then, that the painting should be projected on to a graph with intersecting co-ordinates. It would then be possible to write complicated mathematical expressions which would enable another person who knew the system to construct for himself as close an approximation to the exact outlines of the El Greco as we might desire. Would this be an advance towards precision in criticism? Could we say that we had devised a more specific terminology for drawing and painting? I think not, for the most refined concept remains a concept; there is no vanishing point at which it becomes a percept. It is the idea *of* a quality, it

[4]See D. W. Prall, *Aesthetic Analysis*, p. 201.

is not the quality itself. To render a critical verdict we should still have to perceive the quality; but Goldscheider's passage already shows it to us as clearly as language can. The idea of a new and better means of communication presupposes the absence of the sensory contents we are talking about; but criticism always assumes the presence of these contents to both parties; and it is upon this assumption that the vagueness or precision of a critical statement must be judged. Any further illustration of this point will have to be rough and hasty. For the last twenty or thirty years the "correct" thing to say about the metaphysical poets has been this: They think with their senses and feel with their brains. One hardly knows how to verify such a dictum: as a psychological observation it is exceedingly obscure. But it does not follow that it is not acute criticism; for it increases our awareness of the difference between Tennyson and Donne. Many words—like 'subtlety,' 'variety,' 'complexity,' 'intensity'—which in ordinary communication are among the vaguest in the language have been used to convey sharp critical perceptions. And many expressions which have a clear independent meaning are vague and fuzzy when taken in relation to the content of a work of art. An examination of the ways in which the language of concepts mediates between perception and perception is clearly called for, though it is far too difficult to be attempted here.

We have also just seen reason to doubt that any aesthetic quality is ultimately ineffable. 'What can be said' and 'what cannot be said' are phrases which take their meaning from the purpose for which we are speaking. The aesthetics of obscurantism, in its insistence upon the incommunicability of the art object, has never made it clear what purpose or demand is to be served by communication. If we devised a system of concepts by which a work of art could be virtually reproduced at a distance by the use of language alone, what human intention would be furthered? We saw that *criticism* would not be improved: in the way in which criticism strives to "grasp" the work of art, we could grasp it no better then than now. The scientific *explanation* of aesthetic experiences would not be accomplished by a mere change of descriptive terminology. There remains only the *aesthetic* motive in talking about art. Now if we set it up as a condition of communicability that our language should *afford* the experience which it purports to describe, we shall of course reach the conclusion that art is incommunicable. But by that criterion all reality is unintelligible and ineffable, just as Bergson maintains. Such a demand upon thought and language is not only preposterous in that its fulfillment is logically impossible; it is also baneful, because it obscures the actual and very large influence of concepts upon the process of perception (by which, I must repeat, I mean something more than the ordinary *reference* of language to qualities of experience). Every part of the psychology of perception and attention provides us with examples of how unverbalized apperceptive reactions are engrained in the content and structure of the perceptual field. We can also learn from psychology how perception is affected by verbal cues and instructions. What remains unstudied is the play of critical comment in society at large; but we have, each of us in his own experience, instances of differential emphasis and selective grouping which have been brought about through the concepts imparted to us by the writings of critics.

I have perhaps overstressed the role of the critic as teacher, i.e., as one who

affords *new* perceptions and with them new values. There is such a thing as discovering a community of perception and feeling which already exists; and this can be a very pleasant experience. But it often happens that there are qualities in a work of art which are, so to speak, neither perceived nor ignored but felt or endured in a manner of which Leibniz has given the classic description. Suppose it is only a feeling of monotony, a slight oppressiveness, which comes to us from the style of some writer. A critic then refers to his "piled-up clauses, endless sentences, repetitious diction." This remark shifts the focus of our attention and brings certain qualities which had been blurred and marginal into distinct consciousness. When, with a sense of illumination, we say "Yes, that's it exactly," we are really giving expression to the *change* which has taken place in our aesthetic apprehension. The post-critical experience is the true commentary on the pre-critical one. The same thing happens when, after listening to Debussy, we study the chords that can be formed on the basis of the whole-tone scale and then return to Debussy. New feelings are given which bear some resemblance to the old. There is no objection in these cases to our saying that we have been made to "understand" why we liked (or disliked) the work. But such understanding, which is the legitimate fruit of criticism, is nothing but a second moment of aesthetic experience, a retrial of experienced values. It should not be confused with the psychological study which seeks to know the cause of our feelings.

Note

In this article I have tried only to mark out the direction in which, as I believe, the exact nature of criticism should be sought. The task has been largely negative: it is necessary to correct preconceptions, obliterate false trails. There remain questions of two main kinds. Just to establish the adequacy of my analysis, there would have to be a detailed examination of critical phenomena, which present in the gross a fearful complexity. For example, I have paid almost no attention to large-scale or summary judgments—evaluations of artists, schools, or periods. One could quote brief statements about Shakespeare's qualities as a poet or Wagner's as a composer which seem to be full of insight; yet it would be hard to explain what these statements do to our "perception"—if that word can be used as a synonym for our appreciation of an artist's work as a whole.

But if the analysis is so far correct, it raises a hundred new questions. Two of these—rather, two sides of one large question—are especially important. What is the semantical relationship between the language of criticism and the qualities of the critic's or the reader's experience? I have argued that this relationship is not designation (though I do not deny that there *is* a relationship of designation between the critic's language and *some* qualities of a work of art). But neither is it denotation: the critic does not *point* to the qualities he has in mind. The ostensive function of language will explain the exhibition of *parts* or *details* of an art object but not the exhibition of abstract *qualities;* and it is the latter which is predominant in criticism. The only positive suggestion made in this paper can be restated as follows. To say that the critic "picks out" a quality in the work of art is to say that if there did exist a designation for that

quality, then the designation which the critic employs would be what Morris calls an analytic implicate of that designation. (Thus, 'blue' is an analytic implicate of an expression 'H3B5S2' which designates a certain point on the color solid.) This definition is clearly not sufficient to characterize the critic's method; but, more, the antecedent of the *definiens* is doubtful in meaning. A study of terms like 'Rembrandt's chiaroscuro,' 'the blank verse of *The Tempest*,' etc., etc., would probably result in the introduction of an idea analogous to that of the proper name (or of Russell's "definite description") but with this difference, that the entity uniquely named or labelled by this type of expression is not an object but a quality.

If we put the question on the psychological plane, it reads as follows: How is it that (*a*) we can "know what we like" in a work of art without (*b*) knowing what "causes" our enjoyment? I presume that criticism enlightens us as to (*a*) and that (*b*) would be provided by a psychological explanation; also that (*a*) is often true when (*b*) is not.

Contrary to Ducasse[5] and some other writers I cannot see that the critic has any competence as a self-psychologist, a specialist in the explanation of his own responses. There is no other field in which we admit the existence of such scientific insight, unbridled by experimental controls and unsupported by valid general theory; and I do not think we can admit it here. (For that reason I held that critical insight, which does exist, cannot be identified with scientific understanding.) The truth is that, in the present stone age of aesthetic inquiry, we have not even the vaguest idea of the form that a "law of art appreciation" would take. Consider, "It is as a *colorist* that Titian excels"; interpret this as causal hypothesis—for example, "Titian colors give pleasure"; and overlook incidental difficulties, such as whether 'color' means tone or the hue (as opposed to the brightness and the saturation) of a tone. Superficially, this is similar to many low-grade hypotheses in psychology: "We owe the *color* of the object to the retinal rods and cones," "It is the *brightness* and not the color that infuriates a bull," "Highly *saturated* colors give pleasure to American schoolboys." But the difference is that we do not know what test conditions are marked out by our chosen proposition. Would it be relevant, as a test of its truth, to display the colors of a painting by Titian, in a series of small rectangular areas, to a group of subjects in the laboratory? I cannot believe this to be part of what is meant by a person who affirms this hypothesis. He is committed to no such test.

Anyone with a smattering of Gestalt psychology now interposes that the colors are, of course, pleasing *in* their context, not out of it. One has some trouble in understanding how in that case one could know that it is the *colors* that are pleasing. We may believe in studying the properties of wholes; but it is hard to see what scientific formulation can be given to the idea that a quality should have a certain function (that is, a causal relationship to the responses of an observer) in one and only one whole. Yet that appears to be the case with the color scheme in any painting by Titian.

We can be relieved of these difficulties simply by admitting our ignorance and confusion; but there is no such escape when we turn to criticism. For it *is*

[5]*Op. cit.*, p. 117.

as a colorist that Titian excels—this is a fairly unanimous value judgment, and we should be able to analyze its meaning. (I should not, however, want the issue to turn on this particular example. Simpler and clearer judgments could be cited.) Now when our attention is called, by a critic, to a certain quality, we respond to that quality *in its context*. The context is never specified, as it would have to be in any scientific theory, but always assumed. Every descriptive statement affects our perception of—and our feeling for—the work as a whole. One might say, then, that we agree with the critic if and when he gets us to like the work about as well or as badly as he does. But this is clearly not enough. For he exerts his influence always through a specific discrimination. Art criticism is analytic, discriminating. It concerns itself less with over-all values than with merits and faults in specified respects. It is the quality and not the work that is good or bad; or, if you like, the work is good or bad "on account of its qualities." Thus, we may agree with his judgment but reject the critic's grounds (I have shown that the "grounds," to which he is really appealing are not the same as those which he explicitly states or designates); and when we do this, we are saying that the qualities which he admires are not those which we admire. But then we must know what we admire: we are somehow aware of the special attachment of our feelings to certain abstract qualities rather than to others. Without this, we could never reject a reason given for a value judgment with which we agree—we could never be dissatisfied with descriptive evaluation. There must therefore exist an analyzing, sifting, shredding process within perception which corresponds to the conceptual distinctness of our references to "strong form but weak color," "powerful images but slovenly meter," and so on.

This process is mysterious; but we can get useful hints from two quarters. Artists and art teachers are constantly "experimenting," in their own way. "Such a bright green at this point is jarring." "Shouldn't you add more detail to the large space on the right?" We can compare two wholes in a single respect and mark the difference in the registration upon our feelings. Implicit comparisons of this kind, with shifting tone of feeling, are what are involved in the isolation of qualities from the work, at least in *some* critical judgments. I am afraid that as psychology, as an attempt to discover the causes of our feelings, this is primitive procedure; but as a mere analysis of what is meant by the praise and blame accorded to special qualities, it is not without value.

If, in the second place, we could discover what we mean by the difference between the "object" and the "cause" of an emotion, *outside* the field of aesthetics; if we could see both the distinction and the connection between two such judgments as "I hate his cheek" and "It is his cheek that inspires hatred in me"; if we knew what happens when a man says, "Now I know why I have always disliked him—it is his pretence of humility," there would be a valuable application to the analysis of critical judgments.

INTENTION AND INTERPRETATION

INTRODUCTION

In 1946, W. K. Wimsatt and Monroe C. Beardsley wrote their much-discussed essay "The Intentional Fallacy." It contains two related claims. The first is that knowledge of an artist's intentions is irrelevant to the evaluation of what the artist has achieved. The second is that knowledge of an artist's intentions is irrelevant to the interpretation of what the artist has produced. These claims, while sometimes a bit tricky to disentangle, are clearly distinct in principle. A complication is introduced, however, when the second claim—the one about interpretation—is refined. For Wimsatt and Beardsley make a distinction between two different kinds of intention: (1) intention for which there is "internal" evidence, and (2) intention for which there is "external" evidence. It turns out that it is only knowledge of the second kind of intention which is not relevant to the interpretation of artworks. Thus, for Wimsatt and Beardsley, knowledge of intentions may, after all, be relevant to the interpretation of an artist's work—but *only* if the interpreter has "internal" evidence for those intentions. Much of the discussion that this essay has received has centered upon the distinction between "internal" and "external" evidence, a distinction which the authors don't make ideally clear. What exactly is "internal" supposed to mean? Does it mean internal to the work of art? Or internal to the work of art plus certain other works of art (perhaps by the same artist)? Or does it mean internal to the work or works of art plus a certain cultural context? In attempting to answer these questions, it will help to look at the essay by Michael Baxandall reprinted in this section. For Baxandall, although he doesn't mention Wimsatt and Beardsley by name, does give a plausible account of the kinds of evidence for intention which might be relevant to interpretation. Wimsatt and Beardsley's essay suffers from an important obscurity, then; but the main ideas behind it are clear enough. And the issues it raises have intrigued philosophers ever since it first appeared.

The Intentional Fallacy

W. K. Wimsatt, Jr. and Monroe C. Beardsley

> *He owns with toil he wrote the following scenes;*
> *But, if they're naught, ne'er spare him for his pains:*
> *Damn him the more; have no commiseration*
> *For dullness on mature deliberation.*

—William Congreve
Prologue to *The Way of the World*

I

The claim of the author's "intention" upon the critic's judgment has been challenged in a number of recent discussions, notably in the debate entitled *The Personal Heresy*, between Professors Lewis and Tillyard. But it seems doubtful if this claim and most of its romantic corollaries are as yet subject to any widespread questioning. The present writers, in a short article entitled "Intention" for a *Dictionary*[1] of literary criticism, raised the issue but were unable to pursue its implications at any length. We argued that the design or intention of the author is neither available nor desirable as a standard for judging the success of a work of literary art, and it seems to us that this is a principle which goes deep into some differences in the history of critical attitudes. It is a principle which accepted or rejected points to the polar opposites of classical "imitation" and romantic expression. It entails many specific truths about inspiration, authenticity, biography, literary history and scholarship, and about some trends of contemporary poetry, especially its allusiveness. There is hardly a problem of literary criticism in which the critic's approach will not be qualified by his view of "intention."

"Intention," as we shall use the term, corresponds to *what he intended* in a formula which more or less explicitly has had wide acceptance. "In order to judge the poet's performance, we must know *what he intended."* Intention is design or plan in the author's mind. Intention has obvious affinities for the author's attitude toward his work, the way he felt, what made him write.

We begin our discussion with a series of propositions summarized and abstracted to a degree where they seem to us axiomatic.

1. A poem does not come into existence by accident. The words of a poem, as Professor Stoll has remarked, come out of a head, not out of a hat. Yet to insist on the designing intellect as a *cause* of a poem is not to grant the design or intention as a *standard* by which the critic is to judge the worth of the poet's performance.

2. One must ask how a critic expects to get an answer to the question about intention. How is he to find out what the poet tried to do? If the poet succeeded in doing it, then the poem itself shows what he was trying to do. And if the poet did not succeed, then the poem is not adequate evidence, and the

[1]*Dictionary of World Literature,* Joseph T. Shipley, ed. (New York, 1942), 326–329.

critic must go outside the poem—for evidence of an intention that did not become effective in the poem. "Only one *caveat* must be borne in mind," says an eminent intentionalist[2] in a moment when his theory repudiates itself; "the poet's aim must be judged at the moment of the creative act, that is to say, by the art of the poem itself."

3. Judging a poem is like judging a pudding or a machine. One demands that it work. It is only because an artifact works that we infer the intention of an artificer. "A poem should not mean but be." A poem can *be* only through its *meaning*—since its medium is words—yet it *is*, simply *is*, in the sense that we have no excuse for inquiring what part is intended or meant. Poetry is a feat of style by which a complex of meaning is handled all at once. Poetry succeeds because all or most of what is said or implied is relevant; what is irrelevant has been excluded, like lumps from pudding and "bugs" from machinery. In this respect poetry differs from practical messages, which are successful if and only if we correctly infer the intention. They are more abstract than poetry.

4. The meaning of a poem may certainly be a personal one, in the sense that a poem expresses a personality or state of soul rather than a physical object like an apple. But even a short lyric poem is dramatic, the response of a speaker (no matter how abstractly conceived) to a situation (no matter how universalized). We ought to impute the thoughts and attitudes of the poem immediately to the dramatic *speaker*, and if to the author at all, only by an act of biographical inference.

5. There is a sense in which an author, by revision, may better achieve his original intention. But it is a very abstract sense. He intended to write a better work, or a better work of a certain kind, and now has done it. But it follows that his former concrete intention was not his intention. "He's the man we were in search of, that's true," says Hardy's rustic constable, "and yet he's not the man we were in search of. For the man we were in search of was not the man we wanted."

"Is not a critic," asks Professor Stoll, "a judge, who does not explore his own consciousness, but determines the author's meaning or intention, as if the poem were a will, a contract, or the constitution? The poem is not the critic's own." He has accurately diagnosed two forms of irresponsibility, one of which he prefers. Our view is yet different. The poem is not the critic's own and not the author's (it is detached from the author at birth and goes about the world beyond his power to intend about it or control it). The poem belongs to the public. It is embodied in language, the peculiar possession of the public, and it is about the human being, an object of public knowledge. What is said about the poem is subject to the same scrutiny as any statement in linguistics or in the general science of psychology.

A critic of our *Dictionary* article, Ananda K. Coomaraswamy, has argued[3] that there are two kinds of inquiry about a work of art: (1) whether the artist achieved his intentions; (2) whether the work of art "ought ever to have been undertaken at all" and so "whether it is worth preserving." Number (2), Coomaraswamy maintains, is not "criticism of any work of art *qua* work of

[2]J. E. Spingarn, "The New Criticism," in *Criticism in America* (New York, 1924), pp. 24–25.
[3]Ananda K. Coomaraswamy, "Intention," in *American Bookman*, I (1944), 41–48.

art," but is rather moral criticism; number (1) is artistic criticism. But we maintain that (2) need not be moral criticism: that there is another way of deciding whether works of art are worth preserving and whether, in a sense, they "ought" to have been undertaken, and this is the way of objective criticism of works of art as such, the way which enables us to distinguish between a skillful murder and a skillful poem. A skillful murder is an example which Coomaraswamy uses, and in his system the difference between the murder and the poem is simply a "moral" one, not an "artistic" one, since each if carried out according to plan is "artistically" successful. We maintain that (2) is an inquiry of more worth than (1), and since (2) and not (1) is capable of distinguishing poetry from murder, the name "artistic criticism" is properly given to (2).

II

It is not so much a historical statement as a definition to say that the intentional fallacy is a romantic one. When a rhetorician of the first century A.D. writes: "Sublimity is the echo of a great soul," or when he tells us that "Homer enters into the sublime actions of his heroes" and "shares the full inspiration of the combat," we shall not be surprised to find this rhetorician considered as a distant harbinger of romanticism and greeted in the warmest terms by Saintsbury. One may wish to argue whether Longinus should be called romantic, but there can hardly be a doubt that in one important way he is.

Goethe's three questions for "constructive criticism" are "What did the author set out to do? Was his plan reasonable and sensible, and how far did he succeed in carrying it out?" If one leaves out the middle question, one has in effect the system of Croce—the culmination and crowning philosophic expression of romanticism. The beautiful is the successful intuition-expression, and the ugly is the unsuccessful; the intuition or private part of art is *the* aesthetic fact, and the medium or public part is not the subject of aesthetic at all.

> The Madonna of Cimabue is still in the Church of Santa Maria Novella; but does she speak to the visitor of to-day as to the Florentines of the thirteenth century?
>
> *Historical interpretation* labors . . . to reintegrate in us the psychological conditions which have changed in the course of history. It . . . enables us to see a work of art (a physical object) as its *author saw* it in the moment of production.[4]

The first italics are Croce's, the second ours. The upshot of Croce's system is an ambiguous emphasis on history. With such passages as a point of departure a critic may write a nice analysis of the meaning or "spirit" of a play by Shakespeare or Corneille—a process that involves close historical study but remains aesthetic criticism—or he may, with equal plausibility, produce an essay in sociology, biography, or other kinds of non-aesthetic history.

[4]It is true that Croce himself in his *Ariosto, Shakespeare and Corneille* (London, 1920), Ch. 7, "The Practical Personality and the Poetical Personality," and in his *Defence of Poetry* (Oxford, 1934), p. 24, and elsewhere, early and late, has delivered telling attacks on emotive geneticism, but the main drive of the *Aesthetic* is surely toward a kind of cognitive intentionalism.

III

> I went to the poets; tragic, dithyrambic, and all sorts. . . . I took them some of
> the most elaborate passages in their own writings, and asked what was the
> meaning of them. . . . Will you believe me? . . . there is hardly a person pre-
> sent who would not have talked better about their poetry than they did them-
> selves. Then I knew that not by wisdom do poets write poetry, but by a sort
> of genius and inspiration.

That reiterated mistrust of the poets which we hear from Socrates may have
been part of a rigorously ascetic view in which we hardly wish to participate,
yet Plato's Socrates saw a truth about the poetic mind which the world no
longer commonly sees—so much criticism, and that the most inspirational and
most affectionately remembered, has proceeded from the poets themselves.

Certainly the poets have had something to say that the critic and profes-
sor could not say; their message has been more exciting: that poetry should
come as naturally as leaves to a tree, that poetry is the lava of the imagination,
or that it is emotion recollected in tranquillity. But it is necessary that we real-
ize the character and authority of such testimony. There is only a fine shade
of difference between such expressions and a kind of earnest advice that
authors often give. Thus Edward Young, Carlyle, Walter Pater:

> I know two golden rules from *ethics,* which are no less golden in *Composition,*
> than in life. 1. *Know thyself;* 2dly, *Reverence thyself.*

> This is the grand secret for finding readers and retaining them: let him who
> would move and convince others, be first moved and convinced himself.
> Horace's rule, *Si vis me flere,* is applicable in a wider sense than the literal one.
> To every poet, to every writer, we might say: Be true, if you would be believed.

> Truth! there can be no merit, no craft at all, without that. And further, all
> beauty is in the long run only *fineness* of truth, or what we call expression, the
> finer accommodation of speech to that vision within.

And Housman's little handbook to the poetic mind yields this illustration:

> Having drunk a pint of beer at luncheon—beer is a sedative to the brain, and
> my afternoons are the least intellectual portion of my life—I would go out
> for a walk of two or three hours. As I went along, thinking of nothing in
> particular, only looking at things around me and following the progress of
> the seasons, there would flow into my mind, with sudden and unaccount-
> able emotion, sometimes a line or two of verse, sometimes a whole stanza at
> once.

This is the logical terminus of the series already quoted. Here is a confession
of how poems were written which would do as a definition of poetry just as
well as "emotion recollected in tranquillity"—and which the young poet might
equally well take to heart as a practical rule. Drink a pint of beer, relax, go
walking, think on nothing in particular, look at things, surrender yourself to
yourself, search for the truth in your own soul, listen to the sound of your own
inside voice, discover and express the *vraie vérité.*

It is probably true that all this is excellent advice for poets. The young
imagination fired by Wordsworth and Carlyle is probably closer to the verge
of producing a poem than the mind of the student who has been sobered by

Aristotle or Richards. The art of inspiring poets, or at least of inciting something like poetry in young persons, has probably gone further in our day than ever before. Books of creative writing such as those issued from the Lincoln School are interesting evidence of what a child can do.[5] All this, however, would appear to belong to an art separate from criticism—to a psychological discipline, a system of self-development, a yoga, which the young poet perhaps does well to notice, but which is something different from the public art of evaluating poems.

Coleridge and Arnold were better critics than most poets have been, and if the critical tendency dried up the poetry in Arnold and perhaps in Coleridge, it is not inconsistent with our argument, which is that judgment of poems is different from the art of producing them. Coleridge has given us the classic "anodyne" story, and tells what he can about the genesis of a poem which he calls a "psychological curiosity," but his definitions of poetry and of the poetic quality "imagination" are to be found elsewhere and in quite other terms.

It would be convenient if the passwords of the intentional school, "sincerity," "fidelity," "spontaneity," "authenticity," "genuineness," "originality," could be equated with terms such as "integrity," "relevance," "unity," "function," "maturity," "subtlety," "adequacy," and other more precise terms of evaluation—in short, if "expression" always meant aesthetic achievement. But this is not so.

"Aesthetic" art, says Professor Curt Ducasse, an ingenious theorist of expression, is the conscious objectification of feelings, in which an intrinsic part is the critical moment. The artist corrects the objectification when it is not adequate. But this may mean that the earlier attempt was not successful in objectifying the self, or "it may also mean that it was a successful objectification of a self which, when it confronted us clearly, we disowned and repudiated in favor of another."[6] What is the standard by which we disown or accept the self? Professor Ducasse does not say. Whatever it may be, however, this standard is an element in the definition of art which will not reduce to terms of objectification. The evaluation of the work of art remains public; the work is measured against something outside the author.

IV

There is criticism of poetry and there is author psychology, which when applied to the present or future takes the form of inspirational promotion; but author psychology can be historical too, and then we have literary biography, a legitimate and attractive study in itself, one approach, as Professor Tillyard would argue, to personality, the poem being only a parallel approach. Certainly it need not be with a derogatory purpose that one points out personal studies, as distinct from poetic studies, in the realm of literary scholarship. Yet

[5]See Hughes Mearns, *Creative Youth* (Garden City, 1925), esp. pp. 27–29. The technique of inspiring poems has apparently been outdone more recently by the study of inspiration in successful poets and other artists. See, for instance, Rosamond E. M. Harding, *An Anatomy of Inspiration* (Cambridge, 1940); Julius Portnoy, *A Psychology of Art Creation* (Philadelphia, 1942); Rudolf Arnheim and others, *Poets at Work* (New York, 1947); Phyllis Bartlett, *Poems in Process* (New York, 1951); Brewer Ghiselin, ed., *The Creative Process: A Symposium* (Berkeley and Los Angeles, 1952).
[6]Curt Ducasse, *The Philosophy of Art* (New York, 1929), p. 116.

there is danger of confusing personal and poetic studies; and there is the fault of writing the personal as if it were poetic.

There is a difference between internal and external evidence for the meaning of a poem. And the paradox is only verbal and superficial that what is (1) internal is also public: it is discovered through the semantics and syntax of a poem, through our habitual knowledge of the language, through grammars, dictionaries, and all the literature which is the source of dictionaries, in general through all that makes a language and culture; while what is (2) external is private or idiosyncratic; not a part of the work as a linguistic fact: it consists of revelations (in journals, for example, or letters or reported conversations) about how or why the poet wrote the poem—to what lady, while sitting on what lawn, or at the death of what friend or brother. There is (3) an intermediate kind of evidence about the character of the author or about private or semiprivate meanings attached to words or topics by the author or by a coterie of which he is a member. The meaning of words is the history of words, and the biography of an author, his use of a word, and the associations which the word had for *him*, are part of the word's history and meaning.[7] But the three types of evidence, especially (2) and (3), shade into one another so subtly that it is not always easy to draw a line between examples, and hence arises the difficulty for criticism. The use of biographical evidence need not involve intentionalism, because while it may be evidence of what the author intended, it may also be evidence of the meaning of his words and the dramatic character of his utterance. On the other hand, it may not be all this. And a critic who is concerned with evidence of type (1) and moderately with that of type (3) will in the long run produce a different sort of comment from that of the critic who is concerned with (2) and with (3) where it shades into (2).

The whole glittering parade of Professor Lowes' *Road to Xanadu*, for instance, runs along the border between types (2) and (3) or boldly traverses the romantic region of (2). " 'Kubla Khan' " says Professor Lowes, "is the fabric of a vision, but every image that rose up in its weaving had passed that way before. And it would seem that there is nothing haphazard or fortuitous in their return." This is not quite clear—not even when Professor Lowes explains that there were clusters of associations, like hooked atoms, which were drawn into complex relation with other clusters in the deep well of Coleridge's memory, and which then coalesced and issued forth as poems. If there was nothing "haphazard or fortuitous" in the way the images returned to the surface, that may mean (1) that Coleridge could not produce what he did not have, that he was limited in his creation by what he had read or otherwise experienced, or (2) that having received certain clusters of associations, he was bound to return them in just the way he did, and that the value of the poem may be described in terms of the experiences on which he had to draw. The latter pair of propositions (a sort of Hartleyan associationism which Coleridge himself repudiated in the *Biographia*) may not be assented to. There were certainly other combinations, other poems, worse or better, that might have been written by men who had read Bartram and Purchas and Bruce and Milton. And this will be true no matter how many times we are able to add

[7]And the history of words *after* a poem is written may contribute meanings which if relevant to the original pattern should not be ruled out by a scruple about intention.

to the brilliant complex of Coleridge's reading. In certain flourishes (such as the sentence we have quoted) and in chapter headings like "The Shaping Spirit," "The Magical Synthesis," "Imagination Creatrix," it may be that Professor Lowes pretends to say more about the actual poems than he does. There is a certain deceptive variation in these fancy chapter titles; one expects to pass on to a new stage in the argument, and one finds—more and more sources, more and more about "the streamy nature of association."[8]

"Wohin der Weg?" quotes Professor Lowes for the motto of his book. "Kein Weg! Ins Unbretretene." Precisely because the way is *unbetreten*, we should say, it leads away from the poem. Bartram's *Travels* contains a good deal of the history of certain words and of certain romantic Floridian conceptions that appear in "Kubla Khan." And a good deal of that history has passed and was then passing into the very stuff of our language. Perhaps a person who has read Bartram appreciates the poem more than one who has not. Or, by looking up the vocabulary of "Kubla Khan" in the *Oxford English Dictionary*, or by reading some of the other books there quoted, a person may know the poem better. But it would seem to pertain little to the poem to know that *Coleridge* had read Bartram. There is a gross body of life, of sensory and mental experience, which lies behind and in some sense causes every poem, but can never be and need not be known in the verbal and hence intellectual composition which is the poem. For all the objects of our manifold experience, for every unity, there is an action of the mind which cuts off roots, melts away context—or indeed we should never have objects or ideas or anything to talk about.

It is probable that there is nothing in Professor Lowes' vast book which could detract from anyone's appreciation of either *The Ancient Mariner* or "Kubla Khan." We next present a case where preoccupation with evidence of type (3) has gone so far as to distort a critic's view of a poem (yet a case not so obvious as those that abound in our critical journals).

In a well-known poem by John Donne appears this quatrain:

> Moving of th'earth brings harmes and feares,
> Men reckon what it did and meant,
> But trepidation of the spheares,
> Though greater farre, is innocent.

A recent critic in an elaborate treatment of Donne's learning has written of this quatrain as follows:

> He touches the emotional pulse of the situation by a skillful allusion to the new and the old astronomy. . . . Of the new astronomy, the "moving of the earth" is the most radical principle; of the old, the "trepidation of the spheares" is the motion of the greatest complexity. . . . The poet must exhort his love to quietness and calm upon his departure; and for this purpose the figure based upon the latter motion (trepidation), long absorbed into the traditional astronomy, fittingly suggests the tension of the moment without arousing the "harmes and feares" implicit in the figure of the moving earth.[9]

[8]Chs. 8, "The Pattern," and 16, "The Known and Familiar Landscape," will be found of most help to the student of the poem.
[9]Charles M. Coffin, *John Donne and the New Philosophy* (New York, 1927), 97–98.

The argument is plausible and rests on a well substantiated thesis that Donne was deeply interested in the new astronomy and its repercussions in the theological realm. In various works Donne shows his familiarity with Kepler's *De Stella Nova*, with Galileo's *Siderius Nuncius*, with William Gilbert's *De Magnete*, and with Clavius' commentary on the *De Sphaera* of Sacrobosco. He refers to the new science in his Sermon at Paul's Cross and in a letter to Sir Henry Goodyer. In *The First Anniversary* he says the "new philosophy calls all in doubt." In the *Elegy* on *Prince Henry* he says that the "least moving of the center" makes "the world to shake."

It is difficult to answer argument like this, and impossible to answer it with evidence of like nature. There is no reason why Donne might not have written a stanza in which the two kinds of celestial motion stood for two sorts of emotion at parting. And if we become full of astronomical ideas and see Donne only against the background of the new science, we may believe that he did. But the text itself remains to be dealt with, the analyzable vehicle of a complicated metaphor. And one may observe: (1) that the movement of the earth according to the Copernican theory is a celestial motion, smooth and regular, and while it might cause religious or philosophic fears, it could not be associated with the crudity and earthiness of the kind of commotion which the speaker in the poem wishes to discourage; (2) that there is another moving of the earth, an earthquake, which has just these qualities and is to be associated with the tear-floods and sigh-tempests of the second stanza of the poem; (3) that "trepidation" is an appropriate opposite of earthquake, because each is a shaking or vibratory motion; and "trepidation of the spheares" is "greater farre" than an earthquake, but not much greater (if two such motions can be compared as to greatness) than the annual motion of the earth; (4) that reckoning what it "did and meant" shows that the event has passed, like an earthquake, not like the incessant celestial movement of the earth. Perhaps a knowledge of Donne's interest in the new science may add another shade of meaning, an overtone to the stanza in question, though to say even this runs against the words. To make the geocentric and heliocentric antithesis the core of the metaphor is to disregard the English language, to prefer private evidence to public, external to internal.

V

If the distinction between kinds of evidence has implications for the historical critic, it has them no less for the contemporary poet and his critic. Or, since every rule for a poet is but another side of a judgment by a critic, and since the past is the realm of the scholar and critic, and the future and present that of the poet and the critical leaders of taste, we may say that the problems arising in literary scholarship from the intentional fallacy are matched by others which arise in the world of progressive experiment.

The question of "allusiveness," for example, as acutely posed by the poetry of Eliot, is certainly one where a false judgment is likely to involve the intentional fallacy. The frequency and depth of literary allusion in the poetry of Eliot and others has driven so many in pursuit of full meanings to the *Golden Bough* and the Elizabethan drama that it has become a kind of commonplace

to suppose that we do not know what a poet means unless we have traced him in his reading—a supposition redolent with intentional implications. The stand taken by F. O. Matthiessen is a sound one and partially forestalls the difficulty.

> If one reads these lines with an attentive ear and is sensitive to their sudden shifts in movement, the contrast between the actual Thames and the idealized vision of it during an age before it flowed through a megalopolis is sharply conveyed by that movement itself, whether or not one recognizes the refrain to be from Spenser.

Eliot's allusions work when we know them—and to a great extent when we do not know them—through their suggestive power.

But sometimes we find allusions supported by notes, and it is a nice question whether the notes function more as guides to send us where we may be educated, or more as indications in themselves about the character of the allusions. "Nearly everything of importance . . . that is apposite to an appreciation of 'The Waste Land,' " writes Matthiessen of Miss Weston's book, "has been incorporated into the structure of the poem itself, or into Eliot's Notes." And with such an admission it may begin to appear that it would not much matter if Eliot invented his sources (as Sir Walter Scott invented chapter epigraphs from "old plays" and "anonymous" authors, or as Coleridge wrote marginal glosses for *The Ancient Mariner*). Allusions to Dante, Webster, Marvell, or Baudelaire doubtless gain something because these writers existed, but it is doubtful whether the same can be said for an allusion to an obscure Elizabethan:

> The sound of horns and motors, which shall bring Sweeney to Mrs. Porter in the spring.

"Cf. Day, *Parliament of Bees*": says Eliot,

> When of a sudden, listening, you shall hear,
> A noise of horns and hunting, which shall bring
> Actaeon to Diana in the spring,
> Where all shall see her naked skin.

The irony is completed by the quotation itself; had Eliot, as is quite conceivable, composed these lines to furnish his own background, there would be no loss of validity. The conviction may grow as one reads Eliot's next note: "I do not know the origin of the ballad from which these lines are taken: it was reported to me from Sydney, Australia." The important word in this note—on Mrs. Porter and her daughter who washed their feet in soda water—is "ballad." And if one should feel from the lines themselves their "ballad" quality, there would be little need for the note. Ultimately, the inquiry must focus on the integrity of such notes as parts of the poem, for where they constitute special information about the meaning of phrases in the poem, they ought to be subject to the same scrutiny as any of the other words in which it is written. Matthiessen believes the notes were the price Eliot "had to pay in order to avoid what he would have considered muffling the energy of his poem by extended connecting links in the text itself." But it may be questioned whether

the notes and the need for them are not equally muffling. F. W. Bateson has plausibly argued that Tennyson's "The Sailor Boy" would be better if half the stanzas were omitted, and the best versions of ballads like "Sir Patrick Spens" owe their power to the very audacity with which the minstrel has taken for granted the story upon which he comments. What then if a poet finds he cannot take so much for granted in a more recondite context and rather than write informatively, supplies notes? It can be said in favor of this plan that at least the notes do not pretend to be dramatic, as they would if written in verse. On the other hand, the notes may look like unassimilated material lying loose beside the poem, necessary for the meaning of the verbal symbol, but not integrated, so that the symbol stands incomplete.

We mean to suggest by the above analysis that whereas notes tend to seem to justify themselves as external indexes to the author's *intention*, yet they ought to be judged like any other parts of a composition (verbal arrangement special to a particular context), and when so judged their reality as parts of the poem, or their imaginative integration with the rest of the poem, may come into question. Matthiessen, for instance, sees that Eliot's titles for poems and his epigraphs are informative apparatus, like the notes. But while he is worried by some of the notes and thinks that Eliot "appears to be mocking himself for writing the note at the same time that he wants to convey something by it," Matthiessen believes that the "device" of epigraphs "is not at all open to the objection of not being sufficiently structural." "The *intention*," he says, "is to enable the poet to secure a condensed expression in the poem itself." "In each case the epigraph *is designed* to form an integral part of the effect of the poem." And Eliot himself, in his notes, has justified his poetic practice in terms of intention.

> The Hanged Man, a member of the traditional pack, fits my purpose in two ways: because he is associated in my mind with the Hanged God of Frazer, and because I associate him with the hooded figure in the passage of the disciples to Emmaus in Part V. . . . The man with Three Staves (an authentic member of the Tarot pack) I associate, quite arbitrarily, with the Fisher King himself.

And perhaps he is to be taken more seriously here, when off guard in a note, than when in his Norton Lectures he comments on the difficulty of saying what a poem means and adds playfully that he thinks of prefixing to a second edition of *Ash Wednesday* some lines from *Don Juan:*

> I don't pretend that I quite understand
> My own meaning when I would be *very* fine;
> But the fact is that I have nothing planned
> Unless it were to be a moment merry.

If Eliot and other contemporary poets have any characteristic fault, it may be in *planning* too much.

Allusiveness in poetry is one of several critical issues by which we have illustrated the more abstract issue of intentionalism, but it may be for today the most important illustration. As a poetic practice allusiveness would appear to be in some recent poems an extreme corollary of the romantic intentional-

ist assumption, and as a critical issue it challenges and brings to light in a special way the basic premise of intentionalism. The following instance from the poetry of Eliot may serve to epitomize the practical implications of what we have been saying. In Eliot's "Love Song of J. Alfred Prufrock," toward the end, occurs the line: "I have heard the mermaids singing, each to each," and this bears a certain resemblance to a line in a Song by John Donne, "Teach me to heare Mermaides singing," so that for the reader acquainted to a certain degree with Donne's poetry, the critical question arises: Is Eliot's line an allusion to Donne's? Is Prufrock thinking about Donne? Is Eliot thinking about Donne? We suggest that there are two radically different ways of looking for an answer to this question. There is (1) the way of poetic analysis and exegesis, which inquires whether it makes any sense if Eliot-Prufrock *is* thinking about Donne. In an earlier part of the poem, when Prufrock asks, "Would it have been worth while, . . . To have squeezed the universe into a ball," his words take half their sadness and irony from certain energetic and passionate lines of Marvell's "To His Coy Mistress." But the exegetical inquirer may wonder whether mermaids considered as "strange sights" (to hear them is in Donne's poem analogous to getting with child a mandrake root) have much to do with Prufrock's mermaids, which seem to be symbols of romance and dynamism, and which incidentally have literary authentication, if they need it, in a line of a sonnet by Gérard de Nerval. This method of inquiry may lead to the conclusion that the given resemblance between Eliot and Donne is without significance and is better not thought of, or the method may have the disadvantage of providing no certain conclusion. Nevertheless, we submit that this is the true and objective way of criticism, as contrasted to what the very uncertainty of exegesis might tempt a second kind of critic to undertake: (2) the way of biographical or genetic inquiry, in which, taking advantage of the fact that Eliot is still alive, and in the spirit of a man who would settle a bet, the critic writes to Eliot and asks him what he meant, or if he had Donne in mind. We shall not here weigh the probabilities—whether Eliot would answer that he meant nothing at all, had nothing at all in mind—a sufficiently good answer to such a question— or in an unguarded moment might furnish a clear and, within its limit, irrefutable answer. Our point is that such an answer to such an inquiry would have nothing to do with the poem "Prufrock"; it would not be a critical inquiry. Critical inquiries, unlike bets, are not settled in this way. Critical inquiries are not settled by consulting the oracle.

R E A D I N G 2 8

INTRODUCTION

Roland Barthes was an influential figure in the development of contemporary French, and French-inspired, philosophy; and "The Death of the Author," written in 1968, is one of his best-known works. In it, Barthes announces that texts, and works of art in general, should be interpreted without reference to the known,

stated, or even merely suspected intentions of their creators. Audiences must be free to accept and to appreciate works of art as they find them. The argument is thus very much of its time; and we include it here for the considerable influence it has had on subsequent critical theory. (But it is a poignant comment on the mutual ignorance that typifies the relation between French philosophy and English-speaking analytic philosophy that Barthes's essay should have been credited with freeing the interpreter from the tyrannical, if sometimes posthumous, authority of the artist. Does Barthes's essay really say anything that had not been said twenty-two years before by Wimsatt and Beardsley? Wimsatt and Beardsley, however, called their piece "The Intentional Fallacy," which made it sound promisingly like something in logic, and so guaranteed it the attention of philosophers in the analytic tradition, but of nobody else. Whereas Barthes came up with a far more flamboyant title, which made it sound as if something had actually *happened*, and so secured an audience of different, and doubtless livelier, sensibilities.)

The Death of the Author

Roland Barthes

In his story *Sarrasine* Balzac, describing a castrato disguised as a woman, writes the following sentence: *'This was woman herself, with her sudden fears, her irrational whims, her instinctive worries, her impetuous boldness, her fussings, and her delicious sensibility.'* Who is speaking thus? Is it the hero of the story bent on remaining ignorant of the castrato hidden beneath the woman? Is it Balzac the individual, furnished by his personal experience with a philosophy of Woman? Is it Balzac the author professing 'literary' ideas on femininity? Is it universal wisdom? Romantic psychology? We shall never know, for the good reason that writing is the destruction of every voice, of every point of origin. Writing is that neutral, composite, oblique space where our subject slips away, the negative where all identity is lost, starting with the very identity of the body writing.

No doubt it has always been that way. As soon as a fact is *narrated* no longer with a view to acting directly on reality but intransitively, that is to say, finally outside of any function other than that of the very practice of the symbol itself, this disconnection occurs, the voice loses its origin, the author enters into his own death, writing begins. The sense of this phenomenon, however, has varied; in ethnographic societies the responsibility for a narrative is never assumed by a person but by a mediator, shaman or relator whose 'performance'—the mastery of the narrative code—may possibly be admired but never his 'genius'. The author is a modern figure, a product of our society insofar as, emerging from the Middle Ages with English empiricism, French rationalism and the personal faith of the Reformation, it discovered the prestige of the individual, of, as it is more nobly put, the 'human person'. It is thus logical that in literature it should be this positivism, the epitome and culmination of capitalist ideology, which has attached the greatest importance to the 'person' of the author. The *author* still reigns in histories of literature, biographies of writers, interviews, magazines, as in the very consciousness of men of let-

ters anxious to unite their person and their work through diaries and memoirs. The image of literature to be found in ordinary culture is tyrannically centred on the author, his person, his life, his tastes, his passions, while criticism still consists for the most part in saying that Baudelaire's work is the failure of Baudelaire the man, Van Gogh's his madness, Tchaikovsky's his vice. The *explanation* of a work is always sought in the man or woman who produced it, as if it were always in the end, through the more or less transparent allegory of the fiction, the voice of a single person, the *author* 'confiding' in us.

Though the sway of the Author remains powerful (the new criticism has often done no more than consolidate it), it goes without saying that certain writers have long since attempted to loosen it. In France, Mallarmé was doubtless the first to see and to foresee in its full extent the necessity to substitute language itself for the person who until then had been supposed to be its owner. For him, for us too, it is language which speaks, not the author; to write is, through a prerequisite impersonality (not at all to be confused with the castrating objectivity of the realist novelist), to reach that point where only language acts, 'performs', and not 'me'. Mallarmé's entire poetics consists in suppressing the author in the interests of writing (which is, as will be seen, to restore the place of the reader). Valéry, encumbered by a psychology of the Ego, considerably diluted Mallarmé's theory but, his taste for classicism leading him to turn to the lessons of rhetoric, he never stopped calling into question and deriding the Author; he stressed the linguistic and, as it were, 'hazardous' nature of his activity, and throughout his prose works he militated in favour of the essentially verbal condition of literature, in the face of which all recourse to the writer's interiority seemed to him pure superstitition. Proust himself, despite the apparently psychological character of what are called his *analyses*, was visibly concerned with the task of inexorably blurring, by an extreme subtilization, the relation between the writer and his characters; by making of the narrator not he who has seen and felt nor even he who is writing, but he who *is going to write* (the young man in the novel—but, in fact, how old is he and who is he?—wants to write but cannot; the novel ends when writing at last becomes possible), Proust gave modern writing its epic. By a radical reversal, instead of putting his life into his novel, as is so often maintained, he made of his very life a work for which his own book was the model; so that it is clear to us that Charlus does not imitate Montesquiou but that Montesquiou—in his anecdotal, historical reality—is no more than a secondary fragment, derived from Charlus. Lastly, to go no further than this prehistory of modernity, Surrealism, though unable to accord language a supreme place (language being system and the aim of the movement being, romantically, a direct subversion of codes—itself moreover illusory: a code cannot be destroyed, only 'played off'), contributed to the desacralization of the image of the Author by ceaselessly recommending the abrupt disappointment of expectations of meaning (the famous surrealist 'jolt'), by entrusting the hand with the task of writing as quickly as possible what the head itself is unaware of (automatic writing), by accepting the principle and the experience of several people writing together. Leaving aside literature itself (such distinctions really becoming invalid), linguistics has recently provided the destruction of the Author with a valuable analytical tool by showing that the whole of the

enunciation is an empty process, functioning perfectly without there being any need for it to be filled with the person of the interlocutors. Linguistically, the author is never more than the instance writing, just as *I* is nothing other than the instance saying *I:* language knows a 'subject', not a 'person', and this subject, empty outside of the very enunciation which defines it, suffices to make language 'hold together', suffices, that is to say, to exhaust it.

The removal of the Author (one could talk here with Brecht of a veritable 'distancing', the Author diminishing like a figurine at the far end of the literary stage) is not merely an historical fact or an act of writing; it utterly transforms the modern text (or—which is the same thing—the text is henceforth made and read in such a way that at all its levels the author is absent). The temporality is different. The Author, when believed in, is always conceived of as the past of his own book: book and author stand automatically on a single line divided into a *before* and an *after*. The Author is thought to *nourish* the book, which is to say that he exists before it, thinks, suffers, lives for it, is in the same relation of antecedence to his work as a father to his child. In complete contrast, the modern scriptor is born simultaneously with the text, is in no way equipped with a being preceding or exceeding the writing, is not the subject with the book as predicate; there is no other time than that of the enunciation and every text is eternally written *here and now*. The fact is (or, it follows) that *writing* can no longer designate an operation of recording, notation, representation, 'depiction' (as the Classics would say); rather, it designates exactly what linguists, referring to Oxford philosophy, call a performative, a rare verbal form (exclusively given in the first person and in the present tense) in which the enunciation has no other content (contains no other proposition) than the act by which it is uttered—something like the *I declare* of kings or the *I sing* of very ancient poets. Having buried the Author, the modern scriptor can thus no longer believe, as according to the pathetic view of his predecessors, that this hand is too slow for his thought or passion and that consequently, making a law of necessity, he must emphasize this delay and indefinitely 'polish' his form. For him, on the contrary, the hand, cut off from any voice, borne by a pure gesture of inscription (and not of expression), traces a field without origin—or which, at least, has no other origin than language itself, language which ceaselessly calls into question all origins.

We know now that a text is not a line of words releasing a single 'theological' meaning (the 'message' of the Author-God) but a multi-dimensional space in which a variety of writings, none of them original, blend and clash. The text is a tissue of quotations drawn from the innumerable centres of culture. Similar to Bouvard and Pécuchet, those eternal copyists, at once sublime and comic and whose profound ridiculousness indicates precisely the truth of writing, the writer can only imitate a gesture that is always anterior, never original. His only power is to mix writings, to counter the ones with the others, in such a way as never to rest on any one of them. Did he wish to *express himself,* he ought at least to know that the inner 'thing' he thinks to 'translate' is itself only a ready-formed dictionary, its words only explainable through other words, and so on indefinitely; something experienced in exemplary fashion by the young Thomas de Quincey, he who was so good at Greek that in order to translate absolutely modern ideas and images into that dead language,

he had, so Baudelaire tells us (in *Paradis Artificiels*), 'created for himself an unfailing dictionary, vastly more extensive and complex than those resulting from the ordinary patience of purely literary themes'. Succeeding the Author, the scriptor no longer bears within him passions, humours, feelings, impressions, but rather this immense dictionary from which he draws a writing that can know no halt: life never does more than imitate the book, and the book itself is only a tissue of signs, an imitation that is lost, infinitely deferred.

Once the Author is removed, the claim to decipher a text becomes quite futile. To give a text an Author is to impose a limit on that text, to furnish it with a final signified, to close the writing. Such a conception suits criticism very well, the latter then allotting itself the important task of discovering the Author (or its hypostases: society, history, psyché, liberty) beneath the work: when the Author has been found, the text is 'explained'—victory to the critic. Hence there is no surprise in the fact that, historically, the reign of the Author has also been that of the Critic, nor again in the fact that criticism (be it new) is today undermined along with the Author. In the multiplicity of writing, everything is to be *disentangled*, nothing *deciphered*; the structure can be followed, 'run' (like the thread of a stocking) at every point and at every level, but there is nothing beneath: the space of writing is to be ranged over, not pierced; writing ceaselessly posits meaning ceaselessly to evaporate it, carrying out a systematic exemption of meaning. In precisely this way literature (it would be better from now on to say *writing*), by refusing to assign a 'secret', an ultimate meaning, to the text (and to the world as text), liberates what may be called an anti-theological activity, an activity that is truly revolutionary since to refuse to fix meaning is, in the end, to refuse God and his hypostases—reason, science, law.

Let us come back to the Balzac sentence. No one, no 'person', says it: its source, its voice, is not the true place of the writing, which is reading. Another—very precise—example will help to make this clear: recent research (J.-P. Vernant[1]) has demonstrated the constitutively ambiguous nature of Greek tragedy, its texts being woven from words with double meanings that each character understands unilaterally (this perpetual misunderstanding is exactly the 'tragic'); there is, however, someone who understands each word in its duplicity and who, in addition, hears the very deafness of the characters speaking in front of him—this someone being precisely the reader (or here, the listener). Thus is revealed the total existence of writing: a text is made of multiple writings, drawn from many cultures and entering into mutual relations of dialogue, parody, contestation, but there is one place where this multiplicity is focused and that place is the reader, not, as was hitherto said, the author. The reader is the space on which all the quotations that make up a writing are inscribed without any of them being lost; a text's unity lies not in its origin but in its destination. Yet this destination cannot any longer be personal: the reader is without history, biography, psychology; he is simply that *someone* who holds together in a single field all the traces by which the written text is constituted. Which is why it is derisory to condemn the new writing in the name of a

[1][Cf. Jean-Pierre Vernant (with Pierre Vidal-Naquet), *Mythe et tragédie en Grèce ancienne*, Paris 1972, esp. pp. 19–40, 99–131.]

humanism hypocritically turned champion of the reader's rights. Classic criticism has never paid any attention to the reader; for it, the writer is the only person in literature. We are now beginning to let ourselves be fooled no longer by the arrogant antiphrastical recriminations of good society in favour of the very thing it sets aside, ignores, smothers, or destroys; we know that to give writing its future, it is necessary to overthrow the myth: the birth of the reader must be at the cost of the death of the Author.

READING 29

INTRODUCTION

Both Wimsatt and Beardsley, on the one hand, and Barthes, on the other, argue that authorial intention does not fix the meaning of a text and, hence, that knowledge of authorial intention—at least to the extent that it is based on evidence external to the text—is irrelevant to interpretation. In "In Defense of the Author," a chapter of his book *Validity in Interpretation* (1967), E. D. Hirsch, Jr., argues that the "banishment of the author" by theorists like Wimsatt and Beardsley and Barthes threatens the very idea of validity in interpretation. For a valid interpretation is one that captures the meaning(s) of a text, and meaning, Hirsch argues, "is an affair of consciousness." If banishing the author is banishing "the affair of consciousness" from a text, then banishing the author rules out the possibility of finding meaning in a text. But can we avoid banishing the author? According to Hirsch, we can. He examines four types of argument often offered in support of the claim that an author does not determine the meaning(s) of his or her text, and he suggests that none of these arguments is conclusive. In his defense of the author, Hirsch raises a number of themes echoed in later essays in this section by Wollheim, Baxandall, and Robinson.

In Defense of the Author

E. D. Hirsch, Jr.

> *It has been said of Boehme that his books are like a picnic to which the author brings the words and the reader the meaning. The remark may have been intended as a sneer at Boehme, but it is an exact description of all works of literary art without exception.*
> —Northrop Frye

A. Banishment of the Author

It is a task for the historian of culture to explain why there has been in the past four decades a heavy and largely victorious assault on the sensible belief that a text means what its author meant. In the earliest and most decisive wave of the attack (launched by Eliot, Pound, and their associates) the battleground

was literary: the proposition that textual meaning is independent of the author's control was associated with the literary doctrine that the best poetry is impersonal, objective, and autonomous; that it leads an afterlife of its own, totally cut off from the life of its author.[1] This programmatic notion of what poetry should be became subtly identified with a notion of what all poetry and indeed all forms of literature necessarily must be. It was not simply desirable that literature should detach itself from the subjective realm of the author's personal thoughts and feelings; it was, rather, an indubitable fact that all written language remains independent of that subjective realm. At a slightly later period, and for different reasons, this same notion of semantic autonomy was advanced by Heidegger and his followers.[2] The idea also has been advocated by writers who believe with Jung that individual expressions may quite unwittingly express archetypal, communal meanings. In some branches of linguistics, particularly in so-called information theory, the semantic autonomy of language has been a working assumption. The theory has found another home in the work of non-Jungians who have interested themselves (as Eliot did earlier) in symbolism, though Cassirer, whose name is sometimes invoked by such writers, did not believe in the semantic autonomy of language.[3] As I said, it is the job of the cultural historian to explain why this doctrine should have gained currency in recent times, but it is the theorist's job to determine how far the theory of semantic autonomy deserves acceptance.

Literary scholars have often contended that the theory of authorial irrelevance was entirely beneficial to literary criticism and scholarship because it shifted the focus of discussion from the author to his work. Made confident by the theory, the modern critic has faithfully and closely examined the text to ferret out its independent meaning instead of its supposed significance to the author's life. That this shift toward exegesis has been desirable most critics would agree, whether or not they adhere to the theory of semantic autonomy. But the theory accompanied the exegetical movement for historical not logical reasons, since no logical necessity compels a critic to banish an author in order to analyze his text. Nevertheless, through its historical association with close exegesis, the theory has liberated much subtlety and intelligence. Unfortunately, it has also frequently encouraged willful arbitrariness and extravagance in academic criticism and has been one very important cause of the prevailing skepticism which calls into doubt the possibility of objectively valid interpretation. These disadvantages would be tolerable, of course, if the theory were true. In intellectual affairs skepticism is preferable to illusion.

The disadvantages of the theory could not have been easily predicted in the exciting days when the old order of academic criticism was being overthrown. At that time such naïvetés as the positivistic biases of literary history, the casting about for influences and other causal patterns, and the post-romantic fascination with the habits, feelings, and experiences surrounding the act

[1]The classic statement is in T. S. Eliot, "Tradition and the Individual Talent," reprinted in this volume.
[2]See, for example, Martin Heidegger, *Unterwegs zur Sprache* (Pfullingen, 1959).
[3]See Ernst Cassirer, *The Philosophy of Symbolic Forms:* Vol. 1, *Language,* trans. R. Manheim (New Haven, 1953), particularly pp. 69, 178, 213, 249–250, and passim.

of composition were very justly brought under attack. It became increasingly obvious that the theoretical foundations of the old criticism were weak and inadequate. It cannot be said, therefore, that the theory of authorial irrelevance was inferior to the theories or quasi-theories it replaced, nor can it be doubted that the immediate effect of banishing the author was wholly beneficial and invigorating. Now, at a distance of several decades, the difficulties that attend the theory of semantic autonomy have clearly emerged and are responsible for that uneasiness which persists in the academies, although the theory has long been victorious.

That this state of academic skepticism and disarray results largely from the theory of authorial irrelevance is, I think, a fact of our recent intellectual history. For, once the author had been ruthlessly banished as the determiner of his text's meaning, it very gradually appeared that no adequate principle existed for judging the validity of an interpretation. By an inner necessity the study of "what a text says" became the study of what it says to an individual critic. It became fashionable to talk about a critic's "reading" of a text, and this word began to appear in the titles of scholarly works. The word seemed to imply that if the author had been banished, the critic still remained, and his new, original, urbane, ingenious, or relevant "reading" carried its own interest.

What had not been noticed in the earliest enthusiasm for going back to "what the text says" was that the text had to represent *somebody's* meaning—if not the author's, then the critic's. It is true that a theory was erected under which the meaning of the text was equated with everything it could plausibly be taken to mean. . . .

The theory of semantic autonomy forced itself into such unsatisfactory, ad hoc formulations because in its zeal to banish the author it ignored the fact that meaning is an affair of consciousness not of words. Almost any word sequence can, under the conventions of language, legitimately represent more than one complex of meaning.[4] A word sequence means nothing in particular until somebody either means something by it or understands something from it. There is no magic land of meanings outside human consciousness. Whenever meaning is connected to words, a person is making the connection, and the particular meanings he lends to them are never the only legitimate ones under the norms and conventions of his language.

One proof that the conventions of language can sponsor different meanings from the same sequence of words resides in the fact that interpreters can and do disagree. When these disagreements occur, how are they to be resolved? Under the theory of semantic autonomy they cannot be resolved, since the meaning is not what the author meant, but "what the poem means to different sensitive readers."[5] One interpretation is as valid as another, so long as it is "sensitive" or "plausible." Yet the teacher of literature who adheres to Eliot's theory is also by profession the preserver of a heritage and the con-

[4]The random example that I use is the sentence: "I am going to town today." Different senses can be lent to the sentence by the simple device of placing a strong emphasis on any of the six different words.

[5]The phrase is from T. S. Eliot, *On Poetry and Poets* (New York, 1957), p. 126.

veyor of knowledge. On what ground does he claim that his "reading" is more valid than that of any pupil? On no very firm ground. This impasse is a principal cause of the loss of bearings sometimes felt though not often confessed by academic critics.

One ad hoc theory that has been advanced to circumvent this chaotic democracy of "readings" deserves special mention here because it involves the problem of value, a problem that preoccupies some modern literary theorists. The most valid reading of a text is the "best" reading.[6] But even if we assumed that a critic did have access to the divine criteria by which he could determine the best reading, he would still be left with two equally compelling normative ideals—the best meaning and the author's meaning. Moreover, if the best meaning were not the author's, then it would have to be the critic's—in which case the critic would be the author of the best meaning. Whenever meaning is attached to a sequence of words it is impossible to escape an author.

Thus, when critics deliberately banished the original author, they themselves usurped his place, and this led unerringly to some of our present-day theoretical confusions. Where before there had been but one author, there now arose a multiplicity of them, each carrying as much authority as the next. To banish the original author as the determiner of meaning was to reject the only compelling normative principle that could lend validity to an interpretation. On the other hand, it might be the case that there does not really exist a viable normative ideal that governs the interpretation of texts. This would follow if any of the various arguments brought against the author were to hold. For if the meaning of a text is not the author's, then no interpretation can possibly correspond to *the* meaning of the text, since the text can have no determinate or determinable meaning. . . . If a theorist wants to save the ideal of validity he has to save the author as well, and, in the present-day context, his first task will be to show that the prevailing arguments against the author are questionable and vulnerable.

B. "The Meaning of a Text Changes—Even for the Author"

A doctrine widely accepted at the present time is that the meaning of a text changes.[7] According to the radical historicistic view, textual meaning changes from era to era; according to the psychologistic view, it changes from reading to reading. Since the putative changes of meaning experienced by the author himself must be limited to a rather brief historical span, only the psychologistic view need concern us here. Of course, if any theory of semantic mutability were true, it would legitimately banish the author's meaning as a normative principle in interpretation, for if textual meaning could change in any respect

[6]It would be invidious to name any individual critic as the begetter of this widespread and imprecise notion. By the "best" reading, of course, some critics mean the most valid reading, but the idea of bestness is widely used to embrace indiscriminately both the idea of validity and of such aesthetic values as richness, inclusiveness, tension, or complexity—as though validity and aesthetic excellence must somehow be identical.
[7]See René Wellek and Austin Warren, *Theory of Literature* (New York, 1948), Chap. 12.

there could be no principle for distinguishing a valid interpretation from a false one. . . . Here I need not discuss the general (and insoluble) normative problems that would be raised by a meaning which could change, but only the conditions that have caused critics to accuse authors of such fickleness.

Everyone who has written knows that his opinion of his own work changes and that his responses to his own text vary from reading to reading. Frequently an author may realize that he no longer agrees with his earlier meaning or expression and will revise his text. Our problem, of course, has nothing to do with revision or even with the fact that an author may explain his meaning differently at different times, since the authors are sometimes inept explainers of their meanings, as Plato observed. Even the puzzling case of the author who no longer understands his own text at all is irrelevant to our problem, since his predicament is due to the fact that an author, like anyone else, can forget what he meant. We all know that sometimes a person remembers correctly and sometimes not, and that sometimes a person recognizes his mistakes of memory and corrects them. None of this has any theoretical interest whatever.

When critics assert that the author's understanding of his text changes, they refer to the experience that everybody has when he rereads his own work. His response to it is different. This is a phenomenon that certainly does have theoretical importance—though not of the sort sometimes allotted to it. The phenomenon of changing authorial responses is important because it illustrates the difference between textual meaning and what is loosely termed a "response" to the text.

Probably the most extreme examples of this phenomenon are cases of authorial self-repudiation, such as Arnold's public attack on his masterpiece, *Empedocles on Etna,* or Schelling's rejection of all the philosophy he had written before 1809. In these cases there cannot be the slightest doubt that the author's later response to his work was quite different from his original response. Instead of seeming beautiful, profound, or brilliant, the work seemed misguided, trivial, and false, and its meaning was no longer one that the author wished to convey. However, these examples do not show that the meaning of the work had changed, but precisely the opposite. If the work's meaning had changed (instead of the author himself and his attitudes), then the author would not have needed to repudiate his meaning and could have spared himself the discomfort of a public recantation. No doubt the *significance* of the work to the author had changed a great deal, but its meaning had not changed at all.

This is the crux of the matter in all those cases of authorial mutability with which I am familiar. It is not the meaning of the text which changes, but its significance to the author. This distinction is too often ignored. *Meaning* is that which is represented by a text; it is what the author meant by his use of a particular sign sequence; it is what the signs represent. *Significance,* on the other hand, names a relationship between that meaning and a person, or a conception, or a situation, or indeed anything imaginable. Authors, who like everyone else change their attitudes, feelings, opinions, and value criteria in the course of time, will obviously in the course of time tend to view their own work in different contexts. Clearly what changes for them is not the meaning

of the work, but rather their relationship to that meaning. Significance always implies a relationship, and one constant, unchanging pole of that relationship is what the text means. Failure to consider this simple and essential distinction has been the source of enormous confusion in hermeneutic theory.

If we really believed that the meaning of a text had changed for its author, there could be only one way that we could know it: he would have to tell us. How else could we know that his understanding had changed—understanding being a silent and private phenomenon? Even if an author reported that his understanding of his meaning had changed, we should not be put off by the implausibility of the statement but should follow out its implications in a spirit of calm inquiry. The author would have to report something like this: "By these words I meant so and so, but now I observe that I really meant something different," or, "By these words I meant so and so, but I insist that from now on they shall mean something different." Such an event is unlikely because authors who feel this way usually undertake a revision of their text in order to convey their new meaning more effectively. Nevertheless, it is an event that *could* occur, and its very possibility shows once again that the same sequence of linguistic signs can represent more than one complex of meaning.

Yet, even though the author has indeed changed his mind about the meaning he wants to convey by his words, he has not managed to change his earlier meaning. This is very easily proved by his own report. He could report a change in his understanding only if he were able to compare his earlier construction of his meaning with his later construction. That is the only way he could know that there is a difference: he holds both meanings before his mind and rejects the earlier one. But his earlier meaning is not thereby changed in any way. Such a report from an author would simply force a choice on the interpreter, who would have to decide which of the author's two meanings he is going to concern himself with. He would have to decide which "text" he wanted to interpret at the moment. The critic is destined to fall into puzzlement if he confuses one text with the other or if he assumes that the author's will is entirely irrelevant to his task.

This example is, as I said, quite improbable. I do not know of a single instance where an author has been so eccentric as to report without any intention to deceive that he now means by his text what he did not mean. (Deliberate lies are, of course, another matter; they have no more theoretical interest than failures of memory.) I was forced into this improbable example by the improbability of the original thesis, namely that an author's meaning changes for himself. What the example showed on the contrary was that an author's original meaning *cannot* change—even for himself, though it can certainly be repudiated. When critics speak of changes in meaning, they are usually referring to changes in significance. Such changes are, of course, predictable and inevitable, and since the primary object of criticism, as distinct from interpretation, is significance, I shall have more to say about this distinction later, particularly in Chapter 4. For the moment, enough has been said to show that the author's revaluation of his text's significance does not change its meaning and, further, that arguments which rely on such examples are not effective weapons for attacking either the stability or the normative authority of the author's original meaning.

C. "It Does Not Matter What an Author Means—Only What His Text Says"

As I pointed out in section A, this central tenet in the doctrine of semantic autonomy is crucial to the problem of validity. If the tenet were true, then any reading of a text would be "valid," since any reading would correspond to what the text "says"—for that reader. It is useless to introduce normative concepts like "sensitive," "plausible," "rich," and "interesting," since what the text "says" might not, after all, be any of those things. Validity of interpretation is not the same as inventiveness of interpretation. Validity implies the correspondence of an interpretation to a meaning which is represented by the text, and none of the above criteria for discriminating among interpretations would apply to a text which is dull, simple, insensitive, implausible, or uninteresting. Such a text might not be worth interpreting, but a criterion of validity which cannot cope with such a text is not worth crediting.

The proponents of semantic autonomy in England and America can almost always be relied on to point to the example of T. S. Eliot, who more than once refused to comment on the meanings of his own texts. Eliot's refusals were based on his view that the author has no control over the words he has loosed upon the world and no special privileges as an interpreter of them. It would have been quite inconsistent with this view if Eliot had complained when someone misinterpreted his writings, and, so far as I know, Eliot with stoical consistency never did complain. But Eliot never went so far as to assert that he did not mean anything in particular by his writings. Presumably he did mean something by them, and it is a permissible task to attempt to discover what he meant. Such a task has a determinate object and therefore could be accomplished correctly or incorrectly. However, the task of finding out what a text says has no determinate object, since the text can say different things to different readers. One reading is as valid or invalid as another. However, the decisive objection to the theory of semantic autonomy is not that it inconveniently fails to provide an adequate criterion of validity. The decisive objection must be sought within the theory itself and in the faultiness of the arguments used to support it.

One now-famous argument is based on the distinction between a mere intention to do something and the concrete accomplishment of that intention. The author's desire to communicate a particular meaning is not necessarily the same as his success in doing so. Since his actual performance is presented in his text, any special attempt to divine his intention would falsely equate his private wish with his public accomplishment. Textual meaning is a public affair. The wide dissemination of this argument and its acceptance as an axiom of recent literary criticism can be traced to the influence of a vigorous essay, "The Intentional Fallacy," written by W. K. Wimsatt and Monroe Beardsley and first published in 1946.[8] The critic of the arguments in that essay is faced with the problem of distinguishing between the essay itself and the popular use that has been made of it, for what is widely taken for granted as established truth was not argued and could not have been successfully argued in

[8]Reprinted in this volume.

the essay. Although Wimsatt and Beardsley carefully distinguished between three types of intentional evidence, acknowledging that two of them are proper and admissible, their careful distinctions and qualifications have now vanished in the popular version which consists in the false and facile dogma that what an author intended is irrelevant to the meaning of his text.

The best way to indicate what is fallacious in this popular version is to discuss first the dimension in which it is perfectly valid—evaluation. It would be absurd to evaluate the stylistic felicity of a text without distinguishing between the author's intention to convey a meaning and, on the other hand, his effectiveness in conveying it. It would be similarly absurd to judge the profundity of a treatise on morality without distinguishing between the author's intention to be profound and his success in being so. Evaluation is constantly distinguishing between intention and accomplishment. Take this example: A poet intends in a four-line poem to convey a sense of desolation, but what he manages to convey to some readers is a sense that the sea is wet, to others that twilight is approaching. Obviously his intention to convey desolation is not identical with his stylistic effectiveness in doing so, and the anti-intentionalists quite justly point this out. But the intentional fallacy is properly applicable *only* to artistic success and to other normative criteria like profundity, consistency, and so on. The anti-intentionalist quite properly defends the right and duty of the critic to judge freely on his own criteria and to expose discrepancies between wish and deed. However, the intentional fallacy has no proper application whatever to verbal meaning. In the above example the only universally valid meaning of the poem is the sense of desolation. If the critic has not understood that point, he will not even reach an accurate judgment—namely, that the meaning was ineptly expressed and perhaps was not worth expressing in the first place.

Beneath the so-called intentional fallacy and, more generally, the doctrine of semantic autonomy lies an assumption which if true would at least render plausible the view that the meaning of a text is independent of its author's intention. I refer to the concept of a public consensus. If a poet intended his poem to convey desolation, and if to every competent reader his poem conveyed only a sense that twilight is approaching, then such public unanimity would make a very strong case (in this particular instance) for the practical irrelevance of the author's intention. But when has such unanimity occurred? If it existed generally, there would not be any problems of interpretation.

The myth of the public consensus has been decisive in gaining wide acceptance for the doctrine that the author's intention is irrelevant to what the text says. That myth permits the confident belief that the "saying" of the text is a public fact firmly governed by public norms. But if this public meaning exists, why is it that we, who are the public, disagree? Is there one group of us that constitutes the true public, while the rest are heretics and outsiders? By what standard is it judged that a correct insight into public norms is lacking in all those readers who are (except for the text at hand) competent readers of texts? The idea of a public meaning sponsored not by the author's intention but by a public consensus is based upon a fundamental error of observation and logic. It is an empirical fact that the consensus does not exist, and it is a logical error to erect a stable normative concept (i.e. *the* public mean-

ing) out of an unstable descriptive one. The public meaning of a text is nothing more or less than those meanings which the public happens to construe from the text. Any meaning which two or more members of the public construe is ipso facto within the public norms that govern language and its interpretation. Vox populi: vox populi.

If a text means what it says, then it means nothing in particular. Its saying has no determinate existence but must be the saying of the author or a reader. The text does not exist even as a sequence of words until it is construed; until then, it is merely a sequence of signs. For sometimes words can have homonyms (just as, by analogy, entire texts can), and sometimes the same word can be quite a different word. For example, when we read in Wordsworth's *Intimations Ode* the phrase "most worthy to be blessed," are we to understand "most" as a superlative or merely an intensifier like "very"? Even on this primitive level, signs can be variously construed, and until they are construed the text "says" nothing at all.

D. "The Author's Meaning Is Inaccessible"

Since we are all different from the author, we cannot reproduce his intended meaning in ourselves, and even if by some accident we could, we still would not be certain that we had done so. Why concern ourselves, therefore, with an inherently impossible task when we can better employ our energies in useful occupations such as making the text relevant to our present concerns or judging its conformity to high standards of excellence? The goal of reproducing an inaccessible and private past is to be dismissed as a futile enterprise. Of course, it is essential to understand some of the public facts of language and history in order not to miss allusions or mistake the contemporary senses of words, but these preliminary tasks remain squarely in the public domain and do not concern a private world beyond the reach of written language.

Before touching on the key issue in this argument—namely, that the author's intended meaning cannot be known—I would like to make an observation about the subsidiary argument respecting the public and private dimensions of textual meaning. According to this argument, it would be a mistake to confuse a public fact—namely, language—with a private fact—namely, the author's mind. But I have never encountered an interpretation that inferred truly private meanings from a text. An interpreter might, of course, infer meanings which according to our judgment could not possibly under any circumstances be implied by the author's words, but in that case, we would reject the interpretation not because it is private but because it is probably wrong. That meaning, we say, cannot be implied by those words. If our skepticism were shared by all readers of the interpretation, then it would be reasonable to say that the interpretation is private. However, it is a rare interpretation that does not have at least a few adherents, and if it has any at all, then the meaning is not private; it is at worst improbable.

Whenever an interpretation manages to convince another person, that in itself proves beyond doubt that the author's words *can* publicly imply such a meaning. Since the interpreted meaning *was* conveyed to another person, indeed to at least two other persons, the only significant interpretive question

is, "Did the author really intend that public meaning by his words?" To object that such a meaning is highly personal and ought not to have been intended is a legitimate aesthetic or moral judgment, but is irrelevant to the question of meaning. That meaning—if the author did mean it—has proved itself to be public, and if the interpreter manages to do his job convincingly, the meaning can become available to a very large public. It is simply a self-contradiction for a member of the public to say, "Yes, I see that the author did mean that, but it is a private not a public meaning."

The impulse that underlies this self-contradictory sort of argument is a sound insight that deserves to be couched in terms more suitable than "public" and "private." The issue is first of all a moral and aesthetic one. It is proper to demand of authors that they show consideration for their readers, that they use their linguistic inheritance with some regard for the generality of men and not just for a chosen few. Yet many new usages are bound to elude the generality of men until readers become habituated to them. The risk of resorting to semiprivate implications—available at first only to a few—is very often worth taking, particularly if the new usage does finally become widely understood. The language expands by virtue of such risky innovations. However, the soundest objection to so-called private meanings does not relate to moral and aesthetic judgment but to the practice of interpretation. Those interpreters who look for personal implications in such formalized utterances as poems very often disregard genre conventions and limitations of which the author was very well aware. When an author composes a poem, he usually intends it as an utterance whose implications are not obscurely autobiographical. There may be exceptions to this rule of thumb, and poetic kinds are too various to warrant any unqualified generalizations about the conventions of poetry and the intentions of authors, but too many interpreters in the past have sought autobiographical meanings where none were meant. Such interpreters have been insensitive to the proprieties observed by the author and to his intentions. The fallacy in such interpretations is not that the inferred meanings are private, but that they are probably not the author's meanings. Whether a meaning is autobiographical is a neutral and by itself irrelevant issue in interpretation. The only thing that counts is whether the interpretation is probably right.

The genuine distinction between public and private meaning resides in the first part of the argument, where it is asserted that the author's intended meaning cannot be known. Since we cannot get inside the author's head, it is useless to fret about an intention that cannot be observed, and equally useless to try to reproduce a private meaning experience that cannot be reproduced. Now the assertion that the author's meaning cannot be reproduced presupposes the same psychologistic theory of meaning which underlies the notion that an author's meaning changes even for himself. Not even the author can reproduce his original meaning because nothing can bring back his original meaning experience. But as I suggested, the irreproducibility of meaning experiences is not the same as the irreproducibility of meaning. The psychologistic identification of textual meaning with a meaning experience is inadmissible. Meaning experiences *are* private, but they are not meanings.

The most important argument to consider here is the one which states that the author's intended meaning cannot be *certainly* known. This argument can-

not be successfully met because it is self-evidently true. I can never know another person's intended meaning with certainty because I cannot get inside his head to compare the meaning he intends with the meaning I understand, and only by such direct comparison could I be certain that his meaning and my own are identical. But this obvious fact should not be allowed to sanction the overly hasty conclusion that the author's intended meaning is inaccessible and is therefore a useless object of interpretation. It is a logical mistake to confuse the impossibility of certainty in understanding with the impossibility of understanding. It is a similar, though more subtle, mistake to identify knowledge with certainty. A good many disciplines do not pretend to certainty, and the more sophisticated the methodology of the discipline, the less likely that its goal will be defined as certainty of knowledge. Since genuine certainty in interpretation is impossible, the aim of the discipline must be to reach a consensus, on the basis of what is known, that correct understanding has *probably* been achieved. The issue is not whether certainty is accessible to the interpreter but whether the author's intended meaning is accessible to him. Is correct understanding possible? That is the question raised by the thesis under examination.

Most of us would answer that the author's meaning is only partially accessible to an interpreter. We cannot know all the meanings the author entertained when he wrote down his text, as we infer from two familiar kinds of evidence. Whenever I speak I am usually attending to ("have in mind") meanings that are outside my subject of discourse. Furthermore, I am always aware that the meanings I can convey through discourse are more limited than the meanings I can entertain. I cannot, for example, adequately convey through words many of my visual perceptions—though these perceptions are meanings, which is to say, objects of consciousness. It is altogether likely that no text can ever convey all the meanings an author had in mind as he wrote.

But this obvious fact is not decisive. Why should anyone with common sense wish to equate an author's textual meaning with all the meanings he happened to entertain when he wrote? Some of these he had no intention of conveying by his words. Any author knows that written verbal utterances can convey only verbal meanings—that is to say, meanings which can be conveyed to others by the words he uses. The interpretation of texts is concerned exclusively with sharable meanings, and not everything I am thinking of when I write can be shared with others by means of my words. Conversely, many of my sharable meanings are meanings which I am not directly thinking of at all. They are so-called unconscious meanings. It betrays a totally inadequate conception of verbal meaning to equate it with what the author "has in mind." The only question that can relevantly be at issue is whether the *verbal* meaning which an author intends is accessible to the interpreter of his text.

Most authors believe in the accessibility of their verbal meaning, for otherwise most of them would not write. However, no one could unanswerably defend this universal faith. Neither the author nor the interpreter can ever be certain that communication has occurred or that it can occur. But again, certainty is not the point at issue. It is far more likely that an author and an interpreter can entertain identical meanings than that they cannot. The faith that speakers have in the possibility of communication has been built up in the very

process of learning a language, particularly in those instances when the actions of the interpreter have confirmed to the author that he has been understood. These primitive confirmations are the foundation for our faith in far less primitive modes of communication. The inaccessibility of verbal meaning is a doctrine that experience suggests to be false, though neither experience nor argument can prove its falsity. But since the skeptical doctrine of inaccessibility is highly improbable, it should be rejected as a working assumption of interpretation.

Of course, it is quite reasonable to take a skeptical position that is less sweeping than the thesis under examination: certain texts might, because of their character or age, represent authorial meanings which are now inaccessible. No one would, I think, deny this reasonable form of skepticism. However, similar versions of such skepticism are far less acceptable, particularly in those theories which deny the accessibility of the author's meaning whenever the text descends from an earlier cultural era or whenever the text happens to be literary. These views are endemic respectively to radical historicism and to the theory that literary texts are ontologically distinct from non-literary ones. Both of these theories are challenged in subsequent chapters. However, even if these theories were acceptable, they could not uphold the thesis that an author's verbal meaning is inaccessible, for that is an empirical generalization which neither theory nor experience can decisively confirm or deny. Nevertheless, with a high degree of probability, that generalization is false, and it is impossible and quite unnecessary to go beyond this conclusion.

E. "The Author Often Does Not Know What He Means"

Ever since Plato's Socrates talked to the poets and asked them with quite unsatisfactory results to explain "some of the most elaborate passages in their own writings," it has been a commonplace that an author often does not really know what he means.[9] Kant insisted that not even Plato knew what he meant, and that he, Kant, could understand some of Plato's writings better than Plato did himself.[10] Such examples of authorial ignorance are, no doubt, among the most damaging weapons in the attack on the author. If it can be shown (as it apparently can) that in some cases the author does not really know what he means, then it seems to follow that the author's meaning cannot constitute a general principle or norm for determining the meaning of a text, and it is precisely such a general normative principle that is required in defining the concept of validity.

Not all cases of authorial ignorance are of the same type. Plato, for instance, no doubt knew very well what he meant by his theory of Ideas, but it may have been, as Kant believed, that the theory of Ideas had different and

[9]Plato, *Apology*, 22b–c.
[10]Immanuel Kant, *Critique of Pure Reason*, trans. N. K. Smith (London, 1933), A 314, B 370, p. 310: "I shall not engage here in any literary enquiry into the meaning which this illustrious author attached to the expression. I need only remark that it is by no means unusual, upon comparing the thoughts which an author has expressed in regard to his subject, whether in ordinary conversation or in writing, to find that we understand him better than he has understood himself."

more general implications than those Plato enunciated in his dialogues. Though Kant called this a case of understanding the author better than the author understood himself, his phrasing was inexact, for it was not Plato's meaning that Kant understood better than Plato, but rather the subject matter that Plato was attempting to analyze. The notion that Kant's understanding of the Ideas was superior to Plato's implies that there is a subject matter to which Plato's meaning was inadequate. If we do not make this distinction between subject matter and meaning, we have no basis for judging that Kant's understanding is better than Plato's. Kant's statement would have been more precise if he had said that he understood the Ideas better than Plato. If we do not make and preserve the distinction between a man's meaning and his subject matter, we cannot distinguish between true and false, better and worse meanings.

This example illustrates one of the two main types of authorial ignorance. It has greatest importance in those genres of writing that aspire to tell the truth about a particular subject matter. The other principal type of authorial ignorance pertains not to the subject matter but to the author's meaning itself, and can be illustrated whenever casual conversation is subjected to stylistic analysis:

"Did you know that those last two sentences of yours had parallel constructions which emphasized their similarity of meaning?"
"No! How clever of me! I suppose I really did want to emphasize the similarity, though I wasn't aware of that, and I had no idea I was using rhetorical devices to do it."

What this example illustrates is that there are usually components of an author's intended meaning that he is not conscious of. It is precisely here, where an interpreter makes these intended but unconscious meanings explicit, that he can rightfully claim to understand the author better than the author himself. But here again a clarification is required. The interpreter's right to such a claim exists only when he carefully avoids confusing meaning with subject matter, as in the example of Plato and Kant. The interpreter may believe that he is drawing out implications that are "necessary" accompaniments to the author's meaning, but such necessary accompaniments are rarely unavoidable components of someone's *meaning*. They become necessary associations only within a given *subject matter*.[11] For example, although the concept "two" necessarily implies a whole array of concepts including those of succession, integer, set, and so on, these may not be implied in a given usage of the word, since that usage could be inadequate or misconceived with respect to the subject matter in which "two" falls. Only within that subject matter does there subsist necessity of implication. Thus, by claiming to perceive implications of which the author was not conscious, we may sometimes distort and falsify the meaning of which he was conscious, which is not "better understanding" but simply misunderstanding of the author's meaning.

[11]This distinction was not observed in the interesting essay by O. Bollknow, "Was heisst es einen Verfasser zu verstehen besser als er sich selber verstanden hat?" in *Das Verstehen, Drei Aufsätze sur Theorie des Geisteswissenschaften* (Mainz, 1949).

But let us assume that such misunderstanding has been avoided and that the interpreter really has made explicit certain aspects of an author's undoubted meaning of which the author was unconscious—as in stylistic analysis of casual conversation. The further question then arises: How can an author mean something he did not mean? The answer to that question is simple. It is not possible to mean what one does not mean, though it is very possible to mean what one is not conscious of meaning. That is the entire issue in the argument based on authorial ignorance. That a man may not be conscious of all that he means is no more remarkable than that he may not be conscious of all that he does. There is a difference between meaning and consciousness of meaning, and since meaning is an affair of consciousness, one can say more precisely that there is a difference between consciousness and self-consciousness. Indeed, when an author's meaning is complicated, he cannot possibly at a given moment be paying attention to all its complexities. But the distinction between attended and unattended meanings is not the same as the distinction between what an author means and what he does not mean. No example of the author's ignorance with respect to his meaning could legitimately show that his intended meaning and the meaning of his text are two different things.

Other varieties of authorial ignorance are therefore of little theoretical interest. When Plato observed that poets could not *explain* what they meant, he intimated that poets were ineffectual, weak-minded, and vague—particularly with respect to their "most elaborate passages." But he would not have contended that a vague, uncertain, cloudy, and pretentious meaning is not a meaning, or that it is not the poet's meaning.[12] Even when a poet declares that his poem means whatever it is taken to mean (as in the case of some modern writers who believe in the current theory of public meaning and authorial irrelevance), then, no doubt, his poem may not mean anything in particular. Yet even in such a limiting case it is still the author who "determines" the meaning.

One final illustration of authorial ignorance, a favorite among literary critics, is based on an examination of an author's early drafts, which often indicate that what the author apparently intended when he began writing is frequently quite different from what his final work means. Such examples show how considerations of style, genre, and local texture may play a larger part in his final meaning than that played by his original intention, but these interesting observations have hardly any theoretical significance. If a poet in his first draft means something different than he means in his last, it does not imply that somebody other than the poet is doing the meaning. If the poet capitalizes on a local effect which he had not originally intended, so much the better if it makes a better poem. All this surely does not imply that an author does not mean what he means, or that his text does not mean what he intends to convey.

If there is a single moral to the analyses of this chapter, it is that meaning is an affair of consciousness and not of physical signs or things. Consciousness is, in turn, an affair of persons, and in textual interpretation the persons

[12]Or at least that of the muse who temporarily possesses him—the muse being, in those unseemly cases, the real author.

involved are an author and a reader. The meanings that are actualized by the reader are either shared with the author or belong to the reader alone. While this statement of the issue may affront our deeply ingrained sense that language carries its own autonomous meanings, it in no way calls into question the power of language. On the contrary, it takes for granted that all meaning communicated by texts is to some extent language-bound, that no textual meaning can transcend the meaning possibilities and the control of the language in which it is expressed. What has been denied here is that linguistic signs can somehow speak their own meaning—a mystical idea that has never been persuasively defended.

READING 30

INTRODUCTION

Richard Wollheim is professor of philosophy at the University of California, Berkeley. In "Criticism as Retrieval" (1980), he suggests that the practice of criticism is essentially a matter of reconstructing the creative process which, as he puts it, "terminates on the work of art itself." In some respects this position is echoed in the essays by Baxandall and by Robinson elsewhere in this section. However, Wollheim develops his position in a distinctive fashion. He defends the idea that criticism involves "retrieving" the creative processes which culminated in the work under consideration by analyzing two other models of the practice of criticism. The first of these models is "criticism as revision," according to which the critic is in the business of showing how a work of art can speak "to us, today." (Wollheim regards Eliot's essay "Tradition and the Individual Talent" [see Section 1] as implicitly endorsing this model of criticism.) The second model is "criticism as scrutiny," according to which the job of the critic is to focus on the work itself to the exclusion of anything that might be regarded as "external to the work"—such as the intentions or creative acts of the artist. (Although Wollheim does not mention Wimsatt and Beardsley explicitly, the conception of criticism which they endorse in "The Intentional Fallacy" has much in common with the conception of criticism as "scrutiny.") In his defense of "criticism as retrieval," as opposed to "revision" or "scrutiny," Wollheim lends support to the idea that artistic intention may often be an appropriate object of interpretive inquiry.

Criticism as Retrieval

Richard Wollheim

It is a deficiency of at least the English language that there is no single word, applicable over all the arts, for the process of coming to understand a particular work of art. To make good this deficiency I shall appropriate the word 'criticism', but in doing so I know that, though this concurs with the way the

word is normally used in connection with, say, literature, it violates usage in, at any rate, the domain of the visual arts, where 'criticism' is the name of a purely evaluative activity.

The central question to be asked of criticism is, What does it do? How is a piece of criticism to be assessed, and what determines whether it is adequate? To my mind the best brief answer, of which this essay will offer an exposition and a limited defence, is, Criticism is *retrieval*. The task of criticism is the reconstruction of the creative process, where the creative process must in turn be thought of as something not stopping short of, but terminating on, the work of art itself. The creative process reconstructed, or retrieval complete, the work is then open to understanding.

To the view advanced, that criticism is retrieval, several objections are raised.

1. The first objection is that, by and large, this view makes criticism impossible: and this is so because, except in exceptional circumstances, it is beyond the bounds of practical possibility to reconstruct the creative process.

Any argument to any such conclusion makes use of further premises—either about the nature of knowledge and its limits, or about the nature of the mind and its inaccessibility—and the character of these further premises comes out in the precise way the conclusion is formulated or how it is qualified. For, though an extreme form of the objection would be that the creative process can never be reconstructed, the conclusion is likelier to take some such form as that criticism is impossible unless the critic and the artist are one and the same person, or the work was created in the ambience of the critic, or the creative process was fully, unambiguously, and contemporaneously documented by the artist. This is not the place to assess the general philosophical theses of scepticism or solipsism, or their variants, but it is worth observing that these theses ought not to be credited with greater force outside general philosophy than they are inside it. The observation is called for, because traditionally philosophers of art permit the creative process, or, more broadly, the mental life of artists, to give rise to epistemological problems of an order that they would not sanction in inquiry generally.

These difficulties apart, the objection in its present form offers a persuasive rather than a conclusive argument against the retrieval view. For maybe the truth is that criticism *is* a practical impossibility, or is so outside very favoured circumstances. But sometimes the objection is stated to stronger effect, and then an incompatibility is asserted between the sceptical or solipsistic premises, however framed, and not just the practice of criticism as retrieval but the view that criticism is retrieval.

A step further, and it is asserted that from these same premises an alternative view of criticism follows. This alternative view may be expressed as, Criticism is *revision*, and it holds that the task of criticism is so to interpret the work that it says most to the critic there and then. Assuming the critical role, we must make the work of art speak 'to us, today'.

It is clear that this derivation too must require further premises, though less clear what they would be. One thing seems certain, though it is often ignored by adherents of the revisionary view, and that is this: If criticism is justifiably revision when we lack the necessary evidence for reconstructing the

creative process, then it must also be revision when we have, if we ever do, adequate evidence for retrieval. We cannot as critics be entitled to make the work of art relate to us when we are in a state of ignorance about its history without our having an obligation to do so, and this obligation must continue to hold in the face of knowledge. Otherwise revision is never a critical undertaking: it is only, sometimes, a *pis-aller*, or a second best to criticism. Indeed, the strongest case for the revisionary view of criticism draws support from a thesis which appears to dispense with scepticism or, at any rate, cuts across it.

The thesis I have in mind, which is generally called 'radical historicism' and is best known through the advocacy of Eliot, holds that works of art actually change their meaning over history. On this thesis the task of the critic at any given historical moment is not so much to impose a new meaning upon, as to extract the new meaning from, the work of art. That works of art are semantically mobile in this way is to be explained not simply—to take the case of a literary work—by reference to linguistic change or to shifts in the meaning of words and idioms, but, more fundamentally, more radically, by appeal to the way in which every new work of art rewrites to some degree or other every related, or maybe every known, work of art in the same tradition.[1] To this central contention the thesis adds the corollary that, as some particular meaning of a work of art becomes invalid or obsolete, it also becomes inaccessible: it ceases to be a possible object of knowledge.

Radical historicism is a doctrine, like the Whorfian thesis about the non-intertranslatability of natural languages, with which indeed it has much in common, that has its greatest appeal when it gets us to imagine something which on reflection turns out to be just what it asserts is unimaginable. So, for instance, under the influence of radical historicism (or so it seems) we start to imagine how a contemporary of Shakespeare's would find the inherited reading of Chaucer's *Troilus* dull or dead, and we find ourselves readily sympathizing with his preference for a new revitalized reading inspired by *Troilus and Cressida*. And then we reflect that, if radical historicism is indeed true, just such a comparison was not open to one of Shakespeare's contemporaries, and is even less so to us. To him only one term to the comparison was accessible: to us neither is.

2. A second objection to the retrieval view of criticism goes deeper in that it concentrates upon the view itself and not merely upon its consequences. According to this objection, retrieval is, from the critical point of view, on any given occasion either misleading or otiose. From the outset the objection contrasts retrieval with its own favoured view of criticism, which may be expressed as, Criticism is *scrutiny*—scrutiny of the literary text, of the musical score, of the painted surface—and it holds that retrieval is misleading when its results deviate from the findings of scrutiny and it is otiose when its results concur with the findings of scrutiny. In this latter case it is (note) retrieval that is reckoned otiose, not scrutiny, and the reason given is that reliance upon retrieval presupposes scrutiny but not *vice versa*. Scrutiny is presupposed because it is only with the findings of scrutiny also before us that we can be certain that we are dealing with a case where the results of retrieval merely

[1]See Eliot, "Tradition and the Individual Talent," reprinted in this volume.

reduplicate those of scrutiny, and hence that retrieval is not misleading. So, overall, retrieval can never do better than scrutiny, sometimes it can do worse, and which is the case cannot be determined without the benefit of scrutiny.

But how does this objection characterize the difference between the cases where retrieval does no worse than, and those where it does worse than, scrutiny? The cases are distinguished in that, given a work of art and the creative process that terminates on it, there are two possibilities. One is that the creative process realizes itself in the work of art: the other is that it fails to. Now it is in the latter case that retrieval is misleading, whereas in the former case it is merely otiose. In the former case, scrutiny will show the critic that the work is as retrieval laboriously allows him to infer that it is: in the latter case, retrieval will lead him to infer that the work is as scrutiny will soon reveal it not to be.

This objection to the retrieval view shows itself vulnerable on a number of counts.

In the first place, though it is indubitably true that the creative process either is or is not realized in the work of art, nevertheless, if 'realized' means (as it presumably does) 'fully realized', this is not, from the point of view of criticism, the best way of setting out the alternatives. For critically it is a highly relevant fact that the creative process may be realized in the work of art to varying degrees. (There are, indeed, theoretical reasons of some strength, which I shall not assess, for thinking that the creative process is never realized in a work of art either to degree I or to degree 0: realization must always be to some intermediate degree.) But, it might be thought, this presents no real problem. For the objection can surely concede that the creative process may be realized to varying degrees, and can then further concede that sometimes, even when the creative process has not been fully realized, retrieval may not be misleading. All that it has to insist upon, surely, is that, if the creative process may be harmlessly, though otiosely, reconstructed up to the point to which it was realized in the work of art, retrieval is misleading if, and as soon as, it is carried beyond this point. However, as we shall see, this concession brings its difficulties in train.

Secondly: Suppose we confine ourselves (as the objection says) to that part of the creative process which is realized in the work of art. It becomes clear that there is something that reconstruction of this part of the process can bring to light which scrutiny of the corresponding part of the work cannot. It can show that that part of the work which came about through design did indeed come about through design and not through accident or error. Scrutiny, which *ex hypothesi* limits itself to the outcome, cannot show this. (A parallel in the philosophy of action: If an action is intentional, then, it might be thought, reconstruction of the agent's mental process will not tell us more about it than we could learn from observation of the action: but we can learn this from observation of the action only if we already or independently know that the action is intentional.) Accordingly—and as yet the point can be made only hypothetically—if criticism is concerned to find out not just what the work of art is like but what the work is like by design, then, contrary to what the objection asserts, scrutiny, to be a source of knowledge, must presuppose retrieval.

Thirdly: The objection, as emended, states that that part of the creative

process which is not realized in the work of art is not to be reconstructed. But how is this part of the process to be identified? There are two distinct grounds on which the distinction could be effected, and they give different results. We could exclude from critical consideration any part of the creative process in which the work of art is not (subject to the necessary qualifications)[2] more or less directly prefigured: alternatively, we might exclude only that part of the creative process which has no bearing at all upon the character of the work. Two kinds of case show how crucial it is which way the distinction is effected. The first case is where the artist changes his mind. Rodin's *Monument to Balzac* started off as a nude sculpture. Is the critically relevant part of the creative process only that which includes Rodin's change of mind to, and his subsequent concentration upon, the draped Balzac: or should it also embrace his concentration upon, and his subsequent change of mind from, the naked Balzac? The second case is where an artist sticks to his intention but fails in it. In writing *The Idiot* Dostoievsky set out to portray a totally good man. Prince Myshkin is not a totally good man, but Dostoievsky's depiction of him is clearly not unaffected by the original aim: it is the failed depiction of a totally good man. Should we, or should we not, regard Dostoievsky's original aim, unsuccessfully realized though it is in the work of art, as a critically relevant part of the creative process?

In the light of the next, or fourth, point, the previous two points can be sharpened. For the objection, in claiming that scrutiny can establish everything that at one and the same time is critically relevant and can be established by retrieval, totally misconceives the nature of the interest that criticism might take in the creative process and, therefore, what it stands to gain from reconstructing it. For the objection appears to assume that, if the critic is interested in the creative process, this is because, or is to be accounted for by the degree to which, it provides him with good evidence for the character of the work. The critic seeks to infer from how the work was brought about how it is. Now, of course, if this were so, then there would, on the face of it at any rate, be reason to think that retrieval was at best a detour to a destination to which scrutiny could be a short cut. But that this is a misconception is revealed by the fact that the critic committed to retrieval is not committed to any assumptions about the likely degree of match between the creative process and the resultant work and he will continue to be interested in the creative process even in the case when he knows that there is a mismatch between the two. The critic who tries to reconstruct the creative process has a quite different aim from that which the objection to the retrieval view assumes. He does so in order to understand the work of art—though it would be wrong to say, as some philosophers of art tend to, that he seeks understanding rather than description. Understanding is reached through description, but through profound description, or description profounder than scrutiny can provide, and such description may be expected to include such issues as how much of the character of the work is by design, how much has come about through changes of intention, and what were the ambitions that went to its making but were not realized in the final product.

[2]See Section 23 of Richard Wollheim, *Art and Its Objects* (Cambridge University Press, 1980).

But, fifthly, and finally, the objection, in opposing scrutiny to retrieval presents scrutiny as though it were itself quite problematic: or as though, given a work of art, there would be no difficulty, or at any rate no theoretical difficulty, in dividing its properties into those which are accessible and those which are inaccessible to scrutiny. In considering the objection I have gone along with this, particularly in the second point I raise. However, in the main body of *Art and Its Objects* I rejected this traditional assumption (sections 24, 33), though I preferred to make my point by considering specific properties that resisted the dichotomy (sections 25–31). Here I shall consider the matter more directly.

Crucially the view that criticism is scrutiny is seriously under-defined until an answer is given to the question, Scrutiny by whom? The following cases illustrate the problem: The listener who is ignorant of the mission of Christ will miss much of the pathos in the St Matthew Passion: a viewer who has not gathered that Bernini's mature sculpture requires a frontal point of view, as opposed to the multiple viewpoint against which it reacted, will fail to discern the emotional immediacy it aims at: a reader's response to Hardy's 'At Castle Boterel' will be modified when he learns that the poet's wife had just died, and then it will be modified again as he learns how unhappy the marriage had been: the spectator who is made aware that in the relevant panel of the S. Francesco altarpiece Sassetta uses to paint the cloak that the Saint discards, thereby renouncing his inheritance, the most expensive and most difficult pigment available will come to recognize a drama first in the gesture, then in the picture as a whole, of which he had been previously ignorant. With any form of perception—and scrutiny is a form of perception—what is perceptible is always dependent not only upon such physical factors as the nature of the stimulus, the state of the organism, and the prevailing local conditions, but also upon cognitive factors. Accordingly, the scrutiny view needs to be filled out by a definition of the person whose scrutiny is authoritative, or 'the ideal critic', and any such definition must be partly in terms of the cognitive stock upon which the critic can draw. There are a number of possible definitions, for each of which the appeal of the scrutiny view, as well as its right to go by that name, will vary.

A heroic proposal, deriving from Kant, the aim of which is to ensure the democracy of art, is to define the ideal critic as one whose cognitive stock is empty, or who brings to bear upon the work of art zero knowledge, beliefs, and concepts. The proposal has, however, little to recommend it except its aim. It is all but impossible to put into practice, and, if it could be, it would lead to critical judgments that would be universally unacceptable.

Another proposal is to define the cognitive stock on which scrutiny is based as consisting solely of beliefs that could themselves have been derived—though in practice they may not have been derived—from scrutiny of the work of art concerned. But this takes us round in a circle: for what requirement is placed upon the cognitive stock on which the scrutiny that gives rise to these beliefs itself depends?

A third proposal is to define the cognitive stock on which the ideal critic is entitled to draw by reference not to its source of origin but to its function. Whether or not the beliefs have been derived, or could have been derived, from scrutiny is now reckoned immaterial, and the requirement is only that they

should contribute to scrutiny. Now, it is true that most beliefs capable of modifying our perception of a work of art are beliefs that, given appropriate background beliefs, could have been derived from perception of the work—or, at any rate, of some other related work by the same artist. Nevertheless, there are some beliefs of this kind that could not have been, they need to be acquired independently, and the novelty of the present proposal is that it says that these too are available to the ideal critic. Examples of beliefs that could not be gleaned from, yet could contribute to, perception of works of art are the following: That Palladio believed that the ancient temple evolved from the ancient house and therefore thought temple fronts appropriate facades for private villas; that Mozart's favourite instruments were the clarinet and the viola; that Franz Hals was destitute and in a state of total dependence upon the Regents and Regentesses of the Old Men's Almshouses in Haarlem when he painted their two great group-portraits; that the Athenian Geometric vase-painters who introduced lions on to their pots could never have seen such an animal; and that Titian painted the altar piece of *St Peter Martyr* in competition with Pordenone and wanted to outdo him in dramatic gesture.

However, it is important to see that a shift has just occurred in the argument. It is not plausible to regard the new proposal as, like the first two, operating within the scope of the scrutiny view in that it imposes a substantive restriction upon the cognitive stock that the critic may draw upon in scrutiny. For that a belief on which criticism is based should be capable of modifying perception is a minimal condition if the resultant criticism is to count as scrutiny. Accordingly, we need another way of taking the proposal, and one that suggests itself is to see it as proposing scrutiny as a restriction upon retrieval. In other words, reconstruction of the creative process is admitted as the, or at least a, central task of criticism, but it must have a purpose in mind, and that purpose is that its findings should be put to use in scrutinizing the work. Retrieval is legitimate because, but only in so far as, through its findings it contributes to perception.

But with this change in direction the question must be asked: Is this new thesis legitimate? Does it impose an acceptable constraint upon retrieval? Are the only facts about a work of art that are critically relevant those which modify, or could modify, our perception of it?

Standardly this question is raised, and the thesis tested, in a special and highly artificial context, and, unless great care is taken, the very artificiality of the context can seriously distort the answer we give. The context is that of the 'perfect forgery'. Let us suppose that there are two paintings, one by Rembrandt, the other a forgery of it, and they are perceptually indistinguishable. Now, *ex hypothesi* the facts of authorship cannot modify our perception of either painting. In this case, are they not critically irrelevant, and critically irrelevant for just this reason?

It is initially to be observed that the supposed case is not simply implausible, it is also highly subversive. To appreciate this we must concentrate on just what it asks us to entertain. If it merely asked us to believe that up till now, or some specific historical moment, no-one had discerned the difference between the original and the forgery, then the supposition would, at worst, subvert our expectations of criticism—and it might not even do this if there

was a sufficiently good historical explanation why the forgery went undetected (cf. Ossian, or the first of the van Meegeren Vermeers). But, in asking us to believe that there is no such difference, the supposition subverts our expectations of art itself. It subverts, for instance, the belief that it takes an artist of genius to produce a work of art of genius—and all derivative beliefs. And, even then, the fully subversive character of the supposition of a perfect forgery is muted because of the form it presently takes. In its present form the supposition requires us only to believe that the forger should be able to produce an indistinguishable copy of an existent autograph Rembrandt: in other words, it employs the weak notion of forgery that Nelson Goodman uses to introduce the autographic/allographic distinction. Only strengthen the supposition, and suppose that the forger could rival Rembrandt not merely (as a seventeenth-century theorist would have put it) in *esecuzione* but also in *invenzione*, and then we would be forced to downgrade our views, first of Rembrandt, and then of art, very considerably. But, even as things stand, we slight both Rembrandt and art in entertaining the supposition seriously.

But suppose we do so. Is it so clear that in such a case the belief that one painting is a forgery of the other cannot modify our perception of either? What the supposition of the perfect forgery brings out is an important ambiguity in the thesis under test. For there are two different ways in which an item in a critic's cognitive stock could be said to influence his perception of a work of art. It could affect what he perceives in a work—belief might make him sensitive to something he would otherwise have missed, like the anamorphic skull in Holbein's *Ambassadors,* or the use that Manet makes of the man's reflection in the *Bar aux Folies-Bergères* to inculpate the spectator in the man's sexual advances—or it could affect how he perceives the work. Consideration suggests that it cannot be only the first way that secures critical relevance for a belief: the second way must too. Part of coming to understand a work of art is learning how to perceive it, where this is over and above taking perceptual account of everything that is there to see. Now, there is nothing in the supposition of the perfect forgery to eliminate *ex hypothesi* influence of the critic's belief about the authorship of the paintings upon how he sees the two paintings. All that the supposition eliminates is the influence of this belief—indeed of any belief—upon what he sees in the paintings: because there is nothing to be seen in the paintings which corresponds directly to the difference of authorship or to the fact that one is a forgery of the other.

This last point is best brought out by again varying the supposition. For it may well be that, even as the supposition stands, the capacity imputed to the forger so depreciates Rembrandt, and consequently the attribution of one painting to Rembrandt, that it is no longer clear how this belief might, or indeed whether it should, modify perception of that painting. Given the supposition, a disillusioned spectator might react with ' "By Rembrandt"—so what?' So let us instead suppose a pair of paintings which are perceptually indistinguishable, one of which is by Rembrandt and the other by a highly gifted pupil, and then it should be easier to recognize how a spectator might look at both paintings, know who each is by, and be influenced by this knowledge in the way in which he sees each of them. He could look at the Rembrandt differently from the way he looks at the Aert de Gelder, just because

he knows it is by Rembrandt, even though he has the evidence of his eyes to tell him that Aert de Gelder, in a certain frame of mind, could paint indistinguishably from his master.

But there is a more fundamental objection to the thesis under test, and this the supposition does not bring out. Indeed, it helps to obscure it. For what the thesis presupposes is an unduly atomistic conception of criticism. Certainly, in seeking to understand a particular work of art, we try to grasp it in its particularity, and so we concentrate on it as hard as we can: but at the same time we are trying to build up an overall picture of art, and so we relate the work to other works and to art itself. Nearly everything that we learn about the work that is critically relevant contributes to both projects. But there could be some information about a work that is of critical value but contributes only to the second project. It is arguable that, if the supposition of the perfect forgery has any theoretical value, just what it should show us is that there are concepts which have a fundamental role to play in organizing our experience of art—in this case, the concepts of autograph and forgery—but which might, in certain special and altogether insulated circumstances, have no influence upon our perception of individual works of art.

3. A third objection to the retrieval view, which is open to adherents of both the revisionary view and the scrutiny view and also to others, is that it confuses the meaning of the work of art and the meaning of the artist, and it encourages the critic to pursue the second at the expense of the first. The distinction upon which this objection rests is initially not hard to grasp. Eliot has pointed out the mistake that Poe evidently made when he wrote 'My most immemorial year', and in *Chrome Yellow* Aldous Huxley describes a young poet who is inordinately satisfied with the line 'Carminative as wine' until the next morning he looks up the first word in a dictionary. Neither poet meant what his words mean. But these are very simple cases, and problems arise as soon as we try to project the distinction into areas of interest.

The basic problem is this: In order to determine the meaning of a work of art we have first to determine what the meaning-bearing properties of the work are, and it is only on a very naïve view of the matter that we can do this without invoking the creative process itself and thus losing the clarity of the distinction which the simple cases promised. A typical naïve view would be one that equated the meaning-bearing properties of a poem with the ordered and aligned words, or the 'text'. In Essay II I have argued that, if we take this view, absurd consequences follow even as far as the identity of poems is concerned, and something similar goes for similar views. Nevertheless to say that we have to invoke the creative process in order to fix the meaning-bearing properties of the work of art does not commit us to the view, already dismissed, that every work of art has every meaning-bearing property that the artist wished it to have. The retrieval view concedes that an artist may fail. The objection then misfires. The retrieval view has no difficulty in distinguishing—in principle, that is—between the meaning of the work of art and the meaning of the artist, and it identifies the former as the proper object of critical attention.

All objections apart, and I shall consider no more, the retrieval view invites, in one significant respect, clarification. For the arguments that I have

been considering for and against the view that the creative process is the proper critical object bear a close resemblance to arguments advanced of recent years for and against the critical relevance of the artist's intentions. It, therefore, seems appropriate to ask, How are the creative process (as I have introduced it) and the artist's intention (as it figures in recent debate) related?

The creative process, as I envisage it, is a more inclusive phenomenon than the artist's intentions, and in two ways. In the first place, the creative process includes the various vicissitudes to which the artist's intentions are subject. Some of these will be themselves intentional—change of mind—but some will be chance or uncontrolled. Secondly, the creative process includes the many background beliefs, conventions, and modes of artistic production against which the artist forms his intentions: amongst these will be current aesthetic norms, innovations in the medium, rules of decorum, ideological or scientific world-pictures, current systems of symbolism or prosody, physiognomic conventions, and the state of the tradition.

A consequence follows which is of major importance for the process of retrieval. In recording an artist's intention the critic must state it from the artist's point of view or in terms to which the artist could give conscious or unconscious recognition. The critic must concur with the artist's intentionality. But the reconstruction of the creative process is not in general similarly restrained. The critic must certainly respect the artist's intentionality, but he does not have to concur with it. On the contrary he is justified in using both theory and hindsight unavailable to the artist if thereby he can arrive at an account of what the artist was doing that is maximally explanatory. Retrieval, like archaeology, and archaeology provides many of the metaphors in which retrieval is best thought about, is simultaneously an investigation into past reality and an exploitation of present resources. Anachronism arises not when the critic characterizes the past in terms of his own day, but only when in doing so he falsifies it. There is no anachronism involved in tracing the *Virgin and Child with St Anne* to Leonardo's Oedipal strivings, or in describing Adolf Loos as bridging the gap between C. F. A. Voysey and Le Corbusier—if, that is, both these statements are true. In *Art and Its Objects,* I have said that the constant possibility of reinterpretation is one of the sources of art's continuing interest for us, and I stand by this.

On a related point, however, I expressed myself obscurely, when I talked about the ineliminability of interpretation (*Art and Its Objects,* sections 37–38), and I should like to clarify this point. For any discussion of the issue ought to be prefaced—as that in the text was not—by a simple but all-important distinction between different ways in which interpretations of the same work of art may be related. They may be compatible: they may be incommensurable: they may be incompatible. The first kind of case presents no problem, the third is clearly unacceptable, so it is only the second that need detain us, though not the least of our problems is that of identifying such cases. Indeed, whether incommensurability is a real feature of sets of interpretations, or whether it is only an epistemic mirage induced by our inability to see just how the interpretations fit together, is a fundamental question. Ultimately it relates to the limits of our cognitive powers. In the present state of the problem the best that can be done for aesthetics is to point out that the very same difficulties break

out in the domain of psychological explanation. We are given explanations of others in terms, on the one hand, of moral inadequacy, and, on the other hand, of early experience, or, again, in terms of social roles and of self-interest, and our knowledge of human nature is such, and may always remain such, that we do not know how to accommodate these pairs of explanations or how to emphasize each member of the pair appropriately.

A question remains: Is a limit set to retrieval? Obviously where evidence is lacking, our understanding stops short. The 30,000 years or so of Palaeolithic art must remain ultimately a mystery to us, short of a landslide victory for archaeology. We shall probably never know the authentic rhythm or phrasing of medieval plainsong. But are there cases where both retrieval is impossible (or barely possible—for it must be conceded that, like the creative process itself, reconstruction of the creative process is realizable to varying degrees) and the explanation lies in a radical difference of perspective between the artist and us, the interpreters?

I suspect that there are, and an analogy gives us an insight into the situation. For an outward parallel to the reconstruction of the creative process is provided, at any rate in the case of the visual arts, by the physical restoration of the work of art. Admirers of French romanesque architecture, well aware that originally a great deal of the sculpture that adorns such buildings would have been brightly painted, are nevertheless likely, when confronted with attempts to restore it to its original condition—for instance, the historiated capitals at Issoire—to deplore the result. The heavy hand of the restorer is partly to blame, but not totally. For the modern spectator there seems to be no way of getting anything like the original colours to make anything like the intended impact upon him. We might restate the point in terms of the present discussion and say that he seems powerless to reconstruct the creative process in a way that at once meets the demands of internal coherence and seems naturally to terminate on the work before him. Maybe he can do so computationally but he cannot internalize the result, and the consequence is that here we may have reached the limits of retrieval.

In such an eventuality the restorer may resort to a compromise. He may hit on a colour scheme that is acceptable to our eyes and is functionally equivalent to the original scheme. Similarly a musicologist may orchestrate Monteverdi's madrigals for modern instruments and we may listen to them in a comfortable concert hall. Or a clever modern producer may present Antigone as a political drama about women's rights, or relate *The Merchant of Venice* to twentieth-century central European anti-Semitic rhetoric. Any such attempt will be to varying degrees anachronistic. Some of the great art of the past is accessible to us, some is not. When it is accessible, we should, surely, wish to retrieve it. But when it is not, or when it is retrievable only to an inadequate degree, we may be wise to settle for a counterpart. Either way round, it is better that we know what we are doing.

READING 31

INTRODUCTION

Michael Baxandall is probably best known for his work on the arts of the Renaissance. But he is a distinguished theorist, as well as practitioner, of art history. The essay reprinted here comes from his book *Patterns of Intention* (1985), in which he attempts to explain how pictures can be interpreted and appreciated in terms of their histories and the circumstances which surrounded their creation. Specifically, Baxandall argues that an artist's *intentions* can be inferred from a consideration of these factors. In "Intentional Visual Interest," Baxandall reconstructs, in detail, the intentions lying behind one important picture of the present century—Picasso's *Portrait of Kahnweiler;* and he shows how an awareness of these intentions can both sharpen our understanding of the picture and enhance our enjoyment of it. It is important to notice that Baxandall's interpretation does not rest upon the reconstruction of some private state of mind that Picasso experienced in 1910, when he painted the portrait. That is, Baxandall's account does not offer to retrieve "intentions" considered as mental states. (If it did, then his account would be vulnerable to some of the objections raised by Wimsatt and Beardsley in "The Intentional Fallacy.") Rather, Baxandall conceives of intention as a relation between an object—for instance a painting—and its circumstances, such that the nature of the object is explained as a function of its having been produced in a particular context and under particular conditions. When the object in question is a painting, those conditions will certainly include known facts about the artist; but they will not include any (unknowable) facts about conditions inside the artist's head. If Baxandall's method is sound, then it will establish a place for intention not only in the interpretation of paintings, but in the interpretation of works of art, and of artifacts, of every kind.

Intentional Visual Interest: Picasso's *Portrait of Kahnweiler*

Michael Baxandall

Don't talk to the driver!
 —Picasso, to Metzinger

Intention

A word must be said about 'intention', I suppose. I have declared an interest in addressing pictures partly by making inferences about their causes, this both because it is pleasurable and because a disposition towards causal inference seems to penetrate our thought and language too deeply to be excised, at least without doing oneself a quite disabling mischief. But since pictures are human productions, one element in the causal field behind a picture will be volition, and this overlaps with what we call 'intention'.

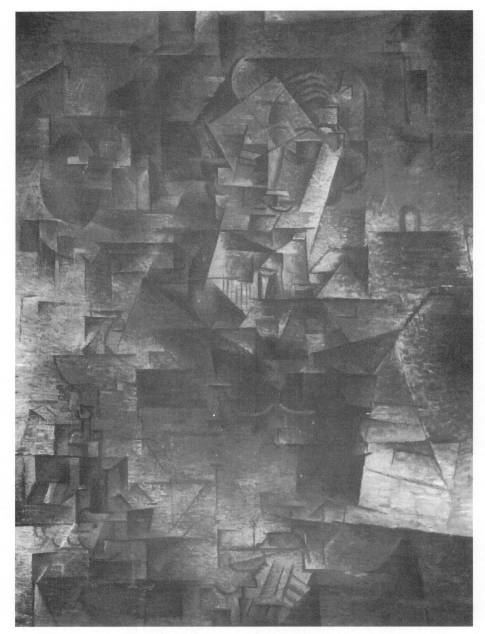

Pablo Picasso, Spanish, 1881–1973, Daniel-Henry Kahnweiler, oil on canvas, 1910, 100.6 × 72.8 cm, Gift of Mrs. Gilbert W. Chapman, 1948.561. Photograph © 1994, The Art Institute of Chicago, all rights reserved.

I am not aligned or equipped to offer anything useful on the matter of whether it is necessary to appeal to an author's historical intention in interpreting a picture (or, of course, a poem). The arguments for doing so—that it is necessary if there is to be any determinate meaning in a work, that the relation between intention and actual accomplishment is necessary to evaluation, and so on—are often attractive, but they sometimes seem to refer to a slightly different sort of intention (a complex word) or to intention seen from a slightly different angle from what I feel committed to. The intention to which I am committed is not an actual, particular psychological state or even a historical set of mental events inside the heads of Benjamin Baker or Picasso, in the light of which—if I knew them—I would interpret the Forth Bridge or the *Portrait of Kahnweiler*. Rather, it is primarily a general condition of rational human action which I posit in the course of arranging my circumstantial facts or moving about on the triangle of re-enactment. This can be referred to as 'intentionality' no doubt. One assumes purposefulness—or intent or, as it were, 'intentiveness'—in the historical actor but even more in the historical objects themselves. Intentionality in this sense is taken to be characteristic of both. Intention is the forward-leaning look of things.

It is not a reconstituted historical state of mind, then, but a relation between the object and its circumstances. Some of the voluntary causes I adduce may have been implicit in institutions to which the actor unreflectively acquiesced: others may have been dispositions acquired through a history of behaviour in which reflection once but no longer had a part. Genres are often a case of the first and skills are often a case of the second. In either case I may well want to expand the 'intention' to take in the rationality of the institution or of the behaviour that led to the disposition: this may not have been active in the man's mind at the time of making the particular object. Even his own descriptions of his own state of mind—like Baker's of his aesthetic intention and, most certainly, Picasso's later remarks about his—have very limited authority for an account of intention of the object: they are matched with the relation between the object and its circumstances, and retouched or obliquely deployed or even discounted if they are inconsistent with it.

So 'intention' here is referred to pictures rather more than to painters. In particular cases it will be a construct descriptive of a relationship between a picture and its circumstances. In general intentionality is also a pattern posited in behaviour, and it is used to give circumstantial facts and descriptive concepts a basic structure. In fact, 'intention' is a word I shall use as little as possible, but when I do use it I do not know what other word I could use instead. 'Purpose' and 'function' and the rest present their own difficulties and anyway their force is different.

The Pictorial Charge and the Painter's Brief

The issue is now whether the pattern of intention derived from Benjamin Baker's Forth Bridge can be adapted to meet the demands of Picasso's *Portrait of Kahnweiler*. To recollect: at Queensferry Benjamin Baker was seen as being possessed of a general Charge—'Bridge!' or 'Span!'—and a specific Brief that included such matters as strong side winds, silt, and shiproom. He selected

and deployed resources to meet these. In the case of Picasso's *Kahnweiler* it was less clear what Charge and Brief were, and also who delivered them.

A painter's Charge is indeed more elusive than a bridge-builder's. By definition, the bridge-builder's role has been to span: the manner in which he has done so has varied within his circumstances, the character of the site and of the material and intellectual resources of his culture. To find anything like as long-running a role for the painter it is necessary, temporarily, to be rather general. (The need to do so at all will shortly disappear.) In a quite arbitrary and stipulative way I shall say for the moment that the painter's role has been to make marks on a plane surface in such a way that their visual interest is directed to an end. This is less a definition of painting than a specification of the sort of painting I wish to cover. We can all think of pictures that we would say lacked visual interest, or in which the visual interest does not seem directed to an identifiable end. In saying this we would often be making a negative value judgement. In either case this would not be the sort of picture I shall be concerned with. Further, the specification—'intentional visual interest' for short—involves a sort of demarcation against such historical objects as the Forth Bridge. The Forth Bridge is visually interesting, but is not so capitally: it does not meet its Charge, attain its end, primarily by being visually interesting. Visual interest is secondary and, even though not excluded, incidental.

This may seem an unduly exclusive stipulation, ruling out whole historical episodes in painting, but that is not so. Take, for example, the medieval religious image. To say that it is a thing of intentional visual interest may seem an anti-historical superimposition of a modern aestheticizing point of view. But while our own culture is obviously involved in putting it in this way, in describing its role in these particular terms, the terms do not produce something untrue, just something very general that fails to describe the particular qualities of the medieval image. Medieval religious pictures—and for that matter such Renaissance religious images as Piero della Francesca's *Baptism of Christ*—were produced with a degree of conformity to a general rubric with a history of argument behind it. The thinking took its stand on the fact that, of the five senses, vision is the most precise and the most powerful in the mind, more precise and vivid than hearing, the sense which brings us the Word. Because it was the most precise and vivid faculty given us by God, it was to be used to a pastoral purpose, and its special quality directed to three specified ends. First, it was to expound religious matter clearly: its precision equipped it and the painter's medium for this task. Secondly, it was to expound the matter in such a way as to move the soul: the vividness in the mind of seen things gave it great power here, more power (it was felt) than the word, a heard thing. Thirdly, it was to expound the matter memorably: vision is more retentive than hearing, and things seen stick in the mind better than things heard. Thus the painter's general rubric—made more particular, of course, in particular circumstances—was determined by a recognition that vision was the first sense and gave him a peculiar potentiality: he could use his medium to do things other mediums could not. If we rewrite this as "intentional visual interest" we are generalizing it, not excluding it.

But 'intentional visual interest' is too general to be useful in the particular

case. Its usefulness is purely as a nondescript base—nondescript enough to accommodate as much of the last five hundred years of European painting as I want to—on which to hang the specific qualifications involved in particular cases. The Charge is featureless. Character begins with the Brief. And since things are becoming unpleasantly abstract I shall propose at this point three elements in Picasso's Brief of 1910—equivalents, as it were, of silt, side winds and shiproom—without attempting to substantiate them. They are, in fact, simply adapted from Kahnweiler's account of Picasso and Braque in his book *Der Weg zum Kubismus,* written about 1915 and published in 1920, which seems to me the most plausible of the near-contemporary descriptions of early Cubism. What the status of such assertions is, what they are describing, who can be considered as having set Picasso's Brief, and (eventually) how one assesses such claims about intention, are problems I shall return to once we have something concrete to think around.

One element in the Brief would come out of the fact that representational painters like Picasso represent a three-dimensional reality on a two-dimensional surface, this being a very old issue indeed. How is one both to represent things and persons, tables and art-dealers, recalcitrantly three-dimensional, and yet also positively to acknowledge the two-dimensional plane of the canvas? How does one make a virtue of this curious relation rather than play at what can be seen as a mountebank's game of creating on the plane an illusion of depth? The issue was involved in much recent painting. Impressionism had offered canvases that played on a tension between an openly dabbed-on plane surface and a rendering of sense-impressions of seen objects that put emphasis on their hues. Matisse and others had subsequently dabbed less and played with an oscillation between perception of flatter patterns of hues on the picture surface and our inference about the patterning of the object of representation. There was a problem here.

A second element is a question about the relative importance of form and of colour, again an ancient issue in painting and in thinking about painting. Impressionist painting and some Post-Impressionist painting had made much, both pictorially and verbally, of the overriding importance to us of colour, in the sense of hues. But colour is an accident of vision, a function of the beholder not an intrinsic quality of real objects; whereas form is not only real but offers the security of perception through more than one sense, since we can apprehend form not only with vision but also with touch. How then can a grownup spend time playing about with colour when the form of the objective world is available to him?

A third element is a question about the fictive instantaneousness of much painting. The convention (if that is what it is; I am not sure) that the painter is offering a moment of experience was in question, partly because of unease about the programme of Impressionism. Matisse, for one, raised it in an essay of 1908. The point is, of course, that in fact it takes a painter much longer than a moment to paint a picture: it takes hours or months. Might there be a case for the painter acknowledging *in the character of his depiction* the fact that this is a record of sustained perceptual and intellectual engagement with the object of representation? Should one not make a virtue, again, of the truth, which is that we do not just have a single sense-impression of an object important

enough to us to paint? We have thought about it, analytically about its parts and synthetically about their constitution. We have studied it in different lights, very probably, and from different angles. And—an important point entailed in a remark of Braque's in 1908—our emotions are less about the object itself than about the history of our minds' engagement with the object.

Who Set Picasso's Brief?

In order to have something to work on, let us posit these three—the tension between the plane of the canvas and the three dimensions of the object; the tension between form and colour; and the tension between fictive instanta-neousness and the fact of sustained engagement—as conceptualizations of three out of the specific elements in the problem that Picasso was electing to address around 1906–1910. There were, of course, others.

Now clearly he would not have stated them like this; if he had heard them stated like this he would have scoffed, with one of the joky put-offs for which he was then well known. ('There are no feet in Nature', 'Don't talk to the dri-ver', and so on.) For him these issues could not be a matter of verbalization like this. They were embodied in complex feelings about a range of other pic-tures, both other men's and his own—pictures he more or less liked and pic-tures he more or less disliked. What we are doing with our conceptualizations is trying to cover—ostensively again and for our own reflective purpose again—a balance within Picasso's attitude to pictures as we infer it, first, from the character of his pictures in relation to other pictures and, second, from the developing character of his own pictures during these years.

There is therefore a strong historical-cum-critical dimension to the painter's Brief. The specific terms of the painter's problem are liable to be pri-marily a specific view of past painting. The same is so of the Charge: indeed we can now let the Charge and the clumsy catch-all 'intentional visual inter-est' wither away. Picasso's Charge really resided in the body of previous paint-ing Picasso would have acknowledged as painting worthy of the term, even if not of his kind or to his purpose. He may or may not have conceptualized to himself on what painting is about. One would guess he did now and then, but it is not necessary to us that he should have, and we are not concerned to reconstruct his actual thoughts if he did.

Then who set Picasso's Charge—he had no Forth Bridge Company—and Brief for the *Portrait of Kahnweiler*? A preliminary half-answer would be that Picasso at least formulated his own. The painter registers his individuality very much by his particular perception of the circumstances he must address. Indeed, if one is to think of a painter 'expressing himself', it is most of all here, in the analysis of his environment which schematically speaking (more of that later) precedes the process of painting itself, that one can most securely locate an individuality. There is often a curious impersonality about the actual work-ing out of a solution in the medium. The painter's medium of forms and colours and distances visually perceived and pictorially deployed is almost as impersonal as the structural properties of steel. But the painter's formulation of a Brief is a very personal affair indeed. Benjamin Baker's problem had been made up of elements—silt and side winds and so on—that were objectively

pressing. He did not himself select them as the matter of his problem-solving, even though he (like Thomas Bouch) was free to put a personal emphasis, relatively, on this or on that. But the elements of Picasso's problem were rather more freely selected by Picasso out of an array, and arranged by Picasso into a problem constituting the immediate Brief.

However, if Picasso is to be thought of as formulating his own Brief, he did so as a social being in cultural circumstances. And how to think or talk tactfully about this relation between Picasso and his culture is a real difficulty. The difficulty lies in the structure of the relation: one wants to keep it very loose and very reciprocal. . . .

Excursus Against Influence

A parenthesis: Mention just now of Cézanne brings me to a stumbling-block or scandal—the notion of artistic 'influence', of one painter 'influencing' another—which I must spend a couple of pages trying to kick just enough out of my road to pass on.

'Influence' is a curse of art criticism primarily because of its wrong-headed grammatical prejudice about who is the agent and who the patient: it seems to reverse the active/passive relation which the historical actor experiences and the inferential beholder will wish to take into account. If one says that X influenced Y it does seem that one is saying that X did something to Y rather than that Y did something to X. But in the consideration of good pictures and painters the second is always the more lively reality. It is very strange that a term with such an incongruous astral background has come to play such a role, because it is right against the real energy of the lexicon. If we think of Y rather than X as the agent, the vocabulary is much richer and more attractively diversified: draw on, resort to, avail oneself of, appropriate from, have recourse to, adapt, misunderstand, refer to, pick up, take on, engage with, react to, quote, differentiate oneself from, assimilate oneself to, assimilate, align oneself with, copy, address, paraphrase, absorb, make a variation on, revive, continue, remodel, ape, emulate, travesty, parody, extract from, distort, attend to, resist, simplify, reconstitute, elaborate on, develop, face up to, master, subvert, perpetuate, reduce, promote, respond to, transform, tackle . . .—everyone will be able to think of others. Most of these relations just cannot be stated the other way round—in terms of X acting on Y rather than Y acting on X. To think in terms of influence blunts thought by impoverishing the means of differentiation.

Worse, it is shifty. To say that X influenced Y in some matter is to beg the question of cause without quite appearing to do so. After all, if X is the sort of fact that acts on people, there seems no pressing need to ask why Y was acted on: the implication is that X simply is that kind of fact—'influential'. Yet when Y has recourse to or assimilates himself to or otherwise refers to X there are causes: responding to circumstances Y makes an intentional selection from an array of resources in the history of his craft. Of course, circumstances can be fairly peremptory. If Y is apprentice in the fifteenth-century workshop of X they will urge him to refer to X for a time, and X will dominate the array of resources that presents itself to Y at that moment; dispositions acquired in this

early situation may well stay with Y, even if in odd or inverted forms. Also there are cultures—most obviously various medieval cultures—in which adherence to existing types and styles is very well thought of. But then in both cases there are questions to be asked about the institutional or ideological frameworks in which these things were so: these are causes of Y referring to X, part of his Charge or Brief.

The classic Humean image of causality that seems to colour many accounts of influence is one billiard ball, X, hitting another, Y. An image that might work better for the case would be not two billiard-balls but the field offered by a billiard table. On this table would be very many balls—the game is not billiards but snooker or pool—and the table is an Italian one without pockets. Above all, the cue-ball, that which hits another, is *not* X, but Y. What happens in the field, each time Y refers to an X, is a rearrangement. Y has moved purposefully, impelled by the cue of intention, and X has been repositioned too: each ends up in a new relation to the array of all the other balls. Some of these have become more or less accessible or masked, more or less available to Y in his stance after reference to X. Arts are positional games and each time an artist is influenced he rewrites his art's history a little.

Let X be Cézanne and Y Picasso. In the autumn of 1906 Cézanne died and Picasso started working towards *Les Demoiselles d'Avignon*. For some time Picasso had been able to see pictures by Cézanne: in particular, his dealer Vollard had large holdings and there were large Cézanne exhibits at the Autumn Salon in 1904 and also in 1907, when there was besides an exhibition of Cézanne watercolours at the Galerie Bernheim Jeune. Many of the new painters were drawing on one or another aspect of Cézanne, never quite the same. For instance, Matisse, who had bought a *Trois Baigneuses* by Cézanne with his wife's dowry in 1899, read in Cézanne a reductive registration of the local structures of the human figure. This reading Matisse put to distinctive use around 1900 as a means to a form both energetically decorative on the picture-plane and suggestive of a toughly colossal sort of object of representation. In time this reading of Cézanne was absorbed into complex modes in which readings of other painters were also active for Matisse, who was an eclectic referrer.

In 1906–1910 Picasso (one infers) saw Cézanne in various ways. In the first place Cézanne was for him part of the history of interesting painting he chose to be aware of and which constituted his Charge. But then, by attending to him, he made him more than that. There were various rather general Cézannian things Picasso accepted *en troc* from the culture, as part of his Brief: one would be Cézanne as an epic model of the determined individual who saw his own sense of the problem of painting as larger than any immediate formulation urged on him by the market; another might be some of Cézanne's verbalizations about painting—'deal with nature in terms of the cylinder, the sphere, the cone . . .' and so on—which, in the form of letters to Emile Bernard, were published in 1907. But then, too, Cézanne was part of the problem Picasso elected to address: there are indications in the composition and in some of the poses of *Les Demoiselles d'Avignon* that one of the elements Picasso was tackling here was a sense of problems left by Cézanne's pictures of bathers, a sense that these were something to tackle. But again, and very obviously, Picasso

also went to Cézanne's pictures as an actual resource, somewhere he could find means to an end, varied tools for solving problems. The matter of Cézannian *passage*—of representing a relation between two separate planes by registering them as one continuous superplane—I have already mentioned, but there are other things too Picasso is considered to have adapted from Cézanne: for instance, high and sometimes shifting view-points that flatten out on the picture-plane arrays of objects phenomenally receding in depth. To Picasso different aspects of Cézanne were what 'Span!' and side winds and the cantilever principle and Siemens steel were to Benjamin Baker—or as, in what is emerging as my grossly oversimplified and over-schematic account, I described them as being to Baker.

To sum all this up as Cézanne influencing Picasso would be false: it would blur the differences in type of reference, and it would take the actively purposeful element out of Picasso's behavior to Cézanne. Picasso acted on Cézanne quite sharply. For one thing, he rewrote art history by making Cézanne a that much larger and more central historical fact in 1910 than he had been in 1906: he shifted him further into the main tradition of European painting. Then again, his reference to Cézanne was tendentious. His angle on Cézanne—to revert to the billiard-table image—was a particular one, affected among other things by his having referred also to such other art as African sculpture. He saw and extracted this rather than that in Cézanne and modified it, towards his own intention and into his own universe of representation. And then again, by doing this he changed for ever the way we can see Cézanne (and African sculpture), whom we must see partly diffracted through Picasso's idiosyncratic reading: we will never see Cézanne undistorted by what, in Cézanne, painting after Cézanne has made productive in our tradition.

'Tradition', by the way, I take to be not some aesthetical sort of cultural gene but a specifically discriminating view of the past in an active and reciprocal relation with a developing set of dispositions and skills acquirable in the culture that possesses this view. But influence I do not want to talk about.

Angles on Process: Positing the Intentional Flux

A more pressing and interesting issue is how an account of intention stands to the element of 'process' in the making of a picture.

One of the apparent differences between the Forth Bridge and the *Portrait of Kahnweiler* was that, with the first, it was not a great strain to distinguish between two phases, a process of design by Baker and a process of execution by William Arrol. But Picasso acted as his own Arrol, and in the *Portrait of Kahnweiler* design and execution must be taken to interpenetrate one another much more. In fact the difference is hardly one of principle: there was interpenetration at Queensferry too, since Baker no doubt modified details and Arrol certainly improvised to meet contingencies. But it did not do much violence to the interest of the case to distinguish quite sharply between design and execution. For many, not all, good pictures this would be destructive.

Cézanne had said, and Picasso later quoted him with approval as saying, that every brushstroke changes a picture. The point they were making was not that a finished picture will look different if even one brushstroke is removed

or changed. They meant that in the course of painting a picture each brush-stroke will modify the effect of the brushstrokes so far made, so that with each brushstroke the painter finds himself addressing a new situation. For instance, the addition of a new tone or hue can modify the relationships and the phenomenal character of the previously placed tones and hues; and because of the simultaneous presence of the elements of a picture this effect is very powerful, however clearly the painter has in mind a final character. This is to say that in painting a picture the total problem of the picture is liable to be a continually developing and self-revising one. The medium, physical and perceptual, modifies the problem as the game proceeds. Indeed some parts of the problem will emerge only as the game proceeds. The sense of a dimension of process, of re-formulation and discovery and response to contingency going on as the painter is actually disposing his pigments, is often important to our enjoyment of the picture and also to our understanding of how styles historically evolve and change. This need not be argued out on the basis of some aesthetic theory of self-discovery; it is intuitively obvious to anyone who has made anything at all.

A static notion of intention, supposing just a preliminary stance to which the final product either more or less conforms, would deny a great deal of what makes pictures worth bothering about, whether for us or for their makers. It would deny the encounter with the medium and reduce the work to a sort of conceptual or ideal art imperfectly realized. There is not just *an* intention but a numberless sequence of developing moments of intention—$I^{1\to2\to3\to}$. . . What is more, this process will have included not only innumerable moments of decision and action but many foregone or cancelled actions, decisions *not* to do or leave something—. . . $I^{3}\to[I^{4}\to I^{5}\to]I^{6}\to$. . .—which have had consequences for the picture we finally see. Can we accommodate this sort of complexity in an account of the intention of a picture?

The answer is clearly both no and yes. We certainly cannot accommodate it on the level of a narrative reconstruction of the thousands of decisions and actions and perceptions and foregone actions that Picasso went through with his picture. Of course, sometimes a visible pentimento and occasionally the availability of studies related to a picture may give us a glimpse of process under way, but not a basis for plotting it stroke by stroke. This is not very worrying: the ambition to narrative is something we have eschewed. And while we cannot narrate process, we can posit it. A particular process may not be reconstructable, but a general assumption of the fact of process can be determining in an account of the intention in a particular picture. Practically the question becomes one of what we think we are making inferences from and about, when we describe intention. And the first point it is worth being clear on is that the intentional items we infer exist on various different levels: some are seen as secondary to others.

At Queensferry one of the primary elements of Baker's problem was the need for a long span and another was the need for the long span to be strong enough to withstand side winds. One of the means he resorted to in addressing these was the use of steel. But this set derivative problems, one being steel's relative sensitivity to shear stress. This secondary or derivative problem, emerging from the medium, was one of the things that Baker then solved with

his tube and lattice girder forms. Something like this is happening in our view of the *Portrait of Kahnweiler*.

As representatives of the problem-complex Picasso evolved from his Brief, I offered three conceptualizations—tension between two and three dimensions; tension between priorities of form and colour; the contradiction between sustained experience and the fictive instant—about the balance of his attitude to painting in the early Cubist years. Those and some others would be something like primary problems. Individually they advance and recede now and then in 1906–1912, but in some degree they are continually there: *Les Demoiselles d'Avignon* had set them out starkly. But as soon as Picasso takes them to the medium—one is speaking schematically—and addresses them with a view to a solution, secondary problems arise and each successive picture is involved with a developing repertory of these. It is, no doubt, these that the painter himself is often most immediately aware of, and this is one reason why painters' statements about their art often seem at odds with what the observer sees. Arriving in 1910, the year of the *Portrait of Kahnweiler*, we are aware of the primary problems still much in play, both as a starting point for the longer development we are watching and as general terms within which we can see the intention of the individual pictures. But the surface narrative is much more complex: a whole evolving set of secondary (and tertiary and so on) problems spring out of the canvases and Picasso's involvement with these has much to do with his development. And in this our sense of development, our knowing what comes before and what comes after a particular picture, is obviously active; we have hindsight and a sort of foresight.

Here are a few of the derivative problems we apprehend in the *Portrait of Kahnweiler*. There is a problem, newly heightened by the leaving open of the plane edges of the figure, of distinction between figure and ground, between the man and what lies around and behind him. The immediate solution has been to establish the distinction tonally and by hue; the man is darker than the ground next to him, and also less yellowish. But this sets another problem. Given our experience of looking at nature and more especially at pictures, it is hard not to apprehend this differentiation as representational of some sort of difference of illumination. And this is related in turn to a further and large problem about what is happening to colour, in the sense of hues. This is basically a duochrome picture. The problem was to increase for a year or so yet, to the point almost of monochromy, before being partly solved and partly evaded—Braque leading on this occasion and Picasso rather hesitantly following—by detaching hue from the hued object itself and redisposing the sum of hues in a more independent arrangement. And this was in turn a solution that was always to be in tension, as a cognitive compact between painter and beholder, with the Cubist ambition about volumes and masses. Then there is a problem—and the African mask that is partly responsible for it happens to be looking straight in its direction—about the residual presence of tonal relief modelling on a basis of directional lighting from the right of the picture. It is clearest in Kahnweiler's face, distinguished by a thick impasto: consider the chin or the concave right cheek *à l'africaine*. The problem of the recomposition of faces was clearly exercising Picasso in 1910. If one looks back to the *Portrait of Vollard* in the spring of 1910, the problem seems simply to have been dodged:

if one half-closes one's eyes the phenomenal Vollard jumps out like a photo-graph. Then there is a problem, which had been emerging during the summer of 1910, about the relation of scale, whether absolute or perceived, to the registration of objects. This is stated very clearly in the passage to the middle right, next to the figure. Then there is a problem about local texture. For instance, all that stippling on the periphery must have been rather uninteresting to do and is also uninteresting to see. As Kahnweiler put it—with the benefit of hind-sight—there was a question as to whether oil-paint was really the medium needed for this particular enterprise. In a year or two a range of diversifying devices, Braque again leading, were to appear—collage and papier collé, dec-orators' graining combs, sand and fine gravel mixed with the oil paint. Above all, there is a problem stated firmly in the still life in the bottom left-hand cor-ner. We know it is a still life because of where it is and because of the read-able bottle at the top. But without these clues we might as easily think it was one of the Spanish hill villages Picasso had been among that summer. The problem is about the relative authority of the immediate object of analysis, on the one hand, and the structural schemes and analytical disposition the painter had developed during a history of looking at many different objects, on the other. Much of the interest of the next years—the so-called synthetic phase—would lie in attempts to solve this.

So Picasso's painting appears as one episode in a serial performance of problem-stating and problem-solving. In this mood we are looking forwards, as it were, towards the performance. But we also have a declaration of Picasso's intention after the fact, the picture itself—or rather the fact that he stopped work on it. When someone relinquishes a piece of work as being done with, they are making a qualified statement of retrospective intention or a ret-rospective statement of intention or both. It is implicit that the work satisfies them in some degree, if only as having got to a point where it seems better to leave off and start a new work in which this or that will be better and the lessons learned in a semi-failure will be put to use. This is often a difficult moment, a pause in the serial process. A short history of European art could be written round the 'finishing' agony or Protogenes predicament, and Picasso in the Cubist years would be part of it. He was a little like the ancient crafts-man who signed his pieces not *X fecit* but *X faciebat*, the imperfect tense admit-ting no more than that he had been at work on the object. It is one of the few documentable facts about Picasso's mind in these years that he was so sensi-tive to this difficulty. *Les Demoiselles d'Avignon* was pronounced unfinished; it stated problems rather than solving them. Earlier in 1910 work had ceased on the *Girl with a Mandolin* only when the girl refused to pose any more: Picasso said afterwards that it might be just as well he had left it as it was. In 1912, when he made an agreement with Kahnweiler to sell him all his production, at prices fixed by size, the only real conditions he made were about retaining drawings still active in the serial process—'drawings I shall judge necessary for my work'—and about himself being judge of whether or not a picture was finished: *"Vous vous en remettez à moi pour decider si un tableau est terminé.'* In the paintings let go by such a careful relinquisher we have a reluctant state-ment that the intention acknowledged at that moment—not I^1 but I^{1001}—has been, not fulfilled surely, but moved towards.

The view of the picture's intention forwards—in terms of a man approaching problems of different orders—and the view backwards from the 'finishing' involve views of the intentional flux that are foreshortened, from either end. But the fact that we have two perspectives on it gives a degree of relief to the process. To put it at its simplest, we can compare before with after—'before' being in practice heavily based on previous pictures, rather as we compare the face of Vollard with the face of Kahnweiler. We infer from the comparison that the second was partly an attempt to address a problem seen in the first.

Notionally we have a similar dual access to any element within the process, even down to the level of any one brushstroke. Every brushstroke is intentional in the sense that it has been made by a man whose skills and dispositions have developed in the course of purposeful activity. The fact that a brushstroke may have been unreflectively made does not isolate it from the skills and dispositions acquired in a history of reflectively purposeful activity. The downstroke I make with my pen as I write the p in 'problem' is something I do not reflect on but it is certainly intentional. Long ago I put conscious effort into learning to write p, and into learning the purposes of doing so: if challenged on why I make this unthinking movement with my hand I could produce a purposeful reason. It is intentional in two ways: it is a disposition acquired in the course of a history of purposeful activity; and it is an action that contributes to a larger purpose—writing the word 'problem'. The intentionality of a brushstroke not reflected on is similar. At the same time the brushstroke we see in the picture lets us assume a decision that it will do, or will have to do. Even in the extreme case of an accidentally made mark—and certainly in the case of a deliberately accidental mark—if it has been left, it has been judged suitable. For an incident to be serendipitous there must be serendipity criteria, and these constitute an intention.

But in fact we do not normally attempt an account of progressive intention on this microscopic level, any more than a weather chart shows individual clouds. Weather charts, positing a developing process, say something about it in a static medium with symbols that are both conventional and generalizing. We, using words, do something a little the same. We posit $I^1{\rightarrow}I^2{\rightarrow}I^3{\rightarrow}$ $[I^4{\rightarrow}I^5{\rightarrow}]I^6{\rightarrow}$. . . rather than describe it, and we cover its interest with large approximations that generalize about the sum of intention.

Kahnweiler, Picasso and Problems

In talking of Picasso's *Kahnweiler* so unremittingly in terms of 'problems' I have been following Kahnweiler's Picasso:

> The beginning of Cubism! The first onslaught. Desperate, Titanic wrestling with all problems at once. With what problems? With the fundamental problems of painting: the representation of the three-dimensional and the coloured on the plane surface, and their comprehension within the unity of this plane surface. But 'representation' and in the strictest, highest sense. Not ['representation' as] counterfeiting of form by means of light and shade, but rather a demonstration of the three-dimensional by means of design on the plane. Not ['comprehension' as] pleasing 'composition', but rather an inexorable

articulated construction. And then the problem of colour as well, and lastly the most central and difficult point, the alloyage and conciliation of the whole.

Daringly Picasso starts to grapple with all the problems at once. He puts sharply angular images on the canvas now, heads and nude figures mostly, in the brightest colours, yellow, red, blue, black. The colours are put on in a thread-like way, to serve as lines of direction and to develop the plastic effect in conjunction with the design. After months of the most intense search Picasso perceives that the problem cannot be completely solved by following this path. . . .

Now follows a short period of exhaustion. The bruised and flagging spirit turns to problems of pure construction. A series of pictures emerges in which only the organization of the colour planes seems to have occupied the painter. Retreat from the diverse multiplicity of the physical world, to the undisturbed calm of the work of art. Indeed, soon Picasso will be in danger of reducing his art to decoration.

Already in the spring of 1908 we find him once again at work, now out to solve one at a time the tasks set him. It is necessary to start from the most important. The most important seems to him the demonstration of form, the representation on the two-dimensional plane of the three-dimensional object and its location in three-dimensional space. As he once said: 'In a painting by Raphael it is not possible to ascertain the distance between the tip of the nose and the mouth. I would like to paint pictures in which that would be possible'. At the same time the problem of comprehension—of construction— remains of course always in the foreground. On the other hand, the problem of colour is completely excluded.

Picasso's view of things in a statement—when modern artists talk about painting what they say is termed a 'statement'—of 1923 seems rather at odds with Kahnweiler:

I can hardly understand the importance given to the word *research* in connection with modern painting. In my opinion to search means nothing in painting. To *find* is the thing. . . .

Among the several sins that I have been accused of, none is more false than that I have, as the principal objective in my work, the spirit of research. When I paint, my object is to show what I have found and not what I am looking for. In art intentions are not sufficient and, as we say in Spanish, love must be proved by deeds and not by reasons. What one does is what counts and not what one had the intention of doing. . . .

The idea of research has often made painting go astray, and made the artist lose himself in mental lucubrations. Perhaps this has been the principal fault of modern art. The spirit of research has poisoned those who have not fully understood all the positive and conclusive elements in modern art and has made them attempt to paint the invisible and, therefore, the unpaintable. . . .

The several manners I have used in my art must not be considered as an evolution, or as steps towards an unknown ideal of painting. All I have ever made was made for the present.

Perhaps Kahnweiler, a reader of philosophy, did tend to intellectualize; and certainly Picasso was speaking, in 1922 or 1923, at a bad moment of disorientation and split idiom, and is also enjoying himself jibing at clichés of the

moment. But let us suppose, for the moment, that they are both describing Picasso in 1906–1912 and are both right.

There may be a danger of equivocation here. A 'problem'—practical or geometrical or logical—is normally a state of affairs in which two things hold: something is to be done, and there is no purely habitual or simply reactive way of doing it. There are also connotations of difficulty. But there is a difference between the sense of problem in the actor and in the observer. The actor thinks of 'problem' when he is addressing a difficult task and consciously knows he must work out a way to do it. The observer thinks of 'problem' when he is watching someone's purposeful behaviour and wishes to understand: 'problem-solving' is a construction he puts on other people's purposeful activity. The intentional behaviour he is watching does not always involve an awareness in the actor of solving problems. Indeed, when the observer is of a different culture from the actor—not Kahnweiler's but the historian's case, to which I shall be returning much later—he may put the construction of problem-solving on behaviour which is habitual: the culture has taught the actor the trick of solving unreflectively a problem he does not know exists. An attention to 'problems' in the observer, then, is really a habit of analysis in terms of ends and means. He puts a formal pattern on the object of his interest.

In logic one technical sense of 'problem' is the question implicit in a syllogism. 'All men are mortal and Socrates is a man, so Socrates is mortal'. The 'problem' implicit in this piece of ratiocination is: 'Is Socrates mortal?', and it is solved in the conclusion. But one could discourse in the propositional style of the syllogism without ever actually formulating the problem as a question: one frequently does. Nevertheless one would have solved the problem and an observer of one's reasoning could identify the problem as part of the underlying structure of one's behaviour. Solving it would be, for him, the end one was moving towards. The relation between Picasso and Kahnweiler is rather the same. Picasso went on as he did and 'found' conclusions, or pictures; Kahnweiler sought to understand his behaviour by formulating implicit 'problems'. To fault him for doing so would be to claim that Picasso's behaviour was undirected, and this would be difficult to sustain of any painter who liked some pictures more than others.

Picasso the participant and Kahnweiler the observer had different angles on the same events of 1906–1912. Their experience of them also came from different levels. For Picasso the Brief and the grand problems might largely be embodied in his likes and dislikes about pictures, particularly his own: he need not formulate them out as problems. His active relation to each of his pictures was indeed always in the present moment, and at the level of process and emerging derivative problems on which he spent his time. As he says, it would feel like finding rather than seeking. In a sense, since it was his pictorial dispositions that were evolving between 1906 and 1912, his painting was at any one moment almost habitual. But even to 'find' presupposes criteria of what is a find: that he was not always reflectively aware of his criteria does not mean he did not have them. And to have criteria by which one assesses one's performance is to act intentionally.

For Kahnweiler, on the other hand, the donné was a series of difficult pictures. For him each picture was a starting-point, not a conclusion of activity.

His active relation with it was as someone else's finished thing which he must understand. What to Picasso might at any moment be habitual appeared to Kahnweiler as idiosyncratic behaviour in need of understanding. Moreover his view of events was more remote, less on the level of process in the making of a single picture, more on the level of differences between one finished picture and another and the sense this gave of development. To understand all this he assumed intentionality, which meant he must think in terms of ends and means. These he inferred from the character of Picasso's pictures in comparison with other men's pictures, and also from a change he perceived in their character over time. And he verbalized ostensively and well about the construction he put on the interest of what he saw. Picasso and Kahnweiler are not so much contradictory as differently placed.

However, the particular case of Picasso and Kahnweiler is not quite so simple. That is the way of particular cases. Kahnweiler's account of Picasso is value-laden: one does surely get the impression from him that wrestling productively with fundamental problems is a good thing to do. And the culture from which Kahnweiler derives this value was one which Picasso partly shared with him. That is to say, Kahnweiler is telling us something about what was available to Picasso in the *troc*. It is impossible to believe Picasso did not pick it up.

The extraordinary thing that happened in 1906–1912 was an abrupt internalization of a represented narrative matter into the representational medium of forms and colours visually perceived. Picasso had long had some leaning towards subject-matter oddly close to the Victorian 'problem-picture': *La Vie*, for instance, but also the early idea for what became *Les Demoiselles d'Avignon* itself, with sailor, student and skull. He had also long had a leaning towards acrobats and performers in motley, often *after* performance; to himself in self-portraits; to people looking at themselves in mirrors; to strained human beings in meditative situations. In 1906–1907 these subjects practically disappeared. Instead Picasso reverted to the pure sub-narrative genres of the tradition—the nude figure, the still life, the landscape, the portrait. At the same time the earlier narrative themes were appropriated by Picasso's own performance: what he had formerly depicted on the canvas he now enacted on the canvas as an acrobatic post-dramatic, occasionally joky meditation on his own perceptual process. Above all the pictures are problem-pictures of a new and double kind. They set the beholder puzzles, for they are difficult to understand, and Picasso surely knew it. But, more to the point, they act out Picasso's own serial performance of problem-finding and problem-solving. Picasso became a cognitive acrobat of a conspicuous and dazzling kind. Kahnweiler's account of these years is both an external account of how things looked and a culturally internal account of an element in Picasso's Brief.

What makes the Cubist enterprise so enjoyable is, of course, a whole set of things. One is the dazzling talents of Picasso, and of Braque. (Braque's role makes Picasso's Cubist episode intermittently a conversation piece as well as a self-portrait.) Another is the stamina with which they sustained this epic serial performance over five years or more. Another is that Picasso fulfilled the first condition of effective 'research', which is to pick the right problems: precisely because they were beginning to emerge in his own idiom in the pre-

Cubist pictures of 1905–1906, his idiom was a medium in which they could be developed and then addressed. When he first set them out formally in *Les Demoiselles d'Avignon* it was not an arbitrary picking of pieces of apparatus on which athletically to twirl: they were *his* problems. Again, Kahnweiler was right to call them fundamental: the problems Picasso first identified in himself and then acted out are real and important problems both of pictures and of the visible world. But in the present context what is fascinating about Picasso's *Portrait of Kahnweiler* and the pictures of 1906–1912 is that the stuff of the narrative is a pattern of intention itself.

READING 32

INTRODUCTION

In "Style and Personality in the Literary Work" (1985), Jenefer Robinson, professor of philosophy at the University of Cincinnati, joins the debate opened up by Wimsatt and Beardsley's essay "The Intentional Fallacy" but she approaches it from a distinctive angle. Like Barthes, Wimsatt, and Beardsley, in denying the importance of the artist's intentions for the interpretation of his or her work, appear to push the artist a long way from center stage. Some have felt that they push the artist too far from center stage; and it is part of Robinson's project (as, in a different way, it is part of Baxandall's project) to redress this balance. In a series of persuasive reflections, Robinson argues that the style of a work of art may reveal important aspects of its creator's personality: the artist's personality is *embodied* in his or her style and in the works that exhibit that style. If she is right, then the relation between the artist and his or her work is a good deal more intimate and enduring than the arguments of Wimsatt and Beardsley, or of Barthes, might lead one to believe. Robinson's account makes the personality of the individual artist a vital component of a work of art's meaning; and it makes understanding that personality a significant goal in the interpretation of an artist's work.

Style and Personality in the Literary Work

Jenefer Robinson

In this paper I want to describe and defend a certain conception of literary style. If we look at literary style in the way I shall suggest, it will explain many of the problems that surround this elusive concept such as why something can be an element of style in the work of one author and not in another, what the difference is between individual style and general style, and how style differs from "signature." The ordinary conception of style is that it consists of nothing but a set of verbal elements such as a certain kind of vocabulary, imagery, sentence structure and so on. On my conception, however, a literary style is

rather a way of *doing* certain things, such as describing characters, commenting on the action and manipulating the plot. I shall claim that an author's way of doing these things is an expression of her personality, or, more accurately, of the personality she seems to have. The verbal elements of style gain their stylistic significance by contributing to the expression of this personality, and they cannot be identified as *stylistic* elements independently of the personality they help to express.

Many theorists and critics have written as if style were an expression of personality. A good recent example is an essay on the first paragraph of Henry James' novel *The Ambassadors,* in which the writer, Ian Watt, claims that

> the most obvious and demonstrable features of James' prose style, its vocabulary and syntax, are direct reflections of his attitude to life and his conception of the novel.[1]

Watt lists some of the most notable elements in James' style: the preference for "non-transitive" verbs, the widespread use of abstract nouns, the prevalence of the word "that," the presence of "elegant variation" in the way in which something is referred to, and the predominance of negatives and near-negatives. Then Watt proceeds to show how these stylistic elements are expressive of James' *interest* in the abstract, his *preoccupation* with what is going on in the consciousness of his characters and his *attitude* of humorous compassion for them.

This essay is an attempt to explain and justify the assumption of Watt and others like him that style is essentially an expression of qualities of mind, attitudes, interests and personality traits which appear to be the author's own. My thesis is a thesis about what Richard Wollheim calls "individual style" and not about the style of periods or of groups of writers within a period.[2] I do not want to suggest that the unity of period or group styles, such as the Augustan style, can be explained in terms of the "personality" of a group or period. One other point should be mentioned. I believe that my remarks apply equally well to the non-literary arts, but for reasons of space I shall not attempt to justify this claim here.

Style as the Expression of Personality

In this first section I shall argue that style is essentially a way of doing something and that it is expressive of personality. Further, I shall suggest that what count as the verbal elements of style are precisely those elements which contribute to the expression of personality.

Intuitively, my style of dress, work, speech, decision-making and so on is the mode or manner or way in which I dress, work, speak and make decisions. In short it is the way I *do* these things. In ordinary contexts, then, a style is

[1]Ian Watt, "The first paragraph of *The Ambassadors:* an explication," reprinted in *Henry James,* ed. Tony Tanner (London: Macmillan, 1968), p. 301.
[2]See Richard Wollheim, "Pictorial Style: Two Views," in *The Concept of Style,* ed. Berel Lang (Philadelphia: University of Pennsylvania Press, 1979), pp. 129–145. My chief debt in this paper is to Wollheim, whose remark that style has "psychological reality" provided its initial stimulus.

always a way of *doing* something. No less intuitively, my style of dressing, working, speaking and making decisions is typically an *expression* of (some features of) my personality, character, mind or sensibility. Thus my vulgar way of dressing is likely to be an expression of my vulgar sensibility, my witty, intellectual way of speaking an expression of my witty, intellectual mind, and my uncompromisingly courageous way of making decisions an expression of my uncompromisingly courageous character.

In saying that a person's way of doing things is an *expression* of that person's traits of mind, character or personality, I am saying (1) that the person's way of doing things exhibits or manifests these traits, and (2) that it is these traits which cause the person to do things in the way she does. Thus these traits leave a matching imprint or trace upon the actions which express them. If my timid way of behaving at parties is an expression of my timid character, then (1) my behavior exhibits or manifests timidity—I behave in a manifestly timid fashion, blushing, refusing to talk to strangers, hiding in the washrooms, etc.—and (2) my timid behavior is caused by my timid character, i.e., it is not due to the fact that (say) I am pretending to be timid, imitating a timid person or acting the part of a timid person in a play, nor is it the result of secret arrogance and contempt for parties. In general, if a person's actions are an expression of her personality, then those actions have the character that they have—compassionate, timid, courageous or whatever—in virtue of the fact that they are caused by the corresponding trait of mind or character in that person, compassion, timidity or courage. In expression, as the word itself suggests, an "inner" state is expressed or forced out into "outer" behavior. An "inner" quality of mind, character or personality causes the "outer" behavior to be the way it is, and also leaves its "trace" upon that behavior. A timid or compassionate character leaves a "trace" of timidity or compassion upon the actions which express it.[3]

Just as a person's style of dressing, working and speaking is the mode or manner or way in which she dresses, works and speaks, so an author's style of description, character delineation and treatment of a theme is the mode or manner or way in which she describes things, delineates character and treats her theme. In other words, it is her way of *doing* certain things, such as describing or characterizing a setting, delineating character, treating or presenting a theme, and commenting on the action. Moreover, the writer's way of describing, delineating, commenting and so on is typically an *expression* of (some features of) her personality, character, mind or sensibility. Thus James' humorous yet compassionate way of describing Strether's bewilderment expresses the writer's own humorous yet compassionate attitude. Jane Austen's ironic way of describing social pretension expresses her ironic attitude to social pretension.

Now, a style is not simply a way of doing something. We do not say that a person has a *style* of doing so-and-so unless that person does so-and-so in a

[3]See especially Richard Wollheim, "Expression," in Royal Institute of Philosophy Lectures, Vol. I, 1966–1967, *The Human Agent* (New York: St. Martin's Press, 1968), and *Art and Its Objects* (2nd edition; Cambridge: Cambridge University Press, 1980), sections 15–19. See also Guy Sircello, *Mind and Art* (Princeton: Princeton University Press, 1972).

relatively consistent fashion. Thus we say I have a vulgar and flamboyant *style* of dressing only if I consistently dress in a vulgar and flamboyant way. It may be, of course, that my way of dressing differs considerably from one day to the next: yesterday I wore a purple silk pyjama suit, today I am wearing a frilly scarlet mini-dress and tomorrow it will be leather dungarees and a transparent blouse. Despite these differences, however, we still say that I have a consistent way of dressing, because all my outfits are consistently vulgar and flamboyant. Moreover, my style of dressing is expressive of a particular feature of my personality, namely vulgarity and flamboyance. In an exactly similar way, we say that Jane Austen has a *style* of describing social pretension, because she consistently describes social pretension in an *ironic* way and the way she describes social pretension is expressive of a particular feature of her outlook, namely her irony.

So far I have talked only about a person's style of doing a particular thing, such as dressing. By contrast, when we say that a person has "a style," we normally mean that he or she has the same style of doing a number of different things. Thus when we accuse John of having a vulgar and flamboyant style, we may be referring to the vulgar and flamboyant way in which John not only dresses but also talks and entertains his dinner guests. Again, in characterizing Mary's style as generous, open, casual and easy-going, we may mean that Mary is generous, open, casual and easy-going in almost everything that she does. In this case Mary's style is expressive not of a single trait but of a number of traits which together "sum up" Mary's personality.

In just the same way, a person's literary style is their style of performing a wide range of (literary) activities. Thus, clearly, Jane Austen's style is not simply her style of doing any one thing, such as describing social pretension, but rather her style of doing a number of things, such as *describing, portraying* and *treating* her characters, theme and social setting, *commenting* on the action, *presenting* various points of view, and so on. In short, to borrow a concept from Guy Sircello, it is the way in which she performs the various "artistic acts"[4] which constitute the writing of a literary work. Now, a style of doing a wide range of things is just like a style of doing a particular thing in that it consistently expresses certain features of the mind, personality, etc., of the agent. We say that Mary has "a style" in virtue of the consistently generous, open, casual and easy-going way in which she does a number of different things. Similarly, a writer has a literary style in virtue of the fact that her style of performing a wide variety of artistic acts expresses the same qualities of (her) mind and temperament. For example, James' style of *treating* Strether, of *portraying* the difference between what Strether thinks of Waymarsh and what he thinks he thinks, of *emphasizing* the abstract and the timeless, of *commenting* on Strether's bewilderment and so on together constitute what we call "James' style." And this style owes its coherence to the fact that all these artistic acts express the same set of attitudes, interests and qualities of mind.

Of course, not every artistic act of a writer in a particular work expresses exactly the same qualities of mind, character or personality. In *Emma*, for exam-

[4]Guy Sircello, "Expressive Properties of Art," reprinted in this volume. I am not sure whether Sircello would approve of the use to which I put the concept of artistic acts.

ple, Jane Austen portrays Mrs. Elton in a quite different way from Jane Fair-
fax. This is because Jane Austen's attitude to Mrs. Elton is quite different from
her attitude to Jane Fairfax. In the one portrayal she expresses (among other
things) her love of the ridiculous, and in the other she expresses (among other
things) her compassion for suffering sensibility. But Jane Austen's way of por-
traying Mrs. Elton and her way of portraying Jane Fairfax, as well as her way
of portraying the other characters in the novel, her way of describing their per-
sonal relationships, her way of developing the plot, and all the other innu-
merable artistic acts which go into writing the novel *Emma* together add up to
the style in which *Emma* is written, a style which expresses all those attitudes
that together form the personality of the author of *Emma*.

If a writer has an individual style, then the way she writes has a certain
consistency: the same trials of mind, character and personality are expressed
throughout her work. Now, at a particular point in a novel, the writer may
seem to express anxiety about, anger at or contempt towards a particular char-
acter, event or idea, although the writer does not seem to be a chronically anx-
ious, angry or contemptuous sort of person. However, such "occasional" prop-
erties should not be thought of as properties of style. Only those properties
which are "standing" or long-term properties can be considered stylistic. Thus
stylistic qualities are likely to be qualities of mind, moral qualities and deep-
seated character traits, rather than mood or emotional qualities such as
"angry," "joyful" and "afraid." In the same way, we do not treat every angry,
joyful or fearful action performed in real life as an expression of basic charac-
ter or personality; it is only when someone consistently acts in a choleric or a
cheerful way, that we infer to her essentially choleric or cheerful nature.

I have argued that a literary style is a way of performing "artistic acts,"
describing a setting, portraying character, manipulating plot and so on, and it
is the writer's way of performing these acts which is expressive of all those
standing traits, attitudes, qualities of mind and so on that together form her
personality. What, then, is the relation between the performance of these acts
and what have traditionally been thought of as the verbal elements of style,
such as a certain vocabulary, imagery and sentence structure? When a writer
describes a setting and portrays character, she uses words, and the kind of
word she uses, the sort of sentence structure she forms and so on together con-
stitute the elements of verbal style. If a writer manipulates his theme from the
point of view of one whose main interest is in thought and the development
of consciousness (James) or if she portrays her characters with a judicious mix-
ture of irony and compassion (Austen), then he or she does so by using lan-
guage in certain ways.

Obviously the presence of certain verbal elements does not *entail* that a
particular personality is being expressed.[5] If, however (on a reasonable inter-
pretation), those verbal elements are being used by a writer to perform artis-
tic acts in a particular way, then we can infer from the way the acts are per-
formed to characteristics of the writer's mind, character and personality. For
example, Henry James uses negatives, abstract nouns, etc., in order to describe
Strether's state of consciousness, to comment on Strether's bewilderment and

[5]See Frank Sibley, "Aesthetic Concepts," reprinted in this volume.

to characterize Strether's attitude to Waymarsh, and he thereby expresses qualities of his own mind and personality.

Moreover, negatives, abstract nouns, non-transitive verbs, elegant variation and so on are verbal elements which at first sight seem to have nothing in common. What links them all together, however, as elements of "James' style" is their use in the artistic acts James performs: they are all elements of his style because they all contribute to the expression of his personality and attitudes. For example, using these particular verbal elements, James thereby describes Strether's state of consciousness in a particular judicious, abstractive, expository way and thereby expresses his own "subjective and abstractive tendency,"[6] his interest in the relations between minds (Strether's, the narrator's, the reader's), his moral sensitivity and his cool and judicious intellect.

The Personality of the Implied Author

So far in this essay I have written as if the personality expressed by the style of a work were that of the writer herself. I have suggested that we infer from the way in which the writer performs the artistic acts in a work to the presence of personality traits and so on *in the writer* which cause her to perform those acts in the way that she does. But this is an oversimplification. What is more typically expressed by the style of a work is not the personality of the actual author, but of what, following Wayne Booth, we might call the "implied author,"[7] that is, the author as she seems to be from the evidence of the work. Thus however querulous and intolerant the actual Tolstoy may have been in real life, the implied author of *Anna Karenina* is full of compassionate understanding.

Because the way in which people act typically expresses features of their minds, attitudes and personalities, we are justified in making inferences from the way in which people perform actions to the presence in them of certain character or personality traits. If we see Mary constantly acting in a generous and compassionate way, then, barring any evidence to the contrary, it is reasonable to infer that Mary has a generous and compassionate nature which is responsible for her generous and compassionate actions.[8] The situation is more complicated, however, when we are considering acts performed by an author in the composition of a literary work. Although it may sometimes be legitimate to infer from the way these acts are performed to personality traits in the actual author, it is normally the case that the personality expressed by

[6]Watt, "The first paragraph of *The Ambassadors*," p. 291.

[7]Wayne Booth, *The Rhetoric of Fiction* (Chicago: University of Chicago Press, 1961), especially pp. 70–77. Kendall Walton has developed the related, but more general notion of an "apparent artist" in his paper "Points of View in Narrative and Depictive Representation," *Nôus* 10 (1976), pp. 49–61, and elsewhere. Walton's own theory of style, in which the idea of the "apparent artist" plays an important role, is to be found in "Style and the Products and Processes of Art," in *The Concept of Style*, ed. Berel Lang (Philadelphia: University of Pennsylvania Press, 1979).

[8]What "having a compassionate nature" means is a large question: presumably at the least it involves having certain beliefs and desires and being prone to certain kinds of behavior. For a discussion of compassion, see Lawrence Blum, "Compassion," in *Explaining Emotions*, ed. Amelie Rorty (Berkeley: University of California Press, 1980).

the style of a literary work is not that of the actual author but that of the implied author.

 This might sound as if the author were trying to mislead us. After all if in real life it turns out that Mary's generous and compassionate actions are entirely due to her desire to impress John, then we might well accuse her of deceiving us—or at least John—about her true nature. She seems to be a generous and compassionate person but in fact is not. However, the situation is significantly different in the literary case. It is, after all, a commonplace convention of fiction-writing that the author more or less consciously "puts on" or "adopts" a persona to tell "her" story, but normally at any rate the author is not thereby trying to deceive us into believing that this assumed persona or personality is her own.[9] When we make inferences from the way the artistic acts in a work are performed to the personality of this implied author, the "person" who seems to be performing these acts, we are aware that the personality which leaves its "trace" on the way those acts are performed is a personality created and adopted by the author and which may be different from that of the author herself.[10] Thus, as Booth points out, even the implied author of *Emma* does not have all her qualities in common with the real Jane Austen. Both are wise, witty, unsentimental and so on, but the implied author of *Emma* has a moral perfection beyond the scope of the real Jane Austen.[11]

 Some literary works deliberately exploit a number of different styles. A good example is James Joyce's *Ulysses*. In this case the style of at least some of the different episodes of the book should be identified with the style not of the implied author "James Joyce" but of the narrator of that episode. The personality expressed by the style of the Cyclops episode, for example, is not the personality which the author seems to have; the coarse and unpleasant personality expressed belongs only to the nameless narrator of the episode. Notice, however, that this kind of case is parasitic upon the normal case: it is because a style is normally an expression of the personality of the writer that we infer from the style of the Cyclops episode to the presence of a coarse and unpleasant person writing or narrating it.[12]

[9]It is not appropriate for me to argue here for any general thesis about the correct way to interpret literary texts, but it is interesting to notice that my view that style is the expression of personality fits very nicely with a plausible theory of critical interpretation recently defended by Alexander Nehamas ("The Postulated Author: Critical Monism as a Regulative Ideal," *Critical Inquiry* 8 (Autumn, 1981), pp. 133–149. In his words,

> To interpret a text is to consider it as its author's production. Literary texts are produced by agents and must be understood as such. . . . And since texts are products of expressive actions, understanding them is inseparably tied to understanding their agents.

Here Nehamas uses the word "author" to mean "implied author." His claim is that a text must be read as an expression of the attitudes and so on of the implied author. Of course it could turn out that Nehamas is wrong and the correct way to read literary texts is as the expression of attitudes in the actual author. My thesis can accommodate either view.

[10]Compare the way in which actors "adopt" the personality which they express.

[11]See Booth, *The Rhetoric of Fiction*, p. 265.

[12]Compare *Tristram Shandy* which is written in Tristram's (the narrator's) style. The implied author seems to have a personality much like that of Tristram, but he is distinct from Tristram and appears from time to time to correct Tristram's opinions in helpful footnotes.

Does it make sense to talk about "the style" of *Ulysses?* In a way it does not, because *Ulysses* contains so many different styles (some of which are not even "individual" styles).[13] Nevertheless, we can identify an implied author of *Ulysses* and detect the way in which he appears to *manipulate* the narrative point of view, *treat* the *Ulysses* theme, *characterize* Molly Bloom, etc. The way these artistic acts are performed is part of *the style of Ulysses.* For example, the presence of many different narrators with different styles is itself a feature of *Joyce's* style and it is expressive of certain traits that Joyce seems to have, such as a boisterous creativity, a delight in the expressive capacities of language and an interest in the way reality can be viewed and reported from so many different points of view.[14]

One of the ways in which we identify "Joyce's style" is by looking at Joyce's oeuvre as a whole. Thus we may be inclined to see the style of the early Stephen episodes in *Ulysses* (as opposed to, say, the Cyclops episode) as in "Joyce's style" partly because they are in somewhat the same style as other works by Joyce, notably *A Portrait of the Artist.* The style of an oeuvre, just like the style of an individual work, is an expression of the personality of the implied author of that oeuvre. Just as we sometimes find a variety of styles in a single work (like *Ulysses*), so it is possible to find in a single oeuvre a variety of styles corresponding to radically different implied authors. But in the normal case the implied author of different works in a single oeuvre is recognizably the "same person." Of course no two works do or even can express exactly the same personality, but there will normally be striking similarities. Typically, the personality expressed by an author's style matures over time. Thus the implied author of Jane Austen's books becomes less acerbic in her wit, more compassionate and tender;[15] the implied author of Henry James' works becomes ever more complex, subtle and abstract in his thinking and moralizing. A style grows and matures with the personality it expresses.

An Objection Considered

My thesis has been that the defining feature of a literary work which has an individual style is that the work is an expression of the personality of the implied author,[16] and that what links the diverse verbal elements of style together into a coherent whole is that they all contribute to the expression of this particular personality. One objection to this thesis is that there are many qualities of a work which *prima facie* are qualities of its style but which do not seem to express any qualities of mind or personality in the implied author. In particular, there are formal qualities (euphonious, Latinate, colloquial, ornate)

[13]See, for example, *The Oxen of the Sun* episode.

[14]Notice that plays can have individual style despite the fact that they contain many different "voices."

[15]However, the implied author of the late fragment *The Watsons* may seem less mature than the implied author of *Persuasion.*

[16]From now on I shall write as if the personality expressed by the style of a work were that of the implied author, because typically this is the case. However the implied author may sometimes have all his or her properties in common with the actual author. Moreover, as I have already noticed, in some cases the personality expressed is that of the narrator.

and expressive qualities (dramatic, heroic, violent) which may be attributed to the style of a work but which are not (or need not be) qualities of the implied author's mind or personality.

In this section of the paper I shall argue that such formal and expressive qualities are not always qualities of the individual style of a work, and that when they are it is only because they contribute to the expression of qualities of mind, personality, etc. in the implied author. Among works which possess striking formal or expressive qualities (euphony, violence, etc.), I distinguish three sorts of case: (1) works which have such properties but lack style altogether, (2) works which have such properties and also belong to a general style category but which lack individual style, and (3) works which have such properties and which also possess individual style.

(1) Intuitively, there could be a piece of characterless prose which nevertheless happens to be *euphonious*, i.e., the words it contains make a pleasing musical sound. Imagine, for example, an incompetent Freshman English paper in which the ideas are unclearly expressed, the sentence structure confused and the choice of words unimaginative. No one reading the paper would attribute to it an individual style. Yet, quite by chance, the ill-chosen words are euphonious: l's, m's and n's predominate, there are only a few plosives or fricatives, and the vowel sounds fit together in a melodious way. To say that this work is in a "euphonious style," however, is at best misleading, since intuitively it is not in a style at all. The possession of just one striking formal quality, such as euphony, is not normally sufficient to endow a work with style. Indeed even a string of nonsense syllables may be euphonious, although presumably they cannot be in a style. Hence euphony does not always contribute to individual style, just because it may be a quality of a work that lacks style altogether. On my view, of course, a euphonious work that lacks individual style is a euphonious work which fails to express any individual personality in the implied author.

(2) A more interesting situation arises when a work is in a "euphonious style" in the sense that it belongs to what Wollheim calls a "general" style category, although it does not possess *individual* style. General style categories, such as period or school styles, group together writers, painters or other artists who seem to the critic and historian to have important characteristics in common, for example, the Elizabethan pastoral lyric style or the style of the school of Donne (the Metaphysical style). To belong to a general category of literary style often involves obeying certain conventions and using certain techniques. Thus the style of Elizabethan pastoral love lyrics demands a certain stylized way of referring to the lover and the beloved, of describing their surroundings and so on. The imagery and the poetic forms employed all fall within a fairly narrow and predictable range. More importantly for my present argument, membership in a particular general style category often requires a work to have certain formal and expressive qualities. Thus the style of an Elizabethan pastoral love lyric is supposed to be charming and euphonious, the Metaphysical style colloquial and dramatic, and the Miltonic epic style (i.e., the style of works which imitate *Paradise Lost*) Latinate and heroic.

Now, intuitively, there is a distinction between merely belonging to a general style category and having a formed individual style. For example,

although a poem must be (somewhat) colloquial and (somewhat) dramatic in order to count as a Metaphysical poem at all, it does not follow that every minor lyric by Carew or Suckling has an individual style. Indeed we may often be hard-pressed to distinguish between the lesser works of Carew and Suckling, just because they do lack "individuality." Similarly, many of the poems in the collection *England's Helicon* obey all the requirements of the Elizabethan pastoral lyric style and yet remain "characterless." They are charming and euphonious but they have an anonymous air about them: they do not seem to have been written by anyone in particular. In short, a work which belongs to a general style category may have certain striking formal or expressive qualities even though it lacks individual style. An Elizabethan love lyric may be euphonious, a Metaphysical poem dramatic, a Miltonic epic Latinate without necessarily being in an individual style.

One of the merits of my theory of style is that it allows us to define and explain this intuitive distinction between individual and general style. On my view, the crucial difference is that whereas having an individual style necessarily involves the expression of personality in the implied author, belonging to a general style category has no such implications. Elsewhere[17] I have argued for this position in much greater detail than is either possible or appropriate here. If I am right, however, it follows that there can be works belonging to a general style category which possess the formal and expressive qualities characteristic of that style but which do not express any individual personality in the implied author. Hence these formal and expressive qualities, although qualities of general style, do not contribute to any individual style in the work just because they do not contribute to the expression of an individual personality in the implied author of the work.

(3) Finally, formal and expressive qualities such as "Latinate," "euphonious" and "dramatic" may be qualities that are present in works of individual style and which do contribute to the expression of personality in those works. It does not follow, however, that the implied author is a Latinate, euphonious or dramatic sort of fellow. These qualities in themselves do not express any particular trait in the implied author. Rather they can help to express many diverse traits, depending upon the artistic acts to which they contribute. In a similar way, Henry James' fondness for negatives does not in itself express any feature of "his" personality; it is the way the negatives are used in the performance of artistic acts, such as describing Strether's state of mind, which gives this feature of James' work its stylistic significance.

The quality of euphony, for example, may indeed contribute to individual style, but it does so by contributing to the expression of individual personality in a work. Consequently the contribution it makes is very different in different works. Both Swinburne's "Garden of Proserpine" and large passages of

[17]"General and Individual Style in Literature," *The Journal of Aesthetics and Art Criticism*, 43 (1984). I argue there that if a work belongs to a general style category, such as a school or period style, then it obeys certain rules and observes certain conventions, some of which undoubtedly foster certain kinds of formal and expressive properties. However, it is possible to write works which belong to a general style category and succeed to some extent in achieving the formal and expressive goals of that category without thereby expressing an individual personality in the implied author.

Milton's "Paradise Lost" can be described as euphonious, but the personalities expressed in the individual style of these two works are very different. In the Swinburne poem the gentle, musical sounds help to express the implied author's sense of world-weariness, melancholy and resignation,[18] whereas the famous Miltonic melody generally serves to help express the implied author's sense of the dignity and grandeur of his theme. To say that both works are in a "euphonious style" means simply that euphony is a formal quality of both works, which in both cases contributes to individual style. The way it contributes, however, is quite different in the two cases. Similarly it could be argued that both Jane Austen and Donne have *dramatic* styles, but clearly the dramatic qualities in each help to express quite different personalities and hence contribute quite differently to the styles of each.[19]

In summary then, the formal and expressive qualities I have been discussing are not always qualities of the individual style of a work: they may be present in works lacking any style at all or in works which belong to a general style category but do not have individual style. Moreover, even when such qualities contribute to the individual style of a work, they do so in very different ways. The "same" quality in two different works may contribute to the expression of quite different traits of mind and personality in the implied authors of those works.

There are two interesting corollaries of my discussion. First, it would seem to follow that no verbal element or formal or expressive quality in a work is always and inevitably an element or quality of individual style. Even such qualities as "euphonious" and "Latinate" do not contribute to individual style wherever they appear, and even when they do contribute to individual style, they do so in virtue of how they are used in the artistic acts in the work. Secondly, it would also seem to follow that *any* verbal element or formal or expressive quality in a work *can* be an element or quality of individual style, provided it contributes in the appropriate way to the expression of personality in the implied author.

In short, if my thesis is correct, then there is no "taxonomy" or checklist of style elements, that is, elements which contribute to individual style wherever they appear.[20] Euphony, Latinate diction and the presence of many negatives are elements of individual style only if they are used in such a way as

[18]There go the loves that wither,
 The old loves with wearier wings;
 And all dead years draw thither,
 And all disastrous things.

[19]Sometimes a writer performs the artistic act of "expressing" some quality in the external world, as when she, for example, "expresses" the violence of a battle or the fragility of an elf. Again, however, it is not the violence or fragility themselves which contribute to style, but the way in which violence or fragility is "expressed" (in this sense) by the writer. Thus one woman may "express" the violence of a battle with gusto, thereby expressing "her" enjoyment of fast-moving action and enthusiasm for heroic exploits, whereas another may "express" the violence with cool detachment, thereby expressing "her" ironic awareness of human folly. For further discussion of this issue, see Guy Sircello, *Mind and Art*, Chapter 4, and my "Expressing the Way the World Is," *Journal of Aesthetic Education* 13 (1979), pp. 29–44.

[20]cf. Richard Wollheim, "Pictorial Style: Two Views." It is possible that there are taxonomies for *general* style categories, unlike individual style.

to contribute to the expression of traits of mind and personality in the implied author.

We cannot, therefore, identify the elements of individual style merely as the most striking or salient features of a work. On the one hand there are striking features which do not invariably contribute to individual style. I have argued that euphony, for example, may be a striking feature of works which lack individual style. Again, it would be a striking feature of a work if all the proper names in it began with the letter "X," yet intuitively this would not be a feature of its *style* (although it could be if, for example, it were used to express the implied author's sense of fun).

On the other hand, moreover, there are many elements which are not particularly salient but which contribute to individual style. Thus a certain writer who has a formed individual style may have a preference for the indefinite article over the definite which contributes in a small way to the expression of her generalizing imagination and tendency to abstraction. Again, any careful, sensitive reader of *The Ambassadors* can tell that James tends to "interpolate" elements in his sentences, but we may not notice that the interpolations typically occur between verb or adjective and complement, or between auxiliary and main verb, and that they cluster towards the center of a sentence.[21] Yet it is non-salient elements such as these which contribute significantly to James' style, because they all help to express "James' " characteristic attitudes, inter-
.ests and qualities of mind and personality.

Some Problems Resolved

I have argued that if a literary work has an individual style, the artistic acts in the work are performed in such a way as to express qualities of mind, attitudes, personality traits, etc., which make up the individual personality of the implied author of the work. The verbal elements of (individual) style are those elements which contribute to the expression of this personality. There is no "checklist" of elements or qualities which inherently or intrinsically contribute to individual style, no matter where they appear.

So far I have merely tried to make my thesis seem reasonable and to forestall some possible objections to it. In this final section I should like to make some more positive remarks in its favor. The best reason for accepting my theory is that it answers an array of difficult questions surrounding the concept of style.

(1) First, my theory explains why a correct description of a writer's style mentions some of its verbal characteristics but not others. On my view, what count as the elements of a style are precisely those verbal elements which contribute to the expression of the implied author's personality. In Henry James,

[21]See Seymour Chatman, *The Later Style of Henry James* (Oxford: Blackwell 1972), pp. 126–127. Chatman's book contains many more examples of non-salient (as well as salient) verbal features that are important to James' style. In his comparison between a successful parody of James' style (by Max Beerbohm) and a rather unsuccessful one (by W. H. D. Rouse), Chatman shows how Beerbohm incorporates into his parody many features of James' style which were obviously not salient to Rouse.

for example, the relevant verbal elements include the recurrent use of non-transitive verbs, abstract nouns, negatives and the word "that." These all help to contribute to the expression of "James" personality. But we could, no doubt, if we searched for them, discover many recurrent elements in James' work which are not stylistically significant. Thus perhaps it would turn out that James had a penchant for nouns beginning with the letter "f" or that his sentences invariably had an even number of words in them. A description of James' style would not mention these elements, however, precisely because they do not contribute to the expression of the personality of the implied author. In short, many quite diverse and seemingly unrelated verbal elements belong to the same style in virtue of the fact that they all contribute to the expression of the same personality. It is only if the frequent use of nouns beginning with the letter "f" can be shown to contribute to this personality that this particular verbal characteristic would be an element of style.

(2) For similar reasons, my theory explains why it is that the same verbal element may have stylistic significance in one work or author and no stylistic significance, or a different significance, in another work or author. For the same stylistic element may play no expressive role in the one case and an important role in the other. Alternatively, it may simply play different expressive roles in the two cases. Suppose, for example, that two writers tend to use the indefinite article rather than the definite. In one writer, who has a formed individual style, this may contribute to the expression of her generalizing imagination and tendency to abstraction. In the other writer, it may be an accident and it may have no expressive effect in the work, or perhaps it indicates a lack of strength and precision in the style. In the first writer we have located the presence of a stylistic element; in the second writer the same element has no stylistic significance or a different one. If we were to view a person's style as consisting of a set of elements which we can check off on a checklist, then it would make no sense to say that a particular element is sometimes stylistic and sometimes not. But if we view style as a function of the literary personality expressed by a work in the way I have suggested, then the problem dissolves.

(3) It is commonly believed that if a writer or a work has an individual style, this implies that the various stylistic elements have a certain unity. Yet there are no intrinsic connections among the features of James' style, for example: why should negatives, abstract nouns and "elegant variation" go together to form a unified style? My theory explains in a clear way what stylistic unity amounts to: a style has a unity because it is the expression of the personality of the implied author. Just as we see the way a person performs the various actions of daily life as expressive of different facets of her personality, so we see the way in which a writer seems to perform the various artistic acts in a literary work as expressive of different facets of "her" personality. The many disparate elements of verbal style fit together only because they are being used to express the "same" personality: the writer uses the elements of verbal style to describe her characters, treat her theme, etc., thereby seeming to reveal a set of personality traits, qualities of mind, attitudes and so forth which "makes sense" out of (unifies) this multitude of artistic acts.

The question arises as to whether this set of "standing" traits forms a coherent personality. The concept of a "unified" or coherent personality is admittedly somewhat vague, since the most disparate and apparently inconsistent psychological traits seem capable of coexisting in normal, rational people.[22] All I need to insist on, however, is that if a work has an individual style then the different traits expressed by the various artistic acts in the work (portraying Jane Fairfax, characterizing Emma's treatment of her father, etc.) coexist in a way which is consistent with our knowledge of persons and human nature. Moreover, the same traits must be consistently expressed throughout a work. Thus the implied author of *Le Rouge et le Noir* both admires and despises the aristocratic world to which Julien Sorel aspires, but because he does so consistently and because the conflict in his attitudes is one which we recognize as possible in a basically rational person, his admiration and scorn are both part of the personality expressed by the style of the work.[23] If however, a work expresses no individual personality at all or if the personality expressed is a confusion of different traits which do not fit together in an intelligible way, then it follows from my thesis that the work in question lacks individual style.[24]

(4) It used to be a commonplace of literary theory that the subject-matter of a text is *what* the writer writes about, whereas the style is *how* she writes about it. This distinction has recently been questioned by several writers, including Nelson Goodman who argues that

> some differences in style consist entirely of differences in what is said. Suppose one historian writes in terms of military conflicts, another in terms of social changes; or suppose one biographer stresses public careers, another personalities.[25]

The theory of style which I have outlined in this essay accounts for the intuition that sometimes features of subject-matter may be stylistic features and explains which features of subject-matter will count as stylistic and why. Briefly, a feature of subject-matter is of stylistic relevance just in case it is expressive of the implied author's personality. Thus it is reasonable to construe the subject-matter of *The Ambassadors* as the development of Strether's consciousness. In this case the choice of subject-matter is clearly of stylistic relevance. Again the differences in the histories and biographies envisioned by Goodman are clearly differences in the personalities of the implied authors of these works.

[22]See the work on emotions by Amelie Rorty, "Explaining Emotions," and Patricia Greenspan, "A Case of Mixed Feelings: Ambivalence and the Logic of Emotion," both in Rorty, ed., *Explaining Emotions.*

[23]Lee Brown brought this example to my attention.

[24]If for example, *for no apparent reason,* an author describes a certain character with unqualified approval in chapters 1, 3 and 5 and with a certain kind of qualified disapproval in chapters 2, 4 and 6, then it might be that the implied author is schizophrenic or, more likely, simply a confused creation.

[25]Nelson Goodman, "The Status of Style," *Critical Inquiry* 1 (1975), p. 801. Goodman's explanation for this fact is different from mine, however.

(5) My theory also has a satisfying explanation for the difference between what Goodman calls "style" and "signature." A "signature" is anything which identifies a work as being by a particular author, school, or whatever, such as an actual signature. A "signature," however, may have no stylistic significance. Goodman says:

> Although a style is metaphorically a signature, a literal signature is no feature of style.[26]

It is true that a style, like a "signature," may *identify* a work or an author, but the way it performs the identification is quite different. A "signature" may have nothing to do with the qualities of the implied author expressed by a work. Perhaps it is an actual signature or perhaps some other convention is used: a writer might be uniquely identifiable by the particular Latin tag which appears at the head of all her books, regardless of their subject-matter or style (if any). A style, on the other hand, identifies a work or an author because it is an expression of a set of attitudes, qualities of mind, character traits and so on which are unique to the implied author of that work or oeuvre.

(6) Finally, as I have already remarked, one of the virtues of my theory is that it allows me to clarify the distinction between general and individual style.[27] If a work belongs to a general style category, then, although it may have formal and expressive qualities that are distinctive of that style, it may nevertheless remain "characterless": no personality "informs" the work. Alternatively, there may be personality traits expressed but they do not seem to belong to any particular individual. The work has an "anonymous" air about it, because the artistic acts are performed in a way which is common to a large number of different writers.[28] By contrast, as I have argued throughout this paper, the defining quality of an individual style is that it expresses a coherent set of attitudes, qualities of mind and so on which seem to belong to the individual writer of the work: a work which has an individual style expresses the personality of the implied author of that work.[29]

[26]Goodman, "The Status of Style," p. 807.

[27]See also my "General and Individual Style in Literature."

[28]There are some general style categories such as the heroic epic, in which individual style is rarely found and might even be deemed inappropriate. The Homeric epics, however, do seem to contain passages that have individual style. It is interesting to note that the argument over the authorship of the *Iliad* is partly an argument about style and personality in the work. Those parts of the *Iliad* which have individual style provide a strong argument for scholars who wish to argue that there was one central author of the *Iliad* (call him "Homer") even though parts of it had been handed down by an oral tradition. By contrast, scholars who argue that there were a number of bards who contributed importantly to the creation of the *Iliad* point to the fact that there is no individual style to the *Iliad* as a whole. Interestingly, both sets of experts seem implicitly to grant the connection between individual style and an individual personality which is expressed in the style. For an introduction to the problem of multiple authorship in the *Iliad*, see E. R. Dodds, "Homer," in *The Language and Background of Homer*, ed. G. S. Kirk (Cambridge: Cambridge University Press, 1964), pp. 1–21.

[29]Many people have helped to improve this paper. I am particularly indebted to Lee Brown, Ann Clark, John Martin, Francis Sparshott, Kendall Walton, Richard Wollheim and the editors and referees of *The Philosophical Review*. I am also grateful to Berel Lang whose NEH Seminar on the Concept of Style aroused my interest in this topic.

READING 33

INTRODUCTION

In "Is There a Text in This Class?" (1980), Stanley Fish, professor of literature at Duke University, argues that sentences such as the one in his title have the meanings that they do in virtue of the contexts in which they are understood. The intentions of the speaker, that is, do not fix the meaning of an utterance. Furthermore, he says, contexts can be ambiguous: In any given situation, a sentence may properly be understood in more than one way. What are the implications of this for the interpretation of artworks? The prime implication, according to Fish, is that it makes no sense to claim that any artwork has a single determinate meaning (for instance, one fixed by the artist's intention), and, hence, that it makes no sense to suppose that there could be a single "correct" interpretation of any work of art. Rather, the meaning of an artwork will depend upon the context in which it is understood (and such contexts may vary widely); and the interpretation that is given of the artwork will depend upon the context within which the interpreter approaches the work. Fish is aware that his position here is vulnerable to the charge that it makes one interpretation as good as any other—that it is a version of relativism. (Such a charge might be made on the strength of the considerations offered by Hirsch elsewhere in this section.) But Fish argues that his claim that meaning is indeterminate does not, in fact, commit him to relativism; and he suggests that it doesn't commit him to solipsism either.

Is There a Text in This Class?

Stanley Fish

On the first day of the new semester a colleague at Johns Hopkins University was approached by a student who, as it turned out, had just taken a course from me. She put to him what I think you would agree is a perfectly straightforward question: "Is there a text in this class?" Responding with a confidence so perfect that he was unaware of it (although in telling the story, he refers to this moment as "walking into the trap"), my colleague said, "Yes; it's the *Norton Anthology of Literature*," whereupon the trap (set not by the student but by the infinite capacity of language for being appropriated) was sprung: "No, no," she said, "I mean in this class do we believe in poems and things, or is it just us?" Now it is possible (and for many tempting) to read this anecdote as an illustration of the dangers that follow upon listening to people like me who preach the instability of the text and the unavailability of determinate meanings; but in what follows I will try to read it as an illustration of how baseless the fear of these dangers finally is.

Of the charges levied against what Meyer Abrams has recently called the New Readers (Derrida, Bloom, Fish) the most persistent is that these apostles of indeterminacy and undecidability ignore, even as they rely upon, the "norms and possibilities" embedded in language, the "linguistic meanings" words undeniably have, and thereby invite us to abandon "our ordinary realm of experience in speaking, hearing, reading and understanding" for a world in

which "no text can mean anything in particular" and where "we can never say just what anyone means by anything he writes."[1] The charge is that literal or normative meanings are overriden by the actions of willful interpreters. Suppose we examine this indictment in the context of the present example. What, exactly, is the normative or literal or linguistic meaning of "Is there a text in this class?"

Within the framework of contemporary critical debate (as it is reflected in the pages, say, of *Critical Inquiry*) there would seem to be only two ways of answering this question: either there *is* a literal meaning of the utterance and we should be able to say what it is, or there are as many meanings as there are readers and no one of them is literal. But the answer suggested by my little story is that the utterance has *two* literal meanings: within the circumstances assumed by my colleague (I don't mean that he took the step of assuming them, but that he was already stepping within them) the utterance is obviously a question about whether or not there is a required textbook in this particular course; but within the circumstances to which he was alerted by his student's corrective response, the utterance is just as obviously a question about the instructor's position (within the range of positions available in contemporary literary theory) on the status of the text. Notice that we do not have here a case of indeterminacy or undecidability but of a determinacy and decidability that do not always have the same shape and that can, and in this instance do, change. My colleague was not hesitating between two (or more) possible meanings of the utterance; rather, he immediately apprehended what seemed to be an inescapable meaning, given his prestructured understanding of the situation, and then he immediately apprehended another inescapable meaning when that understanding was altered. Neither meaning was imposed (a favorite word in the anti-new-reader polemics) on a more normal one by a private, idiosyncratic interpretive act; both interpretations were a function of precisely the public and constituting norms (of language and understanding) invoked by Abrams. It is just that these norms are not embedded in the language (where they may be read out by anyone with sufficiently clear, that is, unbiased, eyes) but inhere in an institutional structure within which one hears utterances as already organized with reference to certain assumed purposes and goals. Because both my colleague and his student are situated in that institution, their interpretive activities are not free, but what constrains them are the understood practices and assumptions of the institution and not the rules and fixed meanings of a language system.

Another way to put this would be to say that neither reading of the question—which we might for convenience's sake label as "Is there a text in this class?"$_1$ and "Is there a text in this class?"$_2$—would be immediately available to any native speaker of the language. "Is there a text in this class?"$_1$ is interpretable or readable only by someone who already knows what is included under the general rubric "first day of class" (what concerns animate students, what bureaucratic matters must be attended to before instruction begins) and who therefore hears the utterance under the aegis of that knowledge, which is not applied after the fact but is responsible for the shape the fact immediately

[1]M. H. Abrams, "The Deconstructive Angel," *Critical Inquiry*, 3, no. 3 (Spring 1977), 431, 434.

has. To someone whose consciousness is not already informed by that knowledge, "Is there a text in this class?"₁ would be just as unavailable as "Is there a text in this class?"₂ would be to someone who was not already aware of the disputed issues in contemporary literary theory. I am not saying that for some readers or hearers the question would be wholly unintelligible (indeed, in the course of this essay I will be arguing that unintelligibility, in the strict or pure sense, is an impossibility), but that there are readers and hearers for whom the intelligibility of the question would have neither of the shapes it had, in a temporal succession, for my colleague. It is possible, for example, to imagine someone who would hear or intend the question as an inquiry about the location of an object, that is, "I think I left my text in this class; have you seen it?" We would then have an "Is there a text in this class?"₃ and the possibility, feared by the defenders of the normative and determinate, of an endless succession of numbers, that is, of a world in which every utterance has an infinite plurality of meanings. But that is not what the example, however it might be extended, suggests at all. In any of the situations I have imagined (and in any that I might be able to imagine) the meaning of the utterance would be severely constrained, not after it was heard but in the ways in which it *could*, in the first place, be heard. An infinite plurality of meanings would be a fear only if sentences existed in a state in which they were not already embedded in, and had come into view as a function of, some situation or other. That state, if it could be located, would be the normative one, and it would be disturbing indeed if the norm were free-floating and indeterminate. But there is no such state; sentences emerge only in situations, and within those situations, the normative meaning of an utterance will always be obvious or at least accessible, although within another situation that same utterance, no longer the same, will have another normative meaning that will be no less obvious and accessible. (My colleague's experience is precisely an illustration.) This does not mean that there is no way to discriminate between the meanings an utterance will have in different situations, but that the discrimination will already have been made by virtue of our being in a situation (we are never not in one) and that in another situation the discrimination will also have already been made, but differently. In other words, while at any one point it is always possible to order and rank "Is there a text in this class?"₁ and "Is there a text in this class?"₂ (because they will always have already been ranked), it will never be possible to give them an immutable once-and-for-all ranking, a ranking that is independent of their appearance or nonappearance in situations (because it is only in situations that they do or do not appear).

Nevertheless, there is a distinction to be made between the two that allows us to say that, in a limited sense, one is more normal than the other: for while each is perfectly normal in the context in which their literalness is immediately obvious (the successive contexts occupied by my colleague), as things stand now, one of those contexts is surely more available, and therefore more likely to be the perspective within which the utterance is heard, than the other. Indeed, we seem to have here an instance of what I would call "institutional nesting": if "Is there a text in this class?"₁ is hearable only by those who know what is included under the rubric "first day of class," and if "Is there a text in this class?"₂ is hearable only by those whose categories of understanding include the concerns of contemporary literary theory, then it is obvious that in

a random population presented with the utterance, more people would "hear" "Is there a text in this class?"$_1$ than "Is there a text in this class?"$_2$; and, moreover, that while "Is there a text in this class?"$_1$ could be immediately hearable by someone for whom "Is there a text in this class?"$_2$ would have to be laboriously explained, it is difficult to imagine someone capable of hearing "Is there a text in this class?"$_2$ who was not already capable of hearing "Is there a text in this class."$_1$ (One is hearable by anyone in the profession and by most students and by many workers in the book trade, and the other only by those in the profession who would not think it peculiar to find, as I did recently, a critic referring to a phrase "made popular by Lacan.") To admit as much is not to weaken my argument by reinstating the category of the normal, because the category as it appears in that argument is not transcendental but institutional; and while no institution is so universally in force and so perdurable that the meanings it enables will be normal for ever, some institutions or forms of life are so widely lived in that for a great many people the meanings they enable seem "naturally" available and it takes a special effort to see that they are the products of circumstances.

The point is an important one, because it accounts for the success with which an Abrams or an E. D. Hirsch can appeal to a shared understanding of ordinary language and argue from that understanding to the availability of a core of determinate meanings. When Hirsch offers "The air is crisp" as an example of a "verbal meaning" that is accessible to all speakers of the language, and distinguishes what is sharable and determinate about it from the associations that may, in certain circumstances, accompany it (for example, "I should have eaten less at supper," "Crisp air reminds me of my childhood in Vermont"),[2] he is counting on his readers to agree so completely with his sense of what that shared and normative verbal meaning is that he does not bother even to specify it; and although I have not taken a survey, I would venture to guess that his optimism, with respect to this particular example, is well founded. That is, most, if not all, of his readers immediately understand the utterance as a rough meteorological description predicting a certain quality of the local atmosphere. But the "happiness" of the example, far from making Hirsch's point (which is always, as he has recently reaffirmed, to maintain "the stable determinacy of meaning")[3] makes mine. The obviousness of the utterance's meaning is not a function of the values its words have in a linguistic system that is independent of context; rather, it is because the words are heard as already embedded in a context that they have a meaning that Hirsch can then cite as obvious. One can see this by embedding the words in another context and observing how quickly another "obvious" meaning emerges. Suppose, for example, we came upon "The air is crisp" (which you are even now hearing as Hirsch assumes you hear it) in the middle of a discussion of music ("When the piece is played correctly the air is crisp"); it would immediately be heard as a comment on the performance by an instrument or instruments of a musical air. Moreover, it would *only* be heard that way, and to hear it in Hirsch's way would require an effort on the order of a strain. It could be objected that in Hirsch's text "The air is crisp"$_1$ has no contextual setting at all;

[2] *Validity in Interpretation* (New Haven: Yale University Press, 1967), pp. 218–219.
[3] *The Aims of Interpretation* (Chicago: University of Chicago Press, 1976), p. 1.

it is merely presented, and therefore any agreement as to its meaning must be because of the utterance's acontextual properties. But there *is* a contextual setting and the sign of its presence is precisely the absence of any reference to it. That is, it is impossible even to think of a sentence independently of a context, and when we are asked to consider a sentence for which no context has been specified, we will automatically hear it in the context in which it has been most often encountered. Thus Hirsch invokes a context by not invoking it; by not surrounding the utterance with circumstances, he directs us to imagine it in the circumstances in which it is most likely to have been produced; and to so imagine it is already to have given it a shape that seems at the moment to be the only one possible.

What conclusions can be drawn from these two examples? First of all, neither my colleague nor the reader of Hirsch's sentence is constrained by the meanings words have in a normative linguistic system; and yet neither is free to confer on an utterance any meaning he likes. Indeed, "confer" is exactly the wrong word because it implies a two stage procedure in which a reader or hearer first scrutinizes an utterance and *then* gives it a meaning. The argument of the preceding pages can be reduced to the assertion that there is no such first stage, that one hears an utterance within, and not as preliminary to determining, a knowledge of its purposes and concerns, and that to so hear it is already to have assigned it a shape and given it a meaning. In other words, the problem of how meaning is determined is only a problem if there is a point at which its determination has not yet been made, and I am saying that there is no such point.

I am *not* saying that one is never in the position of having to self-consciously figure out what an utterance means. Indeed, my colleague is in just such a position when he is informed by his student that he has not heard her question as she intended it ("No, No, I mean in this class do we believe in poems and things, or is it just us?") and therefore must now figure it out. But the "it" in this (or any other) case is not a collection of words waiting to be assigned a meaning but an utterance whose already assigned meaning has been found to be inappropriate. While my colleague has to begin all over again, he does not have to begin from square one; and indeed he never was at square one, since from the very first his hearing of the student's question was informed by his assumption of what its concerns could possibly be. (That is why he is not "free" even if he is unconstrained by determinate meanings.) It is that assumption rather than his performance within it that is challenged by the student's correction. She tells him that he has mistaken her meaning, but this is not to say that he has made a mistake in combining her words and syntax into a meaningful unit; it is rather that the meaningful unit he immediately discerns is a function of a mistaken identification (made before she speaks) of her intention. He was prepared as she stood before him to hear the kind of thing students ordinarily say on the first day of class, and therefore that is precisely what he heard. He has not misread the text (his is not an error in calculation) but mis*pre*read the text, and if he is to correct himself he must make another (pre)determination of the structure of interests from which her question issues. This, of course, is exactly what he does and the question of how he does it is a crucial one, which can best be answered by first considering the ways in which he *didn't* do it.

He didn't do it by attending to the literal meaning of her response. That is, this is not a case in which someone who has been misunderstood clarifies her meaning by making more explicit, by varying or adding to her words in such a way as to render their sense inescapable. Within the circumstances of utterance as he has assumed them her words are perfectly clear, and what she is doing is asking him to imagine other circumstances in which the same words will be equally, but differently, clear. Nor is it that the words she does add ("No, No, I mean . . .") direct him to those other circumstances by picking them out from an inventory of all possible ones. For this to be the case there would have to be an inherent relationship between the words she speaks and a particular set of circumstances (this would be a higher level literalism) such that any competent speaker of the language hearing those words would immediately be referred to that set. But I have told the story to several competent speakers of the language who simply didn't get it, and one friend—a professor of philosophy—reported to me that in the interval between his hearing the story and my explaining it to him (and just how I was able to do that is another crucial question) he found himself asking "What kind of joke is this and have I missed it?" For a time at least he remained able only to hear "Is there a text in this class" as my colleague first heard it; the student's additional words, far from leading him to another hearing, only made him aware of his distance from it. In contrast, there are those who not only get the story but get it before I tell it; that is, they know in advance what is coming as soon as I say that a colleague of mine was recently asked, "Is there a text in this class?" Who are these people and what is it that makes their comprehension of the story so immediate and easy? Well, one could say, without being the least bit facetious, that they are the people who come to hear me speak because they are the people who already know my position on certain matters (or know that I will *have* a position). That is, they hear, "Is there a text in this class?" even as it appears at the beginning of the anecdote (or for that matter as a title of an essay) in the light of their knowledge of what I am likely to do with it. They hear it coming from *me,* in circumstances which have committed me to declaring myself on a range of issues that are sharply delimited.

My colleague was finally able to hear it in just that way, as coming from me, not because I was there in his classroom, nor because the words of the student's question pointed to me in a way that would have been obvious to any hearer, but because he was able to think of me in an office three doors down from his telling students that there are no determinate meanings and that the stability of the text is an illusion. Indeed, as he reports it, the moment of recognition and comprehension consisted of his saying to himself, "Ah, there's one of Fish's victims!" He did not say this because her words identified her as such but because his ability to see her as such informed his perception of her words. The answer to the question "How did he get from her words to the circumstances within which she intended him to hear them?" is that he must already be thinking within those circumstances in order to be able to hear her words as referring to them. The question, then, must be rejected, because it assumes that the construing of sense leads to the identification of the context of utterance rather than the other way around. This does not mean that the context comes first and that once it has been identified the construing of sense can begin. This would be only to reverse the order of precedence, whereas prece-

dence is beside the point because the two actions it would order (the identification of context and the making of sense) occur simultaneously. One does not say "Here I am in a situation; now I can begin to determine what these words mean." To be in a situation is to see the words, these or any other, as already meaningful. For my colleague to realize that he may be confronting one of my victims is *at the same time* to hear what she says as a question about his theoretical beliefs.

But to dispose of one "how" question is only to raise another: if her words do not lead him to the context of her utterance, how does he get there? Why did he think of me telling students that there were no determinate meanings and not think of someone or something else? First of all, he might well have. That is, he might well have guessed that she was coming from another direction (inquiring, let us say, as to whether the focus of this class was to be the poems and essays or our responses to them, a question in the same line of country as hers but quite distinct from it) or he might have simply been stymied, like my philosopher friend, confined, in the absence of an explanation, to his first determination of her concerns and unable to make any sense of her words other than the sense he originally made. How, then, did he do it? In part, he did it because he *could* do it; he was able to get to this context because it was already part of his repertoire for organizing the world and its events. The category "one of Fish's victims" was one he already had and didn't have to work for. Of course, *it* did not always have *him*, in that his world was not always being organized by it, and it certainly did not have him at the beginning of the conversation; but it was available to him, and he to it, and all he had to do was to recall it or be recalled to it for the meanings it subtended to emerge. (Had it not been available to him, the career of his comprehension would have been different and we will come to a consideration of that difference shortly.)

This, however, only pushes our inquiry back further. How or why was he recalled to it? The answer to this question must be probabilistic and it begins with the recognition that when something changes, not everything changes. Although my colleague's understanding of his circumstances is transformed in the course of this conversation, the circumstances are still understood to be academic ones, and within that continuing (if modified) understanding, the directions his thought might take are already severely limited. He still presumes, as he did at first, that the student's question has something to do with university business in general, and with English literature in particular, and it is the organizing rubrics associated with these areas of experience that are likely to occur to him. One of those rubrics is "what-goes-on-in-other-classes" and one of those other classes is mine. And so, by a route that is neither entirely unmarked nor wholly determined, he comes to me and to the notion "one of Fish's victims" and to a new construing of what his student has been saying.

Of course that route would have been much more circuitous if the category "one of Fish's victims" was not already available to him as a device for producing intelligibility. Had that device not been part of his repertoire, had he been incapable of being recalled to it because he never knew it in the first place, how would he have proceeded? The answer is that he could not have proceeded at all, which does not mean that one is trapped forever in the cat-

egories of understanding at one's disposal (or the categories at whose disposal one is), but that the introduction of new categories or the expansion of old ones to include new (and therefore newly seen) data must always come from the outside or from what is perceived, for a time, to be the outside. In the event that he was unable to identify the structure of her concerns because it had never been his (or he its), it would have been her obligation to explain it to him. And here we run up against another instance of the problem we have been considering all along. She could not explain it to him by varying or adding to her words, by being more explicit, because her words will only be intelligible if he already has the knowledge they are supposed to convey, the knowledge of the assumptions and interests from which they issue. It is clear, then, that she would have to make a new start, although she would not have to start from scratch (indeed, starting from scratch is never a possibility); but she would have to back up to some point at which there was a shared agreement as to what was reasonable to say so that a new and wider basis for agreement could be fashioned. In this particular case, for example, she might begin with the fact that her interlocutor already knows what a text is; that is, he has a way of thinking about it that is responsible for his hearing of her first question as one about bureaucratic classroom procedures. (You will remember that "he" in these sentences is no longer my colleague but someone who does not have his special knowledge.) It is that way of thinking that she must labor to extend or challenge, first, perhaps, by pointing out that there are those who think about the text in other ways, and then by trying to find a category of his own understanding which might serve as an analogue to the understanding he does not yet share. He might, for example, be familiar with those psychologists who argue for the constitutive power of perception, or with Gombrich's theory of the beholder's share, or with that philosophical tradition in which the stability of objects has always been a matter of dispute. The example must remain hypothetical and skeletal, because it can only be fleshed out after a determination of the particular beliefs and assumptions that would make the explanation necessary in the first place; for whatever they were, they would dictate the strategy by which she would work to supplant or change them. It is when such a strategy has been successful that the import of her words will become clear, not because she has reformulated or refined them but because they will now be read or heard within the same system of intelligibility from which they issue.

 In short, this hypothetical interlocutor will in time be brought to the same point of comprehension my colleague enjoys when he is able to say to himself, "Ah, there's one of Fish's victims," although presumably he will say something very different to himself if he says anything at all. The difference, however, should not obscure the basic similarities between the two experiences, one reported, the other imagined. In both cases the words that are uttered are immediately heard within a set of assumptions about the direction from which they could possibly be coming, and in both cases what is required is that the hearing occur within another set of assumptions in relation to which the same words ("Is there a text in this class?") will no longer be the same. It is just that while my colleague is able to meet that requirement by calling to mind a context of utterance that is already a part of his repertoire, the reper-

toire of his hypothetical stand-in must be expanded to include that context so that should he some day be in an analogous situation, he would be able to call it to mind.

The distinction, then, is between already having an ability and having to acquire it, but it is not finally an essential distinction, because the routes by which that ability could be exercised on the one hand, and learned on the other, are so similar. They are similar first of all because they are similarly *not* determined by words. Just as the student's words will not direct my colleague to a context he already has, so will they fail to direct someone not furnished with that context to its discovery. And yet in neither case does the absence of such a mechanical determination mean that the route one travels is randomly found. The change from one structure of understanding to another is not a rupture but a modification of the interests and concerns that are already in place; and because they are already in place, they constrain the direction of their own modification. That is, in both cases the hearer is already in a situation informed by tacitly known purposes and goals, and in both cases he ends up in another situation whose purposes and goals stand in some elaborated relation (of contrast, opposition, expansion, extension) to those they supplant. (The one relation in which they could not stand is no relation at all.) It is just that in one case the network of elaboration (from the text as an obviously physical object to the question of whether or not the text is a physical object) has already been articulated (although not all of its articulations are in focus at one time; selection is always occurring), while in the other the articulation of the network is the business of the teacher (here the student) who begins, necessarily, with what is already given.

The final similarity between the two cases is that in neither is success assured. It was no more inevitable that my colleague tumble to the context of his student's utterance than it would be inevitable that she could introduce that context to someone previously unaware of it; and, indeed, had my colleague remained puzzled (had he simply not thought of me), it would have been necessary for the student to bring him along in a way that was finally indistinguishable from the way she would bring someone to a new knowledge, that is, by beginning with the shape of his present understanding.

I have lingered so long over the unpacking of this anecdote that its relationship to the problem of authority in the classroom and in literary criticism may seem obscure. Let me recall you to it by recalling the contention of Abrams and others that authority depends upon the existence of a determinate core of meanings because in the absence of such a core there is no normative or public way of construing what anyone says or writes, with the result that interpretation becomes a matter of individual and private construings none of which is subject to challenge or correction. In literary criticism this means that no interpretation can be said to be better or worse than any other, and in the classroom this means that we have no answer to the student who says my interpretation is as valid as yours. It is only if there is a shared basis of agreement at once guiding interpretation and providing a mechanism for deciding between interpretations that a total and debilitating relativism can be avoided.

But the point of my analysis has been to show that while "Is there a text

in this class?" does not have a determinate meaning, a meaning that survives the sea change of situations, in any situation we might imagine the meaning of the utterance is either perfectly clear or capable, in the course of time, of being clarified. What is it that makes this possible, if it is not the "possibilities and norms" already encoded in language? How does communication ever occur if not by reference to a public and stable norm? The answer, implicit in everything I have already said, is that communication occurs within situations and that to be in a situation is already to be in possession of (or to be possessed by) a structure of assumptions, of practices understood to be relevant in relation to purposes and goals that are already in place; and it is within the assumption of these purposes and goals that any utterance is *immediately* heard. I stress immediately because it seems to me that the problem of communication, as someone like Abrams poses it, is a problem only because he assumes a distance between one's receiving of an utterance and the determination of its meaning—a kind of dead space when one has only the words and then faces the task of construing them. If there were such a space, a moment before interpretation began, then it would be necessary to have recourse to some mechanical and algorithmic procedure by means of which meanings could be calculated and in relation to which one could recognize mistakes. What I have been arguing is that meanings come already calculated, not because of norms embedded in the language but because language is always perceived, from the very first, within a structure of norms. That structure, however, is not abstract and independent but social; and therefore it is not a single structure with a privileged relationship to the process of communication as it occurs in any situation but a structure that changes when one situation, with its assumed background of practices, purposes, and goals, has given way to another. In other words, the shared basis of agreement sought by Abrams and others is never not already found, although it is not always the same one.

Many will find in this last sentence, and in the argument to which it is a conclusion, nothing more than a sophisticated version of the relativism they fear. It will do no good, they say, to speak of norms and standards that are context specific, because this is merely to authorize an infinite plurality of norms and standards, and we are still left without any way of adjudicating between them and between the competing systems of value of which they are functions. In short, to have many standards is to have no standards at all.

On one level this counterargument is unassailable, but on another level it is finally beside the point. It is unassailable as a general and theoretical conclusion: the positing of context- or institution-specific norms surely rules out the possibility of a norm whose validity would be recognized by everyone, no matter what his situation. But it is beside the point for any particular individual, for since everyone is situated somewhere, there is no one for whom the absence of an asituational norm would be of any practical consequence, in the sense that his performance or his confidence in his ability to perform would be impaired. So that while it is generally true that to have many standards is to have none at all, it is not true for anyone in particular (for there is no one in a position to speak "generally"), and therefore it is a truth of which one can say "it doesn't matter."

In other words, while relativism is a position one can entertain, it is not a

position one can occupy. No one can *be* a relativist, because no one can achieve the distance from his own beliefs and assumptions which would result in their being no more authoritative *for him* than the beliefs and assumptions held by others, or, for that matter, the beliefs and assumptions he himself used to hold. The fear that in a world of indifferently authorized norms and values the individual is without a basis for action is groundless because no one is indifferent to the norms and values that enable his consciousness. It is in the name of personally held (in fact they are doing the holding) norms and values that the individual acts and argues, and he does so with the full confidence that attends belief. When his beliefs change, the norms and values to which he once gave unthinking assent will have been demoted to the status of opinions and become the objects of an analytical and critical attention; but that attention will itself be enabled by a new set of norms and values that are, for the time being, as unexamined and undoubted as those they displace. The point is that there is never a moment when one believes nothing, when consciousness is innocent of any and all categories of thought, and whatever categories of thought are operative at a given moment will serve as an undoubted ground.

Here, I suspect, a defender of determinate meaning would cry "solipsist" and argue that a confidence that had its source in the individual's categories of thought would have no public value. That is, unconnected to any shared and stable system of meanings, it would not enable one to transact the verbal business of everyday life; a shared intelligibility would be impossible in a world where everyone was trapped in the circle of his own assumptions and opinions. The reply to this is that an individual's assumptions and opinions are not "his own" in any sense that would give body to the fear of solipsism. That is, *he* is not their origin (in fact it might be more accurate to say that they are his); rather, it is their prior availability which delimits in advance the paths that his consciousness can possibly take. When my colleague is in the act of construing his student's question ("Is there a text in this class?"), none of the interpretive strategies at his disposal are uniquely his, in the sense that he thought them up; they follow from his preunderstanding of the interests and goals that could possibly animate the speech of someone functioning within the institution of academic America, interests and goals that are the particular property of no one in particular but which link everyone for whom their assumption is so habitual as to be unthinking. They certainly link my colleague and his student, who are able to communicate and even to reason about one another's intentions, not, however, because their interpretive efforts are constrained by the shape of an independent language but because their shared understanding of what could possibly be at stake in a classroom situation results in language appearing to them in the same shape (or successions of shapes). That shared understanding is the basis of the confidence with which they speak and reason, but its categories are their own only in the sense that as actors within an institution they automatically fall heir to the institution's way of making sense, its systems of intelligibility. That is why it is so hard for someone whose very being is defined by his position within an institution (and if not this one, then some other) to explain to someone outside it a practice or a meaning that seems to him to require no explanation, because he regards it as natural. Such a person, when pressed, is likely to say, "but that's just the

way it's done" or "but isn't it obvious" and so testify that the practice or meaning in question is community property, as, in a sense, he is too.

We see then that (1) communication does occur, despite the absence of an independent and context-free system of meanings, that (2) those who participate in this communication do so confidently rather than provisionally (they are not relativists), and that (3) while their confidence has its source in a set of beliefs, those beliefs are not individual-specific or idiosyncratic but communal and conventional (they are not solipsists).

Of course, solipsism and relativism are what Abrams and Hirsch fear and what lead them to argue for the necessity of determinate meaning. But if, rather than acting on their own, interpreters act as extensions of an institutional community, solipsism and relativism are removed as fears because they are not possible modes of being. That is to say, the condition required for someone to be a solipsist or relativist, the condition of being independent of institutional assumptions and free to originate one's own purposes and goals, could never be realized, and therefore there is no point in trying to guard against it. Abrams, Hirsch, and company spend a great deal of time in a search for the ways to limit and constrain interpretation, but if the example of my colleague and his student can be generalized (and obviously I think it can be), what they are searching for is never not already found. In short, my message to them is finally not challenging, but consoling—not to worry.

READING 34

INTRODUCTION

The essays in this section reflect, from a variety of perspectives, our modern obsession with the nature and possibility of interpretation. Despite their differences, most of the essays represent interpretation as a desirable and important part of our experience of art. In "Against Interpretation" (1964), Susan Sontag seeks to disrupt this consensus. We often represent our desire to interpret works of art—a desire which Sontag traces to the theories of Plato and Aristotle (*see* Section 4)—as part of a serious attempt to engage with what really matters about art: its meaning or content. However, Sontag argues, what really matters about art is not its content but its form, not *"what it means"* but *"how it is what it is, even that it is what it is."* Although Sontag does not explicitly endorse a formalist theory of art (*see* the essays by Bell and Greenberg in Section 2), her views about the proper function of criticism would seem to presuppose the truth of some version of formalism. As she puts it, the business of criticism is to "reveal the sensuous surface of art without mucking about in it." (Interestingly, she finds criticism of this sort most prevalent in writings about film.) The urge to interpret, she believes, typically reflects an urge to replace the work of art itself with something else, a "meaning," thereby evading the often difficult and disturbing nature of the works themselves. "Interpretation," she says, "is the revenge of the intellect upon art."

Against Interpretation

Susan Sontag

> *Content is a glimpse of something, an encounter like a flash. It's very tiny—very tiny, content.*
>
> *—Willem de Kooning, in an Interview*

> *It is only shallow people who do not judge by appearances. The mystery of the world is the visible, not the invisible.*
>
> *—Oscar Wilde, in a Letter*

The earliest *experience* of art must have been that it was incantatory, magical; art *was* an instrument of ritual. (Cf. the paintings in the caves at Lascaux, Altamira, Niaux, La Pasiega, etc.) The earliest *theory* of art, that of the Greek philosophers, proposed that art was mimesis, imitation of reality.

It is at this point that the peculiar question of the *value* of art arose. For the mimetic theory, by its very terms, challenges art to justify itself.

Plato, who proposed the theory, seems to have done so *in order* to rule that the value of art is dubious. Since he considered ordinary material things as themselves mimetic objects, imitations of transcendent forms or structures, even the best painting of a bed would be only an "imitation of an imitation." For Plato, art is neither particularly useful (the painting of a bed is no good to sleep on), nor, in the strict sense, true. And Aristotle's arguments in defense of art do not really challenge Plato's view that all art is an elaborate *trompe l'oeil*, and therefore a lie. But he does dispute Plato's idea that art is useless. Lie or no, art has a certain value according to Aristotle because it is a form of therapy. Art is useful, after all, Aristotle counters, medicinally useful in that it arouses and purges dangerous emotions.

In Plato and Aristotle, the mimetic theory of art goes hand in hand with the assumption that art is always figurative. But advocates of the mimetic theory need not close their eyes to decorative and abstract art. The fallacy that art is necessarily a "realism" can be modified or scrapped without ever moving outside the problems delimited by the mimetic theory.

The fact is, all Western consciousness of and reflection upon art have remained within the confines staked out by the Greek theory of art as mimesis or representation. It is through this theory that art as such—above and beyond given works of art—becomes problematic, in need of defense. And it is the defense of art which gives birth to the odd vision by which something we have learned to call "form" is separated off from something we have learned to call "content," and to the well-intentioned move which makes content essential and form accessory.

Even in modern times, when most artists and critics have discarded the theory of art as representation of an outer reality in favor of the theory of art as subjective expression, the main feature of the mimetic theory persists. Whether we conceive of the work of art on the model of a picture (art as a picture of reality) or on the model of a statement (art as the statement of the artist), content still comes first. The content may have changed. It may now be less figurative, less lucidly realistic. But it is still assumed that a work of art is its

content. Or, as it's usually put today, that a work of art by definition *says* some-thing. ("What X is saying is . . ." "What X is trying to say is . . ." "What X said is . . ." etc., etc.)

2

None of us can ever retrieve that innocence before all theory when art knew no need to justify itself, when one did not ask of a work of art what it *said* because one knew (or thought one knew) what it *did*. From now to the end of consciousness, we are stuck with the task of defending art. We can only quar-rel with one or another means of defense. Indeed, we have an obligation to overthrow any means of defending and justifying art which becomes particu-larly obtuse or onerous or insensitive to contemporary needs and practice.

This is the case, today, with the very idea of content itself. Whatever it may have been in the past, the idea of content is today mainly a hindrance, a nuisance, a subtle or not so subtle philistinism.

Though the actual developments in many arts may seem to be leading us away from the idea that a work of art is primarily its content, the idea still exerts an extraordinary hegemony. I want to suggest that this is because the idea is now perpetuated in the guise of a certain way of encountering works of art thoroughly ingrained among most people who take any of the arts seri-ously. What the overemphasis on the idea of content entails is the perennial, never consummated project of *interpretation*. And, conversely, it is the habit of approaching works of art in order to *interpret* them that sustains the fancy that there really is such a thing as the content of a work of art.

3

Of course, I don't mean interpretation in the broadest sense, the sense in which Nietzsche (rightly) says, "There are no facts, only interpretations." By inter-pretation, I mean here a conscious act of the mind which illustrates a certain code, certain "rules" of interpretation.

Directed to art, interpretation means plucking a set of elements (the X, the Y, the Z, and so forth) from the whole work. The task of interpretation is vir-tually one of translation. The interpreter says, Look, don't you see that X is really—or, really means—A? That Y is really B? That Z is really C?

What situation could prompt this curious project for transforming a text? History gives us the materials for an answer. Interpretation first appears in the culture of late classical antiquity, when the power and credibility of myth had been broken by the "realistic" view of the world introduced by scientific enlightenment. Once the question that haunts post-mythic consciousness—that of the *seemliness* of religious symbols—had been asked, the ancient texts were, in their pristine form, no longer acceptable. Then interpretation was sum-moned, to reconcile the ancient texts to "modern" demands. Thus, the Stoics, to accord with their view that the gods had to be moral, allegorized away the rude features of Zeus and his boisterous clan in Homer's epics. What Homer really designated by the adultery of Zeus with Leto, they explained, was the union between power and wisdom. In the same vein, Philo of Alexandria inter-preted the literal historical narratives of the Hebrew Bible as spiritual para-

digms. The story of the exodus from Egypt, the wandering in the desert for forty years, and the entry into the promised land, said Philo, was really an allegory of the individual soul's emancipation, tribulations, and final deliverance. Interpretation thus presupposes a discrepancy between the clear meaning of the text and the demands of (later) readers. It seeks to resolve that discrepancy. The situation is that for some reason a text has become unacceptable; yet it cannot be discarded. Interpretation is a radical strategy for conserving an old text, which is thought too precious to repudiate, by revamping it. The interpreter, without actually erasing or rewriting the text, *is* altering it. But he can't admit to doing this. He claims to be only making it intelligible, by disclosing its true meaning. However far the interpreters alter the text (another notorious example is the Rabbinic and Christian "spiritual" interpretations of the clearly erotic Song of Songs), they must claim to be reading off a sense that is already there.

Interpretation in our own time, however, is even more complex. For the contemporary zeal for the project of interpretation is often prompted not by piety toward the troublesome text (which may conceal an aggression), but by an open aggressiveness, an overt contempt for appearances. The old style of interpretation was insistent, but respectful; it erected another meaning on top of the literal one. The modern style of interpretation excavates, and as it excavates, destroys; it digs "behind" the text, to find a sub-text which is the true one. The most celebrated and influential modern doctrines, those of Marx and Freud, actually amount to elaborate systems of hermeneutics, aggressive and impious theories of interpretation. All observable phenomena are bracketed, in Freud's phrase, as *manifest content*. This manifest content must be probed and pushed aside to find the true meaning—the *latent content*—beneath. For Marx, social events like revolutions and wars; for Freud, the events of individual lives (like neurotic symptoms and slips of the tongue) as well as texts (like a dream or a work of art)—all are treated as occasions for interpretation. According to Marx and Freud, these events only *seem* to be intelligible. Actually, they have no meaning without interpretation. To understand *is* to interpret. And to interpret is to restate the phenomenon, in effect to find an equivalent for it.

Thus, interpretation is not (as most people assume) an absolute value, a gesture of mind situated in some timeless realm of capabilities. Interpretation must itself be evaluated, within a historical view of human consciousness. In some cultural contexts, interpretation is a liberating act. It is a means of revising, of transvaluing, of escaping the dead past. In other cultural contexts, it is reactionary, impertinent, cowardly, stifling.

4

Today is such a time, when the project of interpretation is largely reactionary, stifling. Like the fumes of the automobile and of heavy industry which befoul the urban atmosphere, the effusion of interpretations of art today poisons our sensibilities. In a culture whose already classical dilemma is the hypertrophy of the intellect at the expense of energy and sensual capability, interpretation is the revenge of the intellect upon art.

Even more. It is the revenge of the intellect upon the world. To interpret is to impoverish, to deplete the world—in order to set up a shadow world of "meanings." It is to turn *the* world into *this* world. ("This world"! As if there were any other.)

The world, our world, is depleted, impoverished enough. Away with all duplicates of it, until we again experience more immediately what we have.

5

In most modern instances, interpretation amounts to the philistine refusal to leave the work of art alone. Real art has the capacity to make us nervous. By reducing the work of art to its content and then interpreting *that,* one tames the work of art. Interpretation makes art manageable, comfortable.

This philistinism of interpretation is more rife in literature than in any other art. For decades now, literary critics have understood it to be their task to translate the elements of the poem or play or novel or story into something else. Sometimes a writer will be so uneasy before the naked power of his art that he will install within the work itself—albeit with a little shyness, a touch of the good taste of irony—the clear and explicit interpretation of it. Thomas Mann is an example of such an overcooperative author. In the case of more stubborn authors, the critic is only too happy to perform the job.

The work of Kafka, for example, has been subjected to a mass ravishment by no less than three armies of interpreters. Those who read Kafka as a social allegory see case studies of the frustrations and insanity of modern bureaucracy and its ultimate issuance in the totalitarian state. Those who read Kafka as a psychoanalytic allegory see desperate revelations of Kafka's fear of his father, his castration anxieties, his sense of his own impotence, his thralldom to his dreams. Those who read Kafka as a religious allegory explain that K. in *The Castle* is trying to gain access to heaven, that Joseph K. in *The Trial* is being judged by the inexorable and mysterious justice of God. . . . Another *oeuvre* that has attracted interpreters like leeches is that of Samuel Beckett. Beckett's delicate dramas of the withdrawn consciousness—pared down to essentials, cut off, often represented as physically immobilized—are read as a statement about modern man's alienation from meaning or from God, or as an allegory of psychopathology.

Proust, Joyce, Faulkner, Rilke, Lawrence, Gide . . . one could go on citing author after author; the list is endless of those around whom thick encrustations of interpretation have taken hold. But it should be noted that interpretation is not simply the compliment that mediocrity pays to genius. It is, indeed, *the* modern way of understanding something, and is applied to works of every quality. Thus, in the notes that Elia Kazan published on his production of *A Streetcar Named Desire,* it becomes clear that, in order to direct the play, Kazan had to discover that Stanley Kowalski represented the sensual and vengeful barbarism that was engulfing our culture, while Blanche Du Bois was Western civilization, poetry, delicate apparel, dim lighting, refined feelings and all, though a little the worse for wear to be sure. Tennessee Williams' forceful psychological melodrama now became intelligible: it was *about* something, about the decline of Western civilization. Apparently, were it to go on being

a play about a handsome brute named Stanley Kowalski and a faded mangy belle named Blanche Du Bois, it would not be manageable.

6

It doesn't matter whether artists intend, or don't intend, for their works to be interpreted. Perhaps Tennessee Williams thinks *Streetcar* is about what Kazan thinks it to be about. It may be that Cocteau in *The Blood of a Poet* and in *Orpheus* wanted the elaborate readings which have been given these films, in terms of Freudian symbolism and social critique. But the merit of these works certainly lies elsewhere than in their "meanings." Indeed, it is precisely to the extent that Williams' plays and Cocteau's films do suggest these portentous meanings that they are defective, false, contrived, lacking in conviction.

From interviews, it appears that Resnais and Robbe-Grillet consciously designed *Last Year at Marienbad* to accommodate a multiplicity of equally plausible interpretations. But the temptation to interpret *Marienbad* should be resisted. What matters in *Marienbad* is the pure, untranslatable, sensuous immediacy of some of its images, and its rigorous if narrow solutions to certain problems of cinematic form.

Again, Ingmar Bergman may have meant the tank rumbling down the empty night street in *The Silence* as a phallic symbol. But if he did, it was a foolish thought. ("Never trust the teller, trust the tale," said Lawrence.) Taken as a brute object, as an immediate sensory equivalent for the mysterious abrupt armored happenings going on inside the hotel, that sequence with the tank is the most striking moment in the film. Those who reach for a Freudian interpretation of the tank are only expressing their lack of response to what is there on the screen.

It is always the case that interpretation of this type indicates a dissatisfaction (conscious or unconscious) with the work, a wish to replace it by something else.

Interpretation, based on the highly dubious theory that a work of art is composed of items of content, violates art. It makes art into an article for use, for arrangement into a mental scheme of categories.

7

Interpretation does not, of course, always prevail. In fact, a great deal of today's art may be understood as motivated by a flight from interpretation. To avoid interpretation, art may become parody. Or it may become abstract. Or it may become ("merely") decorative. Or it may become non-art.

The flight from interpretation seems particularly a feature of modern painting. Abstract painting is the attempt to have, in the ordinary sense, no content; since there is no content, there can be no interpretation. Pop Art works by the opposite means to the same result; using a content so blatant, so "what it is," it, too, ends by being uninterpretable.

A great deal of modern poetry as well, starting from the great experiments of French poetry (including the movement that is misleadingly called Sym-

bolism) to put silence into poems and to reinstate the *magic* of the word, has escaped from the rough grip of interpretation. The most recent revolution in contemporary taste in poetry—the revolution that has deposed Eliot and elevated Pound—represents a turning away from content in poetry in the old sense, an impatience with what made modern poetry prey to the zeal of interpreters.

I am speaking mainly of the situation in America, of course. Interpretation runs rampant here in those arts with a feeble and negligible avant-garde: fiction and the drama. Most American novelists and playwrights are really either journalists or gentlemen sociologists and psychologists. They are writing the literary equivalent of program music. And so rudimentary, uninspired, and stagnant has been the sense of what might be done with *form* in fiction and drama that even when the content isn't simply information, news, it is still peculiarly visible, handier, more exposed. To the extent that novels and plays (in America), unlike poetry and painting and music, don't reflect any interesting concern with changes in their form, these arts remain prone to assault by interpretation.

But programmatic avant-gardism—which has meant, mostly, experiments with form at the expense of content—is not the only defense against the infestation of art by interpretations. At least, I hope not. For this would be to commit art to being perpetually on the run. (It also perpetuates the very distinction between form and content which is, ultimately, an illusion.) Ideally, it is possible to elude the interpreters in another way, by making works of art whose surface is so unified and clean, whose momentum is so rapid, whose address is so direct that the work can be . . . just what it is. Is this possible now? It does happen in films, I believe. This is why cinema is the most alive, the most exciting, the most important of all art forms right now. Perhaps the way one tells how alive a particular art form is, is by the latitude it gives for making mistakes in it, and still being good. For example, a few of the films of Bergman—though crammed with lame messages about the modern spirit, thereby inviting interpretations—still triumph over the pretentious intentions of their director. In *Winter Light* and *The Silence,* the beauty and visual sophistication of the images subvert before our eyes the callow pseudo-intellectuality of the story and some of the dialogue. (The most remarkable instance of this sort of discrepancy is the work of D. W. Griffith.) In good films, there is always a directness that entirely frees us from the itch to interpret. Many old Hollywood films, like those of Cukor, Walsh, Hawks, and countless other directors, have this liberating anti-symbolic quality, no less than the best work of the new European directors, like Truffaut's *Shoot the Piano Player* and *Jules and Jim,* Godard's *Breathless* and *Vivre Sa Vie,* Antonioni's *L'Avventura,* and Olmi's *The Fiancés.*

The fact that films have not been overrun by interpreters is in part due simply to the newness of cinema as an art. It also owes to the happy accident that films for such a long time were just movies; in other words, that they were understood to be part of mass, as opposed to high, culture, and were left alone by most people with minds. Then, too, there is always something other than content in the cinema to grab hold of, for those who want to analyze. For the

cinema, unlike the novel, possesses a vocabulary of forms—the explicit, complex, and discussable technology of camera movements, cutting, and composition of the frame that goes into the making of a film.

8

What kind of criticism, of commentary on the arts, is desirable today? For I am not saying that works of art are ineffable, that they cannot be described or paraphrased. They can be. The question is how. What would criticism look like that would serve the work of art, not usurp its place?

What is needed, first, is more attention to form in art. If excessive stress on *content* provokes the arrogance of interpretation, more extended and more thorough descriptions of *form* would silence. What is needed is a vocabulary—a descriptive, rather than prescriptive, vocabulary—for forms.* The best criticism, and it is uncommon, is of this sort that dissolves considerations of content into those of form. On film, drama, and painting respectively, I can think of Erwin Panofsky's essay, "Style and Medium in the Motion Pictures," Northrop Frye's essay "A Conspectus of Dramatic Genres," Pierre Francastel's essay "The Destruction of a Plastic Space." Roland Barthes' book *On Racine* and his two essays on Robbe-Grillet are examples of formal analysis applied to the work of a single author. (The best essays in Erich Auerbach's *Mimesis,* like "The Scar of Odysseus," are also of this type.) An example of formal analysis applied simultaneously to genre and author is Walter Benjamin's essay, "The Story Teller: Reflections on the Works of Nicolai Leskov."

Equally valuable would be acts of criticism which would supply a really accurate, sharp, loving description of the appearance of a work of art. This seems even harder to do than formal analysis. Some of Manny Farber's film criticism, Dorothy Van Ghent's essay "The Dickens World: A View from Todgers'," Randall Jarrell's essay on Walt Whitman are among the rare examples of what I mean. These are essays which reveal the sensuous surface of art without mucking about in it.

9

Transparence is the highest, most liberating value in art—and in criticism—today. Transparence means experiencing the luminousness of the thing in itself, of things being what they are. This is the greatness of, for example, the films of Bresson and Ozu and Renoir's *The Rules of the Game.*

Once upon a time (say, for Dante), it must have been a revolutionary and

*One of the difficulties is that our idea of form is spatial (the Greek metaphors for form are all derived from notions of space). This is why we have a more ready vocabulary of forms for the spatial than for the temporal arts. The exception among the temporal arts, of course, is the drama; perhaps this is because the drama is a narrative (i.e., temporal) form that extends itself visually and pictorially, upon a stage. . . . What we don't have yet is a poetics of the novel, any clear notion of the forms of narration. Perhaps film criticism will be the occasion of a breakthrough here, since films are primarily a visual form, yet they are also a subdivision of literature.

creative move to design works of art so that they might be experienced on several levels. Now it is not. It reinforces the principle of redundancy that is the principal affliction of modern life.

Once upon a time (a time when high art was scarce), it must have been a revolutionary and creative move to interpret works of art. Now it is not. What we decidedly do not need now is further to assimilate Art into Thought, or (worse yet) Art into Culture.

Interpretation takes the sensory experience of the work of art for granted, and proceeds from there. This cannot be taken for granted, now. Think of the sheer multiplication of works of art available to every one of us, superadded to the conflicting tastes and odors and sights of the urban environment that bombard our senses. Ours is a culture based on excess, on overproduction; the result is a steady loss of sharpness in our sensory experience. All the conditions of modern life—its material plenitude, its sheer crowdedness—conjoin to dull our sensory faculties. And it is in the light of the condition of our senses, our capacities (rather than those of another age), that the task of the critic must be assessed.

What is important now is to recover our senses. We must learn to *see* more, to *hear* more, to *feel* more.

Our task is not to find the maximum amount of content in a work of art, much less to squeeze more content out of the work than is already there. Our task is to cut back content so that we can see the thing at all.

The aim of all commentary on art now should be to make works of art—and, by analogy, our own experience—more, rather than less, real to us. The function of criticism should be to show *how it is what it is*, even *that it is what it is*, rather than to show *what it means*.

10

In place of a hermeneutics we need an erotics of art.

4

ART: PURPOSES AND PERILS

READING 35

INTRODUCTION

In the *Republic*, Plato (who lived from about 427 to 347 B.C.) sets out to describe what he holds to be the ideal state. He devotes a large part of the work to discussing the character of the leaders of such a state. The question arises: How are future leaders to be educated for leadership? Plato's view is that only philosophers—lovers of wisdom—are appropriately qualified for the task of leadership. Thus the question becomes, in effect, one whose significance is quite general: How can people be educated into the love of wisdom? Plato himself recognized the importance of art to a well-rounded education; however, he expresses some extremely controversial views about the kind of art that should be included in the curriculum, and, indeed, about what sort of art should be allowed in an ideal state at all. In Books II, III, and X of the *Republic,* from which the following passages are excerpted, he discusses not only the role of art in education but also the relationships between art, knowledge, and morality in general. Some of his worries about art and artists can also be seen in the *Ion* (*see* Section 1), but it is in the *Republic* that they receive their fullest expression. Here Plato issues a challenge to which artists and philosophers have been responding ever since. (In what follows, we have reprinted Professor Cornford's introductory remarks as well as his translation of the text.)

From the *Republic*

Plato

Censorship of Literature for School Use (376 E–392 C)

Plato begins with the content of the poetry used in early education. The Athenian child took his notions of the gods chiefly from Homer and Hesiod, who, as Xenophanes more than a century earlier had complained, attributed to them every sort of immorality. Plato's censorship of the poets as school-books is in line with the practice of modern parents and schoolmasters; but later it develops into a more general attack on poetry.

 In the fourth century highly educated men had ceased to believe in the existence

of supernatural persons called Zeus, Athena, Apollo, &c., with their mythical attrib-
utes and adventures. Myths were not dogma, and no one was required to profess a
belief in them. Priests had no authority over belief; they were officials whose duty was
to carry out the ritual. The state required only that the cult should be maintained and
that the existence of gods, as implied by this worship, should not be blatantly denied.
Plato does not propose to abolish or to reform the state religion, though in his old age
he would have liked to add a cult of the heavenly bodies as symbols of the beauty and
harmonious order of the universe, which, he believed, manifested the working of a
beneficent intelligence.

He uses the singular 'god' and the plural 'the gods' with an indifference startling
to the modern monotheist. For this reason the translation avoids the expression 'God,'
though the reason may be insufficient, since modern philosophers use the term with
astonishing latitude and often in senses which they neglect to define.

The words 'fiction,' 'fictitious,' are used to represent the Greek pseudos, *which*
has a much wider sense than our 'lie': it covers any statement describing events which
never in fact occurred, and so applies to all works of imagination, all fictitious narra-
tives ('stories') in myth or allegory, fable or parable, poetry or romance. As Plato does
not confuse fiction with falsehood or identify truth with literal statements of fact,
pseudos *should be rendered by 'fiction' or 'falsehood' according to the context, and*
sometimes by 'lie'. It can also mean 'error' when it corresponds to the passive verb
epseusthai = *'to be deceived' or 'mistaken' (as at 382 B 535 E).*

This chapter has been shortened by condensation and by omitting a number of
passages from the poets which Plato rejects as impious or immoral.

What is this education to be, then? Perhaps we shall hardly invent a system
better than the one which long experience has worked out, with its two
branches for the cultivation of the mind and of the body. And I suppose we
shall begin with the mind, before we start physical training.

Naturally.

Under that head will come stories;[1] and of these there are two kinds: some
are true, others fictitious. Both must come in, but we shall begin our educa-
tion with the fictitious kind.

I don't understand, he said.

Don't you understand, I replied, that we begin by telling children stories,
which, taken as a whole, are fiction, though they contain some truth? Such
story-telling begins at an earlier age than physical training; that is why I said
we should start with the mind.

You are right.

And the beginning, as you know, is always the most important part, espe-
cially in dealing with anything young and tender. That is the time when the
character is being moulded and easily takes any impress one may wish to
stamp on it.

Quite true.

Then shall we simply allow our children to listen to any stories that any-
one happens to make up, and so receive into their minds ideas often the very
opposite of those we shall think they ought to have when they are grown up?

[1]In a wide sense, tales, legends, myths, narratives in poetry or prose.

No, certainly not.

It seems, then, our first business will be to supervise the making of fables and legends, rejecting all which are unsatisfactory; and we shall induce nurses and mothers to tell their children only those which we have approved, and to think more of moulding their souls with these stories than they now do of rubbing their limbs to make them strong and shapely. Most of the stories now in use must be discarded.

What kind do you mean?

If we take the great ones, we shall see in them the pattern of all the rest, which are bound to be of the same stamp and to have the same effect.

No doubt; but which do you mean by the great ones?

The stories in Hesiod and Homer and the poets in general, who have at all times composed fictitious tales and told them to mankind.

Which kind are you thinking of, and what fault do you find in them?

The worst of all faults, especially if the story is ugly and immoral as well as false—misrepresenting the nature of gods and heroes, like an artist whose picture is utterly unlike the object he sets out to draw.

That is certainly a serious fault; but give me an example.

A signal instance of false invention about the highest matters is that foul story, which Hesiod repeats, of the deeds of Uranus and the vengeance of Cronos;[2] and then there is the tale of Cronos's doings and of his son's treatment of him. Even if such tales were true, I should not have supposed they should be lightly told to thoughtless young people. If they cannot be altogether suppressed, they should only be revealed in a mystery, to which access should be as far as possible restricted by requiring the sacrifice, not of a pig, but of some victim such as very few could afford.[3]

It is true: those stories are objectionable.

Yes, and not to be repeated in our commonwealth, Adeimantus. We shall not tell a child that, if he commits the foulest crimes or goes to any length in punishing his father's misdeeds, he will be doing nothing out of the way, but only what the first and greatest of the gods have done before him.

I agree; such stories are not fit to be repeated.

Nor yet any tales of warfare and intrigues and battles of gods against gods, which are equally untrue. If our future Guardians are to think it a disgrace to quarrel lightly with one another, we shall not let them embroider robes with the Battle of the Giants[4] or tell them of all the other feuds of gods and heroes with their kith and kin. If by any means we can make them believe that no one has ever had a quarrel with a fellow citizen and it is a sin to have one, that is the sort of thing our old men and women should tell children from the first; and as they grow older, we must make the poets write for them in the same strain. Stories like those of Hera being bound by her son, or of He-

[2]Hesiod, *Theogony*, 154 ff. A primitive myth of the forcing apart of Sky (Uranus) and Earth (Gaia) by their son Cronos, who mutilated his father. Zeus, again, took vengeance on his father Cronos for trying to destroy his children. These stories were sometimes cited to justify ill-treatment of parents.

[3]The usual sacrifice at the Eleusinian Mysteries was a pig, which was cheap. In a mystery unedifying legends might be given an allegorical interpretation, a method which had been applied to Homer since the end of the sixth century B.C.

[4]Such a robe was woven by maidens for the statue of Athena at the Great Panathenaea.

phaestus flung from heaven by his father for taking his mother's part when she was beaten, and all those battles of the gods in Homer, must not be admitted into our state, whether they be allegorical or not. A child cannot distinguish the allegorical sense from the literal, and the ideas he takes in at that age are likely to become indelibly fixed; hence the great importance of seeing that the first stories he hears shall be designed to produce the best possible effect on his character.

Yes, that is reasonable. But if we were asked which of these stories in particular are of the right quality, what should we answer?

I replied: You and I, Adeimantus, are not, for the moment, poets, but founders of a commonwealth. As such, it is not our business to invent stories ourselves, but only to be clear as to the main outlines to be followed by the poets in making their stories and the limits beyond which they must not be allowed to go.

True; but what are these outlines for any account they may give of the gods?

Of this sort, said I. A poet, whether he is writing epic, lyric, or drama, surely ought always to represent the divine nature as it really is. And the truth is that that nature is good and must be described as such.

Unquestionably.

Well, nothing that is good can be harmful; and if it cannot do harm, it can do no evil; and so it cannot be responsible for any evil.

I agree.

Again, goodness is beneficent, and hence the cause of well-being.

Yes.

Goodness, then, is not responsible for everything, but only for what is as it should be. It is not responsible for evil.[5]

Quite true.

It follows, then, that the divine, being good, is not, as most people say, responsible for everything that happens to mankind, but only for a small part; for the good things in human life are far fewer than the evil, and, whereas the good must be ascribed to heaven only, we must look elsewhere for the cause of evils.

I think that is perfectly true.

So we shall condemn as a foolish error Homer's description of Zeus as the 'dispenser of both good and ill.'[6] We shall disapprove when Pandarus' violation of oaths and treaties is said to be the work of Zeus and Athena, or when Themis and Zeus are said to have caused strife among the gods. Nor must we allow our young people to be told by Aeschylus that 'Heaven implants guilt in man, when his will is to destroy a house utterly.' If a poet writes of the sorrows of Niobe or the calamities of the house of Pelops or of the Trojan war, either he must not speak of them as the work of a god, or, if he does so, he must devise some such explanation as we are now requiring: he must say that what the god did was just and good, and the sufferers were the better for being chastised. One who pays a just penalty must not be called miserable, and his misery then laid at heaven's door. The poet will only be allowed to say that

[5]The words of Lachesis in the concluding myth (617 E) illustrate Plato's meaning.
[6]Some further instances from Homer are here omitted.

the wicked were miserable because they needed chastisement, and the punishment of heaven did them good. If our commonwealth is to be well-ordered, we must fight to the last against any member of it being suffered to speak of the divine, which is good, being responsible for evil. Neither young nor old must listen to such tales, in prose or verse. Such doctrine would be impious, self-contradictory, and disastrous to our commonwealth.

I agree, he said, and I would vote for a law to that effect.

Well then, that shall be one of our laws about religion. The first principle to which all must conform in speech or writing is that heaven is not responsible for everything, but only for what is good.

I am quite satisfied.

Now what of this for a second principle? Do you think of a god as a sort of magician who might, for his own purposes, appear in various shapes, now actually passing into a number of different forms, now deluding us into believing he has done so; or is his nature simple and of all things the least likely to depart from its proper form?

I cannot say offhand.

Well, if a thing passes out of its proper form, must not the change come either from within or from some outside cause?

Yes.

Is it not true, then, that things in the most perfect condition are the least affected by changes from outside? Take the effect on the body of food and drink or of exertion, or the effect of sunshine and wind on a plant: the healthiest and strongest suffer the least change. Again, the bravest and wisest spirit is least disturbed by external influence. Even manufactured things—furniture, houses, clothes—suffer least from wear and tear when they are well made and in good condition. So this immunity to change from outside is characteristic of anything which, thanks to art or nature or both, is in a satisfactory state.

That seems true.

But surely the state of the divine nature must be perfect in every way, and would therefore be the last thing to suffer transformations from any outside cause.

Yes.

Well then, would a god change or alter himself?

If he changes at all, it can only be in that way.

Would it be a change for the better or for the worse?

It could only be for the worse; for we cannot admit any imperfection in divine goodness or beauty.

True; and that being so, do you think, Adeimantus, that anyone, god or man, would deliberately make himself worse in any respect?

That is impossible.

Then a god cannot desire to change himself. Being as perfect as he can be, every god, it seems, remains simply and for ever in his own form.

That is the necessary conclusion.

If so, my friend, the poets must not tell us that 'the gods go to and fro among the cities of men, disguised as strangers of all sorts from far countries';

nor must they tell any of those false tales of Proteus and Thetis transforming themselves, or bring Hera on the stage in the guise of a priestess collecting alms for 'the life-giving children of Inachus, the river of Argos.'[7] Mothers, again, are not to follow these suggestions and scare young children with mischievous stories of spirits that go about by night in all sorts of outlandish shapes. They would only be blaspheming the gods and at the same time making cowards of their children.

No, that must not be allowed.

But are we to think that the gods, though they do not really change, trick us by some magic into believing that they appear in many different forms?

Perhaps.

What? said I; would a god tell a falsehood or act one by deluding us with an apparition?

I cannot say.

Do you not know that the true falsehood—if that is a possible expression—is a thing that all gods and men abominate?

What do you mean?

This, I replied: no one, if he could help it, would tolerate the presence of untruth in the most vital part of his nature concerning the most vital matters. There is nothing he would fear so much as to harbour falsehood in that quarter.

Still I do not understand.

Because you think I mean something out of the ordinary. All I mean is the presence of falsehood in the soul concerning reality. To be deceived about the truth of things and so to be in ignorance and error and to harbour untruth in the soul is a thing no one would consent to. Falsehood in that quarter is abhorred above everything.

It is indeed.

Well then, as I was saying, this ignorance in the soul which entertains untruth is what really deserves to be called the true falsehood; for the spoken falsehood is only the embodiment or image of a previous condition of the soul, not pure unadulterated falsity. Is it not so?

It is.

This real falsehood, then, is hateful to gods and men equally. But is the spoken falsehood always a hateful thing? Is it not sometimes helpful—in war, for instance, or as a sort of medicine to avert some fit of folly or madness that might make a friend attempt some mischief? And in those legends we were discussing just now, we can turn fiction to account; not knowing the facts about the distant past, we can make our fiction as good an embodiment of truth as possible.

Yes, that is so.

Well, in which of these ways would falsehood be useful to a god? We cannot think of him as embodying truth in fiction for lack of information about the past.

No, that would be absurd.

So there is no room in his case for poetical inventions. Would he need to tell untruths because he has enemies to fear?

[7]The allusions are to the *Odyssey* and to a lost play of Aeschylus.

Of course not.

Or friends who are mad or foolish?

No; a fool or a madman could hardly enjoy the friendship of the gods.

Gods, then, have no motive for lying. There can be no falsehood of any sort in the divine nature.

None.

We conclude, then, that a god is a being of entire simplicity and truthfulness in word and in deed. In himself he does not change, nor does he delude others, either in dreams or in waking moments, by apparitions or oracles or signs.

I agree, after all you have said.

You will assent, then, to this as a second principle to guide all that is to be said or written about the gods: that they do not transform themselves by any magic or mislead us by illusions or lies. For all our admiration of Homer, we shall not approve his story of the dream Zeus sent to Agamemnon;[8] nor yet those lines of Aeschylus where Thetis tells how Apollo sang at her wedding:

> Boding good fortune for my child, long life
> From sickness free, in all things blest by heaven,
> His song, so crowned with triumph, cheered my heart.
> I thought those lips divine, with prophecy
> Instinct, could never lie. But he, this guest,
> Whose voice so rang with promise at the feast,
> Even he, has slain my son.

If a poet writes of the gods in this way, we shall be angry and refuse him the means to produce his play. Nor shall we allow such poetry to be used in educating the young, if we mean our Guardians to be godfearing and to reproduce the divine nature in themselves so far as man may.

I entirely agree with your principles, he said, and I would have them observed as laws.

So far, then, as religion is concerned, we have settled what sorts of stories about the gods may, or may not, be told to children who are to hold heaven and their parents in reverence and to value good relations with one another.

Yes, he said; and I believe we have settled right.

We also want them to be brave. So the stories they hear should be such as to make them unafraid of death. A man with that fear in his heart cannot be brave, can he?

Surely not.

And can a man be free from that fear and prefer death in battle to defeat and slavery, if he believes in a world below which is full of terrors?

No.

Here again, then, our supervision will be needed. The poets must be told to speak well of that other world. The gloomy descriptions they now give must be forbidden, not only as untrue, but as injurious to our future warriors. We shall strike out all lines like these:

[8]*Iliad* ii. 1 ff.

I would rather be on earth as the hired servant of another, in the house of a landless man with little to live on, than be king over all the dead.[9]

or these:

Alack, there is, then, even in the house of Death a spirit or a shade; but the wits dwell in it no more.[10]

We shall ask Homer and the poets in general not to mind if we cross out all passages of this sort. If most people enjoy them as good poetry, that is all the more reason for keeping them from children or grown men who are to be free, fearing slavery more than death.

I entirely agree.

We must also get rid of all that terrifying language, the very sound of which is enough to make one shiver: 'loathsome Styx,' 'the River of Wailing,' 'infernal spirits,' 'anatomies,' and so on. For other purposes such language may be well enough; but we are afraid that fever consequent upon such shivering fits may melt down the fine-tempered spirit of our Guardians. So we will have none of it; and we shall encourage writing in the opposite strain.

Clearly.

Another thing we must banish is the wailing and lamentations of the famous heroes. For this reason: if two friends are both men of high character, neither of them will think that death has any terrors for his comrade; and so he will not mourn for his friend's sake, as if something terrible had befallen him.

No.

We also believe that such a man, above all, possesses within himself all that is necessary for a good life and is least dependent on others, so that he has less to fear from the loss of a son or brother or of his wealth or any other possession. When such misfortune comes, he will bear it patiently without lamenting.

True.

We shall do well, then, to strike out descriptions of the heroes bewailing the dead, and make over such lamentations to women (and not to women of good standing either) and to men of low character, so that the Guardians we are training for our country may disdain to imitate them.

Quite right.

Once more, then, we shall ask Homer and the other poets not to represent Achilles, the son of a goddess, as 'tossing from side to side, now on his face, now on his back,' and then as rising up and wandering distractedly on the seashore, or pouring ashes on his head with both hands, with all those tears and wailings the poet describes; nor to tell how Priam, who was near akin to the gods, 'rolled in the dung as he made entreaty, calling on each man by name.'[11] Still more earnestly shall we ask them not to represent gods as lamenting, or at any rate not to dare to misrepresent the highest god by making him

[9]Spoken by the ghost of Achilles, *Od.* xi. 489.
[10]Spoken by Achilles when the ghost of Patroclus eludes his embrace, *Iliad* xxiii. 103. Other lines from Homer describing the misery of the dead are omitted.
[11]When Priam saw Achilles maltreating the body of Hector, *Iliad* xxii. 414.

say: 'Woe is me that Sarpedon, whom I love above all men, is fated to die at the hands of Patroclus.' For if our young men take such unworthy descriptions seriously instead of laughing at them, they will hardly feel themselves, who are but men, above behaving in that way or repress any temptation to do so. They would not be ashamed of giving way with complaints and outcries on every trifling occasion; and that would be contrary to the principle we have deduced and shall adhere to, until someone can show us a better.

It would.

Again, our Guardians ought not to be overmuch given to laughter. Violent laughter tends to provoke an equally violent reaction. We must not allow poets to describe men of worth being overcome by it; still less should Homer speak of the gods giving way to 'unquenchable laughter' at the sight of Hephaestus 'bustling from room to room.' That will be against your principles.

Yes, if you choose to call them mine.

Again, a high value must be set upon truthfulness. If we were right in saying that gods have no use for falsehood and it is useful to mankind only in the way of a medicine, obviously a medicine should be handled by no one but a physician.

Obviously.

If anyone, then, is to practise deception, either on the country's enemies or on its citizens, it must be the Rulers of the commonwealth, acting for its benefit; no one else may meddle with this privilege. For a private person to mislead such Rulers we shall declare to be a worse offence than for a patient to mislead his doctor or an athlete his trainer about his bodily condition, or for a seaman to misinform his captain about the state of the ship or of the crew. So, if anyone else in our commonwealth 'of all that practise crafts, physician, seer, or carpenter,' is caught not telling the truth, the Rulers will punish him for introducing a practice as fatal and subversive in a state as it would be in a ship.

It would certainly be as fatal, if action were suited to the word.

Next, our young men will need self-control; and for the mass of mankind that chiefly means obeying their governors, and themselves governing their appetite for the pleasures of eating and drinking and sex. Here again we shall disapprove of much that we find in Homer.[12]

I agree.

Whereas we shall allow the poets to represent any examples of self-control and fortitude on the part of famous men, and admit such lines as these: 'Odysseus smote his breast, chiding his heart: Endure, my heart; thou has borne worse things than these.'

Yes, certainly.

Nor again must these men of ours be lovers of money, or ready to take bribes. They must not hear that 'gods and great princes may be won by gifts.'

No, that sort of thing cannot be approved.

If it were not for my regard for Homer, I should not hesitate to call it downright impiety to make Achilles say to Apollo: 'Thou has wronged me,

[12]In order to save space, illustrations from Homer of the self-indulgence of heroes and gods and of disrespect for rulers are omitted here and below.

thou deadliest of gods; I would surely requite thee, if I had but the power.'
And all those stories of Achilles dragging Hector round the tomb of Patroclus
and slaughtering captives on the funeral pyre we shall condemn as false, and
not let our Guardians believe that Achilles, who was the son of a goddess and
of the wise Peleus, third in descent from Zeus, and the pupil of the sage Chi-
ron, was so disordered that his heart was a prey to two contrary maladies,
mean covetousness and arrogant contempt of gods and men.

You are right.

We have now distinguished the kinds of stories that may and may not be told
about gods and demigods, heroes, and the world below. There remains the lit-
erature concerned with human life.

Clearly.

We cannot lay down rules for that at our present stage.

Why not?

Because, I suspect, we shall find both poets and prose-writers guilty of the
most serious misstatements about human life, making out that wrongdoers are
often happy and just men miserable; that injustice pays, if not detected; and
that my being just is to another man's advantage, but a loss to myself. We shall
have to prohibit such poems and tales and tell them to compose others in the
contrary sense. Don't you think so?

I am sure of it.

Well, as soon as you admit that I am right there, may I not claim that we
shall have reached agreement on the subject of all this inquiry?

That is a fair assumption.

Then we must postpone any decision as to how the truth is to be told about
human life, until we have discovered the real nature of justice and proved that
it is intrinsically profitable to its possessor, no matter what reputation he may
have in the eyes of the world.

That is certainly true.

How Representation in Art Is Related to Truth (Book X.595A–608B)

*Readers who take this chapter as stating, for its own sake, an aesthetic theory of the
nature of art are surprised and shocked: the point of view seems as perverse, and even
stupid, as Tolstoy's in* What is Art? *The main object of attack, however, is the claim,
currently made by sophists and professional reciters of the Homeric poems,[13] that
Homer in particular, and in a less degree the tragedians, were masters of all techni-
cal knowledge, from wagon-building or chariot-driving to strategy, and also moral and
religious guides to the conduct of life.[14] As such, the poet becomes the rival of the
philosopher as conceived by Plato, and the study of poetry an alternative to the severe
intellectual training of the Academy. If wisdom is to be gained only through knowl-
edge of the real world of Forms disclosed by Dialectic, the claim that the poet can edu-*

[13]Such as Ion in Plato's dialogue of that name, reprinted in this volume.
[14]In Xenophon's *Symposium*, iii. 5, Niceratus says his father made him learn all Homer by heart in
order that he might become a good man.

cate mankind to virtue must be as hollow as the pretence that the artist knows all about shoemaking because he can paint a life-like picture of a shoemaker. How much knowledge of ultimate values does the poet need in order to paint in words his pictures of human life?

The painter is taken first by way of illustration. A picture of a bed is a two-dimensional representation of the appearance of a solid object seen at a certain angle. The object itself is only a particular bed, which, as a part of the material world, is not a wholly real thing, since it comes into being and perishes and is perpetually changing; it belongs to the realm of Becoming characterized in Chapter XIX. This actual bed, however, is nearer to reality than the picture, because it is one of many embodiments of the essential nature common to all beds. Beds can be made of wood or iron or canvas and may vary indefinitely in size, shape, colour, etc. But they cannot be called beds at all unless they serve the purpose of a bed, a thing designed to be slept on. This purpose, however hard to define, may be called the essence or Form of Bed, and in Plato's view it is the unique and unvarying reality which must be, however imperfectly, embodied in any bed, and is in one sense the meaning of the word 'Bed.' (Plato speaks here of this essential Bed as 'in the nature of things,' i.e. in the real world of Forms, and as made by a god, though the Forms are elsewhere described as not made by anyone, but eternal, and there is a difficulty in supposing eternal Forms of the products of human workmanship. These points, however, need not be pressed. The bed was perhaps chosen for illustrative purposes because beds are obviously made by a practical craftsman, whom Plato wishes to contrast with the fine artist, whereas the maker of natural objects, the divine Demiurge of the Timaeus, is a mythical figure who could not be introduced without a long explanation.) The upshot is that the artist's picture of a bed is at two removes from the essential Form. It is only as it were a mirror-image of a sensible thing, which itself is only one embodiment (with many accidental features) of the real Form, the object of knowledge.

Poetry is like a picture in words, a representation of life. However skilfully executed, it is no evidence that the poet really possessed the knowledge required for the right conduct of actual life. This knowledge is not to be gained by studying his portraits of heroic characters, any more than we can learn how to drive a chariot or conduct a campaign from his descriptions of a chariot-race or of the Trojan war. Socrates' examination of the poets had convinced him that they worked, not with conscious intelligence, but from inspiration, like seers and oracle-mongers who do not understand the meaning of the fine language they use (Apology, 22 B).

In this chapter mimesis has a wider sense than dramatic impersonation: the nearest English word is 'representation,' applicable to many forms of fine art. The usual rendering 'imitation' is misleading. We do not say that Garrick, still less that Shakespeare, imitated the character of Hamlet; or that Raphael imitated Julius II; or that the Passion music imitates religious emotion. In all these cases mimesis would be used. The substantive mimetes can be rendered in this context by 'artist.' On the other hand, mimesis does also mean 'imitation,' and this encourages the suggestion that tragic acting is on a level with mimicry and that fine art in general is no more than a copying of external appearances. The view that a work of art is an image or likeness (eikon) of some original, or holds a mirror up to nature, became prominent towards the end of the fifth century together with the realistic drama of Euripides and the illusionistic painting of Zeuxis. Plato's attack adopts this theory. The art which claims to be 'realistic' is, in his view, as far as possible from reality.

Indeed, I continued, our commonwealth has many features which make me think it was based on very sound principles, especially our rule not on any account to admit the poetry of dramatic representation.[15] Now that we have distinguished the several parts of the soul, it seems to me clearer than ever that such poetry must be firmly excluded.

What makes you say so?

Between ourselves—for you will not denounce me to the tragedians and the other dramatists—poetry of that sort seems to be injurious to minds which do not possess the antidote in a knowledge of its real nature.

What have you in mind?

I must speak out, in spite of a certain affection and reverence I have had from a child for Homer, who seems to have been the original master and guide of all this imposing company of tragic poets.[16] However, no man must be honoured above the truth; so, as I say, I must speak my mind.

Do, by all means.

Listen then, or rather let me ask you a question. Can you tell me what is meant by representation in general? I have no very clear notion myself.

So you expect me to have one!

Why not? It is not always the keenest eye that is the first to see something.

True; but when you are there I should not be very desirous to tell what I saw, however plainly. You must use your own eyes.

Well then, shall we proceed as usual and begin by assuming the existence of a single essential nature or Form for every set of things which we call by the same name? Do you understand?

I do.

Then let us take any set of things you choose. For instance there are any number of beds or of tables, but only two Forms, one of Bed and one of Table.

Yes.

And we are in the habit of saying that the craftsman, when he makes the beds or tables we use or whatever it may be, has before his mind the Form[17] of one or other of these pieces of furniture. The Form itself is, of course, not the work of any craftsman. How could it be?

It could not.

Now what name would you give to a craftsman who can produce all the things made by every sort of workman?

He would need to have very remarkable powers!

Wait a moment, and you will have even better reason to say so. For, besides producing any kind of artificial thing, this same craftsman can create all plants and animals, himself included, and earth and sky and gods and the heavenly bodies and all the things under the earth in Hades.

[15]At 398 A Plato seemed to exclude all dramatic poetry because this contains no narrative but involves the impersonation (*mimesis*) of all types of character, good or bad; whereas epic, for instance, can limit speeches in character to the representation of virtuous or heroic types. He will now argue that all poetry and other forms of art are essentially *mimesis*. The meaning of the word is obviously enlarged where he speaks just below of 'representation in general.'

[16]The plots of Greek tragedy were normally stories borrowed from epic poetry. Hence Homer was spoken of as the first tragic poet.

[17]'Form' does not mean 'shape,' but the essential properties which constitute what the thing, by definition, is.

That sounds like a miraculous feat of virtuosity.

Are you incredulous? Tell me, do you think there could be no such craftsman at all, or that there might be someone who could create all these things in one sense, though not in another?[18] Do you not see that you could do it yourself, in a way?

In what way, I should like to know.

There is no difficulty; in fact there are several ways in which the thing can be done quite quickly. The quickest perhaps would be to take a mirror and turn it round in all directions. In a very short time you could produce sun and stars and earth and yourself and all the other animals and plants and lifeless objects which we mentioned just now.

Yes, in appearance, but not the actual things.

Quite so; you are helping out my argument. My notion is that a painter is a craftsman of that kind. You may say that the things he produces are not real; but there is a sense in which he too does produce a bed.

Yes, the appearance of one.

And what of the carpenter? Were you not saying just now that he only makes a particular bed, not what we call the Form or essential nature of Bed?

Yes, I was.

If so, what he makes is not the reality, but only something that resembles it. It would not be right to call the work of a carpenter or of any other handicraftsman a perfectly real thing, would it?

Not in the view of people accustomed to thinking on these lines.[19]

We must not be surprised, then, if even an actual bed is a somewhat shadowy thing as compared with reality.

True.

Now shall we make use of this example to throw light on our question as to the true nature of this artist who represents things? We have here three sorts of bed: one which exists in the nature of things and which, I imagine, we could only describe as a product of divine workmanship; another made by the carpenter; and a third by the painter. So the three kinds of bed belong respectively to the domains of these three: painter, carpenter, and god.

Yes.

Now the god made only one ideal or essential Bed, whether by choice or because he was under some necessity not to make more than one; at any rate two or more were not created, nor could they possibly come into being.

Why not?

Because, if he made even so many as two, then once more a single ideal Bed would make its appearance, whose character those two would share; and that one, not the two, would be the essential Bed. Knowing this, the god, wish-

[18]The divine Demiurge of the creation-myth in the *Timaeus* is pictured as fashioning the whole visible world after the likeness of the eternal Forms, which he does not create but uses as models. He is thus the maker of natural objects, corresponding to the carpenter who makes artificial objects; and both, as makers of actual things, are superior to the painter or poet, who makes all things only 'in a way,' by creating mere semblances like images in a mirror.

[19]Familiar with the Platonic doctrine, as opposed to current materialism, which regards the beds we sleep on as real things and the Platonic Form as a mere 'abstraction' or notion existing only in our minds.

ing to be the real maker of a real Bed, not a particular manufacturer of one particular bed, created one which is essentially unique.

So it appears.

Shall we call him, then, the author of the true nature of Bed, or something of that sort?

Certainly he deserves the name, since all his works constitute the real nature of things.

And we may call the carpenter the manufacturer of a bed?

Yes.

Can we say the same of the painter?

Certainly not.

Then what is he, with reference to a bed?

I think it would be fairest to describe him as the artist who represents the things which the other two make.

Very well, said I; so the work of the artist is at the third remove from the essential nature of the thing?

Exactly.

The tragic poet, too, is an artist who represents things; so this will apply to him: he and all other artists are, as it were, third in succession from the throne of truth.

Just so.

We are in agreement, then, about the artist. But now tell me about our painter: which do you think he is trying to represent—the reality that exists in the nature of things, or the products of the craftsman?

The products of the craftsman.

As they are, or as they appear? You have still to draw that distinction.[20]

How do you mean?

I mean: you may look at a bed or any other object from straight in front or slantwise or at any angle. Is there then any difference in the bed itself, or does it merely look different?

It only looks different.

Well, that is the point. Does painting aim at reproducing any actual object as it is, or the appearance of it as it looks? In other words, is it a representation of the truth or of a semblance?

Of a semblance.

The art of representation, then, is a long way from reality; and apparently the reason why there is nothing it cannot reproduce is that it grasps only a small part of any object, and that only an image. Your painter, for example, will paint us a shoemaker, a carpenter, or other workman, without understanding any one of their crafts;[21] and yet, if he were a good painter, he might deceive a child or a simple-minded person into thinking his picture was a real carpenter, if he showed it them at some distance.

[20]The distinction is needed to exclude another possible sense of *mimesis*, the production of a complete replica.
[21]Knowledge of carpentry is the essence of the carpenter, what makes him a carpenter. The painter could not reproduce this knowledge in his picture, even if he possessed it himself. This may sound absurd as an objection to art, but Plato is thinking rather of the application to the poet, for whom it was claimed that he both possessed technical and moral knowledge and reproduced it in his work.

No doubt.

But I think there is one view we should take in all such cases. Whenever someone announces that he has met with a person who is master of every trade and knows more about every subject than any specialist, we should reply that he is a simple fellow who has apparently fallen in with some illusionist and been tricked into thinking him omniscient, because of his own inability to discriminate between knowledge and ignorance and the representation of appearances.

Quite true.

Then it is now time to consider the tragic poets and their master, Homer, because we are sometimes told that they understand not only all technical matters but also all about human conduct, good or bad, and about religion; for, to write well, a good poet, so they say, must know his subject; otherwise he could not write about it. We must ask whether these people have not been deluded by meeting with artists who can represent appearances, and in contemplating the poets' work have failed to see that it is at the third remove from reality, nothing more than semblances, easy to produce with no knowledge of the truth. Or is there something in what they say? Have the good poets a real mastery of the matters on which the public thinks they discourse so well?

It is a question we ought to look into.

Well then, if a man were able actually to do the things he represents as well as to produce images of them, do you believe he would seriously give himself up to making these images and take that as a completely satisfying object in life? I should imagine that, if he had a real understanding of the actions he represents, he would far sooner devote himself to performing them in fact. The memorials he would try to leave after him would be noble deeds, and he would be more eager to be the hero whose praises are sung than the poet who sings them.

Yes, I agree; he would do more good in that way and win a greater name.

Here is a question, then, that we may fairly put to Homer or to any other poet. We will leave out of account all mere matters of technical skill: we will not ask them to explain, for instance, why it is that, if they have a knowledge of medicine and not merely the art of reproducing the way physicians talk, there is no record of any poet, ancient or modern, curing patients and bequeathing his knowledge to a school of medicine, as Asclepius did. But when Homer undertakes to tell us about matters of the highest importance, such as the conduct of war, statesmanship, or education, we have a right to inquire into his competence. 'Dear Homer,' we shall say, 'we have defined the artist as one who produces images at the third remove from reality. If your knowledge of all that concerns human excellence was really such as to raise you above him to the second rank, and you could tell what courses of conduct will make men better or worse as individuals or as citizens, can you name any country which was better governed thanks to your efforts? Many states, great and small, have owed much to a good lawgiver, such as Lycurgus at Sparta, Charondas in Italy and Sicily, and our own Solon. Can you tell us of any that acknowledges a like debt to you?'

I should say not, Glaucon replied. The most devout admirers of Homer make no such claim.

Well, do we hear of any war in Homer's day being won under his command or thanks to his advice?

No.

Or of a number of ingenious inventions and technical contrivances, which would show that he was a man of practical ability like Thales of Miletus or Anacharsis the Scythian?[22]

Nothing of the sort.

Well, if there is no mention of public services, do we hear of Homer in his own lifetime presiding, like Pythagoras, over a band of intimate disciples who loved him for the inspiration of his society and handed down a Homeric way of life, like the way of life which the Pythagoreans called after their founder and which to this day distinguishes them from the rest of the world?

No; on the contrary, Homer's friend with the absurd name, Creophylus,[23] would look even more absurd when considered as a product of the poet's training, if the story is true that he completely neglected Homer during his lifetime.

Yes, so they say. But what do you think, Glaucon? If Homer had really possessed the knowledge qualifying him to educate people and make them better men, instead of merely giving us a poetical representation of such matters, would he not have attracted a host of disciples to love and revere him? After all, any number of private teachers like Protagoras of Abdera and Prodicus of Ceos[24] have succeeded in convincing their contemporaries that they will never be fit to manage affairs of state or their own households unless these masters superintend their education; and for this wisdom they are so passionately admired that their pupils are all but ready to carry them about on their shoulders. Can we suppose that Homer's contemporaries, or Hesiod's, would have left them to wander about reciting their poems, if they had really been capable of helping their hearers to be better men? Surely they would sooner have parted with their money and tried to make the poets settle down at home; or failing that, they would have danced attendance on them wherever they went, until they had learnt from them all they could.

I believe you are quite right, Socrates.

We may conclude, then, that all poetry, from Homer onwards, consists in representing a semblance of its subject, whatever it may be, including any kind of human excellence, with no grasp of the reality. We were speaking just now of the painter who can produce what looks like a shoemaker to the spectator who, being as ignorant of shoemaking as he is himself, judges only by form and colour. In the same way the poet, knowing nothing more than how to represent appearances, can paint in words his picture of any craftsman so as to impress an audience which is equally ignorant and judges only by the form of expression; the inherent charm of metre, rhythm, and musical setting is enough

[22]Thales (early sixth cent.) made a fortune out of a corner in oil-mills when his knowledge of the stars enabled him to predict a large olive harvest, thus proving that wise men could be rich if they chose (Aristotle, *Politics*, i. 11). Anacharsis was said to have invented the anchor and the potter's wheel (Diog. Laert. i. 105).

[23]Creophylus' name is supposed to be derived from two words meaning 'flesh' and 'tribe.' He is said to have been an epic poet from Chios.

[24]Two of the most famous Sophists of the fifth century. Plato's *Protagoras* gives a vivid picture of them on a visit to a rich patron at Athens.

to make them think he has discoursed admirably about generalship or shoe-making or any other technical subject. Strip what the poet has to say of its poetical colouring, and I think you must have seen what it comes to in plain prose. It is like a face which was never really handsome, when it has lost the fresh bloom of youth.

Quite so.

Here is a further point, then. The artist, we say, this maker of images, knows nothing of the reality, but only the appearance. But that is only half the story. An artist can paint a bit and bridle, while the smith and the leather-worker can make them. Does the painter understand the proper form which bit and bridle ought to have? Is it not rather true that not even the craftsmen who make them know that, but only the horseman who understands their use?[25]

Quite true.

May we not say generally that there are three arts concerned with any object—the art of using it, the art of making it, and the art of representing it?

Yes.

And that the excellence or beauty or rightness of any implement or living creature or action has reference to the use for which it is made or designed by nature?[26]

Yes.

It follows, then, that the user must know most about the performance of the thing he uses and must report on its good or bad points to the maker. The flute-player, for example, will tell the instrument-maker how well his flutes serve the player's purpose, and the other will submit to be instructed about how they should be made. So the man who uses any implement will speak of its merits and defects with knowledge, whereas the maker will take his word and possess no more than a correct belief, which he is obliged to obtain by lis-tening to the man who knows.

Quite so.

But what of the artist? Has he either knowledge or correct belief? Does he know from direct experience of the subjects he portrays whether his repre-sentations are good and right or not? Has he even gained a correct belief by being obliged to listen to someone who does know and can tell him how they ought to be represented?

No, he has neither.

If the artist, then, has neither knowledge nor even a correct belief about the soundness of his work, what becomes of the poet's wisdom in respect of the subjects of his poetry?

It will not amount to much.

And yet he will go on with his work, without knowing in what way any of his representations is sound or unsound. He must, apparently, be repro-

[25]In the *Parmenides* (127 A) Plato's half-brother Antiphon, who had transferred his interest from philosophy to horses, is discovered instructing a smith about making a bit. Ancient craftsmen were far less specialized than ours. A blacksmith and a cobbler to-day might need instructions from a jockey.

[26]This recalls the association of a thing's peculiar excellence or 'virtue' with its function, 352 D.

ducing only what pleases the taste or wins the approval of the ignorant multitude.[27]

Yes, what else can he do?

We seem, then, so far to be pretty well agreed that the artist knows nothing worth mentioning about the subjects he represents, and that art is a form of play, not to be taken seriously. This description, moreover, applies above all to tragic poetry, whether in epic or dramatic form.

Exactly.[28]

Dramatic Poetry Appeals to the Emotions, Not to the Reason

The psychological objections to poetry in this and the following chapter are based on the earlier division of the soul into three parts, and apply especially to the drama and the element of dramatic impersonation in epic poetry. The appeal of dramatic poetry is not to the reason but to a lower part, the emotions, which, like the senses, are subject to illusions. As optical and other such illusions can be corrected by the calculating and reflective part (logistikon) *which ascertains the true facts by measurement, so illusory exaggerations of feeling should be corrected by reflection. But the dramatist is concerned rather to rouse sympathetic emotion than to check its excesses, and while we enter into the joys or sorrows of a hero on the stage, the reason is held in abeyance. Thus drama is as far removed as visual art from true reality and from wisdom.*

But now look here, said I; the content of this poetical representation is something at the third remove from reality, is it not?

Yes.

On what part of our human nature, then, does it produce its effect?

What sort of part do you mean?

Let me explain by an analogy. An object seen at a distance does not, of course, look the same size as when it is close at hand; a straight stick looks bent when part of it is under water; and the same thing appears concave or convex to an eye misled by colours. Every sort of confusion like these is to be found in our minds; and it is this weakness in our nature that is exploited, with a quite magical effect, by many tricks of illusion, like scene-painting and conjuring.

True.

But satisfactory means have been found for dispelling these illusions by measuring, counting, and weighing. We are no longer at the mercy of apparent differences of size and quantity and weight; the faculty which has done the counting and measuring or weighing takes control instead. And this can only be the work of the calculating or reasoning element in the soul.

[27]Living in the world of appearances, the poet reproduces only 'the many conventional notions of the mass of mankind about what is beautiful or honourable or just' (479 D).

[28]It should now be clear that this chapter is not concerned with aesthetic criticism, but with extravagant claims for the poets as moral teachers. It may leave the impression that Plato has been irritated by some contemporary controversy, and is overstating his case with a slightly malicious delight in paradox.

True.

And when this faculty has done its measuring and announced that one quantity is greater than, or equal to, another, we often find that there is an appearance which contradicts it. Now, as we have said, it is impossible for the same part of the soul to hold two contradictory beliefs at the same time. Hence the part which agrees with the measurements must be a different part from the one which goes against them; and its confidence in measurement and calculation is a proof of its being the highest part; the other which contradicts it must be an inferior one.

It must.

This, then, was the conclusion I had in view when I said that paintings and works of art in general are far removed from reality, and that the element in our nature which is accessible to art and responds to its advances is equally far from wisdom. The offspring of a connexion thus formed on no true or sound basis must be as inferior as the parents. This will be true not only of visual art, but of art addressed to the ear, poetry as we call it.

Naturally.

Then, instead of trusting merely to the analogy from painting, let us directly consider that part of the mind to which the dramatic element in poetry appeals, and see how much claim it has to serious worth. We can put the question in this way. Drama, we say, represents the acts and fortunes of human beings. It is wholly concerned with what they do, voluntarily or against their will, and how they fare, with the consequences which they regard as happy or otherwise, and with their feelings of joy and sorrow in all these experiences. That is all, is it not?

Yes.

And in all these experiences has a man an undivided mind? Is there not an internal conflict which sets him at odds with himself in his conduct, much as we were saying that the conflict of visual impressions leads him to make contradictory judgements? However, I need not ask that question; for, now I come to think of it, we have already agreed[29] that innumerable conflicts of this sort are constantly occurring in the mind. But there is a further point to be considered now. We have said[30] that a man of high character will bear any stroke of fortune, such as the loss of a son or of anything else he holds dear, with more equanimity than most people. We may now ask: will he feel no pain, or is that impossible? Will he not rather observe due measure in his grief?

Yes, that is nearer the truth.

Now tell me: will he be more likely to struggle with his grief and resist it when he is under the eyes of his fellows or when he is alone?

He will be far more restrained in the presence of others.

Yes; when he is by himself he will not be ashamed to do and say much that he would not like anyone to see or hear.

Quite so.

What encourages him to resist his grief is the lawful authority of reason, while the impulse to give way comes from the feeling itself; and, as we said,

[29]In the analysis of the conflict of motives at 439 c ff., p. 136.
[30]At 387 D, p. 77.

the presence of contradictory impulses proves that two distinct elements in his nature must be involved. One of them is law-abiding, prepared to listen to the authority which declares that it is best to bear misfortune as quietly as possible without resentment, for several reasons: it is never certain that misfortune may not be a blessing; nothing is gained by chafing at it; nothing human is matter for great concern; and, finally, grief hinders us from calling in the help we most urgently need. By this I mean reflection on what has happened, letting reason decide on the best move in the game of life that the fall of the dice permits. Instead of behaving like a child who goes on shrieking after a fall and hugging the wounded part, we should accustom the mind to set itself at once to raise up the fallen and cure the hurt, banishing lamentation with a healing touch.

Certainly that is the right way to deal with misfortune.

And if, as we think, the part of us which is ready to act upon these reflections is the highest, that other part which impels us to dwell upon our sufferings and can never have enough of grieving over them is unreasonable, craven, and faint-hearted.

Yes.

Now this fretful temper gives scope for a great diversity of dramatic representation; whereas the calm and wise character in its unvarying constancy is not easy to represent, nor when represented is it readily understood, especially by a promiscuous gathering in a theatre, since it is foreign to their own habit of mind. Obviously, then, this steadfast disposition does not naturally attract the dramatic poet, and his skill is not designed to find favour with it. If he is to have a popular success, he must address himself to the fretful type with its rich variety of material for representation.

Obviously.

We have, then, a fair case against the poet and we may set him down as the counterpart of the painter, whom he resembles in two ways: his creations are poor things by the standard of truth and reality, and his appeal is not to the highest part of the soul, but to one which is equally inferior. So we shall be justified in not admitting him into a well-ordered commonwealth, because he stimulates and strengthens an element which threatens to undermine the reason. As a country may be given over into the power of its worst citizens while the better sort are ruined, so, we shall say, the dramatic poet sets up a vicious form of government in the individual soul: he gratifies that senseless part which cannot distinguish great and small, but regards the same things as now one, now the other; and he is an image-maker whose images are phantoms far removed from reality.

Quite true.

The Effect of Dramatic Poetry on Character

A further psychological objection is that dramatic poetry, tragic or comic, by encouraging the sympathetic indulgence of emotions which we are ashamed to give way to in our own lives, undermines the character. If poetry cannot be defended from this charge, it must be restricted to celebrating the praises of the gods and of good men.

But, I continued, the heaviest count in our indictment is still to come. Dramatic poetry has a most formidable power of corrupting even men of high character, with a few exceptions.

Formidable indeed, if it can do that.

Let me put the case for you to judge. When we listen to some hero in Homer or on the tragic stage moaning over his sorrows in a long tirade, or to a chorus beating their breasts as they chant a lament, you know how the best of us enjoy giving ourselves up to follow the performance with eager sympathy. The more a poet can move our feelings in this way, the better we think him. And yet when the sorrow is our own, we pride ourselves on being able to bear it quietly like a man, condemning the behaviour we admired in the theatre as womanish. Can it be right that the spectacle of a man behaving as one would scorn and blush to behave oneself should be admired and enjoyed, instead of filling us with disgust?

No, it really does not seem reasonable.

It does not, if you reflect that the poet ministers to the satisfaction of that very part of our nature whose instinctive hunger to have its fill of tears and lamentations is forcibly restrained in the case of our own misfortunes. Meanwhile the noblest part of us, insufficiently schooled by reason or habit, has relaxed its watch over these querulous feelings, with the excuse that the sufferings we are contemplating are not our own and it is no shame to us to admire and pity a man with some pretensions to a noble character, though his grief may be excessive. The enjoyment itself seems a clear gain, which we cannot bring ourselves to forfeit by disdaining the whole poem. Few, I believe, are capable of reflecting that to enter into another's feelings must have an effect on our own: the emotions of pity our sympathy has strengthened will not be easy to restrain when we are suffering ourselves.

That is very true.

Does not the same principle apply to humour as well as to pathos? You are doing the same thing if, in listening at a comic performance or in ordinary life to buffooneries which you would be ashamed to indulge in yourself, you thoroughly enjoy them instead of being disgusted with their ribaldry. There is in you an impulse to play the clown, which you have held in restraint from a reasonable fear of being set down as a buffoon; but now you have given it rein, and by encouraging its impudence at the theatre you may be unconsciously carried away into playing the comedian in your private life. Similar effects are produced by poetic representation of love and anger and all those desires and feelings of pleasure or pain which accompany our every action. It waters the growth of passions which should be allowed to wither away and sets them up in control, although the goodness and happiness of our lives depend on their being held in subjection.

I cannot but agree with you.

If so, Glaucon, when you meet with admirers of Homer who tell you that he has been the educator of Hellas and that on questions of human conduct and culture he deserves to be constantly studied as a guide by whom to regulate your whole life, it is well to give a friendly hearing to such people, as entirely well-meaning according to their lights, and you may acknowledge Homer to be the first and greatest of the tragic poets; but you must be quite

sure that we can admit into our commonwealth only the poetry which celebrates the praises of the gods and of good men. If you go further and admit the honeyed muse in epic or in lyric verse, then pleasure and pain will usurp the sovereignty of law and of the principles always recognized by common consent as the best.

Quite true.

So now, since we have recurred to the subject of poetry, let this be our defence: it stands to reason that we could not but banish such an influence from our commonwealth. But, lest poetry should convict us of being harsh and unmannerly, let us tell her further that there is a long-standing quarrel between poetry and philosophy. There are countless tokens of this old antagonism, such as the lines which speak of 'the cur which at his master yelps,' or 'one mighty in the vain talk of fools' or 'the throng of all-too-sapient heads,' or 'subtle thinkers all in rags.'[31] None the less, be it declared that, if the dramatic poetry whose end is to give pleasure can show good reason why it should exist in a well-governed society, we for our part should welcome it back, being ourselves conscious of its charm; only it would be a sin to betray what we believe to be the truth. You too, my friend, must have felt this charm, above all when poetry speaks through Homer's lips.

I have indeed.

It is fair, then, that before returning from exile poetry should publish her defence in lyric verse or some other measure; and I suppose we should allow her champions who love poetry but are not poets to plead for her in prose, that she is no mere source of pleasure but a benefit to society and to human life. We shall listen favourably; for we shall clearly be the gainers, if that can be proved.

Undoubtedly.

But if it cannot, then we must take a lesson from the lover who renounces at any cost a passion which he finds is doing him no good. The love for poetry of this kind, bred in us by our own much admired institutions, will make us kindly disposed to believe in her genuine worth; but so long as she cannot make good her defence we shall, as we listen, rehearse to ourselves the reasons we have just given, as a counter-charm to save us from relapsing into a passion which most people have never outgrown. We shall reiterate that such poetry has no serious claim to be valued as an apprehension of truth. One who lends an ear to it should rather beware of endangering the order established in his soul, and would do well to accept the view of poetry which we have expressed.

I entirely agree.

Yes, Glaucon; for much is at stake, more than most people suppose: it is a choice between becoming a good man or a bad; and poetry, no more than wealth or power or honours, should tempt us to be careless of justice and virtue.

Your argument has convinced me, as I think it would anyone else.

[31]The source of these poetical attacks on philosophy is unknown. The earliest philosophers to denounce Homer and Hesiod had been Xenophanes and Heraclitus, about the beginning of the fifth century.

READING 36

INTRODUCTION

Aristotle (384–322 B.C.) is one of the most important figures in the history of philosophy. The scope of his interests and knowledge was prodigious: It has been remarked that he was probably the last person who knew everything there was to be known in his own time. Aristotle's treatise on drama, the *Poetics*, originally contained two books: one dealing primarily with tragedy and the other dealing with comedy. Unhappily, the second book has been lost to us; but the book on tragedy is a classic work in the philosophy of art. Aristotle's approach to the study of tragedy is, like his approach to everything, teleological. He thinks that we can understand tragedy only if we understand its purpose, or what it is *for*. Hence, in Chapter 6 of the *Poetics*, we are given a definition of tragedy that culminates in what Aristotle takes to be its purpose: the *catharsis* of pity and fear. The precise meaning of "catharsis" has been a subject of intense scholarly debate, but whatever its meaning, it seems clear that Aristotle is, at some level, responding to Plato's charge that poetry damages us by encouraging the development of emotion to the cost, as he saw it, of reason. Aristotle, in contrast, considers the emotional effect of tragedy to be a positive one. Aristotle may also be responding to Plato in Chapter 9 of the *Poetics*, where he discusses what he calls the "philosophical" character of poetry. Unlike Plato, he held that art could be a source of knowledge. Aristotle's treatise represents one of the most sustained series of reflections upon the nature of tragedy that we have. It has been and continues to be one of the most important texts in the history of the philosophy of art and, indeed, in the history of literary criticism.

From the *Poetics*

Aristotle

Chapter 1

To discuss the art of poetry in general, as well as the potential of each of its types; to explain the unity of plot required for successful poetic composition; also to analyse the number and nature of the component parts of poetry; and to deal similarly with the other questions which belong to this same method of enquiry—these are my proposed topics, beginning in the natural way from first principles.

Now, epic and tragic poetry, as well as comedy and dithyramb (and most music for the pipe or lyre), are all, taken as a whole, kinds of mimesis. But they differ from one another in three respects: namely, in the *media* or the *objects* or the *mode* of mimesis. For just as there are people who produce mimetic images of many things in the media of colours and shapes (some relying on a skilled art, some on practice), and others who use the medium of the voice, so in the case of all the arts mentioned above mimesis is effected in the media of rhythm, language and melody.

But these can be employed separately or in combination, as follows:

1. The arts of the pipe and lyre (and any other arts with a similar potential, such as that of the pan-pipes) use melody and rhythm alone.
2. The art of dancing presents mimesis in the medium of rhythm without melody (for dancers, through the rhythms which shape their movements, engage in the mimesis of character, emotions and actions).
3. The art which employs language alone, or language in metrical form (whether in a combination of metres or just one kind), is still without a name. For we have no common name for the mimes of Sophron and Xenarchus and Socratic dialogues, nor for any mimetic work which might be written in iambic trimeters or elegiac couplets or something else of this kind. It is of course true that people attach the verbal idea of 'poetry' *(poiein)* to the name of the metre, and so call these writers 'elegiac poets' *(elegopoioi)*, 'epic poets' *(epopoioi)*, and so on; but the categories refer not to their status as poets in virtue of mimesis, but to the metre they have in common: since, if a work of medicine or natural philosophy is written in metre, people still use these same descriptions. But Homer and Empedocles have nothing in common except their metre; and so, while one must call the former a poet, the latter should be called a natural philosopher rather than a poet. A corollary is that even if someone should produce a mimesis in a mixture of all the metres (as Chairemon did in his mixed rhapsody, *Centaur*), he too must be called a poet. So let distinctions of these kinds be drawn in these matters.
4. Finally, there are some poetic arts which employ all the stated media (that is, rhythm, melody and metre), such as dithyramb, nome, tragedy and comedy: they differ, though, in that some use all throughout, some only in parts. These, then, are the distinctions between the arts as regards the media of their mimesis.

Chapter 2

Since mimetic artists portray people in action, and since these people must be either good or bad (for men's characters practically always conform to these categories alone), they can portray people better than ourselves, worse than ourselves, or on the same level. The same is true in painting: Polygnotus portrayed men who are superior, Pauson worse, and Dionysius on the same level. And it is evident that each of the stated types of mimesis will exhibit these differences, and will thus be distinguishable according to the variations in the objects which it represents. For such differences are possible in dancing, and in music for the pipe and lyre, as well as in the arts which use language alone or language in metre: for instance, Homer represented superior men, Cleophon men like us, Hegemon of Thasos (the first writer of parodies) and Nicochares (author of the *Deiliad*) inferior men. The same principle applies in dithyramb and the nome, as one sees . . . and from the possibility of portraying the

Translator's note: The following notations are used in the translation: (1) . . . marks a lacuna in the Greek text and (2) [. . .] indicates an omission, usually of technicalities, from the translation. Such omissions have been kept to a minimum, and will be found mostly in XXV, where Aristotle gives a number of quotations whose relevant points cannot be successfully rendered into English.

Cyclopes in the manner of Timotheus and Philoxenus. This very distinction also separates tragedy from comedy: the latter tends to represent men worse than present humanity, the former better.

Chapter 3

Beside the two already cited, there is a third distinction: namely, the mode in which the various objects are represented. For it is possible to use the same media to offer a mimesis of the same objects in any one of three ways: first, by alternation between narrative and dramatic impersonation (as in Homeric poetry); second, by employing the voice of narrative without variation; third, by a wholly dramatic presentation of the agents.

So then, as indicated at the outset, mimesis can be distinguished in these three respects: by its *media,* its *objects,* and its *modes.* Consequently, in one respect Sophocles uses the same mimesis as Homer, for in both cases the objects are good men; while in another respect, Sophocles and Aristophanes are parallel, since both use the mimetic mode of dramatic enactment.

It is because of this that some people derive the term *drama* itself from the enactive mimesis of agents *(drôntas).* And for this reason, the Dorians even lay claim to both tragedy and comedy: in the case of the latter, the Megarians here on the mainland claim that it was invented during their democratic period, while the Megarians in Sicily think it theirs because the poet Epicharmus, who greatly predated the Athenians Chionides and Magnes, came from there; and as for comedy, some of the Dorians in the Peloponnese lay claim to it. The Dorians regard the terminology as evidence, since they assert that their own name for rural districts is *kômai,* while the Athenians call them 'demes'; and they suppose that the name for comic actors, *kômôdoi,* was derived not from revelling *(kômazein)* but from the fact that, when barred as unrespectable from the town, they toured through the villages *(kômai).* Similarly, the Dorians say that their verb for activity is *dran,* while the Athenians use *prattein.*

So then, let these remarks suffice to cover the number and nature of the mimetic distinctions.

Chapter 4

Poetry in general can be seen to owe its existence to two causes, and these are rooted in nature. First, there is man's natural propensity, from childhood onwards, to engage in mimetic activity (and this distinguishes man from other creatures, that he is thoroughly mimetic and through mimesis takes his first steps in understanding). Second, there is the pleasure which all men take in mimetic objects.

An indication of the latter can be observed in practice: for we take pleasure in contemplating the most precise images of things whose sight in itself causes us pain—such as the appearance of the basest animals, or of corpses. Here too the explanation lies in the fact that great pleasure is derived from exercising the understanding, not just for philosophers but in the same way for all men, though their capacity for it may be limited. It is for this reason that men enjoy looking at images, because what happens is that, as they con-

template them, they apply their understanding and reasoning to each element (identifying this as an image of such-and-such a man, for instance). Since, if it happens that one has no previous familiarity with the sight, then the object will not give pleasure *qua* mimetic object but because of its craftsmanship, or colour, or for some other such reason.

Given, then, that mimetic activity comes naturally to us—together with melody and rhythm (for it is evident that metres are species of rhythm)—it was originally those with a special natural capacity who, through a slow and gradual process, brought poetry into being by their improvisations. And poetry was split into two types according to the poets' own characters: the more dignified made noble actions and noble agents the object of their mimesis; while lighter poets took the actions of base men and began by composing invectives, just as the other group produced hymns and encomia. Now, we cannot cite an invective by any individual poet before Homer's time, though it is likely there were many such poets; their known history starts with Homer, with his *Margites* and other such works. It was appropriate that in these works the iambic metre came to find its place—and this is why it is called 'iambic' now, because it was in this metre that they abused one another (in the manner called *iambizein*).

Of the old poets, some composed in epic hexameters, others in iambics. Just as Homer was the supreme poet of serious subjects (for he was unique both in the quality and in the *dramatic* nature of his poetry), similarly he was the first to reveal the form of comedy, by producing dramatic poetry which dealt not with invective but with the ridiculous. For the *Margites* stands in the same relation to later comedies as do the *Iliad* and *Odyssey* to tragedies. And when the possibility of tragedy and comedy had been glimpsed, men aspired to either type of poetry according to their personal capacities; so some became poets of comedy instead of iambic verses, while others abandoned epic for tragedy, because the latter's forms were greater than, and superior to, epic's.

To consider whether tragedy is by now sufficiently developed in its types—judging it both in itself and in relation to audiences—is a separate matter. At any rate, having come into being from an improvisational origin (which is true of both tragedy and comedy, the first starting from the leaders of the dithyramb, the second from the leaders of the phallic songs which are still customary in many cities), tragedy was gradually enhanced as poets made progress with the potential which they could see in the genre. And when it had gone through many changes, tragedy ceased to evolve, since it had attained its natural fulfilment.

It was Aeschylus who first increased the number of actors from one to two, reduced the choral parts, and gave speech the leading role; the third actor and scene-painting came with Sophocles. A further aspect of change concerns scale: after a period of slight plots and humorous diction, it was only at a late stage that tragedy attained dignity by departing from the style of satyr-plays, and that the iambic metre replaced the trochaic tetrameter. To begin with, poets used the tetrameter because the poetry had more of the tone of a satyr-play and of dance; and it was only when speech was brought in that the nature of the genre found its appropriate metre (the iambic is the most colloquial of metres, as we see from the fact that we frequently produce the rhythm of

iambic lines in our conversation, while we rarely produce hexameters and only by departing from the register of ordinary speech).

There were further developments concerning the number of episodes, and we shall take as read the other particular elaborations which are said to have been effected, since it would be a large task to give a thorough account of every detail.

Chapter 5

Comedy, as I earlier said, is a mimesis of men who are inferior, but not in a way which involves complete evil: the comic is one species of the shameful. For the comic is constituted by a fault and a mark of shame, but lacking in pain or destruction: to take an obvious example, the comic mask is ugly and misshapen, but does not express pain. Now, while the stages of tragedy's development, and those responsible for them, have been preserved, comedy's have not been, because it was not originally given serious attention: the archon first granted a comic chorus at quite a late date; before that, the performers were volunteers. The first recorded comic poets belong to the era when the genre already possessed some established forms. We are simply ignorant about such matters as who invented masks, or introduced prologues, or increased the number of actors, and other such details. But as for the use of poetic plot-structures, that originally came from Sicily; and of Athenian poets Crates was the first to abandon the iambic concept and to compose generalised stories and plots.

Epic conforms with tragedy insofar as it is a mimesis, in spoken metre, of ethically serious subjects; but it differs by virtue of using *only* spoken verse and of being in the narrative mode. There is also a difference of scale: whereas tragedy strives as far as possible to limit itself to a single day, epic is distinctive by its lack of a temporal limit, although in the early days poets of tragedy were as free in this respect as those of epic. The parts of epic are all common to tragedy, but the latter has some peculiar to itself. Consequently, whoever knows the difference between a good and a bad tragedy knows the same for epic too; for epic's attributes all belong to tragedy as well, though not all of tragedy's are shared by epic.

Chapter 6

I shall discuss epic mimesis and comedy later. But let us deal with tragedy by taking up the definition of its essential nature which arises out of what has so far been said.

Tragedy, then, is a representation of an action which is serious, complete, and of a certain magnitude—in language which is garnished in various forms in its different parts—in the mode of dramatic enactment, not narrative—and through the arousal of pity and fear effecting the *katharsis* of such emotions.

By 'garnished' language I mean with rhythm and melody; and by the 'various forms' I mean that some parts use spoken metre, and others use lyric song. Since the mimesis is enacted by agents, we can deduce that one element of tragedy must be the adornment of visual spectacle, while others are lyric

poetry and verbal style, for it is in these that the mimesis is presented. By 'style' I mean the composition of the spoken metres; the meaning of 'lyric poetry' is entirely evident.

Since tragedy is a representation of an action, and is enacted by agents, who must be characterised in both their character and their thought (for it is through these that we can also judge the qualities of their actions, and it is in their actions that all men either succeed or fail), we have the plot-structure as the mimesis of the action (for by this term 'plot-structure' I mean the organization of the events) while characterisation is what allows us to judge the nature of the agents, and 'thought' represents the parts in which by their speech they put forward arguments or make statements.

So then, tragedy as a whole must have six elements which make it what it is: they are plot-structure, character, style, thought, spectacle, lyric poetry. Two of these are the media, one the mode, and three the objects, of the mimesis—and that embraces everything. Many poets have exploited these parts in order to produce certain types of play [. . .].

The most important of these elements is the structure of events, because tragedy is a representation not of people as such but of actions and life, and both happiness and unhappiness rest on action. The goal is a certain activity, not a qualitative state; and while men do have certain qualities by virtue of their character, it is in their actions that they achieve, or fail to achieve, happiness. It is not, therefore, the function of the agents' actions to allow the portrayal of their characters; it is, rather, for the sake of their actions that characterisation is included. So, the events and the plot-structure are the goal of tragedy, and the goal is what matters most of all.

Besides, without action you would not have a tragedy, but one without character would be feasible, for the tragedies of most recent poets are lacking in characterisation, and in general there are many such poets. Compare, among painters, the difference between Zeuxis and Polygnotus: while Polygnotus is a fine portrayer of character, Zeuxis' art has no characterisation. Furthermore, if a poet strings together speeches to illustrate character, even allowing he composes them well in style and thought, he will not achieve the stated aim of tragedy. Much more effective will be a play with a plot and structure of events, even if it is deficient in style and thought.

In addition to these considerations, tragedy's greatest means of emotional power are components of the plot-structure: namely, reversals and recognitions. Moreover, it is symptomatic that poetic novices can achieve precision in style and characterisation before they acquire it in plot-construction—as was the case with virtually all the early poets. And so, the plot-structure is the first principle and, so to speak, the soul of tragedy, while characterisation is the element of second importance. (An analogous point holds for painting: a random distribution of the most attractive colours would never yield as much pleasure as a definite image without colour.) Tragedy is a mimesis of action, and only for the sake of this is it mimesis of the agents themselves.

Third in importance is thought: this is the capacity to produce pertinent and appropriate arguments, which is the task in prose speeches of the arts of politics and rhetoric. The older poets used to make their characters speak in a political vein, whereas modern poets do so in a rhetorical vein. Character is

the element which reveals the nature of a moral choice, in cases where it is not anyway clear what a person is choosing or avoiding (and so speeches in which the speaker chooses or avoids nothing at all do not possess character); while thought arises in passages where people show that something is or is not the case, or present some universal proposition.

The fourth element is style: as previously said, I mean by this term the verbal expression achieved through the choice of words, which has the same force whether in verse or in prose. Of the remaining elements, lyric poetry is the most important of garnishings, while spectacle is emotionally powerful but is the least integral of all to the poet's art: for the potential of tragedy does not depend upon public performance and actors; and, besides, the art of the mask-maker carries more weight than the poet's as regards the elaboration of visual effects.

Chapter 7

Given these definitions, my next topic is to prescribe the form which the structure of events ought to take, since this is the first and foremost component of tragedy. We have already laid down that tragedy is a representation of an action which is complete, whole and of a certain magnitude (for something can be whole but of no magnitude).

By 'whole' I mean possessing a beginning, middle and end. By 'beginning' I mean that which does not have a necessary connection with a preceding event, but which can itself give rise naturally to some further fact or occurrence. An 'end', by contrast, is something which naturally occurs after a preceding event, whether by necessity or as a general rule, but need not be followed by anything else. The 'middle' involves causal connections with both what precedes and what ensues. Consequently, well designed plot-structures ought not to begin or finish at arbitrary points, but to follow the principles indicated.

Moreover, any beautiful object, whether a living creature or any other structure of parts, must possess not only ordered arrangement but also an appropriate scale (for beauty is grounded in both size and order). A creature could not be beautiful if it is either too small—for perception of it is practically instantaneous and so cannot be experienced—or too great, for contemplation of it cannot be a single experience, and it is not possible to derive a sense of unity and wholeness from our perception of it (imagine an animal a thousand miles long). Just, therefore, as a beautiful body or creature must have some size, but one which allows it to be perceived all together, so plot-structures should be of a length which can be easily held in the memory.

An artistic definition of length cannot be related to dramatic competitions and the spectators' concentration. For if a hundred tragedies had to compete, they would measure them by the water-clock (as people say they once did). The limit which accords with the true nature of the matter is this: beauty of size favours as large a structure as possible, provided that coherence is maintained. A concise definition is to say that the sufficient limit of a poem's scale is the scope required for a probable or necessary succession of events which produce a transformation either from affliction to prosperity, or the reverse.

Chapter 8

A plot-structure does not possess unity (as some believe) by virtue of centring on an individual. For just as a particular thing may have many random properties, some of which do not combine to make a single entity, so a particular character may perform many actions which do not yield a single 'action'. Consequently, all those poets who have written a *Heracleid* or *Theseid*, or the like, are evidently at fault: they believe that because Heracles was a single individual, a plot-structure about him ought thereby to have unity. As in other respects, Homer is exceptional by the fineness of his insight into this point, whether we regard this as an acquired ability or a natural endowment of his: although composing an *Odyssey*, he did not include everything that happened to the hero (such as his wounding on Parnassus or his pretence of madness at the levy—events which involved no necessary or probable connection with one another). Instead, he constructed the *Odyssey* around a single action of the kind I mean, and likewise with the *Iliad*.

So then, just as in the other mimetic arts a unitary mimesis is a representation of a unitary object, so the plot-structure, as the mimesis of action, should be a representation of a unitary and complete action; and its parts, consisting of the events, should be so constructed that the displacement or removal of any one of them will disturb and disjoint the work's wholeness. For anything whose presence or absence has no clear effect cannot be counted an integral part of the whole.

Chapter 9

It is a further clear implication of what has been said that the poet's task is to speak not of events which have occurred, but of the kind of events which *could* occur, and are possible by the standards of probability or necessity. For it is not the use or absence of metre which distinguishes poet and historian (one could put Herodotus' work into verse, but it would be no less a sort of history with it than without it): the difference lies in the fact that the one speaks of events which have occurred, the other of the sort of events which could occur.

It is for this reason that poetry is both more philosophical and more serious than history, since poetry speaks more of universals, history of particulars. A 'universal' comprises the *kind* of speech or action which belongs by probability or necessity to a certain *kind* of character—something which poetry aims at *despite* its addition of particular names. A 'particular', by contrast, is (for example) what Alcibiades did or experienced.

This point has become clear in the case of comedy, where it is only after constructing a plot in terms of probable events that they give the characters ordinary names, so diverging from the iambic poets' practice of writing about individuals. In tragedy, on the other hand, the poets hold to the actual names. (The reason for this is that people are ready to believe in what is possible; and while we may not yet believe in the possibility of things that have not already happened, actual events are evidently possible, otherwise they would not have occurred.) Even so, there are some tragedies in which one

or two of the familiar names are kept, while others are due to the poet; and some plays in which all are new, as in Agathon's *Antheus*: for in this play both the events and the names are equally the poet's work, yet the pleasure it gives is just as great. So, fidelity to the traditional plots which are the subject of tragedies is not to be sought at all costs. Indeed, to do this is absurd, since even familiar material is familiar only to a minority, but it can still afford pleasure to all.

It is clear, then, from what has been said that the poet should be a maker of plot-structures rather than of verses, in so far as his status as poet depends on mimesis, and the object of his mimesis is actions. And he is just as much a poet even if the material of his poetry comprises actual events, since there is no reason why *some* historical events should not be in conformity with probability, and it is with respect to probability that the poet can make his poetry from them.

Of simple plot-structures and actions the worst are episodic. I call an 'episodic' plot-structure one in which the episodes follow in a succession which is neither probable nor necessary. Such plays are produced by bad poets through their own fault, and by good poets because of their actors: for in composing declamatory set-pieces, and straining the plot-structure to excess, they are often compelled to distort the dramatic sequence.

Since tragic mimesis portrays not just a whole action, but events which are fearful and pitiful, this can best be achieved when things occur contrary to expectation yet still on account of one another. A sense of wonder will be more likely to be aroused in this way than as a result of the arbitrary or fortuitous, since even chance events make the greatest impact of wonder when they *appear* to have a purpose (as in the case where Mitys's statue at Argos fell on Mitys's murderer and killed him, while he was looking at it: such things do not *seem* to happen without reason). So then, plot-structures which embody this principle must be superior.

Chapter 10

Plot-structures can be divided into the simple and the complex, for the actions which they represent consist naturally of these types. By a 'simple' action I mean one which is, as earlier defined, continuous and unitary, but whose transformation occurs without reversal or recognition. A 'complex' action is one whose transformation involves recognition or reversal, or both. Reversal and recognition should arise from the intrinsic structure of the plot, so that what results follows by either necessity or probability from the preceding events: for it makes a great difference whether things happen because of one another, or only *after* one another.

Chapter 11

Reversal, as indicated, is a complete swing in the direction of the action; but this, as we insist, must conform to probability or necessity. Take, for example, Sophocles' *Oedipus Tyrannus*, where the person comes to bring Oedipus happiness, and intends to free him from his fear about his mother; but he pro-

duces the opposite effect, by revealing Oedipus' identity. And in *Lynceus* the one person is led off to die, while Danaus follows to kill him; yet it comes about that the latter's death and the former's rescue result from the chain of events.

Recognition, as the very name shows, is a change from ignorance to knowledge, bringing the characters into either a close bond, or enmity, with one another, and concerning matters which bear on their prosperity or affliction. The finest recognition occurs in direct conjunction with reversal—as with the one in the *Oedipus*. There are, of course, other kinds of recognition, for recognition can relate to inanimate or fortuitous objects, or reveal that someone has, or has not, committed a deed. But the type I have mentioned is the one which is most integral to the plot-structure and its action: for such a combination of recognition and reversal will produce pity or fear (and it is events of this kind that tragedy, on our definition, is a mimesis of), since both affliction and prosperity will hinge on such circumstances. And since recognition involves people, there are cases where one person's recognition by another takes place (when this other's own identity is clear), and cases where the recognition must be reciprocal: for instance, Iphigeneia was recognised by Orestes through the sending of the letter, but another means of recognition was needed for Iphigeneia's identification of *him*.

Well then, reversal and recognition form two components of the plot-structure; the third is suffering. To the definitions of reversal and recognition already given we can add that of suffering: a destructive or painful action, such as visible deaths, torments, woundings, and other things of the same kind.

Chapter 12

Having earlier given the parts of tragedy which determine its qualities, the quantitative divisions of the genre can be listed as: prologue, episode, *exodos*, choral unit. The latter can be divided into the choral entry *(parodos)* and the choral ode *(stasimon)*, which are common to all plays, while actors' songs and lyric exchanges *(kommoi)* are peculiar to only certain plays.

The prologue is the entire portion of a tragedy preceding the choral entry. An episode is an entire portion of a tragedy lying between complete choral odes. The *exodos* is the entire portion of a tragedy which follows the final choral ode. Of the choral elements, the *parodos* is the first entire choral utterance; a *stasimon* is a choral song in a metre other than anapaestic or trochaic; while a *kommos* is a lamentation shared between chorus and actors.

The parts of tragedy which determine its qualities were given earlier, while those above are the divisions of a quantitative analysis.

Chapter 13

It follows on from my earlier argument that I should define what ought to be aimed at and avoided in plot-construction, as well as the source of tragedy's effect. Since, then, the structure of the finest tragedy should be complex, not simple, and, moreover, should portray fearful and pitiful events (for this is the distinctive feature of this type of mimesis), it is to begin with clear that:

1. Good men should not be shown passing from prosperity to affliction, for this is neither fearful nor pitiful but repulsive.
2. Wicked men should not be shown passing from affliction to prosperity, for this is the most untragic of all possible cases and is entirely defective (it is neither moving nor pitiful nor fearful).
3. The extremely evil man should not fall from prosperity to affliction, for such a plot-structure might move us, but would not arouse pity or fear, since pity is felt towards one whose affliction is undeserved, fear towards one who is like ourselves (so what happens in such a case will be neither pitiful nor fearful).

We are left, then, with the figure who falls between these types. Such a man is one who is not preeminent in virtue and justice, and one who falls into affliction not because of evil and wickedness, but because of a certain fallibility (*hamartia*). He will belong to the class of those who enjoy great esteem and prosperity, such as Oedipus, Thyestes, and outstanding men from such families.

It is imperative that a fine plot-structure be single and not double (as some assert), and involve a change from prosperity to affliction (rather than the reverse) caused not by wickedness but by a great fallibility on the part of the sort of agent stipulated, or one who is better, not worse, than indicated. Actual practice tends to confirm my thesis. For in the beginning the poets' choice of stories was arbitrary, whereas now the finest tragedies are constructed around a few families—Alcmaeon, for example, Oedipus, Orestes, Meleager, Thyestes, Telephus, and others who have suffered or committed terrible deeds.

This, then, is the plot-pattern for the tragedy which best fulfils the standards of poetic art. Those who fault Euripides for following this, and for ending many of his plays with affliction, make the same mistake as mentioned above. For such an ending is legitimate, as argued, and the greatest confirmation is that such plays make the most tragic impression in acted competition (provided they are staged effectively), and Euripides, whatever other faults of organisation he may have, at least makes the most tragic impression of all poets.

The second-best pattern (which some hold to be the best) is the kind which involves a double structure (like the *Odyssey*) and contrasting outcomes for good and bad characters. It is the weakness of audiences which produces the view of this type's superiority; poets are led to give the spectators what they want. But this is not the proper pleasure to be derived from tragedy—more like that of comedy: for in that genre people who are outright foes in the plot (say, Orestes and Aegisthus) go off as friends at the end, and nobody is killed.

Chapter 14

The effect of fear and pity can arise from theatrical spectacle, but it can also arise from the intrinsic structure of events, and it is this which matters more and is the task of a superior poet. For the plot-structure ought to be so composed that, even without seeing a performance, anyone who hears the events

which occur will experience terror and pity as a result of the outcome; this is what someone would feel while hearing the plot of the *Oedipus*. To produce this effect through spectacle is not part of the poet's art, and calls for material resources; while those who use spectacle to produce an effect not of the fearful but only of the sensational fall quite outside the sphere of tragedy: for it is not every pleasure, but the appropriate one, which should be sought from tragedy. And since the poet ought to provide the pleasure which derives from pity and fear by means of mimesis, it is evident that this ought to be embodied in the events of the plot.

Let us, then, take up the question of what sort of circumstances make an impression of terror or pity. These are the only possibilities: such actions must involve dealings between those who are bonded by kinship or friendship; or between enemies; or between those who are neither. Well, if enemy faces enemy, neither the deed nor the prospect of it will be pitiful (except for the intrinsic potential of visible suffering); and the same is true of those whose relations are neutral. What must be sought are cases where suffering befalls bonded relations—when brother kills brother (or is about to, or to do something similar), son kills father, mother kills son, or son kills mother. Now, one cannot alter traditional plots (I mean, Clytemnestra's death at Orestes' hands, or Eriphyle's at Alcmaeon's) but the individual poet should find ways of handling even these to good effect.

I should explain more clearly what I mean by 'to good effect'. It is possible

1. for the deed to be done with full knowledge and understanding, as the old poets used to arrange it, and in the way that Euripides too made Medea kill her children.
2. for the deed to be done, but by agents who do not know the terrible thing they are doing, and who then later recognise their bond-relationship to the other, as with Sophocles' *Oedipus* (that is an instance where the deed occurs outside the drama, but Astydamas' *Alcmaeon,* and Telegonus in *Odysseus Wounded,* supply examples within the play itself.
3. alternatively, for one who is on the point of committing an incurable deed in ignorance to come to a recognition before he has done it.

These are the only possibilities, for either the deed is done or it is not, and the agents must either know the facts or be ignorant of them. Of these cases, the worst is where the agent, in full knowledge, is on the point of acting, yet fails to do so: for this is repulsive and untragic (as it lacks suffering). Consequently, poets only rarely do this (for instance, Haemon's intention against Creon in *Antigone*). Not much better is for the deed to be executed in such a case. A superior arrangement is where the agent acts in ignorance, and discovers the truth after acting: for here there is nothing repulsive, and the recognition produces a powerful effect. But the best case is the last I have listed—for example, where Merope is about to kill her son in the *Cresphontes*, but does not do so because she recognises him; likewise with sister and brother in *Iphigeneia*, and in the *Helle*, where the son, on the point of handing her over, recognises his mother. Hence, as said before, tragedies concentrate on a few

families. Luck not art led poets to find how to achieve such an effect in their plots; so they have to turn to the families in which such sufferings have occurred.

Enough, then, about the structure of events and the required qualities of plots.

Chapter 15

Regarding characterisation, there should be four aims:

1. first and foremost, that the characters be good. Characterisation will arise, as earlier explained (ch.6), where speech or action exhibits the nature of an ethical choice; and the character will be good when the choice is good. But this depends on each class of person: there can be a good woman and a good slave, even though perhaps the former is an inferior type, and the latter a wholly base one.
2. that the characters be appropriate. For it is *possible* to have a woman manly in character, but it is not appropriate for a woman to be so manly or clever.
3. likeness of character—for this is independent of making character good and appropriate, as described.
4. consistency of character. For even where an inconsistent person is portrayed, and such a character is presupposed, there should still be consistency in the inconsistency.

An illustration of unnecessary wickedness of character is Menelaus in *Orestes;* of unbecoming and inappropriate character, the lament of Odysseus in *Scylla*, or Melanippe's speech; and of inconsistency, *Iphigeneia in Aulis* (for the girl who beseeches bears no resemblance to the later girl). In characterisation just as in plot-construction, one should always seek the principle of necessity or probability, so that a necessary or probable reason exists for a particular character's speech or action, and similarly for the sequence of events.

It is evident that the dénouements of plot-structures should arise from the plot itself, and not, as in *Medea,* from a *deus ex machina,* or in the episode of the departure in the *Iliad.* But the *deus ex machina* should be used for events outside the play, whether earlier events of which a human cannot have knowledge, or future events which call for a prospective narrative; for we attribute to the gods a vision of all things. No irrational element should have a part in the events, unless outside the tragedy (as, for example, in Sophocles' *Oedipus*).

Since tragedy is a mimesis of men better than ourselves, the example set by good portrait-painters should be followed: they, while rendering the individual physique realistically, improve on their subjects' beauty. Similarly, the poet, while portraying men who are irascible or lazy or who have other such faults, ought to give them, despite such traits, goodness of character. An example of this is Homer's presentation of Achilles as good, despite his harshness. In addition to observing these points, the poet must guard against contraventions of the perceptions which necessarily attach to poetic art, since there are many ways of making mistakes in relation to these. But I have discussed these matters adequately in my published writings. . . .

Chapter 23

As for the narrative art of mimesis in spoken verse, it is evident that its plot-structures should have a dramatic coherence, just as in tragedy, and that they should concern an action which is unitary and complete (with beginning, middle and end), so that, as with a living creature, the single and entire structure may yield the pleasure which belongs to it. The corollary of this is that plots should not resemble histories, in which one need not find the exposition of a unitary action but of all the contingently connected events which happened to one or more persons in a particular period of time. For just as the battle of Salamis and the Sicilian battle against the Carthaginians occurred at the same time, but without contributing to a common end, so events can sometimes succeed one another in time without yielding any particular end.

Yet this is what probably a majority of epic poets do, and, as I earlier said (ch. 8), this is one respect in which Homer's inspired superiority is evident, because of his refusal to attempt to make a poem about the entire war (despite its clear beginning and end): such a plot would be too bulky, and could not be perceived as a unity; or, if moderate in size, would be too intricately detailed. As it is, Homer has selected a unitary portion of the war, and has used many episodes—the catalogue of ships, and others—to expand his poetry. But other poets, such as the authors of the *Cypria* and the *Little Iliad*, compose about an individual or a single period of time, or an action of many parts. Consequently, the *Iliad* and *Odyssey* provide material for only one or two tragedies each, while the *Cypria* and *Little Iliad* would yield many [. . .].

Chapter 24

Moreover, epic should have the same types as tragedy—the simple, the complex, the character-poem, the poem of suffering. (And epic shares all the same elements, apart from lyrics and spectacle.) For epic has equal need of reversals, recognitions and scenes of suffering. In addition, excellence of thought and diction is called for. All of which Homer has achieved with supreme perfection. Each of his poems is a unified plot—the *Iliad* in the categories of the 'simple' and the poem of suffering, the *Odyssey* in those of the complex (using recognition throughout) and the poem of character. Furthermore, Homer has excelled all other epic in diction and thought.

Epic differs from tragedy in length of plot-structure and in metre. As for length, a sufficient definition has already been given: it should be possible to perceive the beginning and the end as a unity. This condition would be satisfied by structures which are shorter than the old epics but which match the length of the tragedies given at a single hearing. But the scope for considerable extension of length is a particular attribute of epic's. This is because tragedy will not permit the representation of many simultaneous parts of the action, but only the one on stage involving the actors; while epic, on account of its use of narrative, can include many simultaneous parts, and these, provided they are integral, enhance the poem's dignity. This lends epic an advantage in grandeur, in changes of interest for the hearer, and in variety of

episodes (lack of variety soon becomes cloying and causes the rejection of tragedies).

Epic's metre, the hexameter, has been found appropriate by experience. If someone were to compose a narrative mimesis in some other metre, or in a mixture of many, the inappropriateness would be apparent. For the hexameter is the most stately and dignified of metres (hence its special openness to foreign terms and metaphors: narrative mimesis is more out-of-the-ordinary than other kinds), while the iambic trimeter and trochaic tetrameter have a greater sense of movement: the tetrameter suits dancing, the trimeter action. And a mixture of these metres, like Chairemon's, would be even more absurd. Consequently, no one has composed a long epic structure in anything other than the hexameter, but, as I said, nature herself teaches poets to choose what is appropriate for epic.

Among Homer's many other laudable attributes is his grasp—unique among epic poets—of his status as poet. For the poet himself should speak as little as possible, since when he does so he is not engaging in mimesis. Now, other epic poets participate persistently, and engage in mimesis only to a limited extent and infrequently. But Homer, after a short preamble, at once 'brings onto stage' a man, woman or some other figure (and his agents are always fully characterised).

While the marvellous is called for in tragedy, it is epic which gives greater scope for the irrational (which is the chief cause of the marvellous), because we do not actually see the agents. The circumstances of the pursuit of Hector would be patently absurd if put on the stage, with the men standing and refraining from pursuit, and Achilles forbidding them; but in epic the effect is not noticed. The marvellous gives pleasure: this can be seen from the way in which everyone exaggerates in order to gratify when recounting events.

It is above all Homer who has taught other epic poets the right way to purvey falsehoods. What is involved here is a kind of fallacy: if one thing follows from the existence or occurrence of another, people quite erroneously suppose that, where the second fact obtains, the former also must be true. If, therefore, something is false, but, were it true, something else would necessarily follow from it, the poet ought to add this second fact: because, when it knows that *this* is true, our mind fallaciously infers the existence of the first fact also. There is an instance of this in the *Odyssey*'s bath scene.

Events which are impossible but plausible should be preferred to those which are possible but implausible. Plots should not consist of parts which are irrational. So far as possible, there should be no irrational component; otherwise, it should lie outside the plot-structure, as with Oedipus' ignorance of how Laius died, rather than inside the drama, as with the report of the Pythian games in *Electra*, or with the silent character's arrival at Mysia from Tegea in the *Mysians*. To say that otherwise the plot-structure would be ruined is a ridiculous defence: such plot-construction should be avoided *from the start*. But even absurdity can sometimes be handled more or less reasonably. It would be obvious, if they were handled by an inferior poet, just how intolerable the absurdities regarding the disembarkation in the *Odyssey* could be: as it is, Homer uses his other virtues to disguise the absurdity and to make it enjoyable.

Verbal style should be used intensively in portions of the poem which are static and involve no characterisation or statement of thought. By contrast, characterisation and thought can be thrown into shade by an excessively brilliant style.

Chapter 25

On the subject of problems and their solutions, a clear idea of the number and types of issue can be gained from the following considerations. Since the poet, like the painter or any other image-maker, is a mimetic artist, he must in any particular instance use mimesis to portray one of three objects: the sort of things which were or are the case; the sort of things men say and think to be the case; the sort of things that should be the case. This material is presented in language which has foreign terms, metaphors, and many special elements; for we allow these to poets.

Furthermore, correct standards in poetry are not identical with those in politics or in any other particular art. Two kinds of failure are possible in poetry—one intrinsic, and the other contingent. If a poet lacks the capacity to achieve what he sets out to portray, the failure is one of poetic art. But this is not so if the poet *intends* to portray something which is erroneous, such as a horse with its two right legs simultaneously forward, or something which is a technical mistake in medicine or any other field. So, it is from these premises that the solutions to the charges contained in problems must be found.

Firstly, points concerning poetic art itself. Suppose the poet has produced impossibilities, then granted he has erred. But poetic standards will be satisfied, provided he achieves the goal of the art (which has been earlier discussed): that is, if by these means he increases the emotional impact either of the particular part or of some other part of the work. (An example is the pursuit of Hector.) If, however, the goal could be achieved better, or just as successfully, without the particular technical error, then the mistake is not acceptable: for, if possible, poetry should be altogether free of mistakes.

One must also ask whether the error concerns the poetic art or something extrinsic to it. For if, out of ignorance, a painter portrays a female deer *with* horns, this has less significance than attaches to a failure in mimesis.

Next, if the charge is one of falsehood, a possible defence is that things are being portrayed as they *should* be, just as Sophocles said that his poetic characters were as they should be, while Euripides' reflected ordinary reality. If neither category applies, then a solution may appeal to what people say, for instance in matters concerning the gods: as, while it may satisfy neither morality nor truth to say such things (and Xenophanes' criticisms may be justified), nevertheless people *do* say them.

Another possible defence is that something may be imperfect but does represent how things once were. Take the example concerning weapons ('Their spears stood upright on the butt-end'): this used to be the practice at the time, as it still is with the Illyrians. When asking whether someone has spoken or acted morally or otherwise, one should look to see not just if the deed or utterance is good or evil, but also to the identity of the agent or speaker, to the person with whom he deals, and to the occasion, means and

purpose of what is done (e.g. whether the aim is to effect a greater good, or prevent a greater evil).

Other points must be resolved by consideration of style, for example by reference to a foreign term [. . .]. A passage may involve metaphor: for instance, 'All gods and men slept through the night', while in the same passage Homer says 'whenever Agamemnon gazed across to the Trojan plane and the din of flutes and pipes'. 'All' stands by metaphor for 'many', since all is a species of many [. . .]. Accentuation may be relevant, as with the solutions proposed by Hippias of Thasos [. . .] or punctuation [. . .] or double meaning [. . .] or verbal usage [. . .].

Whenever a word appears to entail a contradiction, one should consider how many meanings are possible in the linguistic context [. . .]. One should adopt the opposite procedure to the one which Glaucon describes by saying that some people make an unreasonable assumption and proceed to base their argument on acceptance of it; then, if something contradicts their own preconception, they criticise the poet as though *he* had made the initial assumption. This has happened in the case of Icarius: people presuppose that he was a Laconian, so they find it absurd that Telemachus did not meet him when he went to Sparta. But perhaps the Cephallenians' version is correct, for they claim that Odysseus married one of theirs, and that the father was called Icadius not Icarius. It is plausible that the problem is due to a mistake.

In general, cases of impossibility should be resolved by reference to the requirements of poetry, or to a conception of the superior, or to people's beliefs. Poetic requirements make a plausible impossibility preferable to an implausible possibility . . . not such as Zeuxis painted them, but better, for the artist should surpass his model. Irrationalities should be referred to 'what people say', or shown not to be irrational (since it is likely that some things should occur contrary to likelihood). Contradictory utterances should be examined according to the same principles as verbal refutations, to see whether the sense is the same and has the same reference, and in the same way—if a poet is to be convicted of actually contradicting either himself or something which can be sensibly assumed. But it is correct to find fault with both illogicality and moral baseness, if there is no necessity for them and if the poet makes no use of the illogicality (as with Euripides and the case of Aegeus) or the baseness (as with Menelaus's in *Orestes*).

The charges brought against poets fall under five headings: impossibilities, irrationalities, morally harmful elements, contradictions, and offences against the true standards of the art. The solutions should be sought from the categories discussed above.

Chapter 26

It is reasonable to consider whether epic or tragic mimesis is the superior. If the superior is the less vulgar, and this is the one addressed to the better kind of spectators, it is unarguable that the art which consists entirely of impersonation must be vulgar: for here the performers use a great deal of physical action, as though the audience would not appreciate the point without this emphasis (for instance, with the wheeling motion of bad pipe-players, when

portraying a discus, or their hauling around of the chorus-leader, when playing Scylla's music). Now, tragedy is of this kind, and the point is similar to the opinion which earlier actors held of their successors: Mynniscus used to call Callippides an 'ape', on the grounds of his excesses, and such was also the view held of Pindarus. The relation of the whole art of tragedy to epic is analogous to that between these actors and their predecessors. So people say that epic is for good spectators who require no gestures, while tragedy is for vulgar spectators. Consequently, if tragedy is vulgar, its inferiority would be evident.

But in the first place, the charge pertains not to poetry but to acting, since it is equally possible to use excessive gestures in an epic recitation, like Sostratus, or in a singing contest, which Mnasitheos the Opountian used to do. Secondly, it is not *all* movement (any more than all dancing) which should be rejected, but that of base types—as with the charge made against Callippides, and now made against others, of impersonating non-citizen women. Besides, tragedy, just like epic, achieves its aim even without enactment: for its qualities become apparent through a reading. Therefore, if tragedy is superior in other respects, this particular defect need not be attached to it.

Next there is the fact that tragedy possesses all epic's attributes (it can even use its metre), and in addition it has music and spectacle, which produce very vivid pleasures; so it can achieve vividness either in a reading or in performance. Furthermore, tragedy is superior by achieving the aim of its mimesis in a shorter scope: the relative compression gives greater pleasure than dilution over a long period (consider the hypothetical case of someone setting Sophocles' *Oedipus* in as many verses as the *Iliad*). Also, epic mimesis is less unified (an indication is that several tragedies can be extracted from any epic): consequently, if epic poets produce a single plot-structure, it appears incomplete because of the short exposition, or else diluted if it keeps to the length which suits the metre. What I mean by the latter is, for example, a construction of several actions, like the *Iliad*'s and *Odyssey*'s possession of many parts which are individually substantial. Yet these latter poems are constructed as well as is possible, and come as close as possible to the mimesis of a unitary action.

Therefore, if tragedy differs in all these respects, as well as in the effect of the art (for these genres should yield no ordinary pleasure, but the one stipulated), its superiority over epic in achieving the goal of poetry should be evident.

This completes my discussion of tragedy and epic, their forms and the number and variations of their components, the reasons for success or the reverse, and objections against poetry, with their solutions.

READING 37

INTRODUCTION

Count Leo Tolstoy was born in 1828 and died in 1910. He is of course primarily famous as the author of such literary masterpieces as *War and Peace* and *Anna Karenina*. Later in life, however, Tolstoy underwent a conversion to a primitive form of Christianity and from this spiritual standpoint began to write essays on a number of subjects, including aesthetics, economics, and religion. The best known of these is his essay on art, *What Is Art?* (1898). Tolstoy takes issue with the main aesthetic theories of his day, which, in his view, placed too much weight on the problematic notion of "beauty." Instead, Tolstoy argues, art should be seen principally as a form of communication. Art, according to him, should communicate to an audience the emotions which originally inspired the artist to create his or her work, so binding artist and audience together in a fellowship of shared experience. Tolstoy thus advances a version of the expression theory of art. In addition, Tolstoy has strong views about what *kinds* of emotion art—or good art—ought to communicate. The best art, he claims, expresses emotions that everyone can share: It is not exclusive or elitist. Thus, for him, the greatest art of all is art that has the capacity to bind the whole of humanity together in a brotherhood of common feeling. This requirement—essentially a *moral* requirement—leads Tolstoy to some rather unexpected evaluations. Specifically, it leads him to downgrade much of the art that has traditionally been regarded as the very finest—including his own masterly novels. For many readers this has made it difficult to take Tolstoy's theory entirely seriously. But we should not be put off. For *What Is Art?* contains fascinating insights into the expressive powers of art; it invites us to reflect more deeply upon the moral effects that art might have; and it forces us to consider the various roles that art can play in a wider social context. And, apart from anything else, there has to be some presumption that, as one of the greatest artists who ever lived, Tolstoy might actually have known what he was talking about. After all, as George Bernard Shaw remarked, in Tolstoy's essay "we hear the voice of the master."

From *What Is Art?*

Leo Tolstoy

'What is art? What a question! Art is architecture, sculpture, painting, music, and poetry in all its forms,' usually replies the ordinary man, the art amateur or even the artist himself, imagining the matter about which he is talking to be perfectly clear and uniformly understood by everybody. But in architecture, one inquires further, are there not simple buildings which are not objects of art, and buildings with artistic pretensions which are unsuccessful and ugly and therefore not to be considered works of art? Wherein lies the characteristic sign of a work of art?

It is the same in sculpture, in music, and in poetry. Art in all its forms is bounded on one side by the practically useful, and on the other by unsuc-

cessful attempts at art. How is art to be marked off from each of these? The ordinary educated man of our circle, and even the artist who has not occupied himself specially with æsthetics, will not hesitate at this question either. He thinks the solution was found long ago and is well known to everyone.

'Art is activity that produces beauty,' says such a man. . . .

What then is this conception of beauty, so stubbornly held to by people of our circle and day as furnishing a definition of art?

In its subjective aspect, we call beauty that which supplies us with a particular kind of pleasure.

In its objective aspect, we call beauty something absolutely perfect, and we acknowledge it to be so only because we receive from the manifestation of this absolute perfection a certain kind of pleasure: so that this objective definition is nothing but the subjective conception differently expressed. In reality both conceptions of beauty amount to one and the same thing, namely, the reception by us of a certain kind of pleasure; that is to say, we call 'beauty' that which pleases us without evoking in us desire.

Such being the position of affairs it would seem only natural that the science of art should decline to content itself with a definition of art based on beauty (that is, on that which pleases), and should seek a general definition applicable to all artistic productions, by reference to which we might decide whether a certain article belonged to the realm of art or not. But no such definition is supplied, as the reader may see from those summaries of æsthetic theories which I have given, and as he may discover even more clearly from the original æsthetic works if he will be at the pains to read them. All attempts to define absolute beauty in itself—whether as an imitation of nature, or as suitability to its object, or as a correspondence of parts, or as symmetry, or as harmony, or as unity in variety, and so forth—either define nothing at all, or define only some traits of some artistic productions and are far from including all that everybody has always held and still holds to be art.

There is no objective definition of beauty. The existing definitions (both the metaphysical and the experimental) amount only to one and the same subjective definition, which is (strange as it seems to say so), that art is that which makes beauty manifest, and beauty is that which pleases (without exciting desire). Many æstheticians have felt the insufficiency and instability of such a definition, and in order to give it a firm basis have asked themselves why a thing pleases. And they have converted the discussion on beauty into a question of taste, as did Hutcheson, Voltaire, Diderot, and others. But all attempts to define what taste is must lead to nothing, as the reader may see both from the history of æsthetics and experimentally. There is and can be no explanation of why one thing pleases one man and displeases another, or *vice versa;* so that the whole existing science of æsthetics fails to do what we might expect from it as a mental activity calling itself a science, namely, it does not define the qualities and laws of art, or of the beautiful (if that be the content of art), or the nature of taste (if taste decides the question of art and its merit), and then on the basis of such definitions acknowledge as art those productions which correspond to these laws and reject those which do not come under

them. But this science of æsthetics consists in first acknowledging a certain set of productions to be art (because they please us), and then framing such a theory of art as all these productions which please a certain circle of people can be fitted into. There exists an art-canon according to which certain productions favoured by our circle are acknowledged as being art,—the works of Phidias, Sophocles, Homer, Titian, Raphael, Bach, Beethoven, Dante, Shakespeare, Goethe, and others,—and the æsthetic laws must be such as to embrace all these productions. In æsthetic literature you will constantly meet with opinions on the merit and importance of art, founded not on any certain laws by which this or that is held to be good or bad, but merely on consideration as to whether this art tallies with the art-canon we have drawn up.

The other day I was reading a far from ill-written book by Folgeldt. Discussing the demand for morality in works of art, the author plainly says that we must not demand morality in art. And in proof of this he advances the fact that, if we admit such a demand, Shakespeare's *Romeo and Juliet* and Goethe's *Wilhelm Meister* would not come within the definition of good art; but since both these books are included in our canon of art, he concludes that the demand is unjust. And therefore it is necessary to find a definition of art which shall fit the works; and instead of a demand for morality Folgeldt postulates as the basis of art a demand for the important *(Bedeutungsvolles)*.

All the existing æsthetic standards are built on this plan. Instead of giving a definition of true art and then deciding what is and what is not good art by judging whether a work conforms or does not conform to this definition, a certain class of works which for some reason pleases a certain circle of people is accepted as being art, and a definition of art is then devised to cover all these productions. I recently came upon a remarkable instance of this method in a very good German work, *The History of Art in the Nineteenth Century*, by Muther. Describing the pre-Raphaelites, the Decadents, and the Symbolists (who are already included in the canon of art), he not only does not venture to blame their tendency, but earnestly endeavours to widen his standard so that it may include them all, since they appear to him to represent a legitimate reaction from the excesses of realism. No matter what insanities appear in art, when once they find acceptance among the upper classes of our society a theory is quickly invented to explain and sanction them; just as if there had never been periods in history when certain special circles of people recognized and approved false, deformed, and insensate, art which subsequently left no trace and has been utterly forgotten. And to what lengths the insanity and deformity of art may go, especially when as in our days it knows that it is considered infallible, may be seen by what is being done in the art of our circle to-day.

So that the theory of art founded on beauty, expounded by æsthetics and in dim outline professed by the public, is nothing but the setting up as good of that which has pleased and pleases us, that is, pleases a certain class of people.

In order to define any human activity, it is necessary to understand its sense and importance; and in order to do this it is primarily necessary to examine that activity in itself, in its dependence on its causes and in connexion with its effects, and not merely in relation to the pleasure we can get from it.

If we say that the aim of any activity is merely our pleasure and define it solely by that pleasure, our definition will evidently be a false one. But this is precisely what has occurred in the efforts to define art. Now if we consider the food question it will not occur to any one to affirm that the importance of food consists in the pleasure we receive when eating it. Everybody understands that the satisfaction of our taste cannot serve as a basis for our definition of the merits of food, and that we have therefore no right to presuppose that dinners with cayenne pepper, Limburg cheese, alcohol, and so on, to which we are accustomed and which please us, form the very best human food.

In the same way beauty, or that which pleases us, can in no sense serve as a basis for the definition of art; nor can a series of objects which afford us pleasure serve as the model of what art should be.

To see the aim and purpose of art in the pleasure we get from it, is like assuming (as is done by people of the lowest moral development, for instance by savages) that the purpose and aim of food is the pleasure derived when consuming it.

Just as people who conceive the aim and purpose of food to be pleasure cannot recognize the real meaning of eating, so people who consider the aim of art to be pleasure cannot realize its true meaning and purpose, because they attribute to an activity the meaning of which lies in its connexion with the other phenomena of life, the false and exceptional aim of pleasure. People come to understand that the meaning of eating lies in the nourishment of the body, only when they cease to consider that the object of that activity is pleasure. And it is the same with regard to art. People will come to understand the meaning of art only when they cease to consider that the aim of that activity is beauty, that is to say, pleasure. The acknowledgment of beauty (that is, of a certain kind of pleasure received from art) as being the aim of art, not only fails to assist us in finding a definition of what art is, but on the contrary by transferring the question into a region quite foreign to art (into metaphysical, psychological, physiological, and even historical, discussions as to why such a production pleases one person and such another displeases or pleases some one else), it renders such definition impossible. And since discussions as to why one man likes pears and another prefers meat do not help towards finding a definition of what is essential in nourishment, so the solution of questions of taste in art (to which the discussions on art involuntarily come) not only does not help to make clear in what this particular human activity which we call art really consists, but renders such elucidation quite impossible until we rid ourselves of a conception which justifies every kind of art at the cost of confusing the whole matter.

To the question, What is this art to which is offered up the labour of millions, the very lives of men, and even morality itself? we have extracted replies from the existing æsthetics which all amount to this: that the aim of art is beauty, that beauty is recognized by the enjoyment it gives, and that artistic enjoyment is a good and important thing, because it *is* enjoyment. In a word, that enjoyment is good because it is enjoyment. Thus what is considered the definition of art is no definition at all, but only a shuffle to justify existing art. Therefore, however strange it may seem to say so, in spite of the mountains of books written about art, no exact definition of art has been constructed. And

the reason of this is that the conception of art has been based on the conception of beauty. . . .

In order to define art correctly it is necessary first of all to cease to consider it as a means to pleasure, and to consider it as one of the conditions of human life. Viewing it in this way we cannot fail to observe that art is one of the means of intercourse between man and man.

Every work of art causes the receiver to enter into a certain kind of relationship both with him who produced or is producing the art, and with all those who, simultaneously, previously, or subsequently, receive the same artistic impression.

Speech transmitting the thoughts and experiences of men serves as a means of union among them, and art serves a similar purpose. The peculiarity of this latter means of intercourse, distinguishing it from intercourse by means of words, consists in this, that whereas by words a man transmits his thoughts to another, by art he transmits his feelings.

The activity of art is based on the fact that a man receiving through his sense of hearing or sight another man's expression of feeling, is capable of experiencing the emotion which moved the man who expressed it. To take the simplest example: one man laughs, and another who hears becomes merry, or a man weeps, and another who hears feels sorrow. A man is excited or irritated, and another man seeing him is brought to a similar state of mind. By his movements or by the sounds of his voice a man expresses courage and determination or sadness and calmness, and this state of mind passes on to others. A man suffers, manifesting his sufferings by groans and spasms, and this suffering transmits itself to other people; a man expresses his feelings of admiration, devotion, fear, respect, or love, to certain objects, persons, or phenomena, and others are infected by the same feelings of admiration, devotion, fear, respect, or love, to the same objects, persons, or phenomena.

And it is on this capacity of man to receive another man's expression of feeling and to experience those feelings himself, that the activity of art is based.

If a man infects another or others directly, immediately, by his appearance or by the sounds he gives vent to at the very time he experiences the feeling; if he causes another man to yawn when he himself cannot help yawning, or to laugh or cry when he himself is obliged to laugh or cry, or to suffer when he himself is suffering—that does not amount to art.

Art begins when one person with the object of joining another or others to himself in one and the same feeling, expresses that feeling by certain external indications. To take the simplest example: a boy having experienced, let us say, fear on encountering a wolf, relates that encounter, and in order to evoke in others the feeling he has experienced, describes himself, his condition before the encounter, the surroundings, the wood, his own lightheartedness, and then the wolf's appearance, its movements, the distance between himself and the wolf, and so forth. All this, if only the boy when telling the story again experiences the feelings he had lived through, and infects the hearers and compels them to feel what he had experienced—is art. Even if the boy had not seen a wolf but had frequently been afraid of one, and if wishing

to evoke in others the fear he had felt, he invented an encounter with a wolf and recounted it so as to make his hearers share the feelings he experienced when he feared the wolf, that also would be art. And just in the same way it is art if a man, having experienced either the fear of suffering or the attraction of enjoyment (whether in reality or in imagination), expresses these feelings on canvas or in marble so that others are infected by them. And it is also art if a man feels, or imagines to himself, feelings of delight, gladness, sorrow, despair, courage, or despondency, and the transition from one to another of these feelings, and expresses them by sounds so that the hearers are infected by them and experience them as they were experienced by the composer.

The feelings with which the artist infects others may be most various—very strong or very weak, very important or very insignificant, very bad or very good: feelings of love of one's country, self-devotion and submission to fate or to God expressed in a drama, raptures of lovers described in a novel, feelings of voluptuousness expressed in a picture, courage expressed in a triumphal march, merriment evoked by a dance, humour evoked by a funny story, the feeling of quietness transmitted by an evening landscape or by a lullaby, or the feeling of admiration evoked by a beautiful arabesque—it is all art.

If only the spectators or auditors are infected by the feelings which the author has felt, it is art.

To evoke in oneself a feeling one has once experienced and having evoked it in oneself then by means of movements, lines, colours, sounds, or forms expressed in words, so to transmit that feeling that others experience the same feeling—this is the activity of art.

Art is a human activity consisting in this, that one man consciously by means of certain external signs, hands on to others feelings he has lived through, and that others are infected by these feelings and also experience them.

Art is not, as the metaphysicians say, the manifestation of some mysterious Idea of beauty or God; it is not, as the æsthetic physiologists say, a game in which man lets off his excess of stored-up energy; it is not the expression of man's emotions by external signs; it is not the production of pleasing objects; and, above all, it is not pleasure; but it is a means of union among men joining them together in the same feelings, and indispensable for the life and progress towards well-being of individuals and of humanity.

As every man, thanks to man's capacity to express thoughts by words, may know all that has been done for him in the realms of thought by all humanity before his day, and can in the present, thanks to this capacity to understand the thoughts of others, become a sharer in their activity and also himself hand on to his contemporaries and descendants the thoughts he has assimilated from others as well as those that have arisen in himself; so, thanks to man's capacity to be infected with the feelings of others by means of art, all that is being lived through by his contemporaries is accessible to him, as well as the feelings experienced by men thousands of years ago, and he has also the possibility of transmitting his own feelings to others.

If people lacked the capacity to receive the thoughts conceived by men

who preceded them and to pass on to others their own thoughts, men would
be like wild beasts, or like Kasper Hauser.[1]

And if men lacked this other capacity of being infected by art, people
might be almost more savage still, and above all more separated from, and
more hostile to, one another.

And therefore the activity of art is a most important one, as important as
the activity of speech itself and as generally diffused.

As speech does not act on us only in sermons, orations, or books, but in
all those remarks by which we interchange thoughts and experiences with one
another, so also art in the wide sense of the word permeates our whole life,
but it is only to some of its manifestations that we apply the term in the lim-
ited sense of the word.

We are accustomed to understand art to be only what we hear and see in
theatres, concerts, and exhibitions; together with buildings, statues, poems,
and novels. . . . But all this is but the smallest part of the art by which we com-
municate with one another in life. All human life is filled with works of art of
every kind—from cradle-song, jest, mimicry, the ornamentation of houses,
dress, and utensils, to church services, buildings, monuments, and triumphal
processions. It is all artistic activity. So that by art, in the limited sense of the
word, we do not mean all human activity transmitting feelings but only that
part which we for some reason select from it and to which we attach special
importance.

This special importance has always been given by men to that part of this
activity which transmits feelings flowing from their religious perception, and
this small part they have specifically called art, attaching to it the full mean-
ing of the word.

That was how men of old—Socrates, Plato, and Aristotle—looked on art.
Thus did the Hebrew prophets and the ancient Christians regard art. Thus it
was, and still is, understood by the Mohammedans, and thus it still is under-
stood by religious folk among our own peasantry.

Some teachers of mankind—such as Plato in his *Republic,* and people like
the primitive Christians, the strict Mohammedans, and the Buddhists—have
gone so far as to repudiate all art.

People viewing art in this way (in contradiction to the prevalent view of
to-day which regards any art as good if only it affords pleasure) held and hold
that art (as contrasted with speech, which need not be listened to) is so highly
dangerous in its power to infect people against their wills, that mankind will
lose far less by banishing all art than by tolerating each and every art.

Evidently such people were wrong in repudiating all art, for they denied
what cannot be denied—one of the indispensable means of communication
without which mankind could not exist. But not less wrong are the people of
civilized European society of our class and day in favouring any art if it but
serves beauty, that is, gives people pleasure.

[1]'The foundling of Nuremberg,' found in the marketplace of that town on 23rd May 1828, appar-
ently some sixteen years old. He spoke little and was almost totally ignorant even of common
objects. He subsequently explained that he had been brought up in confinement underground and
visited by only one man, whom he saw but seldom.

Formerly people feared lest among works of art there might chance to be some causing corruption, and they prohibited art altogether. Now they only fear lest they should be deprived of any enjoyment art can afford, and they patronize any art. And I think the last error is much grosser than the first and that its consequences are far more harmful. . . .

I know that most men—not only those considered clever, but even those who are very clever and capable of understanding most difficult scientific, mathematical, or philosophic, problems—can seldom discern even the simplest and most obvious truth if it be such as obliges them to admit the falsity of conclusions they have formed, perhaps with much difficulty—conclusions of which they are proud, which they have taught to others, and on which they have built their lives. And therefore I have little hope that what I adduce as to the perversion of art and taste in our society will be accepted or even seriously considered. Nevertheless I must state fully the inevitable conclusion to which my investigation into the question of art has brought me. This investigation has brought me to the conviction that almost all that our society considers to be art, good art, and the whole of art, far from being real and good art and the whole of art, is not even art at all but only a counterfeit of it. This position I know will seem very strange and paradoxical, but if we once acknowledge art to be a human activity by means of which some people transmit their feelings to others (and not a service of Beauty, or a manifestation of the Idea, and so forth), we shall inevitably have to admit this further conclusion also. If it is true that art is an activity by means of which one man having experienced a feeling intentionally transmits it to others, then we have inevitably to admit further that of all that among us is termed art (the art of the upper classes)—of all those novels, stories, dramas, comedies, pictures, sculptures, symphonies, operas, operettas, ballets, etc., which profess to be works of art, scarcely one in a hundred thousand proceeds from an emotion felt by its author, all the rest being but manufactured counterfeits of art in which borrowing, imitation, effects, and interest, replace the contagion of feeling. That the proportion of real productions of art is to the counterfeits as one to some hundreds of thousands or even more, may be seen by the following calculation: I have read somewhere that the artist painters in Paris alone number 30,000; there will probably be as many in England, as many in Germany, and as many in Russia, Italy, and the smaller states combined. So that in all there will be in Europe, say, 120,000 painters; and there are probably as many musicians and as many literary artists. If these 360,000 individuals produce three works a year each (and many of them produce ten or more), then each year yields over a million so-called works of art. How many then must have been produced in the last ten years, and how many in the whole time since upper-class art broke off from the art of the whole people? Evidently millions. Yet who of all the connoisseurs of art has received impressions from all these pseudo works of art? Not to mention the labouring classes who have no conception of these productions, even people of the upper classes cannot know one in a thousand of them all, and cannot remember those they have known. These works all appear under the guise of art, produce no impression on any one (except when they serve as pastimes for an idle crowd of rich people), and vanish utterly. . . .

Art in our society has become so perverted that not only has bad art come to be considered good, but even the very perception of what art really is has been lost. In order to be able to speak about the art of our society it is, therefore, first of all necessary to distinguish art from counterfeit art.

There is one indubitable sign distinguishing real art from its counterfeit—namely, the infectiousness of art. If a man without exercising effort and without altering his standpoint, on reading, hearing, or seeing another man's work experiences a mental condition which unites him with that man and with others who are also affected by that work, then the object evoking that condition is a work of art. And however poetic, realistic, striking, or interesting, a work may be, it is not a work of art if it does not evoke that feeling (quite distinct from all other feelings) of joy and of spiritual union with another (the author) and with others (those who are also infected by it).

It is true that this indication is an *internal* one and that there are people who, having forgotten what the action of real art is, expect something else from art (in our society the great majority are in this state), and that therefore such people may mistake for this æsthetic feeling the feeling of diversion and a certain excitement which they receive from counterfeits of art. But though it is impossible to undeceive these people just as it may be impossible to convince a man suffering from colour-blindness that green is not red, yet for all that, this indication remains perfectly definite to those whose feeling for art is neither perverted nor atrophied, and it clearly distinguishes the feeling produced by art from all other feelings.

The chief peculiarity of this feeling is that the recipient of a truly artistic impression is so united to the artist that he feels as if the work were his own and not some one else's—as if what it expresses were just what he had long been wishing to express. A real work of art destroys in the consciousness of the recipient the separation between himself and the artist, and not that alone, but also between himself and all whose minds receive this work of art. In this freeing of our personality from its separation and isolation, in this uniting of it with others, lies the chief characteristic and the great attractive force of art.

If a man is infected by the author's condition of soul, if he feels this emotion and this union with others, then the object which has effected this is art; but if there be no such infection, if there be not this union with the author and with others who are moved by the same work—then it is not art. And not only is infection a sure sign of art, but the degree of infectiousness is also the sole measure of excellence in art.

The stronger the infection the better is the art, as art, speaking of it now apart from its subject-matter—that is, not considering the value of the feelings it transmits.

And the degree of the infectiousness of art depends on three conditions: (1) on the greater or lesser individuality of the feeling transmitted; (2) on the greater or lesser clearness with which the feeling is transmitted; (3) on the sincerity of the artist; that is, on the greater or lesser force with which the artist himself feels the emotion he transmits.

The more individual the feeling transmitted the more strongly does it act on the recipient; the more individual the state of soul into which he is transferred the more pleasure does the recipient obtain and therefore the more readily and strongly does he join in it.

Clearness of expression assists infection because the recipient who mingles in consciousness with the author is the better satisfied the more clearly that feeling is transmitted which, as it seems to him, he has long known and felt and for which he has only now found expression.

But most of all is the degree of infectiousness of art increased by the degree of sincerity in the artist. As soon as the spectator, hearer, or reader, feels that the artist is infected by his own production and writes, sings, or plays, for himself, and not merely to act on others, this mental condition of the artist infects the recipient; and, on the contrary, as soon as the spectator, reader, or hearer, feels that the author is not writing, singing, or playing, for his own satisfaction—does not himself feel what he wishes to express, but is doing it for him, the recipient—resistance immediately springs up, and the most individual and the newest feelings and the cleverest technique not only fail to produce any infection but actually repel.

I have mentioned three conditions of contagion in art, but they may all be summed up into one, the last, sincerity; that is, that the artist should be impelled by an inner need to express his feeling. That condition includes the first; for if the artist is sincere he will express the feeling as he experienced it. And as each man is different from every one else, his feeling will be individual for every one else; and the more individual it is—the more the artist has drawn it from the depths of his nature—the more sympathetic and sincere will it be. And this same sincerity will impel the artist to find clear expression for the feeling which he wishes to transmit.

Therefore this third condition—sincerity—is the most important of the three. It is always complied with in peasant art, and this explains why such art always acts so powerfully; but it is a condition almost entirely absent from our upper-class art, which is continually produced by artists actuated by personal aims of covetousness or vanity.

Such are the three conditions which divide art from its counterfeits, and which also decide the quality of every work of art considered apart from its subject-matter.

The absence of any one of these conditions excludes a work from the category of art and relegates it to that of art's counterfeits. If the work does not transmit the artist's peculiarity of feeling and is therefore not individual, if it is unintelligibly expressed, or if it has not proceeded from the author's inner need for expression—it is not a work of art. If all these conditions are present even in the smallest degree, then the work even if a weak one is yet a work of art.

The presence in various degrees of these three conditions: individuality, clearness, and sincerity, decides the merit of a work of art as art, apart from subject-matter. All works of art take order of merit according to the degree in which they fulfil the first, the second, and the third, of these conditions. In one the individuality of the feeling transmitted may predominate; in another, clearness of expression; in a third, sincerity; while a fourth may have sincerity and individuality but be deficient in clearness; a fifth, individuality and clearness, but less sincerity; and so forth, in all possible degrees and combinations.

Thus is art divided from what is not art, and thus is the quality of art, as art, decided, independently of its subject-matter, that is to say, apart from whether the feelings it transmits are good or bad.

But how are we to define good and bad art with reference to its content or subject-matter? . . .

How in the subject-matter of art are we to decide what is good and what is bad?

Art like speech is a means of communication and therefore of progress, that is, of the movement of humanity forward towards perfection. Speech renders accessible to men of the latest generations all the knowledge discovered by the experience and reflection both of preceding generations and of the best and foremost men of their own times; art renders accessible to men of the latest generations all the feelings experienced by their predecessors and also those felt by their best and foremost contemporaries. And as the evolution of knowledge proceeds by truer and more necessary knowledge dislodging and replacing what was mistaken and unnecessary, so the evolution of feeling proceeds by means of art—feelings less kind and less necessary for the well-being of mankind being replaced by others kinder and more needful for that end. That is the purpose of art. And speaking now of the feelings which are its subject-matter, the more art fulfils that purpose the better the art, and the less it fulfils it the worse the art.

The appraisement of feelings (that is, the recognition of one or other set of feelings as more or less good, more or less necessary for the well-being of mankind) is effected by the religious perception of the age.

In every period of history and in every human society there exists an understanding of the meaning of life, which represents the highest level to which men of that society have attained—an understanding indicating the highest good at which that society aims. This understanding is the religious perception of the given time and society. And this religious perception is always clearly expressed by a few advanced men and more or less vividly perceived by members of the society generally. Such a religious perception and its corresponding expression always exists in every society. If it appears to us that there is no religious perception in our society, this is not because there really is none, but only because we do not wish to see it. And we often wish not to see it because it exposes the fact that our life is inconsistent with that religious perception.

Religious perception in a society is like the direction of a flowing river. If the river flows at all it must have a direction. If a society lives, there must be a religious perception indicating the direction in which, more or less consciously, all its members tend.

And so there always has been, and is, a religious perception in every society. And it is by the standard of this religious perception that the feelings transmitted by art have always been appraised. It has always been only on the basis of this religious perception of their age, that men have chosen from amid the endlessly varied spheres of art that art which transmitted feelings making religious perception operative in actual life. And such art has always been highly valued and encouraged, while art transmitting feelings already outlived, flowing from the antiquated religious perceptions of a former age, has always been condemned and despised. All the rest of art transmitting those most diverse feelings by means of which people commune with one another was not condemned and was tolerated if only it did not transmit feelings contrary to reli-

gious perception. Thus for instance among the Greeks, art transmitting feelings of beauty, strength, and courage (Hesiod, Homer, Phidias) was chosen, approved, and encouraged, while art transmitting feelings of rude sensuality, despondency, and effeminacy, was condemned and despised. Among the Jews, art transmitting feelings of devotion and submission to the God of the Hebrews and to His will (the epic of Genesis, the prophets, the Psalms) was chosen and encouraged, while art transmitting feelings of idolatry (the Golden Calf) was condemned and despised. All the rest of art—stories, songs, dances, ornamentation of houses, of utensils, and of clothes—which was not contrary to religious perception, was neither distinguished nor discussed. Thus as regards its subject-matter has art always and everywhere been appraised and thus it should be appraised, for this attitude towards art proceeds from the fundamental characteristics of human nature, and those characteristics do not change.

I know that according to an opinion current in our times religion is a superstition humanity has outgrown, and it is therefore assumed that no such thing exists as a religious perception common to us all by which art in our time can be appraised. I know that this is the opinion current in the pseudo-cultured circles of today. People who do not acknowledge Christianity in its true meaning because it undermines their social privileges, and who therefore invent all kinds of philosophic and æsthetic theories to hide from themselves the meaninglessness and wrongfulness of their lives, cannot think otherwise. These people intentionally, or sometimes unintentionally, confuse the notion of a religious cult with the notion of religious perception, and think that by denying the cult they get rid of the perception. But even the very attacks on religion and the attempts to establish an idea of life contrary to the religious perception of our times, most clearly demonstrate the existence of a religious perception condemning the lives that are not in harmony with it.

If humanity progresses, that is, moves forward, there must inevitably be a guide to the direction of that movement. And religions have always furnished that guide. All history shows that the progress of humanity is accomplished no otherwise than under the guidance of religion. But if the race cannot progress without the guidance of religion,—and progress is always going on, and consequently goes on also in our own times,—then there must be a religion of our times. So that whether it pleases or displeases the so-called cultured people of to-day, they must admit the existence of religion—not of a religious cult, Catholic, Protestant, or another, but of religious perception—which even in our times is the guide always present where there is any progress. And if a religious perception exists amongst us, then the feelings dealt with by our art should be appraised on the basis of that religious perception; and as has been the case always and everywhere, art transmitting feelings flowing from the religious perception of our time should be chosen from amid all the indifferent art, should be acknowledged, highly valued, and encouraged, while art running counter to that perception should be condemned and despised, and all the remaining, indifferent, art should neither be distinguished nor encouraged.

The religious perception of our time in its widest and most practical application is the consciousness that our well-being, both material and spiritual,

individual and collective, temporal and eternal, lies in the growth of brother-
hood among men—in their loving harmony with one another. This perception
is not only expressed by Christ and all the best men of past ages, it is not only
repeated in most varied forms and from most diverse sides by the best men
of our times, but it already serves as a clue to all the complex labour of human-
ity, consisting as this labour does on the one hand in the destruction of phys-
ical and moral obstacles to the union of men, and on the other hand in estab-
lishing the principles common to all men which can and should unite them in
one universal brotherhood. And it is on the basis of this perception that we
should appraise all the phenomena of our life and among the rest our art also:
choosing from all its realms and highly prizing and encouraging whatever
transmits feelings flowing from this religious perception, rejecting whatever is
contrary to it, and not attributing to the rest of art an importance that does not
properly belong to it. . . .

Christian art either evokes in men feelings which through love of God and of
one's neighbour draw them to closer and ever closer union and make them
ready for, and capable of, such union; or evokes in them feelings which show
them that they are already united in the joys and sorrows of life. And there-
fore the Christian art of our time can be and is of two kinds: first, art trans-
mitting feelings flowing from a religious perception of man's position in the
world in relation to God and to his neighbour—religious art in the limited
meaning of the term; and secondly, art transmitting the simplest feelings of
common life, but such always as are accessible to all men in the whole world—
the art of common life—the art of the people—universal art. Only these two
kinds of art can be considered good art in our time.

The first, religious art—transmitting both positive feelings of love of God
and one's neighbour, and negative feelings of indignation and horror at the
violation of love—manifests itself chiefly in the form of words, and to some
extent also in painting and sculpture: the second kind, universal art, trans-
mitting feelings accessible to all, manifests itself in words, in painting, in sculp-
ture, in dances, in architecture, and most of all in music.

If I were asked to give modern examples of each of these kinds of art, then
as examples of the highest art flowing from love of God and man (both of the
higher, positive, and of the lower, negative kind), in literature I should name
The Robbers by Schiller; Victor Hugo's *Les Pauvres Gens* and *Les Misérables*; the
novels and stories of Dickens—*The Tale of Two Cities, The Christmas Carol, The
Chimes,* and others—*Uncle Tom's Cabin;* Dostoévski's works—especially his
Memoirs from the House of Death—and *Adam Bede* by George Eliot. . . .

To give examples from the modern art of our upper classes, of art of the sec-
ond kind: good universal art, or even of the art of a whole people, is yet more
difficult, especially in literature and music. If there are some works which by
their inner contents might be assigned to this class (such as *Don Quixote,*
Molière's comedies, *David Copperfield* and *The Pickwick Papers* by Dickens,
Gógol's and Púshkin's tales, and some things of Maupassant's), these works
for the most part—owing to the exceptional nature of the feelings they trans-
mit, and the superfluity of special details of time and locality, and above all

on account of the poverty of their subject-matter in comparison with examples of universal ancient art (such, for instance, as the story of Joseph)—are comprehensible only to people of their own circle. That Joseph's brethren, being jealous of his father's affection, sell him to the merchants; that Potiphar's wife wishes to tempt the youth; that having attained to highest station he takes pity on his brothers, including Benjamin the favourite—these and all the rest are feelings accessible alike to a Russian peasant, a Chinese, an African, a child, or an old man, educated or uneducated; and it is all written with such restraint, is so free from any superfluous detail, that the story may be told to any circle and will be equally comprehensible and touching to everyone. But not such are the feelings of Don Quixote or of Molière's heroes (though Molière is perhaps the most universal, and therefore the most excellent, artist of modern times), nor of Pickwick and his friends. These feelings are not common to all men but very exceptional, and therefore to make them contagious the authors have surrounded them with abundant details of time and place. And this abundance of detail makes the stories difficult of comprehension to all who do not live within reach of the conditions described by the author.

The author of the novel of Joseph did not need to describe in detail, as would be done nowadays, the blood-stained coat of Joseph, the dwelling and dress of Jacob, the pose and attire of Potiphar's wife, and how adjusting the bracelet on her left arm she said, 'Come to me,' and so on, because the content of feeling in this novel is so strong that all details except the most essential—such as that Joseph went out into another room to weep—are superfluous and would only hinder the transmission of emotion. And therefore this novel is accessible to all men, touches people of all nations and classes young and old, and has lasted to our times and will yet last for thousands of years to come. But strip the best novels of our time of their details and what will remain?

It is therefore impossible in modern literature to indicate works fully satisfying the demands of universality. Such works as exist are to a great extent spoilt by what is usually called 'realism', but would be better termed 'provincialism', in art.

In music the same occurs as in verbal art, and for similar reasons. In consequence of the poorness of the feeling they contain, the melodies of the modern composers are amazingly empty and insignificant. And to strengthen the impression produced by these empty melodies the new musicians pile complex modulations on each trivial melody, not only in their own national manner, but also in the way characteristic of their own exclusive circle and particular musical school. Melody—every melody—is free and may be understood of all men; but as soon as it is bound up with a particular harmony, it ceases to be accessible except to people trained to such harmony, and it becomes strange, not only to common men of another nationality, but to all who do not belong to the circle whose members have accustomed themselves to certain forms of harmonization. So that music, like poetry, travels in a vicious circle. Trivial and exclusive melodies, in order to make them attractive, are laden with harmonic, rhythmic, and orchestral complications and thus become yet more exclusive, and far from being universal are not even national, that is, they are not comprehensible to the whole people, but only to some people.

In music, besides marches and dances by various composers which satisfy the demands of universal art, one can indicate very few works of this class: Bach's famous violin *aria,* Chopin's nocturne in E flat major, and perhaps a dozen bits (not whole pieces, but parts) selected from the works of Haydn, Mozart, Schubert, Beethoven, and Chopin.[2]

Although in painting the same thing is repeated as in poetry and in music—namely, that in order to make them more interesting, works weak in conception are surrounded by minutely studied accessories of time and place which give them a temporary and local interest but make them less universal—still in painting more than in other spheres of art may be found works satisfying the demands of universal Christian art; that is to say, there are more works expressing feelings in which all men may participate.

In the arts of painting and sculpture, all pictures and statues in so-called genre style, representations of animals, landscapes, and caricatures with subjects comprehensible to every one, and also all kinds of ornaments, are universal in subject-matter. Such productions in painting and sculpture are very numerous (for instance, china dolls), but for the most part such objects (for instance, ornaments of all kinds) are either not considered to be art or are considered to be art of a low quality. In reality all such objects if only they transmit a true feeling experienced by the artist and comprehensible to every one (however insignificant it may seem to us to be), are works of real, good, Christian, art. . . .

In painting we must similarly place in the class of bad art all ecclesiastical, patriotic, and exclusive pictures; all pictures representing the amusements and allurements of a rich and idle life; all so-called symbolic pictures in which the very meaning of the symbol is comprehensible only to those of a certain circle; and above all pictures with voluptuous subjects—all that odious female nudity which fills all the exhibitions and galleries. And to this class belongs almost all the chamber and opera music of our times,—beginning especially with Beethoven (Schumann, Berlioz, Liszt, Wagner),—by its subject-matter devoted to the expression of feelings accessible only to people who have developed in themselves an unhealthy nervous irritation evoked by this exclusive, artificial, and complex music.

'What! the *Ninth Symphony* not a good work of art!' I hear exclaimed by indignant voices.

And I reply: Most certainly it is not. All that I have written I have written

[2]While offering as examples of art those that seem to me best, I attach no special importance to my selection; for, besides being insufficiently informed in all branches of art, I belong to the class of people whose taste has been perverted by false training. And therefore my old, inured habits may cause me to err, and I may mistake for absolute merit the impression a work produced on me in my youth. My only purpose in mentioning examples of works of this or that class is to make my meaning clearer and to show how, with my present views, I understand excellence in art in relation to its subject-matter. I must moreover mention that I consign my own artistic productions to the category of bad art, excepting the story *God sees the Truth but Waits,* which seeks a place in the first class, and *A Prisoner of the Caucasus,* which belongs to the second.—L.T.

 (Both the stories mentioned are included in *Twenty-Three Tales* in the 'World's Classics' Tolstóy series.—A.M.)

with the sole purpose of finding a clear and reasonable criterion by which to judge the merits of works of art. And this criterion, coinciding with the indications of plain and sane sense, indubitably shows me that that symphony of Beethoven's is not a good work of art. Of course to people educated in the worship of certain productions and of their authors, to people whose taste has been perverted just by being educated in such a worship, the acknowledgment that such a celebrated work is bad, is amazing and strange. But how are we to escape the indications of reason and common sense?

Beethoven's *Ninth Symphony* is considered a great work of art. To verify its claim to be such I must first ask myself whether this work transmits the highest religious feeling? I reply in the negative, since music in itself cannot transmit those feelings; and therefore I ask myself next: Since this work does not belong to the highest kind of religious art, has it the other characteristic of the good art of our time—the quality of uniting all men in one common feeling—does it rank as Christian universal art? And again I have no option but to reply in the negative; for not only do I not see how the feelings transmitted by this work could unite people not specially trained to submit themselves to its complex hypnotism, but I am unable to imagine to myself a crowd of normal people who could understa nd anything of this long, confused, and artificial production, except short snatches which are lost in a sea of what is incomprehensible. And therefore, whether I like it or not, I am compelled to conclude that this work belongs to the rank of bad art. It is curious to note in this connexion, that attached to the end of this very symphony is a poem of Schiller's which (though somewhat obscu rely) expresses this very thought, namely, that feeling (Schiller speaks only of the feeling of gladness) unites people and evokes love in them. But though this poem is sung at the end of the symphony, the music does not accord with the thought expressed in the verses; for the music is exclusive and does not unite all men, but unites only a few, dividing them off from the rest of mankind.

And just in this same way, in all branches of art, many and many works considered great by the upper classes of our society will have to be judged. By this one sure criterion we shall have to judge the celebrated *Divine Comedy* and *Jerusalem Delivered,* and a great part of Shakespeare's and Goethe's work, and in painting every representation of miracles, including Raphael's Transfiguration, etc.

Whatever the work may be and however it may have been extolled, we have first to ask whether this work is one of real art, or a counterfeit. Having acknowledged, on the basis of the indication of its infectiousness even to a small class of people, that a certain production belongs to the realm of art, it is necessary on this basis to decide the next question, Does this work belong to the category of bad exclusive art opposed to religious perception, or of Christian art uniting people? And having acknowledged a work to belong to real Christian art, we must then, according to whether it transmits feelings flowing from love of God and man, or merely the simple feelings uniting all men, assign it a place in the ranks of religious art, or in those of universal art.

Only on the basis of such verification shall we find it possible to select from the whole mass of what in our society claims to be art, those works which form real, important, necessary, spiritual food, and to separate them from all

the harmful and useless art and from the counterfeits of art which surround us. Only on the basis of such verification shall we be able to rid ourselves of the pernicious results of harmful art and avail ourselves of that beneficent action which is the purpose of true and good art, and which is indispensable for the spiritual life of man and of humanity.

READING 38

INTRODUCTION

In "Art and Civilization," a section of his book *Art as Experience* (1934), John Dewey (1859–1952) investigates the relationships between a civilization's art and its culture—construed broadly in terms of its morals. Art is often distrusted, he suggests, because of its roots in imaginative creativity. And creativity and imagination are distrusted because they are by their very essence subversive; they present a constant threat to the status quo. Art is thus in an important sense opposed to morals, for morals, according to Dewey, are by their essence conservative; they inevitably "reflect the divisions embodied in economic and political institutions." Dewey concludes that only art is capable of allowing us to conceive of a better future; and hence that only with art is there any possibility of achieving such a future. As he says, quoting Shelley, "imagination is the chief instrument of the good."

Art and Civilization

John Dewey

The moral office and human function of art can be intelligently discussed only in the context of culture. A particular work of art may have a definite effect upon a particular person or upon a number of persons. The social effect of the novels of Dickens or of Sinclair Lewis is far from negligible. But a less conscious and more massed constant adjustment of experience proceeds from the total environment that is created by the collective art of a time. Just as physical life cannot exist without the support of a physical environment, so moral life cannot go on without the support of a moral environment. Even technological arts, in their sum total, do something more than provide a number of separate conveniences and facilities. They shape collective occupations and thus determine direction of interest and attention, and hence affect desire and purpose.

The noblest man living in a desert absorbs something of its harshness and sterility, while the nostalgia of the mountain-bred man when cut off from his surroundings is proof how deeply environment has become part of his being. Neither the savage nor the civilized man is what he is by native constitution but by the culture in which he participates. The final measure of the quality of that culture is the arts which flourish. Compared with their influence things

directly taught by word and precept are pale and ineffectual. Shelley did not exaggerate when he said that moral science only "arranges the elements that poetry has created," if we extend "poetry" to include all products of imaginative experience. The sum total of the effect of all reflective treatises on morals is insignificant in comparison with the influence of architecture, novel, drama, on life, becoming important when "intellectual" products formulate the tendencies of these arts and provide them with an intellectual base. An "inner" rational check is a sign of withdrawal from reality unless it is a reflection of substantial environing forces. The political and economic arts that may furnish security and competency are no warrants of a rich and abundant human life save as they are attended by the flourishing of the arts that determine culture.

Words furnish a record of what has happened and give direction by request and command to particular future actions. Literature conveys the meaning of the past that is significant in present experience and is prophetic of the larger movement of the future. Only imaginative vision elicits the possibilities that are interwoven within the texture of the actual. The first stirrings of dissatisfaction and the first intimations of a better future are always found in works of art. The impregnation of the characteristically new art of a period with a sense of different values than those that prevail is the reason why the conservative finds such art to be immoral and sordid, and is the reason why he resorts to the products of the past for esthetic satisfaction. Factual science may collect statistics and make charts. But its predictions are, as has been well said, but past history reversed. Change in the climate of the imagination is the precursor of the changes that affect more than the details of life.

The theories that attribute direct moral effect and intent to art fail because they do not take account of the collective civilization that is the context in which works of art are produced and enjoyed. I would not say that they tend to treat works of art as a kind of sublimated Æsop's fables. But they all tend to extract particular works, regarded as especially edifying, from their milieu and to think of the moral function of art in terms of a strictly personal relation between the selected works and a particular individual. Their whole conception of morals is so individualistic that they miss a sense of the *way* in which art exercises its humane function.

Matthew Arnold's dictum that "poetry is criticism of life" is a case in point. It suggests to the reader a moral intent on the part of the poet and a moral judgment on the part of the reader. It fails to see or at all events to state *how* poetry is a criticism of life; namely, not directly, but by disclosure, through imaginative vision addressed to imaginative experience (not to set judgment) of possibilities that contrast with actual conditions. A sense of possibilities that are unrealized and that might be realized are when they are put in contrast with actual conditions, the most penetrating "criticism" of the latter that can be made. It is by a sense of possibilities opening before us that we become aware of constrictions that hem us in and of burdens that oppress.

Mr. Garrod, a follower of Matthew Arnold in more senses than one, has wittily said that what we resent in didactic poetry is not that it teaches, but that it does not teach, its incompetency. He added words to the effect that

poetry teaches as friends and life teach, by being, and not by express intent. He says in another place, "Poetical values are, after all, values in a human life. You cannot mark them off from other values, as though the nature of man were built in bulkheads." I do not think that what Keats has said in one of his letters can be surpassed as to the way in which poetry acts. He asks what would be the result if every man spun from his imaginative experience "an airy citadel" like the web the spider spins, "filling the air with a beautiful circuiting." For, he says, "man should not dispute or assert, but whisper results to his neighbor, and thus, by every germ of spirit sucking the sap from mold etherial, every human being might become great, and Humanity instead of being a wide heath of Furze and briars with here and there a remote Pine or Oak, would become a grand democracy of Forest Trees!"

It is by way of communication that art becomes the incomparable organ of instruction, but the way is so remote from that usually associated with the idea of education, it is a way that lifts art so far above what we are accustomed to think of as instruction, that we are repelled by any suggestion of teaching and learning in connection with art. But our revolt is in fact a reflection upon education that proceeds by methods so literal as to exclude the imagination and one not touching the desires and emotions of men. Shelley said, "The imagination is the great instrument of moral good, and poetry administers to the effect by acting upon the causes." Hence it is, he goes on to say, "a poet would do ill to embody his own conceptions of right and wrong, which are usually those of his own time and place, in his poetical creations. . . . By the assumption of this inferior office . . . he would resign participation in the cause"—the imagination. It is the lesser poets who "have frequently affected a moral aim, and the effect of their poetry is diminished in exact proportion as they compel us to advert to this purpose." But the power of imaginative projection is so great that he calls poets "the founders of civil society."

The problem of the relation of art and morals is too often treated as if the problem existed only on the side of art. It is virtually assumed that morals are satisfactory in idea if not in fact, and that the only question is whether and in what ways art should conform to a moral system already developed. But Shelley's statement goes to the heart of the matter. Imagination is the chief instrument of the good. It is more or less a commonplace to say that a person's ideas and treatment of his fellows are dependent upon his power to put himself imaginatively in their place. But the primacy of the imagination extends far beyond the scope of direct personal relationships. Except where "ideal" is used in conventional deference or as a name for a sentimental reverie, the ideal factors in every moral outlook and human loyalty are imaginative. The historic alliance of religion and art has its roots in this common quality. Hence it is that art is more moral than moralities. For the latter either are, or tend to become, consecrations of the *status quo*, reflections of custom, reënforcements of the established order. The moral prophets of humanity have always been poets even though they spoke in free verse or by parable. Uniformly, however, their vision of possibilities has soon been converted into a proclamation of facts that already exist and hardened into semi-political institutions. Their imaginative presentation of ideals that should command thought and desire have been treated as rules of policy. Art has been the means of keeping alive the

sense of purposes that outrun evidence and of meanings that transcend indurated habit.

Morals are assigned a special compartment in theory and practice because they reflect the divisions embodied in economic and political institutions. Wherever social divisions and barriers exist, practices and ideas that correspond to them fix metes and bounds, so that liberal action is placed under restraint. Creative intelligence is looked upon with distrust; the innovations that are the essence of individuality are feared, and generous impulse is put under bonds not to disturb the peace. Were art an acknowledged power in human association and not treated as the pleasuring of an idle moment or as a means of ostentatious display, and were morals understood to be identical with every aspect of value that is shared in experience, the "problem" of the relation of art and morals would not exist.

The idea and the practice of morality are saturated with conceptions that stem from praise and blame, reward and punishment. Mankind is divided into sheep and goats, the vicious and virtuous, the law-abiding and criminal, the good and bad. To be beyond good and evil is an impossibility for man, and yet as long as the good signifies only that which is lauded and rewarded, and the evil that which is currently condemned or outlawed, the ideal factors of morality are always and everywhere beyond good and evil. Because art is wholly innocent of ideas derived from praise and blame, it is looked upon with the eye of suspicion by the guardians of custom, or only the art that is itself so old and "classic" as to receive conventional praise is grudgingly admitted, provided, as with, say, the case of Shakespeare, signs of regard for conventional morality can be ingeniously extracted from his work. Yet this indifference to praise and blame because of preoccupation with imaginative experience constitutes the heart of the moral potency of art. From it proceeds the liberating and uniting power of art.

Shelley said, "The great secret of morals is love, or *a going out of our nature* and the identification of ourselves with the beautiful which exists in thought, action, or person, not our own. A man to be greatly good must imagine intensely and comprehensively." What is true of the individual is true of the whole system of morals in thought and action. While perception of the union of the possible with the actual in a work of art is itself a great good, the good does not terminate with the immediate and particular occasion in which it is had. The union that is presented in perception persists in the remaking of impulsion and thought. The first intimations of wide and large redirections of desire and purpose are of necessity imaginative. Art is a mode of prediction not found in charts and statistics, and it insinuates possibilities of human relations not to be found in rule and precept, admonition and administration.

> But art, wherein man speaks in no wise to man,
> Only to mankind—art may tell a truth
> Obliquely, do the deed shall breed the thought.

READING 39

INTRODUCTION

Theodor Adorno, who was born in 1903 and died in 1969, was one of the leading members of the Frankfurt School of philosophy. Concerned equally with sociology, where his approach was Marxist, and with art, where his sympathies were modernist, Adorno's critique of contemporary culture is a potent, and perhaps even a paradoxical, brew. Popular or mass culture he stigmatized as the product of the "culture industry," whose prime function was to perpetuate existing, and hence conservative, social arrangements. And yet modern art, of the kind that Adorno admired, was esoteric, elitist, and almost wholly ill-equipped to attract or to appeal to a mass audience. So it has sometimes been felt that Adorno's double commitment, to modernism and to Marxism, placed him in an untenable position. Yet a more generous interpretation is almost certainly closer to the truth—that the tension between these commitments was an essential and productive force in Adorno's work. His writings on modern art, and on modern music in particular, would seem to bear this out. The tension between his enthusiasm for music and his concern—his suspicion, even—about the function of music in society at large underpins many of his most brilliant insights. And there is no question that Adorno's music criticism would be a great deal less provocative without the sociological reflections it so often includes. (The richness of Adorno's insights is attested to by Thomas Mann's great novel, *Doctor Faustus*, which draws heavily on Adorno's writings.) In the essay reprinted here, "On the Fetish Character in Music and the Regression of Listening" (1938), we find Adorno in typically ambivalent mood about music and its place in culture. Indeed one of his arguments suggests a distinctly negative view. Adapting the Freudian idea of sublimation, in which potentially disruptive drives are displaced into socially acceptable avenues, Adorno suggests that "music represents at once the immediate manifestation of impulse and the locus of its taming." According to Adorno, then, the drives that music raises, it also quells; and this leaves the listener soothed or satisfied and less inclined to question the status quo (which is good news if you're a conservative, but not if you're not). This essay, which places music firmly in the context of the culture industry and which highlights the political significance of art, sounds a number of Adorno's most characteristic themes. It also serves well as an introduction to the complex and provoking thought of one of this century's most original minds.

On the Fetish Character in Music and the Regression of Listening

Theodor Adorno

Complaints about the decline of musical taste begin only a little later than mankind's twofold discovery, on the threshold of historical time, that music represents at once the immediate manifestation of impulse and the locus of its taming. It stirs up the dance of the Maenads and sounds from Pan's bewitching flute, but it also rings out from the Orphic lyre, around which the visions

of violence range themselves, pacified. Whenever their peace seems to be disturbed by bacchantic agitation, there is talk of the decline of taste. But if the disciplining function of music has been handed down since Greek philosophy as a major good, then certainly the pressure to be permitted to obey musically, as elsewhere, is today more general than ever. Just as the current musical consciousness of the masses can scarcely be called Dionysian, so its latest changes have nothing to do with taste. The concept of taste is itself outmoded. Responsible art adjusts itself to criteria which approximate judgments: the harmonious and the inharmonious, the correct and incorrect. But otherwise, no more choices are made; the question is no longer put, and no one demands the subjective justification of the conventions. The very existence of the subject who could verify such taste has become as questionable as has, at the opposite pole, the right to a freedom of choice which empirically, in any case, no one any longer exercises. If one seeks to find out who 'likes' a commercial piece, one cannot avoid the suspicion that liking and disliking are inappropriate to the situation, even if the person questioned clothes his reactions in those words. The familiarity of the piece is a surrogate for the quality ascribed to it. To like it is almost the same thing as to recognize it. An approach in terms of value judgments has become a fiction for the person who finds himself hemmed in by standardized musical goods. He can neither escape impotence nor decide between the offerings where everything is so completely identical that preference in fact depends merely on biographical details or on the situation in which things are heard. The categories of autonomously oriented art have no applicability to the contemporary reception of music; not even for that of the serious music, domesticated under the barbarous name of classical so as to enable one to turn away from it again in comfort. If it is objected that specifically light music and everything intended for consumption have in any case never been experienced in terms of those categories, that must certainly be conceded. Nevertheless, such music is also affected by the change in that the entertainment, the pleasure, the enjoyment it promises, is given only to be simultaneously denied. In one of his essays, Aldous Huxley has raised the question of who, in a place of amusement, is really being amused. With the same justice, it can be asked whom music for entertainment still entertains. Rather, it seems to complement the reduction of people to silence, the dying out of speech as expression, the inability to communicate at all. It inhabits the pockets of silence that develop between people moulded by anxiety, work and undemanding docility. Everywhere it takes over, unnoticed, the deadly sad role that fell to it in the time and the specific situation of the silent films. It is perceived purely as background. If nobody can any longer speak, then certainly nobody can any longer listen. An American specialist in radio advertising, who indeed prefers to make use of the musical medium, has expressed scepticism as to the value of this advertising, because people have learned to deny their attention to what they are hearing even while listening to it. His observation is questionable with respect to the advertising value of music. But it tends to be right in terms of the reception of the music itself. . . .

The illusion of a social preference for light music as against serious is based on that passivity of the masses which makes the consumption of light music contradict the objective interest of those who consume it. It is claimed that they

actually like light music and listen to the higher type only for reasons of social prestige, when acquaintance with the text of a single hit song suffices to reveal the sole function this object of honest approbation can perform. The unity of the two spheres of music is thus that of an unresolved contradiction. They do not hang together in such a way that the lower could serve as a sort of popular introduction to the higher, or that higher could renew its lost collective strength by borrowing from the lower. The whole cannot be put together by adding the separated halves, but in both there appear, however distantly, the changes of the whole, which only moves in contradiction. If the flight from the banal becomes definitive, if the marketability of the serious product shrinks to nothing, in consequence of its objective demands, then on the lower level the effect of the standardization of successes means it is no longer possible to succeed in an old style, but only in imitation as such. Between incomprehensibility and inescapability, there is no third way; the situation has polarized itself into extremes which actually meet. There is no room between them for the 'individual'. The latter's claims, wherever they still occur, are illusory, being copied from the standards. The liquidation of the individual is the real signature of the new musical situation. . . .

The concept of musical fetishism cannot be psychologically derived. That 'values' are consumed and draw feelings to themselves, without their specific qualities being reached by the consciousness of the consumer, is a later expression of their commodity character. For all contemporary musical life is dominated by the commodity form; the last pre-capitalist residues have been eliminated. Music, with all the attributes of the ethereal and sublime which are generously accorded it, serves in America today as an advertisement for commodities which one must acquire in order to be able to hear music. If the advertising function is carefully dimmed in the case of serious music, it always breaks through in the case of light music. The whole jazz business, with its free distribution of scores to bands, has abandoned the idea that actual performance promotes the sale of piano scores and phonograph records. Countless hit song texts praise the hit songs themselves, repeating their titles in capital letters. What makes its appearance, like an idol, out of such masses of type is the exchange value in which the quantum of possible enjoyment has disappeared. Marx defines the fetish character of the commodity as the veneration of the thing made by oneself which, as exchange-value, simultaneously alienates itself from producer to consumer—'human beings.' 'A commodity is therefore a mysterious thing, simply because in it the social character of men's labour appears to them as an objective character stamped upon the product of that labour; because the relation of the producers to the sum total of their own labour is presented to them as a social relation, existing not between themselves, but between the products of their labour.' This is the real secret of success. It is the mere reflection of what one pays in the market for the product. The consumer is really worshipping the money that he himself has paid for the ticket to the Toscanini concert. He has literally 'made' the success which he reifies and accepts as an objective criterion, without recognizing himself in it. But he has not 'made' it by liking the concert, but rather by buying the ticket. To be sure, exchange value exerts its power in a special way in the realm of

cultural goods. For in the world of commodities this realm appears to be exempted from the power of exchange, to be in an immediate relationship with the goods, and it is this appearance in turn which alone gives cultural goods their exchange value. But they nevertheless simultaneously fall completely into the world of commodities, are produced for the market, and are aimed at the market. The appearance of immediacy is as strong as the compulsion of exchange value is inexorable. The social compact harmonizes the contradiction. The appearance of immediacy takes possession of the mediated, exchange value itself. If the commodity in general combines exchange value and use value, then the pure use value, whose illusion the cultural goods must preserve in a completely capitalist society, must be replaced by pure exchange value, which precisely in its capacity as exchange value deceptively takes over the function of use value. The specific fetish character of music lies in this *quid pro quo*. The feelings which go to the exchange value create the appearance of immediacy at the same time as the absence of a relation to the object belies it. It has its basis in the abstract character of exchange value. Every 'psychological' aspect, every ersatz satisfaction, depends on such social substitution.

The change in the function of music involves the basic conditions of the relation between art and society. The more inexorably the principle of exchange value destroys use values for human beings, the more deeply does exchange value disguise itself as the object of enjoyment. It has been asked what the cement is which still holds the world of commodities together. The answer is that this transfer of the use value of consumption goods to their exchange value contributes to a general order in which eventually every pleasure which emancipates itself from exchange values takes on subversive features. The appearance of exchange value in commodities has taken on a specific cohesive function. The woman who has money with which to buy is intoxicated by the act of buying. In American conventional speech, having a good time means being present at the enjoyment of others, which in its turn has as its only content being present. The auto religion makes all men brothers in the sacramental moment with the words: 'that is a Rolls Royce', and in moments of intimacy, women attach greater importance to the hairdressers and cosmeticians than to the situation for the sake of which the hairdressers and cosmeticians are employed. The relation to the irrelevant dutifully manifests its social essence. The couple out driving who spend their time identifying every passing car and being happy if they recognize the trademarks speeding by, the girl whose satisfaction consists solely in the fact that she and her boyfriend 'look good', the expertise of the jazz enthusiast who legitimizes himself by having knowledge about what is in any case inescapable: all this operates according to the same command. Before the theological caprices of commodities, the consumers become temple slaves. Those who sacrifice themselves nowhere else can do so here, and here they are fully betrayed.

In the commodity fetishists of the new model, in the 'sadomasochistic character', in those receptive to today's mass art, the same thing shows itself in many ways. The masochistic mass culture is the necessary manifestation of almighty production itself. When the feelings seize on exchange value it is no mystical transubstantiation. It corresponds to the behavior of the prisoner who

loves his cell because he has been left nothing else to love. The sacrifice of individuality, which accommodates itself to the regularity of the successful, the doing of what everybody does, follows from the basic fact that in broad areas the same thing is offered to everybody by the standardized production of consumption goods. But the commercial necessity of connecting this identity leads to the manipulation of taste and the official culture's pretence of individualism which necessarily increases in proportion to the liquidation of the individual. Even in the realm of the superstructure, the appearance is not merely the concealment of the essence, but proceeds of necessity from the essence itself. The identical character of the goods which everyone must buy hides itself behind the rigour of the universally compulsory style. The fiction of the relation between supply and demand survives in the fictitiously individual nuances.

If the value of taste in the present situation is questioned, it is necessary to understand what taste is composed of in this situation. Acquiescence is rationalized as modesty, opposition to caprice and anarchy; musical analysis has today decayed as fundamentally as musical charm, and has its parody in the stubborn counting of beats. The picture is completed by accidental differentiation within the strict confines of the prescribed. But if the liquidated individual really makes the complete superficiality of the conventions passionately his own, then the golden age of taste has dawned at the very moment in which taste no longer exists. The works which are the basis of the fetishization and become the cultural goods experience constitutional changes as a result. They become vulgarized. Irrelevant consumption destroys them. Not merely do the few things played again and again wear out, like the Sistine Madonna in the bedroom, but reification affects their internal structure. They are transformed into a conglomeration of irruptions which are impressed on the listeners by climax and repetition, while the organization of the whole makes no impression whatsoever.

The memorability of disconnected parts, thanks to climaxes and repetitions, has a precursor in great music itself, in the technique of late romantic compositions, especially those of Wagner. The more reified the music, the more romantic it sounds to alienated ears. Just in this way it becomes 'property'. A Beethoven symphony as a whole, spontaneously experienced, can never be appropriated. The man who in the subway triumphantly whistles loudly the theme of the finale of Brahms' First is already primarily involved with its debris. But since the disintegration of the fetishes puts these themselves in danger and virtually assimilates them to hit songs, it produces a counter tendency in order to preserve their fetish character. If the romanticizing of particulars eats away the body of the whole, the endangered substance is galvanically copper-plated. The climax which emphasizes the reified parts takes on the character of a magical ritual, in which all the mysteries of personality, inwardness, inspiration and spontaneity of reproduction, which have been eliminated from the work itself, are conjured up. Just because the disintegrating work renounces the moment of its spontaneity, this, just as stereotyped as the bits and pieces, is injected into it from the outside. In spite of all talk of new objectivity, the essential function of conformist performances is no longer the performance of the 'pure' work but the presentation of the vulgarized one

with a gesture which emphatically but impotently tries to hold the vulgarization at a distance. . . .

But fetishism takes hold of even the ostensibly serious practice of music, which mobilizes the pathos of distance against refined entertainment. The purity of service to the cause, with which it presents the works, often turns out to be as inimical to them as vulgarization and arrangement. The official ideal of performance, which covers the earth as a result of Toscanini's extraordinary achievement, helps to sanction a condition which, in a phrase of Eduard Steuermann, may be called the barbarism of perfection. To be sure, the names of famous works are no longer made fetishes, although the lesser ones that break into the programmes almost make the limitation to the smaller repertoire seem desirable. To be sure, passages are not here inflated or climaxes overstressed for the sake of fascination. There is iron discipline. But precisely iron. The new fetish is the flawlessly functioning, metallically brilliant apparatus as such, in which all the cogwheels mesh so perfectly that not the slightest hole remains open for the meaning of the whole. Perfect, immaculate performance in the latest style preserves the work at the price of its definitive reification. It presents it as already complete from the very first note. The performance sounds like its own phonograph record. The dynamic is so predetermined that there are no longer any tensions at all. The contradictions of the music material are so inexorably resolved in the moment of sound that it never arrives at the synthesis, the self-production of the work, which reveals the meaning of every Beethoven symphony. What is the point of the symphonic effort when the material on which that effort was to be tested has already been ground up? The protective fixation of the works leads to its destruction, for its unity is realized in precisely that spontaneity which is sacrificed to the fixation. This last fetishism, which seizes on the substance itself, smothers it; the absolute adjustment of the appearance to the work denies the latter and makes it disappear unnoticed behind the apparatus, just as certain swamp-drainings by labour detachments take place not for their own sake but for that of the work. Not for nothing does the rule of the established conductor remind one of that of the totalitarian Führer. Like the latter, he reduces aura and organization to a common denominator. He is the real modern type of the virtuoso, as bandleader as well as in the Philharmonic. He has got to the point where he no longer has to do anything himself; he is even sometimes relieved of reading the score by the staff musical advisers. At one stroke he provides norm and individualization: the norm is identified with his person, and the individual tricks which he perpetrates furnish the general rules. The fetish character of the conductor is the most obvious and the most hidden. The standard works could probably be performed by the virtuosi of contemporary orchestras just as well without the conductor, and the public which cheers the conductor would be unable to tell that, in the concealment of the orchestra, the musical adviser was taking the place of the hero laid low by a cold.

The consciousness of the mass listeners is adequate to fetishized music. It listens according to formula, and indeed debasement itself would not be possible if resistance ensued, if the listeners still had the capacity to make demands beyond the limits of what was supplied. But if someone tried to 'verify' the

fetish character of music by investigating the reactions of listeners with interviews and questionnaires, he might meet with unexpected puzzles. In music as elsewhere, the discrepancy between essence and appearance has grown to a point where no appearance is any longer valid, without mediation, as verification of the essence. The unconscious reactions of the listeners are so heavily veiled and their conscious assessment is so exclusively oriented to the dominant fetish categories that every answer one receives conforms in advance to the surface of that music business which is attacked by the theory being 'verified'. As soon as one presents the listener with the primitive question about liking or disliking, there comes into play the whole machinery which one had thought could be made transparent and eliminated by the reduction to this question. But if one tries to replace the most elementary investigative procedures with others which take account of the real dependence of the listener on the mechanism, this complication of the investigative procedure not merely makes the interpretation of the result more difficult, but it touches off the resistance of the respondents and drives them all the deeper into the conformist behaviour in which they think they can remain concealed from the danger of exposure. No causal nexus at all can properly be worked out between isolated 'impressions' of the hit song and its psychological effects on the listener. If indeed individuals today no longer belong to themselves, then that also means that they can no longer be 'influenced'. The opposing points of production and consumption are at any given time closely co-ordinated, but not dependent on each other in isolation. Their mediation itself does not in any case escape theoretical conjecture. It suffices to remember how many sorrows he is spared who no longer thinks too many thoughts, how much more 'in accordance with reality' a person behaves when he affirms that the real is right, how much more capacity to use the machinery falls to the person who integrates himself with it uncomplainingly, so that the correspondence between the listener's consciousness and the fetishized music would still remain comprehensible even if the former did not unequivocally reduce itself to the latter.

The counterpart to the fetishism of music is a regression of listening. This does not mean a relapse of the individual listener into an earlier phase of his own development, nor a decline in the collective general level, since the millions who are reached musically for the first time by today's mass communications cannot be compared with the audience of the past. Rather, it is contemporary listening which has regressed, arrested at the infantile stage. Not only do the listening subjects lose, along with the freedom of choice and responsibility, the capacity for conscious perception of music, which was from time immemorial confined to a narrow group, but they stubbornly reject the possibility of such perception. They fluctuate between comprehensive forgetting and sudden dives into recognition. They listen atomistically and dissociate what they hear, but precisely in this dissociation they develop certain capacities which accord less with the concepts of traditional aesthetics than with those of football and motoring. They are not childlike, as might be expected on the basis of an interpretation of the new type of listener in terms of the introduction to musical life of groups previously unacquainted with music. But they are childish; their primitivism is not that of the undeveloped, but that of the forcibly retarded. Whenever they have a chance, they display

the pinched hatred of those who really sense the other but exclude it in order to live in peace, and who therefore would like best to root out the nagging possibility. The regression is really from this existent possibility, or more concretely, from the possibility of a different and oppositional music. Regressive, too, is the role which contemporary mass music plays in the psychological household of its victims. They are not merely turned away from more important music, but they are confirmed in their neurotic stupidity, quite irrespective of how their musical capacities are related to the specific musical culture of earlier social phases. The assent to hit songs and debased cultural goods belongs to the same complex of symptoms as do those faces of which one no longer knows whether the film has alienated them from reality or reality has alienated them from the film, as they wrench open a great formless mouth with shining teeth in a voracious smile, while the tired eyes are wretched and lost above. Together with sport and film, mass music and the new listening help to make escape from the whole infantile milieu impossible. The sickness has a preservative function. Even the listening habits of the contemporary masses are certainly in no way new, and one may readily concede that the reception of the pre-war hit song 'Puppchen' was not so very different from that of a synthetic jazz children's song. But the context in which such a children's song appears, the masochistic mocking of one's own wish for lost happiness, or the compromising of the desire for happiness itself by the reversion to a childhood whose unattainability bears witness to the unattainability of joy—this is the specific product of the new listening, and nothing which strikes the ear remains exempt from this system of assimilation. There are indeed social differences, but the new listening extends so far that the stultification of the oppressed affects the oppressors themselves, and they become victims of the superior power of self-propelled wheels who think they are determining their direction.

Regressive listening is tied to production by the machinery of distribution, and particularly by advertising. Regressive listening appears as soon as advertising turns into terror, as soon as nothing is left for the consciousness but to capitulate before the superior power of the advertised stuff and purchase spiritual peace by making the imposed goods literally its own thing. In regressive listening, advertising takes on a compulsory character. For a while, an English brewery used for propaganda purposes a billboard that bore a deceptive likeness to one of the whitewashed brick walls which are so numerous in the slums of London and the industrial cities of the North. Properly placed, the billboard was barely distinguishable from a real wall. On it, chalk-white, was a careful imitation of awkward writing. The words said: 'What we want is Watney's.' The brand of beer was presented like a political slogan. Not only does this billboard give an insight into the nature of up-to-date propaganda, which sells its slogans as well as its wares, just as here the wares masquerade as a slogan; the type of relationship suggested by the billboard, in which masses make a commodity recommended to them the object of their own action, is in fact found again as the pattern for the reception of light music. They need and demand what has been palmed off on them. They overcome the feeling of impotence that creeps over them in the face of monopolistic production by identifying themselves with the inescapable product. They thereby put an end

to the strangeness of the musical brands which are at once distant from them and threateningly near, and in addition, achieve the satisfaction of feeling themselves involved in Mr Know-Nothing's enterprises, which confront them at every turn. This explains why individual expressions of preference—or, of course, dislike—converge in an area where object and subject alike make such reactions questionable. The fetish character of music produces its own camouflage through the identification of the listener with the fetish. This identification initially gives the hit songs power over their victims. It fulfils itself in the subsequent forgetting and remembering. Just as every advertisement is composed of the inconspicuous familiar and the unfamiliar conspicuous, so the hit song remains salutarily forgotten in the half-dusk of its familiarity, suddenly to become painfully over-clear through recollection, as if in the beam of a spotlight. One can almost equate the moment of this recollection with that in which the title or the words of the initial verse of his hit song confront the victim. Perhaps he identifies himself with this because he identifies it and thereby merges with his possession. This compulsion may well drive him to recall the title of the hit song at times. But the writing under the note, which makes the identification possible, is nothing else but the trademark of the hit song. . . .

Regressive listeners have key points in common with the man who must kill time because he has nothing else on which to vent his aggression, and with the casual labourer. To make oneself a jazz expert or hang over the radio all day, one must have much free time and little freedom. The dexterity which comes to terms with the syncopation as well as with the basic rhythm is that of the auto mechanic who can also repair the loudspeaker and the electric light. The new listeners resemble the mechanics who are simultaneously specialized and capable of applying their special skills to unexpected places outside their skilled trades. But this despecialization only seems to help them out of the system. The more easily they meet the demands of the day, the more rigidly they are subordinated to that system. The research finding, that among radio listeners the friends of light music reveal themselves to be depoliticized, is not accidental. The possibility of individual shelter and of a security which is, as always, questionable, obstructs the view of a change in the situation in which one seeks shelter. Superficial experience contradicts this. The 'younger generation'—the concept itself is merely an ideological catch-all—seems to be in conflict with its elders and their plush culture precisely through the new way of listening. In America, it is just the so-called liberals and progressives whom one finds among the advocates of light popular music, most of whom want to classify their activity as democratic. But if regressive hearing is progressive as opposed to the 'individualistic' sort, it is only in the dialectical sense that it is better fitted to the advancing brutality than the latter. All possible mould has been rubbed off the baseness, and it is legitimate to criticize the aesthetic residue of an individuality that was long since wrested from individuals. But this criticism comes with little force from the sphere of popular music, since it is just this sphere that mummifies the vulgarized and decaying remnants of romantic individualism. Its innovations are inseparably coupled with these remnants.

Masochism in hearing is not only defined by self-surrender and pseudo-pleasure through identification with power. Underlying it is the knowledge that the security of shelter under the ruling conditions is a provisional one, that it is only a respite, and that eventually everything must collapse. Even in self-surrender one is not good in his own eyes; in his enjoyment one feels that he is simultaneously betraying the possible and being betrayed by the existent. Regressive listening is always ready to degenerate into rage. If one knows that he is basically marking time, the rage is directed primarily against everything which could disavow the modernity of being with-it and up-to-date and reveal how little has in fact changed. From photographs and movies, one knows the effect produced by the modern grown old, an effect originally used by the sur-realists to shock and subsequently degraded to the cheap amusement of those whose fetishism fastens on the abstract present. For the regressive listener, this effect is fantastically foreshortened. They would like to ridicule and destroy what yesterday they were intoxicated with, as if in retrospect to revenge them-selves for the fact that the ecstasy was not actually such. This effect has been given a name of its own and repeatedly been propagated in press and radio. But we should not think of the rhythmically simpler, light music of the pre-jazz era and its relics as corny; rather, the term applies to all those syncopated pieces which do not conform to the approved rhythmic formula of the present moment. A jazz expert can shake with laughter when he hears a piece which in good rhythm follows a sixteenth note with a punctuated eight, although this rhythm is more aggressive and in no way more provincial in character than the syncopated connection and renunciation of all counterstress practised later. The regressive listeners are in fact destructive. The old-timer's insult has its ironic justification; ironic, because the destructive tendencies of the regressive listeners are in truth directed against the same thing that the old-fashioned hate, against disobedience as such, unless it comes under the tolerated spon-taneity of collective excesses. The seeming opposition of the generations is nowhere more transparent than in rage. The bigots who complain to the radio stations in pathetic-sadistic letters of the jazzing up of holy things and the youth who delights in such exhibitions are of one mind. It requires only the proper situation to bring them together in a united front.

This furnishes a criticism of the 'new possibilities' in regressive listening. One might be tempted to rescue it if it were something in which the 'auratic' characteristics of the work of art, its illusory elements, gave way to the play-ful ones. However it may be with films, today's mass music shows little of such progress in disenchantment. Nothing survives in it more steadfastly than the illusion, nothing is more illusory than its reality. The infantile play has scarcely more than the name in common with the productivity of children. Otherwise, bourgeois sport would not want to differentiate itself so strictly from play. Its bestial seriousness consists in the fact that instead of remaining faithful to the dream of freedom by getting away from purposiveness, the treatment of play as a duty puts it among useful purposes and thereby wipes out the trace of freedom in it. This is particularly valid for contemporary mass music. It is only play as a repetition of prescribed models, and the playful release from responsibility which is thereby achieved does not reduce at all the time devoted to duty except by transferring the responsibility to the mod-

els, the following of which one makes into a duty for himself. In this lies the inherent pretence of the dominant music sport. It is illusory to promote the technical-rational moments of contemporary mass music—or the special capacities of the regressive listeners which may correspond to these moments—at the expense of a decayed magic, which nevertheless prescribes the rules for the bare functioning itself. It would also be illusory because the technical innovations of mass music really don't exist. This goes without saying for harmonic and melodic construction. The real colouristic accomplishment of modern dance music, the approach of the different colours to one another to the extent that one instrument replaces another without a break or one instrument can disguise itself as another, is as familiar to Wagnerian and post-Wagnerian orchestral technique as the mute effects of the brasses. Even in the techniques of syncopation, there is nothing that was not present in rudimentary form in Brahms and outdone by Schonberg and Stravinsky. The practice of contemporary popular music has not so much developed these techniques as conformistically dulled them. The listeners who expertly view these techniques with astonishment are in no way technically educated thereby, but react with resistance and rejection as soon as the techniques are introduced to them in those contexts in which they have their meaning. Whether a technique can be considered progressive and 'rational' depends on this meaning and on its place in the whole of society as well as in the organization of the particular work. Technical development as such can serve crude reaction as soon as it has established itself as a fetish and by its perfection represents the neglected social tasks as already accomplished. This is why all attempts to reform mass music and regressive listening on the basis of what exists are frustrated. Consumable art music must pay by the sacrifice of its consistency. Its faults are not 'artistic'; every incorrectly composed or outmoded chord bespeaks the backwardness of those to whose demand accommodation is made. But technically consistent, harmonious mass music purified of all the elements of bad pretence would turn into art music and at once lose its mass basis. All attempts at reconciliation, whether by market-oriented artists or collectively-oriented art educators, are fruitless. They have accomplished nothing more than handicrafts or the sort of products with which directions for use or a social text must be given, so that one may be properly informed about the deeper background.

The positive aspect for which the new mass music and regressive listening are praised—vitality and technical progress, collective breadth and relation to an undefined practice, into whose concepts there has entered the supplicant self-denunciation of the intellectuals, who can thereby finally end their social alienation from the masses in order to co-ordinate themselves politically with contemporary mass consciousness—this positive is a negative, the irruption into music of a catastrophic phase of society. The positive lies locked up solely in its negativity. Fetishized mass music threatens the fetishized cultural goods. The tension between the two spheres of music has so grown that it becomes difficult for the official sphere to hold its ground. However little it has to do with technical standards of mass music, if one compares the special knowledge of a jazz expert with that of a Toscanini worshipper the former is far ahead of the latter. But regressive listening represents a growing and merciless enemy not only to museum cultural goods but to the age-old sacral func-

tion of music as the locus for the taming of impulses. Not without penalty, and therefore not without restraint, are the debased products of musical culture surrendered to disrespectful play and sadistic humour.

In the face of regressive listening, music as a whole begins to take on a comic aspect. One need only listen to the uninhibited sonority of a choral rehearsal from outside. This experience was caught with great force in a film by the Marx brothers, who demolish an opera set as if to clothe in allegory the insight of the philosophy of history on the decay of the operatic form, or in a most estimable piece of refined entertainment, break up a grand piano in order to take possession of its strings in their frame as the true harp of the future, on which to play a prelude. Music has become comic in the present phase primarily because something so completely useless is carried on with all the visible signs of the strain of serious work. By being alien to solid people, music reveals their alienation from one another, and the consciousness of alienation vents itself in laughter. In music—or similarly in lyric poetry—the society which judged them comic becomes comic. But involved in this laughter is the decay of the sacral spirit of reconciliation. All music today can very easily sound as *Parsifal* did to Nietzsche's ear. It recalls incomprehensible rites and surviving masks from an earlier time, and is provocative nonsense. The radio, which both wears out music and over-exposes it, makes a major contribution to this. Perhaps a better hour may at some time strike even for the clever fellows: one in which they may demand, instead of prepared material ready to be switched on, the improvisatory displacement of things, as the sort of radical beginning that can only thrive under the protection of the unshaken real world. Even discipline can take over the expression of free solidarity if freedom becomes its content. As little as regressive listening is a symptom of progress in consciousness of freedom, it could suddenly turn around if art, in unity with the society, should ever leave the road of the always-identical.

Not popular music but artistic music has furnished a model for this possibility. It is not for nothing that Mahler is the scandal of all bourgeois musical aesthetics. They call him uncreative because he suspends their concept of creation itself. Everything with which he occupies himself is already there. He accepts it in its vulgarized form; his themes are expropriated ones. Nevertheless, nothing sounds as it was wont to; all things are diverted as if by a magnet. What is worn out yields pliantly to the improvising hand; the used parts win a second life as variants. Just as the chauffeur's knowledge of his old second-hand car can enable him to drive it punctually and unrecognized to its intended destination, so can the expression of a beat-up melody, straining under the pressure of clarinets and oboes in the upper register, arrive at places which the approved musical language could never safely reach. Such music really crystallizes the whole, into which it has incorporated the vulgarized fragments, into something new, yet it takes its material from regressive listening. Indeed, one can almost think that in Mahler's music this experience was seismographically recorded forty years before it permeated society. But if Mahler stood athwart the concept of musical progress, neither can the new and radical music whose most advanced practioners give allegiance to him in a seemingly paradoxical way any longer be subsumed exclusively under the concept of progress. It proposes to consciously resist the phenomenon of

regressive listening. The terror which Schonberg and Webern spread, today as in the past, comes not from their incomprehensibility but from the fact that they are all too correctly understood. Their music gives form to that anxiety, that terror, that insight into the catastrophic situation which others merely evade by regressing. They are called individualists, and yet their work is nothing but a single dialogue with the powers which destroy individuality—powers whose 'formless shadows' fall gigantically on their music. In music, too, collective powers are liquidating an individuality past saving, but against them only individuals are capable of consciously representing the aims of collectivity.

READING 40

INTRODUCTION

How are the spheres of the moral and the aesthetic related? Art has sometimes been criticized for its moral effects—as it was in a sweeping way by Plato, and as it is in a more local sense by people who object to particular works on moral grounds (as many have, for example, to the photographs of Robert Mapplethorpe). And art has sometimes been defended—as it was by Dewey—on the grounds of its *beneficial* moral effects. In "The Arts in the Life of Man," a section of his book *Aesthetics: Problems in the Philosophy of Criticism* (1981), Monroe C. Beardsley discusses two views about the relationship between art and morality. The first is "aestheticism," a view sometimes expressed in the slogan "Art for art's sake." According to this view, art simply is not accessible to moral criticism; it would be as senseless (though in a rather different way) to assess a novel in moral terms as it would be to assess a tree in moral terms. The second view is "moralism," which holds that artworks should be judged entirely or largely on the basis of moral considerations. Beardsley rejects both of these positions. On the one hand, he argues that we *can* assess works of art in moral terms, and so aestheticism is wrong. On the other hand, he holds that aesthetic judgments cannot be reduced to moral judgments; and therefore that, although we may often find that works we regard as morally bad are also aesthetically bad, they may not always be. So moralism is wrong. Beardsley goes on to outline a view, based partly on the ideas of Aristotle and Dewey, about the ways in which art is morally and indeed socially valuable for artists as well as for audiences.

The Arts in the Life of Man

Monroe C. Beardsley

The capacity of an object to evoke an aesthetic experience is not, properly speaking, a value unless the experience itself has value. As we have seen, it is not up to the critic to probe into the nature of this second value; he must keep

his eye on the aesthetic object. But it is an unavoidable part of the aesthetician's task.

Certainly anyone who contends that the arts deserve a high place among the goods of culture and the ends of education must back up this contention with evidence that the experiences they afford are, in some important way, good for us. If we insist that college students take courses in poetry, or choose between music and fine arts in planning their studies, we ought to have a good reason, for we are taking time that might otherwise be devoted to obviously useful subjects like psychology or economics or natural science. We allow steel and cement to be diverted from highways and hotels into theatres or art galleries or opera houses; we encourage people to spend years of their lives learning to write or dance or paint or play the viola, when they could be applying their energies to farming or selling life insurance. No doubt the money spent annually in the United States on good aesthetic objects is a small fraction of what is spent on liquor or horseracing, but nevertheless the arts have their social cost, and we must sometime face the question how, or whether, we can answer the practical man who says that they are not worth that cost.

Unfortunately it is just at this point in aesthetics that the available evidence is most scarce. And since it is also at this point that the study of the arts comes into relation with other deep and pressing interests—moral, political, economic—that we have as human beings, the problems that result are, even for this untidy subject, unusually heterogeneous, vague, and unsatisfactory. We must do what we can in the present chapter to sort out these problems, but we shall often have to stop where the available evidence runs out. For about these larger and more far-reaching implications of the arts there is, even more than in the other areas of aesthetics, a great deal of thinking that remains to be done.

Moral and Critical Judgments

In defining "aesthetic value," we have confined our attention to one of the ways in which aesthetic objects affect us: their characteristic, and immediate, effect. But we must now widen our view and ask in what other ways, more remote or indirect, but no less important, aesthetic objects may have an influence upon us. For, to recall a distinction we made earlier, if we are interested not only in a special aesthetic commendation of aesthetic objects, but recommendations of them as something to make, to have recourse to, to possess, then other features of these objects besides their aesthetic value become relevant. In a preformed aesthetic context of choice, as when we have already decided to write for tickets to a play and must now decide which play to see, aesthetic value may sometimes be the only question at issue. But going to one play does not compete for our time and money and energy only with going to another play; it competes with watching ice hockey, going over the checking account, helping the children with their homework, fixing leaky faucets—in fact, with any conceivable human activity that might serve an end-in-view under the existing circumstances.

The effects of a functional object are sometimes divided into two classes. First, there are those effects that proceed from its very function, the conse-

quences of its performing its function well. If a new drug has the specific function of alleviating inhalant allergies, then where it works well, it will, say, eliminate the nasal irritation, stop the sneezing or headaches caused by the allergenic pollens or other particles in the air, and promote greater psychological well-being. These would be counted among the *inherent* effects of the drug: what it is primarily called upon to do. But besides its inherent effects, there may be *side effects*, until further research is able to avoid them: the drug may make you drowsy, or induce a mild indigestion, or slightly discolor your teeth. Or perhaps it will not affect everyone this way, but only some people. Side effects are not necessarily bad; it is the same distinction we make between the main product of a factory, say pork, and its by-products, say soap or lard.

It will clarify our problems if we apply this common-sense distinction to aesthetic objects. Let us consider their inherent effects first. Aesthetic experience is the immediate effect of aesthetic objects. Now suppose there are more remote effects of aesthetic objects, effects they produce *via* aesthetic experience. For example, suppose we could prove that aesthetic experience itself is peculiarly beneficial in providing an outlet for psychological impulses that would be destructive if they overflowed into overt action.[1] In the ordinary course of life, little frustrations and irritations inevitably build up in our minds. Of course if they develop into deep-seated neuroses, no home remedy may be sufficient to cope with them. But most often they are just persistent, nagging, bothersome, capable of taking the edge off our appetite for creative activities, of undermining our confidence in ourselves, of getting in the way of our relations with other people. Now we may try to escape these irritations with the help of various sorts of entertainment—indeed, never in the history of the world before radio and television has it been possible for millions of human beings to be entertained, if they wish, for twenty-four hours a day. I do not suppose we can draw a sharp line between entertainment and aesthetic experience, but there are nevertheless, I believe, vitally important differences between them. Entertainment may be aesthetic experience of a sort, but at a low power: pleasant, passive, easy, and superficial. It is certainly a temporary escape from trouble, but perhaps it is merely an anodyne, and when it is over the gnawing may begin again where it left off; the impulse may only have been blocked and dulled, not drained from the system.

But with the help of aesthetic objects we can work off these destructive impulses, without having them fester inside and without taking them out on our neighbors. This is very plausible as far as literature is concerned, for we can feel as we like about its make-believe world, and run through all sorts of emotions—love, hate, self-satisfaction, moral indignation, cynicism—without fear of injuring anyone. It is even plausible for musical experience; we are caught up in the drive and purposefulness of the musical process, and though full-fledged emotions are not directly manipulated, the tension and restlessness that are their feeling-basis may be used and relieved and quieted by music. And if we think of the experience of painting as an experience that takes

[1] I do not pretend to be giving here an authoritative exegesis of Aristotle's theory of catharsis, but for the purposes of illustration I sketch a hypothesis based upon a generalization of his theory of the tragic effect to the other arts.

time, this experience, too, may turn out to be psychologically beneficial in the same way as music.

This hypothesis, though highly speculative, is not utterly without warrant. We can all find in ourselves by introspection some evidence for it. There is often a very special refreshing feeling that comes after aesthetic experience, a sense of being unusually free from inner disturbance or unbalance. And this may testify to the purgative or cathartic, or perhaps sublimative, effect. What we lack, to make the hypothesis highly acceptable, is adequate physiological and behavioral evidence for that effect. But now, suppose there is such a purgation of feeling. Then further consequences might follow, too. Those who have been treated by aesthetic objects, like those who have given up coffee, might turn out to be more capable of outgoing and affectionate and trustful relations with others; they may be less given to irrational emotional outbursts, to sudden prejudices and lasting resentments. They may become better neighbors, more tolerant, more understanding, more forgiving—better citizens when it comes to voting, serving on juries, and seeing the justice of other people's claims.

I have kept this hypothesis hypothetical because it is primarily an illustration. Whether this claim, or something like it, can be made good we shall consider more fully later, though even in that discussion I am afraid we cannot be very positive about our conclusions. In any case, suppose for the moment that aesthetic objects have such a long-range effect upon people, and have this effect by means of their peculiar aesthetic function, then this effect would be an inherent one. But there could be other effects, more or less independent of aesthetic experience, that some aesthetic objects have upon people. For example, they may be effective at getting children to go to sleep, or at keeping them awake; they may increase juvenile delinquency by spreading wrong ideals of conduct, or by intensifying, instead of purging, certain tensions and destructive impulses; they may strengthen the chastity of young maidens or sharpen the sensuality of the old *roué*. These would be side effects of art, perhaps some bad, perhaps some good, perhaps some indifferent.

It is now reasonably clear, I think, what we can best choose to mean by the "moral judgment" of an aesthetic object. I use the term "moral" in a broad but quite usual sense. To call an action "right" is a moral judgment in a narrow sense; but when we point out the possible effects of sports on the building of character, or the effects of slums on juvenile delinquency, we are making a moral judgment in the broad sense. Thus to make a moral judgment of an aesthetic object is to point out some side effect upon human conduct, and to judge that side effect as good or bad: "This novel is subversive," "This painting is pornographic," "This statue will corrupt the young." Moral judgments and critical judgments are distinct and independent, or so it would seem. That is, we seem to be able to say without contradiction that a poem is a good aesthetic object but will promote unhealthy political views, or that a play is a poor aesthetic object but will undoubtedly promote purity of heart. Whether these statements are contradictory or always false we shall consider shortly.

With the help of these distinctions, we must now examine two broad views—it would be misleading to call them theories—of the moral aspect of art, and about the relation between the moral and the aesthetic.

Aestheticism The simpler of the two views, which I shall call *Aestheticism*,[2] has the merit of setting the issues in the starkest light. It is the view that aesthetic objects are not subject to moral judgment, that only aesthetic categories can be, or ought to be, applied to them. Not because they are *objects,* rather than *acts,* for it may be granted that objects can become subject to moral judgment when their presence affects behavior, but because, according to the view we are now considering, the side effects of aesthetic objects, if any, need not be taken into account.

Aestheticism involves one attitude that deserves sympathetic attention. It is a healthy impatience with the moralistic manner in which society often receives new and trail-breaking aesthetic objects. Departures from the familiar patterns are viewed with alarm or greeted with exaggerated fears of social consequences instead of that eager adventurousness that would betoken a more healthy social order. When we observe the bitter and sometimes violent outbursts against Stravinsky, or Bartók, or James Joyce, or Dylan Thomas, or Picasso, or Henry Moore, we can infer that no mere matters of taste are at stake; deeply-embedded customs, established modes of thought and feeling, vested interests are felt to be threatened. But many of the protests are based upon snap judgments and wild predictions. Where is the evidence of genuine danger? We need not linger over the easy cases. Has it ever been shown that anyone's character has been undermined by an overdose of Picassos? Could they unsettle our notions of human anatomy, or weaken religious faith, or encourage us to drink absinthe in excess? And what possible harm of a lasting sort could be done to anyone by *Rite of Spring* or *The Firebird?* Admittedly there is more room for controversy in, say, the movies. But of all those people who objected violently to *Blackboard Jungle,* the sensational exposé of schoolroom goons, how many of them produced any solid evidence that it would undermine public confidence in the schools or increase the incidence of unlawfulness among high school students? And, when *The Man with the Golden Arm* was refused the Production Code seal of approval because it violated the rule against representing narcotics addiction as easily curable, though it is easy to imagine the unfortunate effects this *might* have on the public, do we really have grounds for predicting these effects with confidence?

There seem to be two main lines of argument, leading to partly incompatible conclusions, that are offered in support of Aestheticism. Indeed, if we were very strict, we should have to distinguish two kinds of Aestheticism. But since neither has been carefully worked out or systematically defended, it does not seem worthwhile to be very strict here, and what is instructive in the general point of view can be brought out anyway. The first line of argument is based upon a firm optimism about the potentialities of aesthetic education. Suppose there are occasional unfortunate effects of aesthetic objects; for example, suppose it is true, as reported, that when the French motion picture *Rififi* was exhibited in Mexico City—this movie showed in great detail how to commit a jewelry shop safe robbery—it had to be withdrawn because it was so instructive that it quadrupled the rate of local robberies. (In Paris the police

[2]This view I take to be that of Walter Pater and Oscar Wilde, for example, and to a lesser extent of Théophile Gautier and James A. McNeill Whistler.

did not object, since, they said, the method was not *en effet* the latest one.) Or, for another example, it may even be that people have been converted to fatalism by the *Rubáiyát of Omar Khayyám of Nishápúr*. Still, such side effects as these would be accidental and correctible, and more to be blamed on faulty upbringing than on aesthetic objects. A proper education in the arts would teach people the right way to respond to aesthetic objects, which is not to take them as inspiration for a half-baked philosophy or as guides to conduct, but as objects to be enjoyed in themselves. In fact, it may be just the unintelligent education in the arts so often given, with the emphasis on inspiring messages and moral uplift, that encourages people to confuse literature with nonliterary discourse and try to put it into practice, even when it is immoral.

Perhaps, then, literature is, or can be made, practically harmless. Therefore, when we are considering aesthetic objects, we can ignore all their supposed side effects and consider only their aesthetic value. The critic's concern is not with art for the sake of citizenship or patriotism or mysticism, or anything else, but with Art for Art's Sake only. The slogan, "Art for Art's Sake," has, of course, meant a good many things, not always consistent and seldom very definite, but it does mark out, roughly, a general attitude.

The line of argument just considered may be called the argument from Innocuousness; I give it a name to distinguish it from another line of argument that starts from a different premise, but emerges somewhere nearby. I shall call it the Argument from Aesthetic Primacy.

Suppose there *are* side effects of aesthetic objects, and even serious and lasting and unpreventable ones. Still, it might be argued, they are completely separable from aesthetic value. Or if there is a connection, it is an inverse one: the higher the aesthetic value, the more likely is the object, from the Philistine point of view, to be unsettling, radical, vigorous, shocking, subversive—at first, anyway. That is because the great artist is always exploring new perspectives, inventing intense new regional qualities, putting things together in hitherto unheard-of ways; and if what he makes is good, it will be the enemy of some established good that is not quite as good.

If, therefore, we must choose between the moral and the aesthetic values of an aesthetic object, what principle shall guide our choice? This is no problem for Aestheticism. What is the good of life itself, except to be as fully alive as we can become—to burn with a hard gemlike flame, to choose one crowded hour of glorious life, to seize experience at its greatest magnitude? And this is precisely our experience of art; it is living in the best way we know how. Far from being a handmaiden to other goals, art gives us immediately, and richly, the best there is in life, intense awareness—it gives us what life itself aims at becoming, but seldom achieves outside of art. This part of the Aestheticist view is connected, of course, with a Psychological Definition of value; it claims that there *is* an end in itself, an intrinsic good, and that aesthetic experience is that good.

If this is true, then the undesirable side effects of art cannot really matter. They are inconveniences we have to put up with for the sake of the best, but, no matter how regrettable, they can never outweigh the aesthetic value of a really good aesthetic object. For a clear-cut example of this conclusion, see George Moore:

> What care I that some millions of wretched Israelites died under Pharaoh's lash or Egypt's sun? It was well that they died that I might have the pyramids to look on, or to fill a musing hour with wonderment. Is there one among us who would exchange them for the lives of the ignominious slaves that died? What care I that the virtue of some sixteen-year-old maid was the price paid for ingres' *La Source?* That the model died of drink and disease in the hospital is nothing when compared with the essential that I should have *La Source,* that exquisite dream of innocence.[3]

With its egotistic posturing, this passage cannot be taken as a philosophical thesis, but it contains a profound warning to those who, in their eagerness to exalt the arts, forget that they are after all human products of human activities, and must find their value in the whole context of human life. Such choices as Moore's have often enough been made. In our own day we have not forgotten the lyrical description by Mussolini's son-in-law of the "beauty" of a bomb exploding among a crowd of unarmed Ethiopians.

In its second form, Aestheticism is a pure and single-minded view, which maintains the supreme value of art over everything else. It is a form of fanaticism, which is just the fixing of any single good as a goal without regard to anything else. From an Instrumentalist point of view, it has no logical justification; it is a mere assertion, or even a mere prejudice, and I do not think any more needs to be said about it here.

Moralism The second point of view we were to consider may be given its ordinary name of *Moralism*. The moralistic critic, to put it first very roughly, is one who judges aesthetic objects solely, or chiefly, with respect to moral standards. We recognize this attitude in the critic who, when he writes of aesthetic objects, is interested wholly, or almost wholly, in their tendency to affect, for better or for worse, the behavior of those who are exposed to them, and whose judgment of the practical disposition of these objects—whether they should be bought or sold, exhibited or performed—is based upon his conclusion about this tendency.

Two somewhat different positions may be distinguished under the broad heading of Moralism; they are based upon different arguments and emerge with different implications. It will be best to deal with them separately.

The first argument starts back where we were in the preceding chapter, at the point where we asked whether aesthetic objects have a function. Suppose there is no such thing as aesthetic experience. Then there is nothing in particular that aesthetic objects can claim to do better than anything else. Now, if this is the case, there is no such thing as aesthetic value, according to the Instrumentalist analysis, and of course there can be no judgment of aesthetic objects on aesthetic grounds.

But that does not mean there can be no judgment of them at all. For we can still ask, "What do aesthetic objects do, if not better than anything else, then at least with reasonable efficiency?" Well, they arouse feelings, they get people worked up in one way or another. This seems a plausible answer. But what good is it to arouse feelings? There is no point in just getting people

[3]George Moore, *Confessions of a Young Man,* New York: Brentano's, 1917, pp. 144–145.

worked up; the value depends on *what* feelings you arouse (some are good, some not), on what you get people worked up *about*. But the distinction between desirable feelings (say love, religious faith, a sense of human brotherhood) and undesirable ones (hatred of others and of oneself, mistrust, fear) is a moral distinction. And so the whole, apparently aesthetic, question whether a particular aesthetic object is a good one or not is reduced to the (moral) question whether the feelings it arouses are good or bad. Let us call this the Argument from Reduction.[4]

We need not follow out here the many important and interesting consequences of the Argument from Reduction; evidently it entails a drastic overhaul of the point of view presented above in Chapters X and XI. It means that all critical evaluation is moral evaluation, that moral questions are the only ones to be considered by the critic. Of course, according to the Moralistic view, he may deal with questions about technique, in so far as they are related to the effectiveness of the object in arousing feelings. But the object is to be judged in the end much as one would judge propaganda; and indeed, there is no fundamental distinction. The qualifications of the critic will be primarily that he have the right moral code or system, and that he be able to make correct predictions of the psychological effects of aesthetic objects. To apply this method wholesale to famous aesthetic objects would, as Tolstoy showed, result in a radical revision of the established comparative ratings, with *Uncle Tom's Cabin*, for example, standing higher than *Hamlet*.

The Argument from Reduction, I think, cannot be accepted. Aesthetic value is not to be analyzed away, for it exists as a distinct kind of value. There is, however, a second argument, the Argument from Correlation,[5] which is used by Moralists of a somewhat different school from the Reductionists. Grant that there is such a thing as aesthetic value, distinct from moral value, but suppose the degree of aesthetic value to depend upon the degree of moral value in some way. Suppose, in other words, that aesthetic objects with a low moral value must be of low aesthetic value, and those of high moral value must be good aesthetic objects. If there is such a correspondence, or correlation, then the critic does not have to concern himself with aesthetic value, but can reach his judgment on moral grounds alone. For even if the correlation is not perfect, he will hold that the deviations are negligible. . . .

Moralistic critics often say that a morally bad poem cannot be a good poem, but they are less likely to claim that a morally good poem cannot be a bad poem. Some of them, too, would be willing to yield to the skepticism of the Aestheticist view about the moral effects of music and nonrepresentational painting, but there are Moralist critics who would apply their categories across the whole field: music may minister to lasciviousness or help to break down self-control, or on the other hand it may strengthen martial courage or deepen moral resolution; even nonrepresentational painting may stimulate a relish for violence and lawlessness by means of its tense designs, garish color combinations, and sharply conflicting patterns, or it may encourage a cool love of order

[4]It is, I take it, one of the important arguments of Plato and Tolstoy.
[5]This is roughly the argument of Ruskin, J. W. R. Purser, L. A. Reid, Yvor Winters, and others.

and decorum and a calm joy in self-discipline. To make out the Argument from Correlation, then, we would have to show that the musical and visual designs that promote positive moral values are those that are more unified, and hence better as aesthetic objects, while the most morally destructive music and painting is that which is most confused.

The argument, indeed, has traditionally relied heavily upon a supposed connection between moral order and aesthetic order, and no doubt there is a deep and profound analogy between them. Many of the regional qualities we find in art are most aptly, but of course metaphorically, named by qualities taken over from the moral aspects of human nature: they are "disciplined," "decisive," "decorous," "controlled," "sound," "strong," "calm," "bold," "healthy," to cite only positive terms. But an analogy is not a causal connection. To prove that decorous music makes us behave decorously, it is not enough to point out the similarity between the music and the hoped-for behavior. Music may be, as St. Augustine said, an image of the moral order, but it does not follow that the better the music the more free it is from undesirable side effects. As far as music and painting are concerned, we do not as yet have a correlation of moral and aesthetic value.

When we turn to representational objects, we can admit more plausibility in the claim that there are moral or immoral effects. These effects are constantly exaggerated by the Puritan, who judges other people's reactions by his own excessive ones, but there is no question that a picture can be a powerful sexual stimulation. And there is common-sense evidence here to support, in a rough way, the Argument from Correlation: generally speaking, the pictures designed for sexual stimulation, whether mild, as in advertisements, or more vigorous, as in pornographic photographs, tend to be poor as visual designs, and those works that are great as visual designs tend not to be so effective in their sexual side effects. The better the design the more likely it is to hold attention to itself, and inhibit reverie and association, but of course there is no *necessary* connection. An obscene picture could be as great as Cézanne or Raphael at their best, though we might find it hard to pay attention to its greatness.

It is in literature and in mass arts like the movies that the side effects of art are most clearly established. Perhaps we can agree with the Moralist that those movies that have the most unfortunate effects, morally speaking, are very often among the very poorest, aesthetically speaking. They are high in entertainment value, apparently, but borderline cases as far as their aesthetic value goes. But the correlation is far from complete.

It is sometimes difficult to decide which of the two arguments the Moralist is using when he talks about aesthetic objects. There is always in his tone the suspicion of a disparagement of, or insensitivity to, aesthetic value (the Argument from Reduction). Consider again the group sculpture, *The American Family*, by Bernard Rosenthal, which was referred to in the Introduction to this book. Some of its critics—those who wanted it to depict the police in action— seemed not to care about aesthetic value at all. On the other hand, the President of the National Sculpture Society, a conservative organization of academic sculptors, wrote to *The New York Times* on March 11, 1955, that it was "really not sculpture, but a metallic monstrosity," which placed it among "the new vestiges of a confused culture that will surely prove deleterious to us

morally." His view seems to have been that sculpture cannot be good sculpture if its moral effects are bad, though he did not explain what harm the statue would do. . . .

So far we have been considering the side effects of art, and the view of them taken by Moralism and Aestheticism. But we have so far left one fundamental problem unexplored. The question was raised whether aesthetic objects have inherent effects that are themselves of great worth. One possible answer—the Aristotelian catharsis—was sketched, by way of illustration. But its truth or falsity was not discussed; it remained hypothetical. Yet evidently our answer to this question is fundamental to any final decision about the elements of truth and falsity in Aestheticism and moralism, and the time has now arrived when the question must be faced. This we shall do in the following, and final, section.

The Inherent Values of Art

In the final analysis, then, what good is art? This question, the bluntest and most far-reaching of all questions in the philosophy of art, is many things to many people. It can be asked skeptically by the practical man who has no doubt that the improvement of plumbing, the control of disease, and the development of automotive engineering are ingredients of progress and civilization, but has a hard time fitting concertos, water colors, and lyric poetry into the picture. Not that he would deny these to people who care for them, but he cannot see that they need to be considered in thinking broadly about the basic needs of society. It can be asked ironically by the Aestheticist, who is equally skeptical of plumbing and automatic gearshifts, as in Théophile Gautier's famous Preface to *Mademoiselle de Maupin*:

> What is the good of music? of painting? Who would be foolish enough to prefer Mozart to Monsieur Carrel,[6] or Michelangelo to the inventor of white mustard?
>
> Nothing is truly beautiful unless it can never be of any use whatsoever.

Have aesthetic objects "no more consequence than a dozen oysters and a pint of Montrachet"?[7]

But whatever its tone, the question deserves an answer. For it goes deep into the philosophy of art. Let us begin by considering what kind of answer it requires. Plumbing, medicine, and automobiles, we may assume, make a contribution to human welfare. They have special functions, but the ends they directly serve are means to many other ends, and there is little doubt of their justification, even though sometimes they may be put to bad uses. Aesthetic objects differ from those directly utilitarian objects in that their immediate

[6]Armand Carrel (1800–1836), a well-known journalist, was killed in a duel the same year that *Mademoiselle de Maupin* appeared. Gautier presumably thought of him as a man who used the art of writing to serve political and social ends.

[7]W. Somerset Maugham, *The Summing Up*, Baltimore: Penguin, 1938, p. 214. See the whole of sec. 76.

function is only to provide a certain kind of experience that can be enjoyed in itself. Can we show that the having of this aesthetic experience is, in turn, justified by longer-range effects that such experience has upon us—in other words, that aesthetic experience makes its own contribution to human welfare?

The question What good is art? probably ought to be divided into two questions, of which the second is the one that concerns us most. What good does the act of creating an aesthetic object do to the creator himself? And what good does the finished aesthetic object do to those who experience it? As regards the first of these questions, our knowledge is limited, but there is something to go on. It makes a considerable difference, however, whether you are talking about the professional creative artist—by this I mean not necessarily one who makes an adequate living at it, but one who has made it his life work—or the amateur. Of course there is no sharp line between them, because the desire to compose music or paint pictures may have any degree of depth. Nevertheless, there are two different kinds of utility involved.

It is almost absurd to ask what good it does the professional creator to do what he does—with an environment that makes it feasible at all, he will find that he cannot help himself. His motivation, and his reward, are out of the common run, for the objects he creates insist upon their existence, and wring themselves out of him in a way that absorbs him completely. His satisfactions are probably not utterly different from those of other kinds of creators—scientists, philosophers, organizers of social and economic institutions—when they can make something that bears the stamp of great goodness, by summoning up and concentrating all their powers.

For the amateur, the dilettante or dabbler, the rewards are different, though they may also be great in their own way. To perform on a musical instrument, to dance, to make up a song, to write stories and poems, to play around with oil paints seems quite clearly to have very beneficial psychological effects upon those who can be encouraged to undertake such activities, even if the results are of little aesthetic value. In recent years educators have widely recognized this fact, and it is pretty much taken for granted now that instruction in music and the fine arts, and participation in plays and concerts, are an important part of elementary and secondary education. Psychologists and psychiatrists may not yet be certain of the exact manner in which creative activity works its effects, but it seems to release pent-up energy, work off frustrations, lessen tensions, restore a sense of balance and perspective, and in these ways promote conditions of mental health. Much of the Aristotelian theory of catharsis, which was summarized in the preceding section, seems to apply here. And indeed some, though not all, of the benefits of art may come as well from producing an aesthetic object that is only fair as from experiencing one that is great.

Even if the specific value of the arts were limited to their value for the creators themselves, there would be ample justification for putting a good deal of social effort into promoting them—helping everyone to become a painter, a musician, a writer as far as it lies in him to do so. And if the establishment of a National Advisory Council on the Arts, or, better, a United States Art Foundation, would provide the means of increasing education in the arts, it

would be well worth the cost. But the private value of artistic creation as mental therapy to the creator must be distinguished from its public value. Of course, the more a person is encouraged to be creative himself, the more he will appreciate and enjoy aesthetic objects created by others. So the two things are connected. But the second question is broader than the first.

Let us now turn to the worth of art to the consumer, so to speak. And let us use the term "inherent value" for the capacity of aesthetic objects to produce good inherent effects—that is, to produce desirable effects by means of the aesthetic experience they evoke. Admirers of the arts from early times have praised them in the highest terms for their inherent value; what we would now like to know is whether this praise is deserved. First of all, to begin very modestly, we do not know that aesthetic experience does people any *harm*. Perhaps it may be overdone, and produce an enervating condition of *fin de sièclism*, though we do not really know whether to blame the decadence of the Decadents on aesthetic objects, or simply to say that these objects failed to cure their deep-seated neuroses. But does aesthetic experience do people any *good*?

Effects of Aesthetic Objects It is to be expected in any branch of philosophy that the most searching questions have the least confident answers—not because search has not been diligent but because the questions are difficult. Tremendous claims have been put forth for the inherent values of art, and it will take much thorough and delicate psychological inquiry before they can be made good. They are not unsupported by evidence, only the evidence is scattered, uncertain, subject to distortion by faulty introspection and emotional bias. It will reflect the present state of our knowledge best, I think, if we set forth the main kinds of inherent value that have been ascribed to aesthetic objects, but in the form of predications rather than outright assertions. I believe that there is some truth in all of them, and enough evidence for some of them to justify the view that aesthetic objects have a very considerable inherent value; but at the same time the case for their inherent value is not complete, and there is much work to be done.[8]

Thus, we might say:

1. That aesthetic experience relieves tensions and quiets destructive impulses. This is the Aristotelian claim that we have already described; one note might be added. If Bertrand Russell was right when he said in his Nobel Prize acceptance speech that the love of excitement is one of the fundamental motives of man, then art may be valuable because it gives scope to this motive, which otherwise, in a civilized society that no longer hunts, sometimes plays its dangerous part in promoting social unrest and war. For, as Russell also said, the excitement of invention or artistic creation and the excitement of discovery including the discovery and exploration of a new complex work of art are two of the highest, purest, and most satisfying types of excitement. In this light, art would be a moral equivalent for violence.

2. That aesthetic experience resolves lesser conflicts within the self, and helps to create an integration, or harmony. When our attention is held by an aesthetic object and we are taken in hand by it, so to speak, we do often feel

[8]In drawing up this list, I have made use especially of Shelley, I. A. Richards, and John Dewey.

a remarkable kind of *clarification,* as though the jumble in our minds were being sorted out. At first there may be a simplification—nothing matters but this chord, or this melody; but later, as complexities arise, the clarity remains, for a place is made for them in a larger, but not less unified, structure. Suppose you are in a restless frame of mind, faced by several obligations that all seem to demand attention, but no one of which predominates to give you a singleness of purpose. Sometimes, under these circumstances, you may read a story, or fall into the contemplation of a picture, or hear a piece of music, and after a while, when you go back to your problems, you may find yourself in a very different state of mind, clearer and more decisive. This is the exhilaration, the tonic effect, of art.

3. That aesthetic experience refines perception and discrimination. Of course we can improve our discrimination of color-tones and musical pitch by practice—that is only saying that aesthetic experience makes you better at having aesthetic experiences. But aesthetic experience does call for an unusual degree of attention to subtle differences in regional quality, not only in the emotions and attitudes of characters in literature, but in the human qualities of paintings and musical compositions. If we can be made more sensitive and perceptive by aesthetic experience, then this would have a wide bearing upon all other aspects of our lives—our emotional relations with other people, for example.

4. That aesthetic experience develops the imagination, and along with it the ability to put oneself in the place of others. In the aesthetic experience we must be open to new qualities and new forms, and the ordinary worn grooves of routine response are broken and passed over. We know what it is to be free of the inhibitions that normally cut down the free play of inventive fancy. And perhaps there is a kind of training of the imagination which would even result in improved ability to think of original scientific hypotheses, to find new ways out of practical dilemmas, to understand more quickly what is going on in other people's minds. We may become more flexible in our responses, better able to adjust to novel situations and unexpected contingencies.

If aesthetic experience may be regarded as working upon the personality in these four ways, then even more remote effects might be predicted—which would also be, but indirectly, part of the inherent value of aesthetic objects. For example, it might be said:

5. That aesthetic experience is, to put it in medical terms, an aid to mental health, but perhaps more as a preventive measure than as a cure. A world in which people, in the normal course of events, found their streets and buildings and working places filled with harmonious shapes and colors, good for the eye and for the spirit; who spent part of each day listening to or performing musical compositions of high aesthetic value; who loved the subtlety of good language, and used it themselves for poetry and storytelling, would be a society, one might hope, in which many common neuroses and psychoses, some of which begin with mild symptoms, would not arise. It has not been tried, and we cannot say for sure, but the astonishing success of classical music concerts in England during World War II may be indirect evidence.

6. That aesthetic experience fosters mutual sympathy and understanding. If the previous predictions are true, we could expect aesthetic experience to

draw men together. This is not the same as saying that art is a form of communication, that we understand the Chinese through their art or the French through their novels. But if two people listen to the same music or see the same painting, in so far as they have learned to make similar responses, they share an experience. All shared experience helps to bring people together in friendship and mutual respect, but aesthetic objects play a special role in the world. The reason is partly practical: many aesthetic objects are more portable than waterfalls, caves, deserts, and earthquakes. But also, they represent a quintessence or distillation of certain qualities of experience, and any two people anywhere who enjoy one of these qualities have a bond between them.

7. That aesthetic experience offers an ideal for human life. This social role of the arts is hard to describe briefly. In aesthetic experience we have experience in which means and ends are so closely interrelated that we feel no separation between them. One thing leads to the next and finds its place in it; the end is immanent in the beginning, the beginning is carried up into the end. Such experience allows the least emptiness, monotony, frustration, lack of fulfillment, and despair—the qualities that cripple much of human life. One of the things that trouble us in our society is, according to some philosophers, the wide gap that often exists between means and ends. Much of labor is itself uninteresting, mechanical, and spiritually deadening, and the laborer has no way of seeing a meaningful connection between what he is doing and what the ultimate product will be—the way a craftsman making a chair can be guided at every step by a vivid realization of its relation to his goal. The means of life lose their satisfaction when the end-in-view is entirely distant and remote—the Saturday night binge, the retirement at sixty-five. But the ends, too, lose their value by the separation. The binge only becomes a wild release, followed by headache and remorse. The retirement brings unutterable boredom and a sense of uselessness. If some of the satisfyingness of the end could be brought into the means, and the means at every stage felt as carrying the significance of the end, we should have in life something more of the quality of aesthetic experience itself. Meanwhile, such experience holds before us a clue to what life can be like in its greatest richness and joy.

READING 41

INTRODUCTION

Why have there been no great women artists? Some have argued that the rarity of great female artists is in fact an illusion: that there have been plenty of them, but that they have been ignored, with the result that they and their work have disappeared from history. Others have argued that the true greatness of women artists is a peculiarly *female* greatness: again, then, it is not that there have been no great female artists but rather that their greatness has not been recognized by what have always been male-dominated institutions. In "Why Have There Been No Great

Women Artists?" (1971), Linda Nochlin, professor of art history at the Graduate Center of the City University of New York, argues that it is a mistake to think that the question can usefully be answered in either of these ways. We must begin, she says, by recognizing that the question itself is "simply the top tenth of an iceberg of misinterpretation and misconception," based on ideas about "genius" and "greatness" that amount to nothing more than "fairy tale and self-fulfilling prophecy." (Christine Battersby has traced a number of such fairy tales and prophecies in her book *Gender and Genius*, two chapters of which are reprinted in Section 1.) Once one has recognized this, argues Nochlin, it is possible to raise the question in a helpful way. And the answer, she suggests, "lies not in the nature of individual genius or the lack of it, but in the nature of given social institutions and what they forbid or encourage." In making this case, Nochlin demonstrates that any consideration of the roles of art in culture, and of the relationship between art and morality, overlooks the institutions of art, and the social circumstances of its creation and reception, at its peril.

Why Have There Been No Great Women Artists?

Linda Nochlin

While the recent upsurge of feminist activity in this country has indeed been a liberating one, its force has been chiefly emotional—personal, psychological, and subjective—centered, like the other radical movements to which it is related, on the present and its immediate needs, rather than on historical analysis of the basic intellectual issues which the feminist attack on the status quo automatically raises.[1] Like any revolution, however, the feminist one ultimately must come to grips with the intellectual and ideological basis of the various intellectual or scholarly disciplines—history, philosophy, sociology, psychology, etc.—in the same way that it questions the ideologies of present social institutions. If, as John Stuart Mill suggested, we tend to accept whatever *is* as natural, this is just as true in the realm of academic investigation as it is in our social arrangements. In the former, too, "natural" assumptions must be questioned and the mythic basis of much so-called fact brought to light. And it is here that the very position of woman as an acknowledged outsider, the maverick "she" instead of the presumably neutral "one"—in reality the white-male-position-accepted-as-natural, or the hidden "he" as the subject of all scholarly predicates—is a decided advantage, rather than merely a hindrance or a subjective distortion.

In the field of art history, the white Western male viewpoint, unconsciously accepted as *the* viewpoint of the art historian, may—and does—prove to be inadequate not merely on moral and ethical grounds, or because it is elitist, but on purely intellectual ones. In revealing the failure of much academic art history, and a great deal of history in general, to take account of the unac-

[1]Kate Millett's *Sexual Politics*, New York, 1970, and Mary Ellman's *Thinking About Women*, New York, 1968, provide notable exceptions.

knowledged value system, the very *presence* of an intruding subject in histor-
ical investigation, the feminist critique at the same time lays bare its concep-
tual smugness, its meta-historical naïveté. At a moment when all disciplines
are becoming more self-conscious, more aware of the nature of their presup-
positions as exhibited in the very languages and structures of the various fields
of scholarship, such uncritical acceptance of "what is" as "natural" may be
intellectually fatal. Just as Mill saw male domination as one of a long series of
social injustices that had to be overcome if a truly just social order were to be
created, so we may see the unstated domination of white male subjectivity as
one in a series of intellectual distortions which must be corrected in order to
achieve a more adequate and accurate view of historical situations.

It is the engaged feminist intellect (like John Stuart Mill's) that can pierce
through the cultural-ideological limitations of the time and its specific "pro-
fessionalism" to reveal biases and inadequacies not merely in dealing with the
question of women, but in the very way of formulating the crucial questions
of the discipline as a whole. Thus, the so-called woman question, far from
being a minor, peripheral, and laughably provincial sub-issue grafted on to a
serious, established discipline, can become a catalyst, an intellectual instru-
ment, probing basic and "natural" assumptions, providing a paradigm for
other kinds of internal questioning, and in turn providing links with para-
digms established by radical approaches in other fields. Even a simple ques-
tion like "Why have there been no great women artists?" can, if answered ade-
quately, create a sort of chain reaction, expanding not merely to encompass
the accepted assumptions of the single field, but outward to embrace history
and the social sciences, or even psychology and literature, and thereby, from
the outset, can challenge the assumption that the traditional divisions of intel-
lectual inquiry are still adequate to deal with the meaningful questions of our
time, rather than the merely convenient or self-generated ones.

Let us, for example, examine the implications of that perennial question
(one can, of course, substitute almost any field of human endeavor, with
appropriate changes in phrasing): "Well, if women really *are* equal to men,
why have there never been any great women artists (or composers, or math-
ematicians, or philosophers, or so few of the same)?"

"Why have there been no great women artists?" The question tolls
reproachfully in the background of most discussions of the so-called woman
problem. But like so many other so-called questions involved in the feminist
"controversy," it falsifies the nature of the issue at the same time that it insid-
iously supplies its own answer: "There are no great women artists because
women are incapable of greatness."

The assumptions behind such a question are varied in range and sophis-
tication, running anywhere from "scientifically proven" demonstrations of the
inability of human beings with wombs rather than penises to create anything
significant, to relatively open-minded wonderment that women, despite so
many years of near-equality—and after all, a lot of men have had their disad-
vantages too—have still not achieved anything of exceptional significance in
the visual arts.

The feminist's first reaction is to swallow the bait, hook, line and sinker,
and to attempt to answer the question as it is put: that is, to dig up examples

of worthy or insufficiently appreciated women artists throughout history; to rehabilitate rather modest, if interesting and productive careers; to "rediscover" forgotten flower painters or David followers and make out a case for them; to demonstrate that Berthe Morisot was really less dependent upon Manet than one had been led to think—in other words, to engage in the normal activity of the specialist scholar who makes a case for the importance of his very own neglected or minor master. Such attempts, whether undertaken from a feminist point of view, like the ambitious article on women artists which appeared in the 1858 *Westminster Review*,[2] or more recent scholarly studies on such artists as Angelica Kauffmann and Artemisia Gentileschi,[3] are certainly worth the effort, both in adding to our knowledge of women's achievement and of art history generally. But they do nothing to question the assumptions lying behind the question "Why have there been no great women artists?" On the contrary, by attempting to answer it, they tacitly reinforce its negative implications.

Another attempt to answer the question involves shifting the ground slightly and asserting, as some contemporary feminists do, that there is a different kind of "greatness" for women's art than for men's, thereby postulating the existence of a distinctive and recognizable feminine style, different both in its formal and its expressive qualities and based on the special character of women's situation and experience.

This, on the surface of it, seems reasonable enough: in general, women's experience and situation in society, and hence as artists, is different from men's, and certainly the art produced by a group of consciously united and purposefully articulate women intent on bodying forth a group consciousness of feminine experience might indeed be stylistically identifiable as feminist, if not feminine, art. Unfortunately, though this remains within the realm of possibility it has so far not occurred. While the members of the Danube School, the followers of Caravaggio, the painters gathered around Gauguin at Pont-Aven, the Blue Rider, or the Cubists may be recognized by certain clearly defined stylistic or expressive qualities, no such common qualities of "femininity" would seem to link the styles of women artists generally, any more than such qualities can be said to link women writers, a case brilliantly argued, against the most devastating, and mutually contradictory, masculine critical clichés, by Mary Ellmann in her *Thinking about Women*.[4] No subtle essence of femininity would seem to link the work of Artemisia Gentileschi, Mme Vigée-Lebrun, Angelica Kauffmann, Rosa Bonheur, Berthe Morisot, Suzanne Valadon, Käthe Kollwitz, Barbara Hepworth, Georgia O'Keeffe, Sophie Taeuber-Arp, Helen Frankenthaler, Bridget Riley, Lee Bontecou, or Louise Nevelson, any more than that of Sappho, Marie de France, Jane Austen, Emily Brontë,

[2]"Women Artists." Review of *Die Frauen in die Kunstgeschichte* by Ernst Guhl in *The Westminster Review* (American Edition), LXX, July 1858, pp. 91–104. I am grateful to Elaine Showalter for having brought this review to my attention.

[3]See, for example, Peter S. Walch's excellent studies of Angelica Kauffmann or his unpublished doctoral dissertation, "Angelica Kauffmann," Princeton University, 1968, on the subject; for Artemisia Gentileschi, see R. Ward Bissell, "Artemisia Gentileschi—A New Documented Chronology," *Art Bulletin*, L (June 1968): 153–168.

[4]New York, 1968.

George Sand, George Eliot, Virginia Woolf, Gertrude Stein, Anaïs Nin, Emily Dickinson, Sylvia Plath, and Susan Sontag. In every instance, women artists and writers would seem to be closer to other artists and writers of their own period and outlook than they are to each other.

Women artists are more inward-looking, more delicate and nuanced in their treatment of their medium, it may be asserted. But which of the women artists cited above is more inward-turning than Redon, more subtle and nuanced in the handling of pigment than Corot? Is Fragonard more or less feminine than Mme Vigée-Lebrun? Or is it not more a question of the whole Rococo style of eighteenth-century France being "feminine," if judged in terms of a binary scale of "masculinity" versus "femininity"? Certainly, if daintiness, delicacy, and preciousness are to be counted as earmarks of a feminine style, there is nothing fragile about Rosa Bonheur's *Horse Fair,* nor dainty and introverted about Helen Frankenthaler's giant canvases. If women have turned to scenes of domestic life, or of children, so did Jan Steen, Chardin, and the Impressionists—Renoir and Monet as well as Morisot and Cassatt. In any case, the mere choice of a certain realm of subject matter, or the restriction to certain subjects, is not to be equated with a style, much less with some sort of quintessentially feminine style.

The problem lies not so much with some feminists' concept of what femininity is, but rather with their misconception—shared with the public at large—of what art is: with the naïve idea that art is the direct, personal expression of individual emotional experience, a translation of personal life into visual terms. Art is almost never that, great art never is. The making of art involves a self-consistent language of form, more or less dependent upon, or free from, given temporally defined conventions, schemata, or systems of notation, which have to be learned or worked out, either through teaching, apprenticeship, or a long period of individual experimentation. The language of art is, more materially, embodied in paint and line on canvas or paper, in stone or clay or plastic or metal—it is neither a sob story nor a confidential whisper.

The fact of the matter is that there have been no supremely great women artists, as far as we know, although there have been many interesting and very good ones who remain insufficiently investigated or appreciated; nor have there been any great Lithuanian jazz pianists, nor Eskimo tennis players, no matter how much we might wish there had been. That this should be the case is regrettable, but no amount of manipulating the historical or critical evidence will alter the situation; nor will accusations of male-chauvinist distortion of history. There *are* no women equivalents for Michelangelo or Rembrandt, Delacroix or Cézanne, Picasso or Matisse, or even, in very recent times, for de Kooning or Warhol, any more than there are black American equivalents for the same. If there actually were large numbers of "hidden" great women artists, or if there really should be different standards for women's art as opposed to men's—and one can't have it both ways—then what are feminists fighting for? If women have in fact achieved the same status as men in the arts, then the status quo is fine as it is.

But in actuality, as we all know, things as they are and as they have been, in the arts as in a hundred other areas, are stultifying, oppressive, and discouraging to all those, women among them, who did not have the good for-

tune to be born white, preferably middle class and, above all, male. The fault lies not in our stars, our hormones, our menstrual cycles, or our empty internal spaces, but in our institutions and our education—education understood to include everything that happens to us from the moment we enter this world of meaningful symbols, signs, and signals. The miracle is, in fact, that given the overwhelming odds against women, or blacks, that so many of both have managed to achieve so much sheer excellence, in those bailiwicks of white masculine prerogative like science, politics, or the arts.

It is when one really starts thinking about the implications of "Why have there been no great women artists?" that one begins to realize to what extent our consciousness of how things are in the world has been conditioned—and often falsified—by the way the most important questions are posed. We tend to take it for granted that there really is an East Asian Problem, a Poverty Problem, a Black Problem—and a Woman Problem. But first we must ask ourselves who is formulating these "questions," and then, what purposes such formulations may serve. (We may, of course, refresh our memories with the connotations of the Nazis' "Jewish Problem.") Indeed, in our time of instant communication, "problems" are rapidly formulated to rationalize the bad conscience of those with power: thus the problem posed by Americans in Vietnam and Cambodia is referred to by Americans as the "East Asian Problem," whereas East Asians may view it, more realistically, as the "American Problem"; the so-called Poverty Problem might more directly be viewed as the "Wealth Problem" by denizens of urban ghettos or rural wastelands; the same irony twists the White Problem into its opposite, a Black Problem; and the same inverse logic turns up in the formulation of our own present state of affairs as the "Woman Problem."

Now the "Woman Problem," like all human problems, so-called (and the very idea of calling anything to do with human beings a "problem" is, of course, a fairly recent one) is not amenable to "solution" at all, since what human problems involve is reinterpretation of the nature of the situation, or a radical alteration of stance or program *on the part of the "problems" themselves.* Thus women and their situation in the arts, as in other realms of endeavor, are not a "problem" to be viewed through the eyes of the dominant male power elite. Instead, *women* must conceive of themselves as potentially, if not actually, equal subjects, and must be willing to look the facts of their situation full in the face, without self-pity, or cop-outs; at the same time they must view their situation with that high degree of emotional and intellectual commitment necessary to create a world in which equal achievement will be not only made possible but actively encouraged by social institutions.

It is certainly not realistic to hope that a majority of men, in the arts or in any other field, will soon see the light and find that it is in their own self-interest to grant complete equality to women, as some feminists optimistically assert, or to maintain that men themselves will soon realize that they are diminished by denying themselves access to traditionally "feminine" realms and emotional reactions. After all, there are few areas that are really "denied" to men, if the level of operations demanded be transcendent, responsible, or rewarding enough: men who have a need for "feminine" involvement with

babies or children gain status as pediatricians or child psychologists, with a nurse (female) to do the more routine work; those who feel the urge for kitchen creativity may gain fame as master chefs; and, of course, men who yearn to fulfill themselves through what are often termed "feminine" artistic interests can find themselves as painters or sculptors, rather than as volunteer museum aides or part-time ceramists, as their female counterparts so often end up doing; as far as scholarship is concerned, how many men would be willing to change their jobs as teachers and researchers for those of unpaid, part-time research assistants and typists as well as full-time nannies and domestic workers?

Those who have privileges inevitably hold on to them, and hold tight, no matter how marginal the advantage involved, until compelled to bow to superior power of one sort or another.

Thus the question of women's equality—in art as in any other realm—devolves not upon the relative benevolence or ill-will of individual men, nor the self-confidence or abjectness of individual women, but rather on the very nature of our institutional structures themselves and the view of reality which they impose on the human beings who are part of them. As John Stuart Mill pointed out more than a century ago: "Everything which is usual appears natural. The subjection of women to men being a universal custom, any departure from it quite naturally appears unnatural."[5] Most men, despite lip service to equality, are reluctant to give up this "natural" order of things in which their advantages are so great; for women, the case is further complicated by the fact that, as Mill astutely pointed out, unlike other oppressed groups or castes, men demand of them not only submission but unqualified affection as well; thus women are often weakened by the internalized demands of the male-dominated society itself, as well as by a plethora of material goods and comforts: the middle-class woman has a great deal more to lose than her chains.

The question "Why have there been no great women artists?" is simply the top tenth of an iceberg of misinterpretation and misconception; beneath lies a vast dark bulk of shaky *idées reçues* about the nature of art and its situational concomitants, about the nature of human abilities in general and of human excellence in particular, and the role that the social order plays in all of this. While the "woman problem" as such may be a pseudo-issue, the misconceptions involved in the question "Why have there been no great women artists?" points to major areas of intellectual obfuscation beyond the specific political and ideological issues involved in the subjection of women. Basic to the question are many naïve, distorted, uncritical assumptions about the making of art in general, as well as the making of great art. These assumptions, conscious or unconscious, link together such unlikely superstars as Michelangelo and van Gogh, Raphael and Jackson Pollock under the rubric of "Great"—an honorific attested to by the number of scholarly monographs devoted to the artist in question—and the Great Artist is, of course, conceived of as one

[5]John Stuart Mill, *The Subjection of Women* (1869) in *Three Essays by John Stuart Mill*, World's Classics Series, London, 1966, p. 441.

who has "Genius"; Genius, in turn, is thought of as an atemporal and myste-
rious power somehow embedded in the person of the Great Artist.[6] Such ideas
are related to unquestioned, often unconscious, meta-historical premises that
make Hippolyte Taine's race-milieu-moment formulation of the dimensions of
historical thought seem a model of sophistication. But these assumptions are
intrinsic to a great deal of art-historical writing. It is no accident that the cru-
cial question of the conditions *generally* productive of great art has so rarely
been investigated, or that attempts to investigate such general problems have,
until fairly recently, been dismissed as unscholarly, too broad, or the province
of some other discipline, like sociology. To encourage a dispassionate, imper-
sonal, sociological, and institutionally oriented approach would reveal the
entire romantic, elitist, individual-glorifying, and monograph-producing sub-
structure upon which the profession of art history is based, and which has only
recently been called into question by a group of younger dissidents.

Underlying the question about woman as artist, then, we find the myth of
the Great Artist—subject of a hundred monographs, unique, godlike—bearing
within his person since birth a mysterious essence, rather like the golden
nugget in Mrs. Grass's chicken soup, called Genius or Talent, which, like mur-
der, must always out, no matter how unlikely or unpromising the circum-
stances.

The magical aura surrounding the representational arts and their creators
has, of course, given birth to myths since the earliest times. Interestingly
enough, the same magical abilities attributed by Pliny to the Greek sculptor
Lysippos in antiquity—the mysterious inner call in early youth, the lack of any
teacher but Nature herself—is repeated as late as the nineteenth century by
Max Buchon in his biography of Courbet. The supernatural powers of the artist
as imitator, his control of strong, possibly dangerous powers, have functioned
historically to set him off from others as a godlike creator, one who creates
Being out of nothing. The fairy tale of the discovery by an older artist or dis-
cerning patron of the Boy Wonder, usually in the guise of a lowly shepherd
boy, has been a stock-in-trade of artistic mythology ever since Vasari immor-
talized the young Giotto, discovered by the great Cimabue while the lad was
guarding his flocks, drawing sheep on a stone; Cimabue, overcome with admi-
ration for the realism of the drawing, immediately invited the humble youth
to be his pupil.[7] Through some mysterious coincidence, later artists including
Beccafumi, Andrea Sansovino, Andrea del Castagno, Mantegna, Zurbarán, and
Goya were all discovered in similar pastoral circumstances. Even when the
young Great Artist was not fortunate enough to come equipped with a flock

[6]For the relatively recent genesis of the emphasis on the artist as the nexus of esthetic experience,
see M. H. Abrams, *The Mirror and the Lamp: Romantic Theory and the Critical Tradition*, New York,
1953, and Maurice Z. Shroder, *Icarus: The Image of the Artist in French Romanticism*, Cambridge,
Massachusetts, 1961.

[7]A comparison with the parallel myth for women, the Cinderella story, is revealing: Cinderella
gains higher status on the basis of a passive, "sex-object" attribute—small feet—whereas the Boy
Wonder always proves himself through active accomplishment. For a thorough study of myths
about artists, see Ernst Kris and Otto Kurz. *Die Legende vom Künstler: Ein Geschichtlicher Versuch*,
Vienna, 1934.

of sheep, his talent always seems to have manifested itself very early, and independent of any external encouragement: Filippo Lippi and Poussin, Courbet and Monet are all reported to have drawn caricatures in the margins of their schoolbooks instead of studying the required subjects—we never, of course, hear about the youths who neglected their studies and scribbled in the margins of their notebooks without ever becoming anything more elevated than department-store clerks or shoe salesmen. The great Michelangelo himself, according to his biographer and pupil, Vasari, did more drawing than studying as a child. So pronounced was his talent, reports Vasari, that when his master, Ghirlandaio, absented himself momentarily from his work in Santa Maria Novella, and the young art student took the opportunity to draw "the scaffolding, trestles, pots of paint, brushes and the apprentices at their tasks" in this brief absence, he did it so skillfully that upon his return the master exclaimed: "This boy knows more than I do."

As is so often the case, such stories, which probably have some truth in them, tend both to reflect and perpetuate the attitudes they subsume. Even when based on fact, these myths about the early manifestations of genius are misleading. It is no doubt true, for example, that the young Picasso passed all the examinations for entrance to the Barcelona, and later to the Madrid, Academy of Art at the age of fifteen in but a single day, a feat of such difficulty that most candidates required a month of preparation. But one would like to find out more about similar precocious qualifiers for art academies who then went on to achieve nothing but mediocrity or failure—in whom, of course, art historians are uninterested—or to study in greater detail the role played by Picasso's art-professor father in the pictorial precocity of his son. What if Picasso had been born a girl? Would Señor Ruiz have paid as much attention or stimulated as much ambition for achievement in a little Pablita?

What is stressed in all these stories is the apparently miraculous, nondetermined, and asocial nature of artistic achievement; this semi-religious conception of the artist's role is elevated to hagiography in the nineteenth century, when art historians, critics, and, not least, some of the artists themselves tended to elevate the making of art into a substitute religion, the last bulwark of higher values in a materialistic world. The artist, in the nineteenth-century Saints' Legend, struggles against the most determined parental and social opposition, suffering the slings and arrows of social opprobrium like any Christian martyr, and ultimately succeeds against all odds—generally, alas, after his death—because from deep within himself radiates that mysterious, holy effulgence: Genius. Here we have the mad van Gogh, spinning out sunflowers despite epileptic seizures and near-starvation; Cézanne, braving paternal rejection and public scorn in order to revolutionize painting; Gauguin throwing away respectability and financial security with a single existential gesture to pursue his calling in the tropics; or Toulouse-Lautrec, dwarfed, crippled, and alcoholic, sacrificing his aristocratic birthright in favor of the squalid surroundings that provided him with inspiration.

Now no serious contemporary art historian takes such obvious fairy tales at their face value. Yet it is this sort of mythology about artistic achievement and its concomitants which forms the unconscious or unquestioned assump-

tions of scholars, no matter how many crumbs are thrown to social influences, ideas of the times, economic crises, and so on. Behind the most sophisticated investigations of great artists—more specifically, the art-historical monograph, which accepts the notion of the great artist as primary, and the social and institutional structures within which he lived and worked as mere secondary "influences" or "background"—lurks the golden-nugget theory of genius and the free-enterprise conception of individual achievement. On this basis, women's lack of major achievement in art may be formulated as a syllogism: If women had the golden nugget of artistic genius then it would reveal itself. But it has never revealed itself. Q.E.D. Women do not have the golden nugget of artistic genius. If Giotto, the obscure shepherd boy, and van Gogh with his fits could make it, why not women?

Yet as soon as one leaves behind the world of fairy tale and self-fulfilling prophecy and, instead, casts a dispassionate eye on the actual situations in which important art production has existed, in the total range of its social and institutional structures throughout history, one finds that the very questions which are fruitful or relevant for the historian to ask shape up rather differently. One would like to ask, for instance, from what social classes artists were most likely to come at different periods of art history, from what castes and subgroup. What proportion of painters and sculptors, or more specifically, of major painters and sculptors, came from families in which their fathers or other close relatives were painters and sculptors or engaged in related professions? As Nikolaus Pevsner points out in his discussion of the French Academy in the seventeenth and eighteenth centuries, the transmission of the artistic profession from father to son was considered a matter of course (as it was with the Coypels, the Coustous, the Van Loos, etc.); indeed, sons of academicians were exempted from the customary fees for lessons.[8] Despite the noteworthy and dramatically satisfying cases of the great father-rejecting *révoltés* of the nineteenth century, one might be forced to admit that a large proportion of artists, great and not-so-great, in the days when it was normal for sons to follow in their fathers' footsteps, had artist fathers. In the rank of major artists, the names of Holbein and Dürer, Raphael and Bernini, immediately spring to mind; even in our own times, one can cite the names of Picasso, Calder, Giacometti, and Wyeth as members of artist-families.

As far as the relationship of artistic occupation and social class is concerned, an interesting paradigm for the question "Why have there been no great women artists?" might well be provided by trying to answer the question "Why have there been no great artists from the aristocracy?" One can scarcely think, before the antitraditional nineteenth century at least, of any artist who sprang from the ranks of any more elevated class than the upper bourgeoisie; even in the nineteenth century, Degas came from the lower nobility—more like the haute bourgeoisie, in fact—and only Toulouse-Lautrec, metamorphosed into the ranks of the marginal by accidental deformity, could be said to have come from the loftier reaches of the upper classes. While the aristocracy has always provided the lion's share of the patronage and the audi-

[8]Nikolaus Pevsner, *Academies of Art, Past and Present*. Cambridge, 1940, p. 96f.

ence for art—as, indeed, the aristocracy of wealth does even in our more democratic days—it has contributed little beyond amateurish efforts to the creation of art itself, despite the fact that aristocrats (like many women) have had more than their share of educational advantages, plenty of leisure and, indeed, like women, were often encouraged to dabble in the arts and even develop into respectable amateurs, like Napoleon III's cousin, the Princess Mathilde, who exhibited at the official Salons, or Queen Victoria, who, with Prince Albert, studied art with no less a figure than Landseer himself. Could it be that the little golden nugget—genius—is missing from the aristocratic makeup in the same way that it is from the feminine psyche? Or rather, is it not that the kinds of demands and expectations placed before both aristocrats and women— the amount of time necessarily devoted to social functions, the very kinds of activities demanded—simply made total devotion to professional art production out of the question, indeed unthinkable, both for upper-class males and for women generally, rather than its being a question of genius and talent?

When the right questions are asked about the conditions for producing art, of which the production of great art is a subtopic, there will no doubt have to be some discussion of the situational concomitants of intelligence and talent generally, not merely of artistic genius. Piaget and others have stressed in their genetic epistemology that in the development of reason and in the unfolding of imagination in young children, intelligence—or, by implication, what we choose to call genius—is a dynamic activity rather than a static essence, and an activity of a subject *in a situation*. As further investigations in the field of child development imply, these abilities, or this intelligence, are built up minutely, step by step, from infancy onward, and the patterns of adaptation-accommodation may be established so early within the subject-in-an-environment that they may indeed *appear* to be innate to the unsophisticated observer. Such investigations imply that, even aside from meta-historical reasons, scholars will have to abandon the notion, consciously articulated or not, of individual genius as innate, and as primary to the creation of art.[9]

The question "Why have there been no great women artists?" has led us to the conclusion, so far, that art is not a free, autonomous activity of a superendowed individual, "influenced" by previous artists, and, more vaguely and superficially, by "social forces," but rather, that the total situation of art making, both in terms of the development of the art maker and in the nature and quality of the work of art itself, occur in a social situation, are integral elements of this social structure, and are mediated and determined by specific and definable social institutions, be they art academies, systems of patronage, mythologies of the divine creator, artist as he-man or social outcast.

[9]Contemporary directions—earthworks, conceptual art, art as information, etc.—certainly point *away* from emphasis on the individual genius and his salable products; in art history, Harrison C. and Cynthia A. White's *Canvases and Careers: Institutional Change in the French Painting World*, New York, 1965, opens up a fruitful new direction of investigation, as did Nikolaus Pevsner's pioneering *Academies of Art*. Ernst Gombrich and Pierre Francastel, in their very different ways, always have tended to view art and the artist as part of a total situation rather than in lofty isolation.

The Question of the Nude

We can now approach our question from a more reasonable standpoint, since it seems probable that the answer to why there have been no great women artists lies not in the nature of individual genius or the lack of it, but in the nature of given social institutions and what they forbid or encourage in various classes or groups of individuals. Let us first examine such a simple, but critical, issue as availability of the nude model to aspiring women artists, in the period extending from the Renaissance until near the end of the nineteenth century, a period in which careful and prolonged study of the nude model was essential to the training of every young artist, to the production of any work with pretentions to grandeur, and to the very essence of History Painting, generally accepted as the highest category of art. Indeed, it was argued by defenders of traditional painting in the nineteenth century that there could be no great painting *with* clothed figures, since costume inevitably destroyed both the temporal universality and the classical idealization required by great art. Needless to say, central to the training programs of the academies since their inception late in the sixteenth and early in the seventeenth centuries, was life drawing from the nude, generally male, model. In addition, groups of artists and their pupils often met privately for life drawing sessions from the nude model in their studios. While individual artists and private academies employed the female model extensively, the female nude was forbidden in almost all public art schools as late as 1850 and after—a state of affairs which Pevsner rightly designates as "hardly believable."[10] Far more believable, unfortunately, was the complete unavailability to the aspiring woman artist of *any* nude models at all, male or female. As late as 1893, "lady" students were not admitted to life drawing at the Royal Academy in London, and even when they were, after that date, the model had to be "partially draped."[11]

A brief survey of representations of life-drawing sessions reveals: an all-male clientele drawing from the female nude in Rembrandt's studio; men working from male nudes in eighteenth-century representations of academic instruction in The Hague and Vienna; men working from the seated male nude in Boilly's charming painting of the interior of Houdon's studio at the beginning of the nineteenth century. Léon-Mathieu Cochereau's scrupulously veristic *Interior of David's Studio*, exhibited in the Salon of 1814, reveals a group of young men diligently drawing or painting from a male nude model, whose discarded shoes may be seen before the models' stand.

The very plethora of surviving "Academies"—detailed, painstaking studies from the nude studio model—in the youthful oeuvre of artists down through the time of Seurat and well into the twentieth century, attests to the central importance of this branch of study in the pedagogy and development of the talented beginner. The formal academic program itself normally proceeded, as a matter of course, from copying from drawings and engravings,

[10]Female models were introduced in the life class in Berlin in 1875, in Stockholm in 1839, in Naples in 1870, at the Royal College of Art in London after 1875. Pevsner, op. cit., p. 231. Female models at the Pennsylvania Academy of the Fine Arts wore masks to hide their identity as late as about 1866—as attested to in a charcoal drawing by Thomas Eakins—if not later.

[11]Pevsner, op. cit., p. 231.

to drawing from casts of famous works of sculpture, to drawing from the living model. To be deprived of this ultimate stage of training meant, in effect, to be deprived of the possibility of creating major art works, unless one were a very ingenious lady indeed, or simply, as most of the women aspiring to be painters ultimately did, restricting oneself to the "minor" fields of portraiture, genre, landscape, or still life. It is rather as though a medical student were denied the opportunity to dissect or even examine the naked human body.

There exist, to my knowledge, no historical representations of artists drawing from the nude model which include women in any role but that of the nude model itself, an interesting commentary on rules of propriety: that is, it is all right for a ("low," of course) woman to reveal herself naked-as-an-object for a group of men, but forbidden to a woman to participate in the active study and recording of naked-man-as-an-object, or even of a fellow woman. An amusing example of this taboo on confronting a dressed lady with a naked man is embodied in a group portrait of the members of the Royal Academy in London in 1772, represented by Zoffany as gathered in the life room before two nude male models: all the distinguished members are present with but one noteworthy exception—the single female member, the renowned Angelica Kauffmann, who, for propriety's sake, is merely present in effigy, in the form of a portrait hanging on the wall. A slightly earlier drawing, *Ladies in the Studio* by the Polish artist Daniel Chodowiecki, shows the ladies portraying a modestly dressed member of their sex. In a lithograph dating from the relatively liberated epoch following the French Revolution, the lithographer Marlet has represented some women sketchers in a group of students working from the male model, but the model himself has been chastely provided with what appears to be a pair of bathing trunks, a garment hardly conducive to a sense of classical elevation; no doubt such license was considered daring in its day, and the young ladies in question suspected of doubtful morals, but even this liberated state of affairs seems to have lasted only a short while. In an English stereoscopic color view of the interior of a studio of about 1865, the standing, bearded male model is so heavily draped that not an iota of his anatomy escapes from the discreet toga, save for a single bare shoulder and arm: even so, he obviously had the grace to avert his eyes in the presence of the crinoline-clad young sketchers.

The women in the Women's Modeling Class at the Pennsylvania Academy were evidently not allowed even this modest privilege. A photograph by Thomas Eakins of about 1885 reveals these students modeling from a cow (bull? ox? the nether regions are obscure in the photograph), a naked cow to be sure, perhaps a daring liberty when one considers that even piano legs might be concealed beneath pantalettes during this era. (The idea of introducing a bovine model into the artist's studio stems from Courbet, who brought a bull into his short-lived studio academy in the 1860s). Only at the very end of the nineteenth century, in the relatively liberated and open atmosphere of Repin's studio and circle in Russia, do we find representations of women art students working uninhibitedly from the nude—the female model, to be sure—in the company of men. Even in this case, it must be noted that certain photographs represent a private sketch group meeting in one of the women artists' homes; in another, the model is draped; and the large group portrait,

a cooperative effort by two men and two women students of Repin's, is an imaginary gathering together of all of the Russian realist's pupils, past and present, rather than a realistic studio view.

I have gone into the question of the availability of the nude model, a single aspect of the automatic, institutionally maintained discrimination against women, in such detail simply to demonstrate both the universality of this discrimination and its consequences, as well as the institutional rather than individual nature of but one facet of the necessary preparation for achieving mere proficiency, much less greatness, in the realm of art during a long period. One could equally well examine other dimensions of the situation, such as the apprenticeship system, the academic educational pattern which, in France especially, was almost the only key to success and which had a regular progression and set competitions, crowned by the Prix de Rome which enabled the young winner to work in the French Academy in that city—unthinkable for women, of course—and for which women were unable to compete until the end of the nineteenth century, by which time, in fact, the whole academic system had lost its importance anyway. It seems clear, to take France in the nineteenth century as an example (a country which probably had a larger proportion of women artists than any other—that is to say, in terms of their percentage in the total number of artists exhibiting in the Salon), that "women were not accepted as professional painters."[12] In the middle of the century, there were only a third as many women as men artists, but even this mildly encouraging statistic is deceptive when we discover that out of this relatively meager number, *none* had attended that major stepping stone to artistic success, the École des Beaux-Arts, only 7 percent had received any official commission or had held any official office—and these might include the most menial sort of work—only 7 percent had ever received any Salon medal, and *none* had ever received the Legion of Honor.[13] Deprived of encouragements, educational facilities and rewards, it is almost incredible that a certain percentage of women did persevere and seek a profession in the arts.

It also becomes apparent why women were able to compete on far more equal terms with men—and even become innovators—in literature. While art making traditionally has demanded the learning of specific techniques and skills, in a certain sequence, in an institutional setting outside the home, as well as becoming familiar with a specific vocabulary of iconography and motifs, the same is by no means true for the poet or novelist. Anyone, even a woman, has to learn the language, can learn to read and write, and can commit personal experiences to paper in the privacy of one's room. Naturally this oversimplifies the real difficulties and complexities involved in creating good or great literature, whether by man or woman, but it still gives a clue as to the possibility of the existence of an Emily Brönte or an Emily Dickinson and the lack of their counterparts, at least until quite recently, in the visual arts.

Of course we have not gone into the "fringe" requirements for major artists, which would have been, for the most part, both psychically and socially closed to women, even if hypothetically they could have achieved the requi-

[12]H. C. and C. A. White, op. cit., p. 51.
[13]Ibid., Table 5.

site grandeur in the performance of their craft: in the Renaissance and after, the great artist, aside from participating in the affairs of an academy, might well be intimate with members of humanist circles with whom he could exchange ideas, establish suitable relationships with patrons, travel widely and freely, perhaps politic and intrigue; nor have we mentioned the sheer organizational acumen and ability involved in running a major studio-factory, like that of Rubens. An enormous amount of self-confidence and worldly knowledgeability, as well as a natural sense of well-earned dominance and power, was needed by the great *chef d'école,* both in the running of the production end of painting, and in the control and instruction of the numerous students and assistants.

The Lady's Accomplishment

In contrast to the single-mindedness and commitment demanded of a *chef d'école*, we might set the image of the "lady painter" established by nineteenth-century etiquette books and reinforced by the literature of the times. It is precisely the insistence upon a modest, proficient, self-demeaning level of amateurism as a "suitable accomplishment" for the well-brought-up young woman, who naturally would want to direct her major attention to the welfare of others—family and husband—that militated, and still militates, against any real accomplishment on the part of women. It is this emphasis which transforms serious commitment to frivolous self-indulgence, busy work, or occupational therapy, and today, more than ever, in suburban bastions of the feminine mystique, tends to distort the whole notion of what art is and what kind of social role it plays. In Mrs. Ellis's widely read *The Family Monitor and Domestic Guide,* published before the middle of the nineteenth century, a book of advice popular both in the United States and in England, women were warned against the snare of trying too hard to excel in any one thing:

> It must not be supposed that the writer is one who would advocate, as essential to woman, any very extraordinary degree of intellectual attainment, especially if confined to one particular branch of study. "I should like to excel in something" is a frequent and, to some extent, laudable expression; but in what does it originate, and to what does it tend? To be able to do a great many things tolerably well, is of infinitely more value to a woman, than to be able to excel in any one. By the former, she may render herself generally useful; by the latter, she may dazzle for an hour. By being apt, and tolerably well skilled in everything, she may fall into any situation in life with dignity and ease— by devoting her time to excellence in one, she may remain incapable of every other.
>
> So far as cleverness, learning, and knowledge are conducive to woman's moral excellence, they are therefore desirable, and no further. All that would occupy her mind to the exclusion of better things, all that would involve her in the mazes of flattery and admiration, all that would tend to draw away her thoughts from others and fix them on herself, ought to be avoided as an evil to her, however brilliant or attractive it may be in itself.[14]

[14]Mrs. Ellis, *The Daughters of England: Their Position in Society, Character, and Responsibilities* (1844) in *The Family Monitor,* New York, 1844, p. 35.

Lest we are tempted to laugh, we may refresh ourselves with more recent samples of exactly the same message cited in Betty Friedan's *Feminine Mystique,* or in the pages of recent issues of popular women's magazines.

The advice has a familiar ring: propped up by a bit of Freudianism and some tag-lines from the social sciences about the well-rounded personality, preparation for woman's chief career, marriage, and the unfemininity of deep involvement with work rather than sex, it is still the mainstay of the Feminine Mystique. Such an outlook helps guard men from unwanted competition in their "serious" professional activities and assures them of "well-rounded" assistance on the home front, so that they can have sex and family in addition to the fulfillment of their own specialized talents at the same time.

As far as painting specifically is concerned, Mrs. Ellis finds that it has one immediate advantage for the young lady over its rival branch of artistic activity, music—it is quiet and disturbs no one (this negative virtue, of course, would not be true of sculpture, but accomplishment with the hammer and chisel simply never occurs as a suitable accomplishment for the weaker sex); in addition, says Mrs. Ellis, "it [drawing] is an employment which beguiles the mind of many cares. . . . Drawing is, of all other occupations, the one most calculated to keep the mind from brooding upon self, and to maintain that general cheerfulness which is a part of social and domestic duty. . . . It can also," she adds, "be laid down and resumed, as circumstance or inclination may direct, and that without any serious loss."[15] Again, lest we feel that we have made a great deal of progress in this area in the past one hundred years, I might bring up the remark of a bright young doctor who, when the conversation turned to his wife and her friends "dabbling" in the arts, snorted: "Well, at least it keeps them out of trouble!" Now as in the nineteenth century, amateurism and lack of real commitment as well as snobbery and emphasis on chic on the part of women in their artistic "hobbies," feeds the contempt of the successful, professionally committed man who is engaged in "real" work and can, with a certain justice, point to his wife's lack of seriousness in her artistic activities. For such men, the "real" work of women is only that which directly or indirectly serves the family; any other commitment falls under the rubric of diversion, selfishness, egomania, or, at the unspoken extreme, castration. The circle is a vicious one, in which philistinism and frivolity mutually reenforce each other.

In literature, as in life, even if the woman's commitment to art was a serious one, she was expected to drop her career and give up this commitment at the behest of love and marriage: this lesson is, today as in the nineteenth century, still inculcated in young girls, directly or indirectly, from the moment they are born. Even the determined and successful heroine of Mrs. Craik's mid-nineteenth-century novel about feminine artistic success, *Olive,* a young woman who lives alone, strives for fame and independence, and actually supports herself through her art—such unfeminine behavior is at least partly excused by the fact that she is a cripple and automatically considers that marriage is denied to her—even Olive ultimately succumbs to the blandishments of love and marriage. To paraphrase the words of Patricia Thomson in *The Vic-*

[15]Ibid., pp. 38–39.

torian Heroine, Mrs. Craik, having shot her bolt in the course of her novel, is content, finally, to let her heroine, whose ultimate greatness the reader has never been able to doubt, sink gently into matrimony. "Of Olive, Mrs. Craik comments imperturbably that her husband's influence is to deprive the Scottish Academy of 'no one knew how many grand pictures.' "[16] Then as now, despite men's greater "tolerance," the choice for women seems always to be marriage *or* a career, i.e., solitude as the price of success *or* sex and companionship at the price of professional renunciation.

That achievement in the arts, as in any field of endeavor, demands struggle and sacrifice is undeniable; that this has certainly been true after the middle of the nineteenth century, when the traditional institutions of artistic support and patronage no longer fulfilled their customary obligations, is also undeniable. One has only to think of Delacroix, Courbet, Degas, van Gogh, and Toulouse-Lautrec as examples of great artists who gave up the distractions and obligations of family life, at least in part, so that they could pursue their artistic careers more singlemindedly. Yet none of them was automatically denied the pleasures of sex or companionship on account of this choice. Nor did they ever conceive that they had sacrificed their manhood or their sexual role on account of their singlemindedness in achieving professional fulfillment. But if the artist in question happened to be a woman, one thousand years of guilt, self-doubt, and objecthood would have been added to the undeniable difficulties of being an artist in the modern world.

The unconscious aura of titillation that arises from a visual representation of an aspiring woman artist in the mid-nineteenth century, Emily Mary Osborn's heartfelt painting, *Nameless and Friendless,* 1857, a canvas representing a poor but lovely and respectable young girl at a London art dealer, nervously awaiting the verdict of the pompous proprietor about the worth of her canvases while two ogling "art lovers" look on, is really not too different in its underlying assumptions from an overtly salacious work like Bompard's *Debut of the Model.* The theme in both is innocence, delicious feminine innocence, exposed to the world. It is the charming *vulnerability* of the young woman artist, like that of the hesitating model, which is really the subject of Osborn's painting, not the value of the young woman's work or her pride in it: the issue here is, as usual, sexual rather than serious. Always a model but never an artist might well have served as the motto of the seriously aspiring young woman in the arts of the nineteenth century.

Successes

But what of the small band of heroic women, who, throughout the ages, despite obstacles, have achieved preeminence, if not the pinnacles of grandeur of a Michelangelo, a Rembrandt, or a Picasso? Are there any qualities that may be said to have characterized them as a group and as individuals? While I cannot go into such an investigation in great detail in this article, I can point to a few striking characteristics of women artists generally: they all, almost without exception, were either the daughters of artist fathers, or, generally later, in

[16]Patricia Thomson, *The Victorian Heroine: A Changing Ideal,* London, 1956, p. 77.

the nineteenth and twentieth centuries, had a close personal connection with a stronger or more dominant male artistic personality. Neither of these characteristics is, of course, unusual for men artists, either, as we have indicated above in the case of artist fathers and sons: it is simply true almost *without exception* for their feminine counterparts, at least until quite recently. From the legendary sculptor, Sabina von Steinbach, in the thirteenth century, who, according to local tradition, was responsible for South Portal groups on the Cathedral of Strasbourg, down to Rosa Bonheur, the most renowned animal painter of the nineteenth century, and including such eminent women artists as Marietta Robusti, daughter of Tintoretto, Lavinia Fontana, Artemisia Gentileschi, Elizabeth Chéron, Mme Vigée-Lebrun, and Angelica Kauffmann—all, without exception, were the daughters of artists; in the nineteenth century, Berthe Morisot was closely associated with Manet, later marrying his brother, and Mary Cassatt based a good deal of her work on the style of her close friend Degas. Precisely the same breaking of traditional bonds and discarding of time-honored practices that permitted men artists to strike out in directions quite different from those of their fathers in the second half of the nineteenth century enabled women, with additional difficulties, to be sure, to strike out on their own as well. Many of our more recent women artists, like Suzanne Valadon, Paula Modersohn-Becker, Käthe Kollwitz, or Louise Nevelson, have come from nonartistic backgrounds, although many contemporary and near-contemporary women artists have married fellow artists.

It would be interesting to investigate the role of benign, if not outright encouraging, fathers in the formation of women professionals: both Käthe Kollwitz and Barbara Hepworth, for example, recall the influence of unusually sympathetic and supportive fathers on their artistic pursuits. In the absence of any thoroughgoing investigation, one can only gather impressionistic data about the presence or absence of rebellion against parental authority in women artists, and whether there may be more or less rebellion on the part of women artists than is true in the case of men or vice versa. One thing, however, is clear: for a woman to opt for a career at all, much less for a career in art, has required a certain amount of unconventionality, both in the past and at present; whether or not the woman artist rebels against or finds strength in the attitude of her family, she must in any case have a good strong streak of rebellion in her to make her way in the world of art at all, rather than submitting to the socially approved role of wife and mother, the only role to which every social institution consigns her automatically. It is only by adopting, however covertly, the "masculine" attributes of singlemindedness, concentration, tenaciousness, and absorption in ideas and craftsmanship for their own sake, that women have succeeded, and continue to succeed, in the world of art. . . .

Conclusion

I have tried to deal with one of the perennial questions used to challenge women's demand for true, rather than token, equality, by examining the whole erroneous intellectual substructure upon which the question "Why have there been no great women artists?" is based; by questioning the validity of the formulation of so-called problems in general and the "problem" of women specif-

ically; and then, by probing some of the limitations of the discipline of art history itself. By stressing the *institutional*—that is, the public—rather than the *individual*, or private, preconditions for achievement or the lack of it in the arts, I have tried to provide a paradigm for the investigation of other areas in the field. By examining in some detail a single instance of deprivation or disadvantage—the unavailability of nude models to women art students—I have suggested that it was indeed *institutionally* made impossible for women to achieve artistic excellence, or success, on the same footing as men, *no matter what* the potency of their so-called talent, or genius. The existence of a tiny band of successful, if not great, women artists throughout history does nothing to gainsay this fact, any more than does the existence of a few superstars or token achievers among the members of any minority groups. And while great achievement is rare and difficult at best, it is still rarer and more difficult if, while you work, you must at the same time wrestle with inner demons of self-doubt and guilt and outer monsters of ridicule or patronizing encouragement, neither of which have any specific connection with the quality of the art work as such.

What is important is that women face up to the reality of their history and of their present situation, without making excuses or puffing mediocrity. Disadvantage may indeed be an excuse; it is not, however, an intellectual position. Rather, using as a vantage point their situation as underdogs in the realm of grandeur, and outsiders in that of ideology, women can reveal institutional and intellectual weaknesses in general, and, at the same time that they destroy false consciousness, take part in the creation of institutions in which clear thought—and true greatness—are challenges open to anyone, man or woman, courageous enough to take the necessary risk, the leap into the unknown.